# Artistic Representation of Latin American Diversity: Sources and Collections

SALALM Secretariat
General Library
University of New Mexico

# Artistic Representation of Latin American Diversity: Sources and Collections

Papers of the Thirty-Fourth Annual Meeting of the
SEMINAR ON THE ACQUISITION OF
LATIN AMERICAN LIBRARY MATERIALS

Alderman Library
University of Virginia
Charlottesville, Virginia

May 31-June 5, 1989

Barbara J. Robinson
Editor

SALALM SECRETARIAT
General Library, University of New Mexico

ISBN: 0-917617-32-0

After decades of obscurity, the
world is finally discovering our work.

—Fernando Sziszlo
*Peruvian painter*

# Contents

## Part Five. Marginalized Peoples and Ideas

# Preface

The theme of the 1989 SALALM conference, "Artistic Representation of Latin American Diversity: Sources and Collections," focused on the visual arts in Latin America since Independence. For the new Latin American nations, the early 1800s also marked the beginning of the Modern Period in the arts. Certain Latin American countries have artistic traditions that cover twenty centuries. Choosing a theme centered on the arts since Independence, however, permitted analysis of new movements and influences from the nineteenth and twentieth centuries, with the carryover of pre-Columbian and colonial traditions. During these two centuries the visual arts played important roles in the search for and consolidation of national cultures and national identities. The results, as Elsa Barberena describes in "Investigación sobre arte latinoamericano," are a diversity of expressions and forms, derived from universal currents and nurtured by elements of "la magia, lo primitivo, lo ancestral, lo popular," but with distinctive unity or oneness in characteristics and features.

In the late 1980s a belated but welcome rediscovery of Latin American arts by the international art community, and by the general public outside Latin America, brought major ground-breaking exhibitions to Europe and the United States, the birth of new museum and art library art collections, and increasing publicity and commercial success for Latin American artists. Equally significant was the development of artistic infrastructures in several Latin American countries, appearance of quality art publications, new art reference sources and databases, and a growing recognition by students and scholars of the importance of Latin American visual images in instruction and research. It seemed timely, for these reasons, for a SALALM program on Latin America's rich and varied artistic resources.

During the six-day conference, those attending enjoyed fifteen panels and workshops, accompanied by a host of visual presentations, art exhibits, and a week-long film and video program on Latin American arts and artists. Tours and receptions at both Ash Lawn, President Monroe's home and museum, and at the University of

xiii

Virginia's Alderman Library and historic grounds, complemented the formal program.

Examination of the visual arts and images from Latin America involves much more than the study of aesthetic concerns. Throughout this volume the visual arts of the region are seen as primary source documents, touching a wide range of human activities. In Latin America the visual arts intertwine with history, sociology, literature, and politics, reflecting and absorbing the values, changes, and moods of their times. Papers in Part One discuss the often close, but not always favorable, relationship between the arts and the state, or arts and politics, which ranges from patronage and promotion, as in Mexico and Cuba, to suppression and neglect, as in Argentina, Chile, and Haiti. In these papers, and in others in Part Two, historians, art experts, literary scholars, and social scientists explore untapped materials—architecture, photographs, films, posters, paintings, and textiles—and demonstrate creative methods and approaches to the integration into their research of Latin American visual media.

Papers on three popular visual art forms which came of age in this century—photography, cinema, and poster art—outnumber those on traditional forms. This unintended bias or emphasis is not surprising, given the general fascination of our times with these forms, the current research trends, and the collecting interests of libraries and archives.

The problems of, and solutions for, intellectual and physical access to visual information are the subjects of other papers in Part Two and Part Three. Librarians and photo-archivists from the United States, Mexico, and Brazil give examples of projects on the organization, access, and preservation of visual documentation, and explore capabilities and limitations of electronic technologies, such as optical disks. As Stella de Sá Rêgo postulates in "Access to Photograph Collections," "the storage and dissemination of [visual] information is as useful as the information itself." David Levy summarizes the legal copyright issues surrounding the use of photographic and artistic works in the United States and Latin America.

Information on the general state of the book trade, bibliography, and dissemination of art publications from Latin America, and specifically from Mexico, Colombia, Bolivia, Central America, and the Caribbean, was the subject of a panel organized by SALALM Libreros, a new interest group. Many of the vendors and book exhibitors distributed catalogs and lists highlighting the arts. These lists and the bibliographies and bibliographical essays published herein are extremely useful selection tools for developing and strengthening collection in this often neglected field.

As the reference librarians' panel verifies, reference service in the arts still relies heavily on information tools outside the field of Latin American studies and on "browsing" sources. Inadequacies abound in index terminology and coverage of Latin American art publications in most of the elite sources and the standard databases, testimony of the subordinate and peripheral status accorded Latin American arts by the world art community. Related fields in the arts are treated by two authors who discuss the creative tensions between classical and popular music and performing arts and the published sources of information.

Two notable U.S. museum collections, the OAS museum in Washington, DC, and the Meadows Museum at Southern Methodist University in Dallas, are described in detail in Part Four; the first is devoted to Latin American art and the second to Spanish art. The U.S. perspective is counterbalanced by a paper discussing German interests since the mid-nineteenth century in Latin American picture archives and poster collections, which form integral parts of larger book collections at several institutions.

This conference continued the tradition of including nonthematic panels and papers on nonmainstream materials. The papers in Part Five, Marginalized Peoples and Ideas, convey important information for the development of quality and balanced research collections on Latin America. Intended as nonthematic offerings, several papers in this section, nonetheless, impart relevant information for collecting "marginalized" visual art and popular iconography. Peter Johnson's "Guidelines" suggests approaches to collecting posters, photographs, and other visual materials created on the fringes of the mainstream. Worth mentioning also is Cavan McCarthy's paper, which touches on the creative and popular cover art of Brazilian cordel literature. Papers from earlier sections feed into the topic of marginalized people and ideas, namely those on posters and Marta Domínguez Díaz's paper on "arte popular chileno."

The conference achieved a diversity of international perspectives and a balance of viewpoints between Latin American specialists— librarians, scholars, and bookdealers—and visual art experts—art and architecture historians, museum curators, and photo archivists—several of whom fall into both camps. Spontaneous and enthusiastic response to the theme from volunteer panelists and invited speakers meant fewer than usual nonthematic papers and workshops but confirmed that Latin Americanists and art experts had neglected for too long the visual arts of Latin America. This conference may be best remembered as SALALM's first, and it is hoped not the last, devoted to the arts in Latin America. Topics in the arts are too numerous to capsulize

comprehensively in one meeting. Interesting to note, it was also the first SALALM meeting at which CD-ROM and computerized databases were exhibited alongside books, videos, and other nonbook media, forecasting an exciting trend for SALALM conferences in the 1990s.

All but a few of the fifty speakers, panelists, and workshop participants contributed to these papers. The exclusions are generally visual presentations that did not easily lend themselves to formal papers or a printed format. The papers have been regrouped and only partly represent the original program sequence. The actual program is reproduced at the end of this volume.

I hope that these papers contribute to the definition of Latin American visual arts and offer to those, whose ways of seeing and evaluating are shaped by Western European cultures and values, additional frames of reference for evaluating the arts from Latin America and reasons for including them within the greater world of the arts.

Barbara J. Robinson

# Acknowledgments

SALALM extends gratitude and recognition to our hosts at University of Virginia's Alderman Library, to University Librarian Dr. Ray Frantz, Jr., and to the Local Arrangements Committee, chaired with Jeffersonian flair by C. Jared Loewenstein, and to the members of the committee: Jacqueline A. Rice, Kenneth O. Jensen, Linda L. Phillips, Rebecca A. Summerford, Carl C. Wuellner, and Margarita Jerabek Wuellner. Special credits go to Linda L. Phillips for her original cover monotype for the conference program and poster art and to Margarita Jerabek Wuellner for the graphic design and layout of the conference program, reproduced in facsimile at the end of this volume.

There would have been no conference, however, without the many participants—panel chairs; book, automation, and art exhibitors; rapporteurs; film and video distributors; Executive Board and committee members—most of whom are recognized individually in the conference program. My special thanks to Rachel Barreto Edensword for her many helpful suggestions during preparations for the conference which led us to Gerald Alexis and the Haitian art exhibit from the Fondation Plein Soleil in Port-au-Prince, directed by Françoise Ibeaux; to Deborah Schindler, printmaker, for the exhibit of contemporary Cuban prints by thirty-six artists from the Taller de Gráfica Experimental in Havana and to the Jefferson-Madison Regional Library for providing the exhibit site; to Argentine artist Marcelo Breitfeld for his exhibit of personal works; to Rhonda L. Neugebauer for organizing the film and video screenings; and to Robert M. Levine for the premier public showing of his videotape documentary *Through the Camera Lens: Views of Slavery in 19th-Century Brazil and the United States*. Everyone involved in the program helped make this SALALM conference a truly singular multimedia event.

I am personally thankful for the support during these many months from the University of Southern California Libraries, from Lynn Sipe, from my student assistants in the Boeckmann Center for Iberian and Latin American Studies, Gabriela García, Gwenn-Ael Lynn, and Marcos Soto, and from my family, especially Lisa and Hilton.

I also want to recognize the invaluable assistance with the final manuscript production from Barbara Valk, chair of SALALM's Editorial Board, from Teresa Joseph and Colleen Trujillo, copy editors, and from Barbara Trelease, typist.

# Part One

# Latin American Diversity in the Arts: Five Country Studies

El artista . . . tiene que estar al tanto de lo que está pasando, el artista debe ser como una antena que está percibiendo todo aquello que sucede en el momento . . .

—Rufino Tamayo
*Mexican painter*

# 1. El papel del gobierno mexicano en apoyo del desarrollo cultural

## Ana María Magaloni

Seguramente nos llevaría cuando menos varias horas analizar el papel del gobierno virreinal en el fomento de la arquitectura y de la pintura de 300 años de colonia en México. Al no haber bancos, mucho del patrimonio se volcaba a la construcción y al decorado de los palacios, conventos y edificios públicos. La huella es evidente. No hay más que caminar por las calles de cualquier ciudad de la Nueva España: México, Zacatecas, Morelia, Querétaro, Mérida, Oaxaca, Puebla, Guanajuato o Taxco. Da igual: en todas ellas hay edificios ricamente adornados y llenos de pinturas del siglo XVII o del XVIII.

El siglo XIX nos encuentra sumidos en constantes luchas y no es posible definir con tanta claridad, debido a ello, el papel del gobierno. Así pues, pasaremos de lleno al siglo XX, a partir del cual, nuevamente y ahora con más fuerza, el gobierno retoma con orgullo el papel que había ido adquiriendo desde los inicios de su identidad como nación separada de la península de origen, a mediados del siglo XVII.

A la fundación que hiciera Justo Sierra, el Ministro de Instrucción de una nueva universidad en 1910, asistieron como invitados de honor los representantes de la Sorbona (alma mater), de Salamanca (cortesía) y de California (ejemplo de modernidad). La Revolución Mexicana contiene un mensaje de democratización de la vida nacional mediante el sufragio que condujera a la representación popular. Parece ser que el lineamiento del Congreso Constituyente de 1917 como primer producto de ese mensaje fue la Constitución General de la República. Esto consistió en subrayar la importancia del conjunto social.

Durante el régimen de Alvaro Obregón, 1920–1924, se experimenta un fuerte empuje a la educación popular con José Vasconcelos al frente de la Secretaría de Educación Pública. En 1921 el presupuesto era de 15 millones de pesos y en 1923 ascendió a 35 millones. Múltiples caminos adquirió la distribución cultural con estos singulares hombres. Así teníamos a Valle Inclán en la ópera, a Gabriela Mistral, la ilustre poetisa chilena, becada por México para realizar los ideales de Vasconcelos, y al gran Diego Rivera en la pintura.

3

Durante el gobierno de Plutarco Elías Calles, 1924–1928, Manuel Gómez Morín, consejero del creador del "México Moderno", recomendaba al presidente y sus ministros que el gobierno le diera al pueblo algo más que bienes culturales artísticos y pedía, contradiciéndose, frutos materiales: carreteras, telégrafos, etc. Productos culturales del régimen fueron escuelas centrales agrícolas, como la escuela rural del "asceta" Moisés Sáenz, el que afirmaba que criar gallinas es una empresa tan importante como leer un poema, instaladas estas escuelas en iglesias y conventos desalojados; el Consejo Nacional de Economía; la Convención del Ramo Textil; una incipiente política habitacional; campañas de salud pública contra el alcoholismo y la mariguana; y el teatro popular de las carpas, la versión mexicana de la arquitectura funcional del "gringo".

El 17 de octubre de 1923, la Secretaría de Educación Pública hace suyo un programa: el de acción de las misiones culturales. Este programa deberá fundarse en el conocimiento de la región en que operan, de la población y del objeto de su misión: geografía regional, razas indígenas. Gabriela Mistral organiza unas propuestas sobre las actividades en las misiones de los maestros con el pueblo, con la finalidad de hacer que el indígena se sienta orgulloso de sus raíces y darle oportunidad a los maestros de ascender. Al final de los veinte la lucha por la autonomía universitaria con la aspiración ideológica de emancipar la universidad del gobierno y su caudillo.

En 1934 Lázaro Cárdenas lanza su candidatura presidencial y expone su plan sexenal. Es la época en que la población estudiantil de la preparatoria era casi de 1700 alumnos y en las universidades cerca de 6500. La cultura popular se incrementa con las reformas de Cárdenas. El presidente consolidó el poder de su gobierno, aprovechó el talento de su sucesor Avila Camacho y con ello dio lugar a una burocracia que creó instituciones propiciadoras de la cultura.

La educación superior para el desarrollo se vio fortalecida con la creación del Instituto Politécnico Nacional y una serie de acciones como los brigadistas, que hicieron trascender el ideal vasconceliano de hacer llegar la cultura a la mayoría del pueblo. El estado-educador inauguraba una modalidad: la difusión cultural mediante una gama de eventos bien promocionados como el teatro Guiñol, el Panzón Soto con su teatro de revista, el recién inaugurado Teatro de las Bellas Artes junto a las representaciones del llamado Quinto Sol en un estadio de la ciudad de México. Se estimuló la corriente del arte pobre de carpas. El propio José Clemente Orozco reconoce en este teatro el mayor influjo que de él obtuvo el muralismo.

Es la época en que irrumpen los medios de comunicación masiva en la radiofonía y en el cine, y se funda el Fondo de Cultura Económica. Se lucha por precisar el concepto de "cultura oficial", oscilando entre lo selecto, lo elitista o lo sofisticado y lo popular, lo populista o lo populachero.

En materia educativa, el régimen de Lázaro Cardenas tomó en cuenta las experiencias del Ateneo de la Juventud que en 1922 había fundado la Universidad Popular en el teatro Díaz de León y que en 1923 desaparecería sin conocer las nuevas corrientes de la pedagogía.

Es Narciso Bassols, Secretario de Educación Pública entre 1931 y 1934, quien opera la transformación de la educación en la Revolución en México. La creación del Instituto Politécnico en 1937 es un acontecimiento ya que ofrecerá carreras profesionales y oficios. Por su parte la Universidad Nacional pone en práctica con Gómez Morín "uno de los mejores estatutos que han normado el ejercicio de la docencia y la investigación". Desde entonces la idea de cultura se referiría a la producción artística y no a la cultura como cúmulo de conocimientos o sabiduría erudita.

Es en los cincuenta cuando los hechos culturales precisan sus ámbitos culturales; cuando por primera vez el crítico de arte Antonio Rodríguez publica desde Difusión Cultural del Instituto Politécnico la revista *Ciencia y Arte: Cultura*. Antes, al hablar de difusión cultural, se hacía referencia a la promoción de actos y eventos artísticos, dejando a un lado la actividad científica.

Durante el alemanismo se funda el Instituto Nacional de Bellas Artes y Literatura. Más tarde el gobierno de Gustavo Díaz Ordaz crea mediante decreto la Academia de Arte. Producto importante del régimen de Miguel Alemán fue la construcción de Ciudad Universitaria, inaugurada en 1954 en el cuarto centenario de la Real y Pontificia Universidad de México. Otro dato cultural importante es la inserción del medio televisivo en la vida política y social de México. En una visita de Alemán a Nueva York lo acompañan Manuel Barbachano y Salvador Novo a fin de que estudiaran los recursos de la televisión. Había dos aspectos a elegir—televisión a la europea (lo cultural) y televisión a la estadounidense (lo comercial).

En los cincuenta, durante la presidencia de Adolfo Ruiz Cortines, el director teatral Enrique Ruelas se translada a Guanajuato a proyectar un centro cultural hispanoamericano. Al cabo de una década surge el Festival Internacional Cervantino. Los entremeses cervantinos demostraron con Ruelas que la cultura bien trazada y dirigida puede operar cambios en la vida de una comunidad.

Durante el sexenio de Adolfo López Mateos se crea la Subsecretaría de la Cultura y al frente doña Amalia González Caballero de Castillo Ledón. Con ella se trató de incorporar a la mujer a niveles a los que tradicionalmente no tenía acceso. Salvador Novo la vuelve obra de teatro al crear "La Culta Dama". Amalia Hernández crea su Ballet Folclórico de México para proyectarse y proyectarlo mundialmente a través del premio del Festival de Naciones celebrado en París. Tuvo tanto éxito como antipatía de sus colegas.

La estafeta de difusión cultural pasó a la Universidad Nacional. En los años sesenta la Dirección General de Difusión Cultural de la Universidad Nacional Autónoma de México estableció el circuito cerrado de la comunicación transformadora: la *Revista de la Universidad*; ciclos de conferencias; visitas guiadas; talleres literarios; seminarios en torno a un tema o personaje; exposiciones de artes plásticas; teatro; cineclub; la serie discográfica "Voz viva de México"; Radio Universidad; y la Casa del Lago con Arreola y otros. Todos contribuyeron a la creación de un estudiante bien informado y por último la universidad abierta.

Es la época en que José Luis Cuevas dibuja seres ásperos en la recaptura de la humanidad perdida, así es como ve al mundo. También es la época del libro de texto gratuito; época en que el Instituto Nacional de Bellas Artes vivió una de sus mejores etapas. Aparte de la Olimpiada Cultural había la magna muestra plástica "Confrontación", organizada por Jorge Hernández Campos; la labor editorial excelente de Antonio Acevedo Escobedo; la actividad musical con Miguel García Mora; el teatro escolar de Xochitl Medina; el teatro trashumante; y la creación de la Compañía Nacional de Teatro en 1970. La cultura se vio fortalecida por la construcción de museos: Dos ejemplos son el de Antropología e Historia y el de Arte Moderno. Además fueron frecuentes las visitas de famosos conjuntos teatrales y ballets.

El régimen de Luis Echeverría es pródigo en reformas educacionales y en la apertura de centros de educación media y superior. La reforma emprendida por Luis Echeverría y llevada a cabo por su Secretario de Educación Pública, Victor Bravo Ahuja, incluye la realización de productos-productores de cultura, que tratan de atacar el problema: el Colegio de Bachilleres; Centros de Bachillerato Técnico, Industrial y de Servicios; la Universidad Autónoma Metropolitana; y el Consejo Nacional de Ciencia y Tecnología. En todas estas trata de que la juventud se informe. El gobierno que sucedió al anterior creó la Comisión Nacional de la Defensa del Idioma y el Claustro de Sor Juana.

Verdadera fiebre de quehacer pseudocultural se apoderó en los años setenta de las instituciones gubernamentales que utilizaban la difusión de actos artísticos a granel. A partir de eso no hay oficina burocrática que no cuente con presupuesto "para promover la cultura en el pueblo".

En el sexenio de Miguel de la Madrid se dedican recursos importantes para la creación de una verdadera Red Nacional de Bibliotecas Públicas. La cultura escrita llega a 2025 municipios y la obra culmina con la inauguración de la Biblioteca Pública de México en noviembre de 1988.

Finalmente la compleja problemática de la difusión cultural en México revela su condicionamiento a los espacios y ambientes que caracterizan la carta geográfica tan contrastante como contradictoria. Para los efectos difusores, en el campo, en las ciudades de provincia y en la Ciudad de México o el Distrito Federal con sus barrios o colonias, el arte y la cultura se difunden en México a través de la Secretaría de Educación Pública, el Instituto Mexicano del Seguro Social, el Instituto de Seguridad y Servicios Sociales para los Trabajadores del Estado, la Secretaría de Relaciones Exteriores, el Departamento del Distrito Federal, y los gobiernos de los estados que contratan cuanto espectáculo los recomienden sus asesores culturales.

Con el aprovechamiento de estos recursos culturales se descubre a la ciudad, a la delegación, al barrio y al país como espacio vital con capacidad de disfrute y convivencia. Se aprende acerca del pasado, se recuperan monumentos civiles, religiosos y militares de la historia, y se aprovechan como recintos depositarios de la cultura. Se revitalizan aspectos tradicionales mediante campañas sobre aspectos del ser y el estar.

El gobierno mexicano, depositario y actor al mismo tiempo de una vasta herencia cultural, ha recibido los mensajes de la historia y de la cultura. Los ha hecho parte de su razón de ser. Los ha enriquecido fomentando la expresión de los creadores contemporáneos en la arquitectura, en la pintura, en la literatura, en la música y en la escultura. Ha propiciado la creación de las obras de los artistas jóvenes y de los ya formados. Ha sido además de mecenas del momento presente, el curador de la cultura nacional, manteniendo museos, y el gran amo de la difusión cultural en gran escala. Como una muestra, se ejemplifica con la puesta en operación en los últimos seis años de 3047 bibliotecas públicas que hacen llegar la cultura escrita a todos los municipios del país que tienen escuela secundaria. Así pues, hoy en día, el pueblo mexicano puede disfrutar de su cultura, gracias a la

acción sistemática que, por mandato suyo, el gobierno ha desempeñado desde hace muchos años.

Algunas veces he escuchado que en México la gente está orgullosa de sus templos, de su arquitectura, de las obras de sus pintores y músicos. Yo creo que es cierto, porque en México la cultura se respira en las piedras de las calles y se ve en los muros de sus edificios públicos.

Desde nuestros inicios como nación diferenciada, la cultura ha formado parte de nuestra vida cotidiana. La hemos sentido en todos los órdenes de nuestro diario acontecer, al comer con platos hechos a mano, al cantar al despertar ante una mañana llena de sol, al recordar a los muertos con altares multiformes y multicolores, y en la misa del domingo dentro de la iglesia que nos abraza con su altar repujado de oro. Por ello en México, el pueblo espera que el gobierno fomente, conserve y difunda la cultura. Y el gobierno, en consecuencia, es el gran mecenas cultural.

# 2. El arte popular chileno

## Marta Domínguez Díaz

La concepción de Estado subsidiario vigente en Chile actualmente supone que éste deja de ser un punto articulador central de la vida cultural de la nación, cediendo el paso a una tendencia a trasladar funciones y aparatos culturales al sector privado. Así, derogada la legislación que protegía el arte popular nacional, la actividad artística comienza a debilitarse en estos niveles. El espacio que deja el Estado es llenado por empresas artísticas orientadas por criterios de ganancia económica. Nacen así, empresas dedicadas al terreno del arte "masivo", que reestructuran, con este propósito, el arte tradicional de las tejedoras de Chiloé, las ceramistas y loceras de Pomaire y Quinchamalí y los Centros Artesanales de la Mujer (CEMA CHILE). Se podría señalar que el Centro de Indagación y Animación Cultural (CENECA) ha centrado sus estudios en este campo, en sus 11 años de investigación y a través de los 140 títulos entregados. (Véase bibliografía adjunta.)

La capacidad de emisión autónoma de los grupos artísticos populares se torna cercana a cero, en un contexto de mercado. Por otra, sus expresiones hallan eco en un público de origen popular, que si bien es vasto, no es muy relevante desde el punto de vista de su capacidad de consumo. De esta manera se cristalizan diferencias culturales que se hacen coincidir con diferencias socioeconómicas y así, se obstaculiza y afecta la "expresividad artística pública", ya que se canalizan menores recursos a su fomento.

La exclusión autoritaria en el ámbito artístico cultural suma a las divisiones culturales un nuevo factor de disgregación: el político-ideológico. En efecto se produce una profunda escisión entre un arte "oficial" y reconocido, y un arte no reconocido, amagado en sus posibilidades de creación y excluido del espacio público. Se produce también una quiebra histórico-cultural cuando se intenta borrar de la memoria y silenciar vertientes artístico culturales que ocupan un lugar en el desarrollo cultural nacional. La muestra más elocuente y probablemente más dramática es el exilio, que ha dado lugar a una cultura nacional de "afuera" y de "adentro" de país. Asimismo la permanente vigencia de sanciones a la expresión artístico-cultural no

oficial genera dos conductas adaptativas: el silencio o la expresión deformada por la censura o autocensura.

Los lenguajes artísticos tienden a llenarse de metáforas, a sustentarse en complejos sistemas de claves que, reiteradas en el tiempo, van gestando modos expresivos diversos que tienden a acentuar la división entre modos culturales oficiales y no oficiales, entre modos históricos y actuales, y entre modos del interior y del exterior del país.

Por último, la fractura organizativa y la ruptura de circuitos de comunicación, generan microculturas locales que, si bien afirman identidades culturales propias de grupos específicos, acentúan también la división entre estratos culturales, al no existir un espacio que les permita tener una proyección más amplia y así conectarse con otras expresiones. Consecuentemente se habla de arte culto y de arte de masas, mirado este último, como degradación, y el arte popular, como manifestaciones ingenuas. Al restringir el concepto de expresión artística a una élite de artistas cultos, excluye automáticamente de la extensión a manifestaciones artísticas populares. La inclusión de lo popular en el terreno artístico nacional ha sido función de los propios sectores populares y de los sectores medios, a través de un arte muralista, arte fotográfico y la pintura espontánea en la calle, como arte de sobrevivencia (retratos, tarjetas, arpilleras, arte carcelario).

El arte no oficial, expulsado de los museos y universidades, borrado de los muros, ausente de la pantalla y del dial, apartado de los grandes escenarios, se torna para los marginados del proyecto oficial, en algo muy importante de rescatar. El lento camino de reaparición de este arte marginal o alternativo es fundamentalmente una respuesta o crítica al orden autoritario en vigencia. Como sustento de su actividad los artistas aficionados, fundamentalmente jóvenes que surgen de los sectores estudiantiles y poblacionales, van constituyendo espacios donde se realiza la creación y difusión de su expresión artística. Estos espacios luego van articulándose, llegando a conformar verdaderos microcircuitos artísticos alternativos. Sobre la base de esta práctica creativa común va gestándose una cierta identidad.

Lo artístico jugó, desde el primer momento, un papel central en la reconstitución de un habla común y de identidades colectivas: la música de raíz folclórica, el teatro callejero y poblacional, las pinturas murales y fotografía testimonial. En este sentido era una cierta memoria histórica donde los sujetos sociales se reconocían en una identidad común. En segundo lugar, la constitución de espacios en torno a lo artístico fue una respuesta primaria a la desarticulación del tejido social provocada por el autoritarismo. Dichas instancias reconstituían además la sociabilidad, la organización y la acción.

La proliferación de estos espacios, grupos creativos y talleres va gestando circuitos de comunicación y creación disgregados de lo público oficial. En el ámbito de la plástica se articulan grupos creativos en torno a talleres o galerías: Taller de Artes Visuales (1974), Galería Central de Arte (1975), Galería Época (1975), Galería Espacio Siglo XX (1976), Taller Sol (1976), Imagen (1975), Galería Cromo (1977), Espacio CAL (1977). Asimismo se crean espacios que unen difusión, creación y docencia, como los Talleres 666 (1976), Centro Imagen (1977), Taller Contemporáneo (1977). Junto a dichos espacios, en el ambiente poblacional, surge una vasta organización cultural vinculada a la estructura solidaria sustentada por la Iglesia Católica: DECU (zona sur), Departamento Cultural Agrupación Cultural Sta. Marta (zona oriente de Santiago) y Agrupación Difusora del Arte (ADA).

Todas ellas abordan un arte crítico o de respuesta a la agresión de que son víctimas. El lenguaje que emana de los símbolos artísticos y valores contenidos en sus posters, arpilleras y murales son la justicia, la paz, la libertad, la solidaridad, el pluralismo. La tendencia general es a reconstruir espacios propios, donde rescatar y preservar un patrimonio cultural que se percibe amenazado. Significativo al respecto, es que lo central en actos culturales del pueblo sean las figuras simbólicas de Pablo Neruda y Violeta Parra. Violeta Parra no sólo volcó su sensibilidad social a través del canto popular, sino que también fue la precursora del arte del tapiz, exhibidos con gran éxito en las Ferias Artesanales Populares de Chile y en galerías de arte de Europa. En la música, en el teatro, en la plástica se alude a la quiebra, al dolor, pero al mismo tiempo a un pasado que quiere proyectarse al futuro.

En esta tarea de rescate y de preservación de una cultura popular y de defensa del derecho a la creación, gran parte de las organizaciones culturales y artísticas funcionan bajo el alero de la Iglesia por cierta seguridad que ella brinda frente a la posible represión gubernamental. Hacia fines de 1977 la presencia pública de este arte marginal había crecido notablemente. Este comienza a verse como una fuerza capaz de interpelar al oficialismo y percibe en su organización y en la suma de éstas, su principal fuente de sustento.

La reacción oficial frente a este arte alternativo es mantener una represión constante contra algunos artistas y comienza a llamar la atención sobre "organizaciones de fachada" para lo que denomina desarrollar actividades políticas y subversivas. Entre 1975 y 1980 se formaron en Santiago más de 70 organizaciones artístico-culturales y más de la mitad de ellas en las poblaciones. Se promueve una actividad artística contestataria y el número de aficionados crece en forma

constante. En 1978 nace la Unión Nacional por la Cultura (UNAC), organismo de carácter nacional que agrupa a la mayoría de las organizaciones existentes. Su objeto es proyectar líneas de desarrollo del "movimiento cultural alternativo". A UNAC se integran una gran cantidad de organizaciones artístico-culturales: talleres de artes, agrupaciones de arte joven, de cineastas, y de músicos jóvenes, grupos de teatro y de escritores, y otros. En el plano de la creación, estos integrantes de UNAC comparten formas creativas donde se percibe fuerte tensión hacia lo nacional, lo popular, y lo latinoamericano.

La coyuntura política chilena ha dado nacimiento a un arte nuevo, de símbolos que dan cuenta de las experiencias subjetivas, de la intimidad cotidiana del pueblo, y de la diversidad de sus catores. Trascienden los límites del registro y de la denuncia para validar estos elementos como expresión artística, bajo un sistema de censura y exclusión.

Renacen las brigadas muralistas Ramona Parra, en homenaje a una brigadista asesinada por la represión, y nacen otras como la brigada "Salvador Cautivo," en memoria de otro brigadista asesinado. Ellos tratan de plasmar en sus murales la realidad que viven: drogadicción, alcoholismo, superexplotación de la mano de obra joven, así, brocha en mano. Algunos drogadictos, luego de asumir el compromiso como brigadistas, han cambiado radicalmente sus hábitos de vida. Levantan brigadas en todas las provincias y las ciudades y realizan cursos plásticos, prácticos y operativos, como una tarea de levantar y masificar el trabajo. Su intención principal es crear dentro de las organizaciones sociales, poblaciones, sindicales y juveniles de cada ciudad, escuelas muralistas que desarrollen un trabajo permanente que expresa artísticamente anhelos de libertad, esperanza y paz, en cada muralla de Chile.

Otra forma de expresión artística de testimonio y de denuncia es la fotografía. Ella es un medio de conocer la verdad, esa que no es posible adornar, ocultar, o desmentir. Son innumerables los hechos de violencia, de alegría y de dolor que la fotografía ha testimoniado en Chile durante las dos últimas décadas. Entre las publicaciones de este tipo, las más impactantes han sido *El pan nuestro de cada día*, de Carlos Tobar (Terranova, 1986) y *Testimonio de un proceso* de Ricardo Andrade Millacura (Santiago de Chile, 1988). Recientemente en 1989 apareció la revista de fotografía *Revisión: La otra imagen*, publicada por Ediciones Ad Populi en Santiago de Chile. Hermosas fotografías artísticas y testimoniales obtienen los reporteros gráficos adjuntos a órganos de prensa chilenos.

Otra expresión relevante de arte alternativo en la coyuntura política ha sido el video, el que pudieron apreciar masivamente los chilenos, con ocasión del plebiscito en la franja televisa que se llamó "Franja del NO". Destacan en video la Productora Teleanálisis, Productora Visual y el Grupo Proceso, cuyos contenidos son precisamente aquellos que los canales de televisión omiten o distorsionan. Teleanálisis es una experiencia chilena de video alternativo que comenzó en 1985 y cuya perspectiva es apoyar la lucha por la democracia en Chile. Sus contenidos son la lucha contra la dictadura emprendida por vastos sectores sociales de Chile; las denuncias de las violaciones a los derechos humanos; la realidad de la pobreza; la situación de las mujeres, de los jóvenes y de los niños, bajo la dictadura; la contingencia política; y las expresiones culturales populares. Sus videos se obtienen por sistema de subscripción o a través de la Unidad Móvil de Exhibiciones. Al cabo de cuatro años de existencia Teleanálisis ha producido alrededor de 180 reportajes sobre la realidad chilena.

La Productora Visual es un centro de servicios de video dedicado a la producción de "spots" comerciales, de documentales, de videos de capacitación, de video "clips", y de videos experimentales. Se plantea el desarrollo del lenguaje y del medio del video en Chile, con identidad propia y no sólo como medio alternativo. Se distribuye a través de CENECA, Pastoral Obrera y Comité Pro-Retorno de Exiliados.

El Grupo Proceso es una institución de comunicación especializada en video y televisión, fundada en 1983, que ha producido a la fecha unos 40 documentales y programas. Este ha privilegiado en los contenidos de sus documentales la realidad del mundo popular, haciéndola protagonista. Pretenden conseguir un lenguaje audiovisual que recree artísticamente las experiencias íntimas y sociales del mundo popular. El acceso a los videos es a través de un servicio de préstamo y un servicio de convenio.

Otra expresión artística alternativa es la que realizan los presos políticos chilenos. Es común que ellos combinen su creación literaria con la plástica. Tenemos el caso de "Poesía prisionera", "La cola de la lagartija", poemas de Paulina Richards, dibujados por Gabriela Richards, y "Se vive para darse", poemas de Ignacio Vidaurrázaga, con dibujos de Fernando Vidaurrázaga, ambos hermanos víctimas de la represión. La artesanía en cuero y metal, fuera de constituir para ellos una terapia, es también una forma de subsistencia. Ha recurrido a formas primitivas de trabajo, pues son muy escasos los elementos de que pueden disponer en prisión. Los canales de comercialización de sus trabajos son los Talleres de las Vicarías y otras instituciones

eclesiásticas, como la Fundación Missio y la Fundación de Ayuda Social de las Iglesias Cristianas (FASIC).

Desde el punto de vista histórico, las artes populares chilenas tuvieron en la artesanía indígena su más genuina manifestación. Desde el período pre-hispánico los indígenas fabricaban objetos utilitarios, atavíos, adornos, y ornamentos con materiales naturales: mineral, orgánico y vegetal. A partir del siglo XVI los mapuches desarrollan la orfebrería en plata. Como los mapuches no tienen escritura, no hay una tradición entre ellos de firmar sus trabajos. La orfebrería mapuche pasa así a ser un arte anónimo. Sólo identifica a los orfebres mapuches la impronta del genio que cada uno de ellos coloca en su labor. Gran parte de este patrimonio nacional desapareció cuando la Casa de Moneda compraba las joyas para fundirlas en sus hornos y fabricar nuevas monedas. Se salvaron aquellas que compraron comerciantes o extranjeros, con las que formaron colecciones. Algunas de las más famosas son la de Raúl Morris von Bennewitz, la de Mayo Calvo de Guzmán, la de Walter Reccius, que tanto el Departamento de Extensión Cultural del Ministerio de Educación como el Museo Chileno de Arte Precolombino se han dado a conocer en hermosas obras de lujo. (Véase bibliografía anexa.)

Un capítulo que merece especial mención al hablar del arte popular marginal chileno es el de las arpilleras. Son expresiones de arte, ingenuo y de gran contenido emotivo y social. Han quedado plasmados en ellas, hechos de hondo dramatismo como el exilio, las ollas comunes, los comedores infantiles, las huelgas de trabajadores, la vida poblacional, los atropellos a los derechos humanos, etc. Son cuadros realizados sobre géneros toscos, generalmente arpillera, en que la temática se expresa con restos de telas de intenso colorido y cuyos personajes y entorno se trabajan en relieve o en tercera dimensión. Este arte, auténticamente popular, ha sido censurado por el régimen militar debido a su temática. Lo realizan mujeres pobladoras como una forma de denuncia de su dolor y a manera de subsistencia, ya que constituyen obras de gran demanda en Chile y en el extranjero. Hay varias publicaciones que abordan el tema, además de innumerables copias fotográficas, que se usan como tarjetas de saludo, posters, como voceros de la denuncia, en recintos públicos y privados de Chile.

## BIBLIOGRAFIA CONSULTADA

Alarcón Rojas, Norma. *Estudio apreciativo del arte popular.* Santiago, 1966. Tesis.

Asesoría Cultural de la Junta de Gobierno y Departamento Cultural de la Secretaría General de Gobierno. *Política cultural del gobierno de Chile.* 1980.

Grupo Proceso. *Videos televisión.* Santiago, 1988. Catálogo.

Lago, Tomás. *Arte popular chileno.* 4. ed. Santiago: Editorial Universitaria, 1985.

Museo Chileno de Arte Precolombino. *Mapuche.* Santiago, 1985.

Paiva, Manuel y María Hernández. *Arpilleras de Chile.* Santiago, 1983.

*Plateros de la luna.* Biblioteca Nacional, julio-agosto 1988. Catálogo exposición.

Rivera, Anny. *Arte y autoritarismo.* Documento trabajo, 33. Santiago: CENECA, 1982.

_____. *Notas sobre movimiento social y arte en el régimen autoritario.* CENECA, 1983.

_____. *Transformaciones culturales y movimiento artístico en el orden autoritario: Chile 1973–1982.* Santiago: CENECA, 1983.

Taller de Arpilleras, Agrupación de Familiares de Detenidos Desaparecidos. *Arpilleras: Otra forma de denuncia.* Santiago, 1988.

Teleanálisis. *Temario de producción.* Santiago, 1984. Catálogo.

Ulloa, Yéssica. *El video independiente en Chile.* Santiago: CENECA/CENCOCEP, 1985.

_____, y Roberto Urbina. *El video en la animación socio-cultural.* Documento de trabajo, 92. Santiago: CENECA, 1987.

## BIBLIOGRAFIA COMPLEMENTARIA

Aguiló, Osvaldo. *Propuestas neo-vanguardistas en la plástica chilena.* Documento trabajo, 27. Santiago: CENECA, 1983.

Aldunate del Solar, Carlos. *Cultura mapuche.* Departamento de Extensión Cultural, MINEDUC, 1985.

Ampuero, Gonzalo. *Cultura diaguita.* Departamento de Extensión Cultural, MINEDUC, 1978.

Andrade Millacura, Ricardo. *Testimonio de proceso.* Santiago: Ediciones Ad Populi, 1988.

Asociación de Fotógrafos Independientes. *Segundo anuario fotográfico chileno.* Santiago, 1982.

Avila, Alamiro de. *Los grabadores populares chilenos: Catálogo de exposición IV, Bienal Americana de Grabado.* Santiago, 1970.

Baytelman Goldenberg, David. *Los dibujos de Baytelman.* Santiago: Emisión, 1987.

Bittmann, Bente. *Cultura atacameña.* Santiago: Departamento de Extensión Cultural, MINEDUC, 1978.

Blume, Jaime. *Cultura mítica de Chiloé.* Santiago: Aisthesis, 1985.

Calogero, Santoro, y Liliana Ulloa, eds. *Culturas de Arica.* Serie Patrimonio Cultural, Culturas Aborígenes. Santiago: Departamento de Extensión Cultural, MINEDUC, 1985.

Castillo Martínez, Licia. *Manifestaciones de arte popular en la ciudad de Angol.* Santiago, 1961. Tesis.

Cornely, Francisco L. *El arte decorativo preincaico de los indios de Coquimbo y Atacama.* La Serena, 1962.

Dittborn, E., C. Flores, y Juan Downey. *Sateliterns: Video-postal de tres artistas chilenos.* Santiago: Flores Delpino, 1983.

Downey, Juan, et al. *Festival Downey: Video porque te ve.* Santiago: Ediciones Visuala Galería, 1987.

Elssaca, Theodoro. *Isla de Pascua. Easter Island. Hombre-Arte-Entorno.* Santiago: Spatium, 1989.

Fuenzalida, Valerio. *Estudios sobre la televisión chilena.* Santiago: C.P.U., 1984.

_____. *Transformaciones en la estructura de la TV chilena.* Santiago: CENECA, 1983.

Granese Philipps, José Luis. *Fotografía chilena contemporánea.* Contemporary Chilean Photography. Santiago, 1985.

Gutiérrez, Paulina. *Chile vive. Memoria activa.* Santiago: CENECA/ICI, 1987.

Hernández, Baltazar. *Las artes populares de Ñuble.* Santiago: Prensa Latinoamericana, 1970.

Hurtado, María de la Luz. *La industria cinematográfica chilena.* Documento de trabajo, 93. Santiago: CENECA, 1987.

Iribarren Charlín, Jorge. *Cultura diaguita y cultura molle.* La Serena, 1969.

_____. "Perspectiva folklórica del medio campesino de Valle Hurtado". En *Contribuciones Arqueológicas* (Museo Arqueológico, La Serena, Chile), 6 (1966) 11-18.

Lobos, Pedro. *Retoños: 10 dibujos de Pedro Lobos.* Santiago de Chile, 1959.

Mesa Redonda. *Arte popular chileno.* Santiago: Ediciones Universidad de Chile, 1959.

Ministerio de Cultura de Madrid, et al. *Chile vive: Muestra de arte y cultura.* Madrid, 1987.

Plath, Oreste. *Arte popular y artesanías de Chile.* Santiago: Museo de Arte Popular Americano, Universidad de Chile, 1972.

Quilaqueo, Sandra. *Acerca del video de autor en cinco videos de autor.* Santiago, 1985.

Richard, Nelly, y Juan Forch. *Arte en Chile.* Santiago: Productora Visual, 1986.

Rosenfeld, Lotty. *Una herida.* Santiago: Productora Visual, 1982. Acción de arte.

_____. *Proposición para (entre) cruzar espacios límites.* Santiago: Productora Visual, 1983.

_____. *Una milla de cruces sobre el pavimento.* Santiago, 1979. Acción de arte.

Saul, Ernesto. *Pintura social en Chile.* Santiago: Quimantú, 1972.

Ulloa, Yéssica. *Video—expresión.* Santiago: CENECA, 1987.

_____. *Video—comunicación.* Santiago: CENECA/CENCOCEP, 1986.

Unanue, Jacqueline. *El arte rupestre chileno: Un encuentro con el hombre primitivo.* Viña del Mar, Chile, 1982.

Vega, Alicia. *Revisión del cine en Chile.* Santiago: CENECA/Editorial Aconcagua, 1979.

Publicación Periódica:

*Enfoque: Revista de cine.* Santiago: Publicaciones y Audiovisuales, Linterna Mágica, 1987–.

# 3. Art and the State in Postrevolutionary Mexico and Cuba

## Peter A. Stern

Although government patronage of the arts (usually in the interaction between religion and ruling elites) is as old as art itself, the interaction of art and politics is a considerably more recent phenomenon. Political art as we might recognize it begins in the eighteenth century with the political cartoon; by the end of the next century the British, Americans, and French had a rich tradition of satire, caricature, and social and political mockery expressed through the institution of the daily press: "The development of caricature and other devices of satiric social art meant that a compelling form of artistic expression had come into being. The artist as social commentator has awesome weapons—wit, symbolism, animalism—to direct at men and institutions."[1]  For political art is by definition subversive, its intent to undermine and weaken, to bring scorn and disrepute upon those in power. "Revolutionary" art as exemplified by the Soviet, National Socialist, or Maoist poster, is not really revolutionary but statist art, designed to bolster popular support for the established ruling regime. Once a revolution that art supports achieves power, its art can no longer be truly called revolutionary, as it is now designed to buttress, rather than bring down, the status quo.  In this sense it is the mocking engraving of Posada, rather than the heroic mural of Rivera which is truly revolutionary in Mexican political art. By the same standards we may ask which is more revolutionary: a gigantic poster of Che with the caption "Ser como él," which exhorts the workers to make greater sacrifices for the state, or the biting satire of *El karikato* against Machado and the cartoons of Ramón Arroyo and Antonio Prohías taking aim at the corruption and brutality of Batista in the 1950s?

Nevertheless, regimes that style themselves "revolutionary," whether Marxist, Nazi, or bourgeois capitalist, employ art as a tool of propaganda, education, and advertisement. In this paper I briefly examine one narrow aspect of the artistic policy of two radically different Latin American revolutionary governments: Mexico under Carranza, Obregón, and his successors, and Cuba under Fidel Castro.

17

All the Mexican muralists, including the famous trio of the post-revolutionary period (Rivera, Orozco, and Siqueiros), began their careers as caricaturists and political cartoonists, and all owe an enormous artistic debt to the father of modern Mexican political art, the cartoonist José Guadalupe Posada. Posada was called "Mexico's Goya" in tribute to his unerring sense of change and strife in the period of the late Porfiriato, his reliance upon well-known symbols, his uncanny journalistic sense, and his deep feelings of identity with the people.[2]    Equally important in Posada's work is the indigenous element: "The greatness of . . . Posada lies in the fact that with regard to both spiritual content and artistic form his work, rooted as it is in the popular mind and art, reveals the first signs of a sound integration of ancient Indian and colonial Spanish elements."[3]    Printmaking in prerevolutionary Mexico was a form of popular art, a means of protest, linked to the penny pamphlet, rhymed corrido, or prose *relato* that it illustrated.[4]

Equally important to the birth of a modern revolutionary art in Mexico was an institution: the Academia Nacional de San Carlos in Mexico City. Founded by Carlos III as an engraving school (two dates given for its founding are 1785 and 1778), the academy was a focus for the development of a national, as opposed to a *peninsular*, artistic style. In fact, so successful was the school in raising the political and social as well as the artistic consciousness of its pupils that in 1911 the art students went on strike against an unpopular anatomy instructor's torpid instruction under the slogan "Down with the científicos in this school. Free suffrage. Liberty and Constitution."[5]  Within three years, as Mexico City writhed in agony under the heel of Victoriano Huerta, suffered through the Decena trágica, and was to be occupied in succession by Zapatistas and Villistas, the Academy came under the direction of a savior.

Gerardo Murillo, known by his *nom de révolution* as "Dr. Atl," was a painter, volcanologist, and consummate agitator. His very name, *atl* (Nahuatl for water), was adopted equally out of love for native culture and rejection of that of the conquistador. He was both an artistic and a political rebel. He traveled widely in Spain, France, and Italy at a time when European art itself was being transformed by a variety of movements: postimpressionism, cubism, futurism, expressionism, and so forth.[6]  Dr. Atl was the leader and organizer of the first artist's union or syndicate, the Centro Artístico. Organized by liberal students and artists in 1910, the group had already been commissioned by Justo Sierra to decorate the interior of the Anfiteatro Bolívar in the capital when the revolution broke out. In 1914, Dr. Atl, the newly appointed

head of the Academy of San Carlos, and a fierce partisan of Carranza, managed to persuade the Academy's workers to abandon their support of the approaching forces of Pancho Villa and transfer their loyalty to Carranza. Whereupon he galvanized the staff of the Academy to pack up the printing presses, linotypes, and other machinery and flee in boxcars to Orizaba. There they set up in abandoned churches and began publishing cartoons, broadsides, posters, and proclamations in support of the *carancistas*. Among the artists working under Atl's direction in Orizaba were Orozco and Siqueiros, (the latter already a captain in Carranza's army). [7]

Atl was always a man of direct action; he had little use for abstract aesthetic considerations. Upon being nominated by Carranza to be head of the Academy, he set about transforming a dreamy shelter for reclusive sensitive artists into a vigorous and productive enterprise. He stated upon his nomination:

Being the foe of academic institutions, how can I present a plan of reform. . . . I find myself in this dilemma: whether to propose that the school be scrapped, or else converted into a workshop geared for production, like any industrial workshop of today, or like all art workshops of all epochs when art flowered vigorously. [8]

Atl placed at the door of the Academy a sign that read "Bricks are also needed to make a revolution." The students puzzled over their director's meaning, but soon discovered, in the words of Siqueiros, "The school of fine arts must transform itself into a popular workshop, a school of arts and crafts rather than a university center." [9] Atl considered his greatest achievement at the school its artistic and political orientation toward nationalism.

Although neither the Academy nor Dr. Atl trained all the Mexican artists of the ensuing decades, both were central to the development of the socially conscious, realistic, and nationalistic style of art that the muralists, and in particular Rivera, Orozco, and Siqueiros, typified. Atl's transformation of the traditional and staid Academy of San Carlos into a dynamic and politicized focus of artistic training directly anticipated the artistic and political groups of the postrevolutionary period. In 1920, as Obregón took office as the ultimate victor of the Mexican Revolution, Siqueiros was meeting other artists in uniform. In Guadalajara they opened a "congress of artists-soldiers," a direct precursor to the formation in 1922 of the Syndicate of Revolutionary Painters, Sculptors, and Engravers of Mexico, with Diego Rivera as its first president. The final text of its manifesto was as radical in language as any proclamation of a revolutionary party:

The Syndicate of Revolutionary Painters, Sculptors, and Engravers of Mexico considers that, in the present epoch of exasperated class struggle, of imperialism oppressing our people, our native races and peasants, there exists, for intellectual producers and for workers in the painting craft conscious of the historical moment, no other way but to affiliate with each other in a manner disciplined by the struggles of the revolutionary proletariat. Their contributions to the movement are to be works of revolutionary art.[10]

The manifesto went on to state that its new art should not only be political, but should also take into account the Amerindian traditions of Mexico; accordingly, "the Syndicate recommends . . . that native values be connected intimately with international currents of modern art. . . ." The radicals espoused a collective and socialist artistic expression: "We repudiate the so-called easel artist and all such art which springs from ultra-intellectual circles, for it is essentially aristocratic. . . . We hail the monumental expression of art because such art is public property.[11] The members of the new body concluded by stating:

In concrete terms the Syndicate . . . means to do work useful to Mexico's popular classes in their struggle, meanwhile producing an art aesthetically and technically great. To blend these two values is the essence of its doctrine. . . . The Syndicate . . . is in favor of collective work. It desires to destroy all egocentrism, replacing it by disciplined group work, the great collective workshops of ancient times to serve as models.[12]

With the Syndicate headed by a man whose ego was as great as his talent, Rivera, the last part of the group's manifesto was never to be a serious component of its philosophy. Nevertheless, the original credo of the Syndicate is clearly aimed at creating a collectivist and radical body of art dedicated to the inclusion of the working and peasant classes of Mexico and to the rediscovery and incorporation of the pre-Hispanic tradition in its work.

The members of this radical new Syndicate matched their actions to their words; they bought and stockpiled pistols and rifles with which to defend the regime of Obregón. Their prime weapon, was, however, their art. Their members founded a political newspaper with the symbolic name *Machete*, the common tool and weapon of the Mexican peon. Its slogan read:

The machete is used to reap cane,
To clear a path through an underbrush,
To kill snakes, end strife,
And humble the pride of the impious rich.[13]

*Machete* was a ten-centavo broadsheet filled with proclamations, corridos, and woodcut engravings by Siqueiros, Orozco, and Xavier Guerrero, and embellished with red highlights (which added to its printing expenses). Its history (it later became the official organ of the

Mexican Communist Party) is a perfect illustration of the turbulent relationship between the majority of Mexican artists in the 1920s and the cultural policy of the postrevolutionary Mexican government.

Although radical agrarian movements participated in the struggle, the Mexican Revolution began as a moderate, reformist revolt under the nominal leadership of Francisco Madero. After ten years of turmoil and a million casualties, the Revolution ended with the victory of Obregón, with Madero, Carranza, and Zapata dead and Villa to die shortly. The new Mexican government, committed to implement the constitution drafted at Querétaro in 1917, was also interested in survival, political and economic. Agrarian reform proceeded cautiously and was modest in scope. The Communist Federation of Mexican Workers and the IWW, the Wobblies, were excluded from the labor movement's leadership. In short, the new "revolutionary" government was anything but radical. In the years to come this cautious approach to change on the part of succeeding administrations would bring them into conflict with the far more radical artists of the muralist community.

The key to the initial period of postrevolutionary mural art in Mexico lies in the political and moral philosophy of José Vasconcelos, Obregón's Minister of Education. Vasconcelos in his early years was a believer in positivism, the philosophy of social Darwinism which formed the ideological basis of so many Latin American governments in the last quarter of the nineteenth century. But the young Vasconcelos saw in the creed of the Mexican *científicos*, which encouraged foreign investment in the economy of the country, the dangers of the Yankee colossus to the north, the Anglicizing of Mexico. In 1909 he joined a group of fifty young intellectuals to form the Ateneo de Juventud, an organization that had as its aim the downfall of the Porfiriato, the restoration of Mexican economic sovereignty, and the dilution of positivism in the cultural life and educational system of the republic.[14] After the outbreak of the revolution, Vasconcelos supported Madero, and acted as a confidential agent in Washington, D.C. for the *maderistas* after Madero was forced to flee Mexico.

In 1920 he was appointed Minister of Public Education, in charge of three areas: schools, libraries, and fine arts. Vasconcelos was nothing if not energetic; between 1921 and 1924 the government built more than one thousand rural schools—more than in the fifty previous years—and established 1,911 new libraries in the republic.[15] Under Carranza, 1 percent of the national budget had been allotted for education; this was increased to 15 percent under Obregón, largely due to Vasconcelos. "That the state and society had the obligation to educate and improve the lot of the masses was fundamental to

Vasconcelos' ideology during the 1920s," one scholar wrote of him.[16] To this end he initiated an ambitious program in culture as well as in education. He sponsored the reorganization of orchestras throughout Mexico. He encouraged popular song and dance, sponsoring open-air festivals. Exhibits of Indian folk crafts, glee clubs for workers, student art exhibits were all subsidized under his administration: All these "were considered an essential cultural stimulus for the masses, forms of relaxation as well as sources of national pride and spiritual expression."[17] And he originated the policy of commissioning painters to decorate public buildings; "the most usual subjects came to be the glories of the pre-conquest Mexican civilization, the Reforma and the Revolution, all presented in a frankly propagandist light."[18]

Vasconcelos's aim was greater social integration in Mexico, which he believed could best be achieved by cultivating a national cultural identity. Both the murals of the postrevolutionary period and the curriculum he designed for the public schools reflected this goal. In both the text he wrote for pupils (*Compendio de la historia de México*) and those he approved for general use he promoted greater cultural independence, the cultivation of a pan-Hispanic and Latin American identity, and the erasure of racial distinctions among Mexicans.[19]

Vasconcelos's most enduring contribution to Mexican national culture, was, of course, his sponsorship of public mural painting. Vasconcelos the nationalist, the Hispanicist, and Catholic reformer commissioned works from the ranks of prominent Mexican painters: Diego Rivera, José Clemente Orozco, Fermín Revueltas, Alfaro Siqueiros, Jean Charlot, Fernando Leal, Amado de la Cueva, Ramón Alva, and Emilio Amero.[20] In November, 1921, Vasconcelos took Rivera and a group of artists and intellectuals on a trip to Yucatán to view Chichén Itza and Uxmal in an effort to acquaint them with Mexico's heritage. The next year Rivera was commissioned to paint a mural, *Creation*, in the National Preparatory School. Underlying Vasconcelos's commission were more than artistic or aesthetic reasons: he wished to replace the stigma of another mural he remembered from his own days in the Preparatoria. Over the principal stairway there had once existed Juan Cordero's mural *Triumph of Science and Labor over Ignorance and Sloth*, an emblem of positivism, which Vasconcelos wished to supersede with his own egalitarian and broadly visionary policies.[21] Vasconcelos generously gave Rivera funds to travel to Tehuantepec; upon his return Rivera incorporated Mexican tropical flora and fauna in his mural. Vasconcelos was to lend both financial and moral support to his commissioned muralists, especially in the face

of bitter political attacks by conservative politicians, and condemnation by other figures within the Mexican art community.

Within two years, Rivera had been named Head of the Department of Plastic Arts in the Ministry of Education and was at work on a set of murals for the new Secretaría de Educación Pública. In contrast to his work at the Preparatoria, these murals were unmistakably political in nature and radical in tone. The murals are deeply rooted in pre-Hispanic forms and traditions; overdoor verses from pre-Hispanic literature emphasized the indigenous sentiment of the work. [22] Mexican peasants are portrayed as victims of injustice, exploitation, oppression. Porfiristas, *rurales*, capitalists, the bourgeoisie are caricatured; Mexican workers and peasants carry arms, organize, seize land, fight back, make their own revolution. [23] The titles of the various sections are illustrative of the project's themes: Women of Tehuantepec, The Dyers, Peasants Waiting for the Harvest, the Pottery Makers, Sugar Refiners, The Hacendado, Burial of a Worker, The Iron Foundry, Yaqui Ceremonial Dance, Distribution of Land among the Peasants, The First of May. [24] The work itself engendered not only political but artistic controversy as well. Notwithstanding the collectivist and anti-egotistical aims of the Syndicate radicals, Rivera clashed with two other artists assigned to paint different parts of the Ministry interior. He objected to the painting of Charlot and de la Cueva on the grounds that their work did not harmonize with the whole and they were dropped from the project.

Vasconcelos stood by his artists; "He believed in freedom and for this reason imposed no dogmas either aesthetic or ideological on the artists." [25] While he can hardly have been pleased at Rivera's depiction of the First of May, with the figures of Frida Kahlo and Tina Modoti handing out rifles and cartridges to the workers, he continued his program of commissioning murals for government buildings. Vasconcelos wrote Siqueiros, who was studying in Paris, urging him to return to Mexico, where he believed a renaissance in the arts was in the making. Vasconcelos cut off the subsidy Siqueiros, former captain of the revolution, was receiving from the government, in order to force his return to Mexico. He then offered Siqueiros his choice of the uncompleted walls in the Preparatoria; Siqueiros worked on numerous frescoes and paintings at the school between 1922 and 1924, as did De la Cassal, Fermín Revueltas, and Jean Charlot.

Orozco, the third figure in the trilogy of the *muralistas*, was nearly bypassed by the postrevolutionary renaissance that Vasconcelos wrought. Owing partly to his association with Carranza, a foe of Vasconcelos, and his early reputation as a cartoonist, he was not given a mural commission. The poet Tabalad spoke for his friend Orozco to

government officials at a banquet; in 1923 he was given a mural at the Preparatoria. His most striking contribution to that immense project was *The Trench*, an anguished composition of bodies locked in struggle. Orozco deliberately avoided the indigenous style of his fellow muralists:

> Such thoughts led me to eschew once and for all the painting of Indian sandals and dirty clothes. From the bottom of my heart I do wish that those who wear them would discard such outfits and get civilized. But to glorify them would be like glorifying illiteracy, drunkenness, or the mounds of garbage that "beautify" our streets, and that I refuse to do. . . . In all my serious works there is not one Indian sandal and not one Mexican straw hat.[26]

Orozco instead selected as his theme the universality of mankind: "Not a breath of folklore is to cheapen the climate of the fancied mural world that he is bent on creating, not an Indian to narrow the boundaries of its geography. The human body is to be his only subject matter, stripped of all racial tags."[27] Although much of Orozco's work is political in content, he always chose a more allegorical style than the direct radical assault of his fellow *sindicalistas*.

The Vasconcelos period of muralist art came to an abrupt end in 1924. The victory of Obregón, the murders of Carranza and Zapata, had not brought peace or tranquillity to Mexico. The year before General De la Huerta had attempted a revolt against the Obregón regime; it had been crushed. Felipe Carrillo Puerta, the governor of Yucatán, and his three brothers and ten followers were executed as a result of supporting the losing side. De la Huerta partisans were to be persecuted, even assassinated. The murder of a Mexican senator prompted Vasconcelos to resign from a government from which he was becoming estranged. Although persuaded to return (he would quit for good seven months later), his influence and power were clearly in eclipse. It had been remarked that the muralists were dependent upon the secretary in the same way that painters of the Italian renaissance were picked and protected by popes, princelings, or reigning *condotierri*.[28] Detractors began to criticize the muralists like jackals circling for the kill. One conservative critic's attack on the muralists and their creations set the tone of the reaction:

> Such works have been carried to a conclusion, not in a noble exercise of freedom, but owing to the hermetic and despotic dictatorship of a small literary group now in power, an imposition that weighs like a stone upon the spirit of the whole nation. . . .
> The imposition is not restricted to boosting Rivera as a rival of Velásquez and branding his critics as dumbbells; it has also stuck his pictures on walls as now irreclaimable. Why etch a controversial work on walls instead of on canvas or on a panel? Once a work of art . . . is incrusted into a wall, people stand between the two horns of a dilemma: to accept the work or to destroy it.

Because walls cannot be separated from a building and put into storage, if one wishes to avoid the sight of the pictures, one's only recourse is to erase, to destroy them.[29]

With the papers carrying rumors of Vasconcelos's imminent second, and final, resignation, there was every chance that a coat of whitewash might eradicate the labor of Rivera, Orozco, Siqueiros, and others forever. Students at the Preparatoria, not all of whom by any means were radical supporters of egalitarian or people's art, actually began to deface or scrape some of the murals off the walls of the school, helped by some in the Ministry of Education. Badgered by a mob of students with a petition, a weary Vasconcelos on the verge of quitting ordered that the ongoing mural project under Rivera's direction be halted. Orozco was fired the same day. The Syndicate of Painters and Sculptors issued a letter of protest, blaming not the students who had desecrated the murals, but antisocial elements in Mexican society:

The true culprits are reactionary teachers . . . puritanical aristocrats, who burrow within the educational system, plotting to poison our youth. They are the rich and their breed, who intrigue against all that comes from the people and is of use to the people . . . the reactionary press that shields them, the irresponsible revolutionaries who do not realize that their lack of affinity with revolutionary painting disclosed within them a percentage of the bourgeois still rampant. . . .[30]

Vasconcelos resigned, Siqueiros and Orozco were dismissed, and Obregón issued a presidential decree suspending most mural work. Ironically, Vasconcelos's departure did not bring an end to mural painting; it merely ended the initial phase of the movement. Succeeding administrations of Mexican presidents, especially Lázaro Cárdenas (1934-1940), the great agrarian reformer, continued to commission artists to decorate the walls of public buildings. Rivera painted murals at the National School of Agriculture at Chapingo, the Palacio de Cortés in Cuernavaca, the Department of Health and Palacio de Bellas Artes in the capital, perhaps his crowning achievement his monumental work on the stairway of the National Palace in the Zócalo. Rivera had a successful, even sensational career outside Mexico. His mural in the RCA Building in New York City included Lenin in a group of technicians, and so was ordered destroyed by the Rockefeller family. Much of Orozco's work was done in the United States, as he became embittered over the years with the complacency and corruption of postrevolutionary governments. He returned to Mexico in 1934, and eventually painted murals in Guadalajara at the University and the Palacio del Gobierno, and at the Palace of Fine Arts and Supreme Court in the capital. Siqueiros was the most political and radical of the trio. He worked at organizing labor syndicates, and

attended the Fourth Congress of the Comintern in Moscow in 1929 as
a delegate of Mexican miners. Imprisoned in Mexico for his radical
politics, he eventually broke with Rivera over questions of art and
communism. (He was involved in at least one attempt on the life of
Trotsky, and remained an ardent Stalinist to the end of his days.) His
public murals include paintings at the Centro de Artes Realistas
Modernas, the Palace of Fine Arts, the Treasury Building, the UNAM
library, and his most famous, *Social Revolution*, in Chapultepec Castle.

Despite the cyclical nature of the Mexican political temperament
(conservative followed by more "liberal" regimes), mural art has
remained a fixture of government cultural policy since the days of Justo
Sierra during the Porfiriato. Successive Mexican regimes have
encouraged several generations of mural painters to interpret Mexican
history, culture, and society through their own personal artistic and
political temperaments. The results have been mixed; Octavio Paz, one
of the foremost interpreters of Mexican culture, voiced a number of sad
but undeniable truths about muralism in Mexico. Asked in an interview
about the most popular Mexican art form, he expressed the opinion
that three equivocations stood between spectator and art—emotional
and ideological veils that helped to obscure them:

In the first place, nationalism. The Mexican muralists have been turned into
saints. People looking at their paintings are like devotees of sacred images. The
walls are not painted surfaces but fetishes that we must venerate. The Mexican
government has made muralism a national cult and of course in all cults criticism
is outlawed. Mural painting belongs to what might be called the wax museum of
Mexican nationalism, presided over by the figurehead of the taciturn Juárez.[31]

Paz's second objection was on grounds of aesthetic incongruity;
"revolutionary" murals painted on the walls of seventeenth- and
eighteenth-century buildings were "an intrusion, an abuse, something
like giving the Venus de Milo a liberty cap." But the third objection is
the most trenchant, going straight to the heart of the contradictions
inherent in government-sponsored "revolutionary art":

The third equivocation is more serious. It is of the moral and political order.
These works that call themselves revolutionary and that, in the cases of Rivera and
Siqueiros, expound a simplistic and Manichean Marxism, were commissioned,
sponsored and paid for by a government that was never Marxist and had ceased
being revolutionary. The government accepted the painters painting a pseudo-
Marxist "black and white" version of the history of Mexico on the official walls
because this painting helped give it a progressive and revolutionary face. The
mask of the Mexican state has been one of popular and progressive nationalism.[32]

When asked whether the muralists painted "social realism," Paz is
again critical:

Nobody knows what "social realism" means. The truth is that, as with almost all works pertaining to this tendency, their painting is not realistic and even less is it socialistic. It is allegorical painting, and this is one of the least modern characteristics of Mexican mural painting. Allegory was the preferred mode of expression in the Middle Ages. Today it is in disuse. . . . The painting of our muralists . . . is very far from . . . complexity and subtlety: it is a dualistic and statist version of history. In the case of Rivera and Siqueiros this allegorical Manicheanism proceeds from a primary version of Marxism, in which each visual image represents either the forces of progress or those of reaction. The good and the bad. . . . [Their] murals show the conquest of Mexico as a true malediction, as the triumph of reaction, that is to say, of evil. Thus they idealize pre-Columbian society—Rivera even exalted human sacrifice and cannibalism—while they accentuated the negative and gloomy traits of the conquerors to the point of caricature.[33]

Can muralism as an art form ever make more than simplistic and allegorical statements about a complicated past? Scholarship paints a more complex picture of Cortés as conqueror and colonizer than does Rivera on the walls of the Nacional Palace, where he maliciously portrays a handsome and robust man as a wizened, deformed cretin. Historians make more equivocal judgments about the reforms of Juárez (which destroyed the Indian *ejidos*) and the development policies of the Porfiriato than do the muralists.

To be fair, they gave the government what it wanted. With Madero, Villa, and Zapata dead and in their graves, their images were and remain useful political icons in the official state tapestry of Mexican history. This official history, or more properly myth, is promulgated in the textbooks and on the walls of the republic.

The interaction between art and government in Cuba is a very different, certainly less convoluted story. Although Cuba had a flourishing artistic community before the revolution of 1959, there was little government patronage of the arts; certainly there is no parallel to Vasconcelos and the mural movement in Mexico. The Instituto Nacional de Artes Plásticos existed as an official body; in 1940 it organized with government funding an exposition, "Three Hundred Years of Art in Cuba."[34] Yet the scale of patronage of the arts in Cuba could not compare before the revolution with that in Mexico. Art in Cuba existed in a state to be found everywhere—that is, in a free market, where some mediocre artists grew rich, many good artists starved in garrets (or their Cuban equivalent), and the public and critics waged their eternal battle over questions of taste and popularity.

This situation changed dramatically after the triumph of the revolution. In 1961 Fidel Castro made his celebrated Address to the Intellectuals, in which he declared "Everything within the Revolution; nothing against the Revolution."[35] When the Union of Writers and

Artists was founded in August, 1961, its declaration of principles
restated that proposition explicitly:    "We regard it as absolutely
essential that all writers and artists, regardless of individual aesthetic
differences, should take part in the great work of defending and
consolidating the Revolution.  By using severe self-criticism we shall
purge our means of expression to become better adapted to the needs
of the struggle."[36]  This rhetoric was no more radical than that of the
Mexican syndicate of artists formed thirty-nine years before by
unabashed admirers of the Bolshevik Revolution.  The crucial
difference is that the Mexicans perceived themselves as outsiders
engaged in a struggle to fulfill the largely abandoned precepts of the
Mexican revolution.  In a Marxist-Leninist Cuba, the Union was
comprised of insiders.  In 1964 President Dorticós remarked that "Our
principle idea has been full freedom for those who support the
Revolution, nothing for those who are opposed,"[37] and a year later
Fidel explained "that his view of art had much in common with his view
of truth: 'Art is not an end in itself.  Man is the end.  Making men
happier, better.'"[38]

To this ominous end both art and culture are organized,
channeled, directed in Cuba.  They are usually, although not inevitably
filtered through an ideological medium; an introduction to a study of
Cuban cultural policy begins by declaring "The forms of Cuban culture
could not help reflecting the fact that, until the triumph of the
Revolution, Cuba was a country dominated, first by colonialism, and
later by imperialism."  The study points out that it was the Cuban
intellectuals and artists (José Martí being the foremost exemplar) who
were the vanguard of the national, anticolonial struggle: "This patriotic
drive for freedom was resisted by various reactionary political
tendencies, but the finest and most genuine among the Cuban
intellectuals of the day—professionals, academics, artists and
writers—joined ranks with the peasants, former slaves, craftsmen and
other urban workers.  As happened in other Latin American countries,
cultural life was stirred by patriotic fervour."[39]  The official line claims
that, as in Mexico, the Russian Revolution had an enormous impact
upon the Cuban intelligentsia:

... the Cuban revolutionary process drew inspiration from the most advanced
ideas of its time, and so did Cuban intellectual life.  The October Revolution
influenced the avant-garde and impressed their outstanding creative minds.
Prominent cultural figures saw themselves in the context of the new age, embraced
the anti-imperialist cause, took their place alongside the working class, advocated
its revolutionary ideology and, in many instances, joined ranks with the advocates
of Marxism-Leninism or led the social and political struggle.[40]

This is frankly exaggerated, for there was in Cuba no discernible artistic movement as political in nature and distinctive in style as that of the muralists of Mexico. However, a group of young Abstract Expressionists, Los Once (The Eleven), actively opposed Batista during the 1950s. Upon the triumph of Castro in 1959, "far-reaching changes" were deemed indispensable "to the cultural transformation called for by the new historical reality."

Among those changes have been: participation of the masses in cultural activity; the reappraisal of the most important works of national art and literature and of universal culture; the foundation of cultural bodies, institutions, and groups; the creation of a Cuban cinema; an increase in the number of libraries, galleries, and museums; the revival of the mass media and their gradual transformation; and "significant" achievements in the field of artistic creation. To this end the government created and runs the National Cultural Council, the aforementioned Cuban Writers and Artists Union, Casa de las Americas, and film and music groups. In 1976 the National Cultural Council, the Instituto Cubano del Arte e Industria Cinematográficos, and the Instituto Cubano del Libro were amalgamated into a Ministry of Culture. [41]

The political basis of the cultural policy of Cuba is clearly spelled out:

Under the Constitution of the Republic of Cuba, the State guides, fosters, and promotes education, culture, and sciences in all their forms. The State accordingly bases its educational and cultural policy on the scientific conception of the world established and developed by Marxism-Leninism.

Only socialism recognizes the true values of art and literature, emphasizes their social function, and gives the artist the freedom and material stability that assure him the decent life to which he is entitled. Socialism creates the conditions which make genuine creative freedom a practical possibility.

Only in a society free of exploitation, whose fundamental objectives are to satisfy the ever-growing material and spiritual needs of the human being and to develop a new form of social relations, can culture attain its finest flowering and raise human life itself to aesthetic levels.

Under socialism, art and literature are untrammeled by the pressures of supply and demand ruling in the bourgeois society, and there is every opportunity for aesthetic expression and enjoyment. Capitalism, as Marx pointed out, is inimical to the development of art and literature, in that the work of art becomes a commodity serving the interests of the ruling class. [42]

According to official policy, the Revolution has removed

the impediments with which the capitalist market hampers artistic and literary work. Creative artists are assured of sufficient resources to cover their needs and are thus able to develop their talents without any hindrance whatsoever. . . . The conditions of penury and humiliation, which formerly beset literature and the arts are a thing of the past. No longer do creative artists live on the fringe of society:

they are now fully integrated in the social structure as factors vital to the building of socialism. The exclusivist character with which the bourgeoisie invested certain forms of artistic expression has been erased; the foundations have been laid for the development of a socialist culture.[43]

Does state subsidy under socialism dictate form and content of art any more than under capitalism? No one suggests that all art in Cuba is "revolutionary," or follows the dictates of state policy. But the existence of a large group of émigres working outside of Cuba does suggest that for many, state sponsorship steers a course too close to state control. The consequences of "deviationism" are clearly spelled out: "The Constitution guarantees freedom of artistic creation, provided that its content is not inconsistent with the Revolution, and declares that the forms of artistic expression are free."[44]

And the state has created a vast artistic infrastructure, from exhibits at Casa de las Americas to "popular art" employed in the service of the Revolution. Muralism, the graphic arts, photography, and caricature are prevalent and popular forms of people's art, although Cuba has not produced any figures on the same level as Rivera, Siqueiros, and Orozco. Graphic arts are displayed everywhere: posters are pasted on every wall and every street in Cuba; billboards exhort defiance against the United States, solidarity with those on "internationalist" duties, and imitation of the selfless example of Che Guevara. Health, political participation at the local level, education, production, solidarity, the iconography of the past, and the promise of the future are subjects for the people's art—or at least for the people's graphics. Cartoonists regularly take aim at bureaucracy, *machismo*, and abuses of the Cuban system, but not at the party's domestic or foreign policy, much less the party or *el jefe máximo* himself. As Félix Beltrán, head of the Visual Artists Section of the artists union, admitted, "We have a topic restriction. Our revolution cost a lot of time and a lot of lives, and that is why it is impossible to be against it."[45]

Are there parallels between the Mexican and Cuban revolutionary experiences in the uneasy alliance between art and the state? In both societies the vanguard of the intelligentsia fought against corrupt and repressive regimes, and in both a radical new beginning in society and culture was sought after the triumph of that revolution. But the Mexican Revolution was the first of this century, before the ideologies of fascism and Communism polarized political movements into hemispheres of light and darkness. The naive and optimistic progressivism of the artists of the WPA in Franklin Delano Roosevelt's depression-era America and even the uncritical Communism of the *muralistas* belong to a younger era long vanished. It was a tired and

cynical revolutionary who finally took power in 1920, and the changes he and his supporters engendered in Mexico were cautious, moderate, and essentially developmentally capitalist rather than radically socialist. Vasconcelos was a reformer, not a revolutionary. He subscribed to a progressive and conciliatory philosophy; and he tolerated and encouraged the more radical artists whom he employed to interpret their mythical vision of Mexico's past and future. When their vision outstripped his, it was his intellectual and moral honesty that made him support and defend them against conservative reaction.

Obregón survived a ten-year struggle, and climbed shakily to the top of the greasy pole of power in Mexico. Castro literally was the Cuban Revolution; when he declared it to be Marxist he drew certain boundaries which permit no dissent or discussion of the parameters of acceptable political art. Octavio Paz declares the 1910 revolution to be an agrarian and nationalist revolt, not an ideological revolution. Castro declares his victory to be a triumph in a long struggle against imperialism, colonialism, and capitalism. The forty years between the two revolutions have seen a polarization which admits no flexibility or compromise in the political arena. Is it surprising then that there is as little flexibility in the art of the revolution? To employ an old cliché, when artists stand outside the system, when they are marginalized, they can be revolutionary, part, as they would suggest, of the solution. When they are coopted and become part of the system, they are transformed into part of the problem.

## NOTES

1. Morton Keller, *The Art and Politics of Thomas Nast* (New York, NY: Oxford University Press, 1968), pp. 3-6.

2. Ron Tyler, "Posada's Mexico," in *Posada's Mexico*, Ron Tyler, ed. (Washington, DC: Library of Congress, 1979), p. 5.

3. Laurence E. Schmeckebier, *Modern Mexican Art* (Minneapolis: University of Minnesota Press, 1939), p. 21.

4. Jean Charlot, *The Mexican Mural Renaissance, 1920-1925* (New Haven, CT: Yale University Press, 1963), p. 35.

5. Ibid., p. 44.

6. See Antonio Luna Arroyo, *El Dr. Atl: Sinopsis de us vida y su pintura* (Mexico, DF: Editorial Cultura, 1952).

7. Schmeckebier, pp. 33-34.

8. In *Boletín* 1 (1914), 74; cited in Charlot, p. 49.

9. Siquieros, *Autobiografía*; cited in Charlot, pp. 49-50.

10. Charlot, p. 243.

11. Cited in Ivor Davies, "Diego Rivera and Mexican Art," *Studio International* 200, 1018 (Nov. 1987), p. 33.

12. Charlot, pp. 243-244.

13. See fig. 38 in Charlot.

14. John H. Haddox, *Vasconcelos of Mexico: Philosopher and Prophet* (Austin: University of Texas Press, 1967), 5.

15. Ibid., p. 6.

16. John Skirius, "Barreda, Vasconcelos, and Mexican Educational Reforms," *Aztlán* 14, 2 (Fall 1983), 309.

17. Ibid., p. 316.

18. John Rutherford, *Mexican Society during the Revolution: A Literary Approach* (Oxford: Clarendon Press, 1972), p. 54.

19. Skirius, pp. 315-316.

20. J. E. Spilimbergo, *Diego Rivera y el arte de la revolución mejicana* (Buenos Aires: Editorial Indoamérica, 1954), p. 22.

21. Stanton L. Caitlin, "Mural Census: Anfiteatro Bolívar," in *Diego Rivera: A Retrospective* (New York, NY: Founders Society Detroit Institute of Arts and W.W. Norton Company, 1986), p. 237.

22. Charlot, p. 261.

23. See *Diego Rivera: Los murales en la Secretaría de Educación Pública* (Mexico, DF: Dirección General de Publicaciones y Medios, [1986]).

24. Schmeckebier, pp. 114-121.

25. Octavio Paz, "Social Realism in Mexico: The Murals of Rivera, Orozco, and Siquieros," *Artscanada* 232-233 (Dec. 1979/Jan. 1980), 56.

26. Unpublished manuscript, cited in Charlot, p. 227.

27. Charlot, p. 228.

28. Ibid., p. 281.

29. Nemesio García Naranjo, "Imposiciones estéticas," *El Universal*, July 16, 1924; quoted in Charlot, p. 281.

30. Proclamation released July 2, 1924, quoted in Charlot, p. 288.

31. Paz, p. 59.

32. Ibid.

33. Ibid., p. 62.

34. Rafael Marquina, "Pintura en Cuba y pintura cubana," in *Libro de Cuba. Edición conmemorativa del cincuentenario de la independencia, 1902-1952 y del centenario del nacimiento de José Martí, 1853-1953* (Havana: Publicaciones Unidas, 1954), p. 580.

35. Quoted in Hugh Thomas, *Cuba: The Pursuit of Freedom* (New York, NY: Harper & Row, 1971), p. 1465.

36. *Hoy*, August 23, 1961; cited in Thomas, p. 1465.

37. Dorticós to Mark Schleiffer, *Monthly Review*, April 1964, p. 655; quoted in Thomas, p. 1465.

38. Lee Lockwood, *Castro's Cuba, Cuba's Fidel*, p. 207, quoted in Thomas, p. 1465.

39. Jaime Saruski and Gerardo Mosquera, *The Cultural Policy of Cuba* (Paris: UNESCO, 1979), p. 11.

40. Ibid., pp. 11-12.

41. Ibid., pp. 15-17.

42. Ibid., p. 21.

43. Ibid., p. 15.

44. Ibid., p. 21.

45. Eva Sperling Cockcroft, "Apolitical Art in Cuba?" *New Art Examiner* 13, 4 (Dec. 1985), 34.

# 4. The Broken Mirror: Argentine Art in the 1980s

## Marta Garsd

The Argentine military regime proclaimed the "Process of National Reorganization" between 1976 and 1983. It was one of the most repressive periods in the history of that nation, following political violence and turmoil after Juan Domingo Perón's death in 1974. Recent studies address the impact of the military dictatorship on Argentine filmmaking, literature, and the performing arts during the 1970s. Films and novels about those years proliferated with the advent of democracy in 1983 and attracted international interest.[1] The visual arts from 1976 to the present have not received equal attention. There are some art-historical research difficulties in analyzing the arts under the recent military regime. For example, some painters simply judge art production under the "Process" as a wasteland. Moreover, accurate data are scarce; some artists who lived in Argentina at the time are reluctant to provide details. In contrast, there is a wealth of available information related to the more recent Argentine past, provided by the prolific and outspoken generation that emerged in the 1980s. Entirely new factors intervene in the making of the emergent art, and conclusions can only be tentative because it is an ongoing process. Yet part of the harvest of the bitter years is being reaped now as young men and women artists, who came of age during the "Process," begin to exhibit their work.

The objective of this paper is twofold. First, it outlines a few of the multiple effects of the "Process of National Reorganization" on art-mediating factors such as museums, schools, and systems of promotion during the late 1970s. Second, although the study of visual expressions from that period is far from an exhausted topic, it will address some artistic tendencies of the generation of the 1980s. The research is based primarily on a series of interviews conducted in 1987 with Argentine artists, art dealers, and art educators in Argentina and, more recently, with Argentine émigré artists and officials living in the United States. The extent of the second part of my analysis is limited to the young artists who work in Buenos Aires, a city that still monopolizes cultural opportunities.

Let me briefly discuss the context in which the arts operated in the late 1970s. The downward spiral of violence and general deterioration that Argentina suffered during that decade began with a crescendo of terror from both the left and the right. A coup d'état and state terrorism followed. Repression engulfed many nonviolent opponents of the regime. In 1982, the Malvinas/Falklands War prompted the collapse of the military government.[2] It is relevant to recall that some authors argued that Argentina was not ruled by an authoritarian state during the years of the military regime. The notion of state is interpreted here as an abstract and rational legal structure or bureaucracy that coordinates individual and group conflicts. Argentine-born sociologist Juan E. Corradi observed that, under the umbrella of the military, "armed bands were sovereign in many fields," and "powerful rival groups roamed uncontrolled."[3] Journalist Robert Cox, a long-time observer of Argentine society, described the Argentina of the late 1970s as a "feudalistic and anarchic" place.[4]

In this context, political repression affected visual artists and art students according to their individual beliefs or political participation. Painting does not seem to have been, however, the target of the authoritarian restrictions that influenced film, television, and the performing arts.[5] Yet the effects of the regime were no less devastating on the visual arts than on other areas of culture. There were arbitrary acts that can only be explained in the framework of the uncontrolled powers ruling Argentina during those years. One such instance was the suspension of payments to award winners of the First National Prize, a lifelong pension awarded annually to the best young artists. Although art juries continued to select awardees, all winning artists were deprived, without further explanation, of the only subsidy offered by the Argentina state.

Opportunities for promotion, in particular for the youngest, were as scarce as the possibilities of financial reward. During those years, authorities considerably reduced the number of officially sponsored Argentine art exhibitions abroad. In the United States, for example, there were only a few shows devoted to already established artists who resort to abstract or lyrical imagery.[6] Students were confronted with art academies with stagnated curricula.[7] An increasing number of young painters opted to train with older independent artists rather than in the official art schools.[8] The neglect of cultural expressions extended to museums and archives, their visual collections suffered from often irreversible deterioration, depriving art students and professionals of valuable elements of their cultural heritage.[9] Under

these circumstances it is not surprising that many of the practicing artists emigrated or abandoned painting.[10]

It should also be pointed out that the "Process" had no aesthetic doctrine of art, nor were there any impositions characteristic of other totalitarian or state-oriented regimes through history.[11] The most important effort—both official and previously supported—to employ visual imagery for ideological purposes took place during the World Soccer Cup held in Buenos Aires in 1978. Posters, cartoons, and newsprint and television advertisements depicted an Argentina that, as a slogan put it, had "won over the world."[12] At the time, the mirror held before the Argentines showed the illusory image of people in togetherness and peace. One of the typical pictures selected to represent an alleged "Argentine life-style" was that of a middle class family walking on an open field, looking confidently toward the horizon and oblivious to the underlying conflicts of an Argentina that was heading to internal and external catastrophe.[13]

That fabricated vision of a consolidated, nonviolent, and optimistic society was blasted into a multiplicity of pieces in the painting of the young Argentine artists who came of age within that social climate and began to exhibit in the 1980s. What does the new art tell us? Within a great plurality of expressions, it is possible to perceive two tendencies. One group opts for the elimination of all direct allusion to locality or historical reality. Within a second group, the young artists' imagery seems to be cathartic of the violence, deterioration, instability, and uprooting experienced by many Argentines in recent years.

The first group is rather homogeneous. The painters adhere to prevailing trends of international mainstream art generated primarily in West Germany, Italy, and the United States. These tendencies of the so-called New Subjectivity or New Image Painting have been sanctioned by museums in the Western world and its art market since the early 1980s.[14] Guillermo Kuitca (1961–) and Alfredo Prior (1952–) represent these trends in Argentina. Among emergent Argentina artists, Kuitca, Prior, and a few others are the most likely to be known by a foreign audience, as they have been recently promoted abroad by some cultural institutions in Argentina.[15] Art dealers contribute to this patronage because the tendency Kuitca and Prior stand for supposedly has potential viability in the international art market.

Kuitca paints oversized, windowless spaces often furnished like bedrooms or living rooms. Within these alienating and suffocating rooms, small-scaled, precarious figures stand immobile or perform strange, clownesque acts (illus. 1).* Sometimes the space resembles an

---

*See Illustrations Cited in Text, below, after the Notes.

empty theatrical set and the painter himself appears, in a rather narcissistic way, as the center of the created scenario (illus. 2). Prior also renders dwarfed figures in large abstract spaces that illustrate allegorical and biblical stories or myths (illus. 3, 4, and 5).

Two characteristics are to be noted in the art of these New Subjectivity painters. First, the miniaturization of figuration, or the "doll-house syndrome," as an American critic has called it.[16] The scale reduction and the doll-like or mannequin-like attributes of Kuitca's and Prior's figures allude to docility or powerlessness. The second feature, evident in the case of Prior, is withdrawal into the realm of myth through images that are often childish and incapacitatingly melancholy. This is an art trend of a declared nihilism for which, according to an Argentine art critic, "all projects seem to dissolve."[17]

The second category of emergent Argentine artists remains less fashionable than the New Subjectivity painters. The artists of this second group employ a great diversity of art methodologies. The work of Germán Gargano (1954–) mobilizes memories of chaos and violence in the recent Argentine past.[18] In *The Assault*, abstract silhouettes, suggestive of humans, run, fall, and are entangled in confusion as if in a riot or confrontation beside what appear to be barricades in desolate environments (illus. 6). As in a close-up, *A Break* shows fragmentary views of corpses lying on the ground (illus. 7). Gargano's iconography reveals the disturbing characteristics of an obsessive fascination with death, which one could perceive as an experience expected from or inflicted on others. Other paintings by Gargano allude to barbarism. *Remains*, for example, is a configuration that recalls a putrescent piece of meat or part of a body abandoned on a table or a stretcher (illus. 8).

Political turmoil and violence run through different periods of Argentine history, and Argentine artists have dealt with these issues well before Gargano. Among those artists are two with whom Gargano studied. Luis Felipe Noé (1933–), who addressed barbarism and anarchy in nineteenth-century Argentine society in his *Federal Series* of the 1960s, and Carlos Gorriarena (ca. 1930–), who late in the 1980s painted some gory scenes of mutilation and violence (illus. 9).

Another young artist whose imagery relates to the recent Argentine experience is Jorge Méndez Matta (1953–). His paintings are about inhospitable landscapes and interiors that are filled with layers of debris and rendered passionless with crisp delineation and pale watercolor hues (illus. 10 and 11). In his open environments, often drawn from the perspective of a cliff's edge, the ground has cracked open in clear-cut pieces that recall ice blocks (illus. 12). Those who are familiar with contemporary Argentine literature would associate Matta's

fractured ground with Antonio de Benedetto's poetic vision of the broken sidewalks of Buenos Aires, metaphors of the city's open "wounds," inflicted by the devastation of dictatorship on the collective spirit.[19]

Finally, I might add that not all is gloom. The emergent art's iconography sometimes touches sensitive areas of the Argentine soul with certain humor. Such is the case of Mónica Girón (1959–), who is obsessed with themes of migration.[20] Exile is both a painful reality and a fantasy for many Argentines. A recent poll indicates that 25 percent of the population fantasizes about emigrating, and it is estimated that between 800,000 and 2.5 million Argentines emigrated in recent decades from a nation of about 30 million.[21] Girón alludes to these themes by means of shifting landscapes—as one perceives things from an airplane in flight—and cartoon-like figurations that symbolize different means of departure such as airplanes, ships, and people suspended in the air (illus. 13, 14, and 15).

Even within the group of artists who work in Buenos Aires this account is limited and preliminary. The emergent art reveals withdrawal from reality (Kuitca and Prior), memories of violence (Gargano), visions of chaotic environments (Matta), and images of uprooting (Girón). Above all, the new art points to some of the conflicts and emotions characteristic of Argentine society in the 1970s which, yet unresolved, are part of the Argentina of the 1980s.

## NOTES

1. See Julianne Burton, "Exiles and Emigrés: Crosscurrents in Cinema from the 1890s to the 1980s," and Lyman Chaffee, "Intellectual-Cultural Migrations: An Argentine Perspective," in *Intellectual Migrations: Transcultural Contributions of European and Latin American Emigrés* (Madison: The University of Wisconsin, 1986), pp. 44-45 and 29-38, respectively (hereafter *Intellectual Migrations*).

2. There is a wealth of literature—to a great extent written by Argentines—which refers to the complexities of that period. See, e.g., Comisión Nacional Sobre la Desaparición de Personas, *Nunca más* (Buenos Aires: EUDEBA, 1984); Juan E. Corradi, *The Fitful Republic: Economy, Society, and Politics in Argentina* (Boulder, CO, London: Westview Press, 1985), with selective bibliography; and Organization of American States, Inter-American Commission on Human Rights, *Report on the Situation of Human Rights in Argentina*, Ser. L, vol. II.49, doc. 19, corr. 1 (Washington, DC, 1980).

3. Ibid, p. 122.

4. Ibid.

5. *Intellectual Migrations*.

6. Personal interview with Dr. Liliana Iribarne, Cultural Attaché, Argentine Consulate, New York, March 3, 1988.

7. Personal interviews with Sofia Althabe de Contín, Rector, School of Visual Arts Prilidiano Pueyrredón, Buenos Aires, November-December 1987.

8. Personal interview with Argentine painter Carlos Gorriarena, Buenos Aires, February 1988.

9. Indifference toward Argentine's cultural patrimony cannot be exclusively blamed on the recent military regime. For a brief discussion of museum collections and management in Argentina during the last two decades, see Cristina Bonasega, "Argentina," *Museum News* 67, 1 (Sept.-Oct. 1988), 35-36.

10. For a personal perspective on artistic practice during these years see Pablo Bobbio, "El devenir de una catedral," *Arte al día* 21 (Aug. 1985), 22-23.

11. See, e.g., Umberto Silva, *Ideologia e arte del Fascismo* (Milan: Gabriele Mazzotta, 1973); Alexandre Cirici, *La estética del franquismo* (Barcelona: Gustavo Gili, 1977); and Theda Shapiro, *Painters and Politics* (New York, NY: Elsevier, 1976), pp. 212-213.

12. See *La Nación* (Buenos Aires) 1978: June 22, sec. 3, 16; June 25, sec. 2, 3; and June 29, sec. 3, 21.

13. At that time, the Montonero guerilla group circulated a Spanish-English brochure about human rights violations being committed in Argentina. The publication invited the reader to look into terror and torture by means of a slick, attractively designed brochure. See Andrew Graham-Yooll, "The Wild Oats They Sowed: Latin American Exiles in Europe and Some of Their Publications," in *Intellectual Migrations*, p. 52.

14. On the subject of the critical notoriety and commercial success of the Italian and German avant-garde movements see Marcia E. Vetrocq, "Utopias, Nomads Critics," *Arts Magazine* (April 1989), 49-54; and Kim Levin, *Beyond Modernism: Essays on Art from the '70s and '80s* (New York, NY: Harper and Row, 1988), pp. 207-215.

15. Kuitca and Prior were selected to represent the emergent generation in an exhibition in the United States organized under the advice, among others, of the Centro de Arte y Comunicación Visual and Galería Ruth Benzacar (which represents these artists) in Buenos Aires. See *New Image Painting: Argentina in the Eighties*, Exhibition catalog (New York, NY: The Americas Society, 1988). See also my review of that exhibition in *Art in America*, forthcoming issue.

16. For a discussion of the human figure in contemporary Western art see Klauss Kertess, "Figuring It Out," *Artforum* 19, 13 (Nov. 1980), 33-34.

17. Guillermo Whitelow, *Premio Joven Pintura Argentina–1988*, Exhibition catalog (Buenos Aires: Casa Fortabat, 1988), Foreword (without pagination).

18. Gargano shies away from direct associations of his paintings with the recent Argentine past. His images, he emphasizes, are not intended as narratives but as "metaphors of psychic states." Personal interview, Buenos Aires, Feb. 27, 1988.

19. Quoted in Osvaldo Bayer, "De regreso: El viejo y el nuevo país," in *Intellectual Migrations*, p. 18.

20. Personal interview, Buenos Aires, Feb. 25, 1988.

21. See Chaffee, *Intellectual-Cultural Migrations*, p. 31.

## ILLUSTRATIONS CITED IN TEXT

1. Guillermo Kuitca, *Untitled*, 1986, oil and acrylic on canvas, 55 by 78 inches. Collection Sergio Tissenbaum, New York.

2. _____, *I, As the Angel*, 1986, acrylic and oil on canvas, 74.80 by 125.98 inches. Collection of the artist, Buenos Aires.

3. Alfredo Prior, *Piel de Asno*, 1988, acrylic on canvas, 76.77 by 68.89 inches. Collection Ruth Benzacar Gallery, Buenos Aires.

4. _____, *Paradise*, 1988, acrylic on canvas, 78 by 76 inches. Collection Ruth Benzacar Gallery, Buenos Aires.

5. _____, *Bête noire*, 1988, acrylic on canvas, 76.77 by 68.89 inches. Collection of the artist, Buenos Aires.

6. Germán Gargano, *The Assault*, 1986, acrylic on canvas, 47 by 51 inches. Collection of the artist, Buenos Aires.

7. _____, *A Break*, 1984, acrylic on canvas, 31 by 35 inches. Collection of the artist, Buenos Aires.

8. _____, *Remains*, acrylic on canvas, 39 by 47 inches. Collection of the artist, Buenos Aires.

9. Carlos Gorriarena, *Noche plateada por la luna*, 1986, acrylic on canvas, 78 by 55 inches. Collection of the artist, Buenos Aires.

10. Jorge Méndez Matta, *Room*, 1987, watercolor on paper, 14 by 11 inches. Collection of Studio Art Galerie, Montreal.

11. _____, *Untitled*, 1987, watercolor on paper, 14 by 12 inches. Collection of Studio Art Galerie, Montreal.

12. _____, *Mujer a la hora del rancho*, 1987, acrylic on canvas, 39 by 33 inches. Collection of Studio Art Galerie, Montreal.

13. Mónica Girón, *Territories*, 1988, acrylic on canvas, 40 by 48 inches. Collection of the artist, Buenos Aires.

14. _____, *Cascos*, 1988, acrylic on canvas, 40 by 48 inches. Collection of the artist, Buenos Aires.

15. _____, *Waiting*, 1987, acrylic on canvas, 12 by 32 inches. Collection of the artist, Buenos Aires.

# 5. Haitian Art in the Twentieth Century

## Gerald Alexis Fils

If we look back in time, over nearly two centuries of independence of the Republic of Haiti, we will see that the development of its visual arts, if compared with literature, poetry, dance, music, and architecture, has been very seriously impaired. This was the case up to the 1940s, mostly because of a lack of continuing institutional support and the total absence of infrastructures such as museums and art galleries. The potential art buyers, whose tastes were mainly fashioned by traditional European academic trends, were all this time totally uncaring for the local talents. This situation curiously prevailed in the first half of the twentieth century, in spite of a growing national awareness stimulated by the American occupation of Haiti from 1915 to 1934. This nationalist spirit was strongest among Haitian writers and poets at first. Painters referred to as the "Indigenists" soon joined in the search for these values that, while compensating for hurt pride, were to become the essence of a Haitian identity.

Whereas the literature of the time got world recognition, the Indigenist painters remained fairly unnoticed in Haiti and abroad, although *Market on the Hill* by the painter and novelist Petion Savain won first prize in the IBM Corporation 1938 Contest and was shown that same year in the "Contemporary Art of the Western Hemisphere" exhibition at the San Francisco World's Fair.

In their quest for identity and their reevaluation of the indigenous elements of their culture, these artists and the writers and poets as well, looked to the peasant and poorer classes for inspiration. Since they were all from the upper middle class and the aristocracy, their vision of the lower classes, over the enormous gap that separated them, was often too superficial, as was their pictorial representations of these social strata. Their works at that time were unattractive, on the one hand, to the poorer classes who could not find themselves in these idealized genre scenes and, on the other hand, to the potential buyers among the elites who, refusing to deal with such realities, found these works of art totally unacceptable.

40

The taste of the elites for European styles had, since the Concordat of 1860, been reinforced by the Catholic clergy both in their parishes and in the schools that were established to educate the sons and daughters of this elite. The church indeed had strongly imposed its iconography and was unsympathetic to any pictorial interpretation of the holy scriptures by local artists, fearing some form of syncretism with voodoo.

In the early 1940s, a group of young painters, very much in line with the manifesto of the Indigenists, created a series of murals representing scenes of the life of Christ, in a chapel on the outskirts of Port-au-Prince, the capital of Haiti. The head of the Catholic Church, a Frenchman, who attended the unveiling ceremony, ordered that the murals be immediately destroyed because he said they were sacrilegious.

It is no wonder that, at the time, an artistic career in Haiti seemed abhorrent. One easily understands why. In the hope of finding new opportunities, Haitian artists so eagerly supported the American painter Dewitt Peters who, soon after his arrival in Haiti in 1943, thought of opening a school in Port-au-Prince, the "Centre d'Art," where "artists could come and paint and exchange ideas."[1]

Several young talents, eager to learn, joined the Centre after it opened in May of 1944, with a major exhibition of the works of some twenty local artists. From then on, and for a short while, works of a whole generation of artists who had remained in total anonymity were displayed for public viewing and also for sale. Names like Lucien Price, Maurice Borno, Gerald Bloncourt, Antonio Joseph, Andrée Mallebranche, Luce Turnier, Andrée Naudé, and Tamara Baussan became known to a larger public. This was a particularly great victory, for the women in particular, for whom engaging in an artistic career represented enormous difficulties.

Soon after the Centre d'Art opened, Peters organized, with the help of Cuban writer Alejo Carpentier and Cuban art critic José Gomez Sicré, an exhibition of vanguard Cuban painters which had just been shown in New York at the Museum of Modern Art. Some of the artists represented in that show, Wifredo Lam, Cundo Bermudez, Mario Carreno, and Rene Portocarrero, came to Haiti and held classes and workshops for their colleagues of the Centre d'Art. Gomez Sicré reports that the Haitian painters were

eager to find new guidelines, and the Cuban show . . . provided the appropriate example, since Haitians could identify geographically with the Cuban artists and respond with no difficult to the tropical boldness of their works. In discussions

that [he] had with them, [Gomez Sicré] tried to open new routes, new directions that would not take them too far from their own origins. [2]

American painters and sculptors also came to the Centre d'Art, and soon these artists who, because of their education, were mostly oriented toward academic art, became familiar with a more modern pictorial language that seemed to suit them better. Modernism had then definitely reached Haiti.

It is also in that same period that an event occurred at the Centre d'Art which none of its members, instructors, and students had expected. An artist from the northern city of Cap Haitian sent in a painting titled *Visit of President F. D. Roosevelt in Cap Haitian, on July 5, 1934*. His name was Philomé Obin. For several years he had been a "Sunday painter" of very modest origins and barely knew how to read and write. His work then consisted of portraits commissioned by local Masonic lodges and mostly of historical scenes which were to become one of his favorite subjects. Obin was born and raised a Christian. In answer to a letter from Dewitt Peters who was gathering information for a book (which he never published), Obin replied: "As far as my painting is concerned, I never had any masters, no directors nor teachers, it is a gift of God." And he added: "The spirit teaches me always that painting is a beautiful art."[3] This apparently minor detail is stressed here because other popular painters who were to come to the Centre d'Art in the months to follow were, for the most part, voodoo adepts. From then on, voodoo was going to become an important element of Haitian art, as art had always been an important element of the voodoo religion.

Peters at first, and his artist friends as well, found Obin's work particularly awkward, but, as more artists from the lower classes came to the Centre, it became evident that their art could have, and indeed had, some interesting qualities. Peters and one of his close friends, also involved in the Centre d'Art, the Haitian writer Philippe Thoby Marcelin, set out to look to the lower levels of society for such unknown talents. One of their most extraordinary finds was Hector Hyppolite, who had also been painting for several years decorating houses and store fronts in provincial towns. Hyppolite, it is said, also made hand-painted postcards that he sold during the American occupation to foreign visitors and marines. Hyppolite, of whom many stories have been told, was a voodoo adept, and his works cannot be understood outside of his religious beliefs.

Hyppolite's work, like that of Obin, was undeniably interesting visually. However, contrary to the work of Obin whose narrative paintings were often made from photographs,[4] Hyppolite's work

showed unusual aesthetic features such as the circular composition in the middle of which he would sometimes place his main subject. But aside from its aesthetic values, the work of Hyppolite was unusual because its meaning was particularly evasive. Reading such works literally led nowhere. Their real meaning went far beyond the plain representation. Of course, at the time, very few people had looked to voodoo for a possible explanation: André Breton, who visited Haiti then, called Hyppolite a surrealist.

Popular religion had survived clandestinely. Since colonial times it had been strongly repressed and was still, officially, by nearly all governments of the independent republic. The Catholic Church, several times, had demanded and obtained the destruction of voodoo temples around the country.

Those who did understand what Hyppolite and other popular painters like him were expressing, were a handful of intellectuals who, as of the mid 1930s, came to regard voodoo as no longer practices of the devil but—they were very cautious in their statements—as representing an interesting field of study. As a matter of fact they had, at the time, started to collect objects created for the voodoo cult which showed the ability of the masses to render, in their own ways, their ancestral traditions.

Whereas the Haitian-trained artists were beginning to understand and appreciate what in the work of the popular masters could be the elements leading to a Haitian aesthetic, most art experts from around the world remained very close to their superficial aspects, and so they spoke of phenomenon, of miracle. They went so far as to say that the Centre d'Art, and Dewitt Peters more precisely, had created a true Haitian art. They were interpreting, very loosely, a statement by Peters where he said: "I could not understand that in a country of such extraordinary natural beauty, the visual arts were practically nonexistent."[5]

Dewitt Peters, eager as he was to create a market for Haitian art, got involved in an intense promotion campaign oriented particularly toward the American collectors. In the limelight were the popular painters, the stars, the creators of such marvels. Being that of untrained artists, the newly revealed form of expression came instantly to be coined as "primitive." In the shadow were kept of course those Haitian artists who had received some training and who were judged by the "promoters" of Haitian art as "not authentic" and unworthy of being presented to a sophisticated public. Since they were marginalized, the "nonprimitives" were kept out of the project of decorating the walls of the Episcopalian Cathedral in Port-au-Prince, a

project that included only those qualified as "primitives." These murals, of undeniable interest, remain to this day a most remarkable accomplishment.

The distance thus created between the two groups was responsible for the tense atmosphere that prevailed at the Centre d'Art at the end of the 1940s. The trained artists, the intellectuals of the time, strongly rejected the term "primitive," which they found derogatory and insulting, because, in the Western world, naturalistic representations like those of the popular masters were thought to be the true indication of the technological and intellectual level of a culture.[6] Many have said that the tension was created in part by social conflicts arising between the two groups, but time has proven that this was not so.

In the early forties, Haiti was undergoing important social and political changes that were to culminate in the overthrow, in 1946, of the Government of Elie Lescot, a man of the elite, who was replaced by Dumarsais Estime, a politician of lower social background. The needs and possibilities of the masses then became more and more understood. The trained artists, disappointed by the establishment and strongly influenced by postwar ideas, became more and more concerned with controversial social issues, and their works well reflected such concerns. When, in 1950, they left the Centre d'Art to create the "Foyer des Arts Plastiques," they became totally involved in these issues, and many of them developed and kept for several years a style that was later referred to as "Realisme de Cruauté," or harsh faith realism.

Many of those who had been called "primitive" soon felt trapped and justly feared that this commercialization might lead to their destruction. Just as the trained artists were learning from them, they felt that they should have the right to learn from the trained artists ways to improve their techniques and to be more in control. Several of them also left the Centre d'Art to join the Foyer. In the months and years to follow, they indeed showed spectacular changes. Others remained at the Centre d'Art and tried desperately to move away from their initial style.

The future of the Foyer des Arts Plastiques looked rather dark, and indeed, soon after its opening, the group faced serious problems. By moving away from the Centre d'Art, the dissident "primitives" had also moved away from the only possible market at the time, the U.S. market, and thus found themselves starving. The trained painters, the leaders of the "rebellion," were put under tremendous political pressure. Promoters of Haitian art in the United States were not ready to accept such radical activities which they equated with political extremism. We must not forget the almost pathological fear of

communist infiltration that prevailed in the United States in the years that followed World War II, commonly called McCarthyism. At the time, Senators in the U.S. Congress, particularly Georges A. Dondero, Representative from Michigan, rose against Modern art. In his congressional speech on August 16, 1949, Dondero said that Modern art, to him, seemed to be communist inspired because of the "depraved" and "destructive" nature of its forms.[7] The work of the Haitian moderns corresponded to the ideas that Senator Dondero had expressed. We do not have records of any direct intervention by the U.S. State Department, but the fact still remains that artists of the Foyer, who were reported to be communists, got absolutely no support from the newly formed military government of General Paul Magloire. Some even had to leave the country. Lucien Price, considered today as the father of Modern art in Haiti, suffered a serious breakdown and later committed suicide in the attic of his family mansion, in the plush neighborhood of Port-au-Prince. The Foyer des Arts Plastiques did not survive. Frustration, exile, depression, death were the price paid for Modern Haitian art's becoming what it is today. Yet, outside of Haiti it is still so often denied.

Many of the "primitives" that had joined the Foyer, and who could not stand the pressure, returned to the Centre d'Art and to their initial style. But in the meantime, the Centre had recruited a new generation of artists, also labeled "primitive," in spite of their lack of spontaneity. A boom in tourism and an ever increasing demand for exotic and decorative paintings contributed considerably to the success of this new breed of artists. Some of them, interviewed by Dr. Michael Philippe Lerebours, a Haitian art historian, admitted having chosen this style because it was guaranteed to sell.

By the mid-fifties, a broader local clientele started to develop. Although recognizing the qualities of the early popular masters, they showed a strong preference for the works of the modern artists because of their increased appreciation of the Indigenist literature, with its social and political implications. They better understood the struggles the modern artists had endured. Articles in the local press also contributed to this increased interest in the moderns. This younger generation of arts, contrary to their elders, had few personal means of survival, but, although limited, patronage by some well-to-do Haitians allowed them to pursue their careers. Artists, intellectuals, and patrons met regularly at the Galerie Brochette, the new gathering place of the avant-garde. There again, some young talents, scrupulously selected, were allowed to join. Other groups and institutions, such as the

Academy of Fine Arts, Calfou, and Poto-Mitan, created in the late fifties and early sixties, strengthened the modern art movement.

In 1956, the military government of Paul Magloire came to an end, and the General President left for exile. A period of uncertainty followed, where provisional governments were constantly changing. In 1957, Francois Duvalier came to power and the political situation further deteriorated, killing the tourist industry that so heavily supported the Haitian "primitives." Many of these artists abandoned their careers and some left Haiti for the United States with the illusion that they would become famous. Among those who remained in Haiti, Salnave Philippe Auguste continued to paint his fantasies, and his disciples, in different ways, also exploited the theme of the lush tropical vegetation. Often they left out Adam and Eve, creating what has become the popular "Jungle Scenes" that recently were aid to be, again by experts, "reminiscent of the ancestral land of these 'sons of African slaves'." Other artists, having been freed from the constraints of the market, moved closer and closer to what the modern artists were doing. Paul Beauvoir created, with other former "primitives," an intermediary style in which the artists retained the vivid colors of their earlier works but dealt more freely with forms. Others, following the trends of the time, took a strong turn toward realism. Younger artists, particularly from the southwest, started to develop a style where one finds elaborate, dream-like landscapes. Although highly technical, the works of these artists are still called "primitive" by some. Also considered "primitive" is the work of younger artists of the north of Haiti who, even though they have remained in the realist tradition of the School of Philomé Obin, have shown tremendous technical progress.

Times have changed, of course, and today Haitian artists, whatever their social or economic background, are not as isolated as they used to be; they know and often travel to see what is going on outside their island. Most refuse now the limitations of the labels that had been affixed to their works.

Am I trying here to say that what had been called "primitive" Haitian art no longer exists? Not at all. As a matter of fact, in the past ten years, such talents as Lafortune Felix and Pierre Joseph Valcin have emerged to prove that such an art can still exist and be very strong. The point that I really want to get across is that, if indeed there is a way in which untrained Haitian artists express themselves, it must also be understood that other artists have developed more universal ways to express these same realities, those of Haitian people. Such diversity in expression should be considered as reflection of this immensely rich culture that is ours. The point that I want to make is

that Haitian artists of equal talent and genius should be dealt with equally and not according to the taste of a market so misinformed. Because, unless we can transcend and destroy all of the preconceived ideas about Haitian art, our artists, whether they be trained or untrained, are bound to remain prisoners of these ridiculous cliches and will never be able to achieve their full potential.

## NOTES

1. From Dewitt Peters's speech on the day of the inauguration of the Centre d'Art in Port-au-Prince, Haiti.

2. José Gomez Sicré, Foreword in Eleanor Ingalls Christensen, *The Art of Haiti* (Cranbury, NJ: A.S. Barnes and Co., 1975).

3. Letter from Philomé Obin to Dewitt Peters, April 2, 1956.

4. A reproduction of the photograph used by Obin as a model for *Visit of President F. D. Roosevelt in Cap Haitian* is shown in James H. McCrocklin, *1915 Garde d'Haiti 1934* (Annapolis, MD: U.S. Naval Institute, 1956), p. 225.

5. From Dewitt Peters's memoirs and widely publicized in the American press of the fifties.

6. Meyer Shapiro, "Style," in *Anthropology Today* (Chicago University Press), (1953), 287-312.

7. William Hauptman, "The Suppression of Art in the McCarthy Decade," *Artforum* 12, 2 (Oct. 1973), 48-52.

# Part Two
# Visual Art Forms

Literature, music painting, film, photography and sculpture, summon emotions as sentences evoke images.

—Victor Artur Carneiro
*Brazilian artist*

# I. Architecture

# 6. Argentine Architect Julián García Núñez, 1875–1944

## Margarita Jerabek Wuellner

### The Case Study Concept

The work of the prominent Argentine architect Julián García Núñez (1875–1944) is acknowledged as an important precedent in the evolution of Latin American architecture. García Núñez is credited today with having striven with some success to create an Argentine national style.

The sources García Núñez turned to for knowledge and inspiration were the projects and experiments of the avant-garde architectural movement in Europe. He has been recognized for his work in the Art Nouveau style and for his later evolution into the more severe Sezessionstil.[1]

García Núñez was active during a period when Latin American architecture was in the early phase of his identity crisis following Independence. The accomplishments of his career are considered representative of the period following Independence, corresponding to the theme of SALALM XXXIV.

By learning about the work and life of Julián García Núñez, some of the issues and problems at the base of Latin American architecture will become clear and help to give insight into its history and development.

### The Significance of Julián García Núñez:
### Latin American Precursor to Concrete Rationalism

A major problem of architecture in the nineteenth and twentieth centuries has been the issue of style. The babel of styles that resulted in stylistic chaos at the end of the nineteenth century required the development of a new approach to architecture and design.

In Latin America during the last third of the nineteenth century, Italian Romantic Classicism and French Second Empire were the most prevalent styles. With the beginning of the twentieth century, the French academic style of the École des Beaux-Arts gained greater influence, replacing previous styles. With independence, Latin American architects who wished to express their cultural and political

identities without reference to colonial or European powers turned to such artistic movements as Art Nouveau and Modernismo as a means to this end.[2]

Avant-garde architecture, until 1914, was related fundamentally to Art Nouveau, from which the various modern artistic movements evolved. The key innovators in these antitraditional artistic movements were, initially: Victor Horta (Belgium, 1861–1947); Hector Guimard (France, 1867–1942); Henry Van de Velde (Belgium and Germany, 1863–1957); Charles Rennie Mackintosh (Scotland, 1868–1928); and Antoní Gaudí (Spain, 1852–1926).

After the Art Nouveau movement was well defined and established in Europe, the work of Otto Wagner (Austria, 1841–1918); Josef Hoffman (Austria, 1870–1956); Joseph M. Olbrich (Austria, 1867–1908); Peter Behrens (Germany, 1868–1940); and Adolf Loos (Austria, 1870–1933) provided a transition from Art Nouveau, through the Sezessionstil and Jugendstil, to Modern architecture. It is significant to point out that the Belgian Art Nouveau, the German Jugendstil, and the Viennese Sezessionstil were among the earliest antitraditional artistic movements to appear.[3]

Modernismo, a specifically Catalán antitraditional artistic movement, had its roots in Art Nouveau as well. In Spain, Madrid and Barcelona were the most important art centers. Barcelona, above all, introduced Spain's new artistic works to Europe. At the end of the nineteenth and the beginning of the twentieth centuries there was a group of especially innovative, talented architects in the area of Barcelona: Francisco Rogent, Enrique Sagnier, Francisco Berenguer, José Puig y Cadafalch, Lluís Domènech i Montaner, and Antoní Gaudí.

Julián García Núñez was a student of the Barcelona group; he studied with Domènech i Montaner and was a disciple of Gaudí. He later represented their artistic movement in Argentina, introducing antitraditional avant-garde architecture to Argentina.[4]

Domènech i Montaner and Gaudí were the most representative architects of Modernismo and represented the two warring trends at the origins of the movement which led, respectively, to Rationalism and Expressionism within the Spanish movement.[5]

As a student of Lluís Domènech i Montaner (1850–1923) in the Escuela Superior de Arquitectura in Barcelona, we can assume García Núñez obtained a complete introduction to the artistic and theoretical makeup of Modernismo. Looking back from a late twentieth-century perspective, it is clear that the architectural education García Núñez brought back to Argentina was antihistorical and revolutionary at the time.

The theoretical influence of Art Nouveau is significant. Around the 1930s the architecture of the renowned Frenchman, Le Corbusier (1887–1965, was adopted as the model for most of the significant architectural construction in Latin America. It was not until the 1950s and 1960s that Latin American architects were able to break away from the Le Corbusian doctrine and fully emerge in their own right. [6]

The foundation of Le Corbusier's theory was based on the functional organicism of Art Nouveau, combined with the theoretical approach of French Rationalism which he applied to the new technology of reinforced concrete. The theoretical foundation for Art Nouveau, and later for Le Corbusier's thought, was laid by Eugène Emmanuel Viollet-le-Duc (1814–1879), who provided a theory of architecture derived from the tradition of French Rationalism which advocated the use of new building technologies, forms, and materials to promote the evolution of a new architectural style that could accommodate the changing needs of society. [7]

The father of Rational concrete construction, Auguste Perret (1874–1954), was Le Corbusier's teacher. Auguste Perret used the theory of Rationalism developed by Viollet-le-Duc to develop a new system of concrete construction that programmatically, functionally, theoretically, and aesthetically fit into the traditional Rational school of French architecture. [8]

In Latin America the use of concrete as the primary building material is important. Major construction in the twentieth century has been mostly limited to this material, as the difficulty and cost of obtaining other types of materials have made them prohibitive. Furthermore, the high degree of skill that native craftsmen exhibit in the construction of concrete structures makes the use of this material desirable.

Besides being the most popular international advocate of the use of reinforced concrete in architecture, Le Corbusier's formal and philosophical ideas about architecture were interpreted as appropriate for Latin America politically, humanistically, and socially. His concept of style and its evolution allowed for the development of new forms of architecture for a new and independent Latin America. [9]

Looking back at the period when García Núñez was working as an architect, it is clear that Art Nouveau was the most technologically and artistically advanced form of architecture at the time. Furthermore, it allowed for the development of individual expression which could become a new form, style, or language of architecture separate from any political or historical connection to the past. It was a modern, pragmatic, functional architecture that could accommodate any building

type that a newly established and evolving society required. It was, however, a theory of design developed in Europe. In the case of Antoní Gaudí, he made it the Catalán style. One can imagine that by studying Modernismo in Barcelona, García Núñez was attempting to learn how to create the basis for his own Argentine national style.

Although Art Nouveau did not survive long as a successful movement in either Europe or Latin America, its significance in the development of Modern architecture is undeniable. Art Nouveau is now understood to have been a transitional style between the traditional historical styles and Modern architecture. By rejecting historical styles and striving to develop a new language of architecture for Argentina, it is clear that Julián García Núñez was in a perfect position to make an important contribution to the evolution of Modern architecture in Latin America.

## The Life and Work of Julián García Núñez, Architect

García Núñez was born in Buenos Aires on July 15, 1875. His father was Julián García Vidal, a Castilian. His mother was María Núñez, a Catalán. He obtained his primary education in Buenos Aires and later studied in Spain, where he graduated from the Escuela Superior de Arquitectura in Barcelona with the degree of Architect on September 3, 1900. After completing his studies, he went on an extended sketching tour, as many young architects did in those days, of the Iberian peninsula, Africa, and Italy. Finally, in 1903, he returned to Buenos Aires, married Beatriz Romagoza, a Catalán, and set up his profession.[10]

As an architectural revolutionary in Buenos Aires, he followed a busy social life. He was a member of the Centro de Arquitectos, Constructores de Obras y Anexos; an associate of the Club Español; and an associate of the Casal de Cataluña. He was frequently in correspondence with European architects and was well informed of technological advances by foreign publications which were a part of his library, including: *La Construcción Moderna* (Madrid); *Arquitectura, Ingeniería y Construcciones* (Madrid and Barcelona); *Der Architect* (Vienna); and *The Studio* (London). The term *arquitectura moderna* was used by García Núñez and his colleagues for the architecture that was presented in these magazines, which reproduced the works of, among others, Domènech i Montaner, Gaudí, and even García Núñez himself.[11]

From the time he decided to become an architect, he was supported in his career by his father, a contractor. García Núñez joined his father's construction firm at the commencement of his

professional practice, and the firm was responsible for the construction of most of his design projects. [12]

Every afternoon the elder García would visit his son in his design studio in his home on calle Independencia, until Don Julián García Vidal died in 1924. Apparently, this date corresponds to the period when a major change occurred in the architectural work of García Núñez. After this time nothing more was constructed with a revolutionary conception. García Núñez moved from linear decoration to superficial forms more reminiscent of academic Neoclassicism. Nothing remained of his previous revolutionary vision. At that point he changed the name of his architectural firm from "J. García Núñez" to simply "J. García."[13]

There could have been many reasons for his decision to design in the more traditional, conservative manner. The economic crisis which began at the time could have been the principal cause of this action. The innovations and contributions he had made during the first decade of the century were not understood by some critics who called attention to his originality and stigmatized his work as eccentric. In addition, it became difficult to find artisans that were capable of interpreting new designs. This could have caused innumerable problems and obstructed the construction of his works significantly. Renouncing his revolutionary stance and opting for a readily accepted, traditional style of architecture, with assurance that his designs could be carried out by the builders, most likely provided García Núñez with better advantage in commercial competition and a guarantee of economic security.[14]

There is nothing left of García Núñez's work but his buildings. The economic crisis of 1930 left him bankrupt.[15] He destroyed all his letters, plans, projects, and awards when he left his profession in 1931. He moved out of his large home on the calle Independencia to a small apartment, leaving behind all memories of his social and professional life. In his retirement he continued to do volunteer architectural work for the church. He died in Buenos Aires on November 12, 1944.[16]

Corresponding to his latter period of conservative building design are the rental units on the calle Rincón 226, Pichincha 364, and Rivandavia 755; the restoration and enlargement of the Tienda San Miguel at the corner of Bartolomé Mitre and Suipacha; the Casal de Cataluña, Chacabuco 860; the residence of the Mirás family in Bartolomé Mitre 2000; and the annex of the Hotel España on the calle Tacuaré. After retiring, he completed the enlargement of the Asilo por Ancianos Desemparados in the calle Moreto, and a new chapel there; and designed an altar for a church in Santa Lucía, province of Buenos Aires.[17]

At the turn of the century, Buenos Aires was a growing cosmo-
politan metropolis, open to progress, with new needs. Immigrants
played a significant part in the growth of the city, and at the head of
these groups was the Spanish colony. It was not by accident that
García Núñez, a first-generation Argentine of Spanish descent, was
awarded important commissions. Of note among them are a large
hospital, an asylum, a tall office building, a movie palace, and several
apartment buildings.. These works stand out as his most progressive
and original achievements. They were new building types that
corresponded to the new requirements of an expanding metropolis in a
young independent nation that was striving to define its national
identity.[18]

Like many other artists searching for new forms, he was deter-
mined to detach himself from the past. Participating in the renovation
of the face of his city, his architectural compositions rejected traditional
architectural language. He derived new forms from simplified organic
ornament, reminiscent of Charles Rennie Mackintosh, a founder of the
Art Nouveau movement.[19] Simplification of mass and linear severity
characterized his most original works, which exhibit the influence of
Otto Wagner, the leader of the Viennese Sezessionstil.[20]

In addition, García Núñez introduced color on the exterior and
interior of his buildings, utilizing the innovations of glazed terra-cotta
tiles and colored glass.[21] Colored glass and majolica were used by
members of the Catalán Modernismo movement. "Azulejos," which
include glazed colored tile and glass mosaic, had always been an
important part of the architectural tradition in Latin America. García
Núñez was also preoccupied with light, a major theme in his works.
His facade designs exhibit studied definition of light and shade and the
innovative use of light wells, glass brick, and colored glass. Finally, his
use of new technology, including concrete, steel, glass, and elevators,
combined with his rejection of traditional architectural forms, character-
izes his work as belonging to the early phase of Modern architecture.

The descriptions that follow are based upon black and white
photographs reproduced in Lucía Elda Santalla's book *Julián García
Núñez*. Information about colors and materials found only in the text,
and not distinguishable in the photographs, are noted.

In 1906 the Sociedad Española de Beneficencia, the first Spanish
organization established in the Río de la Plata after Independence,
announced a competition for the construction of an addition to the
Hospital Español, fronting on the calle Belgrano, to accommodate its
expanding services which could not be provided for in the quarters it
occupied. The jury awarded García Núñez second place for his design

entitled "Esperanto" because, although his project provided for the needs of the building better than the other projects, his design failed to fit into the context of the surrounding traditional architecture. Nevertheless, he eventually was awarded the commission after he modified his design to accommodate the aesthetic taste of the majority. [22]

The competition drawings no longer exist for the Hospital Español, but part of the building stands as documentation of his work. Built in 1908, it is one of the most representative works of his career, and it won international acclaim when it appeared in a Spanish magazine. [23]

The Hospital Español is an interesting essay in architectural compromise. The exterior massing and rhythm of the building are derived from the long tradition of Western classical architecture as codified by the French academic school. Yet, none of the architectural elements that make up the building or ornament that decorates the facade belong to the Western classical tradition, or any other tradition. They are original artistic creations, appearing in this building for the first time. So, while the general massing and rhythm of the building accommodated the surrounding urban setting, the architectural elements and decoration, or "architectural language" of the building, are unique.

García Núñez's use of the word "Esperanto" for the title of his work is provoking and allegorical. It is the name of the artificial language invented by Dr. Zamenhof in 1887, for international auxiliary use, made up of the most common words of several European languages based on Latin roots. The word "Esperanto," from the Spanish "esperar," meaning to hope, was used as a synonym by Zamenhof.

Art Nouveau architecture was the first international style. Its principles of design allowed for individual and cultural diversity, making each work unique, while the theory behind the design process remained universal. In addition, each cultural group could derive new stylized forms, based on native cultural traditions and motifs, and develop new national architectural languages. In the Hospital Español, García Núñez combined the best of the European Art Nouveau, traditions from Western architecture, Argentine impulses, and individual creativity. Using the international Art Nouveau as a basis, he created an architectural language that was universally understood yet unique.

The facade of the Hospital Español, [24] of cement, iron, and various colors of majolica, [25] took up a full block of the Avenida Belgrano. It featured three pavilions, a central pavilion and two end pavilions,

connected by three intermediary bays on each side of the central pavilion (figs. 1, 2), a composition typical of Classical nineteenth-century architecture. The building was terminated at each end by an additional octagonal bay, conforming to the street corners. Only one of the three pavilions is still standing. The others have been replaced by a modern building of inferior design.[26]

The first story of the building resembled the rusticated base of traditional Classical architecture, except that the rustication was now simplified into a band of horizontal lines inscribed into the surface of the facade. Each casement window on the first story had a transom featuring leaded colored glass in stylized rosettes, reminiscent of Mackintosh. The windows were surmounted by an unusual pediment in the shape of a rectangle with four prongs, reminiscent of oversized dentils. A plain string course separated the first and second stories.

The second story was surfaced, perhaps in stucco, in a contrasting color. Roughly textured plaques formed a band around the building, hitting at the upper part of each window. The windows had the same decorative transom as in the first story. However, they were surmounted by a majolica mosaic in a detailed version of the stylized thematic motif, squares inscribed on circles, used throughout the building. An arched console framed each window, decorated with inscribed lines which were terminated by squares. A cornice topped the entire second story, except where it was interrupted by the taller pavilions. Each pavilion was three stories high and topped by a domed cupola.

The appearance of the white ornamented domes[27] was reminiscent of works by Otto Wagner.[28] Their scaly textured surfaces were surrounded by a contrasting intensely colored belt,[29] inscribed with lines in which the clock and the oculi were placed.

The central dome featured a clock and a carillon,[30] while the end domes had four oculi each. The clock was surrounded by the stylized design motif. The oculi were each surmounted by a grotesque in the form of a woman's head, with a headdress resembling wings, whose arms came down to hold the window and disintegrated into a stylized organic design surrounding each window.

The central pavilion had three entrance doors surmounted by a decorative wrought iron porch reminiscent of Hector Guimard's Metro entrances.[31] The end pavilions each featured a stone balcony under the second story window, which exhibited the stylized thematic design motif in the structure of the balustrade. This identical design motif appeared in the plaques underneath each of the second story windows as well, forming a horizontal course across the entire facade.

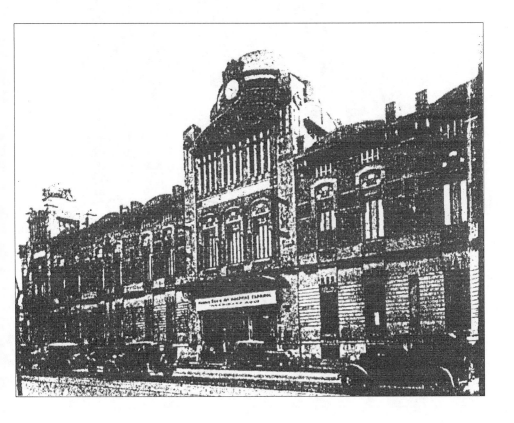

Fig. 1.  Hospital Español

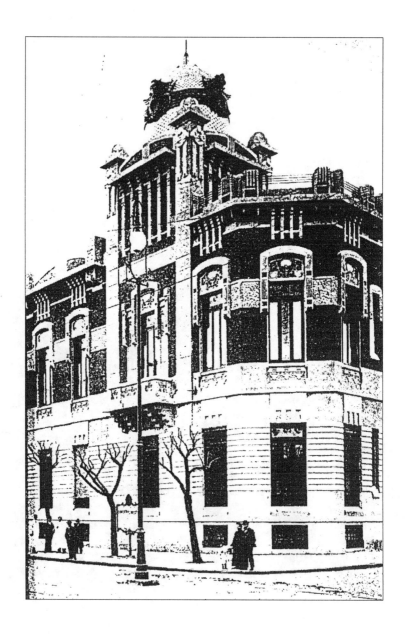

Fig. 2.  Hospital Español, detail

The interior featured a great entrance hall,[32] with a decorative tile floor, ornamented rectangular columns, and a ceiling with plaster decision all reminiscent of the linear and geometric designs on the exterior facade (figs. 3, 4, 5). A screen of columns divided the foyer from a great lobby. A grand staircase ascended from between two columns in the center of the screen.

The staircase, of reinforced concrete perhaps influenced by the innovations of Auguste Perret, seemed to float above the space. The stairs rose up, curving to the left and right from the top of the first landing. The iron stair railing used the thematic design motif in a repetitive pattern. A great portal at the top of the first landing opened to the second floor and had a stone enframement decorated with an inscribed linear design with the circular medallions on either side. A gallery filled with windows extended across each side of the hall, helping to illuminate the lobby below.

All the light fixtures and fittings for the building were designed by the architect using variations on the design motif. Even the numerous leaded-glass casement windows used the design, flooding the great lobby and grand staircase with soft colored light, and enhancing the texture of the interior surfaces.

The massing and rhythm of the building formed a familiar traditional composition that would have related well to the surrounding cityscape. The architectural elements and the ornament, however, were completely original. Structural virtuosity was exhibited in the use of reinforced concrete in the grand staircase. The colored glass and mosaics, the stylized decorative motifs, and the emphasis on working with natural light in the building were individual creative impulses which could have been derived from personal experience or cultural influences from Spain or Argentina.

In 1907, García Núñez was commissioned to devise plans for an annex to the Hospital Español to be located in Temperley, province of Buenos Aires. The Asilo para valetudinarios y crónicos was to be an internment hospital for patients who required prolonged periods of convalescence or who suffered chronic or terminal illness. A sizable piece of land, about seven square blocks, on a plantation outside of Buenos Aires was donated by Elías Romero in 1904 in memory of her father. The cornerstone, a fragment of the Cueva de Covadonga, was carried from Spain by the Saralegui family and laid in place in December, 1908. The inauguration of the hospital took place November 9, 1913.[33]

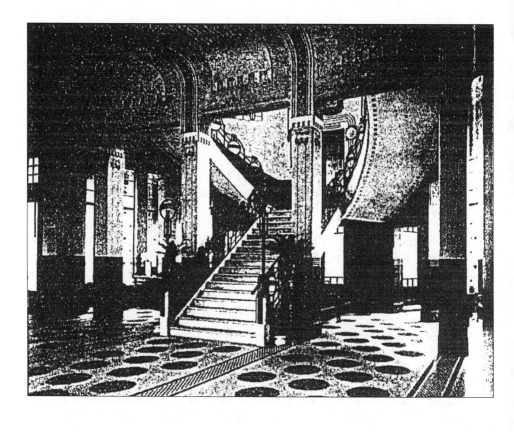

Fig. 3.  Hospital Español, interior

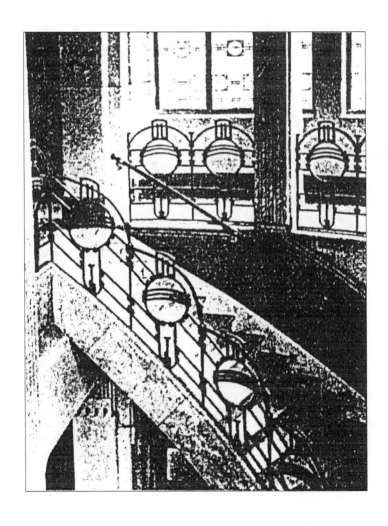

Fig. 4. Hospital Español, interior detail

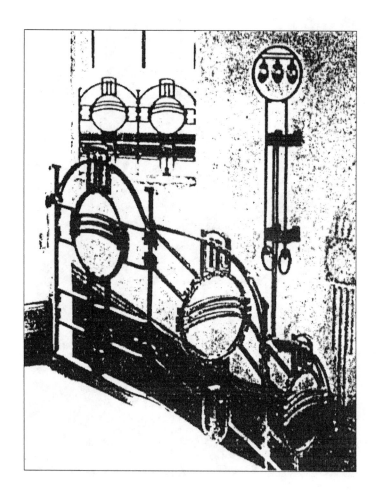

Fig. 5.　Hospital Español, interior detail

The Asilo para valetudinarios y crónicos was designed as a large complex of about twenty-seven buildings providing for all the needs of the patients and the necessary support services. The general concept seems to have been that of a small, self-sufficient community.

The general plan[34] was organized on a vertical axis crossed by several horizontal axes which formed avenues on which the buildings were located (fig. 6). This formal design was reflected also in the individual building design. The whole complex was rotated so it faced southwest, with the main axis running southwest to northeast. The complex was superimposed over a diagonal grid of pathways between the buildings, in contrast to the symmetrical avenues that connected them. This combination of avenues and paths provided for a much greater convenience in circulation between buildings, and was visually and conceptually quite innovative.

The asylum complex was made up of a large number of buildings including two observation buildings, a garage, a gatehouse, an administration building, parking lots, an operation building, seven infirmaries for convalescing patients, seven infirmaries for chronic patients, and the director's residence. The infirmaries each had a capacity for thirty patients, and were named in honor of those who contributed to the establishment of the institution.[35]

In addition there were a cafeteria, a kitchen, two hydrotherapy facilities, a gallery for air cures, a combination pharmacy-linen storage-fraternity building, a church, service buildings, and a children's facility.

Besides the accommodations shown in the general plan, there were an employee's pavilion, offices for the Sisters of Charity, a house for the medical intern, and a house for the commissioner. There were outside consulting areas, a laboratory, two solariums for the sick patients, and a school and studio for mechanical work, painting, quiltmaking, masonry, carpentry, and laundering. Another sector included reservoirs, pumps, and heating services for the asylum. Finally, the plantation had a manor house, farm buildings, and a fish pond.

The centerpiece of the asylum, the Administration Building,[36] was much more severe and revolutionary in design than the Hospital Español, and representative of the character of the architecture of the complex (figs. 7, 8). Constructed of reinforced concrete, its ornament was entirely of cast concrete forms, with designs and textures cast and inscribed in the concrete facade. Light and shadow raking across its stark face, rather than intense colors, lent drama to the building.

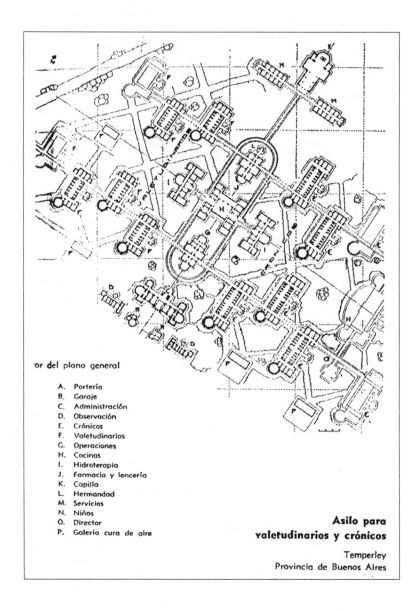

·or del plano general

A. Portería
B. Garaje
C. Administración
D. Observación
E. Crónicos
F. Valetudinarios
G. Operaciones
H. Cocinas
I. Hidroterapia
J. Farmacia y lencería
K. Capilla
L. Hermandad
M. Servicios
N. Niños
O. Director
P. Galería cura de aire

**Asilo para valetudinarios y crónicos**

Temperley
Provincia de Buenos Aires

Fig. 6. Asilo para valetudinarios y crónicos, general plan

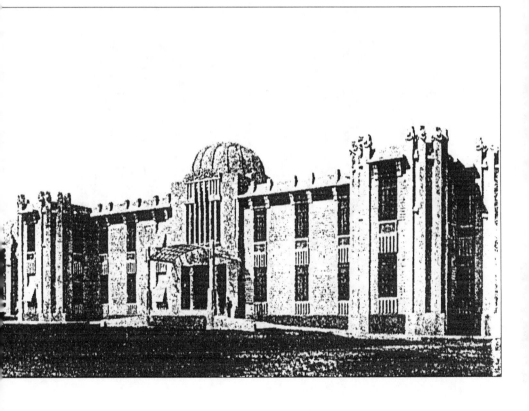

Fig. 7. Asilo para valetudinarios y crónicos

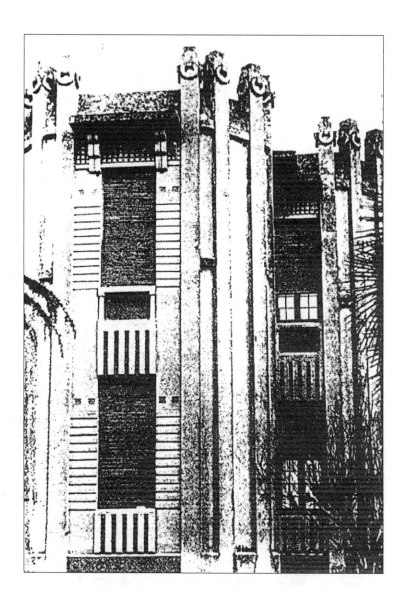

Fig. 8.  Asilo para valetudinarios y crónicos, detail

The plan and massing of the Administration Building were in keeping with the traditional symmetrical qualities of the general plan of the complex but were greatly simplified. Although the massing emphasized the horizontal, García Núñez added visual interest and cohesiveness to the building by his emphasis on verticals in the architectural elements and decoration.

It was a two-story building with a central, domed pavilion, and an iron-and-glass canopy marking the entrance. On either side of the central pavilion there were three-bay wings which were intersected by a cross axis, or transept, with semicircular terminations. The horizontal axis continued through each intersecting transept to terminate in semicircular bays at the end of each wing.

The central entrance pavilion was ornamented almost entirely by vertical lines. The porte cochere was only a simple, arched, iron and glass canopy supported by two pillars with vertical, streamlined designs cast in relief. Graded ramps gave access for automobiles to drive up to the front of the building. The wide, tripartite entrance had two columns dividing the space which were simply cast concrete pillars featuring cast concrete rings with square fasteners in relief near the top which were used throughout the building as a decorative motif.

The second story of the central pavilion had a large tripartite window with vertical mullions in cast concrete, creating a streamlined design. The window was surmounted by a round arched pediment filled with a sculptural relief, including the date of completion of the building, 1911. A concrete dome rose up behind the pediment, its structural round-arched ribs exposed in relief creating a decorative effect.

The end pavilions and transepts featured vertical pilasters extending from the foundation through the cornice, with the cast concrete rings and fastener motif held high, giving a triumphant and monumental air to the facade. The cornice was merely a plain, concrete shelf supported by brackets. A parapet rose above the cornice and had vertical pillars, abbreviating the horizontal silhouette, reminiscent of castle crenellations. The facade had tall casement windows with transoms. The building was inscribed with horizontal lines between the windows. Underneath each window there was a panel of cast concrete with six long vertical prongs.

Although the Administration Building of the Asilo exhibited a traditional plan and massing, its appearance was innovative and looked forward to the geometric style of the Art Deco movement during the 1930s. The design was achieved by the simplification of architectural elements and the use of linear designs, moving away from any reference

to an organic origin, emphasizing abstract, linear qualities in the architectural decoration.

In contrast to the severe style of the Asilo, his private residence on calle Independencia 2442 (1907), now demolished,[37] exhibited the greatest academic and historical influences of any of the architect's works.[38] The design of the facade indicated that an architect, educated in the European Classical tradition, lived and worked there, one with ties to Spanish architecture and to the revolutionary school (fig. 9).

The plan and massing of the building were clearly part of the Italian Classical tradition of the city house, or palazzo. The facade was tripartite, with a wide central section, and two narrower side sections. The lower floor was rusticated plasterwork simulating stone, with two symmetrical entrances to the left and right. Four Ionic columns formed a screen for the loggia centered between the two entrances.

The facade was two stories in the central section. The right-hand section extended up to a third story to form a tower, with a colonnade screen of two Ionic columns. One of the corners of the tower extended into a futuristic streamlined pillar, supporting a tall elaborate weather vane, which triumphantly proclaimed architectural revolution. The left-hand section had a parapet decorated with mosaics, reminiscent of the social revolutionary mural style of Diego Rivera. Oversized brackets extended up through the parapet, becoming streamlined pillars which supported linear wrought iron openwork between them.

The use of Ionic columns was surprising, as it was the only time García Núñez utilized any classical order. They derived from Spanish, perhaps even Catalán, sources, and reflected the influence of Medieval Spain in their decorative qualities and scale.

On the second story there were windows opening onto three wrought iron balconies, exhibiting vegetal motifs suspended regularly within a linear, geometric design motif. The consoles over the windows had rectangles and circles cut into the facade, forming a frame for each window, with floral ornament in relief at the corners of the design. The house was topped by a simple, rather heavy cornice, with a wrought iron balustrade between the two towers to the left and right.

The second story was the main living space. The lower floor included the studio and the office. The house was organized around a large centralized atrium space.

Inside, the doorway had double doors with leaded glass incorporating an abstract simplified rose as its thematic motif, reminiscent of Mackintosh in the glass doors of his Willow Tea Rooms of 1904. This pointed to the revolutionary attitude of García Núñez for those

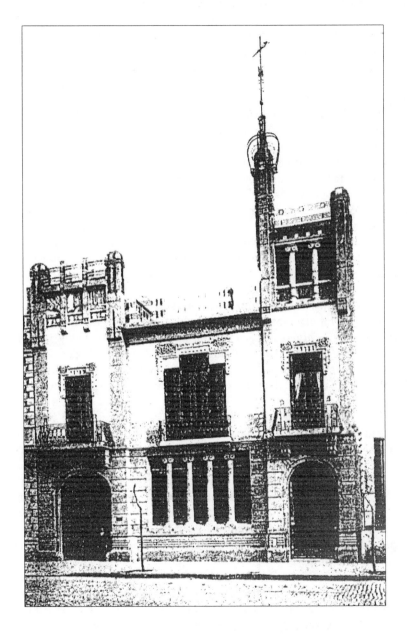

Fig. 9. The architect's residence

knowledgeable of avant-garde architecture (fig. 10).[39] The main
staircase had a rail of wrought iron with the rose motif rhythmically
suspended within a network of geometric design (fig. 11). All the light
fixtures and fittings for the house were designed in this manner.
Everything, including the furniture, was designed and built by García
Núñez with the assistance of his carpenter, and is comparable to the
designs of Mackintosh.[40]

In 1910, García Núñez was selected to design the Pabellón de
España for the International Exposition held in Palermo, Argentina on
the centennial of Argentine Independence (fig. 12). There were three
pavilions, one central domed pavilion and two rectangular basilican
pavilions connected to one another by a gallery, creating a large central
court.[41] This space was designated for an open air theater, a confec-
tionary shop, and a kiosk for music. The large interior of the central
pavilion was designated for public receptions and was put forth by
García Núñez as an example of his innovative architectural design. The
two basilican pavilions were designated for exhibitions of industry,
commerce and agriculture, the fine arts, the decorative arts, the
sciences, and the graphic arts.[42]

The entrance to the complex was marked by four enormous pillars,
connected by superimposed arches of iron, from which were suspended
a framework of forged iron in vegetal motifs (fig. 13). Hung on this
framework were mosaic medallions, possibly of colored glass over a
mixture of white cement.[43] On the left and right corners of the
complex, just behind the entrance, there were round arcaded and
domed kiosks.

The flavor of the entire ensemble was a mixture of the Spanish
Modernismo, the Austrian Sezessionstil, and the individual style of
García Núñez. The two basilicas and the two round kiosks were
abstract innovative interpretations of Spanish Medieval architecture.
The central domed pavilion was clearly influenced by Otto Wagner's
avant-garde church designs.[44] The architectural elements and ornament
were the best of García Núñez, especially the design for the entrance
gate announcing the Spanish exhibit. Futuristic streamlined pillars were
suspended organically, and geometrically inspired wrought iron gates
hung with mosaics.

García Núñez gained national and international recognition for
this work. Nationally he became part of the hierarchy of vanguard
architects. Internationally Spain recognized the merit of García Núñez.
In 1930 King Alfonso XIII awarded him the Cruz de Isabel la Católica,
conferred upon him during a trip to Spain.[45]

Fig. 10. Entry door, the architect's residence

Fig. 11.  The architect's daughters next to the stair
rail and a light fixture

Fig. 12. Plan and renderings for the Pabellón de España

Fig. 13.  Gateway to the Pabellón de España

The public cinema was a new building type just making its appearance early in this century. In 1910, García Núñez designed and built a movie palace at 3272 Belgrano street (fig. 14). [46] The facade was two stories tall, with semicircular pediment, parapets, and pillars forming towers on the left and right. It was divided into three vertical zones.

The central section contained the main entrance and box office. The entrance was marked by a large, arched iron and glass canopy with lights all along the edge of the arch, solving the problem of lighting the facade at night. A sign located above the canopy announced the theater.

The two lateral sections were symmetrical and ornamented with large mosaics of simplified vegetal designs. Four massive pilasters extended up from the first story and continued through the cornice and parapet, becoming large towering pillars festooned with wreaths and garlands. The tops of the pillars resembled geometric sculptures and supported futuristic iron spires.

The tall office building with an elevator was also a new building type which permitted García Núñez to accommodate new architectural forms to the necessities of commerce. In addition, new materials like steel and glass created new possibilities, providing a new medium for architectural expression and interpretation.

In 1910, he designed an office building for the Banco Edificador del Plata, at 78 Chacabuco street (fig. 15). [47] The building featured an open elevator shaft located in a large central vertical core, illuminated by a skylight above (figs. 16, 17). Bridges of glass brick supported by steel beams provided access to the elevator on each floor, and allowed the light from above to filter through all floors. The offices opened off the large central atrium space created by the open elevator shaft. An ironwork balcony rail of abstract vegetal and geometric design surrounded the atrium on each floor.

The design allowed for visual and spacial connection to all levels, with an uninterrupted open elevator shaft. Honesty in the use of materials and structural clarity were unified into a masterful composition, with emphasis on verticality, both in the interior and on the exterior facade. Formal problems were unified with technical problems in the design solution for this elevator building. [48]

Apartment buildings offered García Núñez the possibility of utilizing the elevator once again. In 1913 he designed two such apartment buildings, one on the corner of Viamonté y Paso (figs. 18, 19), and the other at Sarandí y Independencia (figs. 20, 21). [49] The first floor in each was planned for retail establishments; the remaining floors

Fig. 14.  Movie Theater

Fig. 15. Office Building

Fig. 16.  Office Building, interior

Fig. 17. Office Building, interior

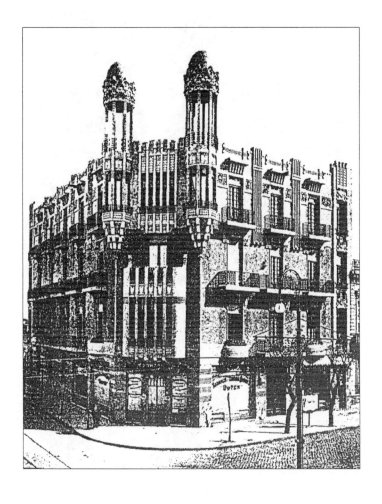

Fig. 18. Apartment Building, corner of Paso and Viamonté

Fig. 19. Apartment Building, corner of Paso and Viamonté, detail

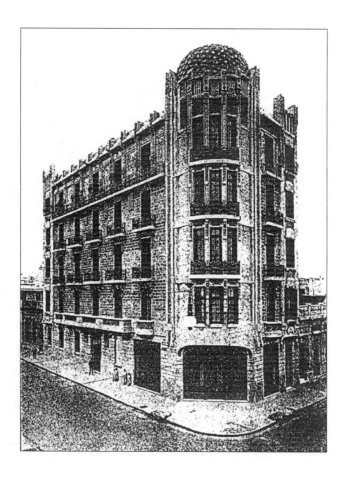

Fig. 20.  Apartment Building, corner of Independencia and Sarandí

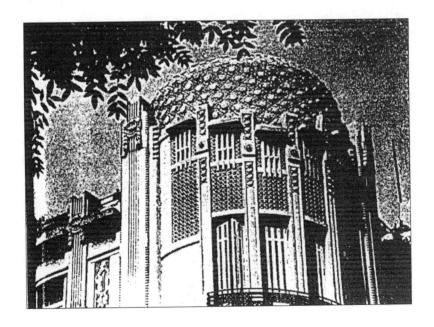

Fig. 21.  Apartment Building, corner of Independencia
and Sarandí, detail

were dedicated to traditional rental units. His preoccupation with light led him again to innovative utilization of vertical light wells.

Finally, in a perspective rendering for a lighthouse on the Río de la Plata, García Núñez expressed his greatest imagination and creativity (fig. 22).[50] An enormous esplanade extended to the river and partly into it, accessed by a tree-lined avenue that terminated in two futuristic obelisks. The esplanade had two galleries made up of grand arches over which terraces were laid, each accessed by four grand staircases. The galleries faced one another across a large plaza. Two more futuristic obelisks marked the entrance to a suspension bridge which crossed the river to the lighthouse. The lighthouse itself was designed in the form of a large futuristic columnar monument topped by a winged eagle. Futuristic obelisks and pillars surrounded the central lighthouse column and anchored the corners of the design. Vertical and curved lines were used to create streamlined volumes and forms achieving great monumental effect.

The architecture of García Núñez can be characterized as being stylistically and technologically advanced for its time. Educated by the best architects in Spain, and knowledgeable of the up-to-date developments in European architecture, he was successful in his creation of original architecture for Buenos Aires, which rivaled similar European works.

García Núñez designed and built several major buildings in Buenos Aires, exhibiting artistic mastery in the creation of unique architectural ornament, and technical virtuosity in the use of new construction materials for new building types. Though he may not have been greatly influential in his own time, his significance remains as a member of the antitraditional movement in architecture which allowed for the acceptance of Modern architecture in Latin America during the 1930s.

Fig. 22. Project for a lighthouse on the Río de la Plata

NOTES

1. Francisco Bullrich, *New Directions in Latin American Architecture* (New York, NY: George Braziller, 1969), p. 15.

2. For a general history of Latin American architecture, see ibid. For the history of architecture in Buenos Aires see José Xavier Martini, *La Ornamentación en la arquitectura de Buenos Aires, 1800–1900* (Buenos Aires: Instituto de Arte Americano e Investigaciones Estéticas, 1966), and José María Peña, *La Ornamentación en la arquitectura de Buenos Aires, 1900–1940* (Buenos Aires: Instituto de Arte Americano e Investigaciones Estéticas, 1967). For summaries of recent developments in Latin American architecture see: Alberto Petrina et al., "La arquitectura moderna en Iberoamerica: revisión y crítica," *Summa* 230 (Oct. 1986), 23-79; Lala Méndez Mosquera et al., "Arquitectura en Iberoamerica: identidad y modernidad I," *Summa* 212 (May 1986), 22-105; idem, "Arquitectura en Iberoamerica: identidad y modernidad II," *Summa* 232 (Dec. 1986), 24-81.

3. See Henry-Russel Hitchcock, *Architecture: Nineteenth and Twentieth Centuries* (New York, NY: Penguin Books, 1977); Nikolaus Pevsner, *The Sources of Modern Architecture and Design* (New York, NY and Toronto: Oxford University Press Ltd., 1973).

4. There are two articles with information on García Núñez: Hernández Rosselot, "Art Nouveau in Buenos Aires," *The Connoisseur* 189, 759 (May 1975), 54-61; and Julio Cacciatore, "Julián García Núñez," *Summa* 197 (March 1984), 16-17.

5. See the *MacMillan Encyclopedia of Architects*; Oriol Bohigas, "Luis Domènech," pp. 585-587, and David Mackay, "Berenguer," in Richards and Pevsner, eds., *The Anti-Rationalists*, pp. 63-71.

6. Marina Waisman, "L'architettura in Argentina oggi," *Domus* 525 (Aug. 8, 1973), 1-8.

7. Peter Collins, *Changing Ideals in Modern Architecture* (Montreal: McGill University Press, 1965); Reyner Banham, *Theory and Design in the First Machine Age* (Cambridge, MA: The MIT Press, 1960).

8. Peter Collins, *Concrete: The Vision of a New Architecture* (New York, NY: Horizon Press, 1959).

9. Henry-Russel Hitchcock and Philip Johnson, *The International Style* (New York, NY, and London: W. W. Norton & Company, 1966).

10. Lucía Elda Santalla, *Julián García Núñez* (Buenos Aires: Universidad de Buenos Aires, 1968), pp. 16-17.

11. Ibid., p. 17.

12. Ibid.

13. Ibid., p. 18.

14. Ibid.

15. Rosselot, p. 56.

16. Santalla, pp. 17-20.

17. Ibid., pp. 19-20.

18. Ibid., p. 21.

19. David Walker, "The Early Works of Mackintosh," and Eduard F. Sekler, "Mackintosh in Vienna," in Richards and Pevsner, eds., *The Anti-Rationalists*, pp. 116-135, 136-142.

20. Otto Antonia Graf, "Wagner and the Vienna School," in Richards and Pevsner, eds., *The Anti-Rationalists*, pp. 85-96.

21. Santalla, p. 22.

22. Ibid., p. 23.

23. Ibid., pp. 23-24.

24. Ibid., "Ilustraciones," illus. 2, 3.

25. Ibid., p. 23.

26. Rosselot, p. 56.

27. Ibid., p. 23.

28. See Wagner's design for the Kirche der Nieder Oest: Landes Heil und Pflegeanstalen, from 1904, in Otto Wagner, *Sketches, Projects and Executed Buildings*, trans. Edward Vance Humphrey (New York, NY: Rizzoli, 1987), p. 180.

29. Santalla, p. 23.

30. Ibid.

31. Pevsner, *The Sources of Modern Architecture and Design*, p. 99.

32. Santalla, "Ilustraciones," illus. 4, 5.

33. Ibid., p. 24.

34. Ibid., p. 25.

35. Ibid., p. 26.

36. Ibid., "Ilustraciones," illus. 6-9.

37. Rosselot, p. 56.

38. Santalla, "Ilustraciones," illus. 12-15.

39. Pevsner, *The Sources of Modern Architecture and Design*, p. 145.

40. Santalla, p. 30.

41. Ibid., "Ilustraciones," illus. 10, 11.

42. Ibid., p. 28.

43. Ibid.

44. Otto Wagner, *Sketches, Projects and Executed Buildings*, p. 180.

45. Santalla, p. 29.

46. Ibid., "Ilustraciones," illus. 16.

47. Ibid., p. 31, and "Ilustraciones," illus. 17-23.

48. Ibid., pp. 31-32.

49. Ibid., "Ilustraciones," illus. 26, 32.

50. Ibid., pp. 40-41, "Ilustraciones," illus. 44-45.

# 7. A Computer Search on Latin American Architecture: Results and Implications

Margarita Jerabek Wuellner
with technical assistance from
Jack S. Robertson

There were two goals to achieve in doing a computer search on Latin American architecture. First, to find out if any recent work had been done on the early twentieth-century architect Julián García Núñez of Buenos Aires; and second, to determine how well Latin American architecture is covered in computerized art literature indexes available in the United States. For more complete information about the databases consulted, see the Appendix, "Art Literature Currently Available by Computerized Keyword Searching through DIALOG."

The search was conducted in May, 1989, and the results were mixed. There were two hits on the topic of Julián García Núñez, which was a pleasant surprise. Information cited on Latin American architecture was, nevertheless, limited. There were forty-eight hits on the topic of Latin American architecture. Considering there is a documented 20-30 percent overlap of information cited in these indexes, that leaves an approximate number of 33.6 to 38.4 hits for Latin American architecture during the last ten to fifteen years. Compared to the great number of publications on the subject of European or American architecture, it is a very small number of citations. This was disappointing, but not surprising as this confirmed suspicions about the lack of availability of indexed information on Latin American architecture in U.S. on-line sources.

There are two theories that might explain the lack of citations on Latin American architecture in these databases. The first has to do with the birth of Latin American architecture in its own right, and of Latin American arts since Independence. Latin American architects have consistently turned to European models for their sources. It has only been in the last forty years that an identifiable Latin American architecture has emerged. Likewise, the publication of information and sources for Latin American architecture has only been a recent phenomenon. As a result, foreign coverage of Latin American developments has been minimal up to this point. Even the most

comprehensive and complete indexing tools and source materials for the arts do not include many entries on Latin American architecture, let alone Latin American art.

The second has to do with the nature of the discipline of architectural history. Conventional architectural history has been criticized as an elitist discipline, biased toward the "Bourgeois Standard" of Western Europe, the "Genteel Tradition," the "Isolated Building," the "Isolated Art," and the "Isolated Discipline."[1] Recently, however, attempts have been made to break self-consciously from the bias it has held.

John Maass has written a poignant article, "Where Architectural Historians Fear to Tread,"[2] in which he surveys the articles published in the American branch of the discipline's most significant trade journal, the *Journal of the Society of Architectural Historians*, over a period of ten years from 1958 to 1967, inclusive. He includes three significant forms of statistical information. The first is a breakdown of the affiliation of the authors represented during this period, on which John Maass reports: ". . . the Society of Architectural Historians has always been equally hospitable to academics, to other professionals, and to amateurs. However, most contributions to the *JSAH* come from the academy."[3]

The second is a record compiled by Bernard Rudofsky[4] that Maass reproduces, of the articles and book reviews published in the *JSAH* which show that all non-Western civilizations were virtually ignored over the period 1958 to 1967.

Finally, the third is a map which shows all the contributions on European architecture that could be assigned to countries during the period 1958–1967, and which is accompanied by a supplementary table including areas outside the United States and Europe. John Maass comments: "It is evident that the architectural historians follow the well-worn path of the eighteenth-century Grand Tour from England through France and Italy . . . smaller nations are badly neglected. . . . Russia does not exist. . . . The absence of articles on Mexico and South America is surprising."[5]  It is important to keep the information Maass reports in perspective. The academy is comprised mainly of historians and architects trained in the history of Western architecture who are working as scholars, professors, or architects. Interest in world architecture lying outside the realm of Western architecture is not encouraged as a major area of study within the discipline. Individuals who choose to pursue other areas of architecture do not usually make it their main area of study. The few who do concentrate on the more exotic forms of architecture frequently find themselves in an

interdisciplinary environment, and as a result may find themselves contributing to journals other than the *JSAH*.

The combination of the recent arrival of Latin American architecture with the above-evidenced bias against the topic in academic circles may have led to the apparent lack of information available through indexed computerized sources on the subject of Latin American architecture in the last ten to fifteen years. Whether or not these theories on the lack of indexed Latin American architectural materials can explain this lack to any extent is arguable.

Whatever the case may be, now is an exciting time for Latin American arts. The artists, architects, and critics have emerged. Periodical publications have been established and annual conferences are continuing to occur. There is a congruence between the flowering of Latin American architecture and the growing interest in the establishment of architecture libraries internationally. In addition, there is an explosion of information available through microcomputer technology and an increase in the speed of access to this information. It is important now to provide a means for the international dissemination of information on Latin American architecture.

An index to nineteenth- and twentieth-century Latin American art and architecture periodicals would be useful, as much of the primary and secondary source material for architecture exists in this format. A Who's Who of Latin American architects could be an important contribution to the preservation of Latin American architectural history and would provide a formal means of international recognition for architects and their work.

A survey of *Ulrich's Index to Current International Periodicals*, 1989, for the subject headings "Architecture," "Building and Construction," and "Housing and Urban Planning" resulted in a count of 122 periodicals published on architecture or building construction in Latin America, Central America, the Caribbean, and the Iberian peninsula. The most direct way to enter into the international forum would be to include consistently Latin American architectural periodicals and journal articles in the *Architectural Periodicals Index*, the *Architecture Database*, and the *Architectural Books Catalogue*.

## NOTES

1. David Watkin, *The Rise of Architectural History* (Westfield, NJ: Eastview Editions, Inc., 1980), pp. 47-48.

2. John Maass, "Where Architectural Historians Fear to Tread," *Journal of the Society of Architectural Historians* 28 (March 1969), 3-8.

3. Ibid., p. 3.

4. *Architecture without Architects* (New York, NY, 1965); cited here from Maass, p. 4.

5. Maass, p. 5.

# APPENDIX
## Art Literature Currently Available by Computerized Keyword Searching through DIALOG

Indexes with abstracts provide more retrieval points for computerized keyword searching, therefore their citations are much more accessible.    The citation overlap of these databases tends to be 20-30 percent.

### Art Literature International

Provider: RILA, J. Paul Getty Trust, Williamstown, MA.
1973 to present. Updated semiannually. (*Note*: 1973-1974 period was issued in a demonstration version which included minimal information.)
Abstracts and indexes publications on the arts: journals, monographs, exhibition catalogs, and anthologies including conference proceedings and *festschriften*. Western art is covered from late antiquity to the present.  Does not include classical or oriental art.

### Artbibliographies Modern

Provider: ABC-CLIO, Santa Barbara, CA.
1974 to present. Updated biannually.
Indexes current art literature: journals, monographs, exhibition catalogs. Until 1988 covered 19th-20th century studies, after 1988 changed focus to full coverage of 20th-century studies and expanded the number of periodicals covered.

### Dissertation Abstracts Online

Provider: University Microfilms, Ann Arbor, MI.
1861 to present. Updated monthly.
Abstracts included for degrees granted after 1980 (increases information retrievable by key word searching; conversely, previous to 1980 searching is limited to key words in title only).  From January 1988 to present includes British University Dissertations.

### America: History & Life

Provider: ABC-CLIO, Santa Barbara, CA.

1964 to present. Updated three times per year.

Abstracts and indexes over 2,000 journals in the sciences and humanities. Covers United States and Canada.

### Architecture Database

Provider: British Architectural Library at the Royal Institute of British Architects, London, G.B.

1978 to present of the *Architectural Periodicals Index* (biannual). In 1984 the *Architectural Books Catalogue* was added to the index.

Indexes articles, interviews, obituaries, and biographies. Includes 400 current periodicals from 45 countries, and about 2,000 cataloged items including monographs, conference proceedings, exhibition catalogs. Fifty percent of the books indexed, and 70 percent of the articles originate outside Britain.

### Arts and Humanities Citation Index

Provider: Institute for Scientific Information, Philadelphia, PA.

1980 to present. Updated every two weeks.

Fully indexes 1,300 Art and Humanities journals, plus selectively indexes 5,000 other journals including social and natural science articles that pertain to the subject area. Cites all information in notes, which significantly increases the value of this database for scholars and researchers. More complicated to use than the other databases listed above.

# II. Photography

# 8. Visual Images of Urban Colombian Women, 1800 to 1930

## Patricia Londoño

I am currently preparing a book that describes and analyzes the changes that occurred in the daily lives of Colombian women of different classes who dwelt in cities between 1800 and 1930. Based on published written information and visual images I want to create a portrait of women's customs which details the life, styles, and ideals of femininity prevalent in nineteenth- and early twentieth-century society. Women are a little studied sector of the population through which it is possible to view the rest of society.

The book describes women's legal condition, daily routines, types of work they performed, and the manner in which they used their leisure time. Particular attention is paid to such issues as women's fulfillment of religious devotions and prevailing female attitudes toward love and eroticism. Finally, I examine women's manners and fashions with regard not merely to clothing itself but in terms of the uses and values implicit in specific forms of attire. I am interested in exploring what some authors refer to as "cultural images," that is, the models or ideal types that mold beliefs and social conduct.

This paper refers to the subjects covered by visual images that I consulted and notes the sources from which they were drawn.

### Visual Information

So far I have reproduced in slides a thousand images portraying women from Colombian cities during the period from 1800 to 1930. Included are a few from the end of the eighteenth century and others produced after 1930 for the purpose of illustrating continuities or alterations in customs and ideals within the period studied. I also chose a few foreign images in order to contrast the ways in which Colombian women were similar to, or different from, women in Spain, England, France, and the United States, countries that served as cultural models for Latin America.

The slides were taken from miniatures, oils, prints, drawings, watercolors, cartoons, lithographs, daguerreotypes and photographs, postcards, pamphlets, and advertisements.

99

The graphic sources from the Colonial period are predominantly religious paintings commissioned by religious communities, guilds, and brotherhoods, or by individual donors. These ex votos give little information about the urban environment, though in the lower part of the painting the person who commissioned the work is sometimes depicted. Another less well-known type of painting from this period is the portrait, used to portray gentlemen and, occasionally, richly dressed local ladies.

During the first years after Independence there was very little production of images, with the exception of a few painters who were commissioned to elaborate miniatures of members of the upper classes. However, as the century advanced, national and foreign artists, all imbued with the romantic spirit of the times, from Mexico to Patagonia, began to illustrate local customs in watercolors, drawings, and prints which at times circulated as lithographs. In these works men and women of different classes appear and illustrate the richness of regional variations.

The artists who stand out from this era are Eduard Mark, and English traveler and painter; the Frenchmen Leon Gauthier and Jean B. Le Gross; the artists of the Chorographic Commission—the Venezuelan Carmelo Fernández, Englishman Enrique Price, and Colombian Manuel María Paz. Other Colombian artists active at the time include José Gabriel Tatis, Ramón Torres Méndez, José María Espinosa, Luís García Hevia, José Manuel Groot, Alberto Urdaneta, Coriolano Leudo, Epifanio Garay, and Francisco Antonio Cano. These men left behind paintings, drawings, and drafts, many of which illustrate contemporary life-styles.

Some of these artists were cartoonists as well. This art was also practiced by professional humorists such as José "Pepe" Gómez (1892–1936) and Alberto Arango (1897–1941). It is interesting to analyze feminine attributes in cartoons because female figures were allegorically used to represent cities, public opinion, government, and other subjects. In addition, cartoons show people in the streets and local characters. There was no lack of allusions to the picturesque "beatas."

## Photography: A Unique Case

The most abundant legacy of images was left by the photographers active in the country from the mid-nineteenth century onward: Emilio Herbruguer, Luís García Hevia, Gonzálo Gaviria, Demetrio Paredes, Fernando Carrizosa, Roberto de J. Herrera, Antonio Faccinni, Pastor Restrepo, and Julio Racines, to mention a few well-known names.

At first, because of the high cost of processing and technical limitations, these artists only made portraits in their studios for members of the local elite who could afford such luxuries. The photography studios were adorned with backdrops and other props imported from Europe or the United States. Needless to say, posing for a photograph was such an important event that one had to wear one's Sunday best, which meant to follow as closely as possible European fashion, even if this required accessories supplied by the photographer himself.

In the twentieth century, as more simplified photographic procedures became available, resulting in lower costs, the clientele and themes portrayed diversified. Photographers such as Benjamín de la Calle, Melitón Rodríguez, and Jorge Obando from Medellín, Juan N. Gómez from Bogotá, and many others focused on everyday people, events, and places in the cities.

At this point, it is worthwhile emphasizing that for the period under consideration there was no distinct documentary tradition such as that which existed in the United States, where as early as the 1870s the Dutch immigrant, Jacob A. Riis, depicted the lower class neighborhoods of New York, and where, in the early twentieth century, the sociologist Lewis A. Hine recorded the sordid working conditions of minors in New York and in Washington, D.C.

In Colombia, photography outside the studio was slow to develop, though in 1881 photographs were used as the basis for prints published in the *Papel Periódico Ilustrado*. The latter required the faithful recording of people, places, and events which this new medium could provide. However, perhaps the high cost of imported materials and delays in the introduction of techniques that facilitated the direct printing of photographs—invented in the 1980s—account for why graphic reporting did not prove to be profitable in Colombia at an early date as it did in other countries.

It was only at the close of the nineteenth century that the arrival of advances in photographic printing and lithography made it possible to print the first photographs—not copies of them rendered by an artist—in magazines such as *El Repertorio Ilustrado* (1896) and *El Montañés* (1897), both in Medellín. It is interesting to remember that *Illustrated American*, a magazine dedicated purely to photography, was published in the United States as early as 1890, an idea revived with *Life* magazine in 1936.

In Colombia, graphic reporting as such took off in Bogotá with the publication of the magazine *El Gráfico* (1910) and continued in the same city with *Cromos* (1916). Newspapers delayed an additional

decade before offering graphic information to the public, whereas in more developed countries it had started at the turn of the century. Colombian photographers working in the documentary genre captured images of armies participating in civil wars, the trenches, an anonymous execution, or the destruction caused by an earthquake or by fire. However, rather than constituting a systematic covering of these events, such documentary pictures were exceptions, and in them women rarely appear.

During the twenties and thirties, as towns became cities, more and more photographs were dedicated to the changing urban landscape and to new ways of social life. The appearance of commercial photography and advertising had much to do with this. A case in point is the photographer Francisco Mejía of Medellín, who left a meticulous registry of the interiors and activities of factories, stores, offices, and charities, all sites in which women were actively present. This collection of images documents the growing variety of situations in which women of different social classes participated. During this period, photographs were frequently taken of public events such as parades, religious processions, beauty contests, carnivals, and funerals. Photos of *comparsas* and groups of costumed women abound.

Other nonstudio photographs were those taken by amateurs. Their subjects, more varied and spontaneous than those captured by formal photographers, provide us with a vision of family life and consequently have greater relevance for the documentation of the daily life of women. But amateur photography, too, was slow to develop in Colombia despite the already established existence of compact cameras, introduced by George Eastman in the United States in 1888. This camera came already loaded with film, but to develop it the entire camera needed to be sent back to providers overseas. This procedure proved too expensive and complex to encourage widespread use by Colombians before the 1930s. This is why the work of Fernando Carrizosa and Roberto de J. Herrera, which spans the years from 1875 to 1940, is quite extraordinary.

To conclude, in the initial years of the period examined in this study, the production of graphic testimony is limited. As the period advances, however, the search for female figures must necessarily become selective, as it is virtually impossible—and would serve little purpose in any case—to provide an all-encompassing overview of available graphic images. It is worth noting that owing to the breadth of the period under examination, and the relatively unorganized state of Colombia's graphic legacy, the search for images is far from being exhaustive, and the various urban centers are not equally represented.

## Origins of the Images

Some reproductions, especially those from Medellín and Bogotá, were copied directly from the original works preserved in Medellín by the Museum of Antioquia and in Bogotá by the National Museum and the Fondo Cultural Cafetero, and as well in the photographic archives mentioned below. The rest were reproduced from books, exposition catalogs, newspapers, magazines, pamphlets, postcards, or advertisements. (See addenda for a list of the principal sources.)

In Colombia, as in other Latin American countries, there is a growing interest in the search for, and the conservation and dissemination of, visual heritage, as evidenced by the number of exhibitions and reproductions of paintings, drawings, cartoons, and photographs that illustrate the local environment and its inhabitants. There have been numerous exhibitions of the work of well-known national artists, which in general include some images that document past life-styles. There have also been exhibitions on the history of nineteenth-century cuisine and table manners, of fashion between 1830 and 1930, and on different facets of social and material life in the year 1886. For each of these exhibitions there is a publication—a catalog, an index, or a book—which serves as a partial guide to the works shown.

With regard to cartoons, during the mid-1980s research teams, organized by the Banco de la República, have gathered and exhibited a history of caricature from Bogotá, Medellín, and Manizales, found dispersed throughout the principal periodicals and magazines of the country. These exhibits left behind rich catalogs.

In what follows I describe in greater detail efforts to gather, preserve, and disseminate historical photographs, especially what has been done since 1984.

### Exhibitions

Concerning exhibitions, I only mention those in any way relevant to women's history, and for which there are catalogs, books, or collections open to the public.

In 1981 the Pilot Public Library in Medellín presented an exhibition titled *Cien años de fotografía en Antioquia*, which led to the discovery of the valuable archive of Benjamín de la Calle (1897–1932).

Simultaneously to the opening of the exposition with the same name, in 1983 the Museo de Arte Moderno in Bogotá published the book *Historia de la fotografía en Colombia*. The show toured main cities of the country. That same year the Centro Colombo-Americano in Bogotá organized the exhibition *Melitón Rodríguez: fotografías entre 1892 a 1938* for which there is a catalog with reproductions of

105 photographs from the show. Two years later the publishing company El Ancora Editores in Bogotá published the book *Melitón Rodríguez: fotografías* with 182 plates.

In Giradot in 1985, the Banco de la República exhibited nearly fifty unpublished photographs taken during the prosperous decade of the thirties when Giradot was an important river port and terminus with a fifty-year export history. As a result of this exhibit other photographs were forthcoming.

At the same time, in commemoration of the 448th anniversary of the founding of Pasto, the same bank organized an exhibit which gathered together almost 400 photographs taken from old family albums and private collections. These document the city and its inhabitants between 1870 and 1950. Two years later, the Biblioteca Luís Ángel Arango of Bogotá mounted a revised version of this exhibit supplemented by materials that emerged as a result of the first exhibit. The library subsequently published a catalog that includes half of the exhibited photographs.

That same year in Pereira there was an exhibit of a collection of nearly 400 negatives currently held by the heirs of the city's 1930s photographer Donato García. It was through this exhibit that the archive of negatives belonging to the amateur photographer Manuel García came to light and was bought by the Banco de la República in that city.

Still in 1985 the Fondo Cultural Cafetero in Manizales, after undertaking a careful search, organized the exhibit Manizales a través de la fotografía, a graphic history of this city between 1850 and 1950. The 1,000 photographs shown were selected from nearly 2,000 which the center managed to collect.

In 1986 the Fundación Antioqueña para los Estudios Sociales (FAES) and the Banco de la República jointly organized an exhibition of the work of Francisco Mejía from Medellín.

In the following year, the Darío Echandía Library under the auspices of the Banco de la República in Ibagué opened an exhibit entitled Historia de Ibagué a través de la fotografía. This exhibit presented ninety photographs which covered the city's life between 1910 and 1950. With these photographs as a base the library founded the Archivo de la Memoria Visual.

The Municipal Institute of Tourism of Calarca initiated a door-to-door collection of old photographs with support from radio advertisements in order to celebrate the city's 100th anniversary. The majority of these photographs were from the 1930s onward.

From December 1986 to February 1987 there was a show in the Museo de Colsubsidios which displayed pictures taken between 1875 and 1940 by two amateur photographers, Fernando Carrizosa and Roberto de J. Herrera. The photographs are kept in the archive Placas Viejas, which is managed by María Carrizosa de Umaña.

In 1987, in Villavicencio, the Fundación para el Archivo Fotográfico de la Orinoquía, created in that same year, organized the exhibition entitled Villavicencio: una imágen del pasado. It was displayed in the Centro Cultural Jorge Eliecer Gaitán using photos from private albums from which reproductions were made in order to create a public archive.

The Banco de la República and the Centro Histórico of Cartagena exhibited a show in 1988 in Cartagena's Museum of Modern Art entitled Cartagena: un siglo de imágenes. The show included 556 photographs, taken between 1860 and 1960, which were selected from family albums and individual collections, reproductions of which are now available in the Fototeca Histórica of this city.

In that same year the Museo del Chicó in Bogotá organized a representative display from the collection of negatives left behind by Juan Nepomuceno Gómez from Santander, who was active in Bogotá between 1917 and 1944. He is considered one of the more notable members of a generation of portrait photographers from the beginning of the century. Aside from the studio portraits, he also captured images of the city and its important events.

In March of 1989 FAES and Banco de la República opened an exhibition with a sample of the pictures taken by Rafael Mesa (Medellín, 1875–1958) and kept in the FAES's Centro de Memoria Visual. The title of the exhibition was Rafael Mesa: el espejo de papel.

*Archives and Collections Open to the Public*

There were only a few collections open to the public previous to the 1980s: One of them is located in Medellín, where the descendants of Melitón Rodríguez (1875–1942) manage an enormous archive of about 20,000 negatives, the contents of which are carefully identified. It is the most important private archive in the country since, for many people, Rodríguez was the best photographer in the first hundred years of Colombian photography.

A second collection is kept in the Romantic Museum in Barranquilla, created by Alfredo de la Espriella, its current director. Located in an old two-story house, the museum exhibits furniture, books, and miscellaneous objects including old photographs. The

pictures are kept either in albums or framed and hung on the walls, though poorly identified and without any classification.

Placas Viejas, mentioned above, is the name of the archive housing the collection of around 1,000 original copies left by Roberto de J. Herrera and Fernando Carrizosa. In the hands of the latter's daughter, this collection also is available to researchers and the public.

All other archives and collections were established after 1983, a year that proved particularly productive for the establishment of Colombia's visual heritage. With the material cold, and properly identified and classified, for the exhibition and book entitled *Historia de la fotografía en Colombia*, the Museo de Arte Moderno in Bogotá opened the Archivo de la Fotografía Colombiana. This archive contains 7,000 photographs. Of these 1,000 are black and white originals, 5,800 are recent black and white copies, 10 are daguerreotypes, 5 are ferrotypes, and 5 ambrotypes. These photographs cover the period from 1850 to 1950. An index identifies the photographs, each with its respective contact print.

Simultaneously in Medellín FAES founded the previously mentioned Centro de Memoria Visual. A model archive in Colombia for this type of document, it contains 7,000 glass negatives left by Benjamín de la Calle, and 20,000 nitrate and acetate negatives which belong to the Rafael Mesa archive. Almost all of the latter are studio photographs taken in Medellín between 1932 and 1956. Today the Centro de Memoria Visual maintains, in addition, the commercial photography archive of Francisco Mejía (1920–1956), and a collection of positives and negatives, from different photographers, which show Medellín, and other towns within the department, during the late nineteenth to mid-twentieth century. The photographs in this archive are from albums and private collections. The latest archive acquired by FAES in 1987 was that of photo-journalist Carlos Rodríguez, popularly known as "Foto Reporter" This collection, given over to FAES in agreement with the national Office of Education and Culture, is made up of 50,000 negatives taken between 1940 and 1960.

Another watershed year for old photographs was 1985. In this year the Archivo Histórico in Cartagena created the Fototeca Histórica. The Fototeca amasses original copies donated by private individuals as well as recent reproductions of photographs borrowed from family albums. In addition, there are nearly 1,000 negatives and prints from different ears and by different photographers.

As a result of the exhibition of old photographs in Giradot, nearly one hundred negatives were located and acquired by the Documentation Center of the Banco de la República in Giradot.

During this same year a representative selection of the material exhibited in Pasto was copied to initiate the Center of Visual Memory belonging to the Banco de la República in this location.

The collection of photographs, acquired by the Banco de la República in Pereira after the 1985 exhibition, is made up of nearly 5,000 negatives exposed between 1937 and 1960. Some of these negatives are in a 12 x 19 cm format, while a much larger number are 35 mm. These negatives are of neither high technical nor aesthetic quality, but they bring together a series of themes and social groups not normally considered by the better-known photographers of this period.

All of the material gathered by the Fondo Cultural Cafetero in Manizales for the 1985 exhibition was reproduced in black and white and is currently stored in the fototeca in Bogotá. The book *Manizales Ayer*, which reproduces 275 photographs from this exhibit, was published in 1987.

The material made public in the 1986 exposition held in Calarca is on permanent exhibit in the headquarters of the Banco Central Hipotecario of Calarca. The index to this exhibit is located in the Documentation Center of the Banco de la República in Armenia, Colombia.

Fotobank of Bogotá, an organization that gathers together the work of the country's best contemporary photographers, acquired the archive of nearly 30,000 negatives from the collection of Photographic Studio J. N. Gómez. The accompanying documentation for this collection, taken from surviving studio accounts, is classified by computer.

It is worth noting that, although some of the collections mentioned are designated in the Addenda under the rubric of "archives," the majority are, in reality, mere collections of negatives or prints, either originals or reproductions, characterized by rather poor systems of identification and classification.

## Other Publications of Photographs

In 1978, Editorial Presencia of Bogotá published the pioneering book *75 años de fotografía, 1865-1940. Personas, hechos, costumbres, cosas*, with photographs by the amateur photographers from Bogotá, Francisco Carrizosa and Roberto de J. Herrera.

Between 1982 and 1986, the Papelería América of Bucaramanga published a series of three books with photographs by Quintilio Gavassa: *Fotografía italiana*, *Las reminisencias del comercio bumangués*, and *El Club del Comercio*.

The year 1983 witnessed the publication of three important works. Taller la Huella produced the first history of Colombian photography entitled *Crónica de la fotografía colombiana, 1841–1948*, published by Carlos Valencia Editores of Bogotá. Shortly afterward, the Museo de Arte Moderno in Bogotá published *Historia de la fotografía en Colombia*, with pictures taken between 1840 and 1950. During the same year FENALCO in Antioquia published the book *El comercio en Medellín, 1900–1930*.

In recent years the number of publications that reproduce elements of our visual patrimony has largely increased. Two magazines deserve special mention: *Lámpara*, a quarterly, published by Intercol since 1948, and the *Boletín cultural y bibliográfico*, published by the Biblioteca Luís Angel Arango of Bogotá, which started to include illustrations with vol. 21, no. 1, 1984. Since then, the graphic research done to complement historical information in the articles has become more specific and has made public new images.

It is also important to mention the publication of four general histories, products of a collective effort, and illustrated with images from the past: *Historia de Colombia*, published in weekly booklets by Editorial la Oveja Negra of Bogotá in 1985 and 1986, is a six-volume set that covers pre-Hispanic cultures to the present. *Historia de Antioquia*, directed by Jorge Orlando Melo, was published first in a weekly section of *El Colombiano*, between June 1987 and March 1988, and later in 1989 as a book by Folio Editorial in Bogotá. The three-volume work *History de Bogotá*, by the Fundación Misión Colombia, was edited by Benjamín Villegas (Bogotá, 1988). Finally, the six volumes of the *Nueva Historia de Colombia*, directed by Alvaro Tirado Mejía, was published by Planeta Editorial Colombiana in 1989.

## Main Subjects Covered by the Images

New subjects of historical interest have arisen, focusing on mentalities and life-styles of ordinary people, which emphasize specific realities rather than general, abstract processes, and give more attention to oral and visual sources as they illustrate aspects that written sources often omit. In particular instances, themes related to the lives of women between 1800 and 1930 are better documented in written than in visual sources. At times, however, the two sources are complementary while in other cases there exists very little written or graphic information.

The themes that the graphic material covers in Colombia are very unevenly distributed. There are more pictures of wealthy than of poor

women, more of public than of private life, more of extraordinary events than of daily life matters.

## Attire

Any image in which women appear, alone or in groups, in street scenes, in special events or ordinary activities, is useful for the study of historical attire. The images range from those posed before the camera, good indicators of what was considered to be elegant, to the clothing used in daily life, according to social class, occasion, weather, and degree of urban sophistication. Though there is more material that illustrates the lives of wealthier women, sufficient material exists in which one can see the clothing and personal appearance of women of lower status.

With these pictures it is possible to construct chronological and regional series, maintaining the distinction between the well-to-do and the poor, in order to discover variations in dress and lags in the adoption of foreign fashions. On these themes little published materials exist other than occasional allusions made in travelers' accounts, genre literature, and advertising.

There are many photographs that detail hairstyles and millinery, the use of mantillas and shawls, shoes, makeup, and accessories such as umbrellas, jewelry, feathers, flowers, and other adornments. It is more difficult to find images that show underclothes, though in part this can be inferred from the advertisements in the foreign catalogs that circulated throughout the country and were reproduced in local newspapers.

## The Feminine Ideal

A more subtle theme that one may analyze in the majority of graphic images concerns changes and variations in the ideal of femininity. Such changes may be interpreted through the analysis of ambience, pose, gesture, the framing of the image, and the decor. In short, all of these elements allow for a dissection of the prevailing tastes of the time.

Other facets of what was normatively considered to be "the beautiful sex," such as submissiveness, candor, or erotic insinuation, can be extracted from the female images used in the first known advertisements of both local and foreign design, which circulated in Colombia from the 1980s onward. Publicity, which promoted a great variety of products for overcoming pains and weaknesses inherent to the female condition, provides eloquent allegories and symbolic representations

of women. All of these graphics reveal how feminine nature was conceived.

This information complements very well the written sources such as sermons, conferences,solemn end-of-year discourses, published letters from fathers to daughters, manuals of etiquette and home economics, and endless articles in feminine publications of the time which dictated how women should carry themselves.

## Women's Work

Women's work and working mothers are themes currently of great interest among social scientists. During the nineteenth century, and at the beginning of the twentieth century, these subjects were not studied in any systematic form, though disperse references can be found throughout travelers' accounts, municipal chronicles, city directories, and local monographs.

Genre paintings of the second half of the nineteenth century often illustrate the labors performed by men and women of the popular sectors of society. Women are shown bringing country goods, selling them in the marketplace, accompanying their mistresses, working as weavers, cigar makers, and water carriers. In the 1920s, the first commercial photographs and advertisements, with the idea of extolling progress and modernization, showed work performed by contracted workers in new industries: saleswomen, secretaries, and telephone operators.

## Other Themes

In spite of an increase in the output of images, until 1930 women's lives were scarcely recorded and some not at all. For example, one finds very little representation of traditional female activities in religious organizations, popular in the first half of the nineteenth century, or in those related to religious communities and charity organizations, which proliferated from 1880 when the power of the Church was strengthened with the signing of the Concordat with Colombia. In the second half of the century, women's education, which after Independence became a common debate involving many people, gave origin to countless publications and produced important changes. Nevertheless, visual documentation on this matter is practically limited to school pictures of classes.

And, curiously, the iconography of great female figures of the time, whether heroines, wives, or lovers of illustrious men, such as Manuela Sáez, the Ibáñez sisters, or others, who stood out for their

atypical lives, such as Soledad Acosta de Samper or María Cano, is rather poor. Most pictures show women who lived more ordinary lives. Another theme for which there is very little visual information is the participation of women in the adoption of new sports, which in many respects undermined nineteenth-century ideals concerning their delicacy and weakness, a pair of virtues essential to the definition of femininity. There are only a few images, almost all photographs, which show women in major cities during the first quarter of this century riding bicycles, playing cricket, tennis, and basketball, and swimming or riding horseback. One encounters occasional references about this theme in newspapers, magazines, local chronicles, and city albums.

Even less documented in written as well as graphic material are home interiors (e.g., bedrooms, kitchens, dining rooms) and private activities, such as child rearing, sewing, embroidery, music lessons, painting, or other handicrafts. Another example is eroticism which, whereas in the United States and Europe produced a plethora of images, in Colombia generated very few and timid in comparison.

Finally, another subject for which there is much graphic material in developed countries and very little in Colombia is that related to feminist activities, common in Europe and the United States in the second half of the nineteenth century and the early twentieth century. Nevertheless, this is not surprising. In Colombia feminist protests were rare and arose some years later, picking up steam in the 1930s. Hence, this subject falls outside the scope of this study.

## ADDENDA

### Archives and Collections of Historical Photography

Archivo de la Fotografía en Colombia, Museo de Arte Moderno, Bogotá.

Archivo de Quintilio Gavassa, Casa de Bolívar, Bucaramanga.

Archivo Juan N. Gómez, Fotobank, Bogotá.

Archivo Fotográfico Placas Viejas, Bogotá.

Archivo Fotográfico de la Orinoquia, Villavicencio.

Archivo Foto Rodríguez.

Centro de Memoria Visual, Centro de Documentación Regional, en las bibliotecas del Banco de la República de Pasto, Pereira, Montería, Armenia, Ibagué y Giradot.

Centro de Memoria Visual, Fundación Antioqueña para los Estudios Sociales (FAES), Medellín.

Colección del Fondo Cultural Cafetero, Bogotá.

Colección de tarjetas de visita, Biblioteca Luís Angel Arango, Bogotá.

Inventario de Patrimonio Artístico, Extensión Cultural Departamental de Antioquia.

Fototeca Histórica de Cartagena, Archivo Histórico de Cartagena.

Museo de Antioquia, Medellín.

Museo Nacional, Bogotá.

Museo Romántico, Barranquilla.

## Exhibition Catalogs (listed chronologically)

*Un siglo de moda en Colombia: 1830–1930.* Bogotá: Fondo Cultural Cafetero, Aug. 1981.

*Benjamín de la Calle: fotógrafo 1869–1934.* Medellín: Biblioteca Pública Piloto y Museo de Arte Moderno, 1982.

*Debora Arango.* Medellín: Museo de Arte Moderno, 1984.

*América: una mirada interior. Figari, Reveron, Santa María.* Bogotá: Biblioteca Luís Angel Arango, 1985.

*América: una confrontación de miradas. Torres Méndez y Edward Mark.* Bogotá: Biblioteca Luís Angel Arango, 1985.

*100 Marías.* Bogotá: Fondo Cultural Cafetero, March, 1985.

*Colombia 1886. Programa Centenario de la Constitución, Banco de la República.* Bogotá: Biblioteca Luís Angel Arango, 1986.

*Marco Tobón Mejía, 1876–1930.* Bogotá y Medellín: Banco de la República, 1986.

*Francisco Mejía.* Medellín: Fundación Antioqueña para los Estudios Sociales (FAES) y Banco de la República, 1986.

*Acuarelas de la Comisión Corográfica.* Bogotá: Museo Nacional, June, 1986.

*La acuarela en Antioquia.* Bogotá: Museo de Arte Moderno y Biblioteca Luís Angel Arango, 1987.

*Pasto a través de la fotografía.* Bogotá: Biblioteca Luís Angel Arango, 1987.

*Cartagena: un siglo de imágenes.* Cartagena: Fototeca Histórica de Cartagena, Museo de Arte Moderno y Banco de la República de Cartagena, 1988.

*Rodríguez Naranjo.* Bucaramanga: Banco de la República, July-Aug. 1988.

*Bogotá en caricaturas.* Bogotá: Biblioteca Luís Angel Arango, Aug.-Oct. 1988.

*Alexander von Humbolt: inspirador de una nueva ilustración de América.* Bogotá: Biblioteca Luís Angel Arango, 1988.

*Alberto Arango: 1897–1941.* Bogotá: Banco de la República, Fondo Cultural Cafetero, 1988.

*Bogotá en caricatura.* Historia de la caricatura en Colombia, 5. Bogotá: Biblioteca Luís Angel Arango, Aug.-Oct. 1988.

*Rafael mesa: el espejo de papel.* Medellín: Fundación Antioqueña para los Estudios Sociales (FAES), Jan. 1989.

*Revelaciones: Pintores de Santa Fé en tiempos de la colonia.* Bogotá: Museo de Arte Religioso, Feb.-March 1989.

*Andrés de Santamaría: Nueva visión. Obras de las colecciones de Bélgica.* Bogotá: Biblioteca Luís Angel Arango, 1989.

**Photography Books (listed by date of publication)**

*75 años de fotografía: 1865–1940. Persona, hechos, costumbres y cosas.* Bogotá: Editorial Presencia, 1978. Con fotografías de Fernando Carrizosa y de Roberto de J. Herrera.

*Fotografía Italiana.* Bucaramanga: Papelería América, 1982. Fotos de Quintilio Gavassa.

Fenalco, Seccional de Antioquia. *El comercio en Medellín, 1900–1930.* Medellín, 1983. Con fotos de Benjamín de la Calle.

*Crónica de la Fotografía Colombiana, 1841–1948.* Bogotá: Taller la Huella, 1983.

*Reminiscencias del comercio bumanguéz.* Bucaramanga: Papelería América, 1983.

Serrano, Eduardo. *Historia de la fotografía en Colombia.* Bogotá: Museo de Arte Moderno de Bogotá, 1983.

*1880–1980: Un siglo de publicidad gráfica en Colombia.* Bogotá: Puma Editores, 1984.

*Melitón Rodríguez: fotografías.* Bogotá: El Ancora Editores, 1985.

Cárdenas, Jorge, y Tulia Ramírez. *Evolución de la pintura y escultura en Antioquia.* Medellín: Fundación Pro Antioquia, 1986.

*El Club del Comercio.* Bucaramanga: Papelería América, 1986.

Fondo Cultural Cafetero. *Manizales de ayer: Album de fotografías.* Bogotá, 1987.

Sánchez Cabra, Efraín. *Ramón Torres Méndez, Pintor de la Nueva Granada, 1809–1885.* Bogotá: Fondo Cultural Cafetero, 1987.

Fundación Misión Colombia. *Historia de Bogotá.* 3 vols. Bogotá: Villegas Editores, 1988.

González, Beatríz. *José Gabriel Tatis: un pintor desconocido*. Bogotá: Carlos Valencia Editores, 1988.

*Historia de Antioquia*. dir. por Jorge Orlando Melo. Bogotá, 1988.

*Historia de Colombia*. 16 vols. Bogotá: Salvat Editores, 1986–1988.

# 9. Images from Inca Lands: An Index of Photographic Slides from the OAS

## Nelly S. González

## Introduction

Europe, the Americas and, indeed, the World are preparing to celebrate the quincentenary of Columbus's voyage to the "New World." Festivities are being prepared on both sides of the Atlantic. Although almost everybody agrees that Columbus's achievement is one of the most profound historical events of all time,[1] not everybody agrees on exactly what to call it. The traditional name for it, *el descubrimiento*, or "the discovery," no longer seems appropriate in our time of heightened sensitivity and respect for cultures other than our own. After all, the native Americans had crossed the Bering Strait from Asia thousands of years before Columbus set sail down the Guadalquivir. Indeed, the organizing committee for the Seville World's Fair commemorating Columbus's achievement is officially calling it the "Meeting between Peoples," in recognition of the cultural achievements of all native Americans encountered by the Europeans, but especially of the Aztecs of central Mexico, the Maya of Yucatán and Central America, and the Inca of the Andean Region. The Inca were encountered by Francisco Pizarro and his conquistadors in 1532. At its most powerful, the Inca empire extended some 2,500 miles from the southern border of Colombia in the north to the central valley of Chile in the south. Some of the most familiar images of the last bastion of the Inca are those of the hilltop sanctuary of Machu Pichu.[2]

This paper discusses the slide collection of the Organization of American States and its Museum of Modern Art of Latin America and the importance of slides in instruction and research. The OAS collection, containing numerous slides of the Land of the Incas, Bolivia, Ecuador, and Peru, is available at the Museum, as well as at a large number of research libraries throughout the United States. However, before discussing the slide collection and index, some general background is in order.

115

## Background

Bibliographic control over nonprint materials, including film and slides, was in its developing stages as recently as 1978.[3] Today, we see that there has been substantial activity on preparing bibliographic resources for film but less for slides. Interest in compiling bibliographies on Latin American cinema has mushroomed during the past dozen years. For example, *The Handbook of Latin American Studies* (HLAS) began a film section with volume 38, 1977, and it continues to appear regularly. Unfortunately, to this date there is no comprehensive bibliography covering the production of slides. This problem is compounded by the fact that during the past decade and a half there was a sudden explosion in the production of slide material without a parallel development in its bibliographic control.

Films may be considered more glamorous, but slides are of equal educational value. Consider the importance of slide materials. With this medium, one watches, hears, and reads. A good slide presentation has the advantage of being flexible. One may update or modify a presentation easily. Furthermore, slides help to explain hard-to-describe matters.[4] Interpretations of audiovisual materials are subjective; thus audiences capture different meanings, which sparks healthy dialogue, often leading to constructive conclusions. Another advantage to slides is that one can develop his or her own script, making it possible to convey and emphasize what one desires that the audience absorb. Slides can also be used to emphasize a particular visual sequence. Moreover, the nature of slides and other audiovisual materials is diverse, so that one slide may be relevant to several different topics. Finally, slide presentations are an excellent method for stimulating future discussions and encouraging independent thinking. They are ideal for use in answering the five Ws and the H used by journalists: who, what, when, where, why, and how. In addition, experience reveals that audiovisual materials have the ability to provoke critical comments, both favorable and unfavorable, ensuring lively interactions between the audience and the lecturer. Consequently, discussions or dialogues after each presentation create an enlightening experience for the audience.

Of course, one must not lose perspective: slides cannot replace books or lectures, but they can add valuable depth to academic courses.[5] Slides are particularly helpful to interdisciplinary studies, which have proliferated in recent years as more universities include new curricula in their undergraduate programs. There have been changes which invite systematic inquiry by social scientists on a much larger scale than in previous decades. In universities across the United States

language courses as well as courses in anthropology and political science often use a variety of nonprint materials to help convey different aspects of Latin American society. These materials provide greater understanding and appreciation of cultural and social life in Latin America, including the Andean Region and its people, the focus of this index.

These slides are available today thanks to the continuous support provided by the Permanent Council of the Organization of American States, which makes possible the publication of many other collections of audiovisual materials that contribute to the study of the cultural history of the Americas. The collection of slides from Inca lands is listed in *The Sights and Sounds of the Americas*, which is classified by general topic and divided in broad categories. Published in 1973, it is a very good guide for identifying and selecting available audiovisual materials that can be used in college courses on Latin America.

## Organization of the Slides and Index

*The Sights and Sounds of the Americas* is a simple listing of slide sets, which are identified by number. The slides come in sets of ten in plastic packets. Each packet is accompanied by a descriptive pamphlet. The slides are classified by general topic and divided in the following categories: (1) General Patterns of Culture in Latin America and the Caribbean; (2) Scenery of Latin American and Caribbean Countries; (3) Pre-Columbian Art; and (4) Art in Latin America.

The index is intended for use by college teachers and undergraduate students. The entries, arranged alphabetically by subject, with cross references and the OAS number for each slide, represent a total of 290 35 mm photographic images from Bolivia, Ecuador, and Peru. Covered at this time are approximately 200 subjects ranging from "Adobe houses—Peru" through "Yungas (Bolivia)—Flora." Subjects are based on the *Library of Congress Subject Headings*, modified by the *HAPI Thesaurus*.[6]

Future updates for this index are planned as well as the expansion of coverage by adding other slide collections.[7] It is hoped that this will create a more comprehensive index and enhance the availability and utility of slides for the study of Latin America.

## NOTES

1. Sandy Kline, *The Conquest: Audio Visual Program* (Washington, DC: OAS, Museum of Modern Art of Latin America, Text. Set no. 139., [1973].

2. Jonathan Norton Leonard and The Editors of Time-Life Books, *Ancient America* (New York, NY: Time, 1967), p. 79.

118 NELLY S. GONZÁLEZ

3. Martin H. Sable, *A Guide to Nonprint Materials for Latin American Studies* (Detroit, MI: Blaine Ethridge, 1979), p. [v].

4. Jane H. Loy, *Latin American: Sights and Sounds* (Gainesville, FL: Latin American Studies Association, 1973), p. 14.

5. Ibid.

6. *Hispanic American Periodicals Index Thesaurus*, Barbara G. Valk, ed. (Los Angeles, CA: UCLA Latin American Center Publications, 1986).

7. Sable, *A Guide to Nonprint Materials for Latin American Studies*, pp. 35-38; *The World History Slide Collection (Non-European History); Master Guide* (Annapolis, MD: Instructional Resources Corporation, 1988).

## Index of Photographic Slides of Bolivia, Ecuador, and Peru Available from the OAS

Adobe houses—Peru, 126 G

Agricultural laborers—
Bolivia—Altiplano, 8 B, E, F, G, I, J

Agricultural laborers—Ecuador, 85 C

Agriculture—Altiplano (Bolivia and Peru), 19 H, 102 C, 103 J

Agriculture—Ecuador, 85 C

Alpaca, 26 A, B, C, E, F, G, H, I, J; 27 A, B, C, D, E, F, G, H, I, J; 123 A, B, C, D, E, F, G, H, I, J

Altars—Ecuador—Cuenca, 83 C

Altiplano (Bolivia and Peru), 18 G, H; 19 E

Andes region (Bolivia), 18 G, H; 25 E

Andes region (Ecuador), 84 A, C, D

Andes region (Peru), 18 G, H; 25 E

Architecture—Ecuador, 82 D, I; 83 B; 115 B, C, D, E, F, H

Architecture—Peru, 126 F, G, I, J

Architecture—Peru—Cuzco, 19 A; 124 C, D, E, F, I, J

Architecture, Spanish colonial, 82 D, I; 115 B, C, D, E, H; 124 I, J

Art—Peru, 125 A, B, C, D, E, F, G, H, I, J

Aymara Indians, 8 J

Aymara Indians—Dances, 23 C, I; 24 C, D, H, I, J

Aymara Indians—Land Tenure, 8 J; 18 H

Balsa wood craft—Lake Titicaca (Bolivia and Peru), 18 B, D, E, F

Barley—Altiplano (Peru and Bolivia), 8 J

Beni, Bolivia (Department), 16 A, B, C, D, E, F, G, H, I, J

Boats and boating—Ecuador, 84 G, H; 85 D

Boats and boating—Lake Titicaca (Bolivia and Peru), 18 B, D, E, F

Buildings—Ecuador—Quito, 115 I

Bullfights—Ecuador, 115 J

Cathedrals—Ecuador, 83 B, C

Cathedrals—Peru—Cuzco, 124 D; 125 H

Chavin culture, 128 B

Chicha (Liquor), 23 E

Children—Altiplano (Bolivia and Peru), 18 E; 24 B; 25 C, D, I

Children—Bolivia—Beni, 16 E

Children—Ecuador, 82 C; 115 G

Children—Peru, 27 E; 124 A

Chimu Indians, 128 E; H, I

Christian saints in art, 125 A

Church architecture—Ecuador, 115 B

Church architecture—Peru, 126 I, J; 127 B, J

Churches—Catholic—Ecuador, 115 B

Churches—Catholic—Peru, 126 I, J; 127 B, I, J

Cities and towns—Altiplano (Bolivia and Peru), 19 I,J; 23 J; 127 I

Cities and towns—Ecuador—Views, 82 A, B, C, D, E, G, H, I, J; 83 A, B, C, D, E, F, G, H, I, J;

# 10. Access to Photograph Collections

### Stella M. de Sá Rêgo

Providing access to photograph collections means bringing together researchers and the images they seek. In an ideal situation, users would have access to all holdings in the collections pertinent to their interest, quickly and independently, in a manner that posed no threat to the security of the materials. For imaging collections, that would mean access through records with visual references, as well as textual description and indexes.

Finding aids help users determine what you have, if you have what they are looking for, and, if so, how to locate it. Physical access may be provided to original materials or—more appropriately—to a reference copy in some form.

Making image collections accessible involves several distinct activities: (1) describing and indexing materials for intellectual access, (2) arranging collections to make retrieval as efficient as possible, and (3) taking preservation measures to minimize damage and loss of original materials.

Of these tasks, the first—providing intellectual access that is both comprehensive and meaningful to users—is certainly the most challenging. Choosing which index terms to include in a catalog record requires logical and discriminating selection, a knowledge of the user group's interests, and some intuition as to what future researchers will want to look for.

The increasing use of computers in archives, museums, and libraries in recent years has lent impetus to efforts to standardize the description of visual materials and to create formats for machine-readable cataloging records. However, no standard vocabulary or cataloging format has yet been widely accepted by visual resources collections in the way that AACR 2 cataloging and MARC format have been for text records. There is even less agreement on descriptive practices among different types of repositories: libraries, archives, and museums.

123

The most notable contributions in the field of image description and cataloging standards have been made by the Library of Congress and by the Art and Architecture Thesaurus Project. Their efforts have resulted in the creation of new tools for describing visual materials in standardized and controlled language, and for cataloging them in machine-readable format that permits electronic searching, retrieval, and sharing of records.

The Library of Congress Prints and Photographs Division has produced three manuals for use in cataloging visual materials. The earliest of these, the *LC Thesaurus for Graphic Materials: Rules for Describing Original Items and Historical Collections* (1982), formulates conventions for expressing and formatting cataloging data in a consistent manner.[1] It deals exclusively with description and not access points. Rules are based on AACR 2 and *Bibliographic Description of Rare Books* (Library of Congress, 1982). The AACR 2 rules for cataloging published graphic materials are not appropriate for original items and historical collections because the research interest and amount of available information differs greatly among these types of visual materials.

Another LC publication, *Descriptive Terms for Graphic Materials: Genre and Physical Characteristics Headings* (1986) is a thesaurus listing standard terms for types of pictorial materials and production processes.[2] These are indexed in MARC fields 655 and 755, respectively. Examples of these terms are: "Group portraits" (Genre term) and "Tintypes" (Physical characteristics term).

The *LC Thesaurus for Graphic Materials: Topical Terms for Subject Access* is an alphabetically arranged thesaurus of subject terms for indexing pictures.[3] It was designed for use in large general collections, such as those found in historical societies, libraries, and archives. Although a number of sources have been used, most of the terms have been selected or adapted from *Library of Congress Subject Headings (LCSH)*, which was devised primarily for book cataloging. It should be noted, however, that terms in the thesaurus are not always identical to those in *LCSH*.

The MARC format for Visual Materials, often referred to as the VM format, appeared in 1984 as update number ten to the *MARC Formats for Bibliographic Data*. Based on the 1976 MARC format for films, it was revised and expanded to include prints and photographs.[4]

To help catalogers use MARC VM format, a compendium of practice has been compiled.[5] The first edition is no longer available; however, a second edition was issued in 1989 by the Society of American Archivists.

The Art and Architecture Thesaurus Project, part of the Getty Art History Information Program, is in the process of completing an undertaking begun in 1979 with the objective of augmenting and improving indexing terms for pictorial and textual materials in the field of art history. The result of their efforts is the *Art and Architecture Thesaurus*, a hierarchically arranged listing of art and architectural terms selected from a number of sources, including such widely used references as *LCSH* and Chenall's *Nomenclature for Museum Cataloging: A System for Classifying Manmade Objects* (American Association for State and Local History, 1978). *Art and Architecture Thesaurus* terms are intended for use with the MARC format. A draft form of *ATT* was distributed to "test user" institutions in 1984. The first published version—in book form and on-line—was made available in late Fall, 1989.

These tools are not yet widely used and are still being refined. In spite of this, they are very helpful and provide the basis for a common language that is necessary if we are to communicate effectively, making easier the work of both catalogers and researchers. Although the MARC format and the various thesauri may be used in either manual or automated systems, such standardization is clearly essential for the effective use and sharing of information on computer databases.

To provide efficient physical access to collections, they must be logically organized. The arrangement of photograph collections is much like that of manuscript collections: large units are broken down into smaller units of related materials, usually at the folder level, so that the internal logic of a collection is readily apparent to users. This makes browsing more efficient for researchers—since photographs of similar subjects are kept together—and retrieval more efficient for the archivist—since fewer folders of a large collection have to be removed and, later, returned to collections. Not only is staff time saved but the reduced circulation of photographs contributes to their preservation and security.[6]

This brings me to the last of the activities I mentioned: taking preservation measures to minimize damage and loss of original materials. If original photographs are made accessible to researchers, they should be protected with enclosures and, where necessary, rigid supports—both made of chemically inert materials. The research area should be provided with environmental controls regulating light, temperature, and humidity. The American National Standards Institute (ANSI) has published standards for filing enclosures and containers to house photographs. Information on proper environmental conditions

can be found in any basic text on care and preservation of photograph collections. [7]

Because handling photographs shortens their useful life—through surface abrasion, broken supports, exposure to light, and possible theft—it is better to give users access to some form of reference copy instead of to valuable—and possibly irreplaceable—original photographs. A reference copy might be a photocopy, copy print, a microform, or—for those fortunate enough to have state-of-the-art technology available to them—a video or digital image. Obtaining satisfactory copies, however, is not a simple matter: photocopies are of poor quality, while copy negatives and prints—let alone video or digital technologies—are often too costly for most repositories.

Microforms are probably the most cost-effective way of providing useful and durable reference copies. Microfilm's high-contrast can result in poor-quality reproductions. Moreover, its linear sequence can make searching tedious. Microfiche is more sequentially flexible and can be produced with greater tonal range, thus giving users access to better—more detailed and truer—reproductions. Photocopies of reference quality can be made from either, using microfilm and fiche printers. Photographic copies can also be generated from microform negatives, thus providing a security backup in the case of loss. Off-site storage of these negatives is routinely available from the microform producers.

I am currently completing a microfiche project, funded by the National Historical Publications and Records Commission, Washington, DC, to produce tonal microfiche reproductions of two of our largest and most-used photograph collections, together with an accompanying indexed guide. The guide will be produced using a custom dBase III+ program, written in-house. Record fields are formatted like a MARC VM record. Descriptive terms are selected from the previously mentioned Library of Congress manuals. While I normally write collection-level records, the need for item identification of the fiche images requires "minimum-level" item records. Collection-level records written in MARC VM format will be entered onto the OCLC database.

At present, only records for photograph collections considered to be of regional or national interest are entered on a national database. The in-house database is not available to library patrons for searching. It is used internally for records management. Public records on collection holdings are made available in the form of bound print-outs. A master record is written for each collection and indexed for subjects, photographers, locales, identified persons, genres, and physical characteristics. Access to collections has been greatly increased and

improved by this finding aid. The indexes have proved to be very helpful, especially in locating items in small, less-memorable collections, or those needle-in-a-haystack items that—although exceptional photographs—might otherwise be lost in large collections of dissimilar material. I am often surprised to find, using the indexes, an image that I had completely forgotten about, proving the danger of over-dependence on the archivist's memory!

Therefore, my own strategy to increase access to the photograph collection that I manage has been to undertake the creation of a data- and image-base reference. First, I am employing the newly available tools—the LC manuals and MARC VM format—in writing catalog records using standardized vocabulary in a format that permits entry and retrieval in national and local databases. Second, I am having original photographs reproduced on tonal microfiche, thus giving researchers direct visual access to browse large image collections in a way that reduces not only the amount of staff time necessary for reference and maintenance, but also the possibility of damage and loss to fragile and, often, unique items. Handling of original photographs is minimized and limited to person knowledgeable about their care: archives staff and professional photographers.

Since only a portion of our collection has been reproduced on fiche at this time, users are still allowed access to some original photographs. In these cases, it is especially important that large collections be well organized. It is preferable, for example, to retrieve, handle, and refile a single folder of family portraits than to take out five boxes where the same pictures are scattered through fifteen or twenty folders. Some of our most heavily used collections, such as those relating to the history of the University of New Mexico, have been photocopied for reference during this Centennial year. The copies have been placed in binders, indexed by broad subject areas, and placed for reference in our archives and in the University Centennial Office. This has greatly reduced the demands on staff time to access these collections, limited circulation of originals, and allowed patrons to conveniently order reproductions using the item identification numbers on the copies without ever having to come to the archives.

Moving from the low to the high end of reprographic technology, video and digitized images offer exciting new options for coordinating access to data and images in visual collections. Video disk is a widely accepted technology that is becoming more commonly used in museums and library image collections. Its large storage (54,000 color images per disk side) and acceptable resolution make it practical for some institutions, in some situations. Interactive systems allow the images on

the disk to be searched and sorted and provide other text data. Digital images, stored on magnetic media or optical disks and displayed on computer monitors, offer better resolution and interesting possibilities for editing and enhancement of photographic images, as well as for their transmission through network and telephone lines. Using WORM (Write-Once-Read-Many) disks, dynamic collections could continuously add to their growing holdings. Recently developed erasable disks could offer the forgiving grace of "a second chance" for updating holdings information.

Digital image bases are not practical for the majority of repositories, being too expensive and largely untested at this time. Adequate storage and reasonable entry and retrieval time join with "bottom-line" considerations on the list of major obstacles to be overcome before these seductive technologies can be seriously considered by most repositories. While sophisticated technologies can enhance access to photograph collections, their application must be preceded by traditional information gathering and selection. The storage and dissemination of information is as useful as the information itself.

Regardless of the physical form of the reference image, description remains the fundamental task in providing access to collections. It is often necessary to do some research in order to verify or discover enough information to make a photograph meaningful. Records for historical collections are, by necessity, often based on information attributed by the cataloger. Photographs are often untitled, by unknown photographers, and of uncertain date. Copy photographs confuse the dating of content by obscuring physical clues, such as photographic process and even the format and dimensions of the original image. Knowledge of the subject areas represented in collections and of the history of photography is essential for archivists cataloging this kind of collection. Writing records with entries in multiple indexes makes it possible for researchers to use Boolean search strategies—such as Subject AND Date Range AND Locale—to find useful images identified only by broad categories. Subject indexing is desirable for all types of visual archives since, as the curator of a major art historical collection has observed, researchers increasingly consider and search for images as ". . . historical documents reflecting the time and place of their creation."[8] To meet these users' needs, pictures must be indexed by subject and, better yet, by a number of access points that can be combined into more specific search strings.

Providing intellectual and physical access to photograph collections is a complex labor- and material-intensive activity. Resources—for both labor and costly archival supplies—are always limited and often inadequate in institutional collections. Yet, precious and fragile photographs of historical and artistic value can be made available in a number of ways that balance researchers' need for accessibility with archivists' responsibility to preserve them for future generations.

## NOTES

1. Elisabeth W. Betz, *Graphic Materials: Rules for Describing Original Items and Historical Collections* (Washington, DC: Library of Congress, 1982).

2. Helena Zinkham and Elisabeth Betz Parker, *Descriptive Terms for Graphic materials: Genre and Physical Characteristic Headings* (Washington, DC: Cataloging Distribution Service, Library of Congress, 1986).

3. Elisabeth Betz Parker, *LD Thesaurus for Graphic Materials: Topical Terms for Subject Access* (Washington, DC: Cataloging Distribution Service, Library of Congress, 1987).

4. Katherine D. Morton, "The MARC Formats: An Overview," *American Archivist* 49 (Winter 1986), 21-30.

5. Linda J. Evans and Maureen O'Brien Will, *MARC for Archival Visual Material: A Compendium of Practice* (Chicago, IL: Chicago Historical Society, 1988).

6. For information on arrangement of photograph collections, as well as other aspects of their management, see: Mary Lynn Ritzenthaler, Gerald J. Munoff, and Margery S. Long, *Archives and Manuscripts: Administration of Photographic Collections* (Chicago, IL: Society of American Archivists, 1984).

7. See, e.g., Sigfried Rempel, *The Care of Photographs* (New York, NY: Nick Lyons Books, 1987); Robert A. Weinstein and Larry Booth, *Collection, Use, and Care of Historical Photographs* (Nashville, TN: American Association for State and Local History, 1977); James M. Reilly, *Care and Identification of 19th-Century Photographic Prints* (Rochester, NY: Eastman Kodak Company, 1986).

8. Helene Roberts, "'Do You Have Any Pictures of . . .?' Subject Access to Works of Art in Visual Collections and Book Reproductions," *Art Documentation* (Fall 1988), 87.

# 11. A Bibliography on Photography

## Martha Davidson

### Care and Conservation of Photographs

Albright, Gary. "Photographs." In *Conservation in the Library: A Handbook of Use and Care of Traditional and Nontraditional Materials*, Susan Garretson Swartzburg, ed. Westport, CT: Greenwood Press, 1983.

> Brief history of photographic processes, discussion of preservation and care of black-and-white and color photos, and selected bibliography.

Conrad, James H. *Copying Historical Photographs: Equipment and Methods*. Technical Leaflet 139. Nashville, TN: American Association for State and Local History, 1981.

> Practical information for establishing an in-house historical photograph copying operation. Includes bibliography.

*Conservation of Photographs*. Rochester, NY: Eastman Kodak Company, 1985.

> Comprehensive and lucid guide to care and conservation of photographs.

Keefe, Jr., Laurence E., and Dennis Inch. *The Life of a Photograph: Archival Processes, Matting, Framing and Storage*. London: Butterworth/Focal Press, 1984.

> Information on processing of film and prints and about storage, display, and framing techniques. Appendix of mail-order suppliers of materials for conservation and display of photos. Bibliography.

Ostroff, Eugene. *Conserving and Restoring Photographic Collections*. Washington, DC: American Association of Museums, 1976.

> Discussion of effects of environment and residual chemicals on photographs; explanation of optical procedures for restoring images; description of materials for storage and display. Includes technical information. Published originally

in *Museum News* (May-Dec. 1974). Spanish edition published by Archivo General de la Nación, Mexico, 1981 (publication #35 SG-AGN-1981).

Reilly, James M. *Care and Identification of Nineteenth-Century Photographic Prints.* Rochester, NY: Eastman Kodak Company, 1986.
> Identification, conservation, and restoration of historical photographs. Contains flowchart guide for identifying types of photographic prints.

Rempel, Siegfried. *The Care of Black-and-White Photographic Collections: Identification of Process.* CCI Technical Bulletin 6. Ottawa: Canadian Conservation Institute, November 1980.
> Procedures for identifying types of black-and-white photographs.

Rempel, Siegfried. *The Care of Black-and-White Photo Collections: Cleaning and Stabilization.* CCI Technical Bulletin 9. Ottawa: Canadian Conservation Institute, December 1980.
> How to handle and store black-and-white photographs.

Weinstein, Robert A., and Larry Booth. *Collection, Use, and Care of Historical Photos.* Nashville, TN: American Association for State and Local History, 1977.
> Comprehensive guide to the use and care of photographs, including methods of dating and identifying photographic images.

## Photography as a Research Tool

Banta, Melissa, and Curtis M. Hinsley. *From Site to Sight: Anthropology, Photography, and the Power of Imagery.* Cambridge, MA: Peabody Museum Press, 1986.
> Exhibition catalog discussing the ways in which anthropologists have used the camera as a recording, analytic, and aesthetic medium, and what their photos reveal about their perceptions of their subjects. Includes a very extensive bibliography.

Becker, Howard S., ed. *Exploring Society Photographically*. Evanston, IL: Northwestern University, 1981.

> Essays by visual anthropologists and sociologists. Includes bibliography.

Collier, Jr., John, and Malcolm Collier. *Visual Anthropology: Photography as a Research Method*. Albuquerque: University of New Mexico Press, 1986.

> Revised edition of classic work on applications of photography to research in the social sciences. Discusses methods of data gathering through photography and analysis of photographic records.

Desnoes, Edmundo. "Cuba Made Me So" and "The Death System." In *On Signs*, Marshall Blonsky, ed. Baltimore, MD: The Johns Hopkins University Press, 1985.

> Observations on how photographs are made and interpreted in the North (United States) and the South (Latin America, the Third World).

Dorronsoro, Josune. *Significación histórica de la fotografía*. Caracas: Equinoccio/Universidad Simón Bolívar, n.d.

> Significance of photographs as historical documents. Includes extensive bibliography.

Hockings, Paul, ed. *Principles of Visual Anthropology*. The Hague: Mouton Publishers, 1975.

> Essays by anthropologists concerning the use of photography in cross-cultural studies.

Levine, Robert E. *Images of History: Nineteenth- and Early Twentieth-Century Latin American Photographs as Documents*. Durham, NC: Duke University Press, 1989.

_____. *Windows on Latin America: Understanding Society through Photographs*. Miami, FL: South Eastern Council on Latin American Studies/University of Miami, 1987.

> Analyses of historical photos by social scientists and historians, with introduction and bibliography on photography of Latin America.

McJunkin, Roy. "A Guide to Research Using Photographs." Occasional paper. Riverside: California Museum of Photography/ University of California, 1986.

> Basic procedures followed by scholars, authors, and artists who use photographs as sources of information or inspiration.

Meyer, Pedro. "Cabos sueltos," *Nexos* 8 (July 1985), 5-8.

> Essay warning of the dangers of technological advances for the integrity of documentary photography.

Mraz, John. "Particularidad y nostalgia." *Nexos* 8 (July 1985), 9-12.

> Discusses the use of photographs as documents for historical analysis.

Vanderbilt, Paul. *Evaluating Historical Photographs: A Personal Perspective*. Technical Leaflet 120. Nashville, TN: American Association for State and Local History, 1979.

> Guidelines for acquisitions in building a collection.

*Visual Resources: An International Journal of Documentation*. Vol. 1, Spring 1980–.

> Articles on the history of pictorial documentation, the organization of picture collections, and new technology for storing and cataloging visual collections. Annual bibliography of publications related to visual materials.

## Guides to Sources

Davidson, Martha, et al. *Picture Collections: Mexico*. Metuchen, NJ: Scarecrow Press, Inc., 1988.

> Guide to over five hundred sources of photos, paintings, prints, drawings, and other pictorial documents in Mexico. Indexed by subject, source, and artist.

*Directory of Photography Collections*. Riverside: California Museum of Photography/University of California, Riverside.

> Directory to nearly a hundred collections found throughout the nine campuses of the University of California, with information about finding aids, compiled on the basis of a year-long survey.

Eakins, Rosemary. *Picture Sources: U.K.* London: MacDonald and
Company, 1985.

> Guide to more than a thousand public and private collections
> in the United Kingdom. Indexed by collection and by subject
> matter. Latin American images can be found by referring to
> country headings in subject index.

Evans, Hilary, and Mary Evans. *Picture Researcher's Handbook.* 3d ed.
Florence, KY: Van Nostrand and Reinhold Co., 1986.

> International guide to sources of historical and contemporary
> photos and other pictorial materials. Emphasis on European
> and North American sources, but with some coverage of
> Latin America.

Nauman, Ann K. *Handbook of Latin American and Caribbean National
Archives.* Detroit, MI: Blain-Ethridge Books, 1984.

> Although this handbook is not oriented specifically toward
> photo collections, national archives generally do include
> historical photos among their documents.

*Repertoire des collections photographiques en France.* 5th ed. Paris: La
Documentation Française/Secretariat General du Gouvernement,
1980.

> Guide to more than a thousand photographic collections in
> France, indexed by subject (Latin American photos may be
> found by country). Includes directory of photo agencies and
> associations and bibliography of other guides to European
> collections.

Robl, Ernest H. *Picture Sources.* 4th ed. New York, NY: Special
Libraries Association, 1983.

> Guide to nearly a thousand public and commercial sources of
> pictures (photos, prints, drawings, etc.) in the United States
> and Canada, including a few (largely commercial) collections
> of Latin American photos. Indexed by source and subject.

Wilgus, A. Curtis. *Latin America: A Guide to Illustrations.* Metuchen,
NJ: Scarecrow Press, Inc., 1981.

> Indexes of published illustrations on topics pertaining to Latin
> America. Picture credits in the publications may be used to
> locate original sources.

# 12. Use and Reproduction of Photographs: Copyright Issues

## David L. Levy

**Definition and term of copyright, fair use, and scope of copyright, with particular regard to artistic materials, specifically photos**

Copyright in the United States originates from the U.S. Constitution, which empowers Congress to "promote the progress of science and the useful arts, by securing for limited times to authors and inventors the exclusive right to their respective writings and discoveries." The term "writings" has been construed to include maps, charts, music, prints, engravings, drawings, paintings, photographs, and photoplays, as well as books, written and printed matter, and so on. There have been several U.S. statutes over the years.

The most recent statute was passed in 1976 and took effect on January 1, 1978 (Title 17 U.S. Code). For works created after January 1, 1978, this new copyright law provides for a term of life plus 50 years, except for an anonymous work, pseudonymous works, and works made for hire, the term is 75 years from the date of first publication or 100 years from the year of its creation, whichever expires first.

The owner of copyright has the exclusive right to reproduce the copyrighted work in copies or phonorecords, to prepare derivative works, to distribute copies or phonorecords of the work, and certain other rights as provided in the copyright law.

Fair use is a limitation on the exclusive rights of the copyright owner. For example, if you wish to use a copyrighted photograph in a magazine, would it be considered copyright infringement or fair use? Section 107 of the copyright law says that fair use may be made of a copyrighted work for criticism, comment, news reporting, teaching (including multiple copies for classroom use), scholarship, or research. Four factors are listed to determine whether a use is "fair"—whether the use is commercial or nonprofit; the nature of the copyrighted work; the amount and substantiality of that which is taken in relation to the copyrighted work as a whole; and the effect of the use upon the potential market of the copyrighted work. You would have to consider all these factors to decide whether the use of the copyrighted photo was

fair or not. Many people, if they have any doubt, contact the copyright owner to ask for permission. If there is any question, it would be up to a court of competent jurisdiction to decide whether or not the use was fair.

Works in the public domain are not protected by copyright and may be freely used by anyone. Before 1978, the term of copyright in the United States was 28 for the first term, renewable for another 28 years. This second term was extended in the years before 1976 because of the impending increase to life plus 50, which is generally about 75 years. If a work was published in 1913 or earlier, it would now be in the public domain, even if it was renewed for a second term of copyright. If a work was published before 1960, but was not renewed, it is also in the public domain. For example, if you find a photo published in Peru, say, in 1920, the question of whether the photo is under copyright or in the public domain in the United States depends on whether the photo was registered for a first term and renewed for a second term of copyright in the United States.

Copyright is considered to be personal property. It may be willed by the copyright owner to whomever he/she wishes. If the copyright owner dies intestate, the right to copyright passes by the law of intestate succession the same way any other personal property would pass, that is, to the closest heirs. The right to copyright is different from the physical copy, as described below.

Section 101 of the copyright law says pictorial, graphic, and sculptural works include two-dimensional and three-dimensional works of fine, graphic, and applied art, photographs, prints, and art reproductions, maps, globes, charts, technical drawings, diagrams, and models. Such works shall include works of artistic craftsmanship insofar as their form but not their mechanical or utilitarian aspects are concerned.

Section 102 of the law describes the subject matter of copyright. Photographs clearly fall within the definition of "pictorial, graphic, and sculptural works" in Section 102(a)(5) of the law. The Copyright Act does not contain a definition of a photograph. The first U.S. court case to hold that photographs were "writings" within the Copyright clause of the U.S. Constitution was *Burrow-Giles Lithographic Co.* v. *Sarony*, U.S. Supreme Court, 111 U.S. 53, 4 S.Ct. 279 (1884).

The Supreme Court held that the photograph in that case (a photograph of Oscar Wilde) exhibited sufficient originality to be entitled to copyright "by posing the said Oscar Wilde in front of the camera, selecting and arranging the costume, draperies, and other various accessories in said photograph, arranging the subject so as to

present graceful outlines, arranging and disposing the light and shade, suggesting and evoking the desired expression. . . ."

More recently, the court in *Chuck Blore and Don Richman, Inc. v. 20/20 Advertising, Inc.*, 674 F. Supp. 671 D. Minn. (1987), echoed substantially the same standard, even in light of the automation of photography, stating that copyright extends to choice of subject matter, selection of lighting, shading and positioning and timing. Also camera angle, framing, make-up, and background.

The 1909 copyright law expressly provided for protection of photographs, Judge Learned Hand noted in the 1921 *Jewelers' Circular Publishing Co.* case, "without regard to the degree of 'personality' which enters into them."[1] Although this provision does not wipe out the requirement for originality that all works must contain, a very modest expression of personality will constitute sufficient originality. As Justice Holmes stated in the 1903 *Bleistein* case, "no photograph, however simple, can be unaffected by the personal influence of the author."[2] Almost any photograph would involve choice of subject matter, angle of photograph, lighting, and determination of the precise time when the photograph is to be taken. Thus a photograph of the New York Public Library and the Zapruder home movie films of the Kennedy assassination have been held copyrightable.

However, a picture created by superimposing one copyrighted photographic image on another is not original for copyright purposes, per the 1983 *Gracen* case.[3] And a photograph of a painting or drawing, if a slavish copy, might be considered to be predetermined and not copyrightable. See the 1916 *Pagano* case.[4]

Thus a photograph could be protected by copyright in the United States but the copyright would not necessarily protect that which is depicted in the photograph.

### Copyright considerations for reproduction and use of historical or contemporary photographs

Section 106 of the copyright law gives certain exclusive rights to the owner of copyright. The owner of copyright has the exclusive right to reproduce the copyrighted work in copies or phonorecords, to prepare derivative works, to distribute copies or phonorecords of the copyright work, and certain performance and display rights. The copyright owner has the exclusive right to display a pictorial work publicly.

Copyright in a work protects against unauthorized copying not only in the original medium in which the work was produced, but also in any other medium as well. Thus copyright in a photograph will prohibit

unauthorized copying by drawing, or any other method, as well as by photographic reproduction. On the other hand, anyone can copy or photograph the subject of the copyright owner's photograph.

Who can register a copyright claim in old pictures that have been found? The copyright law makes a sharp distinction between rights of ownership to a work and the ownership of the physical copy. Ownership of a photo does not mean you own the copyright rights to the photo; conversely, you may own the rights without possessing the photo itself. Only the author, or one who can trace his ownership back to the author, could claim copyright rights in the photo.

### U.S. copyright law and its relation to international copyright, particularly Latin America

The United States has copyright relations with virtually all South American countries through bilateral agreements, the Universal Copyright Convention (UCC), or the Berne Convention. The United States was a signatory to the Buenos Aires Convention of 1910, but the United States never implemented that treaty. Thus the phrase "All Rights Reserved" which was adopted by that treaty was never recognized as a way to obtain or retain a copyright in the United States. The United States has relations with Bolivia, Honduras, and Jamaica only through the Buenos Aires Convention, which means that if published works of nationals of those countries state only "All Rights Reserved," the work is not protected in the United States. United States relations with Grenada, Trinidad, and Tobago are unclear.

For the United States, the proper copyright notice is the word "Copyright," the abbreviation "Copr." or the symbol "©" and the name of the copyright owner, and the year date of publication. The year date may be omitted if the photograph is used in or on greeting cards, postcards, stationery, jewelry, dolls, toys, or any useful articles.

For works published after the effective date of the new U.S. copyright law, January 1, 1978, the use of the words "All Rights Reserved' would not generally be a fatal mistake, because the copyright owner would have five years to correct an error, by using the correct notice, and registering a copyright claim in the United States.

The Berne Convention does not permit formalities such as copyright notice to be imposed as a condition of obtaining copyright protection. Thus there is no longer a requirement, effective March 1, 1989, when the United States joined Berne, for any notice of copyright for works to be protected in the United States for Berne country works. Bolivia, Jamaica, and Honduras are not members of Berne.

It should be noted that there are still advantages to using a copyright notice, including the prevention of innocent infringement. The notice, if used, should be in the correct form, as stated above. The registration system in the Copyright Office, Library of Congress, is not affected by our joining Berne.

### Investigating the copyright status of a photograph

There are several ways to investigate whether a work is under copyright protection and, if so, the facts of the copyright. The main ones are:  (1) examine a copy of the work for such elements as a copyright notice, place and date of publication, author, and publisher; (2) make a search of the Copyright Office catalogs and other records; or (3) have the Copyright Office make a search for you.

Copyright investigations often involve more than one of these methods. Even if you follow all three approaches, the results may not be completely conclusive.  This is because the Catalog of Copyright Entries (CCE), which is available at the Copyright Office and a number of libraries around the country, does not include entries for assignments, and thus cannot be used for searches involving the ownership of rights; and there is usually a time lag of a year or more before the part of the Catalog covering a particular registration is published; and the Catalog entry contains some information of the registration, but not all of it.

Individual searches may be made in the Copyright Office, and the Library of Congress, in Washington, Monday through Friday from 8:30 *a.m.* to 5 *p.m.*

The Copyright Office will search its records at the statutory rate of $10 for each hour or fraction of an hour consumed.  Your request should be addressed to:

> Reference and Bibliography Section, LM-451
> Copyright Office
> Library of Congress
> Washington, DC 20559
> (202) 707-6850

The search does not include the cost of additional certificates, photocopies of deposits, or copies of other office records.

For further information on searches, see Circular R22, "How to Investigate the Copyright Status of a Work."

### Libelous use of images and other legal considerations

Libelous use might mean infringement, or it might involve the right of privacy.

*Infringement.* Only the copyright owner or someone authorized by the owner has the right to reproduce the work, and the other rights stated in Section 106 of the copyright law.

Section 504(b) of the Copyright Act states that the copyright owner who prevails in an infringement action "is entitled to recover the actual damages suffered by him or her as a result of the infringement, *and* any profits of the infringer that are attributable to the infringement. . . ." This permits a recovery of actual damages plus the infringer's profits. It is sometimes hard to measure actual damages, so the law permits recovery of statutory damages. Statutory damages are specific amounts allowed under the law without having to prove actual damages.

*Right of privacy.* This can arise in the photography area when someone publishes a photo of someone else in such a way as to violate that person's privacy. For example, I might let you use my photo to advertise software, but you use my photo instead in a sleazy publication. You may well have invaded my right of privacy. You may also have violated a contractual agreement between the two of us. Such actions do not fall under the copyright law, but may be actionable in a court of law under privacy or contract theory of recovery.

In cases of infringement or other suspected violations of intellectual property rights, consult an attorney. The Copyright Office is prohibited from giving legal advice.

It is important to note that the term of copyright for photographs in some countries is substantially less than it is in the United States, sometimes as little as ten years. In some countries, there is also a subject matter restriction, such as a requirement that the photo be of a documentary or artistic nature, for protection to be available. For an infringement occurring in your country, you should check your country's law. If a collective administration or author's society exists in your country which administers photograph reproduction rights, they may be able to help you to ascertain your rights. The United States does not have such a professional group in this country, similar to the American Society of Composers, Authors and Publishers (ASCAP) or Broadcast Music Inc. (BMI) for music.

## NOTES

1. *Jewelers' Circular Publishing Co.* v. *Keystone Publishing Co.*, 274 Fed. 932, S.D.N.Y. (1921).

2. *Bleistein* v. *Donaldson Lithographing Co.*, 188 U.S. 239; 23 S. Ct. 298 (1903).

3. *Gracen* v. *The Bradford Exchange*, 698 F. 2d 300, U.S. Ct. of Appeals, 7th Circuit (1983).

4. *Pagano* v. *Charles Beseler Co.*, 234 Fed. 963, S.D.N.Y. (1916).

# III. Cinema

# 13. Configuring Women: The Discourse of Empowerment in Latin American Cinema

## Barbara Morris

The recent focus of Latin American fiction films on female experience as a means of visualizing contemporary and historical sociopolitical conditions in the Americas has found expression not only in films made by women, including those of Argentina's María Luisa Bemberg and Cuba's Sara Gómez, but also in the works of numerous male film-makers. Since the extraordinary success of Humberto Solás's *Lucía* (Cuba, 1969), male directors and screenwriters have foregrounded women as protagonists, underscoring the increasing importance of cinematic representations of women, in various films: *Retrato de Teresa* (Pastor Vega, Cuba, 1979), *Mi tía Nora* (Jorge Prelorán, Ecuador, 1982), *Eréndira* (Ruy Guerra, Mexico, 1983), *La historia oficial* (Luís Puenzo, Argentina, 1984), and *Pobre mariposa* (Raúl de la Torre, Argentina, 1986). Other recent films—such as Tomás Gutiérrez Alea's *Hasta cierto punto* (Cuba, 1984), Gregory Nava's *El norte* (United States, 1983), and Jorge Polaco's *Diapasón* (Argentina, 1986)—treat women's issues as part of a more ample framework which features the sociosexual representations of men and women in relation to each other and their political communities.

Three of these films are chosen—*Eréndira, La historia oficial*, and *El norte*—as the objects of an analysis that centers on the relation of gender to the contrasting concerns of colonization, marginality/empowerment, the silencing/speaking of discourse, and exile. Keeping in mind Foucault's notion of the "political technology of the body" (Foucault, 25)—that is, the sociosexual body as referent of knowledge—we could say that the female subjects of these three films embody women's synecdochical relation to the social. While "woman" is frequently portrayed as a metaphoric representational device in narration, one hesitates to consider women's cultural imaging as metaphorical, since metaphoricity tends to deny the materiality of female experience (Spivak, 257), configuring her image as pallid palliative for her actuality. In my view, women's images often function in relation to the social matrix as indicators of specific concerns, rather than as analogies or substitutes for reality. As figures, they emerge

from their grounding in the social matrix, underscoring the problematics of representation, for women are both included in and excluded from the social, "inside and outside of gender, at once within and without representation" (de Lauretis, 10). Using a model of women in synecdochical relation to the social matrix as a point of departure for analysis, I begin with a brief study of gendered subjectivity in the works of three progressive male filmmakers of the developing world.

García Márquez's and Ruy Guerra's *Eréndira* centers on the "sad and incredible" tale of a young woman whose extraordinary compliance with the will of her grandmother exemplifies the culturally construed engendering associated with the sociopsychological phenomena considered as "masculine" domination and "feminine" submission. The difficulty that daughters have in creating separate identity patterns from those of their mothers, learning to fulfill their desires through the expression of the other's will, has been analyzed as the fear of separation and difference which is transposed into submission (Benjamin, 78-79). The cultural construction of masculinity, on the other hand, determines the son as protagonist of a violent struggle to free himself from the physical and psychological bonds of maternal love, in order to attain (the illusion of) independence and (the fantasy of) dominance, if not domination.

As the obedient (grand)daughter, Eréndira services thousands of men without a complaint and, when she is abducted and virtually enslaved by the missionaries, chooses to return to the physical bondage of prostitution, a sphere of subjugation from which the grandmother had been rescued by Amadís, "El Grande." As Mary Berg has pointed out, the grandmother is obsessed with the nostalgic preservation of her (vain)glorious past (p. 25); her version of history is tempered by the masculine discourse of the patriarchs which she has internalized, erupting in her somnambulant delirium, and which she forces on the submissive body of Eréndira. Like García Márquez's sovereign "Mamá Grande," whose potency is manifest in her configuration as all-powerful Mother and authoritative Father, the character of the grandmother reveals the totalitarian aspects of both the masculine *and* the feminine; she absorbs Eréndira's psychological autonomy and dominates her physically with the innumerable sexual acts that others pay to perform on the girl's body.

García Márquez's and Guerra's subversively mythic rendering of the tale (Berg, 25-30) poorly conceals the political background which is ever present in the former's work. Eréndira functions not as symbol but as sign; weighed and sold like goods by the matriarch, violently assaulted sexually—the rapacious colonization of her body by the

hyperbolic hordes of eager consumers illustrates the oppressive subtext of the past which the grandmother holds so dear, the historical violation of Latin America by the descendants of the knightly Amadises. In this literary/cinematic *Bildungsroman* Eréndira's passage, through exploitation, consumerism, advertising, religious enslavement, and political charlatanism, documents the progression of colonization from its violent inception to the vacuity of its political agenda. Extrapolating from the visual representation of Eréndira as passive innocent deprived of a past—her hands have no lines in them—to the social matrix, Eréndira's body signifies the very body of Latin America—exploited, ravaged, materially productive for its exploiter, yet not reproductively fertile. The Senator's slogan—"We are here to defeat nature"—is the discourse played out on Eréndira/America.

The protagonist's ostensible destruction of patriarchal discourse, as configured in the grandmother, is not without irony, however. Three visual elements contrive to temper our reading of the film's closure: lines appear on her hands; she flees with the grandmother's vest of gold coins; the footprints she leaves in the sand are filled in with red. Is it not possible, then, that her "liberation" from exploitation has merely empowered her to do the same? She was given a past; she seized the symbolic mantle of power; and her traces were marked with the blood of the grandmother (Berg, 27). Will not the cycle of domination and submission continue, propagating from generation to generation?

From the opening scene of *La historia oficial* the political referent of the cinematic text is confirmed visually and acoustically. As students and faculty of a private high school in Buenos Aires sing the national anthem (the first verse ends ironically in the words "Libertad, libertad, libertad"), the camera pulls back to establish a 180-degree view of the scene, then moves in on the faces of individual students, finally to rest on Alicia's alert, yet self-contained countenance. The camera's mimicry of the prison panopticon highlights the sinister subtext of the film, the "unofficial" (hi)story of the *desaparecidos*, while placing Alicia in direct relation to the history she literally does not see. As Amos Elon writes in his 1986 "Letter from Argentina": "The violence and the private and state terror in these parts, the disorienting abstractions of economic and political processes had given way, even among the sensitive and the civilized, to a pervasive numbness. Deceiving oneself had become a kind of moral prerequisite for survival [76]." Alicia' self-deception as political subject reveals itself in appropriation of the patriarchal junta's authoritarian discourse. In her history class she values discipline and order over creative thought, in high contrast to Benítez's dramatic

reenactments of historical literature. When Alicia insists that a student adhere to strict documentary referentiality as opposed to long-standing oral tradition, the more politically astute Benítez takes the complaint she has filed on Costa and admonishes her that she might cause grave problems for the innocent young man.

Like Eréndira, Alicia functions as a sign in the cinematic text, albeit an ironic, concealing one which gradually displaces itself toward disclosure of its strength. As the protagonist begins to uncover the veiled discourse of truth through word and image (the photos and texts describing the children of the *desaparecidos*), she begins to discover the full range of her power as female subject. The visual repression of Alicia's female sexuality—the upswept hair, business suits, scarves tightly knotted at the neck—gives way to a softening of her image, as she lets down her hair and loosens her clothes, even beginning a timid flirtation with her colleague Benítez. (She also dons her glasses, the better to "see" the facts she uncovers.)

Although Alicia opens herself to the expression of her femininity, her role as mother remains adopted rather than biologically lived. The hegemonic oppression of another woman's motherhood, of the product of her body, has become a pleasurable benefit for Alicia, obtained without the experience of pain. Nowhere is her guilt and fear more openly demonstrated than in the hospital where she has gone to trace the documents of Gaby's birth and where she glimpses (and hears) through a half-opened door the sight and sounds of a woman giving birth. When she realizes that the silenced discourse of exploitation and domination has been played out violently on the innocent body of her daughter's mother, who has physically suffered to bring the city into the world (and has lost her under utterly terrifying conditions), Alicia attempts to effect within the "safe" space of her family what has been eloquently and singularly absent: the speaking of the truth. Despite her previous adherence to "masculist centralism" (Spivak, 107), Alicia's crisis of conscience as a mother impels her to question the distinctions of center and margin, due in part to the influence of the politicized position of the Grandmothers and Mothers of the Plaza de Mayo who actively demonstrate what Spivak describes in theory: "The only way I can hope to suggest how the center itself is marginal is by not remaining outside in the margin and pointing my accusing finger at the center. I might do it rather by implicating myself in that center and sensing what politics make it marginal [107]." Because of the central position of the mother (if not women) in Argentine culture, the mothers were able, in film and in fact, to "narrate a displacement" (Spivak, 107). As Elon notes in his "Letter":

... Though men conquer and humiliate women as lovers, they adore and worship mothers. The relative immunity enjoyed during the years of the *processo* by the group called Mothers of the Plaza de Mayo may be a case in point. ... They attracted worldwide attention, and greatly embarrassed the generals. ... But in Argentina the same men who raped and tortured and, in most cases, murdered the daughters did not lift a finger against the mothers [18].

The question of gendering and mothering is central to the recuperation of marginalized discourse within political truth; it is precisely the women who are present, the mothers and grandmothers, who refuse to be silenced and who rewrite with image and text the "unofficial" history of the *desaparecidos*. Their recovery of these historical gaps exemplifies the way in which women as individual entities can recapitulate their relation to the social whole. Thus, Alicia's experiential displacement as subject and insertion in political discourse centralizes the issue of marginality in accord with the femininity viewpoint of the personal as political. This illustrates, in the final brutal confrontation with her husband, that the politicization of subjectivity cannot avoid the violent rhetoric it seeks to subvert.

While *La historia oficial* is concerned with Alicia's growing into the fullness of her female subjectivity, *El norte* focuses on Rosa's and Enrique's exile from family, language, and land—hallmarks of the cultural identity that is stripped from them. Emotionally united throughout their arduous geopolitical exodus, the psychopolitical makeup of each character's subjectivity in relation to displacement and acculturation differs substantially. By counterposing the narrative(s) of Rosa and Enrique it shows that the issue of woman in synecdochical relation to the social matrix of the First World is essential to the analysis of gendered subjectivity which is often subsumed in matters of race, class, and national/linguistic barriers.

Despite the brutal exploitation of the peasants in Guatemala (Arturo Xuncax tells Enrique, "Para el rico el campesino es solamente brazo ... brazo para trabajar"), the initial sequences of the film illustrate a countryside almost paradisaic in its pristine beauty, where the cultural identity of the Indians is based on their relation to the land, to their traditions, and to their language. Like his father, Enrique works the land under the gun of the *mestizo* foreman; like her mother, Rosa tends to personal care of her family. The sociosexual roles of the Indians are represented, in action and in dress, as markedly gender-differentiated, stable, and unquestioned.

The expulsion of these two innocents from the "body" of their land is symbolized in their shocking rite of passage through the "vaginal" tunnel. Their rebirth—deprived of identity, language, even

their names (Enrique becomes "Ricky")—into the glittering dream landscape of "el norte" is a shared experience which would seemingly produce similar encounters with their new culture. Yet, for both Rosa and Enrique, this rebirth into a different world brings with it dissimilar experiences of displacement and acculturation.

Rosa's exchange value in the consumer/capitalist system is readily negotiable. Monty, a broker for undocumented alien laborers, offers the *coyote* money for her immediate marketability as a worker. Employment is much more difficult for Enrique to obtain, given the availability of cheap male labor, finally appearing in the literary guise of a deus ex machina: a headwaiter in a BMW in need of a busboy. Once both brother and sister enter the work force, the possibilities of advancement—despite their shared race, class, education, and (illegal) status—escalate more rapidly for Enrique. He pursues his work opportunity aggressively, while Rosa is relegated to manual labor, denied cultural legitimacy (a green card), and disenfranchised due to her gender.

The visual representation of Rosa, like that of Alicia, alters in accord with her shifting perception of her subjectivity as an American. On the eve of her exile from Guatemala she had already donned Western clothing; once in the United States she begins to wear trousers and make-up, two signifiers of her changing cultural identity from the "natural" woman to the more artificial, masculine image of women in "el norte." Although brother and sister celebrate Enrique's change of clothing and position, from laborer to busboy to the tuxedo of the assistant waiter, Rosa's made-up face is ridiculed by her brother. The visual indicia of acculturation are validated in Enrique's case, yet the splitting of the female body's alliance with the natural world is portrayed as a more imitative, artificial shift, highlighting Rosa's position as exile from discourses and culture. While Enrique is seen as "the establisher of distinction, the creator of differences" (de Lauretis, 43), Rosa is not susceptible to profound transformation. Her function as sign of the past, of a lost heritage, is depicted through the hallucinations of her mother and father which recur as she grows ill. As a woman of the developing world, exiled from her traditional social matrix, she is portrayed as unable to live in the progressive present of ot West, marginalized from the "masculine" center of North American culture (even the businesswoman from Chicago is rather mannish and smokes a small cigar), and bound to perish.

In the introductory section of this essay, de Lauretis's theory of the construction of gender as "product and process of representation and self-representation" (p. 9) was mentioned as central to the study of

women's images in culture. Her twofold vision of women functions as a cautionary device to the holistic concept of narrative and representation as exemplified in Fredric Jameson's "model of immanence," which proffers the utopian vision of an ideal unity of consciousness as the subtext of all narrative (pp. 282-283). Many filmmakers of the developing world, in their attempt to create positive self-representations, have drifted toward the idealization of the relation between discourse and objective reality, a corollary of Jameson's theory. Robert Stam and Louise Spence critique this tendency with a clear admonition:

Women and Third World film-makers have attempted to counterpose the objectifying discourse of patriarchy and colonialism with a vision of themselves and their reality as seen "from within." But this laudable intention is not always unproblematic. "Reality" is not self-evidently given and "truth" cannot be immediately captured by the camera [p. 639].

In their analysis of cinematic codes in Latin American cinema, Stam and Spence further advise that films of the developing world can be politically progressive in some of their codes yet retrogressive in others (p. 645), despite the political integrity of the filmmakers. Indeed, one of the problems with male-structured images of women is the risk the filmmaker runs in applying male-centered codes to his representations of women, although neither are women filmmakers completely immune to the pervasive influence of patriarchal discourse.

There are two ideas that come to mind when juxtaposing the female subjects of *Eréndira*, *La historia oficial*, and *El norte*. First, in none of these films is the protagonist configured as a biological mother. While a First World feminist might see this as a positive sign of the enrichment of women's social roles, I see them as figures that represent the central issue of marginality in Latin America, through the separation of body from discourse. A prostitute, an adoptive mother, an illegal alien who works as a housekeeper—this is the reality of Latin American women's social roles. However, the tendency of male filmmakers time and again to configure women as barren images denies them not only the power of reproduction but also the exchange value of the product of their bodies. (Only Alicia, who wants to give up her child, is a "producer"—as a schoolteacher—in society; of course, her discourse is ironically masculine.)

Second, each of these film narratives includes a movement toward empowerment on the part of the protagonist, yet each of them suffers violence in response to her acts either symbolically (the blood on Eréndira's tracks) or in fact (Roberto's abuse of Alicia, Rosa's death). If Eréndira has suffered as object of desire, her transformation into empowered subject will presumably reproduce the patriarchal discourse

she has attempted to flee. Rosa, although seeking to empower herself
through exile and reacculturation, is depicted as resistant to cultural
change and repository of a past that must be obliterated in order to
progress in the First World. Alicia is possibly the only woman who has
even begun to resist patriarchal discourse, yet the price she must pay is
unreasonably high—the loss of her child.

While Latin American women unquestionably form an essential
part of the social matrix which they sustain through labor and
propagate through reproduction, they are excluded from political
discourse which determines the conditions of their existence. I
maintain that their relation to the social is synecdochical; they are an
integral component of the collective whole, at once representative of
and part of the organism. The parallel phenomenon in film production
which configures women as objects of representation, yet excludes them
from the very discourses that represent them, exemplifies the displace-
ment between center and margin that is characteristic of women's
conditions in the developing world and elsewhere. The three films
discussed herein utilize female experience in order to comment on
social reality, yet only one of the female subjects is able to initiate a
reintegration of speech and body, of discourse and history, which might
serve to decolonize women's bodies, women's voices, and women's
images.

## BIBLIOGRAPHY

Benjamin, Jessica. *The Bonds of Love: Psychoanalysis, Feminism, and the Problem of
    Domination.* New York, NY: Pantheon, 1988.
Berg, Mary G. "The Presence and Subversion of the Past in Gabriel García Márquez'
    *Eréndira.*" In Gilbert Paolini, ed., *La Chispa '87: Selected Proceedings.*
    New Orleans: Louisiana Conference on Hispanic Languages and Literatures,
    Tulane University, 1987. Pp. 23-31.
de Lauretis, Teresa. *Technologies of Gender: Essays on Theory, Film, and Fiction.*
    Bloomington: Indiana University Press, 1987.
Elon, Amos. "Letter from Argentina." *The New Yorker* 21 July 1986, pp. 74-86.
Foucault, Michel. *Discipline and Punish: The Birth of the Prison.* Alan Sheridan, trans.
    New York, NY: Vintage Books, 1979.
Jameson, Fredric. *The Political Unconscious: Narrative as a Socially Symbolic Act.* Ithaca,
    NY: Cornell University Press, 1981.
Spivak, Gayatri Chakravorty. *In Other Worlds: Essays in Cultural Politics.* New York, NY,
    and London: Routledge, 1987.
Stam, Robert, and Louise Spence. "Colonialism, Racism, and Representation: An
    Introduction." In *Movies and Methods,* Vol. 2, Bill Nichols, ed. Berkeley and
    Los Angeles: University of California Press, 1985. Pp. 632-649.

# 14. Values and Aesthetics in Cuban Arts and Cinema

## Oscar E. Quirós

### Introduction

The Cuban government established several institutions in the early 1960s to promote national culture through the arts. Art produced under the auspices of the revolution has a very distinctive Cuban character, in the most ample sense of the word. It is the reflection of the Cuban popular culture, which took form through a long process of acculturation between African and Spanish roots. This paper discusses the aesthetic notions of Cuban popular culture and its relation and importance to the political arena. It is accomplished by reviewing some aspects of Marxist aesthetic theories that help one understand the process involved in creating a Cuban cinematographic image, and by giving some examples that illustrate the different trends in Cuban cinema.

The conclusions of the paper focus on the relation among history, cultural values, revolutionary ideology, and aesthetics. Before entering a discussion on aesthetics and cinema, a brief historical overview of Cuban culture is useful.

### Chronicle of Culture and Arts until 1959

Art in Cuba before 1959 was mainly the exercise and admiration of European high art by the ruling white and mestizo groups. The first recorded artistic expression in the New World took place in Santiago de Cuba in 1520 when a local resident was paid 36 pesos by the Church to write a dance to celebrate Corpus Christi.[1] For more than two centuries art was informally transmitted by apprenticeship until the first school of music was established in 1763 in Santiago.[2] In 1803 the first ballet was presented in Havana. Because of its success, Italian, Spanish, and French companies continued to tour Cuba with operas, zarzuelas, and ballets.

From 1776, and for more than a century, many theater houses were opened in Havana, Santiago, Camaguey, Santa Clara, and Cienfuegos.[3] Some of the plays and *tonadillas* written by famous Europeans such as Lope de Vega, Simón Aguado, María de Córdoba y

151

de la Vega, and Manoel Coelho Rebello made references to the richness of the African cultures brought to America and Iberia. African music, dances, and performing arts adopted new forms and styles in Cuba, beginning in the early sixteenth century, and were reshaped into a new mode called "Afrocubanismo."[4]

The Cuban aristocracy never recognized the values of the Afrocuban culture. Any form of cultural and artistic expression of the Afrocubans was consistently censored by the authorities. As early as 1556, the *cabildo* of Havana stipulated that blacks, even if they were free, would not be allowed to continue owning their own *bohíos* (houses) because they drank, smoked, ate, sang, and danced with drums and guitars in an offensive way.[5]

Music is perhaps the most important of the various cultural contributions the Africans brought to Cuba. The slaves introduced not only different percussion instruments and rhythmic styles but also a complex set of religious beliefs that were attached to the practice of music. The adoption of Christian beliefs was, after all, a convenient way for the Afrocubans to be able to exercise their own beliefs. The pre-Lent carnival already existed in Europe, but the African cultures infused a series of Yoruba, Locumi, Congo, and Bantú rituals into it, a fact the Church did not clearly recognize. The use of a band of drums, claves, and jump-dancing are three influences that can be traced to separate African origins. For instance, the drum came from the Yoruba cult of Changó.[6] The use of claves was imported by the Congos from central Africa.[7] The evolution of African music within the Spanish-dominated culture was obviously slow, as was ethnic integration. The music became a heterogeneous mixture of Galician, Andalucian, and Basque influences, with Yoruba, Bantú, Abakuá, and Congo music. This fact is very important to an understanding of the acculturation process, because it determined which combinations became the dominant forms by the mid-nineteenth century.

The process of acculturation took place over time, regardless of its rejection by the local aristocracy. Popular music and dances were considered barbaric, and the most popular of all, the danzón, was called "music of the savages."[8] Even local newspapers openly criticized "some white societies" for dancing to the "danzón, the music of blacks and pardos from Matanzas."[9] Yet the process could not be reversed; Cuban symphonic music introduced Afrocuban themes, while African drum music was enriched by the introduction of string and wind instruments.[10] The latter led to development of the popular Cuban orchestra.

In Santiago, people from all casts were attracted by the colorful and wild carnival of the blacks. Almost everyone joined the blacks in their liberating drunkenness and African rhythms, celebrating Christian festivities in an African way.[11] It was the essence of syncretic evolution that was consolidating a new form of culture in Cuba. Nevertheless, it took several centuries before it was recognized by the creole intellectual elite.

The desire to abolish slavery and to obtain independence from Spain set in motion a revolutionary movement in 1865 that was based on principles of ethnic brotherhood, judicial equality, and political freedom. This, added to the more than three hundred years of slow racial integration and acculturation, initiated a process of consolidation of the national culture. The emergence of an intellectual group capable of incorporating some Afrocuban forms and themes into their literary and musical productions marked the first recognition of the popular culture.

Poets such as José Manuel Poveda and Regino Eladio Boti, and the musician Manuel Saumell pioneered the contact between the European forms and the local content.[12] But it was José Martí who first broke from the traditional *modernista* restraints, using appropriate language to express popular Cuban sentiment.

José Martí broke away from the dominant classic French notion that art was to express an array of personal inner feelings. Instead he developed an artistic expression that communicated the sorrow and joy of a group of people, the Cuban masses. Martí's aesthetic notion had political value that served not only as a model in defining the national culture but also as a point of reference to modern political thought. He placed the simple life of the *guajiro*, or racially mixed peasant, in the center stage of Cuban intellectual and political analysis. Anything related to the guajiro was of artist importance, therefore, of political importance. By emphasizing the importance of the mestizo, or racially mixed, Martí was also able for the first time to shift the attention from the Eurocuban and the Afrocuban cultures to the notion of a Cuban culture.

The national popular culture was consolidated in the period between 1902 and 1933. However, not all ethnic groups and social classes shared that identity. Nevertheless, the African and Spanish roots finally reached a level of fusion that was shared by the majority of Cubans and was recognized as a way of thinking and living. The artistic and literary schools coming from Europe, such as Expressionism, Cubism, Naturalism, and Realism, opened new channels for the local artist to elevate the national culture to a level of international recognition.[13]

As consolidation of the national identity took place, a new cultural influence was arriving. Increased economic dominance of Cuba by the United States also meant the introduction of different cultural values. The upper class adopted the styles and cultural patterns of the North Americans, but the lower class, and most of the small middle class, in conjunction with artists and intellectuals, defended their own Afrocuban culture. [14]

As politicians and political leaders became more aware of the political clout of the national culture issue, the lower class began to gain indirect importance. In other words, for the first time in more than four hundred years of Cuban history, it was a positive sign for any person, especially a politician, to say that he or she identified with the culture of the masses. As dictator Machado was deposed by a coalition of intellectuals, students, and the military, Fulgencio Batista's arrival symbolized the emergence of lower class values. Although his various administrations did not fulfill the expectations of most of his supporters, the fact that he was from the lower class indicated that Cuba had moved away from the days of anti-Afrocubanism. Batista at various times claimed to be the defender of Cuban national culture. This notion of self-awareness had tremendous implication and importance after Batista was overthrown in 1958.

After the "26 de julio" movement gained control of the government on January 1, 1959, Cuban popular culture obtained its highest level of recognition. For the first time the official culture was Afrocuban and not European or North American. This official endorsement of popular culture was the result of an intricate relationship of political, economic, social, and ideological factors that converged in the revolutionary process. By incorporating the culture of the majority into the official political scheme, the populace felt the revolution was for them. The revolutionary process attracted popular participation by direct economic benefits of land reform, rent price-fixing, and so on, and also by performing a nation-building role. Popular identification with the revolution has been, indeed, the most important asset of the Cuban government; thus, it has been able to carry out economic and political programs with a fairly high degree of support.

Using José Martí's socio-aesthetic ideas, Cuba has been engaged in a struggle to develop a cultural policy that allows the growth of native artistic expressions and the controlled infusion of foreign elements. [15] Modern Cuban arts and cinema are the result of that historical cultural formation and the combination of contemporary revolutionary aesthetic thought.

## African and Spanish Aesthetic Influences

A discussion of the aesthetic influences Cuban culture received from Africa and Spain must begin with a definition of aesthetics. Applying the most basic definition, aesthetics refers to the values about beauty, good, happiness, and so on that a person attributes to everything around him/her. More importantly, such values are fixed in the observant's mind by the social environment. "Aesthetics, as part of man's social consciousness, is the group of preferences, conceptions, and ideals elaborated in the social practice."[16] The value attributed to sounds, smells, and images are cultural, not natural. "They are polysemic; that is, they can mean a great many different things to different people."[17]    In other words, particular aesthetic notions develop within the context of particular cultures. Therefore, everything man produces, or judges, is in relation to his/her acquired aesthetic values.

Aesthetics are carried with the individual as he/she moves to different places. This is what occurred in the sixteenth century when the Spaniards and the Africans came to the New World, and were confronted with each other's views of the world and of aesthetics. Although neither culture came to America with the purpose of sharing their values, especially when the ruling culture considered the other culture inferior, long-term exposure under changing economic and political conditions inevitably syncretized those two cultures. Because Spanish culture was that of the dominant class it was at first the only acceptable one in Cuba for the upper class. Nevertheless, African values were able to surpass the boundaries of Afrocuban circles and permeate the mainstream culture. This would later be called "Cuban aesthetics."

The Africans in Cuba, regardless of their area of origin, developed a very gregarious culture in which music played an important role. Music was communal and was closely related to every human activity. African history and traditions were maintained through the practice of dances, pantomime, singing, and music. Many disputes and governance problems were resolved through similar collective activities. European music, however, was for individual entertainment and enjoyment and did not perform a utilitarian role.

Once the Africans were brought to Cuba, they tried to form support groups with other slaves, preferably those from the same ethnic origin, if available. Out of that intermixture of African cultures, some cultural patterns dominated. They tried to maintain their languages, rituals, and religions with partial success. Three clearly defined religions, constructed from African teleological bases and Christian

forms, have survived: Santería, from the Yoruba religion, Abakuá, from Carabalí religions, and Palo, from Congo and Yoruba religions.[18] These and other less important religions have been the best conduits for African aesthetic values in Cuba.

Because African religions are related to other social activities, the practice of religious cults in Cuba helped keep alive other elements of their cultures. In the case of the Yorubas, their highly elaborated religion was also translated into highly defined aesthetic values that influenced other Africans and mulattoes in Cuba.[19] Yoruba/Santería influence was accomplished at two different levels: first, through the secret dissemination of the cult of the different deities, and, second, through the use of certain expressions during Christian festivities.

The cult of the Yoruba deities, as documented by Fernando Ortíz, William Bascom, Lidia Cabrera, and others, prescribed the usage of specific music, dance, color and textures according to the god. The followers of a given deity would not only behave according to the god's taste but would also wear the fabrics, colors, and amulets accordingly.[20] Followers would try to please their god by proudly displaying the god's "fashion." The cult of Ochún, for instance, requires the worshiper to wear delicate gold ornaments in the most visible way. The predominant usage of certain colors and fabrics tended to influence noninitiated blacks and encouraged the practice of wearing those colors. The Santería shrine also imposes a set of colors and forms that the followers try to replicate according to their own taste. It has been claimed that such prescribed forms are vivid examples of the popular taste for ornamentation and decoration.[21]

Ritual music since early colonial days was secularized during public festivities and carnival. Sacred Bata drums were modified in order to be taken to the streets to play African rhythms for certain occasions.[22] These rhythms were first accepted by blacks and mulattoes, and later by whites.[23] These rhythms had specific names such as Bembé, Rumba, Mambo, Maní, Eleguá, Guaguancó, now popular dancing rhythms. Originally each rhythm was accompanied by a choreographic pantomime.

The Eleguá cult is an example of a syncretic transition from African to Cuban culture. The Eleguá dance/cult was performed by a leader who, upon being possessed by the Eleguá god, was called Eleguá during the ritual. The movements were unpredictable and abrupt, so that the Eleguá dancer had room for improvisation. Eleguá would dance in a lascivious way as the other spectators closely imitated his movements.[24] These movements can still be identified in popular dance, especially during carnival.

The rumba, for instance, evolved from its original sexual panto-
mime into a popular dance. The rumba, formerly a drama that
mimicked sexual relations, was divided into different stories around the
same theme. As the rumba became more widely accepted during the
nineteenth century, the choreography became milder yet still sensual.[25]
Today, a rumba is danced by placing the lower torsos of male and
female dancers closer together than the upper chest. It appears that
the sexual tendency of this rhythm prevailed and became part of the set
of values of the popular culture.

Not all the traditions originated within religious cults. Actually
one of the most vivid examples of aesthetic acculturation was initiated
by a group of free Africans of different ethnic backgrounds. The
"Curros," as they were called for more than 300 years, were free blacks.
They disappeared as a social group by mid-nineteenth century, but
during that period they made visual statements with ostentatious
displays of jewelry and fine clothes alluding to their "aristocratic"
condition among blacks. The social importance of clothing, especially
shoes, was for the blacks in Cuba a means to compensate for the
sociopolitical oppression they suffered for more than three centuries.
Although only the free Curros were able to afford ostentatious displays
of fashion, other blacks and mulattoes saw the Curro fashion as a
pattern to follow. Black, mulatto, and white subcultures gradually
emulated this fashion that mixed African and European patterns.[26]

Many influences discussed by anthropologists are still debatable or
not extensively studied yet. Even though Afrocuban religion and music
are the most popular areas of research, the nonreligious and non-
musical culture of the Curros is one of the best laboratories of
interethnic and intercultural mixture among the Afrocubans. Because
of their unique socioeconomic condition, the Curros were free to
borrow from the Europeans and the Africans according to their own
social circumstances, exemplifying their value as an "acculturating"
factor in forming popular culture aesthetics, or the "Cuban aesthetic."

## Revolutionary Aesthetics in Cuba
### Cuban Art and Foreign Influences

Owing to the intrinsic importance that the promotion of national
culture has had in modern Cuba, the national cultural budget supports
a large number of programs: The Casas de Cultura, the national
libraries, the regional museums, publishing houses, film industry, their
national ballet, theater groups, art schools, experimental music groups,
symphony orchestras, recording studios, television stations, and the
Instituto Cubano del Arte e Industria Cinematográfico (ICAIC). The

nature of these programs is didactic and entertaining, but because many produce tangible outputs, they also contribute to the economy, generating employment and making consumer goods such as records, books, and films.

There are about 33,000 theater groups and more than 78 museums. More than 30 million books are printed each year, and 117 Casas de Cultura offer numerous cultural activities and provide space for conferences, music, theater, and recitals.[27] In terms of number and availability of facilities for the arts, the Cuban government holds an impressive record. Artistic expressions come from a fairly large sector and reach most sectors of the population. The creative atmosphere in Cuba, however, is a little more controversial.

It was especially true during the first decade of the revolution when revolutionary fervor limited diversity of opinion. The number of artists in those days was not large, though. The main problem for the government was that it did not develop a clear cultural policy until 1961. There had never been a proper dialog between revolutionary leaders, and artists and writers. The defection of artists, such as Nestor Almendros and Cabrera Infante, who were initially supporters of the revolution, caused even more furor within the art community. A few years later, the short imprisonment of poet Herberto Padilla also fueled the discussion of freedom of expression within the revolution, referenced by Fidel Castro in his speech "Words to the Intellectuals."[28] Although the number of defecting artists has been very small in comparison to the total number of artists in Cuba, those few instances were enough to raise many questions inside the island.

The core of the argument has focused on the "relationship between popular culture and high-art," and the need to "balance international aesthetic vocabularies with their more local interests."[29] This affects all forms of art because there is a need to borrow foreign tendencies and develop new modes and languages. For many years foreign influences were considered negative. Concerts of European symphonic music, analysis of impressionist painters, and viewing a U.S. film implied that the government was at the core of the contradiction, if it promoted these and other types of foreign artistic displays.

One of the contradictions seen in the discussion of aesthetic influences comes from the twelve or so new U.S. films shown in Cuba very year. Controversy began in the early 1970s when the different Cuban and Latin American film critics questioned the practical revolutionary value of Cuban cinema aesthetics. Because Cuban aesthetics developed from the idea that revolutionary cinema should serve a didactic purpose first and entertainment second, the break with

conventional framing, lighting, and editorial techniques and styles gradually alienated large segments of devout filmgoers. People preferred to watch the more appealing Hollywood films than the more intellectual Cuban product. There were many years of controversy, discussion, and experimentation before a cohesive film policy finally developed, in tune with ideological and practical lines of the early 1980s. The film institute was an exception, within the wide gamut of Cuban artistic expression, in that it resolved this dilemma early in the decade. The majority of Cuban artists remained in the middle of the contradiction until very recently.

Even though Afrocuban culture is very rich, an entirely "authentic" Cuban culture is a notion difficult to support by any Cuban. The fine line between Cuban arts and foreign arts is more or less invisible for the creative artist who does not necessarily rationalize his or her art. Even when s/he does so, the validity of Cuban art, many argue, should not be limited to Afrocuban forms. Interestingly enough, many artists supported the argument that "Martí's definition of cultural identity is a product of *mestizaje*, thus affirming the coexistence of diverse influences, and in doing so, warded off provincialism."[30] By focusing on the process of syncretism, "dissident" groups began to win the battle against social and political ostracism.

In January 1988, the fourth Congress of Writers and Artists Union (UNEAC) marked a new level of artistic maturity for Cuba. New artists began to take control of the Union and to gain higher positions inside the Ministry of Culture. A large number of young artists who had been creating "different" art inside the state apparatus were now officially knowledged by Fidel Castro himself. For the first time in more than twenty-five years, Castro met with intellectuals, after three days of alert listening at the congress. Instead of giving them new guidelines, he supported their new artistic vision of freedom, not only the forms but also the content.

Foreign art and foreign mass culture have always been present in revolutionary Cuba. But up until the fourth UNEAC Congress, no theoretical guidelines had been drawn to mediate the discussion between negative and positive foreign influences. The music of the Beatles, perceived as a negative influence during the 1960s, is now generally recognized by musicians as positive. Other U.S. musicians such as Chick Corea, Herbie Hancock, and Stevie Wonder have been considered good and their works worth enjoying and analyzing.[31] Rock 'n' Roll is not per se considered a negative influence, but individual works or musicians generally are analyzed for their artistic merits. In other words, new discussions have opened the way to critical analysis of

forms such as Romanticism, Impressionism, and Rock 'n' Roll that, during the first two decades, were not endorsed by the revolution.

## Marxist Aesthetics

Popular aesthetics in Cuba have been examined and analyzed by Marxist aesthetic theories during the last thirty years. The subject of Marxist aesthetics is complex because it comprises different theories, some of them in partial contradiction, creating an ongoing controversy. Debates in recent years have centered on the discussion of the relationship between aesthetics and the history of art, and between aesthetics and philosophy. It is the intention of this research, however, not to discuss the different positions but to provide a brief synthesis. Therefore we could say that aesthetics is concerned with the study of beauty in all its forms and also with the elucidation of the nature of art and the laws of its inception. "Marxist aesthetics serves to summarize the laws governing man's aesthetic perception of the world." [32]

Marxist aesthetics is based on a materiodialectic principle of social production. Artistic production emerges from productive activities, just as industrial production does. Yet, art is different from industrial production in that it has the quality of uniqueness. Only when art has been differentiated from mass production can there be an aesthetic relationship between the art object and man: "Aesthetic awareness, or consciousness, has a particular social character. . . . [T]he aesthetic relationship of man with the external reality is a social relation. [Thus] the aesthetic judgments man makes on the particular qualities of a concrete productive phenomenon are only accessible to social man." [33] It is, therefore, possible to say that aesthetic values are validated within the context of society where the artistic object is produced, and to a lesser degree in the outer circumcentric boundaries of that society. Aesthetic values are, conclusively, cultural values that are accessible to people within a given culture.

Regardless of the question about ownership of the means of production, and the theoretical approach to interpret it, an artistic object is judged using the aesthetic values of the observer. A work of art does not have aesthetic values of its own, even though it is coded with the values of the society where it was produced. This separation between the aesthetic values of a society and the approaches to aesthetic theory is very important to differentiate in order to understand Cuban arts, particular cinema, during the last thirty years. In other words, regardless of the aesthetical approach used to analyze a film work, the cultural aesthetic values of the public are the guidelines that help the film gain recognition from the Cuban masses.

In the first thirty years of the twentieth century avant-garde artistic movements were cardinal, were developed, and then the movements that attempted to instigate an insurrection against the establishment in Europe coincided with the failed attempt to bring a revolution to power in Cuba in 1933.[34] Cuban Marxists had to wait twenty-five years for their revolutionary opportunity. But in that period Marxist aesthetics matured, particularly in the hands of the Frankfurt School[35] and with the Soviet idealists. The triumph of a revolutionary movement that proposed to create a communist state in Cuba inevitably brought the emergence of Marxist thought to the forefront of artistic discussion in the early 1960s.

The Marxist aesthetic theories emerging from the Frankfurt School have the point of view of Marxists within a capitalist system, which is not the case of the Soviets, nor the Cubans. This difference creates a variation in perspective that is important for Cuban artists. The latter are creating art in a socialist society in which the need to instigate insurrection is nonexistent or at least undesirable. On the contrary, they want to create cinema in order to consolidate socialism, and, therefore, to reach communism. This is because "in a society of men free from poverty and concern for the future, the aesthetic principle acquires incomparably greater significance than it ever had in the past."[36] That is, the closer the Cuban society is to a communist society, the greater the importance of aesthetic values and theories. At the theoretical level in Cuba, the limitations of the Cuban Film Institute (ICAIC) were not in the discussions of Marxist aesthetics but in the lack of a methodology to define their approach.

To build a communist society, Cuban filmmakers have been discussing the correlation between content and form, which is one of the most vital questions of Marxist aesthetics. When approaching this question Marxists depart from the philosophical tenets of dialectical materialism on the unity of content and form—the pre-eminent role of content, the active role of form, and so on. In order to analyze these questions on the nature of art, it is necessary to refer to the basic principle that form and content in art constitute an indivisible whole; and it becomes irrelevant to discuss which should have predominance.[37] This frivolous discussion may have affected the limited impact Cuban film had during the first decade, despite its artistic qualities.

The recognition of African roots in Cuban culture brought the discussion of content and form to a philosophical level without actually resolving the question of what is content and what is form in Cuban art. Owing to the nature of the art and film community in Cuba, and the variety of interpretations of Marxist aesthetics, no single theory has ever

predominated. Films are being produced without the scrutiny of any Marxist aesthetical criteria; although it should be recognized that the Cuban Film Institute leans toward the Marxist idea that "aesthetics cannot be separated from political issues any more than the aesthetic feeling can be [separated] from political, philosophical and ethical issues."[38] As a matter of fact, early Cuban films tended to disregard the content/form dichotomy and gave content a more dominant role, in light of the perceived need to counteract form-dominated Hollywood films.

The prevalent aesthetics in those early films were of political and ethical content, with intentional effort to simplify the form. This position is in line with Marxist materialist aesthetics, represented by aestheticians such as A. Yegórov, and G. A. Nedoshiving, who advocate that beauty is something objective, independent of the human consciousness.[39] In practical terms, this meant that content-dominated works did not match the aesthetical expectations of the public. Cuban masses tended to consider cinema mainly as entertainment, while filmmakers considered it an art product for mass consumption. By the early 1970s, however, the idea that cinema was primarily entertainment began to gain favor with some filmmakers.[40]

The aesthetical expectations of the Cuban public were not necessarily in tune with their own Afrocuban values, but in accordance with the Hollywood product they were accustomed to viewing. Filmmakers considered the aesthetic analysis a viable approach to understand the route to incorporating Afrocuban values and history into cinema. This issue led to a discussion of defining an aesthetical approach that would acknowledge the Hollywood-dominated mind, the need to address revolutionary issues, and the importance of franchising Cuban aesthetics.

The Cuban Film Institute recognized that Cuban films of artistic quality were not reaching a wide audience and saw the need to win the cultural struggle on the commercial screens, in competition with Hollywood-type products.[41] Cuban notions of beauty would have to be incorporated into films, in a Chernyshevskian way, relying on unmanipulated subjective and objective factors.[42] W. Benjamin's argument that only art that uses the techniques of modern technology is able to rescue it from ritual and base it on politics seems to be the best logic for transplanting Cuban aesthetics to the screen.[43] According to Benjamin, the process itself should be enough to emancipate a work of art. Yet, that would have meant that Cuban art had been detrimental to the objectives of the revolution, which it was not, and that by using the language of cinema Cuban art would have been liberated.

Obviously this is outside the limits of this paper because the object of discussion is cinema itself and not other forms of art. What had to be translated on the screen were the normal practices of the Cuban masses, and, in the process, it "could cause a change in the general character of the recipient's consciousness."[44] This seemed to be a better theoretical route for defining an aesthetical approach that would better serve the interests of the revolution, the masses, and the audiences.

Throughout the last thirty of Cuban cinema, filmmakers have maintained the aesthetical discussion. The shift in emphasis from a naturalist to an idealist Marxist aesthetic has meant in practical terms the emergence in popularity, among filmmakers, of the Rochian "aesthetics of hunger"[45] to the "Imperfect" cinema,[46] to what I label "Perfect" cinema. The term "Perfect" is used only to refer to that cinema which does not follow the content-dominated propositions discussed below. "Perfect" cinema made use of Cuban aesthetics in combination with different techniques.

## Cinematographic Aesthetics

The discussion of the image of "Imperfect" and "Perfect" cinema, and the process of transition between one tendency to the other, has to be done with the understanding that none of these definitions necessarily reflects clear-cut aesthetic theories, or schools, or even exclusive propositions. "Imperfect" cinema is a theoretical proposition that "attempted to find answers to concrete cultural problems" faced by Cuban filmmakers.[47] The aesthetic relationship between the film and the viewer should have a demonstrative quality, so that the viewer can make an analysis of the exposed topic. Proponents of this approach argue that if this occurs, "Imperfect" cinema exists as such.

The term "Imperfect" cinema was coined in order to bring attention to the particular ethical, historical, ideological, and economic conditions of Cuban filmmakers that were, and are, different from those for filmmakers in capitalist and developed countries. Because aesthetic and film theories have addressed conditions of other cultural settings, Cubans did not have a theory that served their interests. In other words, lacking theoretical guidelines, "Imperfect" cinema attempted to fill the vacuum. Mainly, this proposition was voiced by Julio García Espinoza, who advised Cuban artists to avoid form-dominated cinema.

By stressing a content-dominated work, it is possible to define an aesthetic style that conveys an ethical value, because it is not possible to convey such value through form.[48] García recognized that "Imperfect" cinema does not have to be boring; it "can also be humorous."[49]

Theoretician Adorno states that a "show may use comedy as a means of portraying the necessity for an obliging acquiescence in the humiliating conditions of social life."[50]

Within the context of "Imperfect" cinema, films such as *La primera carga al machete* (1969), *La lucha cubana contra el demonio* (1971), *Memorias del subdesarrollo* (1968), *Un día de noviembre* (1972) are examples of Marxist materialistic aesthetics, in line with "Imperfect" cinema. These films attempt to show a sense of beauty not by appealing mainly to the cultural iconography of the audience but by exposing a highly interesting topic for the audience. The process and form of exposition is secondary to the validity and argumentability of the content. Extending the argument, it can be said that Cuban aesthetic values were not used to attract and keep the audience entertained, although they are present.

The reception given these films by the Cuban audience ranged from bad to very good. In theoretical terms, "Imperfect" cinema proposes to create a cinema for the masses, yet García acknowledged that the masses do not respond to this cinema "because [they] do not have an aesthetical development."[51] Therefore, to be able to enjoy and appreciate the intrinsic aesthetic value of "Imperfect" films requires preparation. This means that "Imperfect" cinema is not for the masses but for a developed elite.

In theory, "Imperfect" cinema responds to valid needs, although in practical terms it did not reach its goal of stimulating the masses into discussing the creation of a new culture. Yet, many important films, that could be categorized as "Imperfect" cinema, were produced, and one could argue, are still being produced, in Cuba. They represent the first genuine attempt to create a Cuban aesthetical image following a national ethicopolitical argument.

"Imperfect" cinema has never had a solid framework of reference. Furthermore, it has been acknowledged since the early 1970s that the only feasible way to counteract Hollywood is by compromising revolutionary values, using the same ammunition Hollywood uses.[52] The idea is that having an elaborated Cuban image does not mean it conveys the same ethical principles form-dominated cinema does.

The theoretical struggle within the film institute has never meant the domination of one principle over others. Another significant trend in Cuban film is the one that considers cinema a spectacle: "Its main function is to entertain and to provide enjoyment through the representation of events and situations that emerge from reality, and that constitute a fiction which is going to enrich the level of understanding of that known reality."[53] This trend is also supported by the

idea that an entertaining film reinforces establishment values, whatever they may be.  This happens because spectators are distracted from their conflicts with society and the movie creates an illusion of contentment with the establishment.  In other words, this theoretical principle meant that it could be used in a capitalist as well as in a socialist society.

This approach, where the relation between form and content is not predetermined by any principle, allowed a more varied combination of ideas and aesthetic styles.  The social comedy that was inaugurated by Tomás Gutiérrez Alea with *Las doce sillas* (1962) [54] is perhaps the earliest example of the usage of what may be termed "Perfect" cinema.

In the early 1980s "in order to structure [polemic-conflicting] currents better, [ICAIC] divided the film industry, to decentralize it.  Not for economic reasons but for ideological ones, i.e., in function with aesthetic and conceptual affinities and according to the rather different views on realities [filmmakers have]." [55] This decade has seen a growth in "Perfect" cinema thanks to this reorganization.  Films such as *Se permuta* (1984), *Pájaros tirándole a la escopeta* (1984), *Patakín* (1982), *Un hombre de éxito* (1986), *Lejanía* (1985), *Una novia para David* (1985), and *¡Plaf!* (1988), are good examples of the flexible approach to "Perfect" cinema.  In these films are portrayed not only traditional popular culture values but also a number of "bad habits Cubans had picked up under socialism." [56]

The inclusion of popular values serves both to make the audience identify and relate to the topic and to narrow down aesthetic reactions.  *Se permuta* is a comedy about the complicated predicaments of exchanging residences in modern Cuba.  The mother character portrays traditional values.  She wants to move to a better neighborhood and marry her daughter to a "suitable" man.  This value, also still valid in Cuba, is not necessarily something of which to be proud.  Instead, the treatment of her desire to move to a neighborhood that better suits her image ridicules the character without alienating the audience.  The audience identifies with the mother but also laughs at her.  In addition, the mother consistently tries to match her daughter with an influential white man, but the young woman finds herself a hard-working mulatto, to the audience's joy.  The emphasis on the simple image represented by the mulatto was the triumph of the Cuban aesthetics.  It was a very successful film in Cuba.

By translating Cuban aesthetics to the screen, the filmmaker has had a freer hand in dealing with a wider range of topics, especially through comedy.  In *Patakín* (1982) the use of two Yoruba mythological deities serves not only to connect with deeply rooted teleological tales in the masses but also to bring an ethical issue to discussion.  Although

the qualities of the deities Changó and Ogún are stylized, they are still recognizable by the masses. Changó, the god of thunder, is identified by the masses as the god of the drums, therefore he is related to parties and enjoyment. Ogún, the god of fire and metals, is identified as the god of technology, therefore he is associated with work and advancement. Both deities are represented by two characters whose lives are practically antagonistic.

Because the plot evolves around the confrontation between Changó and Ogún, the film makes an ethical statement about the values each character represents. The popular Changó is the main character. However, it is the hard-working Ogún who ends up winning the confrontation. It is easy for the audience to identify with Changó, but when he is in deep trouble, the audience is ready to see him punished or defeated. The audience easily understands that fun is an important part of their culture, but in the long run it is more important to be honest and hard working. This effect, in essence, is the one Cuban filmmakers want to create with their works: good entertainment and excellent content. By referring to cultural roots of the masses, Cuban filmmakers are developing better rapport with the audience.

The so-called young directors such as Juan C. Tabío, Rolando Díaz, Manuel Octavio Gómez are recognized for their contribution to "the recovery of a comic verve likely to serve better as an underpinning for their social critique."[57] Their approach apparently does not follow any particular Marxist aesthetic theory. What they created in the 1980s seems to better follow the experiences of two decades of experimentation than anything else. Their experience in incorporating Cuban popular taste, meeting the visual expectations of the "Hollywood-spoiled" eye, and challenging the ideological perspective of the audience is resulting in a clearer image, as recent films seem to demonstrate. Cuban cinema is now beginning to have a consistent aesthetic identity very much in tune with the history and needs of Cubans.

## Conclusion

The long slow process of acculturation that began in Cuba in 1501 experienced a series of political and economic pressures before maturing. More than 300 years of slavery and abusive racial discrimination, forced the black population to nourish what remained of their African traditions.

During the first half of the nineteenth century the black population was larger than the white. By 1817, 55 percent were black; by 1855 they still dominated with 52 percent.[58] It was this factor that contributed to

the process of ethnic and cultural *mestizaje*. José Martí, and other mestizo artists and leaders, legitimized the acculturation process by late nineteenth century. Martí borrowed from the Afrocuban experience in developing a national cultural identity and transferred it to the larger context of the mestizo population, which also included the blacks, in order to defend Cuba against the growing U.S. penetration. The linkage between cultural values and political discourse is Martí's most important contribution in contemporary Cuban political thought, and constitutes the backbone of current revolutionary cultural policies.

Since 1959 the Cuban government has invested an average of 15 percent of its national budget to nourish the cultural values of the Cuban people, to defend Cuba and the revolution from external aggressions. Cuba offers, in spite of limitations at different moments, unique opportunities for artists that no other Latin American country can attempt to match. Now, even second-rank artists can expect to have a moderate salary to work on their own art and teach others in the process.[59] These policies have supported, for the first time in more than 450 years of Cuban history, artists of peasant origin. Cuban films have been praised from Cannes to Cartagena, paintings from Paris to Moscow, and poetry and narrative in almost every corner of the world. New forms of Western aesthetics have developed in Cuba; and, after twenty years of jealous and dogmatic protectionism, Cuban arts are now confronting old and new foreign schools and aesthetic theories, with the hope of improving their own culture and art.

Cuban filmmakers have finally perfected a Cuban image, responding to the tastes of popular culture and stimulating the audience's understanding of themselves as Cubans, Latin Americans, and socialists. This cinematographic trend is unique in the Latin American, and even in the Third World, context. Because the annual production averages six films, and most of the material can now be acquired in 16 mm and/or videotape in the United States, acquiring a collection of Cuban films is a feasible project.[60] Cuban films are valuable not only for their artistic merits but because they present a wide door to view the history and life-styles of one of the most syncretic cultures, and the only socialist system, in America.

## NOTES

1. L. Fuentes Matons, *Las artes in Santiago de Cuba* (Havana: Editorial Letras Cubanas, 1981), pp. 24-25.

2. Harold Gramatges, "La música culta," in *La Cultura en Cuba* (Havana: Editorial Letras Cubanas, 1982), p. 124.

3. Ibid., p. 130.

4. Fernando Ortíz, *Los negros curros* (Havana: Editorial de Ciencias Sociales, 1986), pp. 153-184.

5. Ibid., pp. xvi-xvii.

6. E. McClelland, *The Cult of Ifá among the Yoruba* (London: Ethnographica Ltd., 1982), pp. 20-23.

7. Fernando Ortíz, *La clave xilofónica de la música cubana* (Havana: Editorial Letras Cubanas, 1984), pp. 65-67.

8. Jorge Ibarra, *Nación y cultura national* (Havana: Editorial Letras Cubanas, 1981), p. 154.

9. Ibid.

10. Ibid., pp. 156-160.

11. Fuentes Matons, p. 29.

12. Ibarra, p. 17.

13. Ibid., p. 31.

14. Ibid., p. 214.

15. Judith A. Weiss, "The Emergence of Popular Culture," in *Cuba: Twenty-Five Years of Revolution, 1959-1984* (New York, NY: Praeger, 1985), pp. 117-119. During the twenty-five year period between 1933 and 1958, different governments tried to stimulate the development of different art forms that expressed the national popular culture. The establishment of the División de Cultura of the Ministry of Education in 1934 was the most important contribution in this respect. But the uneven flow of resources to the División did not allow any substantial results, especially outside Havana.

16. G. A. Nedoshiving, "La estética marxista-leninista como ciencia," *Estética y marxismo* (Mexico: Editorial Era, 1970), pp. 108-109.

17. John Hess, "College Course File. Central America: Film and Video," *Journal of Film and Video* 40, 4 (Fall 1988).

18. Miguel Barnet, "Algunas palabras necesarias," *Areíto* 1, 3 (1974), 5-7.

19. Fernando Ortíz, *Los bailes y el teatro de los negros en el folklore de Cuba* (Havana: Editorial Letras Cubanas, 1981), p. 294.

20. W. Bascom, *Chango in the New World* (Austin: University of Texas Press, Occasional Publications, 1972), p. 5.

21. "La Santería," *Areíto* 1, 3 (1974), 14-15.

22. Ortíz, *Los negros*, p. 179.

23. Ibid., p. 178.

24. Ortíz, *Los bailes*, pp. 298-301.

25. Ibid., p. 432.

26. Ortíz, *Los negros*, p. 40.

27. Fidel Castro, "Il Congreso," *Cuba Update* (New York, Center for Cuban Studies) 2, 1 (1981), 8-9.

28. Max Azicri, *Cuba: Politics, Economics, and Society* (New York, NY: Pinter Publishers, 1987), p. 182.

29. Cuco Fusco, "Drawing New Lines," *The Nation* (New York), October 24, 1988, p. 398.

30. Ibid., pp. 398-399.

31. Reebe Garalfo, "The Reaction to U.S. Music in Cuba," *Cuba Update* (New York, Center for Cuban Studies), 1, 3 (1980), 15.

32. A. Zis, *Foundations of Marxist Aesthetics* (Moscow: Progress Publishers, 1977), p. 8.

33. G. A. Nedoshiving, "La relación estética," *Estética y Marxismo* (Mexico: Editorial Era, 1970), pp. 108-109.

34. Jean-Marc Lachaud, *Marxisme et philosophie de l'art* (Paris: Editions Antropos, 1985), p. 186.

35. Clay Steinman, "Reception of Theory: Film/Television Studies and the Frankfurt School," *Journal of Film and Video* 40, 2 (Spring 1988).

36. Zis, p. 11.

37. Adolfo Sánchez Vázquez, *Estética y marxismo* (Mexico: Editorial Era, 1970), pp. 26-27.

38. Zis, p. 191.

39. Even though materialistic and idealistic aesthetics adopt diametrically opposite stands with regard to the definition of the essence of beauty, materialistic aesthetics acknowledges some importance of subjective elements in evaluating beauty.

40. Tomás Gutiérrez Alea, *Dialéctica del espectador* (Havana: Cuadernos de la Unión, 1982), p. 20.

41. Julianne Burton, "Beyond the Reflection of Reality," *Cinema and Social Change in Latin America: Conversations with Filmmakers* (Austin: University of Texas Press, 1986, interview with Tomás Gutiérrez Alea), p. 125.

42. Zis, p. 185.

43. Pauline Johnson, *Marxist Aesthetics* (London: Routledge & Kegan Paul, 1984), pp. 57-59.

44. Ibid., p. 43.

45. Burton, p. 125.

46. Julio García Espinoza, *Por un cine imperfecto* (Havana: Editorial Salvador de la Plaza, 1973), pp. 11-33.

47. Ibid., p. 40.

48. Idem, *Una imágen recorre el mundo* (Havana: Editorial Letras Cubanas, 1979), pp. 2-5.

49. Ibid., p. 15.

50. Johnson, p. 90.

51. García Espinoza, *Una imágen*, p. 22.

52. Ibid., p. 65.

53. Gutiérrez Alea, p. 20.

54. Michael Chanan, *The Cuban Image: Cinema and Cultural Politics in Cuba* (London: BFI Publishing, 1984), pp. 125-126.

55. Paulo Antonio Paranagua, "News from Havana: A Restructuring of the Cuban Cinema," in *Framework* 35 (1988), 100.

56. Ibid., p. 91.

57. Ibid.

58. Ortíz, *Los negros*, p. 185.

59. Weiss, p. 121.

60. The Center for Cuban Studies, 124 West 23rd Street, New York, NY 10011, (212) 242-0559, has the largest selection of Cuban films for sale in the United States, and it is also one of the best sources of materials from Cuba.

# BIBLIOGRAPHY

Aristarco, Guido. *Marx, le cinéma et la critique de film.* Paris: Lettres Modernes, 1972.

Azicri, Max. *Cuba: Politics, Economics, and Society.* New York, NY: Pinter Publishers, 1987.

Balari, E. R. "Cinco años de trabajo del Instituto Cubano de Investigaciones y Orientación de la Demanda." In *Investigaciones científicas de la demanda en Cuba.* Havana: Editorial Orbe, 1979.

Barnet, Miguel. "Algunas palabras necesarias," *Areíto* 1, 3 (1974).

Bascom, William. *Chango in the New World.* Austin: University of Texas Press, Occasional Publications, 1972.

Burton, Julianne. *Cinema and Social Change in Latin America: Conversations with Filmmakers.* Austin: University of Texas Press, 1986.

Castro, Fidel. *Palabras a los intelectuales.* Havana: Ediciones de Consejo Nacional de Cultura, 1961.

Chanan, Michael. *The Cuban Image: Cinema and Cultural Politics in Cuba.* London: BFI Publishing, 1984.

*Cuba Update* (New York, NY: Center for Cuban Studies) (periodical).

De Juan, Adelaida. "Las artes plásticas en Cuba socialista." *Casa de las Américas* 19, 113 (March-April 1979), 27-39.

Duncan, Raymond W. *The Soviet Union and Cuba.* New York, NY: Praeger, 1985.

Erisman, H. Michael. *Cuba's International Relations: The Anatomy of a Nationalistic Foreign Policy.* Boulder, CO: Westview Press, 1985.

Fuentes Matons, L. *Las artes in Santiago de Cuba.* Havana: Editorial Letras Cubanas, 1981.

Fusco, Cuco. "Drawing New Lines." *The Nation* Oct. 24, 1988, pp. 397-400.

Garalfo, Reebe. "The Reaction to U.S. Music in Cuba." *Cuba Update* (New York, NY: Center for Cuban Studies), 1, 3 (1980), 15.

García Espinoza, Julio. *Por un cine imperfecto.* Havana: Editorial Salvador de la Plaza, 1973.

————. *Una imágen recorre el mundo.* Havana: Editorial Letras Cubanas, 1979.

Gutiérrez Alea, Tomás. *Dialéctica del espectador.* Havana: Ediciones de la Unión, 1982.

Halebsky, Sandor, and John M. Kirk, eds. *Cuba: Twenty Five Years of Revolution, 1959-1984.* New York, NY: Praeger, 1985.

Hart Davalos, Armando. *Del trabajo cultural: selección de discursos.* Havana: Editorial de Ciencias Sociales, 1979.

————. "Discurso de clausura." *Casa de las Américas* 18, 106 (Jan.-Feb. 1978), 61-77.

Hess, John. "College Course File. Central America: Film and Video." *Journal of Film and Video* 40, 4 (Fall 1988).

Ibarra, Jorge. *José Martí: dirigente político e ideológico revolucionario.* Havana: Editorial de Ciencias Sociales, 1980.

————. *Nación y cultura national.* Havana: Editorial Letras Cubanas, 1981.

Johnson, Pauline. *Marxist Aesthetics.* London: Routledge & Kegan Paul, 1984.

*La cultura en Cuba socialista.* Havana: Editorial Letras Cubanas, 1982.

"La Santería." *Areíto* 1, 3 (1974).

Lachaud, Jean-Marc. *Marxisme et philosophie de l'art.* Paris: Editions Antropos, 1985.

Laver, James. *Costume and Fashion.* Norwich, CT: Oxford University Press, 1983.

Lequenne, Michel. *Marxisme et esthétique.* Montreal: La Breche, 1984.

MacGaffey, Wyatt, and Clifford R. Barnett. *Twentieth-Century Cuba: The Background of the Castro Revolution.* New York, NY: Anchor Books, 1965.

McClelland, E. *The Cult of Ifá among the Yoruba.* London: Ethnographica Ltd., 1982.

Menéndez Pelayo, Marcelino. *Historia de las ideas estéticas en España.* Madrid: Consejo de Investigaciones Científicas, 1962.

Nedoshiving, G. A. "La estética marxista-leninista como ciencia." *Estética y marxismo.* Mexico: Editorial Era, 1970.

Ortíz, Fernando. *Los bailes y el teatro de los negros en el folklore de Cuba.* Havana: Editorial Letras Cubanas, 1981.

_____. *Los negros curros.* Havana: Editorial de Ciencias Sociales, 1986.

_____. *La clave xilofónica de la música cubana.* Havana: Editorial Letras Cubanas, 1984.

Sánchez Vázquez, Adolfo. *Estética y marxismo.* Mexico: Editorial Era, 1970.

Smith, Wayne S. "Accommodation Is in the U.S. Interest." *The Nation,* Oct. 24, 1988.

Steinman, Clay. "Reception of Theory: Film/Television Studies and the Frankfurt School." *Journal of Film and Video* 40, 2 (Spring 1988).

Zis, A. *Foundations of Marxist Aesthetics.* Moscow: Progress Publishers, 1977.

# 15. Videos and Films Shown at the Conference

## Rhonda L. Neugebauer

### Videos and Films

#### Art and Revolution in Mexico

Nowhere but in Mexico has history been painted as superbly, nowhere else have outspoken polemical painters, like Rivera and Siqueiros, produced such great art. The art of revolution and the revolution of art seem, in this time and place, to have nurtured each other. In Latin America, art and literature are the shared possessions of all social and educational levels. Text by Octavio Paz. Distributor: Films for the Humanities and Sciences.

#### Art of Central America and Panama

Central America and Panamanian artists are shown with their paintings in their native environment. Producer and Distributor: Museum of Modern Art of Latin America.

#### Art of the Fantastic: Latin America, 1920–1987

This video reviews an exhibition of Latin American fantastic art presented in the Indianapolis Museum of Art. Filmed on location with commentaries by the exhibit curators. Coproducers: Museum of Modern Art of Latin America and the Indianapolis Museum of Art. Distributor: Museum of Modern Art of Latin America.

#### Carmen Carrascal

This intimate portrait of a talented craftswoman explores the many obstacles Carmen encounters in her triple role as mother, wife, and artisan living in an isolated rural area of Colombia. Carmen tells the story of her husband's opposition to her work and her desire to provide an education for her nine children through the sale of her baskets. She recounts how she suffered a serious mental breakdown after collecting the government's highest honor for her excellent basketry. Director: Saraq Bright. Producer: Cine Mujer. Distributor: Women Make Movies.

### Filemon y la Gorda

Utilizing three-dimensional cut-out animation, this film depicts the charming and magical love story of Filemon y la Gorda, set in the countryside of Colombia. Selected as the Latin American entry at the Filmes de Femmes, Sceaux, France, this is the first film by this new animator. Director: Paulina Ponce. Distributor: Women Make Movies.

### Frida

This feature film tells the story of larger-than-life artist Frida Kahlo. Before her short life ended, Frida Kahlo earned a reputation as Latin America's greatest woman artist, political activist, and feminist. The film traces on screen the interior and exterior pathways of its protagonist and examines her relationship with her famous husband, Mexican muralist Diego Rivera, and Russian revolutionary-in-exile Leon Trotsky. Director: Paul Leduc. Producer: Manuel Barbachano Ponce. Distributor: New Yorker Films.

### Nanduti: A Paraguayan Lace

This video depicts the origins and legends of the lace-making tradition in Paraguay. Examples of intricate lace patterns are shown to illustrate the technical complexities and detailed beauty of this creative craft. Producer: International Film Bureau. (Loaned courtesy of the Media Library, University of California, Riverside.)

### Plaff!

This feature film offers a satirical look at life and problems in present-day Cuba. There is frank and humorous social criticism of bureaucracy, opportunism, family relations, and work life which makes this one of the most popular films in Cuba today. The comedy is named for the sound that an egg makes breaking against a wall. Director: Juan Carlos Tabio. Producer: Instituto Cubano de Arte e Industria Cinematográficos.

### Through the Camera Lens: Views of Slavery in 19th Century Brazil and the United States

This documentary uses rare and in many cases unpublished photographs of slaves in Brazil and the United States to examine the ways in which photographers incorporated prevailing social values to interpret and portray their subjects. The video provides detailed examples of how to use visual records for analysis of past peoples and societies. Author: Robert M. Levine, Chair, Department of History, University of Miami. Producer: Charles A. Fox, Media Services, University of Florida, College of Law, Gainesville. Distributor: Robert M. Levine.

**Distributors of Conference Films and Videos**

Films for the Humanities and Sciences, P.O. Box 2053, Princeton, NJ 08543.  (609) 452-1128 x253.

New Yorker Films, 16 West 61st St., New York, NY 10023. (212) 247-6110.

Robert M. Levine, Chairman, Department of History, University of Miami, P.O. Box 248194, Coral Gables, FL 33124.  (305) 284-3660.

Museum of Modern Art of Latin America, General Secretariat, Organization of American States, 1189 F Street N.W., Washington, DC.  (202) 458-6016.

Women Make Movies, 225 Lafayette St., Suite 211, New York, NY 10012.  (212) 925-0606.

# IV.  Posters

# 16. A colonização italiana no sul do Brasil em "posters"

## Sonia T. Dias Gonçalves da Silva

### Introdução

O Museu e Arquivo Histórico Municipal da cidade de Caxias do Sul, no estado do rio Grande do Sul, faz publicar 3 boletins em forma de "posters" como divulgação de seu material documental. Porém, impossível se torna relatar o porque dessa forma para divulgá-lo, sem localizar a cidade e a região no contexto histórico-social brasileiro.

### O início da imigração no Brasil

No limiar do século XIX a economia brasileira, predominantemente agrícola, encontrava-se nas mãos dos grandes proprietários rurais, sendo a terra trabalhada pelos escravos negros. A sociedade brasileira era sustentada pelo tripé monocultura-latifúndio-escravidão. A exploração do mão-de-obra escrava concentrava-se nas regiões extratoras de minérios e produtoras de café e cana-de-açúcar e fazia-se necessário desenvolver o cultivo da terra em pequenas propriedades e povoar o extenso território brasileiro.

As vozes a favor da abolição da escravatura começaravam a clamar, quando, em 1808, com 1/3 da população brasileira composta de escravos, foi decretada a autorização para que todos os estrangeiros residentes no Brasil, pudessem nas mesmas condições que os portugueses, tornarem-se proprietários de terras.

Devido à extinção do tráfico escravagista no Brasil em 1831 e com a interferência britânica no perseguição aos navios negreiros, autorizada pelo "Bill of Aberdeen," viram-se os proprietários agrícolas obrigados a suprir a mão-de-obra na cafeicultura em menor prazo possível.

O trabalhador branco, livre, estrangeiro e proprietário viria substituir o elemento servil, povoar as terras devolutas e aumentar a produção agrícola com mão-de-obra especializada e práticas de trabalho renovadas. Outrossim, contribuiria para o "branqueamento" da população, pois aos estadistas do Reino preocupava a idéia da formação de um Império Negro, o que tornaria o país um fracasso.

Apesar das condições migratórias apresentarem os Estados
Unidos, a Austrália e a Argentina como países mais favoráveis, o Brasil
optou por apresentar a imigração brasileira como se fosse um processo
de colonização, onde seria criada uma camada de pequenos proprie-
tários rurais.

Assim foi iniciada a imigração brasileira, com a vinda das
primeiras levas de suíços em 1819, depois alemães, italianos e poloneses
durante a colonização nos períodos provincial e imperial. Após a
proclamação da República, em 1889, o governo federal transferiu aos
governos locais a responsabilidade no problema da colonização.

**Italianos no Rio Grande do Sul**

Foi grande o fluxo migratório para o estado do Rio Grande do
Sul, devido ao período de crise econômica que o estado atravessava,
acarretada pela ausência de escravos, que se concentravam na região
cafeeira do país. A economia sul-riograndense, até então baseada
exclusivamente na criação de gado, necessitava diversificar-se com
introdução de novas culturas e inovação das práticas agrícolas.

Os primeiros imigrantes que chegaram ao Rio Grande do Sul
foram os alemães, em 1824, na região central do estado. Cinqüenta
anos depois essa população germânica e seus descendentes ocupavam
1/6 de seu território.

Em maio de 1875 iniciou-se a emigração italiana, sendo apontadas
como causa desse movimento a grave crise econômica, política e social
que aquele país atravessava após sua unificação. Como as medidas
adotadas pelo governo italiano atingiam duramente os agricultores,
principalmente os residentes no norte da Itália, viram-se eles diante da
miséria, da fome e do analfabetismo, principalmente no decênio
1880–1890. Foi quando aconteceu considerável aumento da emigração
transoceânica para as Américas. Em 25 anos mais de 1.000.000 de
italianos cruzaram o Oceano Atlântico rumo ao Brasil à procura do
Eldorado que lhes daria trabalho e terra que, devido às condições
econômicas e sociais da Itália, não lhes era permitido ter.

Os que optaram pelo sul, foram fixados na região nordeste do
estado, instalados em colônias do Rio Grande do Sul e dedicaram-se à
lavoura. Inicialmente cultivaram trigo, uva e milho, produzindo para
sua própria subsistência e vendendo o excedente agrícola para o
mercado interno que começava a se formar. Mas entre eles estavam
muitos artesãos e pessoas que tenham conhecimentos técnicos pouco
mais avançados que os cidadãos lusos (serralheiros, ferreiros, carpin-
teiros, funileiros, tecelões), que, paralelamente ao cultivo da terra,

desenvolviam a montagem de pequenas oficinas para fabricação de ferramentas de trabalhos e para suprir as necessidades de casa. Em pouco mais de 50 anos, italianos e seus descendentes somavam quase 300.000 pessoas no estado.

**A região da colonia Caxias**

Foram colocados à disposição dos colonos italianos cerca de 2.500 lotes em região de mata sub-tropical e rica de riachos e fontes, na encosta superior do nordeste. A colonia Caxias, fundada no mesmo ano do início da colonização, sobre o nome de "Colônia nos Fundos de Nova Palmira", contava, em 1878, com uma população de 3.851 colonos, sendo 2.315 italianos. A sede, escolhida em posição central, sob a denominação de Sede Dante, teve um futuro brilhante, pois de local de simples encontro colonial dela originou-se a hoje próspera, culta e industrializada cidade de Caxias do Sul.

Inicialmente foi grande o isolamento pela falta de estradas para as grandes fazendas e para os municípios vizinhos, mas os colonos não desanimaram. Tendo a família como célula de produção—e não mais a grande fazenda, a estância ou a engenho—eles alargaram suas roças, transformaram suas casas de madeiras em casas de pedras e reproduziram nas colonias a Itália que tanto amavam, adotando como sua pátria a terra brasileira. Transcorridos 10 anos, o progresso já é visível e podem-se notar até mesmo teatros, cafés, hotéis e bilhares em plena serra.

Com a inauguração do telégrafo, da via férrea e da energia elétrica no início do século, aconteceu o ponto de partida para seu grande desenvolvimento comercial e industrial, tendo sua elevação à vila acontecido em 1910.

A sede da antiga Colônia Caxias, hoje Caxias do Sul, conta com quase 300.000 habitantes, sendo a maior e mais próspera cidade do estado do Rio Grande do Sul.

**O Museu e Arquivo Histórico Municipal**

Paralelamente à cultura e desenvolvimento econômico e social da cidade, foi sentida a necessidade de se documentar a trajetória de Caxias do Sul, cidade profundamente marcada pelo processo migratório.

Em 1946 foi criado o Museu Municipal e, anexo, foi oficialmente criado, em 1976, o Arquivo Histórico Municipal. Tem ambos como objetivo difundir suas metas de trabalhos inseridas na nova visão da história e das instituições a serviço da conscientização, do rompimento com o tradicional e o superficial, dando lugar à compreensão das

transformações por que passam as sociedades em cada época. Servir aos pesquisadores é apenas uma de suas múltiplas atribuições, pois é no seu total um centro dinamizador e gerador de cultura. Conta com seções de documentos, fotografias, mapas, jornais, livros e seriados, peças e utensílios domésticos.

Grande foi a contribuição da Universidade de Caxias do Sul na organização do Arquivo Histórico, dispondo de alunos bolsistas de seu curso de pós-graduação em história para e pesquisa da história regional.

O trabalho de educação e conscientização da população local é contínuo e foi correspondido na cessão de documentos, fotos, plantas, etc., doando o que era seu para uso coletivo, preservando assim as fontes primárias que contribuiram para que fosse escrita a história caxiense.

Através de exposições temáticas e temporárias de fotos, peças e dos, a comunidade participa dos elementos integrantes de sua história buscando o resgate do passado e o testemunho do presente. Associações, sindicatos, indústrias, comércio, escolas, universidades e povo em geral trabalham com o antigo e o moderno, estabelecendo uma relação dinâmica com o passado, demonstrando assim que a cultura deve ser sempre um patrimônio coletivo a disposição de todos.

O Museu e Arquivo publicam 4 séries: *Caleidoscópio, Memórias, Cenas* e *Ocorrências*. A série *Caleidoscópio* é uma publicação dirigida às escolas, onde assuntos mais específicos são evidenciados, colaborando para a educação não-formal. O boletim *Memória* analisa a história do município no conjundo de suas atividades econômicas, religiosas, sociais, políticas e artísticas. A série *Cenas* registra a história da fotografia local, analisando o produção dos fotógrafos que fizeram com seu ofício a possibilidade de perpetuar o passado no presente através da imagem. O boletim *Ocorrências* divulga o cotidiano do Museu e Arquivo, lançando números simultaneamente com as exposições temáticas, complementando-as.

### O "poster" como forma de divulgação do material e da história local

Das 4 séries citadas, os boletins *Memória, Cenas,* e *Ocorrências* são editados em forma de "posters".

*Memória* e *Cenas* trazem na parte frontal uma foto e atrás a informação. Servem esses periódicos como divulgação das inúmeras fotos dentre as 120.000 constantes da fototeca e dos depoimentos e informações acumulados no banco de memória. A publicação desses "posters" retratando e relatando o passado, é patrocinada por empresas e comércio local, algumas delas agora integrando grandes

conglomerados industriais, dos quais várias são originadas de pequenas oficinas de fundo de quintal. Nesse patrocínio nota-se o trabalho dos pioneiros imigrantes, hoje nas mãos de seus descendentes, construindo o presente do país e colaborando com a cultura na divulgação de sua própria história.

## Conclusão

Sobrevivendo em meio a tantos sofrimentos, o imigrante italiano foi um trabalhador incansável e persistente que, vencendo a nova terra, não se esqueceu do patrimônio cultural de que era portado. Unindo o artesanato ao trabalho especializado e conhecimentos técnicos, cobriu a serra de trigo e uva e forjou o grande parque industrial e comercial que é hoje Caxias do Sul. Juntando os valores culturais com o patrimônio legado por seus ancestrais, criou Museu e Arquivo como instrumentos ativos na busca das verdadeiras raízes plantadas nessa cidade. Através deles conta hoje a história da modificação da natureza e formação de uma nova paisagem pelos pioneiros e divulga-a, para a cidade e o país, sobre a forma de "poster".

E Caxias do Sul transformou-se no Eldorado que seus avós buscaram.

## BIBLIOGRAFIA

Azevedo, Thales de. *Italianos e gaúchos: os anos pioneiros da colonização italiana no Rio Grande do Sul*. Série biênio da colonização e imigração, v. 2. Porto Alegre: A Nação; Instituto Estadual do Libro, 1975.

De Boni, Luís A., e Costa, Rovílio. *Os italianos do Rio Grande do Sul*. 3. ed. Porto Alegre: Escola Superior de Teologia São Lourenço de Brindes; Caxias do Sul e Correio Riograndense, 1984.

*Cenas*. Caxias do Sul: Museu e Arquivo Histórico Municipal, 1-13, setembro 1984–dezembro 1987.

Giron, Loraine Slomp. *Caxias do Sul: evolução histórica*. Caxias do Sul: Prefeitura Municipal e Universidade de Caxias do Sul; Porto Alegre: Escola Superior de Teologia São Lourenço de Brindes, 1977.

Manfroi, Olívio. *A colonização italiana no Rio Grande do Sul: implicações econômicas, políticas e culturais*. Série biênio da colonização e imigração, v. 7. Porto Alegre: Gráfica Editora Fotogravura do Sul Ltda.; Instituto Estadual do Livro, 1975.

Martins, José de Souza. "Apresentação." Em José Vicente Tavares dos Santos, *Os colonos do vinho: estudo*. 2. ed. Coleção ciências sociais. São Paulo: HUCITEC, 1984.

*Memória: Boletim Informativo do Museu e Arquivo Histórico Municipal*. Caxias do Sul: Museu e Arquivo Histórico Municipal, 1-13, outubro 1980–fevereiro 1989.

*Ocorrências: Registro do Museu e Arquivo Histórico Municipal*. Caxias do Sul: Museu e Arquivo Histórico Municipal, 1-9, novembro 1986–dezembro 1988.

*Patrimônio histórico: caso de vida e morte*. Caxias do Sul: Museu e Arquivo Histórico, s.d.

Roche, Jean. *A colonização alemã e o Rio Grande do Sul*. 2 v. Trad. de Emery Ruas. Coleção província. Porto Alegre: Globo, 1969.

Rothwell, Stuart Clark. *The Old Italian Colonial Zone of Rio Grande do Sul, Brazil.* Série ciências, v. 1. Porto Alegre: Edições da Faculdade de Filosofia, 1959. Tese.

Santos, José Vicente Tavares dos. *Os colonos do vinho: estudo sobre a subordinação do trabalho camponês ao capital.* 2. ed. Coleção ciências sociais. São Paulo: HUCITEC, 1984. Tese.

# 17.  Posters and the Sandinista Revolution

## Fred G. Morgner

The gathering of posters as a primary source to document historical events and sociopolitical movements has received relatively little attention from most research libraries. Yet posters are a valuable form of popular art and may convey an emotional sense of a period and provide types of information that the printed word does not.  It is especially true during periods charged with political intensity and fervor such as heightened racial tension, class conflict, war, or revolution.

Revolutionary Nicaragua during the 1980s was a society burning with political passion and conflict, which provoked the printing and dissemination of hundreds of posters from a wide variety of points of view.  The great majority of these propaganda pieces, ranging in size from large flyers to giant sheets several feet in width and length, came from three diverse groups in the region.  The central issue for each of these groups was the success of the Sandinista Revolution and the dislocations provoked by that success.

Following examples set by the Soviet Bolsheviks and Castro's Cuba, the Sandinistas produced a flood of political posters to celebrate their victory, to rally support for their cause, to evoke solidarity against their enemies, and, as the 'eighties progressed, to instill patriotic fervor on behalf of the war against the "Contras" and to protest the policies of the Reagan administration.  As the counterrevolution intensified and regional tension mounted, the Contra political offices in Costa Rica, Honduras, and Miami launched a well-financed propaganda campaign spearheaded by press and video releases, periodical literature, and posters.  In addition to the two warring factions, a third source of poster production developed within Honduras.  As the Honduran government permitted its territory to be utilized as a base for U.S. troops as well as a haven for Contra forces, a number of dissident organizations launched campaigns calling for the expulsion of the foreign troops from their soil and protesting the subservience of their government to U.S. interests.

Given the hundreds of posters printed and disseminated in the region during the decade, book dealers and collecting institutions were

confronted with problems of selection, organization, preservation, and presentation. It was especially true for the great number of Sandinista posters which encompassed a wide variety of themes and art forms. The process I followed in imposing a degree of order on such a diverse collection is as follows: As the collection process evolved, themes became apparent which led to categorization of the material. The best posters in each category were selected, based upon the importance of content as well as artistic merit. A total of 125 posters were selected for notation (see Appendix), and organized into the categories listed below.

SANDINISTA POSTERS (93)
    Commemorative (26)
    Augusto C. Sandino (7)
    Literacy Campaign (5)
    Liberation Theology (27)
    Anti-Imperialism (10)
    National Defense (16)
    Internal Opposition (2)

NICARAGUAN RESISTANCE (CONTRAS) POSTERS (14)

HONDURAN PROTEST POSTERS (18)

With selection and categorization completed, an information key was developed to indicate descriptive information such as poster size, colors, date and publisher (when known), graphic style, text, and visual description (see Appendix, page 197).

Owing to the unwieldy size and delicate nature of many posters, storage and display are problems that collectors and libraries must solve. The most effective manner to store posters without damage or fraying is to utilize trays with protective plastic sheets designed for such a purpose, as used by the University of Miami for its Cuban collection and the Hoover Institution for its Soviet and Nicaraguan collections. Perhaps the most effective means of display is through a gallery show, which is generally impractical due to the demands of space and time. A satisfactory alternative is to photograph and develop a slide transparency for each poster, also utilized by Miami and Hoover. This method allows easy access to researchers, thus minimizing the handling of the original document and also providing a valuable and dramatic visual teaching resource.

A content analysis of posters sparked by the Nicaraguan Revolution and counterrevolution reveals a number of interesting trends in issues and imagery of the period.

During the years directly following their July 19, 1979 triumph, the Sandinistas used posters primarily to express positive themes, such as the joy of revolutionary victory, the heroism of fallen martyrs, and the celebration of national campaigns, such as the drive to stamp out illiteracy. Typical of these early posters was a simple black and white photo of a smiling girl with the caption "Nicaragua: Una revolución por la vida" and a 1982 May Day poster illustrated with workers bearing tools and arms calling for defense of the nation "through the construction of socialism." National heroes, even though not associated with the cause of the Sandinistas, were skillfully exploited to encourage support for the revolution. Martyred journalist Pedro Joaquín Chamorro's name was used to call for unity behind the FSLN Frente Sandinista de Liberación Nacional in one 1980 poster and noted poet Rubén Darío was displayed prominently on another celebrating cultural independence.

No hero was more effectively propagandized than Augusto César Sandino. A giant outline of the anti-imperialist leader still looms above a hill overlooking Managua: his gaunt figure, high boots, and oversized "ten-gallon hat" identifiable to every Nicaraguan. Such imagery was constant in the flurry of posters that appeared in 1984 commemorating the 50th anniversary of Sandino's assassination. "Sandino vive" was a constant proclamation, and his face or silhouette frequently appeared with a rising sun, a smoking volcano, a rifle, and most often with a dove of peace (fig. 1).

The Sandinistas were particularly effective in gaining early international support and aid by publicizing their campaign to eradicate illiteracy. Posters were a key element in this publicity, as the "milicias obreras de alfabetización" and a "Nicaragua victorioso sobre el analfabetismo" were identified equally with the national blue and white flag as well as with the red and black banner of the Sandinistas. The slogan of FSLN founder Carlos Fonseca, "y también enséñeles a leer," was used to advantage in this campaign, as was the recurring imagery of peasants, soldiers, women, and children learning to read before volcanoes or a rising sun.

Another positive theme expressed through the posters of the Sandinistas was the liberation theology movement, presenting an image of Christ as the champion of the oppressed and opponent of social and economic injustice. A striking series of giant full-color posters, each created by art students at Ernesto Cardenal's center at Solentiname and financed by an organization in Germany, presents fifteen stages of Christ's ordeal from sentencing to crucifixion. Supported by the masses

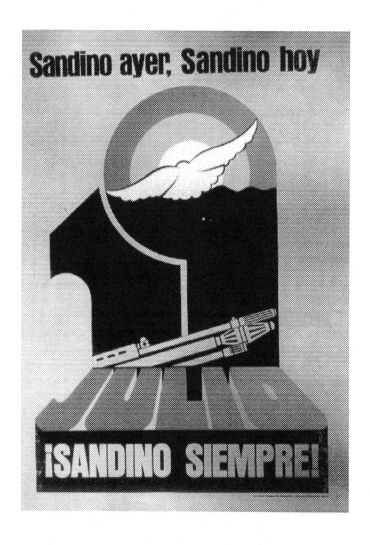

Fig. 1.  Familiar Sandinista symbol and proclamation

bearing red and black FSLN placards, Christ is seen as a humble campesino. The soldiers of the Roman Guard, on the other hand, wear the uniforms of Somoza's National Guard or are labeled as "CIA." The well-dressed bourgeoisie watch approvingly as Jesus is paraded to his death, bearing signs that read "Viva Somoza" and "Muere Jesús." A familiar scene is a peasant rising from the cross as the masses watch below.    Yet another poster shows Sandino and Carlos Fonseca, presumably in heaven, holding the Nicaraguan and FSLN flags and surrounded by children.

The happy images and positive themes that characterized the posters of the first few years of the Sandinista regime soon gave way to more urgent and negative ones.    In 1984 and 1985, as the U.S. economic boycott and the Contra war brought mounting economic deprivation, physical destruction, and death, posters were increasingly dedicated to anti-imperialism and national defense. The Sandinistas found themselves confronted by the same enemies: the defeated remnants of Somoza's National Guard, backed by Washington. "El enemigo es el mismo," screamed one huge poster, "Muerte al Somocismo—muerte al imperialismo." The majority of visual displays utilized the U.S. flag and American eagle as symbolic of war atrocities and opposition to other national struggles of liberation like Korea, Cuba, and Vietnam.    The eagle often appears as a menacing bird of prey and the Stars and Stripes as a banner of destruction, such as one poster with the flag superimposed above black clouds which rain gloom and lightning on bands of peasants mourning their war dead.    As common as the imagery of the Yanqui "enemy of humanity" (as the Sandinista anthem states) is the recurrent theme of an inevitable U.S. defeat, like the portrayal of Uncle Sam fleeing before Sandino's shadow or Superman writhing while held firmly in a clenched fist. Exploiting the history of Washington's frequent interventions in Nicaragua, one cartoon poster shows four drawings of an unhappy and battered Uncle Sam fleeing from Nicaragua in 1856, 1933, 1979, and 1984.    It is interesting to note that such posters almost always employed symbolic imagery rather than specific personalities to illustrate American imperialism and its agents. Curiously, in not one of the posters in the collection presented appears a portrait or drawing of Ronald Reagan, nor a specific visual or verbal reference to the hated Contras. Sandinista cartoon art found in the press, periodicals, and monographs, however, excoriated the American president unmercifully.

As the war escalated and more troops were needed to repel Contra attacks, more posters were printed to encourage patriotism in

defense of the motherland. The slogan of the eighth anniversary of the revolution in 1987, "Aquí no se rinde nadie," was emblazoned on a number of such releases (fig. 2). To encourage young men to enlist or cooperate wholeheartedly with national military inscription, draftees (or *cachorros*) appeared on a number of posters being embraced by sweethearts or mothers, or greeting each other in solidarity as they prepared to leave for the front. Patriotic appeals were often directed at women, as in an early 1983 defense poster to commemorate the day of the Nicaraguan mother. "Madre," proclaimed the text, "tu heroismo sustenta la moral de combatiente." Young women were also encouraged to join in the defense effort. The single most publicized photo to emerge from the revolution, featured on postcards, posters, and painted on a number of government buildings, was of a smiling young woman breast feeding her child with a rifle slung over her shoulder. "Nicaragua debe sobrevivir" reads the text in Spanish and English—"Nicaragua must survive" (fig. 3).

The posters issued by the Contra resistance coalitions, the Unidad Nicaragüense Opositora and the Resistencia Nicaragüense, were far fewer in number than the Sandinista releases but equally emotional in their appeal. In resistance posters, however, it was the Sandinistas who were portrayed as the "enemies of mankind." Sandinista violations of human rights were frequent themes, for example the depiction of a fatherless family weeping because the father was one of 10,000 Sandinista political prisoners or the illustration of a faceless man behind bars. "El Sandinismo me condenó a 30 años de prisión," laments the text. "My crime—to be democratic and oppose Sandinista communism." Other posters effectively exploited specific instances of Sandinista repression. In response to the government's closure of the daily *La Prensa* in 1986, a poster was issued which carried the photo of a typewriter wrapped in chains with "FSLN" written on the padlock. Unlike the Sandinistas, who refrained from attacking individuals on their posters, the Contras seemed to take particular delight in lampooning president Daniel Ortega. In one small poster there appears a photo of Ortega and Libyan leader Muammar Kaddafi with their upraised hands linked together. "La alianza terrorista Kaddafi-Ortega," the caption glares. "Lo esta Vd. viendo!!" (fig. 4). In another 1986 poster a huge caricature of a sheepish Ortega is shown signing the Arias regional peace agreement using a machine gun as a fountain pen.

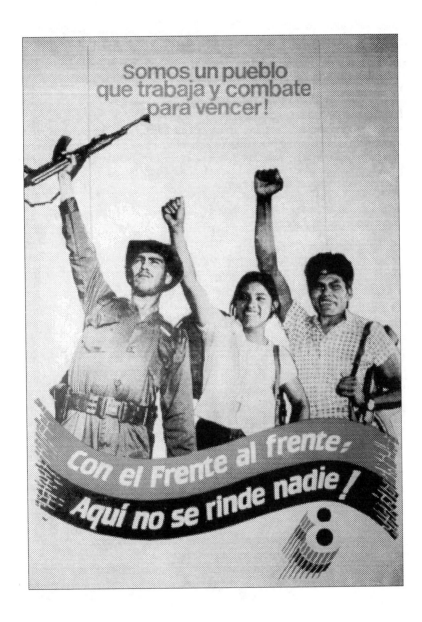

Fig. 2. A militant Sandinista poster

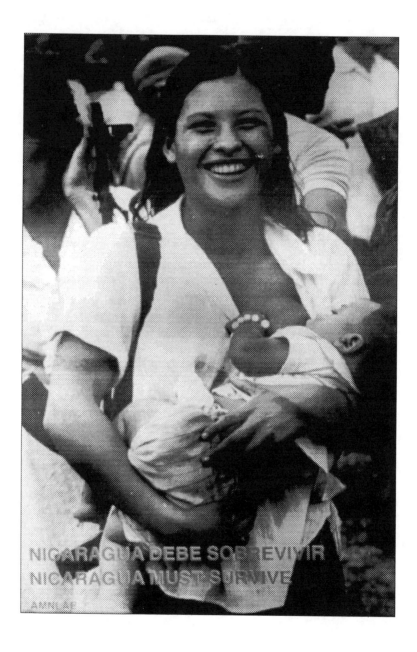

Fig. 3. The most publicized Sandinista poster

Fig. 4.   Contra poster depicting Daniel Ortega
with Libyan leader Muammar Kaddafi

Strong similarities existed between the two sides in the imagery used to win the hearts and minds of their countrymen. The Contras frequently used images of women and mothers grieving over sons slain in the pursuit of freedom, waiting in Costa Rica for the escape of their sons from behind the Sandinista "Berlin Wall," or fleeing to Costa Rica in rags from the "Sandinista terror." In another giant color poster an old woman calls the Sandinistas "asesinos y cobardes" and describes how she lost her three sons to state repression. Perhaps the most effective of all Contra posters in its visual and emotional impact is a huge full-color photo of a young Contra rebel cradling an orphaned infant in his arms. "El fusil y la ternura," states the caption. "Dramáticos símbolos de un pueblo que lucha por su libertad en contra de la esclavitud comunista." The symbolism, although coming from the other side, is strikingly similar to that used by the Sandinistas in their poster of the revolutionary woman bearing a rifle while breast feeding her infant.

When considering the effectiveness of the propaganda of the Nicaraguan resistance, it is important to bear in mind that only a small fraction of Nicaraguans living in their homeland ever saw it. The possession or display of such material in a nation at war was to invite arrest and imprisonment. Indeed, only two posters of internal dissent are included in the collection, and they were not obtained in the open information marketplace. The posters of the Contras, therefore, were designed primarily to draw Nicaraguan refugees residing in other Central American countries more actively into the resistance movement; to sway public opinion in Honduras and neutral Costa Rica to a more anti-Sandinista viewpoint, and, finally, to influence congressional support in the United States to back the Reagan administration's policy of financial and military aid to enable the Contras to overthrow the Sandinistas. An English text accompanying the Spanish was not uncommon on resistance posters and in their periodical literature (fig. 5).

The attempt by the resistance movement to sway opinion in Honduras met with mixed results. While the government, pressured by the United States and elements within its own army, allowed Nicaraguan rebels to occupy the southern provinces, a significant dissenting force developed to protest that policy. That force, led by peasant groups, labor unions, women's organizations, human rights activists, and leftist elements, was the third source of posters to emerge during the Nicaraguan war.

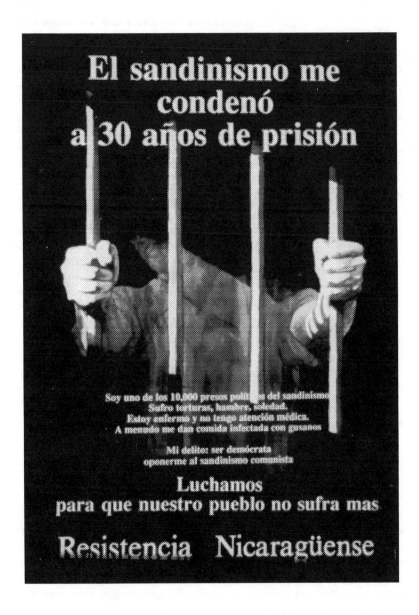

Fig. 5. Nicaraguan resistance poster

The message emerging from their literature and posters was clear: the expulsion of Contra forces from Honduran territory and an end to their government's policy of renting out Honduras as a U.S. aircraft carrier. Once again the familiar images of U.S. imperialism are found, this time to protest the escalation of American troops and bases in Honduras. Typical posters from more moderate groups such as patriotic coalitions and women's organizations portray a young couple attacking a U.S. flag while decrying "intervención gringa" and a machine gun bearing a U.S. flag embedded in a map of Honduras. Radical factions such as leftist student organizations and militant labor unions use more explicit imagery and harsher rhetoric, for example, a skeleton head of Uncle Sam leering over a map of Honduras with the caption "Muerte, SIDA y prostitución infantil" and a photo of a U.S. Marine with the words "Fuera Yanqui basura, fuera bestias rubias." Another popular image employed by critics of U.S. policy is a red, white, and blue military boot crunching down on a Honduran map (figs. 6, 7).

As in the case of Nicaraguan posters, most attention was directed toward the specter of U.S. imperialism, with only minor focus of the Contras themselves. In one large flyer, indirect reference is made to the Nicaraguans. Bearing the caption "$20 milliones," referring to a package of economic aid recently voted by Congress to the rebels, a vampire-like Uncle Sam is seen with his fangs embedded into a bleeding Honduras. Perhaps the most effective and well-disseminated of the dissenting posters of Honduras uses the familiar imagery of a woman to represent national interests. Striking in its color and simplicity, the poster shows a vigorous, clear-eyed beauty in a dress of the Honduran flag with her arms outstretched in an appeal. "La patria," proclaim bold letters, "no se vende, no se alquila, no se presta. Fuera tropas gringas. Fuera Contras."

It is difficult to evaluate the impact and effectiveness of posters on public opinion. Sandinista posters were especially prominent in government buildings, public facilities, and the offices of internationalist support groups. It is doubtful if any posters from whatever side swayed or converted opinion on their own. But they were at least a strong reinforcing agent for the faithful, creating a greater sense of struggle and solidarity among participants. They are of more contemporary value as a special and dramatic body of primary documentary material for use in both research and teaching. Libraries that have developed such collections and have found methods to make them accessible are to be applauded. If exploited as a supplementary source in investigations and utilized as a didactic tool, posters have great educational

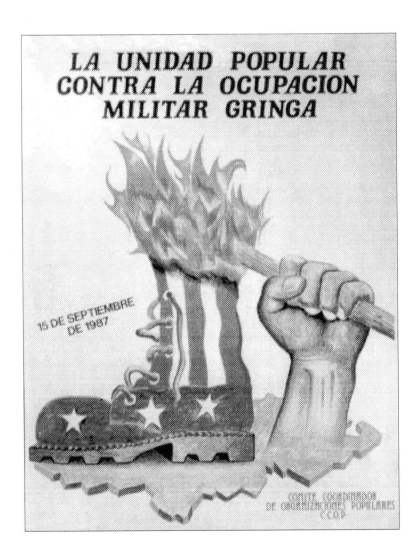

Fig. 6. Honduran dissent poster

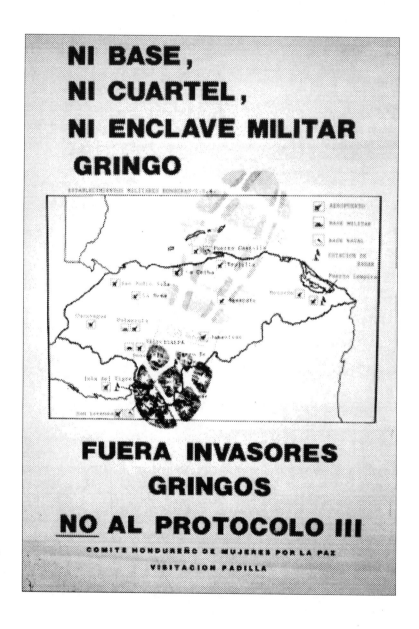

Fig. 7.  Honduran dissent poster

potential. They may be employed as a means to identify the trends and factions of historical controversies in an entertaining and impressionable fashion; to portray the ideals and rhetoric of participants through a medium that conveys emotional as well as intellectual content; and to reinforce an understanding of political movements or social conflicts through the unique and lasting power of visual imagery.

## APPENDIX
### Posters of the Sandinista Revolution

### Poster Information Key

Poster size: (18x12, etc) = size of original poster in inches

Color key:　　fc　= full color　b/w　= black and white
　　　　　　　bl　= blue　　　　r　　= red
　　　　　　　y　　= yellow　　　o　　= orange

Date or approximate date of issue

Organization or publisher issuing poster

Graphic form:　　il　= illustrated
　　　　　　　photo　= photograph
　　　　　　　ar　= art reproduction
　　　　　　　　　　(artist indicated when known)

Text on poster: Noted in italics

Brief physical description of graphics

Information on the availability of slide transparencies of the posters on this list may be obtained by writing me at: P.O. Box 16176, Chapel Hill, NC 27516-6176.

### Sandinista Posters
#### Commemorative
1. *Defendemos la patria por la construcción socialista—1 de mayo.*
   33x21, fc, 1982, Coordinadora Sindical de Nicaragua, il.
   Cheering workers bearing tools and arms.

2. *Nicaragua; una revolución para vida* (includes lengthier quote by P. Casaldaliga).

> 18x12, b/w/r, circa 1981-1984, Centro Antonio Valdivieso, photo.
>
> B/w photo of smiling Nicaraguan girl.

3. *1980: Unidad en la reconstrucción FSLN. Jornada pro-unidad nacional Pedro Joaquín Chamorro.*

> 22x16, w/bl/r, 1980, Secretaria Nacional de Propaganda de Educación Política, FSLN, il.
>
> Outstretched hands holding tools and other symbols of reconstruction.

4. *Rubén Darío: V Jornada de la Independencia Cultural.*

> 18x13, fc, 1986, Ministerio de Cultura, ar by José Salomé García Riviera.
>
> Portrait of Rubén Darío.

5. *Carlos Fonseca Amador: comandante en jefe de la revolución popular Sandinista, 1936–1976.*

> 25x16, fc, 1981, Ministerio de Educación, ar by Rubén Cuadra.
>
> Portrait of Carlos Fonseca.

6. *AMNLAE.*

> 23x17, b/w, circa 1985–1987, Asociación de Mujeres Nicaragüenses Luisa Amanda Espinoza (AMNLAE), photo.
>
> Daniel Ortega in midst of crowd, being embraced by elderly woman.

7. *Luis Alfonso: tu ejemplo vive en nuestra alegría.*

> 22x17, b/w, circa 1980–1983, Asociación de Niños Sandinistas Luis Alfonso Velásquez Flores, il.
>
> Illustration of young boy playing with blocks stacked to form the name "Luis."

8. *V Congreso Nicaragüense de Ciencias Sociales 1986: agresión externa, sobrevivencia y democracia popular.*

> 17x12, fc, 1986, Asociación Nicaragüense de Científicos Sociales, il.
>
> Abstract images of workers and soldiers.

9. *A 7 años defendiendo la patria orgullosas de ser mujer.*
    24x17, w/bl/red, 1986, AMNLAE, photos.
    Seventh anniversary poster. Various photos of women soldiers and workers superimposed on a large "7".

10. *Nada menos de ser mujer. 1 Seminario sobre la Mujer Joven, Managua.*
    22x16, b/w/r, circa 1989, Instituto Nicaragüense de la Mujer, photo.
    Photo of young Nicaraguan woman.

11. *II Congreso Latinoamericano de Derechos Humanos, Managua.*
    25x18, fc, 1989, Comite Permanente de Derechos Humanos de Nicaragua, il.
    Dove of peace and olive branch over map of Nicaragua.

12. *Junio, mes del medio ambiente en Nicaragua.*
    24x18, fc, 1989, Centro Inter-Eclesial de Estudios Teológicos y Sociales (CIEETS), ar.
    Children's art, with trees and sun.

13. *Nicaragua 1979–1989: diez años de cooperación con la Solidaridad Internacional.*
    28x20, fc, 1989, Fundación Augusto C. Sandino, ar by Harald.
    Map of Nicaragua illustrated with geographic, economic, social, and political points of interest.

14. *2 Encuentro Nacional de Mujeres de las Fuerzas Fundamentales. A 10 años de la conquista AMNLAE por el futuro.*
    21x15, b/w/r. 1989, Casa Sandinista de Trabajadores, AMNLAE, photo.
    Woman at desk with photo of Sandino in background. 10th Anniversary poster

15. *Barricada: al encuentro de sus lectores. X aniversario de barricada.*
    24x16, b/w/r. 1989, La Barricada, il.
    Outline of heart in black and red.

16. *Diez.*
> 24x16, b/w/r, 1989, La Barricada, il.
>> 10th Anniversary poster. Five hands raised in victory sign.

17. *Reforma y conquista: América Latina 500 años después.*
> 24x16, fc, 1989, CIEETS, il.
>> Books, a cross, an Indian, and a Spanish vessel.

18. *Venceremos.*
> 26x19, bl/r, circa 1980–1984, n.p., il.
>> Map of Nicaragua between fingers spread in victory sign, flanked by rifles.

19. *Patria libre o morir.*
> 26x19, w/bl/r, circa 1980–1984, n.p., il.
>> Soldier with machine gun raised above his head.

20. *En el 8 de marzo - dignas, valientes, decididas en la lucha por la paz.*
> 22x15, b/w/r, circa 1982–1984, AMNLAE, photo.
>> Photo of smiling Nicaraguan woman.

21. *El cuatro de noviembre vota.*
> 17x11, b/w/r. 1984, Consejo Supremo Electoral, il.
>> Hand with pen marking ballot. This and the following five posters are government and FSLN posters from the 1984 election.

22. *Votar es facil.*
> 28x19, fc, 1984, Consejo Supremo Electoral, il.
>> Worker with sample ballot in hand, with six cartoon illustrations outlining the steps for voting.

23. *Tu voto decide—respeto y garantía del voto popular.*
> 18x12, b/w/r, 1984, Consejo Supremo Electoral, il.
>> Hand placing ballot in box.

24. *For the first time in history, we are going to elect our president, vice president and representative to the National Assembly. To elect you have to vote, but first you have to register.*

> 20x14, b/bl/w, 1984, Consejo Supremo Electoral, photo/il.
>
> Worker with welding helmet and ship. This English poster was designed for display on Nicaragua's Atlantic coast. The same poster was also printed with text in Indian languages.

25. *Boleta electoral para representantes a la Asamblea Nacional.*

> 8x13, fc, 1984, Consejo Supremo Electoral, il.
>
> Sample ballot for 1984 elections with 7 participating parties.

26. *Daniel Ortega para presidente: seguimos con el frente.*

> 34x21, b/w/r, 1984, FSLN, photo.
>
> Ortega with admirers with fist raised in the air.

## *Augusto C. Sandino*

27. *Sandino vive en la lucha por la paz.*

> 20x15, fc, circa 1983–1985, Departamento de Propaganda y Educación Política (DEPEP), ar.
>
> Face of Sandino behind a volcano, with lake and dove of peace in foreground.

28. *A cincuenta años A.C. Sandino vive.*

> 23x15, fc, 1984, DEPEP, ar by Arnoldo Guillen.
>
> Portrait of Sandino.

29. *19 de julio: Sandino ayer, Sandino hoy, Sandino siempre.*

> 21x17, fc, circa 1984–1986, Secretaria Nacional de Educación Política, il.
>
> Sun, dove of peace, and rifle superimposed over a large 19.

30. *50 manira—Sandino rayasa.*

> 21x15, w/r/y, circa 1981–1984, n.p., il.
>
> Portrait of Sandino on red background, with text in Indian dialect.

31. *Nicaragua hoy.*
    19x16, b/bl/r, 1981, n.p., il.
    Small portrait of Sandino over large letter.

32. *Sandino.*
    22x10, fc, 1986, DEPEP, ar by Rubén Cuadra.
    Famous full length portrait of Sandino.

33. *Mientras Nicaragua tenga hijos que la amen, Nicaragua será libre.*
    *Homenaje 51 aniversario a A.C. Sandino.*
    22x17, r/w, 1985, n.p., il.
    Soldiers and workers superimposed over figure of
    Sandino.

## Literacy Campaign

34. *Venceremos en la alfabetización con tu ayuda: milicias obreras de*
    *alfabetización.*
    26x18, fc, circa 1980–1983, Sindicato José Jerez Almacén, il.
    Hand raised in victory superimposed over Nicaraguan
    and FSLN flags, with reading glasses and pencils
    beneath.

35. *¡Hemos cumplido, dirección nacional ordene! Nicaragua: territorio*
    *victorioso sobre el analfabetismo.*
    16x11, fc, 1980, Secretaría Nacional de Propaganda y
    Educación Política, il.
    Pencils bearing flags of Nicaragua and FSLN.

36. *Nicaragua: una educación en pobreza. "Y también enséñeles a leer"*
    *. . . Carlos Fonseca Amador.*
    18x12, b/w, circa 1981–1983, Centro Antonio Valdivieso,
    photo.
    Elderly woman and child reading in classroom.

37. *Alfabeticemos. En ciudad sandino el amanecer dejará de ser una*
    *tentación erradicando el analfabetismo. ¡Por la patria y el futuro*
    *todos alfabetizar!*
    16x12, fc, circa 1981–1983, n.p., ar by A. Fuentes.
    Peasant couple learning to read before a rising sun and
    a volcano.

38. Untitled.

17x12, b/w, circa 1984–1985, CAV, Centro Antonio Valdivieso, photo.

Soldier with rifle at his side, teaching a youth to read.

### Liberation Theology

39-53. *Viacrucis de Solentiname* (series)

20x27, fc, 1984–1985, Peter Hammer Verlag/Public Forum/Asociación para el Desarrollo de Solentiname, ar of primitive art from Solentiname.

Each poster is a reproduction of a painting by different artists from Solentiname. Each represents a stage in the ordeal of Christ's suffering and crucifixion, presented with the values of liberation theology and in the context of revolutionary Nicaraguan politics.

54. *Mural del ciclo pictórico. Historia de Nicaragua—la resurrezione.*

27x19, fc, circa 1985–1986, Impreso de Comunicazione, Italia, ar by Sergio Michilini.

Peasant rising from the cross, supported by workers, soldiers, and children.

55. *Nicaragua: la solidaridad es la ternura de los pueblos.*

27x20, fc, circa 1985–1987, Gráfica Isidori, Italia, ar by Sergio Michilini.

Peasant rising from cross with worker and peasants below.

56. *Mural del ciclo pictórico: historia de Nicaragua—un pueblo nuevo.*

27x29, fc, circa 1985–1986, Impreso de Comunicazione, Italia.

Sandino and Carlos Fonseca with Nicaraguan and FSLN flags, surrounded by clouds and children.

57. *Navidad; Jesús Dios con nosotros—nace pobre entre los pobres.*

22x17, fc, 1981, n.p., ar by Cerezo Barredo.

Joseph, Mary, and the Christ child with biblical quotes stressing the church of the dispossessed.

58. *VIII centenario del nacimiento de Francisco de Asís. Los pobres construyen la iglesia del Cristo.*

   23x17, fc, 1982, Centro Antonio Valdivieso, ar by Cerezo Barredo.

   Asís and campesino constructing a church.

59. *María de la Paz ruega por tus hijos de Centroamérica.*

   21x12, b/w/r, 1983, Centro Antonio Valdivieso, ar by Cerezo Barredo.

   Virgin with Christ child reaching for dove of peace.

60. *Desde Heinrich Böll en los 60 años de Ernesto Cardenal.*

   23x17, fc, circa 1985, Ed. Nueva Nicaragua, photos.

   Photos of altar in a church and of Cardenal greeting Pope at Nicaraguan airport, with additional text.

61. *Vencedora del fiero dragón—insurrección evangélica.*

   27x19, fc, 1985, Companic, il.

   Virgin praying while stepping on serpent.

62. *Yo soy el camino—insurrección evangélica.*

   28x20, fc, circa 1985, Companic, il.

   Christ with arm raised.

63. *Vos sois el dios de los pobres, el dios humano y sencillo, el dios que suda en la calle, el dios de rostro curtido, por eso es que te hablo yo así como habla mi pueblo.*

   27x19, fc, circa 1985, Ministerio de Cultura, photo.

   Face of elderly campesino above text.

64. *Les anuncio una gran alegría; hoy nace un salvador que derriba a los poderosos y enaltece a los humildes. Nicaragua: cada día construyendo y defendiendo la paz.*

   23x18, fc, 1986, CEPA, ar by A. Fuentes F.

   Campesinos and soldiers before infant peasant.

65. *20 aniversario de nacimiento de las comunidades eclesiales de base—parroquia San Pablo Apostal. A XX años de fundación con Cristo y la revolución.*

> 21x15, fc, circa 1985–1987, il.
>
> > Illustration of cross bearing a peasant who is stabbed by a dagger from which hangs the U.S. flag. Below peasants take communion.

## Anti-Imperialism

66. *El enemigo es él mismo—muerte al somocismo, muerte al imperialismo.*

> 15x23, fc, circa 1980–1983, DEPEP, photo.
>
> > Military prisoners with shaved heads before large photo of Somoza, whose face is marked with a black X.

67. *Como Vietnam, Cuba y Corea, ¡Nicaragua vencerá!*

> 22x34, b/w/r, circa 1980–1984, DEPEP, il.
>
> > Fists superimposed over U.S. flag, with detailed texts on each country mentioned.

68. *El enemigo es él mismo—muerte al somocismo, muerte al imperialismo.*

> 21x34, b/w/o, circa 1981–1984, DEPED, photos.
>
> > American eagle superimposed over various photos of war atrocities.

69. *Nicaragua: paz/peace, vida/life.*

> 18x12, fc, circa 1985–1987, Agencia Nueva Nicaragua, il.
>
> > Colorful bird under bright sun, with a group of peasants beneath. On the other side of the bird clouds and lightning threaten beneath a flag of the U.S. while peasants mourn over a grave.

70. *Exigimos respeto a nuestra libertad e independencia. Quinto aniversario tana—soberanía.*

> 22x17, fc, 1986, Tribunal Anti-Imperialista de Nuestra América (TANA), il.
>
> > Uncle Sam fleeing with hat on ground, before a figure of A.C. Sandino looming from the mountains.

71. *No a la intervención en Centroamérica. Ni se vende ni se rinde.*
    16x12, fc, circa 1986–1987, CEPA, il.
    Hand clutching a writhing figure of Superman.

72. *Seguimos de frente con el frente.*
    15x21, fc, 1984, DEPEP, il.
    Four cartoons depicting Uncle Sam being repelled from
    Nicaragua in 1856, 1933, 1979 and 1984.

73. *II Concurso Internacional de Caricatura Anti-imperialista.*
    15x10, fc, 1984, TANA, il.
    Uncle Sam suspended above the points of upturned
    pens. Two volumes, now collectors items, were
    published as the result of these International Anti-
    Imperialist cartoon contests. See *El humor como arma
    de la lucha ideológica.* 2 Vols. (Managua: TANA, 1984,
    1985).

74. *II Festival de la Nueva Canción Latinoamericana: concierto por la
    paz y la no intervención en Centroamérica. Managua.*
    21x14, fc, circa 1984–1986, n.p., il.
    Dove superimposed over musical chords and a guitar.

75. *Convertirán sus espadas en arados y sus lanzas en azadones. Paz y
    bien para todos.*
    23x14, fc, 1988, Centro de Promoción Agraria, il.
    Contra soldiers in various stages: killing a peasant,
    surrendering his arms, embracing workers, and accepting
    tools. Scenes are superimposed on map of Nicaragua.

## National Defense

76. *Juntos en todo. ¡Aquí no se rinde nadie!*
    23x17, w/bl/r, 1986, AMNLAE, photos.
    Interlinked symbols of male and female.

77. *Somos un pueblo que trabaja y combate para vencer. Con el frente
    al frente. Aquí no se rinde nadie.*
    22x16, w/bl/r, 1987, Servicio Militar Patriótico, il.
    Soldiers and workers with arms raised.

78. *Yo, ya me inscribí en el servicio militar patriótico.*

    22x14, b/w/bl, circa 1982–1984, n.p., photo.

    Youth hugging a young woman, with text written on back of his shirt.

79. *Estoy orgullosa de vos—todo para los frentes de guerra, todo para los combatientes.*

    17x22, b/w/bl, 1984, DEPEP, photo.

    Photo of young woman embracing a young Sandinista solider.

80. *Aquí tenemos cachorros cumplidos. Seguimos venciendo.*

    22x16, fc, circa 1986–1988, n.p., il.

    Two conscripts, one in uniform with rifle raised, greeting each other in solidarity.

81. *Madre, tu heroísmo sustenta la moral de combatiente. 30 marzo— Día de Madre Nicaragüense.*

    19x30, b/w/o, 1983, DEPEP, photo.

    Photos of mother and daughter with FSLN soldier superimposed.

82. *Nicaragua debe sobrevivir—Nicaragua must survive.*

    23x17, b/w/r, circa 1984–1986, AMNLAE, photo.

    Smiling young woman breast feeding her infant, with rifle slung over her shoulder.

83. *A fortalecer las milicias locales—esta revolución podría ser agregida, pero jamás conquistada.*

    21x34, b/y, circa 1980–1983, DEPEP, il.

    Soldiers in combat.

84. *El FSLN es la forma superior de organización del pueblo.*

    22x34, fc, circa 1980–1983, DEPEP, photos.

    Six photos of FSLN organizational activities.

85. *Resistiremos—y venceremos.*

    17x21, b/w/y, circa 1980–1983, DEPEP, photo.

    Two Sandinista soldiers manning a machine gun.

86. Untitled.
    21x34, b/w, circa 1980–1983, DEPEP, il., photos.
    Various photos and illustration of Sandinista soldiers.

87. *Defensa y producción—una sola trinchera.*
    22x16, fc, circa 1981–1984, DEPEP, il.
    Tractor and military tank.

88. *El pueblo de Nicaragua no se rendirá.*
    26x19, b/w/bl, circa 1982–1985, n.p., photo.
    Soldiers and workers with fists raised in solidarity.

89. *Nicaragua victoriosa—ni se vende ni se rinde. XII Festival Mundial de la Juventud y Estudiantes.*
    24x18, fc, 1985, Dirección Política del Ejército Popular Sandinista, ar by Darform.
    Soldier with machine gun and dove of peace on his shoulder.

90. *1985—Por la paz todos contra la agresión. Carlos Fonseca.*
    21x13, fc, 1985, Comité Nicaragüense por la Paz, il., photos.
    Il. of Fonseca and dove of peace; photos of Sandinistas.

91. *A ponerse al día. Nicaragua victoriosa—ni se vende ni se rinde.*
    23x17, fc, 1985, Comité Preparatorio del VI Aniversario de la Revolución Popular Sandinista, photos.
    Sandinista peasants and workers with soldier.

### Internal Opposition

92. *¡A negociar con los obreros y no con la contra! Exigimos que el gobierno cumple con los obreros.*
    15x11, b/w, circa 1988, Partido Marxista–Leninista de Nicaragua, il.
    Illustration of worker.

93. *¡Nandaime es Nicaragua! Esquípulas II—libertad.*
    17x11, bl/w, circa 1988, Partido Social Cristiano, il.
    List of arrested protestors; il. of leader Agustin Jarquin.

## Nicaraguan Resistance (Contras)

94. *Una navidad sin presos políticos en Nicaragua. Más de diez mil claman al mundo por su libertad.*

     22x16, b/w/bl, circa 1985–1986, Unidad Nicaragüense Opositora (UNO), il.

     Family around Christmas tree weeping near a prison.

95. *El sandinismo me condenó a 30 años de prisión. Mi delito—ser democrático y oponerme al sandinismo comunista. Luchamos para que nuestro pueblo no sufra más.*

     24x15, b/w, 1989, Resistencia Nicaragüense (RN), il.

     Man in prison clutching bars, with face obscured.

96. *La "libertad de prensa" en Nicaragua.*

     20x17, b/w, circa 1986, UNO, photo.

     Typewriter wrapped in chains with "FSLN" on padlock.

97. *La alianza terrorista Kaddafi—Ortega. ¡Lo está vd. viendo! Combatimos al terrorismo sandinista. Digamos no al comunismo terrorista.*

     8x11, b/w, circa 1986, UNO, photo.

     Muammar Kaddafi and Ortega with hands clasped and arms raised.

98. *Ortega firmará acta de paz.*

     21x16, b/w, 1986, RN, il. by Arcadio.

     Caricature of Daniel Ortega signing regional peace agreement using machine gun as a pen.

99. *Nuestros hijos quieren ser libres. ¡Ayúdenlos! Resistencia nicaragüense.*

     16x10, b/w/bl, circa 1987–1988, RN, photo.

     Woman grieving over a fallen soldier.

100. *¿Cuando podré ver a mi hijo?*

     21x14, fc, 1989, RN, photo.

     Nicaraguan mother waits in Costa Rica for the escape of her son from Nicaragua. Additional text describes the Nicaraguan frontier as a "form of the Berlin Wall in the heart of America."

101. *Huyendo del terror sandinista. Grupo de mujeres y niños atravesando un punto ciego de la frontera entre Nicaragua y Costa Rica.*

    21x14, fc, circa 1988–1989, RN, photo.

    Campesinos entering Costa Rica from Nicaragua.

102. *Los sandinista me dejaron sin hijos. Movimiento de madres de presos políticos de Nicaragua.*

    21x14, fc, 1989, RN, photo.

    Grieving woman, with additional text describing the fate of her three sons at the hands of the Sandinista "asesinos y cobardes."

103. *El valor y el amor. Un soldado de la resistencia nicaragüense sostiene en sus brazos a un niño huérfano víctima de la guerra. El fusil y la ternura—dramáticos símbolos de un pueblo que lucha por su libertad en contra de la esclavitud comunista.*

    21x14, fc, circa 1988, RN, photo.

    Young Contra soldier holding an infant.

104. *Solidaridad para los que quieren democracia, libertad y paz en Nicaragua. La vía democrática para liberar Nicaragua.*

    18x14, bl/w, 1984, UNO, il.

    UNO logo surrounded by the wings of a dove.

105. *Exhiben cadáveres de rebeldes. Los hechos hablan más que las palabras.*

    13x8, b/w, 1985, UNO/Fuerza Democrática Nicaragüense, photo.

    Photo of slain Contra being brought into a Nicaraguan village draped over a mule.

106. *Comandante aureliano: Manuel R. Rugama A.—Médico, combatiente. Lucho por la salud de su pueblo y la libertad de su patria.*

    17x11, b/w/bl, circa 1988–1989, RN, photo.

    Photo of assassinated Contra leader giving medical aid to a child.

107. *Y este hombre está luchando por su libertad. ¿Lo estás tu? Unidad nicaragüense opositora.*
> 22x16, b/w, circa 1986, UNO, photo.
>> Photo of pair of worn combat boots.

*Note:* The Unidad Nicaragüense Opositora, the major umbrella group for most of the forces fighting the Sandinistas, was reorganized and became the Resistencia Nicaragüense in 1986.

## Honduran Protest

108. *Ante la intervención gringa luchemos por la independencia nacional.*
> 16x10, fc, circa 1986, Comité Coordinadora de Organizaciones Patrióticas (CCOP), il.
>> Young couple on map of Honduras, attacking U.S. flag.

109. *Para el gringo agresor—desprecio del pueblo.*
> 17x11, fc, circa 1986, Comité Hondureño de Mujeres por la Paz "Visitación Padilla" (CMVP), il.
>> Machine gun with U.S. flag embedded in map of Honduras.

110. *Tragedia, Vietnam, muerte, SIDA, prostitución infantil.*
> 8x11, b/w, circa 1985, Sindicato de Trabajadores Nacional de Energía Eléctrica (STENEE), il.
>> Skeleton head of Uncle Sam leering over Honduran map.

111. *Fuera tropas extranjeras, fuera yanqui basura, fuera bestias rubias.*
> 8x11, b/w, circa 1985, FESE-FAR, il., photo,
>> Letter X over photo of U.S. soldier carrying rifle and flag.

112. *Ni base, ni cuarte, ni enclave militar gringo. Fuera invasores gringos.*
> 16x11, fc, circa 1986, CMVP, il.
>> Imprint of U.S. military boot on map on Honduras, with U.S. bases indicated.

113. *La unidad popular contra la ocupación militar gringa.*
>    16x12, fc, 1987, CCOP, il.
>> U.S. boot on map of Honduras, with a hand holding a torch and setting fire to the boot.

114. *$20 millones.*
>    17x11, b/w, circa 1987, CMVP, il.
>> Reference to U.S. aid to Contras.   Uncle Sam is portrayed with fangs, biting into a map of Honduras.

115. *La patria; no se vende, no se alquila, no se presta.   Fuera tropas gringas—fuera contras.*
>    22x17, fc, circa 1987, CMVP, il.
>> Woman symbolizing Honduras with arms outstretched in a patriotic appeal.

116. *El odio a la esclavitud fermenta la libertad.*
>    17x14, b/w, circa 1984, CMVP, il.
>> Profile of Indian facing a Spanish conquistador and a U.S. infantryman.

117. *Uno para echar al conquistador.*
>    22x17, b/w/bl, circa 1985, CMVP, il.
>> Indian and workers with weapons raised in defiance.

118. *Hondureño; dentengamos la violencia gringa y el antipatriotismo gobermental.*
>    11x17, b/w, circa 1984, CMVP, photos.
>> Photos of President Azcona and George Schultz, with lengthy text denouncing U.S. military presence in Honduras.

119. *Asamblea nacional de mujeres por la paz, Comayagua, 1986.*
>    18x12, b/w, 1986, CMVP, il.
>> Bird of prey surrounded by aircraft, weapons, and tanks.

120. *El gringo es invador—saquemos el gringo.*
>    15x10, fc, circa 1986, CMVP, il.
>> Honduran woman threatened by U.S. troops and flag.

121. *Asamblea de mujeres. 8 enero—Día Internacional de la Mujer. Por la vida y por la paz.*

> 17x22, b/w, circa 1987, CMVP, il.
>
> Group of women rejoicing amidst doves of peace.

122. *Asamblea de mujeres por la paz. Día Internacional de la Mujer. Tegucigalpa.*

> 22x16, fc, circa 1988, CMVP, il.
>
> Workers sit before map of Central America and fence which spells "paz." Behind fence is a menacing eagle with U.S. flag.

123. *Julio 20: Día de Lempira, primer patriota hondureña. Seguimos tu ejemplo de lucha.*

> 17x11, fc, circa 1988–1989, Comite Patriótico Francisco Morazan, il.
>
> Statue of Lempira with weapon poised.

124. *7 de abril—Día de Dignidad Nacional. Los voces de nuestros héroes y mártires nos llaman a todos a cerrar filas contra el imperialismo yanqui.*

> 16x11, fc, 1989, CCOP, photo.
>
> Photo of demonstrators burning U.S. flag and troops in effigy during protest over kidnapping and extradition of Ramon Matta by U.S. drug agents.

125. *Semana de detenido—desaparecido. Vivos se los llevaron, vivos los queremos.*

> 17x11, fc, 1987, Comité de Familiares de Detenidos—Desaparecidos (COFADEH), ar.
>
> Painting of a chained figure writhing in agony surrounded by abstract figures of women and military men.

# 18. Latin American Posters at the Hoover Institution: The Lexicons of State and Society

## William Ratliff and George Esenwein

Since it was founded in 1919, the Hoover Institution has sought out all sorts of often unusual documentation on political developments in the twentieth century. One of the most colorful and graphic of these categories of documentation is posters. The Institution houses more than 100,000 posters from around the world. Of these, more than 825 are from 17 Latin American countries, the vast majority produced in or dealing with Chile, Costa Rica, Cuba, El Salvador, Honduras, Mexico, and Nicaragua.[1] In addition, there are dozens of posters found in other collections from other parts of the world that deal with Latin American themes, particularly Cuba, El Salvador, and Nicaragua, which were produced either by international organizations (the World Federation of Youth, for example) or by groups in other countries, among them the United States, Germany, and Great Britain.

The Latin American poster collection conveys, often with searing power if uneven artistic quality, the moods of some leaders or would-be leaders, movements and governments around the hemisphere, particularly during the post-1960 time period. Most of the posters came from countries or regions challenged by political, social, and economic stagnation or upheaval, often during civil wars or revolutions. Others originated in the United States with groups sympathetic to movements or governments abroad. These posters, cataloged and available for study or purchase on slide transparencies, range from stuffy, unimaginative bureaucratic propagandizing of some governments to fiery, dramatic revolutionary propagandizing by governments and student, labor, and guerrilla organizations.

Literary critic Susan Sontag has made the point that posters are more than just public notices: whereas the latter aim simply to inform or command, posters encompass a greater spectrum of themes and are directed at a much wider group of people.[2] Political posters such as the ones at Hoover are exhortatory, seeking above all to evoke an immediate response from their audiences. To achieve this, they appeal to the individual on several levels. Thus some are visually striking, using brilliant colors to help convey their message, while others employ

provocative images and/or symbols in order to engage the interest of the passing observer. Most are intended to arouse the intellect and passion in the face of hardship or perceived injustice; to compel one's commitment to the goals of a party or organization standing behind the poster; and to mobilize action in support of the cause put before the public in the poster itself.

The overwhelming majority of Hoover's Latin American posters are concerned with political and economic themes. Topics covered include World War II, U.S. policy in Latin American, civil war and revolution (especially in Central America and the Caribbean), electoral campaigns, one's duties as a citizen and/or revolutionary, and the virtues of a sitting government.

The orientation of the poster is almost always clearly demarcated. The leftist posters, for example, are vehemently anti-United States, equating the U.S. government with imperialism, repression, and terrorism. Typically, leftist posters use iconography to glorify the words and deeds of selected public figures. In some cases the heroes are largely or strictly national—the most obvious example being Carlos Fonseca Amador in Nicaragua—but often the figures most emphasized are transnational, calling for national and hemispheric struggle for liberation and self-determination. Foremost among the transnational figures is the Argentine Che Guevara, to a much lesser extent the Nicaraguan Augusto Sandino, but also, on occasion, such prominent historical individuals as Simón Bolívar.

Posters issued by center and right-wing groups project a different political reality. For the right, revolution is synonymous with social turmoil, and leftists are identified as terrorists. Like their ideological opponents, the right appeals to the viewer on an emotional level. In most instances, right-wing posters play on the public's fear of change and of the unknown, to convey their antirevolutionary message.

The posters were issued by governments, legal and illegal national interest groups, ranging from labor unions to revolutionary (or counterrevolutionary) movements, and by international interest groups, particularly those based in Cuba. The majority are from communist parties, national Marxist-Leninist fronts or movements in non-communist countries, and Cuban international organizations. They were acquired largely through the collecting efforts of the Hoover Institution's curators. Most were secured during excursions to Latin America, from book dealers in the United States and Latin America, or as part of a larger special collection of library/archival materials.

A variety of artistic styles and conventions are represented in the poster collection. Stylistically, some are unimaginative, particularly

electoral appeals.  Others reflect aesthetic values ranging from native art commonly found in street markets through the cheap commercialized tedium found in so many U.S. cities to the highly stylized art usually associated with an urbane community.

What follows is a bare bones survey of some of the notable country collections which we hope will give the prospective researcher/visitor a general idea of the types of Latin American posters that are to be found in the Hoover Institution.[3]

## Chile (118 + 2 versos)

This collection from Chile falls essentially into two sections, those released by and saluting the post-1973 government of Augusto Pinochet and those of groups opposing that government.  The Pinochet posters range from proclamations or what look like enlarged newspaper articles heralding accomplishments by the government in such fields as agriculture, youth affairs, and foreign policy, to unadorned, sometimes colorless, pictures of national scenes reflecting stability under the military government.  Although some of the revolutionary posters are austere, most are more dramatic, illustrating repression and need.  They were issued by such groups as the Communist Party Youth, the Movement of the Revolutionary Left (MIR), the Popular Unity (UP) coalition, under which Salvador Allende served as president from 1970 into 1973, among them photographs of Allende and poet Pablo Neruda, a member of the Central Committee of the Chilean Communist Party and winner of the Nobel Prize in Literature.

## Costa Rica (65 + 1 verso)

Posters from Costa Rica range from plain election photographs to more colorful ideological imagery.  Themes include elections, labor and student affairs, regional war and peace, among the latter a caricature of Nicaraguan President Daniel Ortega signing a peace agreement with a machine gun.

## Cuba (136 + 3 versos)

Cuban posters set the standard for posters produced in Latin America from the 1960s onward.  Most styles seem to be borrowed from the contemporary art world: the commercially successful graphics style of the American Peter Max, for example, is echoed in some Cuban posters depicting revolutionary struggles in Latin America.  In contrast to the Pinochet posters, where social tranquillity is stressed, Cuban posters of the 1960s and early 1970s in particular evoke a sense of flux or forward motion characteristic of an ever-changing society in

permanent revolution. Most posters dating from the Vietnam War era are notable for vibrant colors and theatrical/ornamental qualities, not unlike the "underground" poster art in the United States during the late 1960s, some with raised, clenched fists and many depicting Che Guevara in battle or in various stages of deification.

The main themes are domestic and international, with a heavy preponderance of the latter. Posters dealing with national themes focus on development—from education and attitudes to agriculture—and national defense. Recurring international themes are the evils of "U.S. imperialism" and international solidarity in the face of foreign intervention. In a number of posters, the United States is challenged on both the domestic and international fronts. The militant black power movement in the United States during the late 1960s, for instance, is presented as a justifiable reaction to domestic racial repression. In one poster, Uncle Sam is depicted as a sniveling coward yelling "Mommy!" in response to the international community's condemnation of U.S. policies, while others echo Che Guevara's call for "two, three, many Vietnams." Many posters express international solidarity with other countries of Latin America, particularly Puerto Rico, or with Latin revolutionary heroes, including Sandino and the Colombian guerrilla/priest Camilo Torres. There are posters in solidarity with movements or governments in a dozen African countries, prominent among them Angola, and several in Asia, especially Vietnam.

## El Salvador (27)

The main themes in posters from El Salvador include elections, with campaign-type photographs; peace, with a number of white doves linked to resistance to U.S. policies. In a few posters, there is some powerful symbolism/iconography that link Jesus Christ with the revolution. The main issuing organizations are the Farabundo Martí National Liberation Front (FMLN) guerrillas, the Revolutionary Democratic Front (FDR), headed by Guillermo Ungo and Rubén Zamora, and their associated organizations.

## Honduras (122)

This collection from Honduras consists mostly of poster photographs, some of political candidates in elections, a typical one promising "a new sunrise with Azcona," and some of the prisoners. The imagery is often grim, in dramatic black-and-white or in color: a U.S. eagle digs its talons into a bloody Central America, put out by one of the most active groups, the Committee of Honduran Mothers for Peace

(CHMP); a cadaver of Uncle Sam represents "Yankee intervention"; while stylized mothers scream for the return of the disappeared. In several peace is equated with attacks on the United States, with Che Guevara leading the way. One of the few anti-communist posters proclaims, "God is the Truth; Communism doesn't believe in God."

### Mexico (99)

A number of posters in the Mexican section date from the early decades of this century. Because several historical periods are represented, styles vary from that characteristic of Diego Rivera and the Mexican school of muralists through travel come-ons to the rather drab styles found in political campaign materials. Several are pro-United States, one depicting Abraham Lincoln and Benito Juárez and saying, "Good Neighbors, Good Friends." One pro-communist poster condemns Diego Rivera as a Trotskyite traitor. Some posters are anti-United States. There are several dozen, some of them quite old and extremely rare, released by the Mexican Communist Party, which came from the large Rodolfo Echeverría Mexican Communist Party collection in the Institution's Archives.

### Nicaragua (259 + 7 versos)

The largest and most varied single collection at the Hoover Institution is that from and relating to Nicaragua. The overwhelming majority come from the Sandinista period beginning in 1979. Their main interrelated themes are the anti-United States, anti-Contra war, and national revolution. Revolutionary and Christian themes commingle in posters that define the civil struggle in Nicaragua in terms of the spiritual and physical salvation of the people. Some posters are didactic, ranging from a 20-part history series in black and white to a man sleeping at his desk, with the caption: "Every minute we do nothing we strengthen the enemy." Many depict revolutionary heroes, particularly Sandino, whose name was taken by one of the other leading heroes often depicted here, Carlos Fonseca, when the latter founded the Sandinista National Liberation Front (FSLN) in the early 1960s. Among the most dramatic posters is a shadow outline of Che Guevara's head, the only color being the red star on his cap, with the signature "Che."

Some posters are utilitarian: campaign materials from the 1984 election released by the Sandinistas—"Daniel Para Presidente"—and other contending parties. There is one series of pro-Sandinista posters in a popular, naive style, a virtual Christian passion play with the revolutionaries portrayed as the persecuted saviors of the people. One

in the series shows the revolutionaries—the central figure is clearly Guevara, whose cross bears the sign, "subversive"—who have been crucified by the enemies of the people.

As is common in Latin America generally, satire is a popular rhetorical device. Because the Sandinistas regard satire as an arm of the ideological struggle, it is frequently invoked in their poster works to underscore a political statement. An outstanding example of this genre is the poster-cum-map entitled "The World According to Reagan," which obviously owes its origins to the surrealist school of political satire. In this case, the United States is divided into two large social blocks: California, where Republicans and "True" Americans live, and the "Land of Democrats and Social Parasites." Bordering the United States is "The Land of Acid Rain" (i.e., Canada), "Thatcherland" (pictured as "a Subsidiary of Disneyland"), Corporation Japan, and the Soviet Union, a "land of liars and spies."

Sandinista posters also feature women and children in a positive light. Women are depicted as strong, independent members of society. They are shown performing a variety of essential roles, such as working in the fields and factories, fighting at the Front, maintaining the rearguard, and raising families. Their children represent the hope for the future and symbolize the generation that will reap the benefits from peace and economic progress that presumably will come about as a result of the Sandinista revolutionary movement.

Finally, there are several anti-Sandinista posters: one depicts a soldier's lower legs and worn out boots, with the caption, "This man is fighting for your freedom. What are you doing?" Another, with the caption "Free Press in Nicaragua," is a photograph of a typewriter with a chain around it and an FSLN padlock.

Although the posters summarized above mirror the beliefs and values of contemporary Latin American societies that have recently passed through—or are in the midst of experiencing—profound social and economic upheavals, there are, of course, other important themes reflected in Hoover's poster collection that we have not touched upon. Regardless of the specific ideological purpose they may be put to cultural issues are commonly featured in posters produced in nearly all the Latin American countries. There is also the aesthetic dimension of posters, which we have only alluded to but which may interest students of art and art history.

We hope the descriptive content of the summary will give the reader some idea of the research value of the poster collection at the Hoover Institution. We have found that posters deserve serious study,

not least because they reveal in manifold form information about the society from which they emanate. In addition, we believe that a careful examination of these posters can yield a useful lexicon of terms that can be used to decipher current conditions in Latin America.

## NOTES

1. The numbers of posters from Latin America are: Argentina (6), Bolivia (3), Brazil (12), Chile (118 + 2 versos), Colombia (6), Costa Rica (65 + 1), Cuba (136 + 3), Ecuador (2), El Salvador (27), Guatemala (7), Honduras (122), Mexico (99), Nicaragua (259 + 7), Panama (7), Peru (4), Uruguay (2), Venezuela (3).

2. See Susan Sontag, "Posters: Advertisement, Art, Political Artifact, Commodity," in Dugal Stermer, ed., *The Art of Revolution* (New York, NY: McGraw Hill, 1970), pp. vii-xxiii.

3. Not described here are posters from Argentina, Bolivia, Brazil, Colombia, Ecuador, Guatemala, Panama, Peru, Uruguay, and Venezuela.

# V. Textiles

# 19. Andean Textiles: Aesthetics, Iconography, and Political Symbolism

## David Block

The central Andes is justifiably famous for its textiles. One expert classifies them "among the finest fabrics ever produced." I suspect that in your browsing of pre-Colombian antiquities you have come across illustrations such as those from the abstract designs of Tiahuanaco or the colorful raiment of the Chimu.

Current research on the topic, and I refer you to the bibliography on Andean weaving (chap. 20), centers on textile production as a cognitive activity, a philosophy of visual and tactile ideas. But for this presentation, I intend to ignore these erudite interpretations and stress the textiles' aesthetic and historical properties.

Ironically, most of what we know of ancient Andean textiles comes from a lowland provenance, the desert coast that has preserved even this fragile medium for some 4,000 years.

There are unfortunately few benchmarks for reconstructing a chronology of cloth. Cotton twinings such as surviving fragments from Agua Prieta on the central coast date from ca. 2500 B.C.

Woolen yarns from camelids and heddle technology for pattern weaving appear for the first time in the graves of the Paracas culture, a millennium and a half later. From this time forward, the materials—both threads and dyes—and the techniques--principally the backstrap loom and dye mixing—were in place. The results are inspiring, to the eye and to scholarship.

Students of the Andes have long been impressed by the attention that the first European observers of the area devoted to cloth. The Spaniards saw the last flowering of Andean textile traditions, and while the conquistadores most highly prized precious metals, the Industrial Revolution had yet to dilute their sense of cloth as treasure.

You cannot really make an Andean presentation these days without citing J. V. Murra or projecting Guamán Poma de

---

*Editor's Note:* This paper, originally subtitled "A Script Set to Slides," has been edited for publication by the author.

223

Ayala's images. So I will make my bow toward tradition here at the outset.*

In an essay published a quarter-century ago, Murra gave a classic presentation of the economic and political contexts of cloth in the Tawantinsuyu. He argues that at the time of the Conquest, cloth was the most important commodity in a society rich in gold, silver, and food. Textiles served as the preferred gift between individuals, the main ceremonial good, and one of the principal obligations of subjects to the state. We know also that in Inca times, cloth, fashioned into raiment, denoted a person's status and geographic origin. Even the insignia of the Incaship was a red headband with fringes that fell down into the ruler's eyes (fig. 1; all illustrations follow the text).

More curious to European observers was the Andean Indians' belief in the magico-military importance of cloth. During the Spanish civil wars of the 1540s, the chroniclers noted that Indian troops believed that their enemies could be defeated by making effigies of their clothes. Martín de Morúa wrote in shock that after the Battle of Salinas, Indian allies of both the Pizarrist and Almargist armies stripped the dead and wounded followers of Almagro.

Thanks to surviving artifacts and contemporary descriptions, we have a fair idea of the history of Andean cloth from 1533 forward. I should point out that nearly all Andean cloth was shaped to utilitarian patterns, mostly clothing.

At least in Inca times, and probably well before, cloth production followed two identifiable traditions: *Q'ompi* (or cumbi to the Spanish ear), a fine tapestry weave, and *awasqa*, a rough patterned cloth produced in a village context. *Q'ompi* was a specialty, produced by state-supported, male weavers in a cottage industry setting. Its production did not long survive the Conquest. *Awasqa*, however, as more a subsistence activity, did not require state subventions and continues to be produced in some regions of the Andes today.

The basic pieces of feminine attire were the *acsu* or skirt, the *llicla* or shawl, and the *waka* or sash. A painting from the seventeenth century, showing a privileged woman of Indian tradition from the Lake Titicaca region, gives an idea of the colors these garments assumed (fig. 2).

---

*Murra's essay is "Cloth and Its Function in the Inca State," *American Anthropologist* 64, 4 (Aug. 1962), 710-728. The "definitive" edition of Guamán Poma is that edited by Murra and Rolena Adorno, Felipe Guamán Poma de Ayala, *El primer nueva cronica y buen gobierno*, 3 vols., 2d ed. (Mexico: Siglo XXI, 1988).

Men wore an *uncu* or long shirt, and *llacota* or cape sometimes gathered at the waist as Guamán Poma's representation of the Inca Manco Capac shows (fig. 3).

The other piece of cloth that was ubiquitous in Andean dress was the coca bag, *chuspa* in Quechua, *sonco* in Aymara, which held both leaf and the mineral that releases its alkaloid.

Easily recognizable successors to these costumes survive in parts of the Andes today. Areas such as Chinchero, near Cuzco, and the Bolivian villages of Charazani, to the east of Lake Titicaca, Macha, in northern Potosi, and Tarabuco, near the legal capital of Sucre, preserve a great deal of Andean textile traditions.

The Tarabuco men show a version of the *uncu*, still horizontally oriented but no longer sewn down the sides, and women from all three villages wear skirts, shawls, and belts similar to those illustrated by Guamán Puma nearly four centuries before.

Andean weavers have traditionally used two primary materials, cotton and camelid wool. Camelids—vicunas, alpacas, and llamas—give Andean fabrics an unusual strength and sheen. Their fibers support fine spinning and extensive coloration.

Antique and modern pieces show a subtle spinning technique, the use of clockwise and counterclockwise spun strands in juxtaposition. The work, which locals call *espina de pez* (herringbone), creates a striped effect even among threads of the same color.

The traditional Andean weaving machine is little more than a series of sticks staked to the ground or supported between a fixed point and the back of the weaver (fig. 4). But what this contraption may lack in mechanical sophistication, it recoups in giving its operator an almost unlimited flexibility to experiment with pattern, hue, and density.

The weaver passes weft threads across the warp in combinations that produce varied designs, then she packs the threads using a shuttle. She can also vary the effect of her work by alternating the tension on the warp threads.

Color is determined by the wide variety of local wool stuffs and by a rich dyeing inventory. Ancient dyers used madder, cochineal, and a form of indigo. Contact with the European world brought other natural and mineral dyes into use, and industrial chemistry fostered the onset of aniline dyes in the late nineteenth century and the synthetic pre-colored yarns now being produced in both Bolivia and Peru.

Dyes have more than an aesthetic importance. Using early Aymara and Quechua dictionaries, Teresa Gisbert has described the symbolic importance of several colors, including red, associated with

the local deities or *huacas*, and white which is a feminine color, characteristic of fertility.

Design is another important element that lends itself to show and tell. The principal orientation of contemporary Andean weaving is striped. Again, this pattern is more than aesthetic. The striped technique in weaving carries an Aymara term, *lloque*, which lends cloth a magical quality. *Lloque* can be achieved in two major ways: contrasting colors or *espina de pez*. Both protect the wearer from enemies.

The intricate patterns characteristic of Andean textiles have long fascinated students of the area. In 1574, Viceroy Francisco de Toledo, determined to extirpate the Andean world and replace it with the Spanish, gave a series of *ordenanzas* at Chuquisaca (modern Sucre). Noting that native craftsmen depicted their deities in art objects he ordered, "que no se labren figuras en la ropa, ni en vasos, ni en las casas." The Viceroy went on to describe anthropomorphic figures such as species of animals and birds that they create on the doors of their houses, in cloth, and on the walls of the churches.

Andean architecture preserves some of these figures. Art historians have pointed to the merger of indigenous and Spanish motifs in such colonial structures as the mestizo facades on the churches along the shores of Lake Titicaca. The Pomata church features pumas, Inca celestial bodies, and animals from the jungle mixed discreetly with Christian iconography. We do not know exactly which cloth the Viceroy referred to, but could it have been substantially different from a modern example? A spectacular example of modern weaving from the southern Bolivian village of Potolo shows enough fantastic imagery to offend even the most tolerant Viceroy, which Toledo was not (fig. 5).

Gisbert suggests other manifestations of Andean culture woven into cloth including the *tocapus* (or paneled pattern), the condor, the viscacha, and the Inca sun or eight-pointed star similar to that carved on the Pomata church facade.

The fact that the preceding example was taken from cloth no more than fifty years old shows the vitality of traditional culture in the Andes. Neither Francisco de Toledo nor 450 years of European successors has fully displaced Andean traditions from its people or from its cloth.

ILLUSTRATIONS

Fig. 1. Guamán Poma de Ayala's representation of an
Indian's attire denoting status and geography

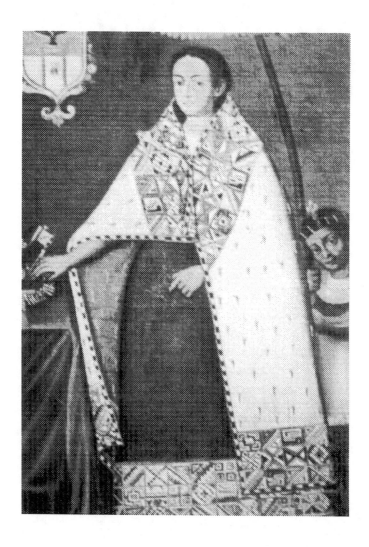

Fig. 2.  Raiment of privileged Indian woman from the Lake
Titicaca region, seventeenth-century painting

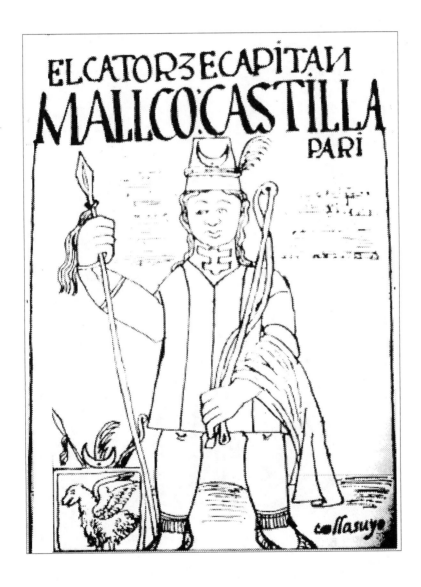

Fig. 3. Guamán Poma de Ayala's representation of the
Inca Manco Capac wearing an *uncu* and *llacota*

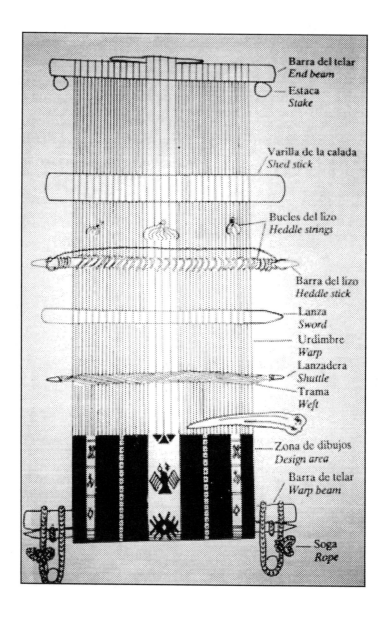

Fig. 4. Diagram of a backstrap weaving loom

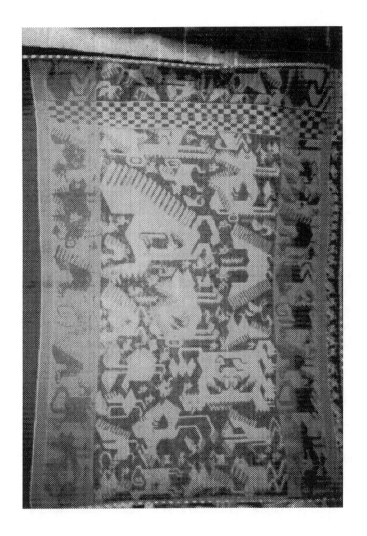

Fig. 5. An example of a modern woven *acsu* from Potolo, Bolivia

# 20.  A Core Bibliography of Andean Weaving

## David Block

The literature of Andean weaving can be loosely typed into three categories: styles and techniques, collectors' descriptions, and studies of cultural contexts.  While these categories are not totally discrete, either chronologically or referentially, they emphasize very different aspects of cloth.  The following compilation comprises a sample of representative works that will serve as an entry into a rich and growing corpus of material.

### Styles and Techniques

Cason, Majorie, and Adele Cahlander. *The Art of Bolivian Highland Weaving*. New York, NY: Watson Guptil, 1976.

D'Harcourt, Raoul. *Textiles of Ancient Peru*. Seattle: University of Washington Press, 1962.

Jaramillo Cisneros, Hernan. *Textiles y tintes*. Quito: Centro Interamericano de Artesanías y Artes Populares, 1988.

O'Neale, Lila. "Weaving." In *Handbook of South American Indians*, Vol. 5. Washington, DC: Government Printing Office, 1949. Pp. 97-131.

### Collectors' Descriptions

Adelson, Laurie, and Bruce Takami. *Weaving Traditions of Highland Bolivia*. Los Angeles, CA: The Craft and Folk Museum, 1978.

Adelson, Laurie, and Arthur Tracht. *Aymara Weavings*. Washington, DC: The Smithsonian Institution, 1983.

Anton, Ferdinand. [Altindianische textilkunst aus Peru. English.] *Ancient Peruvian Textiles*. New York, NY: Thames and Hudson, 1987.

Girault, Louis. *Textiles boliviens: region de Charazani*. Paris: Catalogues du Musée de L'Homme, 1969.

*Textiles of the Andes: Catalog of Amano Collection*. San Francisco, CA: HEIAN, 1979.

Wasserman, Tamara E., and Johnathan S. Hill. *Bolivian Indian Textiles*. New York, NY: Dover Publications Inc., 1981.

## Cultural Contexts

Feminias, Blenda. *Andean Aesthetics: Textiles of Peru and Bolivia*. [Madison, WI]: The Museum, 1987.

Frame, Mary. "The Visual Images of Fabric Structure in Ancient Peruvian Art." In *The Junius Bird Second Conference on Andean Textiles*. Washington, DC: The Textile Museum, 1986.

Franquemont, E. M. "Threads of Time: Andean Cloth and Costume." In *Costumes as Communication*. Bristol, RI: Haffenreffer Museum of Anthropology, 1986.

Gisbert, Teresa. *Arte textil y mundo andino*. La Paz: Gisbert y Cía, 1987.

Moya, Ruth. *Los tejidos y el poder de los tejidos*. Quito: CEDIME, 1988.

Murra, John V. "Cloth and Its Function in the Inca State." *American Anthropologist* 64, 4 (Aug. 1962), 710-728.

Prochaska, Rita. *Taquile: tejiendo un mundo mágico*. Lima: Aries, SA, 1988.

Zorn, Elayne. "*Unkuñas* in Herders' Ritual Bundles (*Senal Q'epi*) of Mascusani, Peru." In *The Junius Bird Second Conference on Andean Textiles*. Washington, DC: The Textile Museum, 1986.

# Part Three
# Art Sources

El impacto y la influencia que las computadoras están ejerciendo ... sobre la comunidad artística pueden ser comparados a la influencia de las técnicas fotográficas sobre la creación artística de finales del siglo pasado ... En aquel entonces ... la llamaron invención diabólica.

—Isaac Víctor Kerlow
*Mexican art critic*

# I. Art Publishing and Information Distribution

# 21. Latin American Government Documents on the Arts: Introductory Guide

## Beverly Joy-Karno

Art documentation existed in Mexico before the arrival of the European discoverers. Exquisite hand-painted codexes reflected indigenous histories, religious beliefs, medical resources, and artistic sensibilities, and although most of the codexes were destroyed by the invaders, enough remained as evidence of the impressive diversity and quality of their work. Art documentation also existed in most other regions of the New World in the form of textile designs, architectural monuments, and sophisticated sculptures.

The governmental patronage that the Iberian conquerors brought with them from the Royal courts continued the role of government subsidization and encouragement of artistic works and their documentation. With the introduction of the printing press into the highly regulated American colonies, documentation required approval from governmental agencies before publication. Thus documentation was selective and often suffered from the vagaries of foreign affairs and the changeable opinions of religious orthodoxy. Nevertheless, shortly after the establishment of printing presses in Mexico City in 1539 and in Lima in 1594, publications pertaining to the arts began to appear, and continued to appear throughout the three centuries of Iberian control. A good example of early art documentation is *Comentaria en Ludovici Vives. Exercitationes Linguae Latina*, written by Francisco Cervantes and published in Mexico City in 1554. This book glorified the architectural and other beauties of Mexico at that time. The colonial governments, aside from sanctioning or refusing to sanction publications, exercised control over the arts by founding and funding various artistic institutions: in Mexico, the Academia de San Carlos in 1785; in Brazil, the Brazilian Academy of Fine Arts in 1816; and in Chile, the Academia de Bellas Artes in 1849 (the first art school in Chile was founded in 1797).

*Editor's Note:* Originally submitted for the 18th Annual Conference of the Art Libraries Society of North America, New York City, February 8-15, 1990, and printed here with permission of the author and the Society.

The first Mexican school of arts and trades was established in Mexico City in the late sixteenth century and a century later the first museum for the storage of antiquities and pertinent documents. Some indication of the great number of publications dealing with art in the colonial period can be seen in the superb bibliography by Guillermo Tovar de Teresa, *Bibliografía novohispana de arte*, published in Mexico in 1988, 2 vols. More than 250 titles are described for the sixteenth, seventeenth, and eighteenth centuries. Vol. 3 of the work is yet to be published.

Governmental patronage involved other areas of public life, including the beautification of cities and public spaces. One of the earliest and most important books that included information on the architecture of the time was Bernardo de Balbuena's *Grandeza mexicana*, published in 1604. The tradition of documenting public works and spaces continues to this day as local and national governments document their achievements.

After the destructive Independence struggles in the early nineteenth century, admiration for the art and customs of non-Hispanic cultures predominated. The bimonthly periodical *Escuela Nacional de Artes y Oficios*, founded in Mexico in 1878 by the Escuela Nacional de Artes y Oficios, is an example of an early government agency still under the influence of the classical, conservative European style. By the end of the nineteenth century, however, incipient nationalism turned to indigenous art forms with governmental agencies nourishing the process of national self-affirmation against the imposition of ideas, styles, and forms from Europe and later, from the United States. The Chilean, E. Cueto y Guzmán, in 1889 addressed the question of what is "authentic" Chilean art in the *Revista de Arts i Letras* (Vol. 15, Santiago). Art documentation increased both in scope and in quantity simultaneously with the Latin American nations' growth in prestige and in wealth. International celebrations in honor of independence justified publications glorifying national accomplishments. State governmental agencies, national museums, and, of course, universities followed suit with their own annual reports, exhibition catalogs, and scholarly monographs. An example from Brazil is the *Album do Pará em 1899 na Administração do Governo de su ex cia o senr. Dr. José Pães de Carvalho* by Henrique Santa Rosa, in which numerous photographs demonstrate the architectural endeavors of the regime in office.

The twentieth century brought a golden age of governmental art documentation. Latin American artists began to receive international recognition, tourists flocked to pre-Hispanic and colonial sites, while academics throughout the world studied and wrote about New World

cultures.   The governments spent large sums in promoting their patrimony.   An example is the Brazilian *Revista do Serviço do Patrimonio Histórico e Artístico Nacional*, first published in the 1930s by the Ministry of Education and Health.   Books on archaeology, architecture, contemporary artists and their schools, photography, and so on poured forth.   Even the smaller countries, such as El Salvador, contributed.   *ARS*, a periodical published in San Salvador, El Salvador in the 1950s, was one of the finest art journals.   Frequent art biennials sparked significant international interest, and the resultant catalogs have become important resource materials.

The current situation in Latin America is that all of the countries have been profoundly affected over the last five to fifteen years by economic and political upheaval.   This has often resulted in a decrease or cessation in all types of publications.   The following is a brief summary of the present situation:

Central America, especially El Salvador, Panama, and Nicaragua, has decreased the number of publications from that of nearly a decade ago.   Guatemala has since shown a small increase.   Costa Rica is still publishing a lot, especially in pre-Columbian and contemporary arts.

Chile has just completed its first election in seventeen years. Government art publishing had suffered greatly in that period of time, but there were still some very good publications coming out of the state university.   Before this period Chile was traditionally a very strong publisher in all of the arts and architecture.   Argentina and Brazil are affected by hyper-inflation, but Brazil is still publishing a lot of material; Argentina is not as active as it was in the 1950s and 1960s. Uruguay, although small, does publish, but not prolifically.

Bolivia does not have great economic resources.   It does have some publications on textile arts and folk arts.   Peru is in a very dire situation, and almost all government related art publications have ceased.   Venezuela has a thriving art community, but since the oil glut there have been cutbacks from the numerous titles published in the past.   Colombia and Ecuador publish on a limited basis.

The first printing press, the first library, and the first university on the American continent were all established in Mexico, and Mexican artists have emerged with a deep-rooted commitment to the arts, and even though economically it is a difficult time, large numbers of artistic titles still appear.

The following is a broad survey of the most active agencies that have published monographs and/or serials within the last five years. Please note that there are many other agencies that publish materials of high quality and importance, and that this is not meant to be a

comprehensive guide. The survey lists only major state, federal, and municipal archives, museums, and educational institutions. Nationalized institutions, such as banks, are not included. Covered are Mexico and the countries of South America and Central America, except for Belize, the West Indies, and the Guyanas. The books and periodicals that have been listed under an institution are only examples of what is published by that particular institution. Occasional papers, bulletins, reports, books, and special publications are listed as monographs. Pre-Columbian, colonial, nineteenth-century, and twentieth-century art and architecture are all represented.

## SURVEY OF LATIN AMERICAN GOVERNMENT AGENCIES PUBLISHING ON THE ARTS

### CENTRAL AMERICA

**COSTA RICA**

**Universidad Autónoma de Centro América**
Calle 15, Avdas. 9-11, Apdo. 7637, San José 1000.

MONOGRAPHS

Baciu, Stefan. *Francisco Amighetti*. Heredia: Editorial Universitaria Nacional Autónoma (EUNA), 1984; 254 p., ii.

**Universidad Estatal a Distancia (Open University)**
Apdo. 2, Plaza González Viquez, San José 1000.

MONOGRAPHS

Echeverría, Carlos Francisco. *Historia crítica del arte costarricense*. San José: EUNED, 1986; 168 p., illus., photos, 6 color plates.

Ferrero Acosta, Luis. *Cinco artistas costarricenses*. San José: Universidad Estatal a Distancia (EUNED), 1985; 145 p., photos.

Ferrero Acosta, Luis. *Sociedad y arte en la Costa Rica del siglo XIX*. San José: EUNED, 1986; 214 p., illus., b/w and color plates.

SERIALS

*Revista Nacional de Cultura*. 1-2 per year.

**Museo de Arte Costarricense**
La Sabana, San José; attached to Ministry of Culture, Youth and Sport. (Primarily nineteenth-century and twentieth-century art)

MONOGRAPHS

Sobke, Christel. *¿Que color tendrá el cielo mañana?* San José: Museo de Arte Costarricense, 1986; 37 p., color plates.

Montero, Guillermo. *Francisco Amighetti*. San José: Museo de Arte Costarricense, 1987; 128 p.

**Museo Nacional de Costa Rica**
Calle 17, Avda. Central y 2, Apdo. 749, San José 1000.

MONOGRAPHS

*Más de cien años de historia.* San José: Ministerio de Cultura, Juventud y Deportes, 1987; 141 p., illus.

Stone, Doris. *Introducción a la arqueología de Costa Rica.* San José: Museo Nacional de Costa Rica, 1958; 54 p., illus.

SERIALS

*Vínculos.* 2 per year, occasional papers. (Includes anthropology)

*Brenesia.* 2 per year. Spanish/English.

**Universidad de Costa Rica**
Ciudad Universitaria Rodrigo Facio, San Pedro de Montes de Oca, San José.

MONOGRAPHS

Herrera Rodríguez, Rafael Angel. *El desorden del espíritu: Conversaciones con Amighetti.* San José: Editorial Universidad de Costa Rica, 1987; 201 p.

**Museo Histórico Cultural Juan Santamaría**
Apdo. 785-4040, Alajuela; attached to the Ministry of Culture, Youth and Sport. (Primarily colonial period)

MONOGRAPHS

Ferrero Acosta, Luis. *Gozos del recuerdo: Ezequiel Jiménez Rojas y su época.* Alajuela: Museo Histórico Cultural Juan Santamaría, 1987; 96 p.

Lemistre Pujol, Annie. *Dos bronces conmemorativos y una gesta heróica: La estatua de Juan Santamaría y el Monumento Nacional.* Alajuela: Museo Histórico Cultural Juan Santamaría, 1988; 171 p., photos, bibl.

**Secretaría de Educación Pública (Ministerio de Educación Pública)**
Edif. Raventós, Apdo. 10087, San José. (Mainly exhibit catalogs)

MONOGRAPHS

*Decoraciones de carretas.* Sala Exposición de Arte de 15 al 22 de septiembre de 1982. San José: Imprenta Nacional; 24 p., illus.

Lines, Jorge A. (Comp.) *Catálogo descriptivo de los objetos expuestos en la primer exposición de arqueología y arte pre-colombino.* Inaugurada en San José en el Teatro Nacional. San José: Secretaría de Educación nacional, Imprenta Nacional; 142 p., illus.

**Museo del Jade, Instituto Nacional de Seguros**
San José, Costa Rica. (Pre-Columbian jade)

MONOGRAPHS

*Jade precolombino de Costa Rica.* San José: Instituto Nacional de Seguros, 1980; 36 p., illus., 75 p. color plates, cat., bibl., map.

## GUATEMALA

**Biblioteca Nacional de Guatemala**
Avda. 7-26, Zona 1, Guatemala City.

MONOGRAPHS

*Pintura Popular en Guatemala.* Guatemala: Biblioteca Nacional de Guatemala, 1987; n.p., illus. Opening show of the VI Bienal de Arte Paiz.

**Instituto Indigenista Nacional**
(Ministerio de Educación Pública). 6 Avda. 1-22, Zona 1, Guatemala City. (Folk and popular arts, anthropology, etc.)

SERIALS

*Guatemala Indígena.* Quarterly.
*Boletín del Instituto Indigenista Nacional.* Occasional.

**Instituto de Antropología e Historia**
Avda. 11-65, Zona 1, Guatemala City. (Archaeology and Spanish colonial history, including art history)

SERIALS

*Antropología e historia de Guatemala.* Annual.

**Universidad de San Carlos de Guatemala**
Ciudad Universitaria, Guatemala 12.

MONOGRAPHS

Alonso de Rodríguez, Josefina. *Arte de la platería en la capitanía general de Guatemala.* 2 vols. Guatemala: Universidad de San Carlos de Guatemala, 1980.

SERIALS

*La tradición popular.* Centro de Estudios Folklóricos. Avenida de la Reforma, No. 0-09, Zona 10, Guatemala City.

**Ministerio de Cultura y Bellas Artes. Dirección General de Cultura y Bellas Artes**
Guatemala City.

MONOGRAPHS

*Pintores de Guatemala.* Cuadernos de Arte. Abascal Valentin et al. Guatemala: Dirección General de Cultura y Bellas Artes, 1967; n.p., illus.

SERIALS

*Boletín de museos y bibliotecas.* Organo de Publicidad y Difusión Cultural. Occasional.

**Consejo Nacional para la Protección de la Antigua Guatemala (CNPAG).**
Part of: **Instituto de Antropología e Historia.** (Colonial art and architecture only)
Avda. 11-65, Zona 1, Guatemala City.

MONOGRAPHS

Alvarez Arévalo, Miguel. *Jesús de Candelaria en la historia del arte y la tradición de Guatemala.* Guatemala: CNPAG, 1983; 121 p., illus.

## HONDURAS

**Instituto Hondureño de Antropología e Historia. Museo Nacional.**
    Apdo. 1518, Villa Roy, Tegucigalpa. (Primarily pre-Columbian, colonial art)
SERIALS
*Yaxkin.* 2 per year.

**Secretaría de Cultura y Turismo**
    Tegucigalpa.
SERIALS
*Clarinero.* 3-4 per year. Art review.

## NICARAGUA

**Ministerio de Cultura**
    Managua, Nicaragua.
MONOGRAPHS
Valle Castillo, Julio. *El inventario del paraíso: Los primitivistas de Nicaragua.* Managua: Ministerio de Cultura, n.d. (c. 1988); 24 p.
SERIALS
*La Chachalaca.* 2 per year.
*Nicarauac: Revista Cultura.* 2 per year.

## PANAMA

**Ministerio de Educación**
    Panama City.
MONOGRAPHS
Lamela, Jorge L., y Carmela Eliet Granados. *Nuestro arte aborigen.* T. y M.D. No. 63. Panamá: Ministerio de Educación, 1967; n.p., 50 illus.

**Ministerio de Comercio e Industrias**
    SENAPI. Panama City.
MONOGRAPHS
Chan Chen, Alberto, y Malcolm Benjamin. *Panama: Artesanías/Handicrafts.* A Guide to National Crafts/Una Guía de las Artesanías Nacionales. Panamá: Ministerio de Comercio e Industrias, 1970; 37 p., illus.

**Universidad de Panamá**
    Ciudad Universitaria "Dr. Octavio Méndez Pereira", El Cangrejo, Apdo. Estafeta Universitaria, Panama City.
MONOGRAPHS
*Actas del IV Simposium Nacional de Antropología, Arqueología y Etnohistoria de Panamá.* Panamá: Universidad de Panamá e Instituto Nacional de Cultura, 1976. Also Núm. V, 1978.
SERIALS
*Maga.* Editorial Signos/Universidad Nacional de Panamá. 3 per year.

**Escuela Nacional de Artes Plásticas**
    Apdo. 1004, Panama 1. Affiliated with Instituto Nacional de Cultura.
SERIALS
*La estrella de Panamá.* Occasional.

**Departamento de Beneficencia Cultural**
    Lotería Nacional de Beneficencia Cultural, Apdo. 21, Panama City 1.
SERIALS
*Revista Lotería.*

## EL SALVADOR

**Ministerio de Educación,** includes the following agencies:

**Dirección General de Bellas Artes**
    San Salvador.

**Ministerio de Cultura y Comunicaciones.** Also listed as: **Ministerio de Cultura.**
    Dirección de Cultura, Ministerio de Educación, San Salvador.
MONOGRAPHS
*Pintura en El Salvador.* San Salvador, Ministerio de Cultura y Comunicaciones, 1986; 95 p., illus.

Boggs, Stanley H. *Figurillas con ruedas de Cihuatan y el oriente de El Salvador.* Colección Antropológica, No. 3. Separata de la *Revista Cultura* del Ministerio de Cultura, No. 59. San Salvador, Ministerio de Cultura, 1973, p. 37074, illus.
SERIALS
*Cultura.* Revista del Ministerio de Cultura y Comunicaciones.

**Dirección de Artes del Ministerio de Educación**
    San Salvador.
SERIALS
*Arte Popular.*

**Ministerio de Educación**
    San Salvador.
MONOGRAPHS
Yanes Díaz, Gonzalo. *El Salvador y su desarrollo urbano en el contexto centroamericano.* San Salvador: Ministerio de Educación, 1974; illus., plans, maps.

**Universidad de El Salvador**
    Ciudad Universitaria, Final 25 Avda. Norte, San Salvador.
MONOGRAPHS
Marino Sánchez, Désar. *Desarrollo de la Escultura en El Salvador.* San Salvador: Universidad de El Salvador, 1974; 269 p., illus., bibl.

## SOUTH AMERICA

### ARGENTINA

#### Buenos Aires

**Universidad de Buenos Aires, Facultad de Filosofía y Letras, Instituto de Ciencias Antropológicas**
   Marcelo T. de Alvear 2230 (1222), Buenos Aires.

SERIALS

*Runa: Archivo para las Ciencias del Hombre.*

**Universidad de Buenos Aires, Facultad de Arquitectura y Urbanismo, Instituto de Arte Americano e Investigaciones Estéticas**
   Ciudad Universitaria, Pabellón 3, Nuñez, Buenos Aires.

MONOGRAPHS

Martini, José Xavier, and José María Peña. *Ornamentación en la arquitectura de Buenos Aires, 1800-1940.* Buenos Aires: Universidad de Buenos Aires, 1966-67, 2 vols.; 65 p., 85 b/w plates; 75 p., 105 b/w plates.

Nadal Mora, Vicente. *Azuelajo en el Río de la Plata: Siglo XIX.* Buenos Aires: Universidad de Buenos Aires, 1949; 94 p., b/w and color plates.

SERIALS

*Anales del Instituto de Arte Americano e Investigaciones Estéticas.* Annual, since 1948.

**Ministerio de Educación y Justicia, Secretaría de Cultura**
   Buenos Aires.

MONOGRAPHS

Dichiara, Martha. *Tierra vieja: Diseño indígena argentino.* Buenos Aires: Dirección Nacional de Artes Visuales, 1989; 94 p., b/w illus., tables. (Pre-Hispanic designs)

**Comisión Nacional de Museos y de Monumentos y Lugares Históricos. (Published by Ministerio de Educación)**
   Avda. de Mayo 556, Buenos Aires.

SERIALS

*Boletín de la Comisión Nacional de Museos y Monumentos Históricos.* Annual since 1939.

*Carta Informativa.* Irregular.

**Museo de Arte Moderno**
   Teatro General San Martín, Corrientes 1530, 1042 Buenos Aires.

MONOGRAPHS

*Paisaje en la Argentina a través de sus pintores en el siglo XX.* Junio/julio de 1980. Buenos Aires: Museo de Arte Moderno, 1980; 5 p., 100+ b/w plates loose in box.

**Museo Nacional de Bellas Artes**
   Avda. Libertador Gen. San Martín 1473, 1425 Buenos Aires.

MONOGRAPHS

*Premio Banco del Acerdo.* Noviembre 1981, Buenos Aires; 42 p., b/w illus.

**Córdoba**

**Universidad Nacional de Córdoba. Facultad de Filosofía y Humanidades, Instituto de Arqueología, Lingüística y Folklore**
    Calle Obispo Trejo y Sanabría 242, 5000 Córdoba. (Archaeology, Folk art only)
SERIALS
*Revista del Instituto de Antropología.* Annual.

**Jujuy**

**Universidad Nacional de Jujuy. Departamento de Antropología y Folklore**
    Bolivia 2335, 4600 San Salvador de Jujuy. (Archaeology and Folk art only)
MONOGRAPHS
Alfaro de Lanzone, Lidia Carlota. *Excavación de la cuenca del Río Doncellas: reconstrucción de una cultura olvidada en la Puna Jujena.* Jujuy, 1988; 164 p., b/w plates and illus., tables.

**Mendoza**

**Universidad Nacional de Cuyo. Facultad de Filosofía y Letras**
    Centro Universitario, Parque Central San Martín, 5500 Mendoza. (Pre-Columbian only)
MONOGRAPHS
Fernández, Jorge. *Historia de la arqueología argentina.* Mendoza: Asociación Cuyano de Antropología, Universidad Nacional de Cuyo, 1982; 320 p.
SERIALS
*Anales de Arqueología y Etnología.* Occasional. (Pre-Columbian only)

**Universidad nacional de Cuyo. Instituto de Historia del Arte**
    Same address as above.
SERIALS
*Cuadernos de Historia del Arte.* Occasional.

**Corrientes**

**Universidad Nacional del Nordeste. Instituto Argentino de Investigaciones de Historia de la Arquitectura y del Urbanismo**
    25 de Mayo 868, 3400 Corrientes.
MONOGRAPHS
Gómez Crespo, Raúl Arnaldo, and Roberto Osvaldo Cova. *Arquitectura marplatense: El pintoresquismo.* Resistencia: Instituto Argentino de Investigaciones de Historia de la Arquitectura y del Urbanismo, 1982; 199 p., b/w illus., tables, plans. (During the 1960s and 1970s very active in publishing on Argentine architecture)

**BOLIVIA**

**Ministerio de Educación y Cultura**
    Avda. Arce 2048, La Paz.

**Instituto Boliviano de Cultura**
Avda. 6 de Agosto 2424, CC 7846, La Paz.

SERIALS

*Fondo de Publicaciones Populares.* Irregular.

**Museo Nacional de Arqueología**
Calle Tihuanaco 93, Casilla Oficial, La Paz. (Pre-Columbian)

SERIALS

*Anales.* Annual.

**Museo Nacional de Arte**
Casilla 7038, Calle Socabaya 485, esq. Calle Comerciao, La Paz. (Colonial and local modern art)

SERIALS

*Arte y arqueología*

**BRAZIL**

**Bahia**

**Universidade Federal da Bahia. Centro de Estudos Baianos**
Rua Augusto Viana s/n, Canela 40000, Salvador, Bahia.

MONOGRAPHS

Ott, Carlos. *A Casa da Câmara da cidade do Salvador.* Universidade da Bahia, 1981; 42 p., b/w illus.

SERIALS

*Estudos Baianos.* (General publication that contains one or more articles that occasionally publishes an issue devoted to colonial architecture or arts of Bahia)

**Brasília, D.F.**

**Ministério de Educação e Cultura Brasileira, Secretaria da Cultura**
70047 Brasília, D.F.

SERIALS

*Cultura.*
The following affiliated agencies publish on art; architecture; decorative, popular, and pre-Columbian art.

**Subsecretaria do Patrimônio Histórico e Artístico Nacional** (Formerly published under name Ministério de Educação e Saúde in Rio de Janeiro) Leading publisher of art and architecture materials.

MONOGRAPHS

*Promessa e milagre, no santuário do dom Jesús de Matosinhos Congonhas do Campo Minas Gerais.* Brasília: Ministério de Educação e Cultura, 1981; 154 p., b/w illus., plans, tables. (Ex-votos, mostly colonial period)

SERIALS

*Revista do Patrimônio Histórico e Artístico Nacional.*

**Museu Nacional de Antropologia.** (Joint publication and exhibit)

MONOGRAPHS

*Arte plumaria del Brasil.* (Spanish) Brasília, 1982; 82 p., color illus., map.

**Rio de Janeiro**

**Museu do Instituto Histórico e Geográfico Brasileiro**
Av. Augusto Severo 8, 20021 Rio de Janeiro.

SERIALS

*Revista do Museu do Instituto Histórico e Geográfico Brasileiro.*

**Museu Histórico Nacional**
Praça Marechal Ancora s/n, 20021 Rio de Janeiro, RJ.

SERIALS

*Anais do Museu Histórico Nacional.* (Published by Ministério de Educação e Cultura).

**Universidade Federal do Rio de Janeiro**
Ilha da Cidade Universitária, Rio de Janeiro, RJ.

SERIALS

*Arquivos da Escola Nacional de Belas Artes.* Annual.

**Centro de Documentação e Pesquisa da Fundação Nacional de Arte (FUNARTE)**
Rio de Janeiro (Agency of Ministério de Educação e Cultura. *See* Brasília). Very active during the 1980s as publisher on contemporary, folk, decorative and colonial art.

MONOGRAPHS

Arestizábal, Irma. *J. Carlos: 100 años.* Coleção Para Todos, 1. Rio de Janeiro: FUNARTE/Instituto Nacional de Artes Plásticas, 1984; 80 p., b/w and color illus.

Lody, Raúl, and Marina de Mello e Souza. *Artesanato Brasileiro madeira.* Rio de Janeiro: FUNARTE/Instituto Nacional do Folclore, 1988; 202 p., b/w and color plates, tables.

**São Paulo**

**Museu de Arte Contemporânea**
CCP 22031, São Paulo, SP. (Attached to the Universidade de São Paulo). Twentieth-century art only

MONOGRAPHS

Oria, Vera Lucia (Coord.). *I quadrienal de fotografia.* São Paulo: Museu de Arte contemporâneo, 1985; n.p., b/w illus.

**Museu de Arte de São Paulo**
Av. Paulista 1578, 01310 São Paulo, SJ. Classical and modern paintings. Extensive holdings of Brazilian colonial, nineteenth- and twentieth-century works. Consistently leading publisher on the arts.

MONOGRAPHS

*Arte do povo brasileiro*, 9 a 27 de abril de 1986. São Paulo: Museu de Arte de São Paulo, 1986; app. 100 p., b/w and color plates.

**Museu Paulista da Universidade de São Paulo**
    Parque da Independência s/n, Ipiranga, CP 42503, 04299 São Paulo, SP.
    Archaeology, ethnography, and some decorative arts.

MONOGRAPHS

Dorta, Sonia Ferraro. *Pariko*: Etnografia de um artefacto plumário. Col. Mus. Paulista,
    *Etnologia*, Vol. 4. S.P. Museu Paulista da Universidade de São Paulo, 1981; 269 p.,
    b/w and color illus., tables, graphs.

SERIALS

*Anais.*
*Coleções do Museu Paulista.*
*Revista do Museu Paulista.*

**Universidade de São Paulo**
    Caixa Postal 8105, 01000, São Paulo, SP.

MONOGRAPHS

Amaral, Aracy A. *A hispanidade em São Paulo: Da casa rural à Capela de Santo Antonio.*
    Editorial da Universidade de São Paulo, 1981; 117 p., b/w photos, plans, maps,
    facs., wrps.

SERIALS

*Revista de Antropologia.* Departamento de Ciências Sociais da Faculdade de Filosofia,
    Letras e Ciências Humanas.

CHILE

**Ministerio de Educación Pública, Departamento de Extensión Cultural**
    Santiago, Chile.    All art (no pre-Columbian), with emphasis on colonial and
    nineteenth-century art.

MONOGRAPHS

*Temas populares en la pintura chilena.* Santiago: Ministerio de Educación Pública.

**Universidad de Chile, Facultad de Arquitectura y Urbanismo**
    Avda. Bernardo O'Higgins 1058, Casilla 10-D, Santiago.    Traditionally strong
    publisher, but over the last sixteen years little activity because of lack of funding.

MONOGRAPHS

*Conjuntos arquitectónicos rurales, casas patronales.* Santiago: Universidad de Chile, 1981;
    2 vols. 263 p., b/w illus., plans.

SERIALS

*Anales de la Universidad de Chile.* (Annual; various subjects, not all art)

**Universidad de Chile, Departamento de Ciencias Sociológicas y Antropológicas. Facultad
de Filosofía, Humanidades y Educación**
    Same address as above. (Pre-Columbian only)

SERIALS

*Boletín de Prehistoria de Chile.* Annual; irregular.

**Museo de Historia Natural**
  Casilla 787, Santiago.  Pre-Columbian only.  Has published good monographs in
  the past.

SERIALS

*Atenea: Revista de Ciencia, Arte e Literatura.*  Semi-annual.
*Boletín del Museo de Historia Natural.*  Annual.

## COLOMBIA

**Universidad Nacional de Colombia**
  Ciudad Universitaria, Apdo. Aéreo 14490, Bogotá.

MONOGRAPHS

Preuss, K. Th.  *Arte monumental prehistórico: Excavaciones hechas en el Alto Magdalena y
  San Agustín* (Colombia).  Bogotá: Universidad Nacional de Colombia, 1974; 503 p.,
  b/w illus., maps.

SERIALS

*Anuario Colombiano de Historia Social y de la Cultura.*  Departamento de Historia,
  Facultad de Ciencias Humanas.  Annual.

**Museo del Oro**
  Calle 16 No. 5-41, Parque de Santander, Bogotá. (Pre-Columbian only. Occasional
  monographs)

MONOGRAPHS

Pérez de Barradas, José.  *Orfebrería prehispánica de Colombia: Estilos tolima y música.*
  2 vols., 1958.

SERIALS

*Boletín de Museo del Oro.*  Annual.

**Departamento Nacional de Planeación**
  Biblioteca, Calle 26, No. 13-19, 16o. Piso, Edificio Seguros Colombia, Bogotá.

SERIALS

*Revista de Planeación y Desarrollo.*

## ECUADOR

**Instituto Nacional de Patrimonio Cultural**
  Quito, Ecuador.

MONOGRAPHS

Sutter Esquenet, Patrick de.  *Técnicas tradicionales en tierra: La construcción de viviendas
  en el área andina del Ecuador.*  Quito, 1985; 44 p., b/w illus., plans, wrps.

## PERU
  Because of severe economic problems in Peru, many publications that were
  consistent over the years are no longer published or are issued sporadically. Many
  of the serials listed below have ceased publication.

**Museo Nacional de la Cultural Peruana**
　　Avda. Alfonso Ugarte 650, Apdo. 3048, Lima 100. Also responsible for the
　　Instituto de Estudios Etnológicos and the Instituto de Arte Peruano.

SERIALS

*Revista del Museo Nacional.* Irregular.

**Instituto Nacional de Cultura**
　　Casillas 5247, Lima.

MONOGRAPHS

*Exposición: Tecnología de los metales.* Lima: Instituto Nacional de Cultura, 1981; 32 p.,
　　b/w illus., tables, map.

SERIALS

*Fenix.*

*Runa.*

**Museo Nacional de Antropología y Arqueología**
　　Plaza Bolívar s/n, Pueblo Libre, Lima 21. (Pre-Columbian only)

MONOGRAPHS

*Arte y cultura de Cabana: La Galgada y Pashash.* Peru: Museo Nacional de Antropología
　　y Arqueología, 1986, n.p., b/w photos, map.

SERIALS

*Boletín.* Irregular.

*Arqueológicas.*

**Archivo General de la Nación**
　　Palacio de Justicia, Calle Manuel Cuadros s/n, Apdo. 3124, Lima. (Good source of
　　colonial art material)

SERIALS

*Revista del Archivo General de la Nación.* 2 per year; irregular.

**Universidad Nacional de Ingeniería**
　　Casilla 1301, San Martín de Porres, Lima.

SERIALS

*Amaru: Revista de Artes y Ciencias.* Ceased publication.

## URUGUAY

**Ministerio de Educación y Cultura**
　　Reconquista 535, Montevideo. Funds the following:

**Instituto Nacional del Libro**
　　San José 1116, Montevideo.

MONOGRAPHS

The Institute has published the following titles over the last 8-10 years: *Figari, Las
casas quintas, La conservación de los monumentos, Artes plásticas, Uruguay: 17
artistas, Figari: Americano integral.*

**Museo Nacional de Artes Visuales**
Avda. Julio Herrera y Reissig s/n, Montevideo.

MONOGRAPHS

Catalogs are produced for exhibitions.

**Museo Histórico Nacional**
Rincón 437, Montevideo. Publishes occasional monographs.

SERIALS

*Revista Histórica.*

**Museo Municipal de la Construcción**
Casa Tomás Toribio (Comisión Especial Permanente de la Ciudad Vieja). Piedras 528, Montevideo. Colonial and nineteenth-century.

SERIALS

*La Gaceta de San Philipe de Montevideo.* 2 per year.

**Museo Municipal de Bellas Artes Juan Manuel Blanes**
Avda. Millán 4015, Montevideo.

MONOGRAPHS

Catalogs are produced for exhibitions.

**VENEZUELA**

**Ministerio de Educación, Dirección de Cultura y Bellas Artes (Consejo Nacional de Cultura)**
Apdo. 50995, Caracas.

SERIALS

*Revista Nacional de Cultura.*

**Museo de Arte Contemporáneo de Caracas**
Zona Cultural, Parque Central, Apdo. 17093, Caracas. (Contemporary art only.)

MONOGRAPHS

*Taller de cerámica: Museo de Arte Contemporáneo de Caracas.* Catálogo (Exposición) 22 de abril, 1977. Museo de Arte Contemporáneo, Consejo Nacional de la Cultura; 60 p., b/w illus.

**Museo de Bellas Artes**
Plaza Morelos, Los Caobos, Caracas 105.

SERIALS

*Visual.* Published by Ministerio de Educación.

**Universidad Central de Venezuela. Facultad de Arquitectura y Urbanismo**
Ciudad Universitaria Los Chaguaramos, Apdo. 103, Caracas 1051.

MONOGRAPHS

Goldberg, Mariano. *Guía de edificaciones contemporáneas en Venezuela.* Parte I: Caracas. Universidad Central de Venezuela, 1980; 319 p., b/w plates, illus., plans, maps.

SERIALS

*Boletín del Centro de Investigaciones Históricas y Estéticas.* Strong on colonial art and architecture.

## MEXICO

Many of the agencies listed below publish in cooperation with each other. Agencies that have often undertaken joint publishing projects are: INBA and SEP; INBA, SEP, and a state government; INAH and INI. (See below for definitions of acronyms.)

## MEXICO CITY

**Archivo General de la Nación (AGN)**
   Ex-Palacio de Lecumberri, Eduardo Molina y Abañiles, Colonia Penitenciaría 06020 México, D.F.

MONOGRAPHS

*Catálogo de material gráfico*. 13 vols. Serie de Información Gráfica. México, 1981; 70 p., illus.

*Catálogo de fotografías*. I. *La Farándula en México, 1908–1925*. México, 1982; 204 photos.

**Instituto Nacional de Antropología e Historia (INAH)**
   Córdoba 45, México 7, D.F. One of the most important research and documentary institutions in the arts. There are numerous sections, consisting of: Dirección de Monumentos Prehispánicos, Dirección de Monumentos Históricos, Dirección de Restauración del Patrimonio Cultural, Dirección de Historia, Departamento de Antropología Física, Departamento de Lingüística, Departamento de Antropología Social. The Institute also controls the following institutions: Museo Nacional de Antropología, Museo Nacional de Virreinato, Museo Nacional de Historia, Museo Nacional de las Intervenciones, Museo Nacional de las Culturas, and numerous regional museums such as Archivo y Laboratorio Fotográfico, Biblioteca Central de Antropología e Historia, Escuela de Restauración. Additionally, there are regional centers in sixteen states.

MONOGRAPHS

Andrews, George F. *Estilos Arquitectónicos del Puuc: Una nueva apreciación*. Serie Arqueología. México: INAH, 1986; 101 p., b/w illus, tables, plans, graphs.

SERIALS

*Anales de Antropología e Historia*. México: INAH, SEP. Annual.

**Instituto Nacional de Bellas Artes (INBA)**
   Palacio de Bellas Artes, Avda. Hidalgo 1, México 1, D.F. The Museo de San Carlos is part of INBA.

MONOGRAPHS

*Cuadernos de arquitectura y conservación al patrimonio artístico*. A monograph series on various aspects of architecture and architectural conservation and restoration.

*Salón Nacional de Artes Plásticas, Sección de Dibujo*, 1986; 96 p., b/w and color illus. facs., plans.

*Signos: El arte y la investigación*. México: INBA, 1988; 272 p., b/w illus.

SERIALS

*México en el Arte.* Nuevo Epoca began in summer of 1983.
*Cuadernos de Bellas Artes.* Irregular.
*Revista de Bellas Artes.* Irregular.

**Universidad Nacional Autónoma de México (UNAM)**
Ciudad Universitaria, Alvaro Obregón, 04510 México, D.F. The largest book publisher in Mexico. Publishes on all aspects of the arts and architecture. UNAM and its many branches throughout Mexico have numerous schools and research institutes.

SERIALS

*Universidad de México: Revista de la Universidad Nacional Autónoma de México.* (Formerly *Revista de la Universidad Nacional de México*).

Under the auspices of UNAM are the following:

**Instituto de Investigaciones Estéticas, Estudios de Arte y Estética**

MONOGRAPHS

*Academias de arte: VII Coloquio Internacional en Guanajuato.* No. 18, 1985; 362 p., b/w plates, facs., tables.

Díaz, Marco. *Arquitectura en el desierto: Misiones jesuíticas en Baja California.* Cuadernos de Historia del Arte, 39. México: UNAM, 1986; 159 p., b/w illus., plans, facs.

SERIALS

*Anales del Instituto de Investigaciones Estéticas.* Irregular.

**Museo Universitario de Ciencias y Arte**

MONOGRAPHS

*Máscaras,* mayo de 1981. México: UNAM; 119 p., 40 color plates.

**Centro de Estudios Mayas.** (Mayan studies only)

MONOGRAPHS

*Memorias del Primer Coloquio Internacional de Mayistas.* México: UNAM, 1987; 146 p., b/w plates, tables, plans.

*Estudios de cultura maya.* Monograph series.

**Centro de Estudios Nahuatl.** (Nahuatl studies only)

MONOGRAPHS

*Estudios de cultura Nahuatl.* Monograph series.

**Facultad de Arquitectura**

SERIALS

*Cuadernos de Arquitectura Mesoamericana.* 3 times per year. Irregular. (Pre-Columbian only)

*Cuadernos de Arquitectura Virreinal.* Irregular, 1 per year. (Colonial only)

**Escuela Nacional de Artes Plásticas**

SERIALS

*Artes Plásticas: Revista de la Escuela Nacional de Artes Plásticas.* Quarterly.

**Museo de Arte Moderno**
    Bosque de Chapultepec, Paseo de la Reforma y Gandhi, 11560 México, D.F.

MONOGRAPHS

*Carlos Aguirre and Rowena Morales: Historias paralelas, paralelos en la historia.* Museo de Arte Moderno, June-August, 1985. México: SEP; 36 p., b/w color illus.

SERIALS

*Artes Visuales.* Joint publication with INBA.

**Secretaría de Educación Pública (SEP)**
    México, D.F.

MONOGRAPHS

*Catálogo nacional de monumentos históricos inmuebles.* México: SEP, INAH, PCF, Gobierno del Estado. Joint project to produce national inventory of architecture by state.

González Jacome, Alba. *Orígenes del hombre americano* (Seminario). México: SEP, 1988; 359 p., b/w illus., maps, tables.

**Museo Nacional de Artes e Industrias Populares**
    Avda. Juárez 44, 06050 México, D.F.

MONOGRAPHS

Espejel, Carlos. *Olinala.* México: Museo Nacional de Artes e Industrias Populares, SEP-INI, 1976.

**Instituto Nacional Indigenista (INI)**
    Avda. Revolución 1279, México 20, D.F.

MONOGRAPHS

*Alma encantada: Anales del Museo Nacional de México.* (Facs. of 1892 *Anales*, Vol. VI, published by Francisco de Paso y Troncoso.) México: INI, Fondo de Cultura Económica, 1987.

SERIALS

*Memorias del Instituto Nacional Indigenista.* Irregular.
*México Indígena.* Monthly.

**Instituto del Fondo nacional de la Vivienda para los Trabajadores (INFONAVIT)**
    Servicio de Información Documental. Barranca del Muerto 280, Colonia Guadalupe Inn, 01029 México, D.F.

SERIALS

*Boletín Informativo INFONAVIT.* Irregular.

**Fondo Nacional para el Fomento de las Artesanías (FONART). Fondo Nacional para Actividades Sociales (FONOPAS)**
    Both of these organizations publish occasional monographs on popular and folk arts. Often they are copublishers.

MONOGRAPHS

*Antología de textos sobre arte popular.* México: FONART/FONOPAS, 1982; 319 p.

REGIONAL RESOURCES

Many Mexican government museums, universities, and government agencies publish, although most publishing is done through or in conjunction with the institutions listed under Mexico City (INBA, INAH, UNAM, SEP). Some of the more active regional publishers are listed below.

### Baja California

#### Centro Cultura Tijuana
Generally publishes jointly with the Gobierno del Estado de Baja California and SEP.

MONOGRAPHS

*Charro pintor: Ernesto Icaza.* Centro Cultural Tijuana, del 20 de noviembre al 21 de diciembre de 1986. Tijuana, 1986; n.p., color plates. Bilingual Spanish/English text.

*Exposición Guillermo Ceniceros: Alquimista de la forma.* México: SEP/Programa Cultural de las Fronteras/Museo Centro Cultura Tijuana, 1987–1988, n.p., b/w and color illus., bios.

### Querétaro

#### Universidad Autónoma de Querétaro

MONOGRAPHS

Anaya Larios, José Rodolfo. *Historia de la escultura queretana.* Colección Encuentro, No. 4. Querétaro: Universidad Autónoma de Querétaro, 1987; 134 p., b/w illus.

### Veracruz

#### Universidad Veracruzana. Jalapa Campus. Instituto de Antropología. (Pre-Columbian only)

MONOGRAPHS

Melgarejo Vivianco, José Luis. *Códice Coacoatzintlan.* Gobierno de Estado de Veracruz, 1984; 71 p., b/w illus.

#### Museo de Antropología de Xalapa (Pre-Columbian only)

MONOGRAPHS

Vizcaíno, Antonio. *Museo de Antropología de Xalapa.* Veracruz: Gobierno del Estado de Veracruz, 1988; 143 p., b/w and color illus.

### Puebla

#### Gobierno del Estado de Puebla, Centro Regional de Puebla

MONOGRAPHS

Aguilera, Carmen. *Códice Cospi.* México: Centro Regional de Puebla (INAH/SEP), 1988; 115 p., plus separate book of códice facs.

### Guadalajara

#### Universidad Autónoma de Guadalajara
Apdo. Postal 10440, 44100 Guadalajara, Jalisco. Escuela de Artes Plásticas.

**Tabasco**

**Gobierno del Estado de Tabasco. Instituto de Cultura de Tabasco**
Calle Sánchez Magallanes, Fraccionamiento. Portal del Agua, Lote 1, CP 886000, Villahermosa, Tabasco.

MONOGRAPHS

*Fontanelly Vasquez: Recuerdos en claroscuro.* Villahermosa: Gobierno del Estado de Tabasco, 1986; 45 p., b/w and color illus., wrps.

**Southern States of Mexico**

**Consejo Nacional para la Cultura y las Artes. Programa Cultural de las Fronteras.** (With the governors of the states of Campeche, Chiapas, Quintana Roo, Tabasco and Yucatán)
Argentina 12, 1ᵉʳ Piso, Oficina 219, 06020 México, D.F., Col. Centro.

SERIALS

*Cultura Sur.* First issue May-June 1989.

*Note:* There is a similar publication for the northern states entitled *Cultura Norte.*

# BIBLIOGRAPHY

Bailey, Joyce Waddell (Ed.). *Manual de arte latinoamericano: A Bibliographic Compilation.* 3 Vols. Santa Barbara: ABC-CLIO, 1986.

*Catálogo de publicaciones periódicas mexicanas de arquitectura, urbanismo y conexos.* Cuadernos de Arquitectura y Conservación del Patrimonio Artístico 30-31. México: INBA, 1985.

Catlin, Stanton Loomis, and Terence Grieder. *Art of Latin America since Independence.* New Haven, CT: Yale University Art Gallery; Austin: University of Texas Art Museum, 1966.

*Conclusiones: Simposio Interamericano de Conservación de Patrimonio Artístico.* Mexico: INBA, 1978.

*Enciclopedia del arte en América.* 5 vols. Argentina: OMEBA, 1968.

Findlay, James A. *Modern Latin American Art, A Bibliography.* Art Reference Collection, No. 3. Westport, CT: Greenwood Press, 1983.

Tovar de Teresa, Guillermo. *Bibliografía novohispana de arte.* 2 vols. Mexico: Fondo de Cultura Económica, 1988.

Valk, Barbara (Ed.). *Hispanic American Periodicals Index (HAPI).* Los Angeles: UCLA Latin American Center, 1978–.

# BOOKDEALERS

The following U.S. bookdealers handle Latin American government documents.

**Howard Karno Books**
P.O. Box 2100, Valley Center, CA 92082-9998
(619) 749-2304    FAX (619) 749-4390

**Libros Latinos**
P.O. Box 1103, Redlands, CA 92373
(714) 793-8423

**Steve Mullin**
> 456 Alcatraz Avenue, Oakland, CA 94609
> (415) 655-6799 (Mexico only)

**Vientos Tropicales**
> P.O. Box 16176, Chapel Hill, NC 27516
> (919) 967-9110 (Central America only)

# 22. El arte pictórico en la bibliografía boliviana

## Werner Guttentag Tichauer

Desde 1961 hasta 1988 se han registrado en la *Bio-bibliografía boliviana* 81 libros sobre arte o temas relacionados con él. Editar un buen libro de arte es muy costoso y, en general, sólo es posible si se hace una edición relativamente grande. Dado el pequeño consumo interno de Bolivia que requiere de una clientela de un cierto nivel económico y los escasos recursos de que disponen editoriales o instituciones públicas, la cantidad de libros sobre arte, de buena calidad, ha sido muy reducida dentro de la bibliografía boliviana; a pesar de contar con una considerable cantidad de pintores y escultores de extraordinaria fuerza creativa en todas las ramas del arte pictórico. Contamos en Bolivia, especialmente en La Paz, Cochabamba y Santa Cruz, con algunas buenas salas de exposición que continuamente exhiben pinturas o esculturas, sean éstas individuales o de un grupo de pintores, y aunque parezca increíble, todas esas salas no alcanzan para la gran producción de los artistas bolivianos.

Varios de ellos han realizado con éxito exposiciones en el exterior y algunos viven permanentemente—o por lo menos por ciertas épocas—en Estados Unidos o Europa, así como también en otros países de América del Sur.

De todas las exposiciones realizadas, hay muy pocos catálogos con ilustraciones fidedignas que correspondan a la verídica creatividad de cierto artista. Uno u otro catálogo, que sobresalió como impreso, ha sido tomado en cuenta en la *Bio-bibliografía boliviana*.

En diferentes revistas que esporádicamente se publican en Bolivia se pueden encontrar ensayos monográficos sobre el arte. También la prensa nacional, especialmente en sus suplementos, dedica un cierto espacio al arte nacional y aunque sus reproducciones son sumamente deficientes, por lo menos dan una idea aproximada sobre el artista y su obra.

Como país con una gran tradición de antiguas e importantes culturas, mayormente ya desaparecidas, antes y durante el coloniaje español, tenemos una rica herencia de arte prehispánico, así como

también una gran faceta del arte colonial de los 300 años de Virreinato Español.

Sobre desaparecidas civilizaciones, como por ejemplo el Imperio Tiwanakota y el Imperio Incaico, hay una cantidad de publicaciones arqueológicas, que en su mayoría tienen ilustraciones (dibujos o fotos) de las diferentes épocas de esos tiempos pasados.

Se puede decir que en el país hay más libros sobre el arte arqueológico y el arte virreinal que sobre el arte pictórico actual.

Aunque añadimos a este ensayo una bibliografía extensa de libros de arte de los últimos 27 años, algunos de los cuales son textos de nivel secundario del sistema educativo en Bolivia, me permito mencionar a continuación algunas obras anteriores y posteriores a 1961 que denotan especial importancia.

Aunque nuestras imprentas, especialmente anteriores a los últimos años, han sido relativamente primitivas y manejadas mayormente por gráficos empíricos, han podido producir, de vez en cuando, algunas obras destacadas sobre arte, de las cuales me permito indicar algunos ejemplos:

En 1952 Rigoberto Villarroel Claure publicó la obra *Arte contemporáneo: pintores, escultores y grabadores bolivianos*, un libro único en la bibliografía boliviana de la época como obra que, aunque describe el arte de 29 artistas en detalle, sólo contiene dos ilustraciones en color y varias otras en unicolor.

En 1957 se editó en los talleres gráficos del Colegio Don Bosco los tomos III y IV de *Tihuanacu, la cuna del hombre americano*, por Arthur Posnansky, financiado por el Ministerio de Educación a cargo de Fernando Diez de Medina (La Paz: Ministerio de Educación, 275 p., edición bilingüe inglés-castellano).

En 1956 José de Mesa y Teresa Gisbert escribieron una obra de 321 páginas, *Holguín y la pintura altoperuana del virreinato* (La Paz: Burrillo, 321 p.); una nueva edición muy mejorada se hizo en el año 1977.

Los mismos autores publicaron en 1961 *Un pintor orureño en el Cuzco: Fray Francisco de Salamanca*, editado por la Universidad Técnica de Oruro.

También hay algunos ensayos como el siguiente por Jean Russe (Seudónimo de Erasmo Barrios Villa), *El arte revolucionario y los desheredados* (La Paz: Casegural, 1958, 157 p.).

En lo que se refiere al período comprendido entre 1961 a 1988, entre todos los autores se destacan por sus conocimientos, su trabajo y su gran bibliografía el matrimonio José de Mesa y Teresa Gisbert, especialmente en lo que se refiere al arte virreinal, de cuya producción

sobresalen los siguientes libros: *Escultura virreinal en Bolivia* (La Paz, 1972); *Monumentos de Bolivia* (La Paz, 1978); *Museos de Bolivia* (La Paz, 1969), del cual saldrá en breve una nueva edición, y de Teresa Gisbert, Silvia Arze y Martha Cajías, *Arte textil y mundo andino* (La Paz, 1987).

Otro autor notable es el potosino Mario Chacón Torres, que se dedicó también a la misma época.

En los años 1961 a 1963 la Dirección nacional de Informaciones de la Presidencia de la República sacó una serie interesante llamada Biblioteca de Arte y Cultura Boliviana y aunque la mayoría de sus libros se refieren a la época colonial, hay algunos números sobre pintores modernos, así como también varios tomos dedicados a museos de Bolivia.

A pesar de no tener ilustraciones, son importantes el texto y bibliografía de *Los estudios de arte en Bolivia*, de Osvaldo Tapia Claure.

Antes de la Guerra del Chaco, vivió muchos años en Bolivia un extraordinario artista flamenco (grabador), Víctor Delhez, cuya biografía ilustrada, *El arte nocturno de Víctor Delhez*, ha sido escrita por don Fernando Diez de Medina en 1938, además de que muchos de sus magníficos cuadros fueron rescatados por el mismo autor, uno de los mejores escritores bolivianos. El mismo, en su libro de ensayos *Sueño de los arcángeles*, y en la edición de la novela *Mateo Montemayor*, ha publicado un sinnúmero de grabados de este artista que puede competir con el arte de Doré.

En 1988 se editó un libro del profesor universitario José Luis Gómez Martínez, de nacionalidad española, que estuvo varios años en el país: *Bolivia: Un pueblo en busca de su identidad*, que tiene aproximadamente 65 reproducciones de arte contemporáneo boliviano.

También cabe destacar la obra *Breve diccionario biográfico de pintores bolivianos contemporáneos, 1900–1985*, dirigida por el pintor Enrique Arnal Velasco, la misma que fue publicada en el año 1986.

El crítico de arte Armando Soriano tiene hace años una obra muy completa y bien ilustrada sobre el arte actual en una imprenta en La Paz, pero lamentablemente por razones posiblemente económicas, ese trabajo todavía no ha sido editado.

En la carátulas de muchos libros, se ha usado cuadros de pintores bolivianos, de los cuales habría que mencionar especialmente los cuadros de la Sra. Carmen Baptista y algunas carátulas de Gil Imaña y Carlos Rimasa.

Muchos libros, especialmente infantiles y de poesía, vienen ilustrados por artistas del país, así como hay algunas obras con excelentes caricaturas de artistas especializados en ese género.

La Unión de Poetas y Escritores de Cochabamba lanzó el año pasado un folleto mensual, en el cual siempre hay alguna obra poética y algún cuento o ensayo, así como ilustraciones de artistas conocidos en nuestro medio.

## BIBLIOGRAFIA DE ARTE BOLIVIANO

*Acuarela, acuarela, acuarela, acuarela.* Oruro: Universidad Técnica de Oruro, 1979. 92 pp.

Alcaldía Municipal, La Paz. *XXVI Salón Anual Pedro Domingo Murillo.* La Paz: Casa Municipal de la Cultura "Franz Tamayo", 1978. 20 pp.

Alurralde Alvarez, Víctor. *Breve historia popular del arte.* Sucre: América, 1962. 198 pp.

Aneiva, Teresa, Fernando Corrante y Francisco Cajías. *El templo de Sica Sica.* La Paz: Instituto Boliviano de Cultura, 1977. 43 pp.

*Arte popular en Bolivia.* La Paz: Instituto Nacional de Antropología, 1982. 144 pp.

Arnal Velasco, Enrique. *Breve diccionario biográfico de pintores bolivianos contemporáneos, 1900–1985.* La Paz: Inboi, 1986. 94 pp.

Baptista, Carmen. *Imagen y visión del amor.* La Paz: Aeronáutica, 1973. 36 pp.

Boeker, Paul. *Arte en la residencia del embajador de los Estados Unidos de América en Bolivia.* La Paz: Agencia de Comunicación Internacional de la Embajada de Estados Unidos, 1980. 32 pp.

Buschiazzo, Mario. *Arquitectura en las misiones de Mojos y Chiquitos.* La Paz: Instituto de Estudios Bolivianos, 1972. 63 pp.

Caballero, Geraldine de, y Rodolfo Mercado M. *Monumentos coloniales Cochabamba.* Cochabamba: Instituto de Investigaciones Antropológicas (UMSS), 1986. 70 pp.

Calvo, Marcelo. *Mística y paisaje.* La Paz: Juventud, 1986. 90 pp.

Cejudo Velázquez, Pablo. *Colorista del collao.* La Paz: Talleres Gráficos Bolivianos, 1966. 169 pp.

————. *Werner.* La Paz: Cromográfica Servia, 1966. 40 pp.

Consulado de la República Argentina. *Tercer Concurso de Artes Plásticas "Semana de Mayo".* Cochabamba: Consulado de la República Argentina, 1987. 12 pp.

Cuellar Aois, Jaime. *Nuevo testamento de Potosí.* Potosí: Gratec, 1988. 35 pp.

Chacón Torres, Mario. *Iconografía de Fray Vicente Bernedo.* Potosí: Editorial Potosí, 1988. 78 pp.

_____. *Pintores del siglo XIX.* Biblioteca de Arte y Cultura Boliviana serie pintores, 5. La Paz: Dirección Nacional de Informaciones, 1963. 58 pp.

_____. *Potosí histórico y cultural.* Potosí: Rotary Club Potosí, 1977. 136 pp.

Davitiants-Vartañan, Tatiana. *Marina Núñez y la escultura boliviana.* La Paz: Hoy, 1985. 16 pp.

*Exposición iconográfica de personajes ilustres siglo XIX–XX.* La Paz: Casa Municipal de la Cultura "Franz Tamayo", 1976. 22 pp.

Giménez Carrazana, Manuel. *Museo Charcas.* Biblioteca de Arte y Cultura Boliviana serie épocas y museos, 2. La Paz: Dirección Nacional de Informaciones, 1962. 29 pp.

Gisbert, Teresa, Silvia Arze, y Martha Cajías. *Arte textil y mundo andino.* La Paz: Gisbert, 1987. 315 pp.

Gisbert, Teresa. *Iconografía y mitos indígenas en el arte.* La Paz: Gisbert, 1980. 250 pp.

_____. *La arquitectura militar en Bolivia.* La Paz: Aeronáutica, 1977. 10 pp.

Gómez Martínez, José Luis. *Bolivia: 1952–1956.* La Paz: El autor, 1987. 282 pp.

_____. *Bolivia: un pueblo en busca de su identidad.* Colección Enciclopedia Boliviana. Cochabamba: Los Amigos del Libro, 1988. 384 pp.

Guerra Gutiérrez, Luis. *Proceso de los conceptos estéticos en la escultura prehistórica de Oruro.* Oruro, 1969. 19 pp.

Ibañez Cueller, Mario, y Virgilio Suárez Salas. *Chiquitos misiones jesuíticas.* Santa Cruz: Universidad Boliviana "Gabriel René Moreno", 1976. 48 pp.

Instituto Boliviano de Cultura. Instituto Andino de Artes Populares. *Arte popular en Bolivia.* La Paz: IBC/IADAP, 1988. 49 pp.

*Jiwasan Arusawa.* La Paz: CIPCA y Radio San Gabriel, 1976. 45 pp.

Larrazábal, Hernando, Edgar Pita, y Carlos Toranzo. *Artesanía rural boliviana.* La Paz: CEDLA/ILDIS, 1988. 384 pp.

Linares Málaga, Eloy. *Como inventariar arte rupestre en los Andes meridionales*. La Paz: Casa Municipal de la Cultura "Franz Tamayo", 1979. 124 pp.

Mariaca G., Raúl, y Héctor E. Lazarte. *Exposición de arte*. La Paz: Banco Nacional de Bolivia, 1902. 59 pp.

*Memoria: primer encuentro de artesanos productores en arte popular de La Paz*. La Paz: Federación Departamental de Artesanos Productores en Arte Popular, 1982. 46 pp.

Mendieta Pacheco, Wilson. *Potosí: Patrimonio de la humanidad*. Potosí: Editora Siglo, 1988. 171 pp.

Mesa, José de, y Teresa Gisbert. *Bernardo Bitti*. Biblioteca de Arte y Cultura Boliviana serie artistas, 2. La Paz: Dirección Nacional de Informaciones, 1961. 30 pp.

————. *Bitti: un pintor manierista en Sudamérica*. La Paz: Instituto de Estudios Bolivianos (UMSA), 1974. 116 pp.

————. *Contribuciones al estudio de la arquitectura andina*. Serie ciencias de la cultura, I. La Paz: Academia Nacional de Ciencias de Bolivia, 1966. 102 pp.

————. *El arte en Perú y Bolivia: 1800–1840*. La Paz: Universidad Mayor de San Andrés, 1966. 43 pp.

————. *El pintor Mateo Pérez de Alesio*. La Paz: Universidad Mayor de San Andrés, 1972. 130 pp.

————. *Escultura virreinal en Bolivia*. La Paz: Academia Nacional de Ciencias de Bolivia, 1972. 490 pp.

————. *Gaspar Berrío*. Serie artistas. La Paz: Dirección Nacional de Informaciones, 1962. 14 pp.

————. *Gaspar de la Cueva*. Biblioteca de Arte y Cultura Boliviana serie escultores, 3. La Paz: Dirección Nacional de Informaciones, 1963. 71 pp.

————. *Gregorio Gamarra*. Biblioteca de Arte y Cultura Boliviana serie artistas, 3. La Paz: Dirección Nacional de Informaciones, 1962. 14 pp.

————. *Holguín*. 2d ed. La Paz: Juventud, 1977. 358 pp.

————. *Iglesias con atrio y posas en Bolivia*. La Paz: Del Estado, 1962. 24 pp.

————. *Iglesias de Oruro*. Biblioteca de Arte y Cultura Boliviana serie monumentos, 2. La Paz: Dirección Nacional de Informaciones, 1962. 54 pp.

_____. *La tradición bíblica en el arte virreinal*. Colección texto y documento. La Paz: Los Amigos del Libro, 1987. 33 pp.

_____. *Las series de ángeles en la pintura virreinal*. La Paz: Aeronáutica, 1976. 7 pp. (Separata de la *Revista Aeronáutica*, núm. 31)

_____. *Leonardo Flores*. Biblioteca de Arte y Cultura Boliviana serie pintores, 1. La Paz: Dirección Nacional de Informaciones, 1963. 39 pp.

_____. *Los ángeles de Calamarca*. La Paz: Compañía Boliviana de Seguros, 1983. 18 pp.

_____. *Melchor Pérez de Holguín*. Biblioteca de Arte y Cultura Boliviana serie artistas, 1. La Paz: Dirección Nacional de Informaciones, 1961. 28 pp.

_____. *Monumentos de Bolivia*. 2d ed. La Paz: Gisbert, 1978. 197 pp.

_____. *Museo de la Casa de la Moneda*. Biblioteca de Arte y Cultura Boliviana serie épocas y museos, 5. La Paz: Dirección Nacional de Informaciones, 1962. 13 pp.

_____. *Museo Nacional de Arte*. La Paz: Ministerio de Educación y Cultura, (s.f.). 17 pp.

_____. *Museos de Bolivia*. La Paz: Ministerio de Información, Cultura y Turismo, 1969. 180 pp.

_____. *Pinacoteca de San Francisco*. La Paz: Universidad Mayor de San Andrés, 1973. 58 pp.

_____. *Pinacoteca nacional*. Biblioteca de Arte y Cultura Boliviana serie épocas y museos, 1. La Paz: Dirección Nacional de Informaciones, 1961. 29 pp.

_____. *Pintura contemporánea*. La Paz: Dirección Nacional de Informaciones, 1962. 50 pp.

_____. *San Francisco de la Paz*. Biblioteca de Arte y Cultura Boliviana serie monumentos, 1. La Paz: Dirección Nacional de Informaciones, 1962. 25 pp.

Ministerio de Educación y Bellas Artes. *Patrimonio artístico*. La Paz: Editorial del Estado, 1962. 16 pp.

Mollins, Jaime. *La ciudad única: Potosí*. 307 pp.

Parroquias de Moxos. *Historia cultural de Mojos*. Cochabamba: Parroquias de Moxos, 1988. 57 pp.

Pérez E., Edwin, J. Gonzalo Morales, y Rolando Jordán U. *Artes plásticas*. La Paz: Bruño, 1987. 354 pp.

Portugal, Maks. *Casa de Murillo.* Biblioteca de Arte y Cultura Boliviana serie épocas y museos, 4. La Paz: Dirección Nacional de Informaciones, 1962. 30 pp.

*Primera Exposición de Arte Boliviano Contemporáneo 1974.* La Paz: Asociación Boliviana de Artistas Plásticos, 1974. 36 pp.

Quintana Aramayo, Rafael. *La estética y el arte en la cultura nacional.* Potosí: Universitaria, 1967. 272 pp.

_____. *Reflexiones en torno al arte nacional.* Potosí: Universidad Tomás Frías, 1964. 52 pp.

*Revista del Museo Nacional de Etnografía y Folklore.* La Paz: MUSEF, 1988. 319 pp.

*Salón de arte moderno Arturo Borda.* La Paz: Municipalidad de La Paz, 1977. 21 pp.

Selaya Rodríguez, Amanda. *Arte y folklore.* Potosí: Universidad Tomás Frías, 1968. 22 pp.

Solón Romero, Wálter. *El quijote y los perros.* 10 pp.

Suárez Saavedra, Fernando. *Historia del arte.* Sucre: Talleres Gráficos Qori Llama, 1982. 243 pp.

Tapia Claure, Osvaldo. *Los estudios de arte en Bolivia.* La Paz: Instituto de Investigaciones Artísticas, 1966. 112 pp.

Vaca, Lorgio. *Murales.* Santa Cruz: Casa de la Cultura "Raúl Otero Reiche", 1984. 12 pp.

Valbert, Christian. *La iconografía simbólica en el arte barroco de Latinoamérica.* La Paz: Los Amigos del Libro, 1987. 122 pp. (Traducido del portugués)

Vázquez Machicado, Humberto. *Estudios sobre la cultura cruceña.* Santa Cruz: Oriente, 1988. 160 pp.

Villarroel Claure, Rigoberto. *Emiliano Luján.* Biblioteca de Arte y Cultura Boliviana serie escultores, 1. La Paz: Dirección Nacional de Informaciones, 1962. 14 pp.

_____. *Introducción a la historia boliviana del arte.* La Paz: Municipalidad de La Paz, 1967. 40 pp. (Separata de la revista *Khana,* núm. 39)

_____. *Marina Núñez.* Biblioteca de Arte y Cultura Boliviana serie escultores, 2. La Paz: Dirección Nacional de Informaciones, 1962. 40 pp.

_____. *Teorías estéticas y otros estudios.* La Paz: Casa Municipal de la Cultura "Franz Tamayo", 1976. 200 pp.

# 23. Art Publishing in the Contemporary Caribbean

## Alan Moss

Let me begin with a qualification. While it is true to say that my remarks bear upon art publishing in the contemporary Caribbean, it would be equally true to say that they relate almost exclusively to the contemporary English-speaking Caribbean, the part of the Caribbean that I know best.

It would appear that there is no long-standing tradition of exhibiting works of art in the English-speaking Caribbean. As recently as 1930 "the very first group exhibition of art and craft"[1] was being held in what was then British Guiana, to be followed soon afterward by the formation of the Art and Craft Society of British Guiana; it was only in 1931 that Edna Manley was exhibiting her sculptures in Jamaica for the first time, although she had by then been living and working in the island for almost ten years; and it was not until 1944 that the inaugural exhibition of the Barbados Arts and Crafts Society was held. I am unable to state with certainty that there were no forerunners of the two societies in their respective countries, but it seems unlikely in view of the almost self-deprecatory names they chose to adopt, as "art," as opposed to "arts and crafts," was considered too lofty a height to be aspired to in the climate of the times.

Without this tradition, in a region which is more developing than developed, and in which as recently as forty years ago even the literary arts had to rely for the most part on overseas publishing houses to provide an avenue for their expression, it is hardly surprising that publishing in the field of the visual arts has not been particularly vibrant. For art publishing is a sophisticated branch of the trade; to be carried out successfully one needs access not only to sophisticated printing establishments but also to a sophisticated clientele to consume the product. There must be capital available to finance the relatively heavy investment required for such publications, and the book-buying public must have both the taste and the ability to buy them. Art publishing, then, comprises only a small fraction of current output in the Caribbean, but there are signs that the fraction is growing, and on more than one front.

269

It is a commonplace to observe that one of the weaknesses of the book trade in the English-speaking Caribbean is the relative dearth of publishing houses. Books are published, but all too often it is not a publisher as such who issues the work but rather the author, or perhaps an organization whose raison d'etre is other than publishing. The absence of a strong art publishing sector is therefore but a symptom of a more general problem.

A variety of methods have been used in the arts to circumvent this weakness. There have been cases where the artist has done as the author of a literary work might do, and publish himself. *Vincent*[2] by Karl Broodhagen, a series of sketches of his young son by Barbados's leading sculptor, may be cited as an example. As happened in this instance, however, the publisher's lack of expertise at his adopted trade may result in an excellent publication not achieving the success it deserves for lack of proper marketing and distribution. Or the author/artist may form himself into a company for the purpose of issuing the books he wishes to see published. Art Heritage Publications, publishers of *Historic Churches of Barbados*,[3] by Barbara Hill and joint publishers of the second edition of *Historic Houses of Barbados*,[4] would be a case in point. Doubtless there are advantages in such an approach, but it is still largely the capital of the individual concerned which is at risk.

But more often it has been an organization that sees art publishing as a legitimate part of its broader role that has filled the breach. Still in Barbados we have the Barbados National Trust, publishers in 1982 of the first edition of *Historic Houses of Barbados*[5] by Fraser and Hughes, and in the U.S. Virgin Islands the St. Croix Historic Landmarks Society, which in 1975, in conjunction with the Dansk Vestindisk Selskab, issued *St. Croix, St. Thomas, St. John: Danish West Indian Sketchbook and Diary, 1843-44*[6] by a Philadelphia clergyman, Henry Morton. The latter work was in fact produced in Denmark. That the Society was able independently to publish a book of almost comparable complexity, *Historic Churches of the Virgin Islands*[7] by William Chapman and William Taylor in 1986, and to have the work done in St. Croix, is perhaps indicative both of a growing confidence and an expanding technical ability.

One of the more successful examples of art publishing in Barbados, *Parkinson's Barbados*,[8] was financed by a trust established for the purpose, Barbadian Heritage Publications Trust, utilizing funds solicited mainly from business houses. A fine collection of photographs by one of Barbados's earliest photographers, Henry Walt Parkinson, it is said to have sold more than 8,000 copies in the five or six years that

it was in print, but since we still await no. 2 in the series (it was published as *Barbados Yesterday and Today*, no. 1), it seems that success even on this scale does not necessarily bring with it the momentum that one might expect.

Happily, in more recent years permanent public galleries have been established in some of the territories, and the publication of exhibition catalogs has made a significant contribution to the availability of reproductions of local artists' works, and information on them. The National Gallery of Jamaica, established in independent premises in 1975, has mounted major retrospective exhibitions of Jamaican artists such as Kapo, Carl Abrahams, and Edna Manley, as well as a variety of group exhibitions. Many of the exhibition catalogs remain in print and provide a unique source of reference on Jamaican art.

In Barbados, while the National Art Collection Foundation pursues its plans for the establishment of a permanent national gallery, three other organizations perform some of the functions of such a gallery, the Barbados Museum and Historical Society, the National Cultural Foundation, and the Barbados Arts Council. The Museum has been able in recent years to organize retrospective exhibitions on the works of Golde Waite (who was instrumental in organizing the 1930 British Guiana exhibition referred to above), and of Hector Whistler, while the National Cultural Foundation's gallery in Queen's Park has since 1985 mounted a regular series of exhibitions, and it is also the venue for the annual National Art Collection Exhibition and Competition, from which the nucleus of a national collection is selected. The catalogs published for these exhibitions, often with the assistance of a sponsor, have a value far beyond the life of the exhibitions themselves. The Barbados Arts Council's exhibitions at its Pelican Gallery are not normally accompanied by substantial catalogs, but it did publish in 1984 a useful *Directory of Artists in Barbados*[9] which makes available in a single source information not otherwise easy to come by.

Both the National Gallery of Jamaica and the National Cultural Foundation in Barbados have associated with them journals that must be numbered among the significant examples of art publishing in the contemporary Caribbean. Although now housed in separate quarters, the National Gallery of Jamaica is an offshoot of the Institute of Jamaica, whose *Jamaica Journal*,[10] with the demise of *Arts Jamaica*,[11] has no serious challenger as the leading periodical on the arts in the English-speaking Caribbean, even though its scope ranges far beyond the arts alone. And the National Cultural Foundation's *Banja*,[12] a much newer face on the scene, regularly features the visual arts among

the variety of topics it covers. Both journals are characterized by a seriousness of intent and a high standard of production.

None of the sources of art publishing so far noted have been publishers in the sense of organizations that exist mainly in order to publish, and in the hope, if not the expectation, of making a profit. It is encouraging to be able to report, however, that there are such publishers; encouraging because if such houses are able to survive as viable operations they are evidence that a market exists which will surely demand to be satisfied, one way or another, and thus ensure for the genre of art publishing a future more secure than the past has proved to be. The companies I have in mind are both Trinidadian, Aquarela Galleries and Paria Publishing Co. Ltd.

Aquarela Galleries has an impressive list of seven current titles, all but one of which can be described as art books, including a portfolio [13] of eleven reproductions of watercolors by the Trinidadian nineteenth-century master Michel Jean Cazabon, and an illustrated biography [14] of Cazabon by Geoffrey MacLean. Their publications are technically of a very high quality, with the work often being contracted outside of the region, presumably in order to reach a standard not achievable in Trinidad. It can cause the interesting anomaly of a book with a Trinidadian imprint bearing a Spanish ISBN, but it also results in books that are a pleasure to handle and consult.

Paria is perhaps more a general publisher than Aquarela, having issued histories of Trinidad, literary works, and children's books, but like Aquarela they can be considered publishers of "quality" material, whatever they issue. One of their earlier art publications, *This Old House* [15] by Gerald G. Watterson, a series of line drawings and descriptions of examples of vernacular architecture in Trinidad, formed part of what seemed at the time to be almost a rash of similar works appearing throughout the Caribbean. In addition to Fraser and Hughes's *Historic Houses of Barbados* (1982) there were *Jamaican Houses* (1983), [16] by Geoffrey de Sola Pinto and Angehelen Arrington Phillips, and, also from Trinidad, John Newel Lewis's *Ajoupa* (1983), [17] all of them serving to make us more aware of buildings which perhaps we were passing without even the most cursory of appreciative glances. A later Paria title, Gerard Bresson's *A Photograph Album of Trinidad at the Turn of the Century*, [18] produced in Trinidad, does full justice to the inherent interest of the subject matter, while their very recent *Maps of the Town of Puerta de Espana as in 1757, 1808, and 1845*, [19] three sheets issued in a folder, is an imaginative addition to the range of material a book publisher might wish to offer.

It is ironic that after my earlier reference to Guyana I have not been able to find the opportunity to mention that country again. I cannot claim the degree of expertise in Guyanese publications which would enable me to state that there are in effect no Guyanese art publications of substance, but I can say that with the exception of Goodall's *Sketches of Amerindian Tribes*,[20] published in London in 1977 for the National Commission for Research Materials on Guiana, few have crossed my path. And indeed it would seem to follow from my earlier remarks that one would not expect there to be an abundance of them, for resources are scarce in Guyana, and so it requires a proportionately greater effort to see that some at least are channeled into the arts. This, of course, is what makes that standard-bearer in another field, *Kyk-over-al*, perhaps even more a miracle in Guyana than it would be elsewhere. But the source of my early reference is itself a major recent publication on the arts in Guyana, *60 Years of Women Artists in Guyana, 1928–1988: A Historical Perspective*,[21] issued to coincide with a retrospective exhibition of the work of women artists in Guyana, which through its biographical sketches of Guyanese women artists and the many examples of their work is able to demonstrate that the artistic tradition has remained alive in Guyana since those early days.

While it may be true, then, that sixty or so years ago art publishing in the English-speaking Caribbean was at best dormant, today it is alive, well, and looking to become better still.

## NOTES

1. *60 Years of Women Artists in Guyana, 1928–1988: A Historical Perspective*, gen. ed., Nesha Z. Hanniff, contrib. writers and researches, O'Donna Allsopp et al. ([Georgetown]: Guyana Women Artists Association, 1988).

2. Karl R. Broodhagen, *Vincent: Drawings* [s.l.: s.n.], 1982.

3. Barbara Hill, *Historic Churches of Barbados*, Henry Fraser, ed. (Barbados: Art Heritage Publications, 1984).

4. Henry Fraser and Ronnie Hughes, *Historic Houses of Barbados*, 2d ed., rev. and enl. ([Bridgetown]: Barbados National Trust and Art Heritage Publications, 1986).

5. Henry Fraser and Ronnie Hughes, *Historic Houses of Barbados: A Collection of Drawings by Henry Fraser*, with historical and architectural notes by Ronnie Hughes and Henry Fraser ([Bridgetown]: Barbados National Trust and Art Heritage Publications, 1982).

6. Henry Morton, *St. Croix, St. Thomas, St. John: Danish West Indian Sketchbook and Diary/Skitsebog og dagbog fra Dansk Vestindien, 1843-44* (Copenhagen: Dansk Vestindisk Selskab and St. Croix Historic Landmarks Society, 1975.

7. William Chapman and William Taylor, *Historic Churches of the Virgin Islands* (St. Croix: St. Croix Historic Landmarks Society, 1986).

8. *Parkinson's Barbados*, Barbados Yesterday and Today, 1 (St. Michael: Barbadian Heritage Publications Trust, 1978).

9. *Directory of Artists in Barbados* ([Bridgetown]: Barbados Arts Council, 1984).

10. *Jamaica Journal: Quarterly of the Institute of Jamaica* (Kingston), 1– (1967–).

11. *Arts Jamaica: A Visual Arts Quarterly* (Kingston), 1–4, 1/2 (1982–1985). Subtitle varies.

12. *Banja: A Magazine of Barbadian Life and Culture* (St. James), 1– (1987–). Twice a year.

13. *Michel J. Cazabon: The William Hardin Burnley Collection* (Port-of-Spain: Aquarela Galleries, 1988).

14. Geoffrey MacLean, *Cazabon: An Illustrated Biography of Trinidad's Nineteenth-Century Painter, Michel Jean Cazabon* (Port-of-Spain: Aquarela Galleries, 1988).

15. Gerald G. Watterson, *This Old House: A Collection of Drawings of Trinidadian Houses* (Port-of-Spain: Paria Publishing Co., [1983]).

16. Geoffrey de Sola Pinto, *Jamaican Houses: A Vanishing Legacy*, drawings by Angehelen Arrington Phillips, text by Geoffrey de Sola Pinto (s.l.: s.n.,] 1982).

17. John Newel Lewis, *Ajoupa* (Trinidad: The author, 1983).

18. Gerard Bresson, *A Photograph Album of Trinidad at the Turn of the Century* (Port-of-Spain: Paria Publishing Co. Ltd., 1985).

19. *Maps of the Town of Puerta de Espana as in 1757, 1808, 1845* (Port-of-Spain: Paria Publishing Co. Ltd., 1988).

20. Edward A. Goodall, *Sketches of Amerindian Tribes, 1841–1843*, with an intro. by M. N. Menezes (London: British Museum Publications for the National Commission for Research Materials on Guyana, 1977).

21. See n. 1.

## ADDRESSES

Aquarela Galleries, 1a, Dere Street, Port-of-Spain, Trinidad.

Arts Jamaica, P.O. Box 79, Kingston 8, Jamaica.

Barbados Museum and Historical Society, St. Ann's Garrison, St. Michael, Barbados.

Barbados Arts Council, 2-3, Pelican Village, St. Michael, Barbados.

Barbados National Trust, Ronald Tree House, , 10th Avenue, Belleville, St. Michael, Barbados.

Institute of Jamaica Publications, Ltd., 2a, Suthermere Road, Kingston 10, Jamaica.

National Cultural Foundation, West Terrace, St. James, Barbados.

National Gallery of Jamaica, Kingston Mall, 12, Ocean Boulevard, Kingston, Jamaica.

Paria Publishing Co. Ltd., Newtown, Port-of-Spain, Trinidad.

St. Croix Historic Landmarks Society, P.O. Box 2855, Fredericksted, St. Croix, U.S. Virgin Islands 00840.

# 24. Colombia: ¿Atenas suramericana . . . o apenas suramericana?

## J. Noé Herrera C.

Los siguientes son textos de preguntas y respuestas extractados de la crónica-reportaje "Colombia en las calles de New York: así nos ven", elaborada por Javier Castaño y publicada en el diario *El Tiempo*, de Bogotá, en su edición del 29 de enero de 1989. Son textos que, sin necesidad de explicación, podrían representar el concepto que de Colombia se tiene en los extractos medios (cultural, social y económicamente hablando) de la población de los Estados Unidos: un pueblo al cual nadie le discute la pretensión de ser el mejor informado del mundo.

"¿Qué sabe usted sobre Colombia?"
"Es el cuartel general de la droga".

"¿Qué piensa usted sobre Colombia?"
"Cualquier país que promueva (sic) la droga . . . no merece pertenecer a la comunidad de las naciones".

"¿Conoce usted algún intelectual o artista de Colombia?"
"No". (Education Consultant, The New York Public Library)

Jugando a la ironía, el título de mi ponencia, este estupendo interrogante, hecho en forma de graffiti en algún muro bogotano, formuló el tema que me sirvió de pretexto y que me orientará en el desarrollo de este trabajo: ¿artísticamente, qué es Colombia, la Atenas Suramericana . . . o apenas Suramericana? Trabajo con el cual no pretendo curar la ignorancia supina del presunto consejero educativo entrevistado en la crónica-reportaje citado; pero sí atender la amable solicitud de la Presidenta de SALALM.

El interrogante, empero, tiene su historia. Cuando Colombia no era todavía el matadero humano en que lo han convertido las guerrillas filocomunistas y otros criminales, ni la caldera del diablo montada por los traficantes del vicio y el crimen para atender el no menos criminal negocio del consumo de drogas, Colombia—y más concretamente

Bogotá—se había distinguido por el culto de las letras, hasta el punto que el renombrado crítico e historiador español de la literatura, Marcelino Menéndez y Pelayo, había expresado "la cultura literaria en Santa Fé de Bogotá, destinada a ser con el tiempo la Atenas de la América del Sur, es tan antigua como la conquista misma . . .".[1]  La opinión de Menéndez y Pelayo fue inclusive reiterada posteriormente por visitantes extranjeros como Miguel Cané, quienes conmovidos y agradecidos por la hospitalidad social e intelectual que les había brindado Bogotá, la calificaron de nuevo como la Atenas Suramericana. Calificación que los colombianos de entonces agradecieron hasta el punto de llegar a creer ingenuamente en ella; pero de la cual—como lo indica el graffiti en referencia—los colombianos de ahora preferimos hacer un chiste.

Concretando, es decir, prescindiendo de las figuras literarias y regresando al tema por desarrollar, se hace necesario, empero, delimitar la temática que en este trabajo se tratará de exponer: el arte colombiano, su desarrollo y su divulgación, bibliográfica primordialmente. Es evidente que ni a Bogotá, ni en general a Colombia, ni artística ni culturalmente, se puede aplicar el título de Atenas Suramericana. Es decir, no se puede catalogar a una u otra como el más decantado y fecundo núcleo artístico o cultural del sur del continente americano. ¿Pero, está Colombia culturalmente ahora, a la altura de la América del Sur, aunque sea sólo por aproximación, como lo sugiere el graffiti de nuestra historia? Por no ser historiador ni crítico de arte, me abstendré de entrar a resolver con juicios críticos y disquisiciones estéticas o filosóficas el anterior interrogante. Limitándome a señalar hechos históricos, conceptos autorizados, datos bibliográficos y nombres representativos útiles para que, quien lo desee, analice el asunto y llegue a sus propias conclusiones.

### Orígenes del arte colombiano

La imprenta, sin la cual la divulgación del arte, por lo menos bibliográficamente, hubiera sido imposible, fue traída a Colombia por los españoles. Aunque, según el historiador Félix Raffán Gómez, en su *Historia de Florida—Valle*, inédita, la primera imprenta había sido introducida a Colombia (entonces Presidencia de la Nueva Granada, o sea la misma Real Audiencia, establecida desde 1550, pero dotada con funciones político-administrativas) en 1669, la verdad históricamente demostrada es que la primera imprenta fue traída a la Nueva Granada por la Compañía de Jesús y comenzó a funcionar en 1738.[2]

Del arte no podría decirse lo mismo que de la imprenta, pues su cultivo, aunque rudimentario, se había iniciado antes de la llegada de

los españoles. Y así lo ratifican el Museo del Oro del Banco de la República en Bogotá; el Parque Arqueológico de San Agustín, lugar donde parece que la humanidad encontró asilo para pensar y expresarse en piedra; las ruinas mismas de la Ciudad Perdida de los Tairona en los alrededores de la Sierra Nevada de Santa Marta, y muchos otros testimonios plasmados en barro, madera, cobre u oro por anónimos artistas y artesanos precolombinos. De todo lo cual hay un extenso inventario.[3]

Refiriéndose a los orígenes del arte colombiano, Eugenio Barney Cabrera escribió que "desde épocas precolombinas sobresale en el panorama indígena la actividad de ceramistas y orfebres, de escultores y artífices . . . (quienes) concibieron un arte que en sus respectivas especialidades emula con el mejor del continente".[4] Concepto que también expuso Roberto Pizano Restrepo: "El sentimiento artístico tiene hondas raíces en el pueblo colombiano. . . . En la civilización precolombina le corresponden honroso lugar, pues, suyos fueron los mejores orfebres del Continente, que modelaron el oro con habilidad maravillosa. . . . Si en la pintura no pasaron de una sencillez primitiva . . . dejaron, en cambio, admirables obras de cerámica y alfarería".[5] Pero, como apunta Juan de Garganta, "las culturas precolombinas existentes en Colombia pertenecen al estadio neolítico" que sólo cultivaron la pintura como decorativa de la escultura y reducida al negro, rojo y amarillo".[6] "De igual manera que la arquitectura, aún más que ella, la pintura fue entre los indios colombianos un arte incipiente, que jamás logró rebasar los límites del más absoluto primitivismo", según el pintor Luis Alberto Acuña.[7] Más como escribió Angel Guido, "pequeña o grande, transcendente o efímera, la cultura del hombre americano era, de cualquier modo que se la aprecie, cultura, al fin. Y al decir 'cultura' va implícito todo un repertorio de valores concomitantes: religión, política, economía, filosofía, idioma y algo fundamental para nosotros: Arte".[8]

Está demostrado, empero, cómo la llegada de los españoles marca el arribo del arte occidental y con él el inicio del arte neogranadino o arte colonial colombiano,[9] que se nutre inicialmente en los lenguajes estéticos europeos, representados por las tallas y pinturas embarcadas desde España como ayudas pedagógicas de los misioneros en su tarea evangelizadora. Ayudas educativas que visualizan lo sagrado, lo religioso, lo místico y convierten la imaginería en un lenguaje más potente que la palabra misma, en el "arma" más poderosa para convertir el Continente Americano al Cristianismo. "El arte de la pintura occidental penetra al Nuevo Reino (de Granada) con el Cristo de la conquista. Es el guión místico que presidió la hazaña . . .".[10]

Tesis también sustentada por Alvaro Gómez Hurtado, cuando observa cómo la apologética de los misioneros recurrió al arte en todas sus expresiones para atraer a los indígenas e imponerles los cultos católicos. Y la pintura y la imaginería se convirtieron en elementos de convicción para franquear la barrera casi insalvable de la multiplicidad de lenguas.[11] Idea que amplía Francisco Gil Tovar cuando escribe: "El arte occidental llegó a Colombia, como a toda América de la mano de la Iglesia" y como medio evangelizador sobre todo. Y durante los tres siglos de la dominación española no sólo predominó lo religioso en el temario artístico, sino que en la Iglesia y en sus feligreses tuvieron los artistas neogranadinos sus mejores clientes. Y lenta, casi imperceptible, se iba operando mientras tanto la transculturación de temas, formas y signos expresivos, la fusión y confusión de estilos, que generaría las actitudes o tendencias que los expertos han encontrado o distinguido en el devenir artístico neogranadino durante el período trisecular de la independencia de España: la actitud hispana y criolla, con la modalidad virreinal; la mestiza y la popular.

"La producción artística y artesana de aquel período", enfatiza Francisco Gil Tovar, "estuvo en su inmensa mayoría al servicio de las devociones y del culto religioso. Tanto que casi resulta redundante hablar de *Arte religioso colonial* en Colombia. La conquista y la colonización de la América Española, ya se sabe, fueron paralelas a la evangelización, al punto de haber sido calificadas de conquista de lo divino; por eso, casi todas las obras de pintura, escultura, orfebrería y otras artes fueron en un comienzo elementos de 'Propaganda Fide', ayudas visuales para la propagación de la fe apoyada en las recomendaciones del contemporáneo Concilio de Trento; más tarde, fueron imágenes de devoción y de culto; siempre, signos de cultura cristiana. Más que su originalidad, sus calidades estéticas y su riqueza material (que de todas formas se da en muchos casos) interesaba su eficacia; más que sus bellezas formales, su sinceridad religiosa . . .".[12] "Los frailes, que en el puerto de Sevilla—el único al que el Consejo de Indias permitía comercio con el Nuevo Mundo—(puntualiza Francisco Gil Tovar) embarcaban para las tierras colonizables no eran diletantes, artistas ni críticos: eran misioneros que, si cargaban cuadros en su equipaje, los cargaban como objetos de culto y de evangelización. No venían (esos frailes) a fundar museos sino iglesias y capillas para encomenderos, en gran parte analfabetos, soldados e indios".[13] Con razón anota Carlos Arbeláez Camacho: "Puede probarse documentalmente, una insistencia tozuda si se quiere por parte de los sínodos, en el sentido de mantener el arte representativo al servicio de los

estímulos religiosos y de hacer énfasis en la finalidad docente de las pinturas y esculturas".[14]

## Mestizaje amplio y transculturación limitada

Se debe observar cómo, no obstante ser Colombia "casa de esquina de América", es decir, punto de paso obligado de Norte a Sur (entonces no había perdido a Panamá), vecina del Atlántico y del Pacífico, artísticamente no resultó favorecida por el constante cruce de influencias foráneas que su posición geográfica implicaba, si se compara la suya con la herencia artística colonial de otras partes del Continente.

Como lo observa Guillermo Hernández de Alba, el arte colonial santafereño puede parecer pobre comparado con el de México, Lima o Quito. Pero es digno de anotar cómo "sin escuelas de artes, sin escuelas de arquitectura", sólo con la guía de uno que otro maestro foráneo, los artistas y artesanos neogranadinos plasmaron los valores estéticos de su tiempo en obras que aún hoy atraen el interés y aún la admiración de críticos y profanos del arte en Cartagena, la Heroica; Tunja, la Mística; Popayán, la Hidalga; y en Santa Fe de Bogotá.

Introducido por los españoles, el arte occidental no sólo quedó condicionado en su desarrollo en la Nueva Granada, a los diques a la transculturación imponía el régimen colonial, empezando por la restricción inmigratoria. También el medio ambiente habría de condicionar su desarrollo. Frenada la inmigración demográfica y restringida—por el limitado comercio bibliográfico—la influencia intelectual foránea, el amplio mestizaje racial no correspondía el nivel de transculturación que se cumplía al mismo tiempo en otros lugares del continente. La carencia de una gran riqueza minera y la más bien tardía utilización durante la colonia de su favorable posición geográfica, que tampoco implicó la incorporación de las regionales al desarrollo, impidieron a la Nueva Granada alcanzar el status económico que disfrutaban otras colonias españoles en el Nuevo Mundo, como Nueva España y Perú. Todo lo cual se refleja y explica en la jerarquización político-administrativa que dentro de sus dominios coloniales España dio a la Nueva Granada, elevada a virreinato solamente en 1739, mientras que México y Lima ostentaban ese categoría desde dos siglos antes. Los mismos doscientos años que, comparada con México, tardó Bogotá en tener instalada su primera imprenta.

Empero, como lo anota Gómez Hurtado, el arte colonial neogranadino, "subyugado por la voluntad política de la evangelización americana", tuvo el propósito hispánico de que en este Nuevo Mundo fuera una extensión de la Cristiandad" y como expresión homogénea de una peculiar concepción del mundo, durante los tres siglos de

predominio e influencia de España fue un instrumento idóneo y efectivo en el servicio y la divulgación de los ideales de ese gigantesco proyecto histórico que fue la colonización española. Tan gigantesco que abarca todo "el concepto geográfico del mundo, el equilibrio universal de las fuerzas políticas, la vigencia del mercantilismo, la formación de la cultura, la redención del hombre y la glorificación de Dios".[15]

### ¿Anti-estilo, estilo de la pobreza o barroco natural?

Resulta conveniente resaltar cómo, si bien parece cierto que "el estilo de la pobreza" o "anti-estilo bogotano", como denominó Marta Traba al arte neogranadino de principios de la Colonia, "no alcanza definiciones y logros estéticos" que lo coloquen en "la órbita del arte y la cultura universales" y "ni siquiera tiene repercusión fuera de la historia interna del país",[16] para autorizados críticos e historiadores del arte, como Francisco Gil Tovar, de los tres siglos durante los cuales dependió de España, Colombia conserva un patrimonio artístico notable, representado por la arquitectura, la escultura, la pintura, la orfebrería, el mobiliario y la talla ornamental, atesorados en primer lugar en 400 iglesias y conventos de la época colonial. Santuarios del arte que están magníficamente representados en varias obras recientes.[17] Es interesante observar cómo para Marta Traba "la economía de la pobreza" que sustenta el arte colonial neogranadino, que según ella en un principio ni siquiera tiene en cuenta, no se inspira, en el medio ambiente donde se desarrolla, y la rápida transculturación impuesta por la urgencia de la evangelización se convierten en factores mediocrizantes del desenvolvimiento artístico. No obstante lo cual, la misma autora reconoce ". . . de 1638 a 1711 vive en Colombia Gregorio Vásquez de Arce y Ceballos. Todo el prestigio de la pintura colonial neogranadina reposa sobre el medio millar de obras que salen de su taller y que se mezclan hoy día con las de su escuela, sus discípulos y epígonos".[18]

Aunque antes que Gregorio Vásquez de Arce y Ceballos había llegado a la Nueva Granada y el pintor andaluz Alonso de Narváez (1538–), se habían incorporado a la historia del arte neogranadino las dos más notables "dinastías" artísticas de la época, formadas por Bernardo Antonio y Jerónimo Acero de la Cruz y por Baltazar de Figueroa "El Viejo" —sevillano—, su hijo Gaspar de Figueroa, el hijo de éste, Baltazar de Vargas Figueroa, y su hermano Nicolás de Vargas Figueroa; familia ésta última en cuyo taller trabajó Gregorio Vásquez de Arce y Ceballos, quien también tuvo un hermano pintor, Juan Bautista Vásquez, y una hija pintora, Feliciana Vásquez Bernal.

"Libremente" (observa Marta Traba, ampliando sus ideas sobre la pobreza que ella misma atribuye al arte colonial neogranadino) "se incorporan elementos de la flora autóctona y se produce un mestizaje, no sólo de temas, sino de oficios y decisiones ornamentales. Las iglesias se visten a medias, se decoran las falsas cúpulas, se encarniza el decorador con el techo de una capilla, con un altar o con un púlpito . . .".[19] "El arte colonial en Colombia" (destaca Francisco Gil Tovar) "desarrollóse, humilde y esforzadamente . . . producto de un mestizaje en el que pesa más lo europeo en sus formas más sencillas, que lo indígena. Pero mestizo en fin, porque mestiza es desde entonces Colombia, ya que en su suelo pudo darse en matrimonio de razas con facilidad mayor que en los virreinatos más ricos, precisamente porque los blancos dominadores, y los indios, dominados, no levantaron las barreras de orgullo con que unos y otros se defendieron en México y Perú. . . . Pero al cruce de sangres no correspondió en igual proporción el de conceptos y formas artísticas . . .".[20]

Con lo anterior está sólo parcialmente de acuerdo Alvaro Gómez Hurtado, cuando escribe "para apreciar el arte colonial neogranadino hay que tener en cuenta las carencias que tuvo que vencer . . . la ausencia casi completa de los vestigios de pintura indígena, la escasez de lienzos y láminas que debían ser importados, la reducción de la gama de los colores que debían ser fabricados con elementos mestizos pero a la usanza europea".[21] Pero en lo que Marta Traba veía la síntesis de la pobreza, Gómez Hurtado encuentra la expresión del Nuevo Mundo ". . . con su naturaleza exuberante, su formidable sensación de lo telúrico, su inmensidad sonora, luminosa a la vez hostil y embrujante; con sus árboles inauditos, sus ríos sin fin, sus soles abrasadores y sus crepúsculos catastróficos, llenos de esperanza y de sangre (que) eran un mundo propicio al barroco en el arte como en la literatura. Era un barroco natural, que estaba ahí y que naturalmente se compenetró con el barroco conceptual que pretendía imponer la nueva civilización hispánica avasalladora . . .".[22]

Más la misma Marta Traba, para quien "la Colonia Colombiana es íntima, de devociones familiares . . . es siesta . . . carece de instinto agresor, es inocente y complaciente . . .", termina reconociendo que el arte colonial neogranadino legó "una obra grandiosa: Cartagena de Indias . . . única ciudad viva que ha dejado la época . . .".[23]

## Del estilo de la pobreza al retrato y la pintura cortesana

Y de ese ambiente colonial, caracterizado por la pobreza, según Marta Traba, "donde se hace lo que se puede", donde "cuando falta la hoja de oro se echa mano del color, del diseño o del relieve", surge la

obra de Joaquín Gutiérrez "con cuyos retratos comienza un línea de obsecuencia artística, reverencial ante las fuentes del poder, aún cuando la justificación de ese poder sea endeble y ficticia".[24]   Líneas de sumisión o estereotipia de los retratos, condensatorios del poder, de la gloria y da la jerarquía, que se mantienen por el resto del siglo XVIII y buena parte del siglo XIX; no obstante la aparición huracanada de los Comuneros.   Que, con José Antonio Galán a la cabeza, al grito de "Viva la libertad" y abajos a los impuestos, interrumpen la beatitud colonial de la Nueva Granada.   Desquiciando la estructura económica de la colonia, fecundando con su sangre los anhelos de independencia, sin perturbar la sumisión y pleitesía del arte de las jerarquías de la autoridad y el poder, pues, el pueblo no logra inspirar a los artistas contemporáneos, ni con su rebeldía comunera, ni posteriormente con su heroísmo y sacrifico libertarios.

Quizá porque, como anota Alvaro Gómez Hurtado, el Reino de la Nueva Granada luego de conseguir lo que pretendió que fuera en los días de la Conquista—una nueva Cristiandad, extensión en el continente americano de la cultura de occidente—al rebelarse contra la metrópolis, sin contar con institución indígena alguna que le sirviera para identificarse salvo su gigantesco mestizaje racial, y tener que adoptar una pose nacionalista, antipeninsular y por lo mismo contra lo occidental, resulta negándose a sí mismo, colocándose culturalmente contra lo que había resultado siendo en virtud de trescientos años de asimilación de la cultura occidental.   De manera que el Nuevo Mundo Hispano sigue siendo lo que había llegado a ser antes de la independencia, no obstante la pose que para intentar ésta había tenido que asumir pero "en la inteligencia latinoamericana siempre quedó la insatisfacción de no haber encontrado una autenticidad perdida que reemplazara a identidad durante el tiempo virreinal".[25]

Hemos tenido—dice Gómez Hurtado—la frustración de no haber encontrado elementos precoloniales o postcoloniales que nos hubiesen permitido presentarnos ante el mundo como exponentes de una cultura original.   "La guerra de independencia determinó una parálisis del arte en el territorio que se convirtió en la actual República de Colombia. El propósito misional dejo de ser el gran motor.   Las artes plásticas tardaron un tiempo en encontrar de nuevo una razón de ser.   La fecundidad artística se trasladó al campo de la literatura y de la poesía donde era posible y necesario realizar el nuevo proselitismo político".[26]

Desde antes de la insurgencia comunera (1782) hasta la consolidación de la independencia, el arte se mantuvo como apologista de la autoridad, representada en las jerarquías religiosas y políticas, gubernamentales y militares, económicas y sociales, así el artista fuera

Joaquín Gutiérrez, Pedro José Figueroa, José Celestino Figueroa, José Manual Figueroa o José María Espinosa. Durante la colonia y en la independencia misma "el mundo neogranadino" está jerarquizado por los virreyes y los próceres, por la gloria y el poder, por el dinero y el prestigio social, y a representar, exaltar y mantener ese universo jerarquizado se circunscribe el arte y en particular la pintura, que por lo mismo se concentra en el retrato. "Las guerras civiles que asolan el país de 1830 a 1903, siguen teniendo a la facción política, al grupo de poder, al héroe como protagonista. La acción épica, que supone la intervención de la comunidad real, no del grupo, no existe en el país. La pintura del siglo XIX realiza la presentación de la historia a la luz de esta verdad: por eso se reduce al retrato de los personajes".[27]

El retrato, pues, aunque encarna la historia, adolece del sentido épico que la participación popular dio a las luchas por la independencia a partir de los Comuneros. Dejando sólo al jerarca, al gobernante, al caudillo e inclusive al héroe. El retrato es una representación autárquica de la historia, que ni siquiera cambia sustancialmente en los retratos de Bolívar, héroe de héroes, pero siempre hombre entre los héroes, cuya "personalidad pertenece a la zona franca de la aventura y no a la postración de los salones de gabinete, [cuya] originalidad conmovedora y contradictoria no soportaba la horma del retrato académico" como señala la autora de la *Historia abierta del arte colombiano*.[28]

## De la iconografía de los próceres al redescubrimiento del país

Empero, según Marta Traba, es Bolívar, el nómada inclemente, escurridizo y dialéctico; ese Bolívar "que muere de joven"; el "héroe sacrificado por la carnicería de la política y su propia rapidez para vivir, consumirse y morir"; ese mito o "invención de la historia como aventura no contada anteriormente", quien con su iconografía "descuartiza la convención del retrato académico y despliega la historia como hipótesis nueva".[29]    Sin embargo, si bien el primer siglo republicano y más concretamente los pintores de los próceres, que logran su máxima expresión en la iconografía de Bolívar, empieza a "cercenar la lenta pero continua corriente de contacto entre la cultura europea y el despertar indígena", hundiendo sus raíces en el arte colonial que les ha precedido, pero inspirándose y concretando su acción en el medio ambiente, en los hechos y personajes que los rodean. Iniciando así un intento de arte local, aunque anárquico y no siempre original. Intento que habrán de consolidar y extender los pintores de la Comisión Corográfica, que a mediados del siglo recorren el país retratando "con un ojo ingenuo, sin elaboraciones cultas lo que

la mano fijaba con pericia indudable en el manejo de la línea y especialmente de la mancha acuarelada".[30]

Mas el transcurrir del primer siglo republicano no sólo implica insurgencia de las provincias, que reduce a ruinas la Gran Colombia, máximo ideal político de Bolívar. También conlleva la transformación de los caudillos militares en caudillos civiles y la conversión de los héroes en políticos institucionales. Quienes, absortos en la tarea imprevista de establecer las instituciones republicanas que deben reemplazar el orden virreinal, para lo cual no estaban preparados, terminan siendo dominados por intereses regionales o de grupo, desacuerdos conceptuales y aún ambiciones egoístas y resentimientos personales. Y aunque la incipiente sociedad republicana neogranadina, debatiéndose en la pobreza con dignidad y la diferenciación social, no encuentra otra manera de subsistir y distinguirse que los acartonados modales de salón y la vida fácil a través del comercio y la burocracia (aún a costa de mantener la esclavitud), la verdad es que, mientras tanto, la Colombia real, el país nacional, empezaba a forjarse, a tomar conciencia de su propia existencia.

En el campo artístico, pues, el país se desarrolla, forzosamente influenciado por, cuando no dependiente del país político-administrativo imperante. País este que, según Miguel Samper, habían estructurado hombres "faltos de una verdadera educación y tradición de gobierno y de auténtico sentido político"; que "se plantearon programas basados en ideas absolutas, de autoridad fuerte los unos, de libertades absolutas los otros"; quienes "veían el mundo político en forma de antítesis irreconciliables" e hicieron del sistema político un Mito, del caudillo un Pontífice Máximo y de los programas partidistas una Causa Sagrada. Causa que, erigida como rígida frontera entre los ciudadanos de una y otra tendencias ideológicas, terminó atentando contra la convivencia social, anulando la responsabilidad personal y menoscabando la libertad misma. La cual desaparece no sólo bajo el peso del totalitarismo sino también frente a la ausencia total de los principios de autoridad y orden, sin los cuales la coexistencia humana es imposible.[31] Situación que, vista desde ángulos diferentes y atribuida a causas distintas, analiza Jaime Jaramillo Uribe, para quien ya no es la rigidez del "sistema neorepublicano sino su turbulencia ideológica o política lo que conlleva a su disgregación y a la inestabilidad nacional, ocasionada por tres causas básicas: desazón religiosa, debilidad económica y tendencia al atomismo político-administrativo" (Federalismo), que Rafael Núñez contrarresta con los "tres propósitos que orientaron su pensamiento político y su gestión de hombre de gobierno: paz religiosa por medio de un régimen concordatorio entre la

Iglesia y el Estado; industrialización como base de una política económica y centralismo político con autonomía administrativa como formula para mantener la unidad de la Nación".[32]

Indalecio Liévano Aguirre, en su excelente biografía del Regenerador, a quien señala como "un gran político, el más grande de nuestros políticos", considera el ascenso de Rafael Núñez al poder como el arribo del país a la "etapa final de un desastre económico al cual había sido lanzado por la mala fe de nuestros políticos y sobre todo por la ineptitud de nuestros economistas" y como el triunfo máximo del Regenerador (Núñez), para quien en adelante "Colombia sería un solo país que progresaría fortificando su unidad y no nueve países marchando suicidamente hacia su disolución", como lo había sido bajo el imperio de la Constitución Federalista de Rionegro, que consagraba el derecho sagrado (sic) de los Estados (Provincias) a la insurrección.[33] Política de unidad nacional que recibe un duro golpe cuando los Estados Unidos, actuando como el "aliado eventual y egoista" de que hablara antes Bolívar, luego de comprometerse a "no menoscabar la soberanía de la República de Colombia", comete el robo del siglo, confesado cínicamente por Teodoro Roosevelt en su tristemente célebre *I Took Panama*; declaración que desde hace tiempos y ahora intentan borrar, ya no los colombianos sino los propios panameños.

Sintetizando, el desarrollo artístico y cultural de Colombia durante el siglo XIX podría escalonarse en los siguientes acontecimientos, realizaciones, instituciones y personajes.

## La Expedición Botánica

La Expedición Botánica, aunque fundada y activa desde fines del siglo XVIII, puede considerarse como una de las instituciones que contribuyeron excepcionalmente al acontecer histórico del siglo XIX, arribando a los principios de este siglo en la plenitud de su quehacer científico y cultural, tan trascendental que ha sido considerado como el redescubrimiento científico del país. "Se ha dicho, y no sin razón", escribió Belisario Betancur, "que la Real Expedición Botánica fue el primer instituto científico de educación superior que tuvimos en Colombia. . . . Fueron los años de su establecimiento, fecundos en nuevos caminos en educación y en violentos sacudimientos sociales . . . como la Rebelión de los Comuneros . . .".[34]

"Nace la Expedición Botánica," anota Eduardo Mendoza Varela, "como uno de los fenómenos más extraordinarios y más extraños de la cultura en la América Hispana. . . . Fue la obra de un hombre empecinado, lleno de fe y de sabiduría. Le ofrece su mano un

gobernante comprensivo y profundo. ... El señor y maestro de la
Expedición se llama José Celestino Mutis. El gobernante que es, por
partida doble, virrey y arzobispo y tiene en sus manos por lo tanto, los
poderes temporales y las prerrogativas del espíritu, se llama Antonio
Caballero y Góngora. ... No fué la Expedición, su contextura, el
andamiaje que le dió consistencia y vida a un mero programa botánica.
Sus iniciales irradiaron o se propusieron irradiar sobre todos los
horizontes de los descubrimientos y el estudio. Lo mismo que la
contemplación y el análisis de la flora, también la mineralogía, la
astronomía, la entomología y la zoología general, inquietaron a su
Director (Mutis) y se mostraron como posibilidades infinitas para su
adición al patrimonio de la Corona (Española) y, más ampliamente, al
conocimiento del hombre peninsular y americano. Las gentes que
rodearon a Mutis no se encontraron solamente con los prodigios del
paisaje neogranadino, esmaltado con sus múltiples posibilidades
vegetales, sino que repartieron su ambición y sus conocimientos al
sondeo de un mundo que, en cierta medida, estaba por descubrir.
Pablo Antonio García, el primero de los pintores de que dispuso Mutis,
pintó al parecer junto con las especias botánicas, una colección de aves,
de la que se tiene noticia por las referencias de la época. Es más, se
habla también de las pinturas de personajes, de tipos indios y criollos,
con lo cual la Expedición Botánica se habría adelantado en varias
décadas a los propósitos de la Corografía. ... La preeminencia del
mundo iconográfico sobre aquel de las descripciones, es incontestable
en el caso de la Expedición . . .".[35]

### De la visita de Humboldt a las acuarelas de Mark

La visita de Alejandro Barón Humboldt en 1801, en su viaje único
al continente americano, acompañado del Francés Amadeo Bonpland,
convierte su encuentro con José Celestino Mutis y la Expedición
Botánica en la unión de la ciencia con el arte. En efecto, según el
sabio alemán "todo cuanto tiende a reproducir la verdad de la
naturaleza da vida nueva al lenguaje".[36] Se convierte así el egregio
visitante en el más autorizado y efectivo divulgador académico de
América en europa. Hasta el punto que su calificación de Francisco
Javier Matis como "el mejor pintor de flores del mundo" se difundió
universalmente y sus cátedras en París y Berlín, como sus publicaciones
sobre el Nuevo Mundo, originaron el viaje de científicos y artistas. Que
vinieron a experimentar en carne y alma propias, por qué Humboldt
escribía sobre América y llegaba al punto de comentar a Goethe "a la
naturaleza hay que sentirla; quien sólo ve y abstrae, puede pasar la
vida en medio de la ardiente vorágine tropical analizando plantas y

animales y creyendo descubrir la naturaleza, que sin embargo le será eternamente ajena".[37]

Siguiendo la tradición iniciada por Humboldt, muchos extranjeros, especialmente europeos, han visitado a Colombia, dejando escritas relaciones de sus viajes, que no sólo suscitaron entonces el interés del mundo por el Nuevo Mundo, sino que han sido, son y serán siempre fuentes inagotables para estudiar el país en todas y cada una de sus dimensiones y realidades, su pasado, su presente y aún su futuro, su geografía y su antropología, su flora y su fauna. Todo aquello que los viajeros foráneos, como posteriormente los nacionales,[38] a veces científicamente, en otras literariamente, y en no pocas artística o pictóricamente, condensaron en letras o dibujos para describir geográficamente el país, sus recursos naturales, los perfiles de sus gentes, que ni el medio ambiente adverso ni el bajo nivel de desarrollo despojan de un cierto grado de cultura y por lo menos de una personalidad propia, como la caracterizada gráficamente en las acuarelas del cónsul británico Edward Walhouse Mark.[39]

"La contribución de Mark a la exposición pictórica del suelo, el hombre y el ambiente de la Nueva Granada," escribe Joaquín Piñeros Corpas, "es tan original como substantiva. Con razón se estima que su colección de acuarelas es la noticia más completa y fiel que extranjero alguno pudo dar sobre nuestro país a todo lo largo del siglo pasado y de lo que va corrido del presente."[40]

Frente a esas sugestivas obras se puede apreciar con claridad el empeño artístico de perpetuar con limpia sinceridad los aspectos geográficos y antropológicos de una nación, generalmente enfocados por los escritores y aún por muchos pintores, con mero interés didáctico o documental. Pudiera decirse que su mayor valor es el de suministrar la sensación de atmósfera de una época que libros de historia, y aún magistrales prosas descriptivas de novelas y cuadros de costumbres, no lograron procurar. Efectivamente, la impresión que causan esas láminas es la de una circunstancia histórica constituida por los más sutiles elementos en los que tanto cuenta el rostro indicativo del ánimo patriarcal, como la plaza de aldea llena de sol y de pereza o el rasgo de moda que sugiere una vivencia romántica. Esta cualidad, tan evidente como difícil de definir, se debe, ante todo, a que fue un auténtico artista el que realizó las acuarelas, y, además, a que el autor no se limitó a un aspecto especial del gran temario nacional, sino que intentó una visión global de la Nueva Granada: medio físico, modalidades costumbristas, características laborales, tipología popular, vivienda, recreación y otras formas de la vida familiar y colectiva.

"El gran mérito de Mark es el de haber historiado a pinceles la vida de una nación en un interesante período en el que el destino común fue decidido, más que por los caudillos y los momentos estelares, por el callado esfuerzo del pueblo; el haber establecido la referencia objetiva del proceso civilizador y cultural, o simplemente de cambio, en el estudio comparativo de lo que es hoy el país y lo que fue en las primeras décadas de su existencia republicana; el haberse anticipado a producir, con su caja de acuarelas y su capacidad artística, el material documental que hoy realiza sin humanidad la fotografía en colores, y el haberse incorporado a la historia del arte en Colombia, en días de relativa pobreza de la pintura, con una obra sistemática, en la que el tema neogranadino vinculó las orientaciones y técnicas de la gran escuela de acuarelistas ingleses de las postrimerías del siglo XVIII y primeros años del siglo XX. . . . En vez de limitarse a registrar las modalidades de la vida neogranadina que se asomaba incidentalmente a su despacho de cónsul, fue en busca del país para conocerlo profundamente, participar de sus costumbres y peculiaridades, complacerse en la identificación con la naturaleza hiperbólica del trópico—que él supo suavizar con los filtros de su temperamento equilibrado—y pintar al pueblo, especialmente al campesino diligente, al constructor de una nueva nación . . .'".[41]

## La Comisión Corográfica y el hallazgo de la Colombia "moderna"

La llegada al país el 22 de febrero de 1849 de Agustín Codazzi, geógrafo, cosmólogo, topógrafo e ingeniero militar italiano, constituye un hito trascendental en la historia de Colombia. Incorporada inmediatamente al ejército de la Nueva Granada, Codazzi es encargado por Tomás Cipriano de Mosquera de emprender obras tan importantes como el levantamiento de un Mapa General del País, el Estudio de Factibilidad de un Canal Inter-oceánico a través del Istmo de Panamá y, como si lo anterior ya no fuera demasiado, del comienzo y desarrollo de la célebre Comisión Corográfica, constituida por Ley del 29 de mayo de 1849.

"En la historia cultural de Colombia", escribió Belisario Betancur, "se hace siempre la forzosa analogía entre la Expedición Botánica de José Celestino Mutis, de Antonio Caballero y Góngora y los últimos virreyes, con la Comisión Corográfica, del coronel de ingenieros Agustín Codazzi y del Presidente Tomás Cipriano de Mosquera y sus sucesores. Pero entre la una y la otra se peleó y se ganó la independencia, se extinguió el virreinato y enseguida se desintegró la Gran Colombia; los granadinos de 1850 tenían entre manos un país nuevo en un mundo distinto; Bolívar era ya leyenda para los hombres que en

carne y hueso lo habían conocido; saber y ciencia tenían otras modulaciones y prioridades. ... El proyecto de la Comisión era descomunal, como lo fueron muchas de las realizaciones que en menos de un decenio logró esa empresa fugaz. ... Los trabajos botánicos de la Comisión son, naturalmente sucesores o continuadores de los de la Expedición Botánica; la obra geográfica y cartográfica emana de una actitud muy conscientemente nacional ...".[42]

"... Mientras la Expedición Botánica representó el pensamiento del despotismo americano con proyecciones americanistas," comentó por su parte Eugenio Barney Cabrera, "la Comisión Corográfica encarnó la expresión de la nacionalidad republicana que intentaba nacionalizar su entidad histórica, social y geográfica; mientras aquella se atuvo al estrecho plan botánico y naturalista, ésta intentó además el conocimiento del hombre y de su economía; mientras la empresa Mutisiana obraba sobre los individuos, el grupo Codazzi investigaba la colectividad; si la de Mutis intentaba enriquecer el muestrario de plantas y animales de la geografía tropical, la Corográfica profundizó en el ser y en la naturaleza del hombre y sus circunstancias, incluyendo el remoto pasado aborigen".[43]

"Con la Comisión Corográfica," señala Barney Cabrera en otro enfoque, "la Nación escudriña su propio ser un busca de identidad geográfica, económica, histórica y social. ... El país ... se integró en la modernidad del siglo, alcanzó a vislumbrar la complejidad de su propio ser y trazó programas infortunadamente frustrados en sus futuras realizaciones. ... En torno y con motivo de la Comisión Corográfica se registra la experiencia gráfica y documental de mayor trascendencia artística, complementaria de la que, cincuenta años antes, cumpliera la Expedición Botánica. Los dibujantes de la Comisión Corográfica recorrieron el país y anotaron en sus pequeñas hojas todas las costumbres, todas la fisonomías, todo el vestuario, todos los accidentes geográficos, toda la capacidad plástica del paisaje colombiano, toda la actividad laboral del habitante campesino y aldeano, toda la miseria y los pobres recursos técnicos, y la rutina y el marginamiento, y la abandonada existencia del hombre de Colombia. Miniaturistas, retratistas y paisajistas, y al mismo tiempo los dibujantes y pintores de la Comisión Corográfica, dejaron en sus láminas el mejor documento etnológico, etnográfico y económico-social de la Nación. ... Naturalmente, esa pintura, lo mismo que la que hicieron los dibujantes mutisianos ha permanecido alguno menos que por fuera de las casillas estéticas, en donde la historia oficial y la crítica tradicional suelen encerrar el producto de la actividad artística. No obstante, gracias a sus auténticas condiciones expresivas y comunicativas, el arte de los tres

dibujantes de la Comisión Corográfica, defectuoso y balbuceante, si se lo mide de acuerdo con los cánones de rigor académico, además del anotado valor anecdótico y documental, es obra genuina del arte colombiano . . .".[44]

La lista de quienes con sus enseñanzas o sus escritos contribuyeron a delinear y afirmar la visión "extranjera" de Colombia, sería tan extensa como imponente su bibliografía, máxime si se complementan una y otra agregando la referencia "de quienes no legaron una elocuente constancia de sus impresiones en óleos, témperas, dibujos y acuarelas, como reveladora ilustración de la tierra que contemplaron, de la sociedad en que eventualmente convivieron y de la época de que fueron testigos de excepción . . .".[45]

Más con fines informativos que antológicos o de selección, podrían mencionarse los siguientes:[46] Edouard André, Luciano Napoleón Bonaparte Wyse, Jean Baptiste Boussingault, Comte Joseph de Brettes, Roger Brew, Jorge Brisson, H. Candelier, Miguel Cané, J. et Lejanne Crevaux, F. G. Daux, Pierre D'Espagnat, Louis Enault, C. P. Etienne, Comte de Gabriac, Leon Gauthier, Carl August Gosselman, John Potter Hamilton, Alfred Hettner, M. A. Isaac Farewell Holton, M. de Kandenole, Gabriel Lafond, August Le Moyne, Julien Mellet, Gaspard Theodor Mollien, James Jerome Parsons, Eliseo Reclus, Ernst Rothlisberger, François Desire Roullin, Charles Saffray, Friedrich von Schenk, F. A. Simons, Soeur Marie Saint Gautier, Henry Ternaux, Charles Wiener.

Entre quienes contribuyeron con su trabajo artístico o pedagógico a la labor divulgadora de los visitantes extranjeros citados, podría mencionarse a Carmelo Fernández, Luis de Llanos, Celestino Martínez Sánchez, Luis Ramelli, Enrique Recio Gil, Antonio Rodríguez y César Sighinolfi.

Empero, antes que todos y por sobre todos los personajes y obras citados, es preciso recordar y exaltar las de Agustín Codazzi y sus colaboradores, de cuya trascendental tarea surgió una extensa bibliografía.[47]

### Del dibujo de flores y la copia de láminas famosas al modernismo, pasando por los "académicos sin academia"

Como lo anotó Barney Cabrera "el dibujo de flores y la copia de láminas famosas serán (entonces) temas únicos no sólo en la enseñanza femenina, sino también en la actividad artística de aficionados" y "con tal producción estética las mujeres de la burguesía colombiana asistieron a concursos y salones hasta fines del siglo XIX o algo más. Las raíces de esos gustos, en consecuencia, y de los amanerados

cuadritos con que en lo sucesivo se nutrirá la producción artística, se originan en aquella enseñanza que, a falta de academias, fue la única que tuvo la juventud colombiana en relación con el arte durante los primeros sesenta años del siglo XIX".[48]

Nutrida básicamente por el aprendizaje, en talleres y tiendas de carácter semiartesanal y semiartístico e inclusive en los talleres de grabado de la Casa de la Moneda en Bogotá, la producción artística, pictórica y escultórica, de buena parte del siglo XIX fue tan escasa como inauténtica, como pocos fueron los artistas sobresalientes de la época: José Gabriel Tatis (1813–1875), José Manuel Groot (1800–1878) y sobre todo José María Espinosa (1796–1883), Ramón Torres Méndez (1808–1875) y Luis García Hevia (1816–1887).

Con razón escribió Germán Arciniegas: "Cuando nosotros éramos indios, y eran un infierno verde nuestras vírgenes montañas, tuvimos escultura monumental: ahí están agarradas a la tierra por las raíces de los cauchos y de los mangos, cosa de doscientas estatuas en San Agustín y sus contornos. Vinieron los españoles, y con ellos, que casi eran todos frailes, los imagineros creadores de bellos retablos, de policromías que cuentan, entre tupido follaje de oro, historias y leyendas cristianas, como pueden verse en el altar mayor de la iglesia de San Francisco (en Bogotá). Llegó luego la República y nos quedamos perplejos. Como si no tuviéramos qué vaciar en el arte corpóreo, renunciamos a él. Las inquietudes europeas nos sorbieron el seso. . . . La República imprimió en el arte la misma vacilación que se llevó a todas las demás esferas del pensamiento. Durante muchos años creíamos que el todo era asimilar las culturas europeas . . . el arte declinó. . . . Si durante la Colonia la producción fue poca, al llegar la República se hizo nula . . .".[49]

Aunque política, económica y socialmente la segunda mitad del siglo XIX fue una época agitada, de guerras y revoluciones, de destrucción bélica y transformaciones económico-sociales, el arte mientras tanto siguió subordinado al poder y la riqueza; así fuera la riqueza empobrecida de la época, cuando predominaron los caciques de provincia convertidos en caudillos y los próceres (sobrevivientes no sólo a la guerra de independencia, sino también a la aniquilación de la Gran Colombia), transformados en prohombres republicanos. Según Luis Eduardo Nieto Arteta, "la segunda mitad del siglo también resulta contradictoria y convulsiva. Al principio, en 1860, se rompen las amarras que todavía ataban a la república a las instituciones coloniales. Economía, legislación, añoranzas de poder y de ostentación, herencias neoclásicas, traducidas al pensamiento y a las técnicas criollas, perduran de alguna manera durante aquellas primeras cinco décadas

republicanas. Pero en 1850 vientos nuevos refrescan al ambiente. El año de 1850 marca el comienzo del apogeo del romanticismo social en la Nueva Granada. Nuestro romanticismo es un movimiento de destrucción alegre de la economía colonial, es una tendencia política liberal . . .".[50]

## La Academia, El Papel Periódico Ilustrado y la Primera Exposición Anual de Pintura

Historiadores, críticos y comentaristas, coinciden en señalar cómo—a la par que realizaciones de la Comisión Corográfica en lo científico y cultural, en general—en el campo artístico, son hechos trascendentales para el devenir histórico del arte plástico colombiano, el implantamiento y aceptación del convencionalismo, estricto y severo de la Academia, la realización de la Primera Exposición Anual de pintura, escultura, arquitectura, grabado, etc. y la fundación de El Papel Periódico Ilustrado. Empresas culturales, las dos últimas, debidas primordialmente al genio organizador de Alberto Urdaneta, Director de la Escuela de Bellas Artes cuando ésta inició actividades el 20 de julio de 1886.

Precursores de la Academia, además de la Expedición Botánica y la Comisión Corográfica, fueron extranjeros como Celestino Martínez Sánchez (1820–1885) y Gerónimo Martínez Sánchez (1826–1895), dibujantes y litógrafos venezolanos que, bien como profesores o ya como empresarios de sus actividades artísticas, actuaron en Bogotá de 1847 a 1861; Felipe Santiago Gutiérrez (1824–1904), mexicano, traído al país por iniciativa de Rafael Pombo y quien merece ser considerado como el máximo maestro foráneo del arte colombiano en el siglo XIX; título que ratifica como fundador de la Academia Gutiérrez en 1881, base ésta de la Academia Vásquez, que funcionó hasta 1886, cuando se convirtió en la Escuela Nacional de Bellas Artes.

También merecen destacarse Luis Llano (–1895), Enrique Recio Gil (1856– ), César Sighinolfi (1833–1902), Luis Ramelli, especialmente por su actividad e influencia pedagógica y estética desde la Escuela de Bellas Artes, y el español Antonio Rodríguez, fundador de la Escuela de Grabado y maestro de Xilografía en el país, a través de su vinculación a El Papel Periódico Ilustrado.[51]

Surgida en los interregnos de las guerras civiles y revueltas populares de fines del siglo, al amparo de la empleomanía diplomática y de la influencia extranjera, a través de la docencia ya mencionada, la Academia se convierte en fuente nutricia del arte colombiano finisecular y de principios del siglo XX, representada por Alberto Urdaneta (como mecenas y divulgador, desde El Papel Periódico

*Ilustrado* y la Escuela de Grabado), Ricardo Moros Urbina (1865–1942), Alfredo Greñas (1859–1947), Lázaro María Girón (1859–1952), Epifanio Garay Caicedo (1849–1903), Francisco Antonio Cano (1865–1935), Ricardo Acevedo Bernal (1867–1930), Coriolano Leudo Obando (1866–1957), Domingo Moreno Otero (1882–1949), Salvador Moreno (1874–1940), Santiago Páramo (1841–1915), Marco Tobón Mejía (1876–1933) y, desde luego, Andrés de Santamaría (1860–1945), de quien afirma Marta Traba "es el gran pintor de principios del siglo en América . . . sacude el arte de Colombia con una poderosa personalidad"[52] y a quien con razón Eduardo Serrano singulariza como un "pintor colombiano de resonancia universal".[53]

"La actualidad artística de Colombia", escribe Barney Cabrera, "pasa desde 1850 en adelante por vaivenes contradictorios, hasta encumbrarse en el convencionalismo severo y riguroso de la academia finisecular. Esos vaivenes principian con los balbuceos espontáneos, frescos y recursivos, de rica imaginación y de atrevidas soluciones plásticas, propio de los dibujantes de la Comisión Corográfica. Siguen luego las disciplinas académicas, severas e inflexibles, aprendidas en los oscuros salones de estudio bajo la autoritaria mirada del maestro. . . . La academia colombiana impone severas normas nacidas en el neoclásico, dos siglos atrás . . . que deben aplicarse en el país sin beneficio de inventario . . .".[54]

Si la Escuela de Bellas Artes y *El Papel Periódico Ilustrado* se constituyeron en los máximos símbolos finiseculares de cátedra, artística y cultural, la tarea divulgativa encontró continuadores como *La Crónica, El Heraldo, El Autonomista, El Monserrate, El Repertorio Colombiano, Revista Contemporánea* y *Lectura y Arte*, publicaciones en las cuales cumplieron fecunda misión críticos e historiadores del arte como Jacinto Albarracín, Sergio Arboleda, José Belver, José Caicedo Rojas, Francisco Antonio Cano, Eduardo Castillo, Luis Augusto Cuervo, Rafael Espinosa Guzmán, Lázaro María Girón, José Manuel Groot, Max Grillo, Ramón Guerra Azuola, Ricardo Hinestrosa Daza, Pedro Carlos Manrique, Rafael Pombo, Baldomero Sanín Cano, Bernardo Torres Torrente y Alejandro Vega.

La Primera Exposición Anual de pintura, escultura, arquitectura, grabado, etc., al exhibir 1.200 obras de arte de todos los tiempos, presentó las artes plásticas en su justa dimensión "enfatizando su valor como patrimonio artístico e iniciando su apreciación en un contexto histórico, e inclusive, universal" y, por sus magnas dimensiones y excelente organización se convirtió en un hito que, utilizando la manoseada expresión, partió en dos la historia artística colombiana. En cuyos anales ya figuraban intrascendentes pero de alguna manera

significativas muestras colectivas de arte, como la Primera Exhibición de la Moral y de la Industria, celebrada en Bogotá en 1941, en la que participaron—además de pintores y retratistas, costureras y bordadoras, lapidarios y plateros, tejedores y ceramistas—sastres y zapateros, herreros y talabarteros. La exhibición se repitió en los años 1843, 1845, 1846 y 1849.

## La exposición nacional de obras de arte y de industria doméstica de 1871

La Primera Exposición de Bellas Artes, es decir, exclusivamente de pintura, dibujo y escultura, se realizó en 1874, con 400 obras. La Exposición de 1886 tuvo el mérito de institucionalizar la presentación periódica del trabajo artístico, especialmente de los alumnos de la Escuela de Bellas Artes, y de haber sido el antecedente de la Exposición de la Fiesta de la Instrucción Pública en 1904, de la Exposición del Centenario de la Independencia de 1910, de la Exposición Nacional de Pintura de 1918 y de la Primera Exposición de Pintura y Escultura organizada por el Círculo de Bellas Artes en 1920, que, junto con la Exposición del Centro de Bellas Artes de 1924, podrían considerarse como intentos iniciales de un Salón de Arte en Colombia, intentos que cristalizaron en 1931, con el Primer Salón de Artistas Colombianos. Sin embargo, la exhibición artista más importante, a fines del siglo XIX y principios del siglo XX, después de la de 1886, fue la de 1899 que, como posteriormente se verá, a causa de la Guerra de los Mil Días, se convirtió en una batalla campal de papel, entre los críticos de arte, "conservadores" y "liberales".

El arte colombiano, pues, hizo tránsito de continuidad del siglo XIX al siglo XX bajo la influencia dominadora y por ende unitaria de la Academia, que lo orientó y reglamentó, aunque algunos de sus valores más representativos se formaron o perfeccionaron en el exterior. Tales fueron los casos de Andrés de Santa María, quien vivió 72 de sus 85 años en Europa; Pantaleón Mendoza (1855–1911), quien estuvo radicado en Madrid; Epifanio Garay Caicedo (1849–1903), máximo retratista en la historia del país y alumno de la Academia "Julián" de París; Ricardo Acevedo Bernal (1867–1930), quien estudió tanto en los Estados Unidos como en Francia; Marco Tobón Mejía (1876–1933), quien luego de radicarse en La Habana fue a París como representante cultural de Cuba; Ricardo Borrero Alvarez (1873–1931), perfeccionado en Sevilla y París; Jesús María Zamora (1875–1949), si no alumno de, sí inspirado por la Escuela Barbizón; Coriolano Leudo Obando (1866–1957), estudiante de la Academia de San Fernando en Madrid, donde también estudiaron Domingo Moreno Otero

(1888–1948), Miguel Díaz Vargas (1886–1956) y Roberto Pizano Restrepo (1896–1930), quien, a semejanza de Alberto Urdaneta, no sólo se reveló como artista, más destacado inclusive que aquél, sino también como maestro, mecenas y divulgador del arte, al fundar el Círculo de Bellas Artes (1920), para estimular la actividad artística, al revivir la Escuela de Bellas Artes, de la cual fue Director, y al promover otras empresas culturales.

Si los lugares de estudio y perfeccionamiento de los artistas mencionados corroboran la tesis de quienes les atribuyen una notoria cuando no excesiva influencia[55] extranjera en su formación estética, las parábolas vitales de esos artistas y más concretamente, las fechas de sus muertes, dan razón a quienes anotan cómo la influencia de la Academia se prolongó por décadas en los principios del siglo XX. Según Marta Traba, en efecto, los artistas finiseculares que figuran como producto y expresión de la Academia, no sólo actuaron a espaldas de la realidad nacional, que cuando no ignoraban tampoco interpretaban cabalmente, sino que se comportaban como académicos en un lugar en donde en realidad no había Academia. Algo que, en principio, parece un contrasentido. Pero que podría explicarse diciendo que ellos actuaban como académicos, aunque no había Academia, porque ellos *eran* la Academia, es decir, la tradición extranjerizante si se quiere. Sin que esos artistas puedan ser atacados, desconocidos o menospreciados por el solo hecho de que supieran y desempeñaran su oficio académicamente, esto es, sometiéndose a "las reglas de luz, composición, diseño, mezcla de colores, transparencias, etc. vigentes . . ."[56] o a la "relación de llenos y vacíos, de equilibrio y composición, de estatismo o dinamismo, de valores de diseño, de importancia de los materiales empleados y de la manera de potenciarlos . . ."[57]; normas o elementos del "lenguaje técnico y específico de las artes plásticas . . .", que, a través del análisis, permiten "un juicio apropiado de valor" sobre la obra de arte.[58]

### De la regeneración a la revolución en marcha

El "nuevo espíritu" que caracterizó a la sociedad colombiana a partir de la organización política, jurídica y social implantada por la Constitución promulgada en 1886 se reflejó, pues, también en el arte, al cual trascendieron los designios de la Regeneración. Que pretendía el restablecimiento de la unidad nacional, quebrantada por el federalismo, la clara determinación de las libertades individuales y la vigorización del principio de autoridad, depositado en un Estado fuerte; todo ello condensado en el lema de Unidad Política y Descentralización Administrativa, proclamado por Rafael Núñez, según la síntesis

afortunada de Eduardo Serrano.[59] Nuevo Espíritu que, en lo artístico-cultural como en lo político-administrativo en general, también afrontó los embates de quienes no estaban de acuerdo con él, sufriendo no sólo las consecuencias nefastas de la Guerra de los Mil Días, bajo cuyo fuego fratricida la Exposición Nacional de 1899 se convirtió en campo de batalla por el sectarismo de la crítica; se cerró transitoriamente la Escuela Nacional de Bellas Artes y algunos maestros de la Escuela y artistas tuvieron que irse del país.

Menos mal que desde 1893 había regresado al país Andrés de Santa María, de quien tardíamente no sólo habían de reconocerse sus excepcionales atributos de artista, sino también el impulso transformador que le dio a la Escuela de Bellas Artes y las dotes de organización que demostró al llevar a término la Exposición de la Fiesta de la Instrucción Pública en 1904, realizada sobre los rescoldos de la guerra y cuando Colombia aún no se había recuperado del estupor que le produjo el atraco a mano armada, del cual resultó la pérdida de Panamá. Andrés de Santa María, con su obra artística, con su labor didáctica y aun con sus ejecutorias en la dirección de la Escuela de Bellas Artes, bajo cuyas dependencias organizó en 1904 la Escuela Profesional de Artes Decorativas e Industriales, señalaría nuevos y definitivos rumbos en el desarrollo artístico colombiano.[60] Exaltado por unos como pintor impresionista, reconocido por otros como "introductor del paisajismo en el país", maestro incuestionable de una pléyade de pintores, de Santa María se ha dicho con razón que "actualizó los conceptos de la pintura colombiana". Su creación y enseñanza estéticas marcan en realidad un hito en el derrotero del arte colombiano.[61]

Andrés de Santa María fue, pues, nexo entre la Academia, predominante durante la Regeneración, y la "Revolución en marcha"[62] que en el país generó la incorporación al trabajo artístico de los movimientos pictóricos contrarios a la imposición de parámetros creativos previamente establecidos. En semejante nexo la convirtieron el aliento modernista que él infundió a su creación estética exhibida en Bogotá[63] y sus enseñanzas en la Escuela de Bellas Artes (donde predica "la validez artística de cualquier tema o sujeto y la libertad interpretativa que asiste al artista" inclusive "para trabajar el desnudo con modelo y pintar al aire libre"); como su devoción al paisajismo, "que devuelve el péndulo de la pintura en Colombia del internacionalismo al nacionalismo temático".[64] "El incipiente nacionalismo implícito en la idea de pintar lo propio, lo cotidiano y lo aledaño, por ejemplo", anota Eduardo Serrano, "habría de generar una pintura idealizada, que canta a las bellezas naturales del país, que alaba sus valles y montañas, que

ensalzar sus costas y sus ríos, que analtece su flora, que exalta su topografía y que glorifica sus ocasos . . .".[65]

Inclusive, al retomar la relación cronológica de las exposiciones o muestras colectivas, que de suyo son testimonio del quehacer artístico e inventario de sus realizaciones, se observa cómo el Primer Salón de Artistas Colombianos en 1931, en plena depresión económica, congregó a varios artistas sobrevivientes del siglo XIX, v.g., Francisco Antonio Cano, Coriolano Leudo, Ricardo Gómez Campuzano y Jesús María Zamora, dando razón a quienes anotan cómo, generacionalmente, el siglo XX del arte colombiano empezó con tres décadas de retraso. Aunque ya en el Primer Salón de 1931 participaron artistas nacidos en el siglo XX, como Luis Alberto Acuña (1904), quien durante sus estudios en Europa conoció a Pablo Picasso, bajo cuyo consejo se orientó "por el arte inspirado en lo vernáculo y lo relacionado con el medio ambiente . . ." y en cuya inspiración criolla o nacionalista se consolidó el Movimiento Bachué, "único intento consciente y relativamente exitoso de conformar un movimiento con teorías propias en el arte colombiano . . .".[66]

Según Eduardo Serrano, el Grupo Bachué asoció pintores como Luis Alberto Acuña y José Domingo Rodríguez (1859–1968); escultores como Rómulo Rozo (1899–1964), de cuya obra Diosa Bachué derivó el nombre, y Ramón Barba (1894–1964), español radicado en Colombia desde 1925; músicos como José Rozo Contreras (1894–1976) y Guillermo Uribe Holguín (1880– ) y aún escritores como José Antonio Osorio Lizarazo (1900–1964) y César Uribe Piedrahita (1897–1951) y se ganó la simpatía de Ignacio Gómez Jaramillo (1910–1970), Pedro Nel Gómez Agudelo (1899-1984) y Gonzalo Ariza (1912– ).

De Ignacio Gómez Jaramillo, Eduardo Serrano afirma: "Su trabajo constituye una de las expresiones más logradas del arte colombiano de este siglo, ejerciendo una fecunda influencia sobre generaciones posteriores . . ." y reintegrando "la conjugación de la contemporaneidad y el nacionalismo en las artes visuales del país . . .".[67] Aunque formado en Europa, Gómez Jaramillo también estudió en México, donde el influjo de Diego Rivera, José Clemente Orozco y David Alfaro Siqueiros le infundió el carácter político y social que caracteriza su pintura. Irguiéndose con Pedro Nel Gómez, Carlos Correa (1912–1985), Débora Arango (1910– ) y Alipio Jaramillo (1913– ), como uno de los más destacados exponentes plásticos de la problemática social, contemporáneamente con la proclamación y vigencia de la Revolución en marcha de López Pumarejo, durante cuyo gobierno y por encargo de éste pintó los controvertidos murales La

*liberación de los esclavos* y *La revolución de los comuneros*, ambos en 1938.

De acuerdo con Carlos Jiménez Gómez, la obra de Pedro Nel Gómez, no sólo fue producto sino expresión del medio, de los problemas que entonces agitaban a la sociedad colombiana: "pobreza, proletarización, migraciones campesinas e interurbanas, urbanización, desempleo, violencia, huelgas, lucha por la tierra, asomos de renovación cultural y cambios de valores . . .". [68]

## De la violencia en lienzo y papel y la violencia institucionalizada a "Las Gordas" de Botero y la "Maja desnuda" de Morales, en "Alas del Condor" de Obregón

Además de Luis Alberto Acuña, Ignacio Gómez Jaramillo, Pedro Nel Gómez, etc. y de Gonzalo Ariza (quien bajo el influjo de su permanencia prolongada en el Japón se convirtió en el más sobresaliente pintor paisajista, "naturalista" o "ecologista" de su tiempo, "aunque con sensación de arte oriental"), son varios los artistas que por sus méritos perduran en el escenario nacional, no obstante el mutable y a veces el inconsecuente vaivén de la crítica y a pesar de la turbulenta época que ha transitado Colombia en sus últimos 50 años. Entre los exponentes del arte conmemorativo, que tiene especial auge con la celebración del primer centenario de la independencia nacional en 1910, se destacan Pedro Quijano (1878–1953), Santiago Martínez Delgado (1906–1954) y Rodrigo Arenas Betancourt (1919– ).

El arte abstracto, como luego el expresionista, siempre bajo el influjo europeo, si bien se esboza inicialmente en Ignacio Gómez Jaramillo y se perfila con Marco Ospina (1912–1983), tiene por representantes destacados a Eduardo Ramírez Villamizar (1923– ); Guillermo Wiedeman (1905–1969), alemán radicado en Colombia desde 1939; Alejandro Obregón (1920– ), nacido en Barcelona pero transplantado pronto a Colombia; Antonio Roda (1921– ), español radicado en Colombia desde 1955; Armando Villegas (1928– ), peruano radicado en Colombia desde 1952; y el escultor Edgar Negret (1920– ).

Para Marta Traba, Alejandro Obregón no sólo fue precursor del arte moderno en Colombia sino que perteneció a él. "Es el primer hombre de la pintura moderna" pues "a Obregón lo ilumina su comprensión de la pintura actual; lo acomoda en un estilo peculiar su vivencia real de la poesía de las cosas y lo salva su vitalidad un poco bárbara . . ." que "lo libra de toda insignificancia" mientras que "su memoria lo liga siempre al espacio abierto entre el mar, cielo, cordilleras o manglares imaginarios . . .". [69] En la temática de Obregón,

refería primordialmente al paisaje, la flora y la fauna tropicales, ocupa sitio prominente el Cóndor de los Andes.

Sin embargo, la pintura figurativa conserva y vigoriza su vigencia decisiva en el escenario nacional, con Enrique Grau (1920– ), Fernando Botero (1932– ), Jorge Elías Triana (1920– ), David Manzur (1929– ), Augusto Rivera (1922–1982), uno de los pioneros del Realismo Mágico o Primitivismo, estilo en el cual sobresalen Sofía Urrutia (1914– ), Luis Fonseca (1928– ) y Ramón Romancero (1945– ). Fernando Botero es, sin lugar a dudas, el artista colombiano más conocido internacionalmente; con una fama sólo superada por Gabriel García Márquez. "Habiendo conformado un mundo pictórico singular y poderoso, donde la monumentalidad, el humor, la ironía, la ingenuidad y el dominio técnico juegan un papel preponderante . . .", según Eduardo Serrano, aunque inicialmente su trabajo parece inspirado por los muralistas mexicanos, ya citados, e influenciado por los maestros del renacimiento italiano, del que se confiesa enamorado, al engordar sus figuras, cristaliza y perpetúa su propio estilo "ese estilo mezcla de realismo y distorsiones, que hace al tiempo original e inclasificable su trabajo".[70]

Los últimos 25 años, aunque siempre bajo o dentro de los linderos volubles de la tradición figurativa y de la emergencia abstracta, y bajo la notoria influencia extranjera y un tanto politizado, el arte colombiano se ha inspirado—como la literatura—intensa y a veces obsesivamente, en el sexo y la violencia, pan cotidiano esta última de la vida colombiana actual. Exponentes de esta época son Norman Mejía (1938– ), Luciano Jaramillo (1933–1984), Carlos Granada (1933– ) Augusto Rendón (1933– ), Pedro Alcántara (1943– ), Luis Caballero (1943– ), Leonel Góngora (1932– ) y, aunque posterior, especialmente memorable por la calidad de sus desnudos, Darío Morales (1944–1988).

Más, la relación detallada de todas las tendencias contemporáneas representativas del arte colombiano y la enumeración de sus artistas destacados serían demasiado extensas, por no decir interminables, para insistir en ellas. Además, los libros *Cien años de arte colombiano*, tantas veces citado, el *Diccionario de artistas en Colombia*, por Carmen Ortega Ricaurte (Barcelona: Plaza y Janes Editores, 1979) y la serie *Panorama artístico colombiano*, editada en 4 vols., por Litografía Arco y la Galería de Arte "El Callejón", presentan una visión completa del patrimonio artístico colombiano actualizada hasta hoy.

### Desarrollo artístico institucional

Con anterioridad al Círculo de Bellas Artes, fundado por Roberto Pizano Restrepo en 1920, que sólo subsistió hasta 1923, se había

tratado de perpetuar en varias oportunidades una institución similar, como fueron las intentadas al fundar la Academia de Bellas Artes en 1902, que supervivió hasta 1913, entre varias otras. Posteriormente se crearon el Centro de Bellas Artes, en 1924; la Academia de Bellas Artes, establecida en 1930 como correspondiente de la Academia San Fernando de Madrid; y la Dirección de Bellas Artes, en 1931.

El desarrollo institucional del arte colombiano, durante los últimos 50 años, presenta hechos memorables como el traslado de la Escuela de Bellas Artes, de la sede de la Academia Colombiana de la Lengua a su propia sede, la primera exposición masiva de la obra de Luis Alberto Acuña (en Palmira, 1934), de Ignacio Gómez Jaramillo (en Bogotá, 1934) y de Pedro Nel Gómez (en Bogotá, 1934).

En 1940, por iniciativa de Jorge Eliécer Gaitán, y para funcionar permanentemente, se creó el Salón Anual de Artistas Colombianos, que "ha sido motivo permanente de discusiones y polémicas, la mayoría de ellas originadas por el advenimiento de una nueva generación pictórica con sus particulares valores y objetivos, y por el rechazo de la generación establecida, cuyos miembros aceptan con frecuencia actuar como jurados, procurando influenciar las decisiones y prolongar la vigencia de su gusto e intereses".[71] El Salón mencionada se repitió casi anualmente hasta 1967, cuando su nombre fue cambiado por el de Salón de Artistas nacionales, que desde 1974 se reúne bajo el nombre de Salón Nacional de Artes Visuales, y desde 1976 es organizado con base en Salas de entrada abierta a quienes deseen participar.

En 1952, por iniciativa del entonces Ministro de Educación Nacional, Aurelio Caicedo Ayerbe, se fundó el Museo de Arte Moderno de Bogotá, que sólo empezó a funcionar en 1962, gracias al empuje organizadora de Marta Traba, su primera Directora, reemplazada posteriormente por Gloria Zea, quien actualmente lo dirige.[72] En la misma época se creó el Museo de Arte Moderno "La Tertulia" de Cali, promotor y escenario de las Bienales de Artes Gráficas, que se han celebrado en 1971, 1973, 1978 y 1981, como de los Festivales de Arte celebrados previamente, en 1967 y 1970. Medellín también ha sido escenario dinámico del arte, como sede del Museo Zea y particularmente del Museo de Arte Moderno de Medellín y de la Biblioteca Pública Piloto, pero sobre todo de la Bienal de Arte de Coltejer. Más aún, Medellín ha sido la única ciudad colombiana capaz de poner en práctica, mediante disposición de su Consejo Municipal una Ley de la República, en la cual se dispone que "todo edificio nacional que se construya tendrá como parte esencial una obra plástica que lo distinga y embellezca".

Aunque en un principio, institucionalmente el arte se desarrolla con un concepto metropolitano, centralizado en Bogotá, gradual y lentamente sus expresiones y realizaciones se han hecho notar, pues, en otras ciudades del país, además de Cali y Medellín. Además de los museos citados, otros como el Museo de Arte Moderno de Cartagena, el Museo de Arte Religioso de Duitama, El Centro de Arte Actual de Pereira, etc., a la par que los salones de exposición de las Cámaras de Comercio en las principales ciudades del país, los Centros Colombo-Americanos y la Alianza Francesa, y desde luego instituciones privadas como el Museo de Arte Contemporáneo del "Minuto de Dios" en Bogotá, han contribuido excepcionalmente a incrementar los escenarios donde se exhibe el arte en sus diversas manifestaciones.

Otro aspecto importante del desarrollo institucional del arte en el país ha sido el establecimiento de galerías comerciales o privadas, que tuvieron como pioneras las Galerías Centrales de Arte S.A., luego denominadas Galerías Centrales de Arte, la Galería "El Callejón" y la Galería "Buchholz", anexas éstas a sendas librerías del mismo nombre. La tarea cumplida en favor de la divulgación artística ha sido trascendental y hoy hay tantas galerías de arte como escuelas de derecho y universidades en general, muchas de las cuales, por su mediocre calidad deberían clausurarse.

### La divulgación artística: Publicaciones periódicas

En realidad, en Colombia no han abundado las publicaciones periódicas especializadas en arte, que se limitan a unos pocos títulos: *Arte en Colombia*, *Colombia Artística*, *Plástica*, *Pluma*, *Prisma*, *Revista del Arte y la Arquitectura en América Latina*, *Revista Diners*. Y últimamente, *Forma y Color de Colombia*, un directorio artístico publicado anualmente.

Sin embargo, muchas de las publicaciones periódicas de este siglo, empezando por los principales diarios del país, le han brindado a la divulgación artística, cuando no columnas permanentes, sí generosos espacios: *Anuario de la Arquitectura en Colombia*, *Arco*, *Arquitectura y Arte*, *Boletín Cultural y Bibliográfico*, *Boletín de Historia y Antigüedades*, *Boletín del Museo de Arte Colonial*, *Bolívar*, *Colombia Ilustrada*, *Cromos*, *Eco*, *El Artista*, *El Espectador–Suplemento Literario*, *El Nuevo Tiempo*, *El País–Suplemento Literario*, *El Siglo–Suplemento Literario*, *El Tiempo*, *Lecturas Dominicales*, *El Gráfico*, *Escala*, *Espiral*, *Hojas de Cultura Popular Colombiana*, *La Crónica*, *Lámpara*, *La Nueva Prensa*, *La Unidad*, *Revista Contemporánea*, *Revista de América*, *Revista de las Indias*, *Revista Javeriana*, *Semana Senderos*, *Vida*, casi todas editadas en Bogotá.

302 J. NOÉ HERRERA C.

## NOTAS

1. Marcelino Menéndez y Pelayo, *Historia de la poesía hispanoamericana*, vol. II, p. 7.

2. Tarcisio Higuera B. *La imprenta en Colombia* (Bogotá: Imprenta Nacional, 1973), p. 73; Eduardo Posada, *La imprenta en Santa Fé de Bogotá en el siglo XVIII* (Madrid: Librería General de Victoriano Suárez, 1917).

3. Luis Arango C., *Recuerdos de guaquería en el Quindío*, 2 vols. (Bogotá: Editorial Cromos, 1942); Alvaro Chaves Mendoza y Mauricio Puerta Restrepo, *Monumentos arqueológicos de Tierradentro* (Bogotá: Talleres Gráficos del Banco de la República, 1986); Carlos Cuervo Márquez, *Estudios arqueológicos y etnográficos*, Serie Biblioteca de la Presidencia de Colombia (Bogotá: Editorial Kelly, 1956); Luis Duque Gómez, *Colombia: monumentos históricos y arqueológicos*, 2 vols. (México: Editorial Fournier, 1955; *Exploraciones arqueológicas de San Agustín* (Bogotá: Imprenta Nacional; Instituto Colombiano de Arqueología, 1964); y *Prehistoria*, Tomo I, *Etnohistoria y arqueología*, Serie Historia Extensa de Colombia (Bogotá: Ediciones Lerner, 1965); Jaime Errázuriz, *Tumaco: La Tolita, una cultura precolombina desconocida* (Bogotá: Carlos Valencia Editores, 1980); Jacinto Jijón y Caamaño, *Las culturas andinas de Colombia*, Serie Biblioteca del Banco Popular (Bogotá: Talleres Gráficos del Banco Popular, 1974); José Pérez de Barradas, *Arqueología agustiniana: excavaciones arqueológicas realizadas en 1937* (Bogotá: Imprenta Nacional, 1943); *Arqueología y antropología de Tierradentro* (Bogotá: Imprenta Nacional, 1937); *El arte rupestre en Colombia* (Madrid: Instituto Bernardino de Sahagún, 1941); *Colombia de norte a sur*, 2 vols. (Madrid: Ediciones del Ministerio de Asuntos Exteriores, 1943); *Orfebrería prehispánica de Colombia: estilo Calima*, 2 vols. (Madrid: Ediciones Jura y Museo del Oro del Banco de la República, 1954); *Orfebrería prehispánica de Colombia: estilos Quimbaya y otros*, 2 vols. (Victoria, España: Talleres de Heraclio Fournier y Museo del Oro del Banco de la República, 1966); *Orfebrería prehispánica de Colombia: estilos Tolima y Muisca*, 2 vols. (Madrid: Ediciones Jura y Museo del Oro del Banco de la República, 1958); *Pueblos indígenas de la Gran Colombia: los Muiscas antes de la conquista*, 2 vols. (Madrid: Consejo Superior de Investigaciones Científicas, 1951); K. T. Preuss, *Arte monumental prehispánico*, 2 vols. (Bogotá: Escuelas Gráficas Salesianas, 1931); Gerardo Reichel-Dolmatoff y Alicia Dussan de Reichel-Dolmatoff, *Estudios antropológicos*, Serie Biblioteca Básica de Cultura Colombiana (Bogotá: Instituto Colombiano de Cultura, 1977); Vicente Restrepo, *Los Chibchas antes de la conquista española: atlas y anexo arqueológico*, Serie Biblioteca Banco Popular (Bogotá: Talleres Gráficos Banco Popular, 1972); María Lucía Sotomayor y María Victoria Uribe, *Estatuaria del macizo colombiano* (Bogotá: Instituto Colombiano de Antropología, 1987); Miguel Triana, *La civilización Chibcha*, Serie Biblioteca Popular de Cultura Colombiana (Bogotá: Editorial ABC, 1951); Ezequiel Uricoechea, *Memoria sobre las antigüedades neo-granadinas*, Serie Biblioteca Banco Popular (Bogotá: Imprenta del Banco Popular, 1971); Liborio Zerda, *El Dorado*, Serie Biblioteca Popular de Cultura Colombiana (Bogotá: Editorial Cahur, 1947).

4. Eugenio Barney Cabrera, *Historia del arte colombiano* (Bogotá: Salvat Editores Colombiana S.A., 1977), p. 1.

5. Roberto Pizano Restrepo, *Gregorio Vásquez de Arce y Ceballos* (Bogotá: Editorial Siglo XVI, 1985), p. 3.

6. Juan de Garganta, *Artes plásticas en Colombia* (Bogotá: Compañía Suramericana de Seguros, 1959), p. 11.

7. Cristina Salazar, Juan Manuel Pavía y Carlos Nicolás Hernández, *Acuña, pintor colombiano* (Bucaramanga: Fundación Santandereana para el Desarrollo Regional [FUSADER], 1988), p. 41.

8. Angel Guido, *Redescubrimiento de América en el arte* (Buenos Aires: "El Ateneo", 1944).

9. "La expresión arte colonial no es, desde luego," aclara Gil Tovar, "una expresión del mundo estético y por ello no indica un modo de concepción de la forma en particular. Se trata de una referencia a un tiempo caracterizado por la dependencia o sometimiento de un país o otro; es decir, de una referencia más política y administrativa que cultural y artística . . ." (Francisco Gil Tovar, *Arte virreinal en Bogotá* [Bogotá: Villegas Editores, 1988], p. 76).

10. Guillermo Hernández de Alba, *Teatro del arte colonial: primera jornada* (Bogotá: Litografía Colombia, 1938), p. 15.

11. Alvaro Gómez Hurtado, "El arte y la identidad americana", en *Arte virreinal en Bogotá* (Bogotá: Villegas Editores, 1988), p. 30.

12. Francisco Gil Tovar, "Conquista, evangelización y arte", en *Arte virreinal en Bogotá* (Bogotá: Villegas Editores, 1988), p. 64.

13. Francisco Gil Tovar, "Introducción", en Carlos Arbeláez Camacho, *El arte colonial en Colombia* (Bogotá: Ediciones Sol y Luna, 1968), p. 13.

14. Ibid., p. 16.

15. Gómez Hurtado, "El arte y la identidad americana", p. 34.

16. Marta Traba, *Historia abierta del arte colombiano* (Cali: Arte Moderno, s.f.), p. 40.

17. María Cecilia Alvarez White, *Chicquinquira: arte y milagro* (Bogotá: Museo de Arte Moderno; Litografía Arco, 1986); Eduardo Mendoza Varela, *Dos siglos de pintura colonial colombiana* (Bogotá: Ediciones Sol y Luna, 1966); Roberto Pizano Restrepo, *Gregorio Vásquez de Arce y Ceballos* (Bogotá: Villegas Editores, 1985); *Los Figueroa: aproximación a su época y a su pintura* (Bogotá: Museo de Arte Moderno, Villegas Editores, 1986) y, para no hacer interminable la lista, en la serie Herencia Colonial, editada por el Banco Cafetero y Litografía Arco y dentro de la cual deben destacarse Bernardo Sanz de Santamaría, *Herencia colonial en las iglesias de Santa Fe de Bogotá*; Alvaro Gómez Hurtado, *Herencia colonial en las iglesias de Bogotá*; Germán Téllez y Donaldo Bossa Erazo, *Herencia colonial en Cartagena de Indias*; Aurelio Caicedo Ayerbe, *Herencia colonial de Popayán* y Gloria Inés Daza y Hernán Díaz, *Herencia colonial de Tuna*.

18. Traba, *Historia abierta*, p. 40.

19. Ibid.

20. Gil Tovar, "Introducción", en Arbeláez Camacho, *El arte colonial*, p. 11.

21. Gómez Hurtado, "El arte y la identidad americana", p. 44.

22. Ibid, p. 36.

23. Marta Traba, *Eco 1960–1975: ensayistas colombianos*, Colección de Autores Colombianos, no. 9 (Bogotá: Instituto Colombiano de Cultura, s.f).

24. Traba, *Historia abierta*, p. 36.

25. Gómez Hurtado, "El arte y la identidad americana", p. 53.

26. Ibid., p. 54.

27. Traba, *Historia abierta*, p. 46.

28. Ibid.

29. Ibid, p. 51.

30. Ibid, p. 50.

31. Miguel Samper, *Selección de escritos*, Biblioteca Básica Colombiana (Bogotá: Instituto Colombiano de Cultura, 1977), pp. 175 y siguientes.

32. Jaime Jaramillo Uribe, *El pensamiento colombiano en el siglo XX* (Bogotá: [s.p.i.]).

33. Indalecio Liévano Aguirre, *Rafael Núñez* (Bogotá: Instituto Colombiano de Cultura, 1972).

34. Belisario Betancur Cuartas, "El gran libro del mundo", en Eduardo Mendoza Varela, *Regreso a la Expedición Botánica* (Bogotá: Litografía Arco, 1983).

35. Eduardo Mendoza Varela, *Regreso a la Expedición Botánica* (Bogotá: Litografía Arco, 1983), pp. 25 y siguientes.

36. Alejandro de Humboldt, *Cuadros de la naturaleza* (Caracas: Monte-Avila Editores, 1972), p. 9.

37. Renato Loschmer, *Catálogo de artistas alemanes en Latinoamérica* (Bogotá: Berlín, 1978), p. 29. (Ver: "La presentación artística de Latinoamérica en el siglo XX bajo la influencia de Alejandro de Humboldt.)

38. Entre los cuales cabe mencionar: Manuel Ancízar, *Peregrinación de Alfabética por las Provincias del Norte de la Nueva Granada en 1850–1851*, Biblioteca de la Presidencia de Colombia (Bogotá: Empresa Nacional de Publicaciones, 1956); José Caicedo Rojas, *Apuntes de ranchería y otros escritos*, Biblioteca Popular de Cultura Colombiana (Bogotá: Imprenta Nacional, 1945); Francisco José de Caldas, *Semanario del Nuevo Reino de Granada*, Biblioteca Popular de Cultura Colombiana, 3 vols. (Bogotá: Editorial Minerva, 1942); Salvador Camacho Roldán, *Notas de viaje . . .* (París: Garnier, 1898); José María Cordovez Moure, *Reminiscencias de Santa Fé y Bogotá*, Biblioteca Básica Colombiana (Bogotá: Instituto Colombiano de Cultura, 1978); José Manuel Groot, *Autor de la conocida* Historia eclesiástica y civil de la Nueva Granada, Biblioteca Autores Colombianos (Bogotá: Editorial ABC, 1953); Santiago Pérez Triana, *De Bogotá al Atlántico*, Biblioteca Popular de Cultura Colombiana (Bogotá: Editorial Kelly, 1842); Eduardo Posada, *El Dorado*, Biblioteca Aldeana de Colombia (Bogotá: Editorial Minerva, 1936); Emiliano Restrepo Echavarría, *Una excursión al territorio de San Martín*, Biblioteca de la Presidencia de Colombia (Bogotá: Editorial ABC, 1957); Rafael Reyes, *Presidente de Colombia: memorias, 1850–1855* (Bogotá: Fondo Cultural Cafetero, 1986); Luciano Rivera y Garrido, *Impresiones y recuerdos*, Biblioteca Popular de Cultura Colombiana, 2 vols. (Bogotá: Editorial ABC, 1946); Manuel Uribe Angel, *Geografía general y compendio histórico del Estado de Antioquia en Colombia* (París: Imprenta de Victor Goupy y Jourdan, 1885); Liborio Zerda, *El Dorado*, Biblioteca Popular de Cultura Colombiana (Bogotá: Editorial Cahur, 1947).

39. Joaquín Piñeros Corpas, *Acuarelas de Mark, 1843–1856: un testimonio pictórico de la Nueva Granada*, 2 ed. (Bogotá: Banco de la República; Litografía Arco, s.f.), pp. iii y siguientes.

40. Ibid.

41. Ibid., pp. iii y siguientes.

42. Belisario Betancur Cuartas, "Prólogo," *Acuarelas de la Comisión Corográfica: Colombia 1850–1859* (Bogotá: Litografía Arco, 1985).

43. Eugenio Barney Cabrera, *Historia del arte colombiano* (Bogotá: Salvat Editores, 1977).

44. Eugenio Barney Cabrera, *Manual de historia de Colombia*, tomo II, 2 ed. (Bogotá: Procultura; Colcultura, 1982). (Ver: "La actividad artística en el siglo XX".)

45. Piñeros Corpas, *Acuarelas de Mark*, pp. iii.

46. Edouard André, explorador e indócito, publicó sus relatos ilustrados en *Le Tour du Monde* que se reprodujeron en "Geografía pintoresca de Colombia" (La Nueva Granada vista por dos viajeros franceses del siglo XIX: Charles Saffray y Edouard André, recopilación: Eduardo Acevedo Latorre [Bogotá: Litografía Arco, 1971]). Luciano Napoleón Bonaparte Wyse, *El canal de Panamá* (París: [s.e.], 1886). Jean Baptiste Boussingault, *Memoires* (Paris, 1892). Comte Joseph de Brettes, "Chez les indiens du Nord de la Colombie: six anales d'explorations", en *Le tour du monde* (Paris, 1898). Roger Brew, *El desarrollo económico de Antioquia, desde la independencia hasta 1920*, Archivo de la Economía Nacional (Bogotá: Banco de la República, 1977). Jorge Brisson, *Casanare* (Bogotá: Imprenta Nacional, 1986); *Exploraciones en el alto Choco* (Bogotá: Imprenta Nacional, 1985). H. Candelier, *Riohacha et les indiens goajires* (Paris, 1893).

Miguel Cané, diplomático argentino nacido en Montevideo "aunque más intelectual que viajero", dejó en su libro *En viaje* (París: Casa Editorial Garnier Hnos., 1883), sus impresiones sobre la Colombia finisecular y en especial sobre el esplendor (sic) social, político y artístico y literario de la para él también "Atenas Suramericana" (*Viajeros extranjeros en Colombia* [Cali: Carvajal & Cía., 1970]). J. et Lejanne Crevaux, "Voyage d'exploration à travers la Nouvelle Granade et le Venezuela", en *Le tour du monde* (Paris, 1882). F. G. Daux, "Quelques semaines en Colombie" (Le Havre, 1885). Pierre D'Espagnat, *Recuerdos de la Nueva Granada*, Biblioteca Popular de Cultura Colombiana (Bogotá: Editorial ABC, 1942). Louis Enault, *L'Amérique Central et Meridionale* (Paris, 1867). C. P. Etienne, *La Nouvelle Granade. Aparçu général sur la Colombie et récits de voyages en Amérique* (Paris, 1828). Comte de Gabriac, *Promenades à travers de L'Amérique du Sud, Nouvelle Granade, Ecuateur, Pérou, Brasil* (Paris, 1868). Leon Gauthier, "Fragments du journal de voyage d'un peintre en Amérique Latine (1848–1855)". Carl August Gosselman, *Viaje por Colombia, 1825–1826*, Archivo de la Economía Nacional (Bogotá: Talleres del Banco de la República, 1981). John Potter Hamilton, *Viajes por el interior de las Provincias de Colombia*, Archivo de la Economía Nacional, 2 vols. (Bogotá: Banco de la República, 1955). Alfred Hettner, *Viajes por los Andes Colombianos (1882–1884)*, Archivo de la Economía Nacional (Bogotá: Banco de la República, 1976). M. A. Isaac Farewell Holton, *La Nueva Granada: veinte meses en los Andes*, Archivo de la Economía Nacional (Bogotá: Banco de la República, 1981). M. de Kandenole, *L'Odysée de Jean Languille: voyage d'exploration à travers la Colombie et le Venezuela* (Abbeville, 1898). Gabriel Lafond, *Voyages dans L'Amérique Espagnole pendant les guerres de l'indépendance* (Paris, 1844). August Le Moyne, *Viajes y estancias en América del Sur, la Nueva Granada, Santiago de Cuba, Jamaica y el Istmo de Panamá*, Biblioteca Popular de Cultura Colombiana (Bogotá: Editorial Centro, 1945). Julien Mellet, *Voyages dans L'Amérique Meridionale, à l'intérieur da la Côte Fermé et aux îles de Cuba et de Jamaique, depuis 1808 jusqu'en 1819* (Paris, 1823). Gaspard Theodor Mollien, *Viaje a la República de Colombia, 1823*, Biblioteca Popular de Cultura Colombiana (Bogotá: Imprenta Nacional, 1944). James Jerome Parsons, *La colonización antioqueña en el occidente de Colombia*, Archivo de la Economía Nacional, 2 ed. (Bogotá: Banco de la República, 1961); *San Andrés y Providencia: una geografía histórica de las Islas Colombianas del mar Caribe occidental*, Archivo de la Economía Nacional (Bogotá: Banco de la República, 1964). Eliseo Reclus, *Colombia*, Biblioteca de la Presidencia de la República (Bogotá: Editorial ABC, 1958); *Viaje a la Sierra Nevada de Santa Marta*, Biblioteca Popular de Cultura Colombiana (Bogotá: Editorial Cahur, 1947). Ernst Rothlisberger, *El Dorado: estampas de viaje y cultura de la Colombia suramericana*, Archivo de la Economía Nacional (Bogotá: Banco de la República, 1963). François Desire Roullin, *Histoire naturelle et souvenirs de voyages* (Paris); ver también Margarita Combes, *Roullin y sus amigos: burguesía desvalida y arriesgada, 1796–1874*, Biblioteca Popular de Cultura Colombiana (Bogotá: Editorial ABC, 1942). Charles Saffray, *Viaje a Nueva Granada*, Biblioteca Popular de Cultura Colombiana (Bogotá: Ministerio de Educación Nacional, 1948). Friedrich von Schenk, *Viajes por Antioquia en el año de 1880*, Archivo de la Economía Nacional (Bogotá: Banco de la República, 1953). F. A. Simons, explorador de la Guajira y de la Sierra Nevada de Santa Marta que divulgó sus experiencias en escritos publicados en Londres hacia 1885. Soeur Marie Saint Gautier, *Voyage en Colombie, de novembre 1890 à janvier 1892* (Paris, 1895). Henry Ternaux, *Essai sur l'ancien Cundinamarca* (Paris, 1842). Charles Wiener, "Amazone et Cordilleres", en *Le tour du monde* (Paris, 1883).

47. *Jeografía física i política de las Provincias de la Nueva Granada: provincias de Tunja y Tundama*, Archivo de la Economía Nacional (Bogotá: Banco de la República, 1958). *Jeografía física i política de las Provincias de la Nueva Granada: provincias de Socorro y Vélez*, Archivo de la Economía Nacional (Bogotá: Banco de la República, 1957). *Jeografía física i política de las Provincias de la Nueva Granada: provincias de Soto, Santander, Pamplona, Ocaña, Antioquia y Medellín*, Archivo de la Economía Nacional (Bogotá: Banco de la República, 1958). *Jeografía física i política de las Provincias de la*

*Nueva Granada: provincias de Córdoba, Cauca, Popayán Pasto y Túquerres*, Archivo de la Economía Nacional (Bogotá: Banco de la República, 1959).

48. Eugenio Barney Cabrera, *Manual de historia de Colombia*, tomo II (Bogotá: Procultura, 1982), p. 579.

49. Alvaro Medina, *Proceso del arte en Colombia* (Bogotá: Colcultura, 1978), p. 566.

50. Luis Eduardo Nieto Arteta, *Economía y cultura en la historia de Colombia* (Bogotá: Ediciones Librería Siglo XX, 1941).

51. *El Papel Periódico Ilustrado*, fundado por Alberto Urdaneta, apareció por primera vez en agosto de 1881 y se publicó hasta el 20 de abril de 1888, en un total de 116 Números. La Primera Exposición Anual de pintura, escultura, arquitectura, grabado, etc., se realizó a partir del 4 de abril de 1886.

52. Traba, *Eco, 1960–1975*, p. 310.

53. Eduardo Serrano, *Andrés de Santamaría: pintor colombiano de resonancia universal* (Bogotá: Museo de Arte Moderno, 1988).

54. Barney Cabrera, *Manual de historia*, p. 598.

55. Influencia convertida en imitación, que Eugenio Cabrera censuraba así: "Copiar a los pintores europeos de épocas pasadas, aunque no se los supere ni venga a cuento, he allí la máxima ambición del artista colombiano finisecular; no le importan a él los factores de la intemperabilidad, el anacronismo, la medianía o la desuetud de los estilos . . ." (ver: "Reseña del arte en Colombia durante el siglo XIX", en *Anuario Colombiano de Historia Social y de la Cultura*, no. 3 [1965]).

56. Traba, *Historia abierta*, p. 68.

57. Ibid.

58. Ibid.

59. Serrano, *Cien años de arte colombiano*, p. 17.

60. Que funcionaba en la sede de La Casa de Moneda y en la cual se enseñaba platería, cerámica, fundición y talla en piedra y en madera, según lo describe Daniel Samper Ortega en su "Breve historia de la Escuela Nacional de Bellas Artes", publicada en *Iniciación de una guía del arte colombiano* (Bogotá: Academia Nacional de Bellas Artes, 1934).

61. Baldomero Sanín Cano, "El impresionismo en Bogotá", en *Escritos*, Biblioteca Básica Colombiana (Bogotá: Instituto Colombiano de Cultura, 1977), p. 559.

62. La "Revolución en marcha" fue el lema que Alfonso López Pumarejo, a la cabeza del sector de avanzada del Partido Liberal, martilló y terminó derrumbando el andamiaje ya decrépito del Régimen Conservador imperante desde 1886, uno de cuyos últimos gobiernos, el de Marco Fidel Suárez, había sido atacado duramente por el propio Laureano Gómez, máximo caudillo conservador del siglo XX.

63. Donde su obra artística empezó a ser conocida, gracias a la Exposición de la Fiesta de la Instrucción Pública en 1904 y a que sobre ella recae la atención de los más destacados críticos de la exhibición: Baldomero Sanín Cano (quien le encontró alguna afinidad con Paul Gauguin), Maximiliano Grillo y Ricardo Hinestroza y Daza.

64. Serrano, *Cien años de arte colombiano*, p. 53.

65. Ibid.

66. Ibid., p. 42 y siguientes.

67. Ibid.

68. Carlos Jiménez Gómez, "Pedro Nel Gómez habla de sí mismo", en *Pedro Nel Gómez* (Bogotá: Banco Central Hipotecario, 1981), p. 12.

69. Traba, *Historia abierta*, pp. 107-134.

70. Serrano, *Cien años de arte colombiano*, p. 136.

71. Ibid., p. 102.

72. Y bajo cuyo patrocinio se ha realizado durante varios años, aunque no regularmente, el llamado Salón Atenas.

# 25.  Central American Art Publications, 1986–1989: A Brief Survey and Bibliography

## Alfonso Vijil

Art is everywhere in Central America: in museums, markets, and homes.  Some cities, such as Antigua, Guatemala, are virtual living museums.  As one of the oldest cities in the region, it has been declared an architectural monument and has strict zoning regulations to help preserve it.  Other cities, an example being my hometown of Granada, Nicaragua, have historic value and face problems of deterioration of their monuments.  Parts of Panama City and Comayaguela, Honduras, are other examples of important historic places.  In addition, pre-Columbian centers of Tikal, Guatemala, and Copán, Honduras, are national treasures which receive thousands of visitors every year.

While interesting art and architecture abound, there is a definite lack of publications dealing with the visual arts in Central America, particularly for the modern period.  Libros Centroamericanos has recorded 4,500 publications from Central America since 1986, with fewer than 100 dealing with any aspect or period of art.  These titles are cited in the accompanying bibliography.

The majority of these materials are from Guatemala and about the pre-Columbian and colonial heritage.  Increasingly folk art studies are published in Guatemala by the Sub-Centro Regional de Artes y Artesanías Populares and by the Museo Ixchel, located in Guatemala City.  (See items 16, 18, 20-22, 56, 67-68, 85 in the Bibliography.)

El Salvador has published very little on art, but this is outweighed by the quality of the studies.  Two important surveys of Salvadoran art, one by José Robert Cea (23) and the other by Ricardo Lindo (51), both appeared in 1986.  Additionally, a monograph on the Museo Nacional David J. Guzmán was published in the same year (64).  This museum occasionally publishes exhibition catalogs.

Costa Rica has three important museums which showcase the country's art: the Museo Nacional and the Museo de Arte Costarricense, in San José, and the Museo Histórico Cultural Juan Santamaría, in Alajuela.  The Museo Nacional celebrated its centennial in 1988 with a beautiful book on its achievements.  The Museo de Arte

Costarricense exhibits contemporary art and publishes exhibition catalogs. Also in 1988, this museum commemorated the 60th anniversary of the work of artist Francisco Amighetti with major exhibitions. The museum in Alajuela has produced several book-length works on Costa Rican art in recent years (32, 33, 48).

Panamá, with the Museo Panameño de Arte Contemporáneo and several well-known artists, has only issued one study in this period, 1986–1989, on the architecture of Caribbean Panamá, a continuation of earlier studies on the architecture of the canal and turn-of-the-century Panamá which were published in the early 1980s (40).

In Belize, Honduras, and Nicaragua there is a scarcity or complete lack of art publications. Belize only has a few works on pre-Columbian monuments; Honduras, not well studied, has only produced books on Copán and the limited colonial architectural heritage (35, 41, 58). Nicaragua, a country with many galleries but few printed materials on artists, has published information on the current art movement in the cultural supplements of the three daily newspapers: *Barricada, La Prensa*, and *El Nuevo Diario*. The Sandinista-affiliated Association of Cultural Workers is covered by *Barricada*'s supplement titled "Ventana"; independent artists are covered in the "Prensa Literaria." The abundance of political posters appearing during the 1980s was a notable contribution to the Nicaraguan art movement. This author has personally collected close to 300 posters. (Editor's note: See also "Posters and the Sandinista Revolution," by F. G. Morgner, in this volume).

## BIBLIOGRAPHY

1.  *Album de recopilación fotográfica, liceo de Costa Rica, 6 de febrero 1887–6 de febrero 1987.* Realizado por: Douglas Porras Arroyo. Auspiciado por: La Fundación Mauro Fernández. San José: Trejos Hnos, 1988. 489 p., photos.

2.  Alfaro Sequeiros, David. *Como se pinta un mural.* Managua: Editorial Nueva Nicaragua, 1985. 231 p., bibl., illus.

3.  Altezor, Carlos. *Arquitectura urbana en Costa Rica: exploración histórica, 1900–1959.* Cártago: Editorial Tecnológica de Costa Rica, 1986. 272 p., photos.

4.  Alvarez Arévalo, Miguel. *Reseña Histórica de las imágenes procesionales de la ciudad de Guatemala.* Guatemala: Serviprensa, 1987. 47 p., photos, bibl.

5.  *Amate: órgano independiente de cultura.* Año 1–, No. 1–. San Salvador: n.p., 1987. Photos, illus.

6.  Arosteguí, Alejandro. *Alejandro Arosteguí: texturas y objetos, 1983–1986.* San José: Museo de Arte Costarricense, 1986. 24 p., plates.

7.  *Arte.* Tegucigalpa: Editora Galería Estudio 5. Photos.

8.  *Arte Visual.* Año 1–, No. 1–. Panamá: n.p., 1986–. Photos, illus.

9.  *El Artesano: órgano informativo de la Dirección de Artesanías.* Boletín, no. 4. Managua: Ministerio de Cultura, 1988. 39 p., photos, illus.

10. Avalos Austria, Gustavo Alejandro. *El retablo guatemalteco: forma y expresión.* México: Tredex Editores, 1988. 181 p., photos, illus., bibl.

11. Baciu, Stefan. *Centroamericanos.* San José: Libro Libre, 1986. 202 p.

12. Baciu, Stefan. *Francisco Amighetti.* Heredia: EUNA, 1985. 254 p., illus.

13. Belize. Laws, statutes, etc. *Ancient Monuments and Antiquities: Arrangement of Sections.* Chapter 259. London: Eyre and Spottiswoode, n.d. 13 p.

14. Berlin, Heinrich. *Ensayos sobre historia del arte en Guatemala y México.* Guatemala: Serviprensa, 1988. 181 p., photos, illus. bibl.

15. Bocaletti Florián, Brenda María. *El retablo barroco: su importancia en la arquitectura guatemalteca.* Tesis, Facultad de Arquitectura de la Universidad Rafael Landívar. Guatemala, 1988. 145 p., bibl. illus.

16. *Boletín del Sub-Centro Regional de Artesanías y Artes Populares*, nos. 14, 15. Guatemala, 1986–87.

17. Bonilla, Antonio. *El feismo en el arte.* San Salvador: Editorial RHD, 1989. 22 p., illus.

18. Bremme de Santos, Ida, et al. *Bibliografía de las artesanías de Guatemala.* Guatemala: Sub-Centro Regional de Artesanías y Artes Populares, 1988. 73 p., photos, bibl.

19. Cámara Nacional de Artesanía y Pequeña Industria de Costa Rica. *Guía de asociados Canapi.* San José: n.p., 1986. 89 p.

20. Camposeco, José Balbino. *Artesanías populares de Guatemala: breves apuntes históricos.* Colección artesanías populares, 6.

Guatemala: Sub-Centro Regional de Artesanías y Artes Populares, 1985. 78 p., photos.

21.  Camposeco, José Balbino, and Armando Ortíz Domingo. *La artesanía de la latinoamericana en Momostenango.* Guatemala: Sub-Centro Regional de Artesanías y Artes Populares, 1988. 95 p., photos, bibl.

22.  Castellanos, Guisela Mayén de. *Tzute and Hierarchy in Solola.* With the collaboration of Idalma Mejía de Rodas, final chapter by Linda Asturias de Barrios. Translated by Ava Navin. Guatemala: Ediciones del Museo Ixchel, 1988. 156 p., photos, illus., bibl.

23.  Cea, José Roberto. *De la pintura en El Salvador: panorama histórico crítico.* San Salvador: Editorial Universitaria, 1986. 289 p., plates, photos, bibl.

24.  *César Valverde.* San José: Editorial L'Atelier, 1986. 264 p., color illus., small folio.

25.  Chase, Diane Z., and Arlen F. Chase. *Offerings to the Gods: Maya Archaeology at Santa Rita Corozal.* Orlando: University of Central Florida, 1986. Unpag., color photos, illus.

26.  Coe, William R. *Tikal: A Handbook of the Ancient Maya Ruins.* 2a ed. Guatemala: Editorial Piedra Santa, 1988. 129 p., map, photos, illus.

27.  Costa Rica. President. Arias Sánchez, Oscar. *El surco fecundo del alma popular: discurso pronunciado en la inauguración de la XII Feria Nacional de Artesanía, el 19 de marzo de 1987.* San José: Imprenta Nacional, 1987. 11 p.

28.  Cueva, J. Adán. *Copán, legendario y monumental: guía español-inglés.* Tegucigalpa: Lito-Tipografía López, 1980. 48 p.

29.  *Diseño del medio ambiente para la ciudad de Santa Tecla.* Jorge Alberto Domínguez Rivas et al. San Salvador: Universidad Politécnica de El Salvador, Facultad de Ingeniería y Arquitectura, 1988. 480 p., illus.

30.  Echeverría, Carlos Francisco. *Historia crítica del arte costarricense.* San José: EUNED, 1986. 168 p., photos.

31.  *Fernando Saravia, II Certamen Nacional de Artes Plásticas, Premio 1987.* Managua: Unión de Artistas Plásticos/Asociación Sandinista de Trabajadores de la Cultura, 1987. 16 p., photos.

32.  Ferrero Acosta, Luis. *Perfiles al aire.* Alajuela: Museo Histórico Cultural Juan Santamaría, 1986. 153 p., plates, photos, bibl.

33. Ferrero Acosta, Luis, and Taizo Shibuya. *Gozos del recuerdo: Ezequiel Jimenes Rojas y su época.* Textos de Luis Ferrero. Fotografías de Taizo Shibuya. Alajuela/San José: Museo Histórico Cultural Juan Santamaría/Imprenta Nacional, 1987. 96 p., plates.

34. *Fibras vegetales de Nicaragua: pita, bambú, mimbre, henequén.* Managua: Ministerio de Cultura, Dirección de Artesanías y Artes Populares, n.d. 80 p., photos, bibl.

35. *Fuerte de San Fernando de Omoa: época colonial.* Víctor C. Cruz R. et al. Estudios antropológicos históricos, 5. Tegucigalpa: Instituto Hondureño de Antropología e Historia, 1985. 86 p., maps, illus., glossary, bibl.

36. García Escobar, Carlos René. *Talleres, trajes y danzas tradiciones de Guatemala: el caso de San Cristóbal Totonicapan.* Centro de Estudios Folklóricos: Colección monografías, 2. Guatemala: Editorial Universitaria, 1987. 129 p., photos, bibl.

37. García Urrea, Carlos. *Tikal: el monumental mundo perdido.* Guatemala: n.p., n.d. 97 p., photos.

38. *Guatemala: Destrucción de sus monumentos por el terremoto de 1976.* Guatemala: UNESCO/Instituto de Antropología e Historia y Consejo Nacional para la Protección de la Antigua Guatemala, 1986. 84 p., photos, illus.

39. *Guide to Antigua.* Guatemala: Printex International, n.d., 24 p., photos.

40. Gutiérrez, Samuel A. *La Arquitectura en dos archipiélagos caribeños: estudio comparado de Bocas del Toro, Panamá y San Andrés y Providencia, Colombia.* Panamá: EUPAN, 1986. 153 p., maps, photos, bibl.

41. Hasemann, George. *Investigaciones arqueológicas en la fortaleza de San Fernando y el asentamiento colonial de Omoa.* Estudios antropológicos e históricos, 6. Tegucigalpa: Instituto Hondureño de Antropología y Historia, 1986. 64 p.

42. Herra Rodríguez, Rafael Angel. *El desorden del espíritu: conversaciones con Amighetti.* San José: Editorial de la Universidad de Costa Rica, 1987. 201 p., plates.

43. *Imágenes de Honduras.* Edición de Oscar Acosta. Madrid: Editorial Iberoamericana, 1988. 48 p., photoplates.

44.  Instituto de Antropología e Historia. *Museo de Arte Colonial,*
     *Antigua Guatemala.* Guatemala: IAH/Organización de
     Estados Americanos, 1986. 24 p., photos.

45.  Instituto Nacional de Antropología e Historia. *Imaginería*
     *virreinal: Guatemala y México.* Guatemala/Tepotzotlán:
     Ministerio de Cultura y Deportes/Ed. de México, 1987. 27 p.,
     photos.

46.  Jickling, David, and Elaine Elliott. *Facades and Festivals of*
     *Antigua.* Guatemala: Piedra Santa, 1989. 75 p., photos, illus.

47.  *José Mejía Vides, pintor de Cuzcatlán.* San Salvador: RHD
     Editorial, 1987. 85 p., plates.

48.  Lemistre Pujol, Annie. *Dos bronces conmemorativos y una gesta*
     *heróica: la estatua de Juan Santamaría y el monumento*
     *nacional.* Alajuela: Museo Histórico Cultural Juan
     Santamaría, 1988. 171 p., plates.

49.  Lentini, Liugi, et al. *Arte y crítica en el siglo XX.* San José:
     EUNED, 1986. 152 p.

50.  León, Zipacna de. *Obras recientes de Zipacna de León.*
     Guatemala: Serviprensa Guatemala, 1987. 12 p., photos,
     illus.

51.  Lindo, Ricardo. *La pintura en El Salvador.* San Salvador:
     Ministerio de Cultura y Comunicaciones, 1986. 95 p.,
     36 p. illus.

52.  Long, Trevor, and Elizabeth Bell. *Antigua Guatemala.*
     Guatemala: Antigua Tours Edición, 1988. 101 p., maps,
     photos, bibl.

53.  Luján Muñoz, Luis. *La lotería de figuras en Guatemala.*
     Guatemala: Serviprensa, 1987. 52 p., photos, bibl.

54.  Luján Muñoz, Luis. *Máscaras y morería de Guatemala. Masks*
     *and Morerias of Guatemala.* Guatemala: Universidad
     Francisco Marroquín/Museo Popol Vuh, 1987. 135 p.,
     photos, illus., bibl.

55.  Luján Muñoz, Luis, and Irma Luján Muñoz. *La pintura popular*
     *en Guatemala.* Programa Permanente de Cultura de la
     Organización Paiz. Guatemala: Serviprensa, [1987]. [42] p.,
     illus.

56.  Luján Muñoz, Luis, and Ricardo Palomo Toledo. *Jícaras y*
     *guacales en la cultura mesoamericana.* Guatemala: Sub-
     Centro Regional de Artesanías y Artes Populares, 1986.
     389 p., photos.

57. Márquez López, José María. *Guía del Museo Arqueológico de Tikal "Sylvanus Griswold Morley"*. Tikal, Petén, julio 1988. N.p.: n.p., 1988. 18 p., illus, bibl.

58. Martínez Castillo, Mario Felipe. *Catedral de la Inmaculada Concepción de Valladolid de Comayagua*. Editor: Ramiro Colindres O. Tegucigalpa: Graficentro Editores, 1988. 24 p., 14 photoplates.

59. Mejía de Rodas, Idalma, and Rosario Miralbés de Polanco. *Cambio en Colotenango: traje, migración y jerarquía*. Guatemala: Ediciones del Museo Ixchel, 1987. 132 p., maps, photos, charts, bibl.

60. Mejía J., Dionisio. *Apuntes de educación artística*. 4a ed. Panamá: Impresora Panamá, 1985. 87 p., photos, bibl.

61. Mobil, José A. *Historia del arte guatemalteco*. Guatemala: Serviprensa Centroamericana, 1985. 416 p., photos, illus., bibl.

62. Molina, Diego. *La increíble Guatemala de Diego Molina: album fotográfico de un gran país*. Guatemala: Everest, 1987. 87 p., illus. (color).

63. Montero Picado, Carlos Guillermo. *Amighetti: 60 años de labor artística*. San José: Museo de Arte Costarricense, 1988. 177 p., color plates, photos, bibl.

64. *Museo Nacional "David J. Guzmán"*. San Salvador: Ministerio de Cultura y Comunicaciones, 1986. 178 p., maps, plates, photos, bibl.

65. Museo Nacional de Costa Rica. *Más de cien años de historia (4 de mayo 1887–4 de mayo 1987)*. San José: Ministerio de Cultura, Juventud y Deportes, 1987. 141 p., photos.

66. *Nicarauac: Revista del Ministerio de Cultura de Nicaragua*. No. 14. Managua, 1987. 158 p., photos, illus.

67. Ortíz, Lesbia, and Adolfo Herrera. *Aproximación al estudio de la platería en Guatemala*. Colección tierra adentro, 6. Guatemala: Sub-Centro Regional de Artesanías y Artes Populares, 1987. 246 p., photos, illus., bibl.

68. Ortíz Domingo, Armando. *Artesanías de madera en Totonicapán*. Colección artesanías populares, 7. Guatemala: Sub-Centro Regional de Artesanías y Artes Populares, 1986. 92 p., photos, bibl.

69. Palacios, Sergio. *Las iglesias coloniales de la ciudad de Comayagua: Guía histórico-turística*. (Cover title).

Tegucigalpa: Instituto Hondureño de Antropología e Historia, 1987. 70 p., map, photos, bibl., glossary.

70. Payne Iglesias, Elizet. *Actividades artesanales en Cártago: siglo XVII.* Maestros, Oficiales y Aprendices. (Cover title). Avances de investigación, 24. [San José]: Universidad de Costa Rica, Centro de Investigaciones Históricas. 1987. 18 p.

71. Pino, Georgina. *Las artes plásticas.* San José: EUNED, 1987. 173 p., illus., glossary.

72. Pinto V., Héctor Abraham. *Moros y cristianos en Ciquimula de La Sierra.* Guatemala: Departamento de Arte Folklórico Nacional, 1983. 171 p., photos, bibl.

73. *Pintura campesina de Nicaragua. Peasant Painting from Nicaragua.* Managua: Editorial La Ocarina, n.d. 24 color plates in 2 portfolios.

74. *Pintura contemporánea de Nicaragua.* Managua: Editorial Nueva Nicaragua/Ediciones Monimbó, n.d. 69 p., color plates, photos.

75. *Poesía Gráfica Contemporánea de Costa Rica.* San José: ECR, 1986. 76 p.

76. *Presente: Revista de Arte y Letras de Centroamérica.* Nos. 120/121/ 122, 125. Tegucigalpa: Roberto Sosa, 1987.

77. *Primer Simposio Mundial sobre Epigrafía Maya dedicado al Dr. Heinrich Berlin y a la memoria de Tatiana Proskouriakoff 1909–1985.* Guatemala: Asociación Tikal, 1987. 181 p., bibl., illus.

78. *Principales monumentos mayas: ruinas de Copán.* Copán, Honduras: San Pedro Sula, Librería Coello, n.d. 9 color photos in envelope.

79. Programa Permanente de Cultura, Organización y Paiz. *VI bienal de arte paiz: catálogo.* Guatemala: Serviprensa, 1988. [80] p., photos, illus.

80. Programa Permanente de Cultura, Organización y Paiz. *Retrospectiva del grabado en Guatemala.* Guatemala: Serviprensa, 1987. 48 p., illus.

81. *Revenar: Revista Semestral de Arte, Literatura y Ciencia.* Nos. 12, 13. San José: Asociación de Autores de Costa Rica, 1987. Photos, plates.

82. *Revista de Arte.* Nos. 5, 6. Tegucigalpa: Galería Estudio 5, 1986–1987. Illus.

83.  *Revista Nacional de Cultura*. No. 1. San José: Universidad Estatal a Distancia, 1988. Color plates, photos.

84.  Rilke, Rainer Maria. *Augusto Rodín*. Biblioteca popular de cultura universal, 40. Managua: Editorial Nueva Nicaragua, 1986. 93, [33] p., plates.

85.  Rodríguez Rouanet, Francisco. *Breve introducción a las artesanías populares en Guatemala*. 2a ed. Colección artesanías populares, 4. Guatemala: Sub-Centro Regional de Artesanías y Artes Populares, 1985. 36 p., photos, bibl.

86.  Rovira, Beatriz. *La arqueología de Panamá*. Panamá: Instituto Nacional de Cultura et al., 1985. 16 p., plans, illus., bibl.

87.  Rubio Sánchez, Manuel. *Historia de la fortaleza y puerto de San Fernando de Omoa*. Tomo I. Guatemala: Editorial del Ejército, 1987. 225 p.

88.  *The Ruins of Altun Ha: A Brief Guide*. [Belize]: Department of Archaeology, n.d. 15 p., illus.

89.  Sánchez, Róger. *Dos de cal, una e arena*. Muñequites, 3. Managua: Editorial El Amanecer, n.d. Unpag.

90.  Sánchez, Róger. *Humor erótico*. Colección Ge Erre Ene, 1. Managua: Editorial Vanguardia, 1986. 187 p., illus.

91.  Sis Pérez, Julio. *Autobiografía de un artista tradicional guatemalteco: Julio Sis Pérez*. Editores: Luis Luján Muñoz y Ricardo Toledo Palomo. Guatemala: n.p., 1988. 61 p., photos, illus.

92.  *Toño Salazar, genio y figura dos*. Colección El Salvador y el arte, 7. San Salvador: Impresos Litográficos de Centroamérica, 1985. 64 p.

93.  Zaporta Pallarés, José. *Historia y vida del convento e iglesia de La Merced en la Antigua Guatemala*. Guatemala: Consejo Nacional para la Protección de la Antigua Guatemala, 1986. 95 p., photos, bibl.

# 26. Optical Disk Possibilities in the Distribution of Information on Latin American Art

## Jorge I. Bustamante

This brief study shows the possibilities of obtaining information on Latin American Art from two Latin American databases available on CD-ROM: Librunam and Venezuela.

### Definition

According to Plato's definition, art includes any orderly human activity, even science. The cult use of the word art tends to mean the beautiful arts (*artes bellas*), in the sense used by Kant; that is to say, when its purpose is to unite pleasure with representation as a means of knowledge. In what follows art is used in the ample sense of Kant's *artes bellas*, but not with the amplitude attached to art by Plato. With this in mind, the arts would include literature, painting and drawing, sculpture, architecture, ceramics, music, dance, theater, rhetoric, oratory, photography, cinematography, xerography, engraving, and the like.

### Accessing Latin American Art

Because art is such a vast subject, when you talk about Latin American art you are dealing with an enormous amount of information. Just one country, such as Mexico, is a mosaic of several dozens of different cultures, each with its own artistic expressions.

In approaching the access problem in the study of the arts, from the point of view of the librarian or information broker, there are three goals: (1) to identify printed material about Latin American art; (2) to provide access to the researcher to printed materials; (3) to provide access to the researcher to nonprint materials in a useful and cost-effective way.

With advances in telecommunications, fast deliveries of packages from one country to another, and generalized use of the fax it is conceivable that a librarian or researcher in the United States, for example, can obtain a copy of a book or any printed material from any country, through an information broker in a matter of 1 to 5 days. All that is required is proper interlibrary loan agreements and the financial

316

resources. Nonprint material is more difficult than printed material to obtain at the moment, except perhaps for film and slide formats. In the near future, optical technologies will permit the access and distribution of nonprint art materials at a reasonable cost.

## Identifying Printed Material about Latin American Art

The large international on-line databases can be searched to obtain information. Now, however, there are some CD-ROM databases from Latin America which are useful for identifying printed art materials and material on or about art. These databases include information from local authors and publishers who produce information and know well the artistic production in their own countries. This information is not normally found in the well-established international databases. The four Latin American databases that contain such information are Latin American Bibliography (165,000 titles), Librunam (350,000 titles), Venezuela (190,000), and ISBN Mexicano (25,000 titles).

## Sample Searches in Librunam and Venezuela

Table 1 and the Appendix show the result of some general searches to explore the art holdings of these two databases: Librunam and Venezuela. Recorded are the number of hits in both databases to words related to art and to different countries. The table also shows the number of hits "in any language" and "in Spanish." The greatest proportion of hits for all countries corresponds to Spanish (with the exception of Brazil), which shows the usefulness of these two databases for identifying Latin American art information, as compared to other international databases which do not include titles in Spanish.

Also in the Appendix are sample listings of some of the titles obtained from Librunam and Venezuela. Fuller descriptions can be obtained from these databases for any of the selected titles.

The searches presented are only illustrative; they are too general for specific needs. To accomplish greater relevance and pertinence, more complex searching strategies need to be used. Along with these databases easy and effective searching tools are available to facilitate this.

Table 1.  Summary of Some Searches from
Librunam and Venezuela Databases

| Search Operations | Librunam | | Venezuela | |
|---|---|---|---|---|
| | Hits any language | Hits Spanish language | Hits any language | Hits Spanish language |
| MEXIC* Y ARTE | 392 | 297 | 51 | 41 |
| MEXIC* Y PINTURA N ARTE | 113 | 88 | 11 | 8 |
| MEXIC* Y MUSICA N ARTE | 71 | 62 | 167 | 160 |
| MEXIC* Y ESCULTURA N ARTE | 43 | 27 | 1 | 1 |
| ARTE Y/3 MEXICO | 188 | 153 | 18 | 14 |
| ARTE Y/3 MEXICANO | 79 | 54 | 2 | 2 |
| MUSICA Y/3 MEXICO N ARTE | 46 | 40 | 161 | 155 |
| PINTURA Y/3 MEXICO N ARTE | 42 | 35 | 8 | 5 |
| ESCULTURA Y/3 MEXICO N ARTE | 15 | 11 | 1 | 1 |
| MUSICA Y/3 MEXICANA | 9 | 9 | 0 | 0 |
| PINTURA Y/3 MEXICANA | 55 | 50 | 6 | 5 |
| ESCULTURA Y/3 MEXICANA | 16 | 14 | 0 | 0 |
| ARGENTINA Y ARTE | 21 | 21 | 11 | 11 |
| BOLIVIA Y ARTE | 7 | 6 | 3 | 3 |
| BRASIL Y ARTE | 33 | 6 | 7 | 2 |
| COLOMBIA Y ARTE | 15 | 13 | 29 | 28 |
| COSTA Y/0 RICA Y ARTE | 4 | 3 | 2 | 1 |
| ECUADOR Y ARTE | 10 | 9 | 7 | 7 |
| GUATEMALA Y ARTE | 13 | 8 | 0 | 0 |
| HONDURAS Y ARTE | 2 | 2 | 0 | 0 |
| PANAMA Y ARTE | 3 | 1 | 1 | 0 |
| PERU Y ARTE | 23 | 15 | 2 | 1 |
| URUGUAY Y ARTE | 2 | 2 | 2 | 2 |
| VENEZUELA Y ARTE | 4 | 4 | 121 | 119 |

# APPENDIX

## Sample Search: Librunam

```
Fecha:25/05/89                                                Página:   1
                          MICROBIBLOS LASER
             SISTEMA DE INFORMACION BIBLIOGRAFICA MEXICANA
             Resultados del Proceso de Recuperación de Información
===============================================================================

Condiciones de búsqueda:

                    Idioma : Español
                    Periodo: 1001-1999

Palabras buscadas:

   (MEXIC* Y ARTE)                     Tema

Total de títulos que cumplen con las condiciones:   297
```

MICROBIBLOS LASER
SISTEMA DE INFORMACION BIBLIOGRAFICA MEXICANA
Resultados del Proceso de Recuperación de Información

```
==============================================================================
```

| Número | Clasificación | Autor | Título | Pie de I. | Fecha |
|---|---|---|---|---|---|

```
==============================================================================
```

| Número | Clasificación | Autor | Título | Pie de I. | Fecha |
|---|---|---|---|---|---|
| 412 | N6555/A5 | AMABILIS, J. MANUEL | EL PABELLON DE MEXIC | MEXICO : | 1929 |
| 5484 | Z5931/O2 | OCAMPO, MARIA LUISA | APUNTES PARA UNA BIB | MEXICO : | 1957 |
| 6296 | N5030/M414 | FERNANDEZ, JUSTINO % | CATALOGO DE LAS EXPO | MEXICO : | 1945 |
| 7573 | N6553/F4 | FERNANDEZ, JUSTINO % | EL RETABLO DE LOS RE | MEXICO : | 1959 |
| 8978 | Z5961.M4/I5 | INSTITUTO NACIONAL I | BIBLIOGRAFIA DE LAS | MEXICO | 1950 |
| 12331 | N6550/M6 | MORENO VILLA, JOSE % | LO MEXICANO EN LAS A | MEXICO : | 1948 |
| 14248 | NK844/R63 | ROMERO DE TERREROS, | LAS ARTES INDUSTRIAL | MEXICO : | 1923 |
| 18125 | F1219/K75 | Krickeberg, Walter % | Las antiguas cultura | Mexico : | 1961 |
| 20138 | Z1411/M5 | MEXICO (CIUDAD), UNI | BIBLIOGRAFIAS DE LOS | MEXICO, | 1961 |
| 21228 | N6550/R4 | REVILLA, MANUEL GUST | EL ARTE EN MEXICO EN | MEXICO : | 1893 |
| 21805 | F1210/R8 | RUBIN DE LA BORBOLLA | MEXICO : MONUMENTOS | MEXICO : | 1953 |
| 22877 | N6553/T68 | TOUSSAINT, MANUEL % | ARTE COLONIAL EN MEX | MEXICO : | 1948 |
| 24362 | N6553/V5 | VILLEGAS, VICTOR MAN | EL GRAN SIGNO FORMAL | MEXICO : | 1956 |
| 30054 | F1219.3E8/W4 | WESTHEIM, PAUL | THE SCULPTURE OF ANC | GARDEN C | 1963 |
| 30829 | N16/M5 | MEXICO, (CIUDAD), UN | ANALES. V. 1 N. 1· | MEXICO | 1937-9999 |
| 34154 | NK9580/M3 | MADRID, MUSEO ARQUEO | LAS FIGURAS MEXICANA | MADRID : | 1934 |
| 35059 | N6550/B4 | BEST MAUGARD, ADOLFO | METODO DE DIBUJO : T | MEXICO : | 1923 |
| 37635 | F1219.3A7/E4 | EMMERICH, ANDRE | ART BEFORE COLUMBUS | NEW YORK | 1963 |
| 38724 | N6555/O52 | OLIVARES, ARMANDO | ALABANZA DE MEXICO | GUANAJUA | 1962 |
| 39428 | NK5000/L4 | LEON, FRANCISCO DE P | LOS ESMALTES DE URUA | MEXICO : | 1939 |
| 39432 | N6553/M3 | MACGREGOR, LUIS | ESTUDIOS SOBRE ARTE | MEXICO : | 1946 |
| 39438 | N655/R42 | REVILLA, MANUEL GUST | EL ARTE EN MEXICO | MEXICO : | 1923 |
| 39628 | F1219.3A7/F4 | FERNANDEZ, JUSTINO % | COATLICUE; ESTETICA | MEXICO : | 1954 |
| 41086 | N6554/R6 | RODRIGUEZ, PRAMPOLIN | LA CRITICA DE ARTE E | MEXICO : | 1964 |
| 42242 | N6555/T5 | TIBOL, RAQUEL | HISTORIA GENERAL DEL | MEXICO : | 1964 |
| 42548 | F1219.3A7/B4 | BERNAL, IGNACIO % 19 | ARTS ANCIENTS DU MEX | PARIS : | 1962 |
| 46434 | F1219.3A7/V5 | VILLA ROJAS, ALFONSO | ARTE PRIMITIVO, FORM | MEXICO : | 1964 |
| 46591 | N6553/A4 | MEXICO, INSTITUTO NA | ARTE PREHISPANICO DE | MEXICO | 1946 |
| 47265 | NB253/M6 | MORENO VILLA, JOSE % | LA ESCULTURA COLONIA | MEXICO E | 1942 |
| 50148 | N7/F6 | | FORMA : REVISTA DE A | MEXICO | 1926-1928 |
| 57581 | N16/M515 | MEXICO (CIUDAD), INS | MEMORIA, 1958-1964 | MEXICO | 1964 |
| 61681 | F1219.1T27/S | SEJOURNE, LAURETTE | EL LENGUAJE DE LAS F | MEXICO : | 1966 |
| 67058 | N6550/D54 | DIEZ BARROSO, FRANCI | EL ARTE EN NUEVA ESP | MEXICO : | 1921 |
| 67408 | N7/A768 | | ARTES DE MEXICO | MEXICO | |
| 67945 | N6554/F45 | FERNANDEZ, JUSTINO % | EL HOMBRE : ESTETICA | MEXICO : | 1962 |
| 70207 | PQ6353/R65 | ROJAS GARCIDUENAS, J | PRESENCIAS DE DON QU | MEXICO : | 1958 |
| 73342 | N6555/N42 | NELKEN, MARGARITA % | EL EXPRESIONISMO EN | MEXICO : | 1964 |
| 74077 | N6555/F473 | FERNANDEZ, JUSTINO % | EL ARTE DEL SIGLO XI | MEXICO : | 1967 |
| 74731 | N6554/F47196 | FERNANDEZ, JUSTINO | EL ARTE DEL SIGLO XI | MEXICO : | 1967 |
| 75525 | N6553/M37 | MAZA, FRANCISCO DE L | LA MITOLOGIA CLASICA | MEXICO : | 1968 |
| 77731 | N6550/G35 | GARCIA RIVAS, HERIBE | PINTORES MEXICANOS, | MEXICO : | 1965 |
| 79886 | ND255/Z8 | ZUNO, JOSE G | HISTORIA DE LAS ARTE | MEXICO : | 1967-9999 |
| 82035 | PQ7165/G6 | GODOY, EMMA | SOMBRAS DE MAGIA : P | MEXICO : | 1968 |
| 83497 | N6550/A57 | ALBA, VICTOR | COLOQUIOS DE COYOACA | MEXICO : | 1956 |
| 85167 | N6555/M4 | MEXICO, UNA, DIRECCI | TENDENCIAS DEL ARTE | MEXICO : | 1967 |
| 85180 | N131/L8 | LUNA ARROYO, ANTONIO | PANORAMA DE LAS ARTE | MEXICO : | 1962 |
| 87157 | GR115/T65 | TORRE DE OTERO, MARI | EL FOLK-LORE EN MEXI | MEXICO | 1933 |
| 88228 | N7790/H45 | HERNANDEZ SERRANO FE | MUSEO DE ARTE RELIGI | MEXICO : | 1950 |
| 92309 | N6555/M33 | MADERO, LUIS OCTAVIO | EL MOMENTO SOCIAL ME | MEXICO : | 1939 |
| 96577 | N6550/R55 | RODRIGUEZ PRANPOLINI | EL AURREALISMO Y EL | MEXICO : | 1969 |
| 98659 | PQ6353/R62 | ROJAS GARCIDUENAS, J | PRESENCIAS DE DON QU | MONTERRE | 1965 |
| 100985 | N6534/M3 | MARTI, JOSE % 1853-1 | ARTE EN MEXICO, 1875 | MEXICO : | 1940 |

## Sample Search: Venezuela

Fecha:26/05/89                                                          Página:   1
MICROBIBLOS LASER
SISTEMA DE INFORMACION BIBLIOGRAFICA VENEZUELA
Resultados del Proceso de Recuperación de Información
================================================================================

Condiciones de búsqueda:

                    Idioma : Español
                    Periodo: 1001-1999

Palabras buscadas:

    (VENEZUELA Y ARTE)                    Tema

Total de títulos que cumplen con las condiciones:   119

MICROBIBLOS LASER
SISTEMA DE INFORMACION BIBLIOGRAFICA VENEZUELA
Resultados del Proceso de Recuperación de Información

| Número | Clasificación | Autor | Título | Pie de I. | Fecha |
|---|---|---|---|---|---|
| 000170 | 707.0987/G89 | Grupo Katarsis | Motivos : existe un | Barquis | 1970-1979 |
| 000217 | 700.987/B516 | Bermúdez, Luis Juli | Cuento y recuento / | Caracas | 1977 |
| 000231 | 745.44987/D8 | Duarte, Carlos F. ( | Domingo Gutiérrez : | Caracas | 1977 |
| 000893 | 708.987/P649 | Pineda, Rafael, 192 | La tierra doctorada | [Caraca | 1978 |
| 001227 | 707/N841 | Noriega, Simón | Algunos aspectos de | Mérida | 1978 |
| 001768 | 759.987/C171 | Calzadilla, Juan, 1 | Pintores venezolano | [Caraca | 1975 |
| 002152 | 709.87/G939 | Guevara, Roberto | Arte para una nueva | Caracas | 1978 |
| 002483 | 709.87/C171 | Calzadilla, Juan, 1 | Movimientos y vangu | Caracas | 1978 |
| 006478 | 709.87/A779 | Arroyo, Miguel, 192 | Arte prehispánico d | Caracas | 1971 |
| 010732 | V-17/C-460 | Vélez Boza, Fermín, | Dieta y menús de 3. | [Caraca | 1963 |
| 010738 | 739.0987/D81 | Duarte, Carlos F. ( | Los maestros fundid | Caracas | 1978 |
| 010940 | | Vélez Boza, Fermín, | Normas de alimentac | 1965 | 1965 |
| 010942 | | Vélez Boza, Fermín, | Normas de alimentac | [Caraca | 1962 |
| 010946 | | Vélez Boza, Fermín, | Normas de alimentac | [Caraca | 1958 |
| 012680 | 708.9877/V45 | Venezuela. Minister | Catálogo general de | Caracas | 1979 |
| 013141 | 371.32/I43 | | Informe TEDUCA sobr | Caracas | 1978 |
| 014209 | :P.O./V-2/C- | Venezuela | Reglamento de la le | Caracas | 1942 |
| 014268 | 709.87/C171o | Calzadilla, Juan, 1 | Obras singulares de | Bilbao | 1979 |
| 014957 | P.O./V-8/C-3 | Venezuela | Ley de archivos nac | Caracas | 1949 |
| 015670 | P.O./V-11/C- | Venezuela | Ley de archivos nac | Caracas | 1946 |
| 016444 | 759.987/B796 | Bracho, Gabriel, 19 | Gabriel Bracho : un | [Caraca | 1973 |
| 016917 | 708.987/R741 | Rojas Jiménez, Osca | Maison Bernard, 196 | Caracas | 1976 |
| 018362 | V-2/C-293 | Escuela de Artes Pl | Catálogo de la déci | [Caraca | 1948 |
| 018364 | V-68/C-70 | Escuela de Artes Pl | Catálogo de la déci | [Caraca | 1949 |
| 018365 | V-12/C-344 | Escuela de Artes Pl | Catálogo de la déci | [Caraca | 1950-1953 |
| 018379 | V-28/C-381 | Escuela de Artes Pl | XX exposición de fi | [Caraca | 1959 |
| 018722 | 708.98713/M9 | Museo de Arte Colon | Catálogo / Museo de | Mérida | 1963 |
| 020034 | 709.87/A786 | | Artes plásticas en | Caracas | 1973-9999 |
| 020626 | 759.9870924/ | Calzadilla, Juan, 1 | Cabré / Juan Calzad | Caracas | 1980 |
| 020681 | 709.87/A786a | | Arte de Venezuela / | Caracas | 1977 |
| 021086 | 378.877/S161 | Salcedo Miliani, An | La integración de l | Mérida | 1979 |
| 022092 | 759.0652/R69 | Rodríguez, Bélgica, | La pintura abstract | Caracas | 1980 |
| 022551 | | Duarte, Carlos F. ( | Historia de la escu | 1 Aven | 1979 |
| 023363 | 745.50987/A7 | | El Artesano / Escue | Barquis | 1949-9999 |
| 024778 | 700.104/C719 | Coloquio sobre la P | Ideas, conclusiones | Barquis | 1980 |
| 030002 | 379.152/D598 | Dirección de Educac | Boletín informativo | [s. l.] | 1965-9999 |
| 030279 | 709.87/T758 | Traba, Marta, 1930- | Mirar en Caracas : | Caracas | 1974 |
| 031583 | 708.987/B213 | Banco Central de Ve | Aspectos históricos | Caracas | 1970 |
| 033743 | 987.00992/P9 | | Primer libro venezo | Caracas | 1895 |
| 034660 | 379/V458 | Venezuela. Despacho | Boletín / Plan Seb | Quinta | 1979-9999 |
| 035678 | 709.87/B551 | Bertrand Perdomo, A | Visualizando los mu | Valenci | 1979 |
| 038085 | 001.1/C322 | | Carta de Venezuela: | Apdo. d | 1956-9999 |
| 039331 | 705/A786 | | Arte plural de Vene | Apdo. d | 1981-9999 |
| 039429 | BX4625/. V4C | Montenegro, Juan Er | La Capilla de Santa | Caracas | 1977 |
| 042293 | 708.9877/V45 | Venezuela. Minister | Catálogo de las obr | Caracas | 1977 |
| 043359 | 709.8747/G64 | González, Leonardo | Guárico y su arte / | San Jua | 1980-1981 |
| 044365 | 759.987/O87 | Boulton, Alfredo, 1 | Alejandro Otero / A | Caracas | 1966 |
| 048297 | 709.87/P723 | Plaza, Ramón de la | Ensayos sobre el ar | Caracas | 1977 |
| 048533 | 860/C764 | | Contrapunto : revis | Cristo | 1948-9999 |
| 048887 | 705/C947 | | Crónica / publicaci | Caracas | 1968-9999 |
| 049042 | 705/C961 | | Cuaderno / Universi | Caracas | 1962-9999 |
| 049223 | 709.87/C171o | Calzadilla, Juan, 1 | El ojo que pasa : c | Caracas | 1969 |

# II. The Arts and Reference Sources

# 27. Art Reference: Visual Information and Sources for Latin America

## Lee R. Sorensen

This paper addresses the bibliography of Latin American art reference from the public service point of view, the "what-can-we-get-and-when-can-we-get-it" school of librarianship. When I work the reference desk, I frequently have to remind patrons that at the University of Arizona Library we are not the Burger King of information: you cannot "have it your way." Information exists, and it is up to the researcher to take what is, in the form it is, and create what is not. That is scholarship. As obvious as this sounds, incredulity among patrons is immense when you tell them that there is no book surveying modern Bolivian women artists—in English—with good color illustrations—that circulates.

There are essentially two kinds of reference books in the humanities: "browsing books" and "retrieval books." The browsing book fills the need of a patron seeking a list, for example, of contemporary Mexican sculptors. A browsing book gives the patron a list of names, which is all he or she wants. A retrieval book works the opposite way. The patron has a specific Mexican sculptor about which he or she needs to learn more. The retrieval kind of book must have the particular name the patron wants in it, or the book has failed. The difference between these books is not simply completeness; it is a matter of how the information is presented. Thieme-Becker, the great German biography of artists, contains many Latin American artists in it, but I would never hand a patron a volume of it and say, "this will have most of what you're looking for," even though it probably will. The patron asking that question needs to have the artists organized by country and evaluated comparatively. That's a browse book. Sadly, Latin American art books are heavy on the browse genre, and light on the retrieval kind. The result is that most Latin American art reference librarians must use browse books for retrieval books.

I do not keep many browse books in my section of the reference library. Space is short, and so I limit my reference collection to volumes that will render short bits of information in a concise manner. Since some browse books do this, I have a few. But by and large, these items reside in the main stacks.

Art bibliographic research, too, has some peculiar annoyances, whether they deal with Latin America or not. Most annoying is that art books can literally be classed anywhere in the Library of Congress system. In other words, browsing among the shelves is virtually impossible for art. For example, LC makes distinctions between "folk crafts" and "decorative arts" which the art historian does not. Ceramics, to mention only one important medium for Latin America, has it particularly bad. Consider the first four entries in the subject catalog of the University Library under "Pottery—Peru": Wendell C. Bennett's *Archaeology of the North Coast of Peru* gets a GN class (anthropology), the Brussels Musée Royaux's *Les vases péruviens . . .* gets F (American history: Peru), Rebeca Carrión Cachot de Girard's *El culto al agua en el antiguo Perú . . .* is placed in BL (religious history), and Ernst Fuhrmann's *Peru II: "Kulturen der Erde"* is placed in CB (history of civilization).

Looking at that list, you may have noticed the next problem: art history speaks with a thick accent—and frequently not the accent of the country from which the art comes. Serious Latin Americanists, that is, ones who read Spanish and Portuguese, are often astounded that they may need to read a French exhibition catalog or German-language museum publication to learn rudimentary information about modern Latin American art.

Now to the sources. The good news in all this is that art boasts two very fine bibliographies of Latin America. Joyce Waddell Bailey's *Handbook of Latin American Art: A Bibliographic Compilation* (1) is a massive three-part set attempting to cover the entire scope of art documentation in Latin America.* Although she states that the "bibliography is designed for the convenience of the general user," the *HLAA* is, in fact, very difficult to use. Annotations, when they exist, appear in the language of the contributor. The cross-indexing system uses a confusing variety of numbered codes for subjects, holding libraries, and citations indexed elsewhere. One citation I counted had eighteen distinct numbers attached to it, not counting dates of publication. This bibliography is useful, but only for librarians who are willing to read a preface and interpret the codes. James A. Findlay's *Modern Latin American Art* (2), while much smaller in scope, is eminently more usable for art patrons. Citations are organized simply around country and media, which patrons know, rather than by author's surname as in Bailey. A greater percentage of the magazines in

---

*Editor's Note:* The number in parentheses refers to the number in the Bibliography below.

Findlay's bibliography are more likely to be in general libraries, which is useful when assisting undergraduates.

Another area of art bibliography particularly well developed is covered in the catalogs of great Latin American libraries. Especially when one is looking for older publications not covered in the on-line databases, these longstanding collections reveal treasures. The University of Texas Library's *Catalog of the Latin American Collection* (8) is the first one I go to, partly for its size (it now has more than 200,000 entries) and partly for the thoroughness with which the books have been assigned subject headings. Library of Congress subject headings are used, so that a patron who has discovered the correct subject headings in our catalog can be left alone with the Texas catalog. Its first supplements make searching it time consuming, however. The other catalog worth checking initially is the *Schlagwortkatalog des Ibero-amerikanischen Instituts* (4) of the Preussischer Kulturbesitz in Berlin. Its 500,000 entries (including sound recordings) understandably cover European collection holdings well. German attention to subject entry is evident. Once you learn their system, you can go through layers of subject headings to find some pretty precise titles. Begin with the term "bildende Kunst" for the fine arts.

To a lesser degree, the collections at Florida (7) and Tulane (5) are also worth a check. I am sorry to say that printed catalogs of art museum libraries are of very little use for Latin America.

Bibliographies and library catalogs, of course, do not yield information themselves. They are, a library school student informed me, the easiest way to get rid of problem patrons. Books that are most likely to actually answer a patron's questions are the general art histories. José Pijoan's *Summa Artis: Historia General del Arte* (14) is a worldwide encyclopedic art history with two recent volumes devoted to colonial and post-colonial Latin American subjects. The set, cowritten by López, Mesa Figueroa, and Gisbert is the finest review of current scholarship on the whole of Latin American art in a single text and should be recommended to anyone with facility in Spanish. Both volumes have outstanding contemporary bibliographies. The first two volumes of the *Enciclopedia del arte en América* (10) form an art history of all the Americas, integrating Canada, the United States, and Central and South America into one cohesive narrative.

Unfortunately, there is no English-language survey of modern artists for Latin America. The best replacement for this lacuna are the numerous exhibition catalogs from U.S. museums. Two large hard-bound ones have found their way to my reference section: the Dallas Museum of Art's *Images of Mexico: The Contribution of Mexico to 20th*

*Century Art* (15) and the Bronx Museum of Art's *The Latin American Spirit: Art and Artists in the United States, 1920–1970* (16). There are, of course, many others. The key to locating these well-illustrated and contemporary titles is the indispensable *Catalogs of the Art Exhibition Catalog Collection of the Arts Library, University of California at Santa Barbara* (6). I cannot get patrons to use microfiche, but when I can, this subject list—using modified LC subject headings—locates the seemingly tiniest exhibition, as well as larger retrospectives. Many of Arizona's neighbors own these titles and, contrary to library wisdom, are as willing to lend them as much as any other material. Even though the on-line databases claim to cover these titles too, many are left out. The *Worldwide Art Catalog Bulletin* (9) updates its entries sooner than the Santa Barbara collection does. Other than the most recent issues, though, I have moved the latter out of reference because Santa Barbara does such a good job.

Similar to exhibition catalogs, magazines often fill in where reference books are lacking. The Latin American art world has had its share of fine arts magazines, many of which are now defunct or on their penultimate issue. Libraries with entire runs of magazines like *Artes de Mexico* (1953–1976) still have a magnificent browsing source of both the traditional arts and contemporary painting. The best index for Latin American art magazines is not an art index but rather the familiar *Hispanic American Periodicals Index* (*HAPI*) (17). Wilson's *Art Index*, still the standard for art periodical literature, is of no value for Latin American art because it indexes no Latin American magazines; *HAPI* and the *Art Index* have no overlapping magazine titles. The problem with using *HAPI* is that the subject headings are not as well developed for art as art librarians are used to. "Mural Painting" is the only kind of painting subject heading available. However, *HAPI* is truly handy for biographical articles on artists, articles that appear as often in literary magazines as in art journals.

Another area patrons often ask about is the location of arts societies, museums, or galleries in a particular American country. Two sources, both English-language, are particularly helpful. The *American Art Directory, 1989–90* (12), published by R. R. Bowker, devotes thirty pages to foreign museums and art schools. Organized by country, each entry lists a contact person, address, and occasionally an area of specialization. Typical of Bowker books, the information is copiously cross-indexed by personal name, organization name, and subject. Patrons using the *AAD* can locate not only art museums in Latin America but museums in the United States and Canada which specialize in Latin American exhibitions. Unfortunately, Bowker's

database is very uneven for many American countries. Perhaps the powerhouse art address book is the annual *International Directory of Arts* (13), a multilingual reference serial from Germany. The two-volume *IDA* is familiar to all art reference librarians because of the wide variety of addresses it provides. Artists, museums, universities, associations, periodical titles, book dealers and restorers of art are all divided by country and city. Where known, the names of directors, department heads, and librarians of the institutions are included. The *IDA* is strictly a commercial venture; some areas require a fee to be listed (not universities or museums), so occasionally information is terse.

Biographical dictionaries are very scarce for Latin American artists. That's a pity, because they are the single handiest kind of book an art reference librarian uses. Lilly Kassner's *Diccionario de escultura mexicana del siglo XX* (11) is a good attempt to collect sculptor's biographies into a single volume. Folk artists were ignored, and the reproductions are so bad that they cannot be used for study. Again, the *Enciclopedia del arte en América* (10) contains biographies, but only of truly major figures.

Finally, a word about computer searching. Today, a computer search must be a part of any serious reference response. The art world is lucky to have three extensive computer databases. While none is strong in Latin American art, their cost is reasonable enough that librarians should routinely perform them. The most rewarding search will be on *Artbibliographies Modern* (19). Although covering only nineteenth- and twentieth-century art, the abstracts are full enough to pick up citations even when only a small part of the article deals with the search subject. For example, searching "Latin America" with "painting" on *ABM* pulled over three hundred citations. Many of these were only ancillarily connected with the area. But when recent printed literature about Latin America is so scarce, it is just these odd references that can open up a new line of research to patrons. *Repertoire International de la Litterature de l'Art* (*RILA*) (18), one of the Getty Museum's copious progeny, is quite poor in post-colonial Latin American subjects, though it makes claims of broad geographical and chronological coverage. The third, *Arts and Humanities Citation Index* (20), is a grab bag of humanities magazine articles. For that very reason, *AHCI* is de rigueur in all art searches. Obscure painters oftentimes receive initial notice in literary or arts magazines as part of poetry pieces, bylines, and so on. Because the entries lack a standardized language, broad subject searches are the least successful.

## BIBLIOGRAPHY

### General Bibliographies

1.  Bailey, Joyce Waddell, ed. *Handbook of Latin American Art* =
    *Manual de Arte Latinoamericano: A Bibliographic Compilation*.
    2 vols. in 3. Santa Barbara, CA: ABC-Clio, 1984. 466+; 503+;
    422 pp.+.

    All periodicals and all countries of Latin American art.
    Publications from the twentieth century. Magazine citations,
    books, exhibition catalogs. Organized by subject, then author.
    Institution code where item was found. Unannotated,
    citations refer to *Handbook of Latin American Studies*
    (*HLAS*) annotations.

2.  Findlay, James A., comp. *Modern Latin American Art*. Art
    Reference Collections, 3. Westport, CT: Greenwood Press, 1983.
    263 pp.+.

    Twentieth-century art only. No magazine articles or mono-
    graphs on individual artists. Arranged geographically, then by
    media. Back index is author and title. *AACR-I* followed for
    museum entries.

3.  Goldman, Shifra M., and Tomás Ybarra-Frausto, eds. *Arte
    Chicano: A Comprehensive Annotated Bibliography of Chicano Art,
    1965–1981*. Berkeley, CA: Chicano Studies Library, 1985.
    715 pp.+.

    Although devoted to Mexican-American art, many sources
    overlap nicely with Latin America. Subject index includes
    "Iconography," "Culture," and "Philosophy of Art." Author/
    Artist, title, and periodicals index.

### Library Catalogs

4.  Ibero-Amerikanisches Institut (Berlin, West Germany). *Schlag-
    wortkatalog des Ibero-amerikanischen Institute*. 30 vols. Boston,
    MA: G. K. Hall, 1970.

    Handy "Person" and general indexes. Glossary of English or
    Spanish terms in German. Best subject heading for art is
    "bildende Kunst."

---

*Author's Note:* Page numbers do not include indexes (indicated after the page
number with a plus sign [+]).

5.  Tulane University Library. *Catalog of the Latin American Library of the Tulane University Library, New Orleans.* 9 vols. Boston, MA: G. K. Hall, 1970. Suppl., 1975, 2 vols.; 1978, 2 vols.

6.  University of California, Santa Barbara. Art Galleries. *Catalogs of the Art Exhibition Catalog Collection of the Arts Library, University of California at Santa Barbara.* 1977–.

    Library of Congress subject listing for exhibition catalogs from U.S. museums. Collection goes back to the early twentieth century.

7.  University of Florida Libraries. *Catalog of the Latin American Collection.* 12 vols. Boston, MA: G. K. Hall, 1973.

8.  University of Texas Library. *Catalog of the Latin American Collection.* 31 vols. Boston, MA: G. K. Hall, 1969. Suppl., 1971, 5 vols.; 1973, 3 vols.; 1975, 8 vols.; 177, 3 vols.

    Integrated author, title, subject catalog. Now known as the Nettie Lee Benson Collection.

9.  *The Worldwide Art Catalog Bulletin.* Boston, MA: Worldwide Boos, 1963–.

    Art exhibition catalogs available through a major vendor.

## Biographical Sources

10. *Enciclopedia del arte en América.* 5 vols. Argentina: Bibliográfica Omeba, 1968.

    Covers all countries of the Americas (incl. United States) from seventeenth century to 1960. First two volumes are a narrative history, final three are an alphabetical dictionary of artists' names and biographies. Strong on caricaturists and other nonacademic artists.

11. Kassner, Lilly. *Diccionario de escultura mexicana del siglo XX.* Coordinación de humanidades. México, D.F.: Universidad Nacional Autonoma de Mexico, 1983. 367 pp.

    Alphabetical entries by artist. Many, but poor quality, black-and-white illustrations. No folk artists.

## Directories

12. *American Art Directory, 1989–90.* 52d ed. New York, NY: R. B. Bowker, 1989. 765 pp.

    Directory of art museums and schools in the Americas. Pages 463-492 contain the "abroad" information. Index to personnel especially helpful.

13. *International Directory of Arts.* 19th ed. 2 vols. Frankfurt am Main: Verlag Müller, 1989.

    Listings for museums, societies, universities, associations, artists (commercial, few for Latin America), book dealers, restorers, etc. Each section divided by country. Lists special interests of the dealer or association.

## Histories and Surveys

14. Pijoan, José, et al. *Summa Artis: Historia General del Arte.* 32 vols. Madrid: Espasa-Calpe, 1955–1988. Specifically,

    López, Santiago Sebastián; Mesa Figueroa, José de; and Mesa, Teresa Gisbert de. *Arte Iberoamericano desde la Colonización a la Independencia.* Vols. 28-29. 2d ed. 1985. 626+, 607 pp.+.

    Solid historical surveys of Latin America by noted Hispanic-language scholars. Excellent "entry-level" bibliographies for serious students.

15. *Images of Mexico: The Contribution of Mexico to 20th Century Art.* Exhibition Catalog. Dallas, TX: Dallas Museum of Art, 1987. 442 pp.+.

    A highly illustrated exhibition catalog covering periods and iconography of all media of Mexican art, including photography and folk art. Essays by major art historians. Excellent brief biographies and bibliographies of Mexican artists.

16. *The Latin American Spirit: Art and Artists in the United States, 1920–1970.* Exhibition Catalog. Bronx, NY: Bronx Museum of the Arts, 1988. 326 pp.+.

**Periodical Indexes**

17. *HAPI: Hispanic American Periodicals Index.* Los Angeles, CA: UCLA Latin American Center Publications, 1975–.

   Relevant subject headings include "Art," "Art and Literature," "Art and Society," "Artists," "Mural Painting and Decoration," "Sculpture," and "Women Artists." Available on-line also.

18. *RILA: Repertoire International de la Litterature de l'Art.* Getty Information Center, 1975–.

   All postclassical periods of Western art, and post-Columbian periods for Latin America. Reflects the low degree of study Latin American arts receive in general art history journals.

19. *Artbibliographies Modern.* ABC-Clio. 1969–.

   Nineteenth- and twentieth-century art only. Excellent on photography. Best of the computer retrieval sources for Latin American artists.

20. *Arts and Humanities Citation Index.* ISI. 1966–. (*Dialog* 1980–.)

   Largest of the art databases. No standardized language. Range of magazines includes all of the humanities. Poorest for broad-subject searches.

# 28.  Basic  Reference  Sources  for Latin American Dramatic Arts

## Scott J. Van Jacob

This paper is about reference sources for the dramatic arts, that is, dance and theater, in Latin America. Depending on the emphasis of your collection, it is quite possible that you have received few reference questions or ordered many materials on the dramatic arts, especially dance. This conspicuous lack of interest and materials does not mean that dance and theater are ignored in Latin America. In fact, dance and theater are integral parts of Latin American culture. Anyone who has ever danced at a social occasion in Latin America knows how much people enjoy popular dancing. Beyond this, both arts have developed into original sustained art forms, and they presently enjoy international respect unparalleled in their history. Owing to this maturation of the art forms and interest in these arts, the time is appropriate for a guide to the reference sources in the Latin American dramatic arts.

A brief summary of the history of Latin American dramatic arts will give a useful context for the arrangement of this guide. Accounts for explorers of the New World describe the primitive theater and dance of the indigenous population. These dramas, often utilizing dance and song, were described in Spanish theater terms as comedies, tragedies, and ritual performances but were different in form and content from the European theater. Since such theater performances could reach large numbers of Indians, the first missionaries used miracle plays, passion plays, and *moros y cristianos* plays, dramatizing the struggle between the Christians and heathens, in an attempt to convert the indigenous population to Catholicism.

By the seventeenth century, the first secular plays were being written and produced. These plays were strongly influenced, to the point of imitation, by such European playwrights as Pedro Calderón de la Barca; it would remain this way well into the twentieth century. In fact, resources that would have supported the colonial dramatists were used to produce European plays and host European touring theater groups.

Dance followed a similar course during these years. Ballroom dancing emulated the European trends, whereas folk dancing evolved,

gaining an identity of its own.    Little changed from the eighteenth through early twentieth centuries, although social protest and realism emerged in the theater as nationalism grew in strength.    The greatest impact on dance during this time was the appearance of African dance and music in the Caribbean and Brazil.

Following World War II, both dramatists and dancers began to assert their own identity.    Alicia Alonso, the great Cuban ballerina, became a principal dancer for the American Ballet Theater and now oversees the Ballet Nacional de Cuba in Havana.    Julio Bocca is currently showing the strength of the Argentine ballet by winning international dance competitions and dancing with some of the greatest companies in the world.    Folk dancing gained popular and scholarly interest and is kept alive by national folk dance companies.    Latin dances and rhythms played a major role in ballroom dancing in the 1920s through the 1950s.    The recent Broadway success of the tango has helped to bring about the revival of ballroom dancing in this country. The absurdist theater of Latin America brought attention to the Latin American theater.    There are currently Latin American theater festivals both at home and abroad.    Also, a number of playwrights have the opportunity to produce their plays in the United States and Europe. There can be no doubt that the dramatic arts have come into their own during these past forty years.

While this brief history demonstrates that the development of the Latin American dramatic arts was inhibited largely by the dominance of the European dramatic arts, there were other reasons for this slow progress.    Volatile political and economic conditions made it difficult for the arts to flourish.    Autocratic regimes censored plays, allowing for little originality of those plays that were officially sanctioned.    While these barriers did not stop playwrights from following their own visions, those that did faced serious problems.    They had no place to perform, no press to publish the plays, and few, if any, financial supporters.    The lack of a middle class to support the arts left only a small wealthy class to fund the arts.    One cannot help but be impressed by these artists who pursued their art in the face of such obstacles.

These problems are some of those brought about by the social, economic, and political conditions in Latin America, but the dramatic arts themselves have limitations that are discipline specific.    Reference librarians need to be aware of these limitations to fully utilize the sources listed below.

Dance has long been known as the "illiterate" art.    The oral tradition of handing down choreography from one dancer to the next impeded the development of a permanent record of a dance.    The

kinetic movement so essential to dance does not translate well to the printed page. The scholarly study of dance is new, more often falling into established disciplines such as anthropology, music, and history than not. For example, Katharine Dunham, one of the most respected American choreographers in this century, has a background in sociology and has written excellent works on Haitian dance. While many of her dances, unless filmed or recorded through labanotation, a written code for recording dance, will perish with her death, her scholarly works will be with us much longer. With the output of scholarly works on dance largely falling into other disciplines, there are few reference sources on dance itself.

Theater, on the other hand, has the advantage of a long history of scholarship and criticism. The academic interest in Europe was applicable to the Latin American drama and gave a jump-off point for scholarship at home. Also, the advantage of a text, that is, the script, allows one to build a body of works from which academics can work. From this background, there are a number of useful reference sources on Latin American drama.

## BASIC REFERENCE MATERIALS
## FOR DANCE AND DRAMA

The following bibliography represents a basic, core reference collection. It is by no means an exhaustive bibliography; rather, it provides a base from which most reference questions can be answered. The materials listed have been placed in the following categories: general reference works for the dramatic arts, primary historical and critical works for each art, selected bibliographies for each art, selected journals on each art, and selected bibliographies of each art by country.

Materials have been selected that focus primarily on the Latin American dramatic arts, although there are sources that offer broad-based coverage of the arts in general. The sources are often discipline rather than dramatic arts specific. Knowing the discipline orientation of your patron's question will greatly help in locating appropriate materials. For example, the ritual dances of indigenous populations will tend to receive the most coverage from anthropology. Sources have been included either for their coverage of current trends, research, practices, and issues, or for their historical value. While most bibliographies have been chosen for their substantial number of citations, for example, about forty and up, there are some that carry a few but essential citations and should be kept in mind. A number of major bibliographies in both dance and drama have not been included here due to the limited coverage of dramatic arts on Latin America.

Descriptions are included for a number of works. Where there is none, the work is generally a familiar one or one not available to me for review.

## General Sources

Acuña, René. *El teatro popular en hispanoamérica: una bibliografía anotada*. México, DF: Universidad Nacional Autónoma de México, 1979. 144 pp.

A fine compilation of monographs and scholarly articles on theater and dance in Latin America. The work is divided into the following chapters: the native theater, which focuses largely on Mexico and Central America and development of the peninsular theater in America; "los moros y cristianos" and the dances of the conquest; and a bird's eye view of South America. The final section's listing of citations for each South American country is sparse. Author index.

*Art Literature International (RILA)*
Available on-line through Dialog.

*Arts and Humanities Citation Index* and *Social Sciences Citation Index*. Philadelphia, PA: Institute for Scientific Information, 1975— and 1972–.

Few articles on the Latin American dramatic arts can be found in these indexes. The citing procedures make them worth pursuing, particularly on-line.

*Artsbibliographies Database*
Available on-line through Dialog.

Davis, Martha Ellen. *Music and Dance in Latin American Urban Contexts: A Selective Bibliography*. Brockport, NY: Department of Anthropology, SUNY–Brockport, 1973. 20 pp.

This bibliography contains only a small number of citations, covering the popular (or commercial) dance and musical forms in urban settings. The works cited largely fall in the field of anthropology.

*Dissertation Abstracts Online*
Available on-line through Dialog.

*Fichero Bibliográfico Hispanoamericano*. 1961–1966. Monthly.

A monthly bibliographic service providing current lists of materials published in Spanish. Useful sections are Anthropology, Music and Dance, and Theater.

*HAPI: Hispanic American Periodicals Index.* Los Angeles, CA: UCLA
Latin American Center Publications, 1975—.

> The foremost source for locating Latin American periodical
> literature. Dance subject headings: Dancing, Ballet, Folk dancing,
> and type of dance, e.g., *cumbia.* Drama subject headings: Theater,
> Drama, Folk drama, Drama reviews, Drama festivals, and
> playwrights by name.

*Handbook of Latin American Studies.* Gainesville: University of Florida
Press, 1936–.

> An annual bibliography. The Humanities volume, appearing every
> other year, contains most of the *Handbook's* references to the
> dramatic arts and music.

Libros Latinos. *Purchasing list No. 159: Latin American Performing Arts.*

> A listing of 136 works emphasizing theater in Mexico and the
> Caribbean.

Loroña, Lionel. *Bibliography of Latin American Bibliographies.*
Metuchen, NJ: Scarecrow, 1987. 223 pp.

> This work and its predecessors identify the small but useful
> number of bibliographies on the dramatic arts.

Thompson, Donald. "Music, Theater and Dance in Central America
and the Caribbean: An Annotated Bibliography of Dissertations and
Theses." *Revista/Review Interamericana* 9/1 (Spring 1979), 115-141.

> This annotated listing of 126 dissertations and theses focuses on
> drama and music.

## Dance

*Critical and Historical Works*

Ellmerich, Luis. *Guia da música e da dança.* São Paulo: Boa Leitura,
1962. 546 pp.

Ellmerich, Luis. *História da dança.* 3d ed. São Paulo: Ricordi, 1969.
326 pp.

> A historical approach to dance from primitive to modern times.
> Latin American dance is covered by country with each containing
> a short history, the dances unique to that country, and composers
> who wrote music for dance. The index includes a selected listing
> of time and location of the first performance of a dance.

Sachs, Curt. *World History of the Dance.* New York, NY: W. W. Norton, 1937. Translated. 469 pp.

This survey describes a number of dances that originated in Latin America. Also offers brief coverage by country.

## Selected Bibliographies

Chase, Gilbert. *A Guide to the Music of Latin America.* 2d ed. New York, NY: AMS, 1972. Reissued. 411 pp.

While the main focus is on music, dance receives brief coverage. Most of the works are scholarly journal articles. Author index.

Forbes, Jr., Fred R. *Dance: An Annotated Bibliography 1965–1982.* New York, NY: Garland, 1986. 261 pp.

The most current dance bibliography to date, reflecting a multidisciplinary approach to dance. Chapters are arranged by discipline, e.g., anthropology, history, and physiology. Although the number of Latin American dance materials is small, the quality is exceptional. Author and subject indexes.

Magriel, Paul David. *A Bibliography of Dancing.* New York, NY: Benjamin Blom, 1966. Reissued. 229 pp.

This is the best of this list's dance bibliographies, due to its extensive coverage, approximately 2,800 citations. The chapter entitled "Folk, National, Regional and Ethnological Dances" includes materials on Mexico, the West Indies, Central and South America, and South and Central American Indians. Most of these works are journal articles. Individual dancers and dances can be located in the author and subject indexes.

Szwed, John F., and Roger D. Abrahams. *Afro-American Folk Culture: An Annotated Bibliography of Materials from North, Central and South America and the West Indies.* 2 vols. Philadelphia, PA: Institute for the Study of Human Issues, 1978.

There are over 300 citations on Afro-American dance from a wide variety of sources and disciplines in volume two. Annotations vary greatly. Subject index.

## Encyclopedias. Catalogs

*Encyclopedia of Dance.* Berkeley: University of California Press, 1989.

New York Public Library. The Research Library. *Dictionary Catalog of the Dance Collection of the Performing Arts Research Center*. New York, NY: G. K. Hall, 1974–.

> A comprehensive annual subject bibliography that supplements the ten-volume catalog published in 1974. Entries include works in a variety of formats and languages. Subject headings: country, dancer, choreographer, folk dancing, and ballet.

## Selected Bibliographies by Country

*Music and Dance in Continental Latin America, with the Exception of Brazil*. New York, NY: Holmes and Meier, 1984. 342 pp.

Parra, Manuel Germán, and Wigberto Jimenez Moreno. *Bibliografía indigenista de México y Centroamérica*. México, DF: Memorias del Instituto Indigenista, 1954.

Royce, Anya Peterson. *Mexican Dance Forms: A Bibliography with Annotations*. Palo Alto, CA: Institute of International Relations, 1967. 12 pp.

> 116 monographs and journal citations compiled for folklorists and anthropologists. Annotations are brief.

## Drama
### Critical and Historical Works

Arrom, José Juan. *Historia del teatro hispanoamericano: época colonial*. 2d ed. México, DF: Ediciones de Andrea, 1967. 151 pp.

> Arrom traces the European influence on drama and the indigenous dramatic tradition.

Carpenter, Charles A. *Modern Drama Scholarship and Criticism 1966–1980*. Toronto: University of Toronto Press, 1986. 587 pp.

> Under the headings "Brazilian Drama" and "Spanish-American Drama," works are organized in the following sections: reference, general and miscellaneous, and playwrights. The work includes monographs, scholarly periodical reviews, criticism, and dissertations, as well as popular periodicals that provide insight into playwrights and their works, e.g., interviews.

Dauster, Frank N. *Historia del teatro hispanoamericano: Siglos XIX y XX*. 2d ed. México, DF: Ediciones de Andrea, 1973. 167 pp.

Gálvez Acero, Marna. *El teatro hispanoamericano*. Madrid: Tauras, 1988. 173 pp.

*Handbook of Latin American Literature*. New York, NY: Garland, 1987. 608 pp.

> While the coverage is spotty, the bibliographies following each chapter provide an adequate listing of critical and historical works on drama. Name index.

Jones, Willis Knapp. *Behind Spanish American Footlights*. Austin: University of Texas Press, 1966. 609 pp.

> Jones surveys the development of theater in each Latin American country. Excellent bibliography.

Saz, Agustin del. *Teatro hispanoamericano*. 2 vols. Barcelona: Editorial Vergara, 1964.

> A survey of the history of Latin American drama.

## Selected Bibliographies

Allen, Richard F. *Teatro hispanoamericano: una bibliografía anotada/ Spanish American Theater: An Annotated Bibliography*. Boston, MA: G. K. Hall, 1987. 633 pp.

> This compilation of dramatic works contains a chapter listing 27 Latin American dramatic anthologies and a listing of plays by country. Each citation includes the location of the work and a brief critical annotation. Author and title indexes.

Grismer, Raymond Leonard. *Bibliography of the Drama of Spain and Spanish America*. 2 vols. in 1. Minneapolis, MN: Burgess-Beckwith, [1967].

Hebblethwaite, Frank P. *A Bibliographical Guide to Spanish American Theater*. Washington, DC: Pan American Union, 1969. 84 pp.

> A listing of critical and historical works on drama in Latin America. Author index.

Lyday, Leon F. *A Bibliography of Latin American Theater Criticism, 1940–1974*. Austin: Institute of Latin American Studies, University of Texas at Austin, 1976. 243 pp.

> A critical bibliography with 2,300 entries including essays, introductions to anthologies, journal articles, and newspaper reviews.

*MLA International Bibliography of Books and Articles on the Modern Languages and Literatures.*  New York, NY: Modern Languages Association, 1963–.

> Offers minimal coverage for dance and music, but it indexes *Dissertation Abstracts*.

Rhoades, Duane.  *The Independent Monologue in Latin American Theater: A Primary Bibliography with Selective Secondary Sources.* Westport, CT: Greenwood Press, 1985.  242 pp.

> An extensive bibliography of an honored form of Latin American theater—the monologue.   The cited monologues are divided chronologically into three sections: From Precursive Unipersonal Genres to Melologues (1550–1840), Monologues (1840–1940), and Monodramas and Related Contemporary One-Character Plays (1940–present).   Includes an appendix listing sources cited in connection with unpublished plays, a secondary bibliography, and works related to the monologue and associated genres.   Author index.

Toro, Fernando de, and Peter Roster.  *Bibliografía del teatro hispano-americano contemporáneo (1900–1980).*  2 vols.  Frankfurt: Vervuert, 1985.  Spanish.

> Volume one includes 6,952 original dramatic works: volume two, 3,132 critical works.  The extensive coverage offered is offset by the lack of an index.

## Dictionaries, Encyclopedias, Catalogs, and Indexes

Hoffman, Herbert H.  *Latin American Play Index.*  Metuchen, NJ: Scarecrow Press, [1983–].  Vol. 1 (1920–1962) 147 pp.; vol. 2 (1962–1980) 131 pp.

> The index contains plays published in four formats: single works, works published in collections, works published in anthologies, and a limited number of works published in periodicals.  Author and title indexes.

*McGraw-Hill Encyclopedia of World Drama.*  2d ed.  New York, NY: McGraw-Hill, 1984.  5 vols.

> Over forty pages are devoted to Latin American drama, while briefer entries exist for Brazilian, Cuban, and Puerto Rican drama. An excellent introduction to this area of study.  Of interest may be the brief coverage of puppets and marionettes in Latin America. Each country of Latin America is given adequate coverage, with the emphasis placed on twentieth-century theater.

New York Public Library. Research Library. *Catalog of the Theater and Drama Collections*. 51 vols. New York, NY: G. K. Hall, 1967—1976.

> The catalog is divided into two parts: part one consists of works by cultural origin and an author listing; part two consists of books on theater.

## Selected Periodicals

*Conjunto* (Cuba)
*Latin American Theater Review* (University of Kansas)
*Modern International Drama* (Binghamton, New York)
*Primer Acto* (Madrid)
*Tramoya*

## Selected Bibliographies by Country

> The following list includes titles not mentioned above.

### Argentina

Foppa, Tito Livo. *Diccionario teatral del Río de la Plata*. Buenos Aires: Ediciones del Carro de Tespis, 1961. 1,046 pp.

Ramos Foster, Virginia. "Contemporary Argentine Dramatists: A Bibliography." *Theater Documentation* 5/1 (1971–72), 13-20.

### Chile

Castedo-Ellerman, Elena. *El teatro chileno de mediados del siglo XX*. Santiago: Editorial Andres Bello, 1982. 240 pp.

Duran Cerda, Julio. *Repertorio del teatro chileno*. Santiago de Chile: Instituto de Literatura Chilena, 1962. 247 pp.

### Colombia

Orjuela, Hector M. *Bibliografía del teatro colombiano*. Bogotá: Instituto Caro y Cuervo, 1974. 312 pp.

### Cuba

Perrier, Joseph Luis. *Bibliografía dramática cubana, incluye a Puerto Rico y Santo Domingo*. New York, NY: Phos Press, 1926. 115 pp.

Rivero Muñiz, José. *Bibliografía del teatro cubano*. Havana: Biblioteca Nacional, 1957. 120 pp.

## Ecuador

Luzuriago, Gerardo. *Bibliografía del teatro: 1900–1982.* Quito: Editorial Casa de la Cultura Ecuatoriana, 1984. 131 pp.

## México

Huerta, Jorge A. *A Bibliography of Chicano and Mexican Dance, Drama and Music.* Oxnard, CA: Colegio Quetzalcoatl, 1972. 59 pp.

Lamb, Ruth Stanton. *Bibliografía del teatro mexicano del siglo XX.* México, DF: Ediciones de Andrea, 1962. 143 pp.

Monterede, Francisco. *Bibliografía del teatro en México.* Monografías bibliográficas mexicanas, 28. México: Secretaria de Relaciones Exteriores, 1933; reprint, New York, NY: B. Franklin, 1970. 649 pp.

Olavarria y Ferrari, Enrique de. *Reseña histórica del teatro en México 1538–1911.* 3d ed. 5 vols. México: Editorial Porrua, 1961.

## Peru

Moncloa y Covarrubias, Manuel. *Diccionario teatral del Perú: indice de artistas nacionales y estranjeros, autores y sus obras, escenografos, empresarios, tecnicismo, fraseología, teatros del Perú, etc. . . .* Lima: Badiola y Berrio, 1905. 198 pp.

## Uruguay

Rela, Walter. *Repertorio bibliográfico del teatro uruguayo, 1816–1964.* Montevideo: Editorial Síntesis, 1965. 35 pp.

# 29. Investigación sobre arte latinoamericano: acceso a través de material publicado

Elsa Barberena B.

## El arte latinoamericano contemporáneo: 1900–1940s

El tema de la conferencia, "Artistic Representation of Latin American Diversity: Sources and Collections", invita a tratar de definir que es el arte latinoamericano contemporáneo. ¿Qué es arte latinoamericano contemporáneo—los artistas latinoamericanos que trabajan, exponen o venden en París o en Nueva York; los grupos de artistas que trabajan en América Latina, unas veces con libertad de expresión y otras no; los veinte y tantos artistas latinoamericanos conocidos? Es un arte que tiene identidad propia como una unidad; una pluralidad de expresiones sin una unidad; una pluralidad de expresiones con características propias del ser latinoamericano; un arte que depende de París o Nueva York parra su expresión y desarrollo; un arte derivado inevitablemente de las corrientes universales, pero que tiene rasgos de originalidad. Me aventuro a decir que para mí la plástica latinoamericana abarca una pluralidad de expresiones dentro de una originalidad, en América Latina y fuera de ella, nacida a partir de las corrientes universales. La plástica latinoamericana se nutre de elementos como la magia, lo primitivo, lo ancestral, lo popular, a los cuales se han sumado nuevos asuntos: lo geométrico, lo figurativo, lo social, lo óptico, lo musical. El muralismo mexicano, la arquitectura brasileña, el cinetismo argentino-venezolano, el constructivismo de Torres García y la conexión entre el cartel, producto artístico, y la sociedad en Cuba, han sido los aportes del arte latinoamericano. Hay originalidad, y es exagerado afirmar que la mayor parte de lo que hoy se hace en América Latina viene de París o Nueva York.

Las circunstancias particulares de los países latinoamericanos son muy diversas unas de otras a través de sus propias historias. De 1920 a 1950 en México se pinta con preferencia lo "social", para después pasar por el arte abstracto y ahora lo conceptual. En São Paulo la Antropofagía, movimiento cultural nacionalista, pretendía acabar con la influencia europea. En Argentina y Uruguay se pensaba en una sucursal de la Escuela de París, por una parte, y por otra en instaurar un arte constructivista concreto, severo, opuesto a la Escuela de París.

Chile miraba por el lado del surrealismo con Matta. Bolivia y Perú vivieron un indigenismo directo al principio que se ha convertido en abstracción "telúrica". Colombia se ha vuelto irónica con el humor negro de Botero y Beatriz González. Venezuela tiene, además del cinetismo derivado de la arquitectura de Villanueva, un representante neofigurativo: Jacobo Borges.[1]

A sus inicios del siglo XX la mayor parte de los artistas latino-americanos hace su aprendizaje o perfeccionamiento en las academias oficiales o en los talleres libres de París y Roma, y vuelven a sus país de origen con las tendencias europeas. No obstante, las principales actividades artísticas en América Latina reflejan una inquietud por parte de los artistas, no solamente en trasplantar estas tendencias al territorio americano, sino en buscar una estética propia.

Entre las tendencias europeas que emigran al continente con retraso está el impresionismo que llega a la Argentina en 1902; el pintor paisajista Martín Malharro, en 1910, siente la necesidad de expresar la honda poesía de la tierra en estas formas que eran nuevas para su tiempo,[2] de esta manera no solamente acepta la vanguardia, sino que le da una expresión propia.

Otra tendencia de vanguardia europea que llega a América Latina es el expresionismo, representado en su versión americana por dos exposiciones en São Paulo: la primera del pintor ruso-alemán Lasar-Segall, en 1913, quien enriquece su repertorio por influencia del clima cultural del Brasil,[3] y la segunda la de Anita Malfatti realizada en 1917.

Desde 1921 se escucha la voz del pintor mexicano David Alfaro Siqueiros quien en el "Manifiesto a los plásticos de América", publicado en Barcelona, en el único número de la revista *Vida Americana*, hace un llamado a los pintores y escultores de la nueva generación americana para que abandonen la labor extemporánea e incoherente, que no produce nada perdurable, y que responda al vigor de las grandes facultades raciales a América Latina. En este mismo año, el pintor uruguayo Pedro Figari expresa un folklore esquematizado en sus figuras que parecen muñecos.[4]

Un año más tarde se consolida la Escuela Mexicana que se interesa por la creación de una conciencia nacional, plasmada en el "Manifiesto del Sindicato de Artistas Revolucionarios en México", en donde de manera radical se insiste en el elemento social del arte, en su aspecto político-revolucionario y en colocar el arte popular como el mejor del mundo. La figura del pintor mexicano Siqueiros vuelva a aparecer para repudiar la pintura de caballete y para glorificar la expresión monumental del arte porque es propiedad pública. A partir de 1922, la Escuela Mexicana es la pintura mural o muralismo

mexicano que, a juicio de algunos críticos como el ecuatoriano Adoum, constituye la más conocida e imitada escuela plástica en América Latina, no sólo por la calidad intrínseca de sus realizaciones, sino también por estar ligada a una gesta colectiva.[5]

En contraste con la Escuela Mexicana que tiene un objetivo nacionalista está el movimiento modernista en Brasil, que ofrece una doble actitud—mirar hacia la vanguardia europea y hacia la propia tierra. En la "Semana de Arte Moderna en Brasil", que tuvo lugar en São Paulo en 1922, el pintor Calvalcanti declara "Rebelión es nuestra estética". Los principios fundamentales de este movimiento son: primero, el derecho permanente a la investigación estética; segundo, la actualización de la inteligencia artística brasileña; y tercero, el establecimiento de una conciencia creativa nacional.

México cuenta con el muralismo, Brasil con el movimiento modernista. En la Argentina se agrupan escritores y artistas plásticos que machacan sobre la necesidad de un cambio; fundan la revista *Martín Fierro* que da origen al movimiento Martinfierrista en 1924. En este mismo año se crea la "Asociación Amigos del Arte", en Buenos Aires. A partir de esta fecha, en Cuba, Víctor Manuel, Carlos Enríquez y Eduardo Abela asimilan las vanguardias y exponen un lenguaje vernacular.[6] En Brasil, no satisfechos con el llamado a una conciencia creativa nacional de Cavalcanti, si inicia un movimiento, en 1928, que tiene como objetivo volver a los indígenas; el movimiento Antropofagía reúne a artistas y literatos. Alfredo Guttero, pintor argentino, hace eco de este interés por la vanguardia y lo vernáculo al organizar el Primer Salón de Arte Nuevo, en 1929, con la colaboración de la "Asociación Amigos del Arte."

Más tarde, artistas brasileños como Goeldi, Segall y Portinari se preocupan, en 1930, por encontrar en su grabado un lenguaje brasileño. A su vez, en ese mismo año, a pesar de la crisis económica y el golpe militar en Argentina, se experimenta un cambio de la pintura argentina hacia una expresión profunda. La década de los 30 es un período en el que el arte latinoamericano apenas adquiere conciencia de rebelión contra lo europeo, de cambiar rastreando raíces indígenas. De alguna manera en estos años se detecta una difusión incipiente al arte latinoamericano. Durante esta década las acciones se realizan dentro y fuera de América Latina. En los Estados Unidos surge interés por conocer el arte de América Latina; el 10 de diciembre de 1930 un grupo de acaudalados norteamericanos interesados en promover la amistad y las relaciones culturales entre la gente de México y la gente de los Estados Unidos organizó la Mexican Art Association, Inc.[7] Uno de los propósitos de la Mexican Art Association, Inc. es

"patrocinar . . . exhibiciones especiales de las bellas artes en México . . . con el fin de estimular el interés, la demanda y la distribución de las artes mexicanas". Aunque la sede de la asociación es en Chicago, probablemente influye en que el Museum of Modern Art de Nueva York empiece a coleccionar arte latinoamericano en 1935.

La presencia de Siqueiros se hace sentir una vez más en el ámbito latinoamericano, esta vez en la "Asociación Amigos del Arte", de Buenos Aires. En 1933, invitado por la escritora y mecenas Victoria Ocampo, presenta una exposición de cuadros, litografías y reproducciones fotográficas de sus murales; da la primera de las tres conferencias programadas, debido a la agitación política que produjo. Los argentinos reconocieron que Siqueiros había llegado a sembrar una semilla de profundas inquietudes.[8] En este mismo año, Portinari, fuertemente influido por el muralismo mexicano, realiza pinturas inspiradas en los trabajos agrícolas brasileños, cuyo tema central era el trabajador.[9] Amelia Peláez, pintora cubana con fuertes raíces nacionalistas que trascienden hacia el arte internacional, empieza en Cuba, en 1934, a difundir el arte contemporáneo de América Latina.

En 1938, Marcelo Milton, Roberto y Mauricio introducen el uso de "brise soleil" como característica de la arquitectura brasileña. Durante la década de los 40 continúa el interés por el arte de América Latina en los Estados Unidos. Esta vez es la arquitectura. La exposición "Brazil Builds" se inaugura en el Museum of Modern Art de Nueva York en 1943. Por lo que se refiere a América Latina, en ese mismo año se crea el Museo de Arte de São Paulo. El impacto mayor o menor del muralismo mexicano dura dos décadas, ya que en los 40 se observa un viraje hacia el abandono de la búsqueda de lo propio e inclusive desprecio sobre la Escuela Mexicana por los artistas dentro y fuera de México.[10]

En 1944, Lucio Fontana y discípulos escriben el "Manifiesto Blanco", en Buenos Aires, que auspicia la llegada de un arte espacial que superará los límites del cuadro de caballete, un arte espacial integrador de la arquitectura. Dos otras actividades relacionadas con la necesidad de buscar una identidad se platean en 1947: el Taller Libre de Venezuela proclama una renovación del arte venezolano que conserve la identidad; y la conclusión a la que llega el 1er Congreso Nacional de Arquitectos Cubanos que en Cuba la arquitectura debe desarrollarse con las características propias del país.

Esta década es de progreso. En Nueva York no solamente se colecciona el arte latinoamericano, sino que se organizan exposiciones, y América Latina cuenta con un museo de arte contemporáneo en la Ciudad de Washington. El arte espacial integrador de la arquitectura

de Fontana tiene relación con los espacios abiertos del continente, y su integración con la arquitectura se podría relacionar con la importancia que ésta va adquiriendo principalmente en Brasil, aunque se manifiestan también inquietudes de cambio en Cuba.

## Hacia una creación artística original: 1950s

En 1950, el mapa informe del arte en América Latina comienza a tomar cuerpo. Ciudades como Buenos Aires, Caracas, São Paulo, se caracterizan por su progreso, su afán de civilización, su capacidad de absorber y recibir lo extranjero. América Latina ha asimilado los transplantes europeos y está en condiciones de convertirse en emisora de movimientos artísticos. En este mismo año, el movimiento de arte concreto tenía un destino brillante no solamente en Europa, sino en Buenos Aires. El Taller de los Disidentes de Venezuela replantea desde su raíz los temas y haberes de la vida y cultura latinoamericana. En 1951, se inicia la Bienal en São Paulo y, por consiguiente, los artistas latinoamericanos ya tienen en su propio territorio una oportunidad de exponer e intercambiar experiencias.

La importancia de la arquitectura latinoamericana se deja sentir a través de la exposición "Latin American Architecture since 1945" que se inaugura en el Museum of Modern Art de Nueva York, en 1955; un año después se inicia la construcción de Brasilia. En Estados Unidos se reconoce la obra de un pintor argentino, Pettoruti, quien obtiene el Premio Guggenheim de las dos Américas, en 1956.

El triunfo del movimiento insurreccional de Fidel Castro, en 1959, hace afirmar a Cossio del Pomar, un año después, que sí hay un arte cubano, ya que la obra de los artistas cubanos contemporáneos lo afirman. Estos artistas mediante su actividad mental y sentimental han sabido asimilar la cultura europea dándole una prestancia de sensibilidad nacional.[11] A fines de la década del 50, la plástica cubana, con el triunfo de la Revolución, llega a nuevas perspectivas y a nuevos puntos de partida: la gráfica y el cartel.

En la década del 50 al 60 no solamente Argentina y Cuba logran definir una tendencia estética mayoritaria, sino Venezuela con su arquitectura de los años 1955 a 1957 y su pintura logra dar un impulso hacia una creación más original. Las ciudades principales de América Latina son cosmopolitas; se encuentran otras salidas a la pintura de caballete: la gráfica y el cartel; el volver a lo indígena se enfoca con elementos de universalidad y no de regionalismo; los artistas latinoamericanos obtienen premios internacionales; se siente un compromiso mayor entre el arte y la sociedad; Brasil no es el único país considerado por su arquitectura original, sino también Venezuela.

## Las décadas definitivas para las artes plásticas latinoamericanas: 1960s–1980s

El año de 1960 es definitivo para las artes plásticas argentinas; el Instituto Torcuato di Tella forma un grupo de artistas originales. En 1960, Cuba rechaza las ideas artísticas norteamericanas y la Revolución cubana determina en gran parte el cambio de la apoliticidad y discusión teórica de los artistas latinoamericanos hacia una franca militancia o una verdadera angustia por integrarse a la zona problematizada de sus sociedades. El artista se define como rebelde.[12] En la Mesa Redonda en torno al arte dentro de las Jornadas de la Cultura Cubana, en 1985, se comentó que, a partir de los años 60, las artes plásticas se involucran en el proceso revolucionario cubano.[13]

En Brasil, en la década del 60 al 70, se logra un auge económico. En este año aparecen las galerías de arte en Brasil, y se funda la Universidad de Brasilia que se considera como una unidad integradora de las artes plásticas. Los 60 en Brasil dan ejemplos de la pluralidad del arte latinoamericano y se consideran los años de los "ismos".

La exposición "The Emergent Decade: Latin American Painters and Painting in the 1960s" se inaugura en el Museo Guggenheim de Nueva York; Thomas Messer, su director, la define como una mirada a la década decisiva de la pintura latinoamericana. En esta década los museos de Estados Unidos y también en Europa se interesan más por el arte latinoamericano. En 1962 el Museo de Arte Moderno en París exhibe obras de Otero, de la Vega, Cruz Díez, Kosice, Demarco, Soto, Le Parc, Tomasello, Lam y Alicia Peñalba. Es a partir de esta década que el arte latinoamericano trata de colocarse al mismo nivel del universal. Es durante este período que podría recordarse la profecía de Voltaire: "Peut-être un jour les Américains viendront enseigner les arts aux peuples de l'Europe".[14]

La década de los 70 se caracteriza por una actitud más recogida, reflexiva, intelectualizada. La década de los 80 incorpora a la pintura que resiste y comprueba su vitalidad, y a las nuevas tendencias: la fotografía, las diapositivas, las películas super 8 y la televisión. Durante estas últimas décadas el arte latinoamericano habla la misma lengua internacional del arte; ya no presenta sujeción a las tendencias europeas y trata de independizarse de la influencia norteamericana. Aunque "América Latina dice por fin 'su' palabra al mundo en materia de artes plásticas"[15] todavía lucha por que se le acepte con su propia aportación en el mercado artístico.

### Las revistas sobre arte latinoamericano: importancia y limitaciones

¿Cuántas y cuáles son las revistas que han provisto y proveen de información sobre el arte latinoamericano? El artista en América Latina cuenta, por lo general, con su experiencia técnica únicamente y carece de la continuidad y de la disponibilidad del instrumento que le ayudaría a conocer mejor el quehacer artístico propio y el de sus colegas del continente: la revista. Y no solamente la publicación de la revista es precaria, sino que los análisis de la problemática del arte latinoamericano no se pueden discutir en artículos biográficos y mayormente acríticos. Tampoco es posible seguir la trayectoria de movimientos y pluralismos artísticos en revistas que difícilmente llegan a la decena de apariciones. Aunado a todo esto, las colecciones de revistas adolecen de las mismas características de la edición, a saber: pocos títulos, disponibilidad reducida de números de revistas por cada título, falta de continuidad de la mayoría de ellas, que obstaculiza la elaboración de índices que analicen su contenido, lo cual presenta un serio inconveniente en un sistema de información. A la falta de revistas que den a conocer las ideologías del arte latinoamericano a través de escritos de críticos, teóricos e historiadores de arte se suma la poca disponibilidad de las colecciones instaladas en las hemerotecas que no pueden difundir ni lo poco que se ha publicado sobre el arte de América Latina.

### Las revistas en América Latina

Las revistas latinoamericanas con información sobre arte se inician desde el año 1907 con *Nosotros*, a revista mensual de letras, arte, historia, filosofía y ciencias sociales, publicada en Buenos Aires. La importancia de la revista radica en las relaciones de algunos artistas, historiadores, arquitectos, con la publicación de artículos o con su presencia como editores o ilustradores.

En 1924, en Argentina, la revista *Martín Fierro* apoya la modernidad del Grupo París, integrado por Forner, Badii, Berni, Spilimbergo y Centurión, quienes insisten sobre la necesidad de un cambio. Se origina el Movimiento Martinfierrista, defensor de la vanguardia latinoamericana. Nelly Perazzo, artista argentina, tuvo a su cargo durante ocho años la Sección de Artes Plásticas, en la *Revista Lyra*, y después fue secretaría de redacción.

Lidy Prati y Tomás Maldonado, también argentinos, publican en 1946 el *Boletín* primero y luego la *Revista* (dos números únicamente) de la Asociación de Arte Concreto-Invención, creada en 1945. Son autores al mismo tiempo de las viñetas y de la portada,

respectivamente. La revista *Arturo*, considerada como el primer grito libertador de la Escuela de París y de su sucursal la Escuela de Buenos Aires, es fundada por pintores Kosice y Arden Quin. Kosice interviene también en las dos revistas *Arte Concreto-Invención* y *Arte Madi*.

En 1948, la revista argentina de arte, literatura y pensamiento modernos, *Ciclo*, es diseñada por Hlito, del Prete y Girola; el diseñador gráfico es Maldonado. Los textos sobre arte concreto, en los dos únicos números publicados, son de los escultores Iommi y Souza. Maldonado elabora el proyecto de la revista *Nueva Visión*, por la pérdida de *Ciclo*, y la fundan Hlito y Méndez Mosquera en 1951. Es la revista considerada de avanzada en el plano de la cultura visual. El número nueve y último aparece en 1957. Abraham Hader, Raúl Lozza y R. H. Lozza escriben los fundamentos teóricos del Movimiento Perceptista, de 1950 a 1953, en los siete números publicados de la revista *Perceptismo*, que expone la nueva estructura espacio y tiempo, matemática y física en la nueva pintura, actuando en defensa del arte no figurativo. En la revista *Contrapunto*, de literatura, crítica y arte, Maldonado, que además de pintor es crítico y teórico, defiende el arte concreto. Es fácil suponer que un cambio tan fundamental de los criterios estéticos tradicionales despertó enconados comentarios, como el del doctor Ivanissevich, Ministro de Educación del Gobierno Peronista al inaugurar el XXXIX Salón Nacional: "El arte morboso, el arte abstracto no cabe entre nosotros".[16]

No solamente los artistas argentinos publican revistas, sino también los historiadores de arte argentinos Aldo Pellegrini la revista *Que*, y Romero Brest la revista *Ver y Estimar*. Existe la necesidad de reconocer la vanguardia por parte de los historiadores. Es así que el valor de los artistas de la Asociación Arte Concreto-Invención se trata de justificar en los artículos de Romero Brest, Brughetti y Córdova Iturburu, estos últimos en las revistas *Cabalgata* y *Clarín*.

El arquitecto venezolano Carlos Raúl Villanueva menciona la falta increíble de comunicación, de intercambio cultural, de información existente desde hace muchas décadas, y del nivel realmente asombroso de ignorancia de las vivencias recíprocas, en que se encuentran los pueblos latinoamericanos, que contrasta con la abundante información de que se dispone de origen norteamericano y europeo.[17] Esta ignorancia, por falta de comunicación, de intercambio y de información, propicia la falta de interés dentro y fuera de los países de América Latina. La revista venezolana que cuenta con mayor número de artículos sobre arte latinoamericano es la revista de carácter general, *Revista Nacional de Cultura*.

Los artistas cubanos, al igual que los argentinos, autores de viñetas y portadas, han incluido reproducciones de sus obras en la *Revista de Avance*, publicada en Cuba. La Casa de las Américas, en La Habana, editora de la revista del mismo nombre, es de acuerdo al ensayista y crítico cubano Ambrosio Fornet, cuando dice que es la casa común del encuentro de todo lo que en Latinoamérica ha estado disperso y fragmentado durante siglos: la plástica, el teatro, la canción de protesta, la música, la literatura.[18]

La problemática de la revista de arte latinoamericano—escasez, falta de continuidad y de disponibilidad—hace difícil que se realice el aprendizaje del arte latinoamericano contemporáneo, porque entre los elementos que no existen—institutos, museos—está el asesoramiento bibliográfico.[19]

### Las revistas en los Estados Unidos

Prácticamente son inexistentes en los Estados Unidos los estudios sobre la publicación de revistas especializadas en arte latinoamericano. El estudio de Joyce Bailey, historiadora del arte latinoamericano, en la Universidad de Harvard, se refiere a las épocas prehispánica, colonial y moderna. En éste se enfatiza que la revista profesional es esencial para la investigación y para poder ventilar los problemas metodológicos, filosóficos y de terminología tan necesarios en el desarrollo del arte latinoamericano.[20]

La investigadora detecta un aumento en el número de artículos en los años 40, cuando la historia del arte en América Latina se establece como una disciplina académica. Existe interés por América Latina en los Estados Unidos a partir de las exposiciones de los artistas latino-americanos trabajando en ese país durante los 30; del establecimiento, dentro del Departamento de Estado de los Estados Unidos, de la División de Relaciones Culturales que, de acuerdo con la Convención para la Promoción de Actividades de Culturales Inter-Americanas, celebrada en Buenos Aires en 1937, inicia intercambio de personas para propósitos culturales; de la Primera Conferencia Americana de Comisiones Nacionales para la Cooperación Intelectual, celebrada en Santiago de Chile en 1939, en la que los representantes de los países americanos, incluyendo Canadá, ratificaron la necesidad de enseñar y estudiar el arte de América Latina; de las resoluciones de esta conferencia, a favor del establecimiento de institutos de arte latino-americano en cada país; del cambio de interés, debido al comienzo de la Segunda Guerra Mundial, de los coleccionistas y museos por adquirir obras del continente americano y no del europeo; y del establecimiento en 1949 del Archivo de Cultura Hispánica en la Hispanic Foundation

de la Library of Congress. A esta situación de bonanza, Bailey añade que el programa de cursos en los Estados Unidos de 1945 a 1978 parece alentador; se ofrecen cursos de arte latinoamericano en 40 "colleges" y en los 300 programas de estudios latinoamericanos.

Por otra parte, la propia investigadora señala un desequilibrio, por lo que se refiere a la época moderna, de la que dice existen menos publicaciones. Menciona la negligencia de la College Art Association en tratar el arte latinoamericano en sus revistas: *College Art Journal*, que continúa como *The Art Bulletin* y *The Art Journal*; las actitudes de los historiadores de arte europeos que al enseñar en los Estados Unidos desacreditaron, en palabras de Paul Kelemen, el estudio de arte en América Latina y la disminución de publicaciones en los 50, los 60 y los 70, cuando a juicio de ella, los historiadores del arte latinoamericano aumentan.

Críticos como Cockcroft[21] señalan cómo el arte cubano tiene más valores sociales que estéticos, condición que ocasiona falta de interés y que se le delegue a un segundo plano. Otro crítico, Harris,[22] menciona que la emigración de los artistas latinoamericanos a Roma y a París se debe a que no existe el patronazgo en América Latina y que la vanguardia en escultura se concentra en un grupo de artistas dedicados que trabajan aislados; es decir, el interés por la escultura en América Latina es reducido.

## Las revistas en Europa y Canadá

En Europa son 12 las revistas que contienen artículos sobre arte latinoamericano, a saber: *Architecture d'aujourd'hui, Art International, Das Kunstwerk, XXe Siècle, Aujourd'hui, L'Oeil, Architectural Review, Domus, Art and Artist, Goya Studio, Werk.* En las revistas europeas se continúa con más información sobre los países de mayor representatividad artística—Argentina, Brasil, Cuba, México, Venezuela—y con un grupo reducido de artistas.

El interés de Canadá por publicar sobre arte latinoamericano está representado únicamente por cinco títulos: *Architecture Canada, Arts Canada, Bulletin: Toronto Art Gallery, Journal of the Royal Architectural Institute of Canada* y *Vie des Arts.* La temática se relaciona con el arte y la arquitectura en América Latina en general.

## Conclusión

Se concluye que la revista profesional no solamente ha sido vehículo de movimientos artísticos en varias ocasiones, sino que es esencial para la investigación. Aunque el acceso a la información es a través de la utilización de los índices publicadas, éstos no son

suficientes y de un total de 227 títulos, se indizan de manera incompleta 79 títulos. Es necesario que los países latinoamericanos se comprometan a la elaboración de los índices de revistas de arte y de ser posible utilizen las tecnologías de computadoras y discos ópticos. De esta manera el material publicado en las revistas será un acceso, además del producto artístico, a la variedad y riqueza de la plástica latinoamericana.

De lo anterior se concluye que es necesario emprender el indizado de las publicaciones periódicas de arte latinoamericano que no han sido indizadas, de utilizar los propios índices de algunas publicaciones periódicas latinoamericanas,[23] de tratar de persuadir a los editores para que publiquen índices y de completar el análisis de las revistas no incluidas en los índices publicados. Se ha observado la importancia de la difusión de los movimientos artísticos a través de las revistas, pero también se ha reflejado el desinterés hacia el arte latinoamericano contemporáneo al disponer de un número reducido de revistas de difícil acceso.

Otra opción para obtener información sobre el arte latinoamericano son las bases de datos, como MEXICOARTE y, en un futuro mediato, los discos ópticos (CD-ROM).

## INDICES CONSULTADOS

1. *Art Index.* New York, NY: H. W. Wilson, 1929–.

   Este índice incluye 240 títulos de publicaciones periódicas de arte en general. No incluye publicaciones periódicas latinoamericanas. Desde enero de 1929 la Asociación Americana de Museos y la Asociación de Directores de Museos de Arte pidieron a la compañía H. W. Wilson iniciar el índice para los museos y bibliotecas. Se publicó el primer número en enero 1930. El índice incluye publicaciones periódicas de arte en inglés, alemán, francés, italiano, holandés y español, y lo patrocina y asesora la American Library Association.

2. *Arts and Humanities Citation Index.* Philadelphia, PA: Institute for Scientific Information, 1977–.

   Los índices incluidos son:

   a.  Fuentes de información: cerca de 80,000 por año, con el autor, el título del artículo completo, la revista que lo cita, año de publicación, número de referencias en la bibliografía, dirección del autor, número de lista completa de las citas empleadas por el autor en la bibliografía o notas al pie de página.

b. Indice de citas: una lista alfabética ordenada por autor citado y todas las referencias contenidas en las bibliografías y notas al pie de página. Se indizan 160,000 referencias anualmente.

c. Indice por tema: una lista alfabética de las palabras o frases importantes que aparecen en los títulos de los artículos indizados.

d. Indice corporativo de autores y organismos especializados en las artes y en las humanidades.

Desafortunadamente, de los 1,000 títulos que indiza, solamente se incluye de Latinoamérica el *Artes de México*, dentro de los 58 títulos en el campo del arte y de los 16 en arquitectura.

3. *Current Contents: Art & Humanities*. Philadelphia, PA: Institute for Scientific Information, 1980–.

Este índice no incluye revistas de arte latinoamericano.

4. *HAPI (Hispanic American Periodicals Index)*. Los Angeles: University of California, Latin American Center, 1975–.

Este índice continúa en cierta forma el *Index to Latin American Periodical Literature*. Incluye, en el campo de las artes:
   *Aiesthesis*. Santiago de Chile.
   *Anales: Instituto de Investigaciones Estéticas*. México, D.F.
   *Artes de México*. México, D.F.
   *Artes Visuales*. México, D.F.
   *Atenea*. Concepción, Chile.
   *Boletín: Academia de Artes y Ciencias de Puerto Rico*. Santurce.
   *Casa de las Américas*. La Habana.
   *México en el Arte*. México, D.F.
   *Revista de Bellas Artes*. México, D.F., 1965–.
   *Revista Nacional de Cultura*. Caracas.
   *Universidad de México*. México, D.F.

5. *Index to Art Periodicals Compiled in the Ryerson Library*. The Art Institute of Chicago. Boston, MA: Hall, 1907–1962. 11 vols.

Incluye 355 títulos de publicaciones periódicas recibidas en la Biblioteca Ryerson. Los títulos de arte latinoamericano que incluye son:
   *Boletín de la Revista de Arte*. Santiago de Chile, 1934–1939.
   *Galería*. Santiago de Cuba.
   *México en el Arte*. México, D.F., 1948–1952.
   *Revista de Arte*. Santiago de Chile, 1934–1940. N.S. 1955–1962.

6. *Indice general de publicaciones periódicas latinoamericanas: humanidades y ciencias sociales (Index to Latin American Periodicals: Humanities and Social Sciences)*, preparado por la Biblioteca Colón de la Organización de los Estados Americanos. Metuchen, NJ: Scarecrow, 1929–1970.

Incluye las publicaciones periódicas recibidas en la Biblioteca Colón en Washington, D.C. Los títulos de arte latinoamericano que incluye son:

*Alcor.* Asunción, 1955–.

*Anales: Instituto de Arte Americano e Investigaciones Estéticas.* Buenos Aires, 1948–1970.

*Anales: Instituto de Investigaciones Estéticas.* México, D.F., 1948–1970.

*Arquitecto Peruano.* Lima, 1937–1970.

*Arquitectura.* Montevideo, 1914–1970.

*Arquitectura Chilena.* Santiago de Chile.

*Arquitectura.* México, D.F., 1938–1970.

*Arquitectura.* Río de Janeiro.

*Ars.* México, D.F., 1942–1943.

*Arts: Revista de Arte.* Buenos Aires.

*Atenea.* Santiago de Chile, 1944–1970.

*Bellas Artes.* Lima, 1941–1970.

*Boletín: Academia de Artes y Ciencias de Puerto Rico.* Río Piedras, 1965–1970.

*Boletín: Buro Interamericano de Arte.* México, D.F., 1951.

*Brasil: Arquitectura Contemporánea.* Río de Janeiro, 1953–1958.

*Casa de las Américas.* La Habana, 1961–1970.

*Cuadernos de Arte y Poesía.* Quito, 1952–1970.

*Cuadernos de Bellas Artes.* México, D.F., 1960–1964.

*Cuadernos de Historia de Arte.* Mendoza, 1961–1970.

*Euterpes.* Buenos Aires, 1949–1970.

*Grafos.* La Habana, 1942–1944.

*Habitat.* São Paulo, 1950–1974.

*Idea: Artes y Letras.* Lima.

*Khana.* La Paz, 1953–1970.

*Mensuario.* La Habana.

*Módulo.* Río de Janeiro, 1955–1965.

*Nuestra Arquitectura.* Buenos Aires, 1929–1970.

*Revista: Instituto Americano de Arte.* Cuzco, 1942–1970.

*Revista de Bellas Artes.* México, D.F., 1965–.

*Revista do Patrimônio Histórico e Artístico Nacional.* Río de Janeiro, 1937–1960.
*Salón 13.* Guatemala, 1960–1970.
*Sociedad Central de Arquitectos (SCA).* Buenos Aires, 1941–1945.

7. *RILA (Repertoire International de la Littérature d'Art.* Williamstown, MA: 1976–.
Este índice no incluye revistas latinoamericanas.

8. *Indice general de publicaciones periódicas cubanas.* La Habana: Biblioteca Nacional "José Martí", 1970–.
Incluye 31 revistas relacionadas con el arte latinoamericano contemporáneo. Estas son:
*Alma Mater.* La Habana.
*Anuario del Centro de Estudios Martianos.* La Habana, 1978–.
*Arquitectura Cubana.* La Habana.
*Bohemia.* La Habana.
*Caimán Barbudo.* La Habana, 1966–.
*Casa de las Américas.* La Habana, 1961–.
*Catálogo: Biblioteca Elvira Cape.* Santiago de Cuba.
*Cuba Internacional*
*España Republicana*
*Gaceta de Cuba.* La Habana.
*Granma Campesino.* La Habana.
*Granma Resumen Semanal.* La Habana, 1968–.
*Islas.* Santa Clara, 1958–.
*Mar y Pesca.* La Habana, 1965–.
*Mensajes*
*Mujeres*
*OCLAE* (Organización Continental Latinoamericana de Estudiantes). La Habana.
*Prisma del Meridiano 80*
*Revista: Biblioteca Nacional "José Martí".* La Habana, 1909–.
*Revista Química*
*Revolución y Cultura.* La Habana, 1967–.
*Romance*
*Santiago.* Santiago de Cuba.
*Signos.* Santa Clara.
*Somos Jóvenes.* La Habana.
*Trabajadores*
*UNESCO: Boletín.* La Habana, 1968–.

*Unión*. La Habana.
*Universidad de La Habana*. La Habana, 1934–.
*UPEC* (Unión de Periodistas de Cuba). La Habana, 1968–.
*Verde Olivo*

De estas revistas solamente *Casa de las Américas* se ha incluido en dos otros índices: *Hispanic American Periodicals Index (HAPI)* e *Indice general de publicaciones periódicas latinoamericanas: humanidades y ciencias sociales*.

9. *MEXICOARTE*. México, D.F.: CONACYT/CICH, UNAM, 1987–. La base de datos sobre arte mexicano, MEXICOARTE, cubre el arte y la arquitectura prehispánicos, coloniales, modernos y contemporáneos sobre una base nacional. MEXICOARTE, un banco de información esencialmente bibliográfico, contiene registros de diferentes tipos de documentos: monografías, artículos de publicaciones periódicas, catálogos de exposiciones, folletos, fotografías y transparencias. Incluye también biografías o referencias de los libros donde se publicó la biografía.

La idea de una base de datos sobre arte mexicano surgió cuando, a través de un análisis de la información sobre arte latinoamericano, se concluyó que América Latina no ofrecía su rica herencia artística por medio de la informática. Además, existe la necesidad en otros países de saber sobre arte latinoamericano. La Sección para América Latina y el Caribe de la IFLA sugiere que cada país latinoamericano elabore su propia base de datos.

La etapa de planeación para MEXICOARTE empezó en 1986. Se tomó la decisión de usar el Formato Común de Comunicación (CCF) y el programa MICROISIS, ambos de la UNESCO. De esta manera se estandarizaría la información y ampliaría la disponibilidad de la base de datos, ya que tanto el formato como el programa son conocidos en los países latino-americanos. La creación de una base de datos artística a nivel nacional era factible, a pesar de que la dimensión de la tarea era grande y los recursos disponibles poco numerosos. El factor de mayor apoyo era la disponibilidad de la información ya existente en forma codificada y las bibliografías publicadas. Faltaba por localizar el material documental en las bibliotecas del país.

MEXICOARTE nació en la Sección de Arte de la Asociación Mexicana de Bibliotecarios, patrocinada por el Consejo Nacional de Ciencias y Tecnología (CONACYT) y con el apoyo tecnológico del Centro de Información Científica y Humanística de la Universidad Nacional Autónoma de México (CICH, UNAM).

Una manera relativamente simple de empezar fue utilizar las bibliografías publicadas, los listados de publicaciones seriadas y sus índices, revisar los catálogos de las bibliotecas, con el objeto de estimar la cantidad de material que se producía en forma impresa y considerar la inclusión de fotografías y diapositivas (aproximadamente 40,000 registros). Se estableció también el número aproximado de artistas (15,000). Con esta información se avanzó a las siguientes etapas: elección de campos y subcampos en base al formato CCF, diseño de la base de datos de acuerdo a los parámetros de MICROISIS y elaboración de los formatos de codificación. La formación de MEXICOARTE se inició en enero de 1987 y, después de un cuidadoso examen de un índice piloto, dio comienzo la captura. Para fines del mes de abril de 1989 se habían registrado 8,000 ítemes.

Ya se cuenta con un vocabulario controlado así como los datos de onomástico y fallecimiento en las biografías de los artistas (700 aproximadamente). MEXICOARTE contiene registros biográficos, bibliográficos y hemerográficos, y en éstos últimos se incluye el registro de las ilustraciones. De los catálogos de exposiciones se dan detalles tales como el nombre de las galerías.

En el presente, MEXICOARTE está disponible en línea a través del sistema TELENET conectado al Centro de Información Científica y Humanística de la UNAM. Se ha pensado en la posibilidad de incluir la información en un disco óptico (CD-ROM) para agilizar la consulta de esta base de datos.

El análisis de los instrumentos bibliográficos que podrían incluir información sobre el arte de México ha dado como resultado que la base de datos MEXICOARTE es la única que incluirá casi en su totalidad el arte de México publicado y disponible en el país. Entre otros de los objetivos de esta base de datos están el incrementar el entusiasmo por el estudio del arte mexicano y reflejar el riquísimo bagaje cultural de México.

## NOTAS

1. Damián Bayón, *Artistas contemporáneos de América Latina* (Barcelona: Ediciones del Serbal/UNESCO, 1981), p. 11.

2. J. A. García Martínez, "Malharro", en *Pintores argentinos del siglo XX* (Buenos Aires: Centro Editor de América Latina, 1980), p. 8.

3. Jorge Romero Brest, *La pintura del siglo XX* (México: Fondo de Cultura Económica, 1952), p. 326.

4. Romero Brest, p. 362.

5. Jorge Enrique Adoum, "El artista en la sociedad latinoamericana", en Damián Bayón, ed., *América Latina en sus artes* (México: Siglo XXI, 1974), p. 181.

6. Adelaida de Juan, "Las artes plásticas en Cuba y el resto del Caribe 1920–1950", en Damián Bayón, ed., *Arte moderno en América Latina* (Madrid: Taurus, 1985), pp. 191-192.

7. Alicia Azuela, *Diego Rivera en Detroit* (México: Instituto de Investigaciones Estéticas, UNAM, 1985), p. 5.

8. Raquel Tibol, *Siqueiros, introductor de realidades* (México: UNAM, 1961), pp. 227-229.

9. Aracy A. Amaral, "Brasil: del modernismo a la abstracción 1910–1950", en Damián Bayón, ed., *Arte moderno en América Latina* (Madrid: Taurus, 1985), p. 276.

10. Jorge Alberto Manrique, "¿Identidad o modernidad?", en Damián Bayón, ed., *América Latina en sus artes* (México: Siglo XXI, 1974), p. 29.

11. Felipe Cossío del Pomar, "Arte contemporáneo en Cuba", *Cuadernos* (Paris) 42 (1960): 100.

12. James B. Lynch, *Handbook of Latin American Studies: Humanities*, vol. 42 (Washington, DC: The Library of Congress, 1972), p. 16.

13. *Uno más uno* (México), 24 de octubre de 1985, p. 24.

14. Prieto María Bardi, *Historia de arte brasileira: pintura, escultura, arquitectura, u otras artes* (São Paulo: Edições Melhoramentos, 1975), p. 22.

15. Manrique, p. 19.

16. Nelly Perazzo, *El arte concreto en la Argentina en la década de los 40* (Buenos Aires: Ediciones de Arte Gaglione, 1983), p. 121.

17. Carlos Raúl Villanueva, "Algunas observaciones sobre el desarrollo actual de la arquitectura iberoamericana", *Cuadernos Hispanoamericanos* 68:202 (166):153.

18. Alexis Marquez Rodríguez, "25 aniversario Casa de las Américas", *Arte Plural de Venezuela* 3:8 (1984): 27.

19. Sául Yurkievich, "Arte latinoamericano: de la práctica dispar a la unidad teórica", *Artes Visuales* 13(1977):18.

20. Joyce Waddell Bailey, "The Study of Latin American Art History in the United States: The Past 40 Years", *Research Center for the Arts Review* 1:2(1978):1-3.

21. E. Cockcroft, "Art in Cuba Today", Interview with Félix Beltrán, *Art in America* 68:1(1980):9-11.

22. P. Harris, "Sculptors in Chile", *Art in America* 50:2(1962):122-123.

23. *Anales del Instituto de Investigaciones Estéticas* (México, D.F.: UNAM, 1937–), en la *Bibliografía del Instituto de Investigaciones Estéticas (1935–1965)* por Danilo Ongay Muza (México, D.F.: Instituto de Investigaciones Estéticas, UNAM, 1966), 149 pp., y en *Dos décadas de trabajo del Instituto de Investigaciones Estéticas: catálogo de sus publicaciones, índice de sus anales* (México, D.F.: Instituto de Investigaciones Estéticas, UNAM, 1957), 64 pp. (Suplemento no. 2 del no. 25 de los *Anales del Instituto de Investigaciones Estéticas*); *Artes de México*, en Elsa Barberena Blásquez, *Indice de la Revista "Artes de México": 1a. época, no. 1-60, 1953–1965*, Cuadernos de historia del arte, 22 (México, D.F.: Instituto de Investigaciones Estéticas, UNAM, 1982), 301 pp.; *Boletín del Centro de Investigaciones Históricas y Estéticas* (Caracas: Facultad de Arquitectura y Urbanismo, Centro de Investigaciones Históricas y Estéticas, Universidad Central, 1964–), "Indice del no. 1 al no. 5", en *Boletín del Centro de Investigaciones Históricas y Estéticas* 6(1966):129-134; *Cuadernos de Bellas Artes* (México, D.F.: Instituto Nacional de Bellas Artes, 1960-1964), en *Indice completo de la Revista Cuadernos de Bellas Artes, 1960–1964*; *La Cultura en México* (México, D.F.), en Alfonso González, *Indice de la "Cultura en México (1962–1972)"* (Los Angeles: Latin American Studies Center, California State University, 1978), 452 pp.; *Revista do Patrimônio Histórico e Artístico Nacional* (Río de

Janeiro:   Ministério de Educação e Cultura, Río de Janeiro, nos. 1-10, 1937–1960), índice
publicado en *Boletim da Biblioteca Almeida Cunha*, nos. 1-10; *Revista Nacional de Cultura.*
*Indice no. 1 al 150* (Caracas: Ministerio de Educación, Dirección de Cultura, s.f.), 336 pp.;
*Summa* (Buenos Aires, 1963–), *Indice general*, nos. 1-14, 1963-1968, por autor y tema.

# 30. From Zarabanda to Salsa: An Overview of Reference Sources on Latin American Music

## Andrew Makuch

In spite of the all too facile and glib alliteration in the title of this bibliographic paper, it encompasses the time frame and the styles of Latin American music, from pre-Columbian and colonial times to the present. The conspicuous paucity of reference works dedicated solely to Latin American music creates a special problem for the library user and the librarian: he or she has to be familiar with the monumental and very general reference works—such as *Grove*, Riemann, Duckles, or the *MGG* (*Musik in der Geschichte und Gegenwart*) in order to be effective in information retrieval and analysis. This bibliographic essay is meant to guide the user and the librarian into "five hundred years of plenitude" of Latin American music, be it Apollonian (ritual and church music), Dionisiac turned Apollonian (zarabanda, chacona, pasacalle), or simply unabashedly Dionisiac (tango, rumba, mambo, conga). "En pocas palabras," I deal here with reference resources both in so-called classical and popular music.

My main purpose is to identify and highlight the most essential reference sources that deal with Latin American music. While various genres of reference material are briefly pursued here—such as indexes, both traditional and electronic; seminal monographs richly equipped with bibliographies for further study; and dictionaries and encyclopedias—the emphasis is on the dictionaries and encyclopedias, be they smaller vade mecums or monumental encyclopedias, like Lavignac's *Encyclopédie de la musique et dictionnaire du conservatoire*, the *New Grove*, or the lexical non plus ultra, the *MGG* (*Musik in der Geschichte und Gegenwart*, which translates into "Music in History and the Present").

Before considering the "flor y nata de los diccionarios de la música," here is a quick overview of the Ibero-American musical dictionaries, of which there are seven: one in Catalan, translated from the French of Roland de Candé (Barcelona, 1967), and two Spanish translations from the Dutch of Casper Höweler (Barcelona, 1958) and that of Frank Onnen (Madrid, 1967). Only one dictionary, that of Otto Mayer Serra (Mexico, 1947), is exclusively devoted to Latin American

music; the three other dictionaries printed in Latin America—Poblete Varas (Valparaiso, 1972), Rubertis (Buenos Aires, 1967) and Urbano (Buenos Aires, 1976)—are general dictionaries dealing with the usual topics besides the entries of Latin American interest. This relative paucity of Latin American musicological lexica is made more tolerable if we examine the dictionaries printed in Spain and Portugal. One should mention here the dictionary by Joaquín Pena and Higinio Anglés (Barcelona, 1954)—very informative on Latin America—as well as the two-volume Portuguese dictionary by Tómas Borba (Lisbon, 1956).

The genre of musical dictionaries and encyclopedias expands dramatically with French, Italian, and German dictionaries and encyclopedias. it is the French monumental *Encyclopédie de la musique et dictionnaire du conservatoire*, edited by Albert de Lavignac and Lionel de la Laurencie, that establishes the tradition of the monumental and exhaustive "macropaedic" encyclopedias of music. This encyclopedia is not in dictionary arrangement but a series of scholarly monographs on various topics in music. Definitely not a work for quick reference (and hence its exclusion from Eugene P. Sheehy's *Guide to Reference Books*, this "universal repository of musical knowledge"—to quote Vincent H. Duckles—was undoubtedly inspired and organized under the influence of Diderot's and d'Alembert's *Encyclopédie* (1751) with its lengthy, monograph-like articles. The scope of this remarkable work is international, but most of the contributors are French. Many articles—actually books, such as the volume on Spain—are still relevant and unsurpassed. The lack of an index makes it difficult to use for reference purposes. While volume 4 deals with Spain, volume 5 deals with more "exotic" topics like North American Indian and Mexican music.

The leading Italian musical encyclopedia, a runner-up to the *Grove* and the *MGG*, is the *Dizionario enciclopedico universale della musica e dei musicisti*. It has extensive signed articles, illustrations, charts and tables. The listings of composers' works are remarkably done—compare, for instance, the entries under Ginastera and Manuel de Falla. It also offers selective bibliographies for further study. In its analysis of music in North America it emphasizes the distinction between "musica colta" and "musica popolare." If the *MGG* shortchanges Latin America in its basically Western and Central European orientation, the "Latin," i.e., Italian, encyclopedias offer a wealth of information, especially on Argentina and Brazil.

*Die Musik in der Geschichte und Gegenwart* is a *summa musicologica*, the Mount Everest never surpassed. The articles in this

monumental compendium are of "highest scholarly merit," to quote Vincent H. Duckles. The dictionary is international in scope, with many international scholars participating. Articles translated from various foreign languages into German give the translator's name. The bibliographic references are very detailed and comprehensive. The articles are of monographic length—such as the one on Latin America. In spite of its international scope, the point of gravity is Western and Central Europe. Emphasis is on European cities as centers of musical culture—hence no entries for Buenos Aires or Mexico City, but there is one for Aachen (Aix-la-Chapelle).

*The New Grove Dictionary of Music and Musicians* is a totally new version of the venerable *Grove* that appeared first in 1878. It is the *summa musicologica* for the English-speaking world, sharing the honor of excellence with the *MGG*. It appears more "liberated" than the *MGG*, hence more attention is given to popular music and music outside the Western tradition. Its articles are signed, and they are monographic in scope. The bibliographies are very generous; the article on Latin American music has about 200 citations under the various subdivisions, such as Indian music, music of blacks in Latin America, and the like. The work lists of composers are intended for further research and study.

## BIBLIOGRAPHY

### Guides, Books, and Bibliographies on Latin American Music

Béhague, Gérard. *Music in Latin America: An Introduction*. Englewood Cliffs, NJ: Prentice-Hall, 1979.

Chase, Gilbert. *A Guide to the Music of Latin America*. 2d ed., rev. and enl. A joint publication of the Panamerican Union and the Library of Congress. Washington, DC: Panamerican Union, 1962; reprinted 1972. 411 pp.

Coover, James B. *Music Lexicography: Including a Study of Lacunae in Music Lexicography and a Bibliography of Music Dictionaries*. 3d ed., rev. and enl. Carlisle, PA: Carlisle Books, 1971.

Cortijo Alahija, L. *Musicología latino-americana. La música popular y los músicos célebres de la América Latina*. Barcelona: Maucci, 1919.

Davies, J. H. *Musicalia: Sources of Information in Music*. 2d ed., rev. and enl. Oxford/New York, NY: Pergamon, 1969.

"Dictionaries of Music." In *Harvard Dictionary of Music*. 2d ed., 1969, pp. 233-234.

Duckles, Vincent H., and Michael A. Keller. *Music Reference and Research materials*. 4th ed. New York, NY: Schirmer Books, 1988.

Eitner, Robert. *Biographisch-bibliographisches Quellenlexikon der Musiker und Musikgelehrten* . . . (Breitkopf, 1900–1904; reprinted in New York: Musurgia, 1947). Predecessor of *RISM*.

*Encyclopédie des musiques sacrées*, publiée sous la direction de Jacques Porte. 4 vols. Paris: Editions Labergerie, 1968-1970.

García, Rolando. *Historia de la música latinoamericana*. Buenos Aires: Libreria "Perlado." 1938.

*Handbook of Latin American Studies*. Gainesville: University of Florida Press, 1936– (annual). Music is under "Humanities"; author index for nos. 1-28 (1936-1966), comp. Francisco José Cardona and María Elena Cardona.

Kuss, Maria Elena. *Latin American Music in Contemporary Reference Sources: A Study Session*. Paramount, CA: Academy Printing and Publishing, 1976.

Orrego Salas, Juan. *Music from Latin America Available at Indiana University*. Bloomington, IN, 1971.

Panamerican Union. Music Division. *Music of Latin America*. Washington, DC: Panamerican Union, 1963; reprint of 3d ed., 1953.

*Repertoire international des sources musicales (RISM)*. Munich: G. Henle, 1960–.

Slonimsky, Nicholas. *Music of Latin America*. New York, NY: Thomas Crowell, 1945.

## Musical Dictionaries

*Dictionaries in Spanish, Portuguese, and Catalan, published in Europe or in Latin America*

Arias Ruíz, Aníbal. *Diccionario práctico de la música*. Madrid: Siler, 1958. 212 pp.

*El arte de la música*. Madrid: Mediterraneo, 1975.

Bach, Ricardo. *Pequeño diccionario musical*. 2d ed.    Barcelona: Ediciones Ave, 1955. 221 pp.

Borba, Tómas. *Dicionario de musica, ilustrado*. 2 vols. (Por) Tómas Borba (e) Fernando Lopez Graça. Lisbon: Edições Cosmos, 1956.

Candé, Roland de. *Diccionari de la musica*. Trans. Hermina Grau de Duran. Barcelona: Ediciones 62, 1967. In Catalan.

Höweler, Casper. *Enciclopedia de la música* . . . Apendice de música española por Federico Sopena. Traducción española de Federico Sopena y Cesar Aynot. Barcelona: Ed. Noguer, 1958.

Lacal, Luisa. *Diccionario de la música, técnico, histórico, bio-bibliográfico*. Madrid: S. F. de Sales, 1899.

Mayer Serra, Otto. *Música y músicos de Latinoamericana*. Mexico: Ed. Atlante, 1947.

Onnen, Frank. *Enciclopedia de la música*. (Versión española: Eduardo Rinsan). Madrid: Aguado, 1967.

Pedrell, Felipe. *Diccionario técnico de la música* . . . Barcelona: Imp. de V. Berdos, 1894. 529 pp.

Pena Joaquín. *Diccionario de la música Labor* . . ., continuado por Higinio Anglés. 2 vols. Barcelona: Labor, 1954.

Pich Santasusana, Juan. *Enciclopedia de la música*. Barcelona: De Gasso Hnos., 1960. 374 pp.

Poblete Varas, Carlos. *Diccionario de la música*. Valparaiso: Ediciones Universitarias de Valparaíso, 1972.

Rubertis, Victor de. *Pequeño diccionario musical: tecnológico y bibliográfica*. 7a ed., corr. y aumentada. Buenos Aires: Ricordi, Americana, 1969.

Urbano, Jorge d'. *Diccionario musical para el aficionado*. Buenos Aires: ANESA, 1976.

Vales, Manuel. *Diccionario de la música*. Madrid: Alianza Editorial, 1971.

## Non-Hispanic Dictionaries

Basso, Alberto, ed. *Dizionario enciclopedico universale della musica e dei musicisti*. 12 vols. Turin: UTET, 1985.

Honneger, Marc, ed. *Dictionnaire de la musique*. 4 vols. Paris: Bordas, 1976. Vols. 1-2: Les hommes et leurs oeuvres. Vols. 3-4: Science de la musique: formes, techniques, instruments.

*Larousse de la musique* . . . Sous la direction de Norbert Dufourcq. Paris: Larousse, 1957.

Lichtenhal, Peter. *Dizionario e bibliografia della musica*. 4 vols. Bologna: Forni, 1970.

Lavignac, Albert. *Music and Musicians*. New York, NY: Holt, 1899; newer ed., 1903.

Mersenne, Marin. *Harmonie universelle: The Books on Instruments.* The Hague: Nijhoff, 1957.

Mitjana y Gordon, Rafael. *. . . La musique en Espagne (art religieux et art profane).* Paris: 1913–1931. Enciclopédie de musique et dictionnaire du conservatoire.

Moore, John Weeks. *A Dictionary of Musical Information.* New York, NY: AMS, 1977, reprint of 1876 ed., published in Boston.

*La musica*; Sotto la direzione di Guido M. Galli, a cura di Alberto Basso. 2 vols. in 6. Turin: UTET, 1966. Part 1a: Enciclopedia storica; parte 2a: Dizionario.

*Die Musik in der Geschichte und Gegenwart: Allgemeine Enzyklopädie der Musik. . . .* Friedrich Blume, ed. 17 vols. Kassel/Basel: Barenreiter, 1949–1968.

*Muzykal'naia entsiklopediia.* Iu. V. Kel'dysh, ed. Moscow: Sovetskaia Entsiklopediia, 1973–1978.

*The New Grove Dictionary of American Music.* London/New York: Macmillan, 1986.

*The New Grove Dictionary of Music and Musicians.* Stanley Sodel, ed. London/New York: Macmillan, 1980.

*The New Harvard Dictionary of Music.* Don Michael Randell, ed. Cambridge, MA: Belknap Press of Harvard University, 1986.

*The New Oxford Companion to Music.* Denis Arnold, gen. ed. Oxford/New York: Oxford University Press, 1983.

Riemann, Hugo. *Dictionary of Music.* Trans. J. S. Shellock. New York, NY: Da Capo Press, 1970; reprint of 1908 ed.

Rizzoli, Ricardi. *Enciclopedia della musica.* Milan: Rizzoli Editore, 1972.

Scholes, Percy Alfred. *The Oxford Companion to Music.* John Owen Ward, ed. 10th ed. New York, NY: Dodd and Mead, 1975.

Westrup, Jack Allan. *The New College Encyclopedia of Music.* New York, NY: W. W. Norton, 1976.

# 31. Arte chileno: Una contribución bibliográfica

## Marta Domínguez Díaz

1. Acuña, Luis Alberto, et al. *¿Por Qué no?* Santiago: Comando Nacional por el No, 1988.

2. Advis, Luis. *Displacer y trascendencia en el arte.* Santiago: Ediciones Universitarias de Valparaíso, 1979.

3. *Agenda nuestra pintura 1989.* Santiago: Patronato Nacional de la Infancia, 1989.

4. Aguilo, Osvaldo. *Propuestas neovanguardistas en la plástica chilena: antecedentes y contexto.* Documento Trabajo, 27. Santiago: CENECA, 1983.

5. Aguirre Silva, Jorge. *El sur de los Andes: como renace un pueblo en el mensaje de su arquitectura y poesía.* Santiago, 1988.

6. Alarcón Rojas, Norma. *Estudio apreciativo del arte popular.* Santiago, Chile, 1966. Tesis.

7. Aldunate del Solar, Carlos. *Cultura mapuche.* Santiago: Departamento de Extensión Cultural, Ministerio de Educación, 1985.

8. _____, et al. *Estudios en arte rupestre.* Santiago: Museo Chileno de Arte Precolombino, 1985.

9. Alfonso, Paulino. "Apuntes sobre la vida de Thomas Somerscales". *Revista del Pacífico Magazine* (Santiago) 17 de febrero de 1913.

10. Aliaga/ Richard/ Olhagaray/ Fargier. *Festival franco-chileno de video arte.* Catálogo 6°. Santiago, 1986.

11. Altamirano, Carlos. *Catálogo Exposición.* Santiago: Galería Bucci, 1985.

12. Alvarez, Luis. "Apuntes sobre la vida de Juan Mauricio Rugendas". *Boletín de la Academia Chilena de la Historia* 14 (1940).

13. _____. "El artista pintor Carlos Wood". *Boletín de la Academia Chilena de la Historia* 7 (1936).

14. _____. *El artista pintor José Gil de Castro*. Santiago: El Imparcial, 1934.

15. Amigos del Arte. *Empresa arte 79*. Santiago: Banco Hipotecario de Comercio, 1980.

16. Ampuero, Gonzalo. *Cultura diaguita*. Santiago: Departamento de Extensión Cultural, Ministerio de Educación, 1978.

17. Ampuero, Gonzalo, y M. Rivera. "Nuevos elementos cerámicos de la cultura El Molle en el Departamento de Ovalle." *Boletín de la Universidad de Chile* 57 (1965):80-83.

18. Amunategui, Domingo. "Juan Mochi". *Anales de la Universidad de Chile* (1892).

19. Andrade Millacura, Ricardo. *Testimonio de un proceso*. Santiago: Ediciones Ad Populi, 1988.

20. Aninat, Isabel. *Catálogo exposición Rodolfo Opazo: pinturas y dibujos recientes*. Santiago: Plástica 3, 1983.

21. Antúñez, Nemesio. *Presentación catálogo de exposición de Dinora Doudtchitzky: cinco años de grabados*. Santiago: Instituto de Extensión de Artes Plásticas, s.d.

22. _____. "Una exposición para Chile". *El Mercurio*, 23 de mayo, 1968.

23. _____. *Carta aérea, reproducción período 1944–1988*. Santiago: Editorial Los Andes, 1988.

24. Astudillo, Felisa. *El telar casero*. Santiago: Instituto de Desarrollo Agropecuario, 1967.

25. Avila, Alamiro de. *Los grabadores populares chilenos*, Catálogo Exposición IV Bienal Americana de Grabado. Santiago, 1970.

26. Azocar, Pablo. "Un tal Matta". *Revista Hoy*, agosto 1985.

27. Baciu, Stefan. *Surrealismo latinoamericano*. Valparaíso: Ediciones Universitarias de Valparaíso, 1979.

28. Balmaceda, Lisette. "Fundación del Museo Nacional de Bellas Artes". *Aisthesis* 9 (1975-1976).

29. Balmes, José, et al. *Balmes 1962/84: mirada pública*. Catálogo Galería Epoca/Plástica 3/Instituto Chileno-Francés de Cultura, Galería Sur. Santiago, 1984.

30. Banco Central de Chile. *Pinacoteca Banco Central de Chile*. Santiago, 1987.

31. Barriga, Juan. "Los paisajes del señor Jarpa". *La Estrella de Chile*, tomo X, 15 de mayo de 1876.

32. Baytelman Goldenberg, David. *Los dibujos de Baytelman*. Santiago: Editorial Emisión, 1984.

33. Belloir et al. *Festival franco-chileno de video arte*. Catálogo 7°. Santiago, 1987.

34. Benmayor, Samy. *Cabeza partida*. Catálogo Galería Plástica 3. Santiago, 1986.

35. Berg Slavo, Lorenzo. *Artesanía tradicional de Chile*. Serie Patrimonio Cultural Chileno. Santiago: Departamento de Extensión Cultural, Ministerio de Educación, 1981.

36. Bianchi, Soledad. *Guillermo Núñez: mirado a Itaca*. Santiago, 1987.

37. Biblioteca Nacional de Chile. *Plateros de la luna*. Colección Raúl Morris Von Bennewitz, Colección Mayo Calvo de Guzmán, Colección Museo de Arte Popular. Santiago, 1988.

38. Bichón, María. *En torno a la cerámica de las monjas*. Santiago, 1947.

39. Bindis, Ricardo, y Waldo Oyarzun. *Calendario-Colección "Historia de la Pintura Chilena, desde Gil de Castro hasta Nuestros Días"*. Santiago: Ediciones Philips, 1984.

40. Bittmann, Bente, R. P. Gustavo Le Paige y Lautaro Núñez. *Cultura atacameña*. Santiago: Departamento de Extensión Cultural, Ministerio de Educación, 1978.

41. Blanco, Arturo. "Alfredo Valenzuela Puelma". *Revista Selecta* 3, junio 1909.

42. _____. *Antonio Smith: pintor de paisajes y caricaturista chileno*. Santiago: Universidad de Chile, 1954.

43. _____. *Estudios sobre la pintura chilena*. Biblioteca de Escritores de Chile, 9. Santiago, 1913.

44. _____. "Manuel Antonio Caro". *Boletín de la Academia Chilena de la Historia* 14 (1940).

45. _____. "El pintor Alfredo Valenzuela Puelma". *Revista Chilena de Historia y Geografía* (octubre-diciembre, 1932).

46. _____. "El pintor Pedro Lira". *El San Lunes* 1 y 2 (1885).

47. Blume, Jaime. *Cultura mítica de Chiloé*. Santiago: Ediciones Aisthesis, 1985.

48. Brito, María Eugenia. "Cuando el arte cae del cielo". *Apsi* 105 (agosto, 1981).

49. Brito, María Eugenia, Diamela Eltit, G. Muñoz, Nelly Richard y Raúl Zurita. *Desacato: sobre la obra de Lotty Rosenfeld.* Santiago: Francisco Zegers Editor, 1986.

50. Bulnes, Alfonso. *Juan Francisco González.* Santiago: Editorial Nascimento, 1933.

51. Bunster, Enrique. "Croquis de Juan Francisco González". *El Mercurio,* 23 de mayo de 1971.

52. _____. "Siete medallas para Valenzuela Puelma". *El Mercurio,* 17 de octubre de 1971.

53. Buntix, Gustavo, Nelly Richard, et al. *El fulgor de lo obsceno.* Santiago: Francisco Zegers Editor, 1988.

54. Calderón, Héctor. *El enigma de las noches blancas: grafismos eróticos.* Santiago: Editorial Barcelona, 1988. (Catálogo Exposición)

55. Calogero, Santoro, y Liliana Ulloa, eds. *Culturas de Arica.* Serie Patrimonio Cultural Chileno. Santiago: Departamento de Extensión Cultural, Ministerio de Educación, 1987.

56. Campbell, Ramón. *El misterioso mundo de Rapanui.* Buenos Aires: Editorial Francisco de Aguirre, 1973.

57. Campos Harriet, Fernando, et al. *Museo del Carmen de Maipú.* Santiago, 1987.

58. Cannut de Bon, Barack. "Sobre el maestro Juan Francisco González". *Revista Meditaciones,* 4 de agosto de 1933.

59. Carrasco, Eduardo. *Distinciones: cultura, arte, política, filosofía.* Serie Arte y Sociedad. Santiago: CENECA, 1988.

60. _____. *Matta: conversaciones.* Santiago: Ediciones Chile América/CESOC, 1987.

61. Carvacho, Víctor. *Fernando Alvarez y sus discípulos.* Santiago: Instituto Cultural de Las Condes, 1977. (Catálogo)

62. _____. *Veinte pintores contemporáneos.* Santiago: Departamento de Extensión Cultural, Ministerio de Educación, 1978.

63. Castedo, Leopoldo. *Historia del arte iberoamericano.* Santiago/Barcelona: Editorial Andrés Bello, 1988.

64. Castillo Martínez, Licia. *Manifestaciones de arte popular en la ciudad de Angol.* Santiago, 1961. Tesis.

65. Cofre, Omar. "Aspectos claves del pensamiento estético de Luis Oyarzún". *Aisthesis* 12 (1979).

66. *Coordinación Artística Latinoamericana.* Santiago, 1977. (Catálogo Exposición)

67. *Coré al Museo.* Santiago: Facultad de Artes, Universidad de Chile, 1983.

68. Cornejo, René, y Amelia Pérez. *Artesanía de la IV Región.* Coquimbo: Universidad de Chile, 1977.

69. Cornely, Francisco L. *El arte decorativo preincaico de los indios de Coquimbo y Atacama.* La Serena, 1962.

70. Cruz de Amenabar, Isabel. *Arte y fe en Chile virreynal.* Santiago: Ediciones Universidad Católica/Instituto Cultural de las Condes, 1987.

71. _____. *Museo de Arte Colonial de San Francisco.* Santiago, 1987.

72. Cruz Ovalle, Isabel. *Pintura y escultura en Chile.* Santiago, 1984.

73. Dannemann, Manuel. *Artesanía chilena.* Santiago: Editorial Gabriela Mistral, 1975.

74. Del Carril, Delia. *Catálogo exposición Marylin Brofmann, Carmen Correa y Lotty Rosenfeld.* Santiago: Galería Paulina Waugh, s.d.

75. Departamento de Extensión Cultural, Ministerio de Educación. *Mirando la pintura chilena.* Serie Patrimonio Cultural, Colección Historia del Arte Chileno. Santiago, 1987.

76. _____. *El Museo del Carmen de Maipú.* Colección Museos de Chile. Santiago, 1979.

77. _____. Serie Patrimonio Cultural Chileno. Colección Historia del Arte Chileno. Santiago, 1978–.

78. Díaz/ Brugnoli/ Sánchez. *Catálogo lumínico de la historia sentimental de la pintura chilena.* Santiago: Centro Cultural Mapocho, 1982.

79. Díaz, Gonzalo, Eugenio Dittborn, Nelly Richard, J. P. Mellado, Ignacio Valdés y G. Múñoz. *Envío a la 5ª Bienal de Sydney.* Santiago: Galería Sur, 1983.

80. Disraeli, Federico. "Ideas estéticas de Juan Francisco González". *Las Ultimas Noticias,* 16 de noviembre de 1950.

81. _____. "Instinto y razón en Juan Francisco González". *Las Ultimas Noticias,* 4 de diciembre de 1950.

82. Dittborn, Eugenio. *Estrategias y proyecciones en la plástica nacional sobre la década del ochenta. Seminario: "La Plástica Chilena Hoy".* Santiago: Grupo Cámara Chile, 1979.

83. _____. *Final de la pista.* Santiago: Galería Epoca, 1977.

84. _____. *Imbunches. Catalina Parra. Análisis.* Santiago: Galería Epoca, 1977.

85. _____. *Postales de Eugenio Dittborn.* Santiago: Francisco Zegers Editor, 1985.

86. Dittborn, Eugenio, Carlos Flores y Juan Downey. *Satelitems.* Santiago: Productora Flores Delpino, 1983.

87. Donoso Phillips, José. *Dimensiones cristianas del arte.* Santiago: Editorial del Pacífico, 1980.

88. Downey, Juan. *Festival Downey: video porque te ve.* Santiago: Ediciones Visuala Galería, 1987.

89. Droguett Alfaro, Luis. *Agustín Abarca o el lirismo pictórico.* Santiago: Universidad de Chile, 1955.

90. Ducci, Mercedes, y Juan Downey. "Llevar las masas al arte y no al contrario". *El Mercurio,* 4 de agosto de 1981.

91. Dufour, Emile. "Ante los cuadros de Matta". *Pro-Arte,* 24 de junio de 1954.

92. Echenique, Javier. *Arte colonial de Chile.* Santiago: Departamento de Extensión Cultural, Ministerio de Educación, 1978.

93. Edwards, Hernan, coord. *Arquitectura tradicional del Valle Central: Agenda 1980.* Santiago: Grupo Cien, 1979.

94. Elgueta Norambuena, Edelberto. *Dos puertas abiertas a la historia de Pomaire: época pre-incásica a 1975.* Santiago, 1981.

95. Ellena, Lihn, y Richard Sommer. *Cuatro grabadores chilenos: catálogo Galería Cromo.* Santiago, 1976.

96. Elliot, Jorge. "El arte moderno y la situación actual de la pintura en Chile". *El Mercurio,* 18 de mayo de 1961.

97. _____. "Roberto Matta pintor o poeta?" *El Mercurio,* 17 de enero de 1961.

98. Elssaca, Theodoro. *Isla de Pascua. Easter Island: hombre, arte, entorno.* Santiago: Spatium, 1989.

99. Englert, Sebastián. *La tierra de Hotu Matua.* 4. ed. Santiago: Editorial Universitaria, 1988.

100. Espinosa V., Ismael, ed. *Autorretrato de Chile, 1850–1915.* Santiago: Autoeditado, 1987.

101. _____. *Santiago de Chile: colección de dibujos de Mauricio Rugendas.* Santiago: Ediciones Artesanales, 1981.

102. Estelle, Patricio. *Imaginería colonial.* Santiago: Editorial Nacional Gabriela Mistral, 1974.

103. *"Estimulemos el arte"*: *concurso de pintura 1987*. Santiago: Centro Casa Verde, 1987.

104. Eyzaguirre, Jaime. *José Gil de Castro, pintor de la independencia americana*. Santiago: Sociedad de Bibliófilos de Chile, 1950.

105. Fernández Vilches, Antonio, dir. *Generación del 13: colección pinacoteca Universidad de Concepción*. Santiago: Banco de Concepción, 1987.

106. Fonseca Velasco, Mario. *Thomas Daskam*. Santiago, 1980.

107. Fontecilla, Exequiel, diagr. *Museo de San Francisco*. Santiago: Ediciones Museo de San Francisco, 1979. (Catálogo)

108. _____. *Santiago de Chile*. Santiago: Ediciones del Museo de San Francisco, 1979.

109. Fuentes, Jordi. *Tejidos prehispánicos de Chile*. Santiago: Editorial Andrés Bello, 1965.

110. Galaz Capechiacci, Gaspar, y Milán Ivelič Kusanovič. "Las artes plásticas en la ciudad". *AUCA* 37 (agosto, 1979).

111. Galaz, Gaspar. "El arte y su compromiso con la realidad". *Aisthesis* 6 (1971).

112. Galaz, Gaspar, y Milán Ivelič. *Chile arte actual*. Valparaíso: Ediciones Universitarias de Valparaíso, 1988.

113. _____. "La escultura en el espacio urbano". *AUCA* 29 (1975).

114. _____. "Artes plásticas y arquitectura: recuento negativo". *AUCA*.

115. _____. *Chile. Pintura chilena: Agenda 1973*. Fotografías R. Combeau. Santiago: Editorial Lord Cochrane, 1973.

116. _____. *Pintura de la pintura*. Catálogo de la Exposición de G. Cienfuengos. Santiago: Galería Epoca, 1984.

117. _____. *La pintura en Chile*. Valparaíso: Ediciones Universitarias de Valparaíso, 1981.

118. _____. "Roberto Matta: primeras notas para una reflexión". *Revista Universitaria* 20 (marzo, 1987).

119. _____. "El video-arte en Chile: un nuevo soporte artístico". *Aisthesis* 19 (1986).

120. Galaz, Gaspar. "Un nuevo ámbito para el arte". *AUCA* 47 (mayo, 1984).

121. *"Galería arte actual 1986–1987"*. Santiago: Ediciones Galería Arte Actual, 1987.

122. *"Galería arte U.C."* Santiago: Ediciones Gráficas, 1987.

123. García Eugenio, y Raúl Menjibar. *Esa ciudad imaginaria.* Santiago: Editorial La Puerta Abierta, 1987.

124. Garreaud, Eduardo. *Notas sobre creación gráfica.* Memoria de Prueba. Santiago: Facultad de Bellas Artes, Universidad de Chile, 1979.

125. Gavilán, Vivian. *Mujer aymara y producción textil: el altiplano de Tarapacá.* Santiago: CEM/PEMCI, 1985.

126. Gay, Claudio. *Imágenes de Chile: diez láminas del atlas de Gay.* Santiago, 1972.

127. _____. *Láminas de costumbres: del atlas de la historia física y política de Chile, de Claudio Gay.* Santiago: Editorial Andrés Bello, 1979.

128. Gil, Antonio. "Lotty Rosenfeld: Una milla de cruces sobre el pavimento/Una milla de cruces sobre arte/Una milla de cruces sobre Chile". *APSI* 78 (julio-agosto, 1980).

129. Giralt-Miracle, D. *Roser Bru: una mirada desde fora.* Catálogo Palau de la Virreina. Barcelona, 1986.

130. Gómez Sicre, José. "Mario Carreño". *Revista Norte* (abril, 1944).

131. _____. *Mario Carreño: catálogo.* Washington, DC: Pan American Union, 1947.

132. González, Juan Francisco. "A propósito de un discurso de Paulino Alfonso sobre Tomás Somerscales". *El Mercurio,* 4 de junio de 1904.

133. "Gracia Barrios: primer premio de dibujo". *Revista de Artes,* segunda época, no. 9-10 (1957).

134. Grava M. R. *Obras maestras de la pintura chilena.* Santiago, 1979.

135. Grez, Vicente. "En el taller de Pedro Lira". *Revista de Santiago,* s.d.

136. _____. "Historia del paisaje en Chile". *Anales de la Universidad de Chile* 9 (1955).

137. Gru, Alfredo. "Sobre Alfredo Valenzuela Puelma". *Zig-Zig* 34 (1905).

138. Guevara, Alvaro. *Dibujos y semblanzas.* Valparaíso: Ediciones Cerro Alegre, 1987.

139. Gutiérrez, Paulina, ed. *Chile vive: memoria activa.* Santiago: CENECA/ICI, 1987.

140. Hardy, Clarisa. *Los talleres artesanales de Conchalí*. Santiago: PET, 1983.

141. Helfant, Ana. *Los pintores de medio siglo en Chile*. Santiago: Departamento Cultural del Ministerio de Educación, 1978.

142. Helfant, Ana, y Víctor Carvacho. *Pintura chilena contemporánea*. 2 vols. Santiago: Departamento de Extensión Cultural, Ministerio de Educación, 1978.

143. Hernández, Baltasar. *Las artes populares en Ñuble*. Santiago: Prensa Latinoamericana, 1970.

144. Huneeus, Cristián. "Cuatro años por el cuerpo de Leppe". En *Reconstitución de escena*. Santiago: Galería Cromo, 1975.

145. Ibáñez, Adolfo. *Reseña histórica: los diez en el arte chileno del siglo XX*. Santiago: Editorial Universitaria, 1976.

146. "Indice de Documentos". En Milán Ivelič y Gaspar Galaz, *Chile arte actual*. Valparaíso: Ediciones Universitarias de Valparaíso, 1988.

147. Iribarren Charlin, Jorge. *Cultura diaguita y cultura molle*. La Serena, 1969.

148. Ivelič Kusanovič, Milán. "Las artes plásticas en la cultura". *Aisthesis* 18 (1985).

149. Ivelič K., Milán. *Artes visuales: una mirada crítica. Muestra de arte y cultura*. Catálogo Chile Vive. Madrid, 1987.

150. Ivelič, Milán. *La asignatura de artes plásticas en la formación del alumno, en los valores formativos en las asignaturas de la enseñanza media*. Santiago: Ediciones Nueva Universidad, 1979.

151. Ivelič, Milán, y Gaspar Galaz. "Camilo Mori, buscador incansable". *AUCA* 26 (1974).

152. _____. *Los caminos recorridos: dispersiones y convergencias*.

153. _____. *Chile: nuevas generaciones*. Santiago: Galería Arte Actual; y Buenos Aires: Museo Sívori, 1987. (Catálogo)

154. _____. "Diez años en las artes plásticas". *AUCA* 32 (1977).

155. _____. *Henriette Petit*. Santiago: Sala B.H.C., 1980. (Catálogo)

156. _____. *Encuentro arte/industria*. Santiago: Museo Nacional de Bellas Artes, 1981. (Catálogo)

157. _____. *La escultura chilena*. Santiago: Departamento de Extensión Cultural, Ministerio de Educación, 1981.

158. _____. *La galería de arte como espacio cultural*. Memoria 1986–1987. Santiago: Galería Arte Actual.

159. _____. *La pintura actual en Chile: panorama Benson y Hedges de la nueva pintura latinoamericana*. Buenos Aires, 1980.

160. Ivelić K., Milán, y Gaspar Galaz C. *La pintura en Chile: desde la colonia hasta 1981*. Valparaíso: Ediciones Universitarias de Valparaíso, 1981.

161. _____. "La pintura su candente realidad". *Aisthesis* 9 (1975–1976).

162. Jarpa, Onofre. "Recuerdos del pintor don Pedro Lira". *Boletín de la Academia Chilena de la Historia* (1920).

163. Kay, Ronald. *Del espacio de Acá*. Santiago: Editores Asociados, 1980.

164. Lago, Tomás. *Arte popular chileno*. 4. ed. Santiago: Editorial Universitaria, 1985.

165. _____. "Veinte años del primer museo de arte popular americano". *Boletín de la Universidad de Chile* 53-54 (1964):4-13.

166. Lamas D., Viviana. *Aproximación a la gráfica contemporánea en Chile*. Memoria de Prueba. Santiago: Facultad de Artes de la Universidad de Chile, 1982.

167. Lastra, Fernando de la. *Ventana a Valparaíso*. Santiago: Instituto Cultural de Las Condes, 1986.

168. Latcham, Ricardo E. *La alfarería indígena chilena*. Exposición Iberoamericana de Sevilla. Concurrencia de Chile. Sevilla, 1928.

169. Latorre, Mariano. "De Monvoisin a Pedro Lira". *Chile Magazine* 7 (1922).

170. Lihn, Enrique. *Eugenio Téllez, descubridor de invenciones*. Santiago, 1988.

171. _____. *El retorno de Coré: catálogo de exposición homónima*. Santiago: Visuala, 1985.

172. Lihn, Enrique, Nelly Richard y Ignacio Valdés. *Roser Bru*. Santiago: Galería Cromo, 1977.

173. Lira, Pedro. "Las bellas artes en Chile". *Revista Ilustrada*, 15 de julio de 1865.

174. _____. *Diccionario biográfico de pintores*. Santiago, 1902.

175. Lobos, Pedro. *Retoños: 10 dibujos de Pedro Lobos*. Santiago, 1987. (Carpeta)

176. López, J. Pablo. "El arte Pop hizo su estreno". *Ercilla* (mayo, 1970).

177. Maldonado, Carlos. *Valenzuela Llanos*. Santiago: Departamento de Extensión Cultural, Ministerio de Educación, 1972.

178. "Matta". *Mensaje* 205 (1971).

179. Matta, Roberto. "Dar un cuadro de la realidad sin mentir". *Pro Arte* (junio, 1954).

180. Mebold K., Luis, y Isabel Cruz, et al. *Catálogo de la pintura colonial en Chile*. Santiago: Ediciones Universidad Católica, 1987.

181. Melcherts, Enrique. *Introducción a la escultura chilena*. Valparaíso, 1982.

182. Mellado, Justo Pastor. *El block mágico de Gonzalo Díaz*. Santiago, 1985.

183. _____. *La disputa de la cita bíblica. Juan Dávila: fábula de la pintura chilena*. Santiago: Arte y Texto, Galería Sur, 1983.

184. _____. *El fantasma de la sequía*. Santiago: Francisco Zegers Editor, 1988.

185. _____. *Meter la pata o presentación de la obra de Gonzalo Díaz, en Chile Vive*. Santiago: Ediciones Visuala, 1987.

186. _____. *Re (en) marcar el paisaje: segunda nota sobre la pintura de Patricio de la O*. Santiago: Instituto Cultural de Las Condes, 1987.

187. Millar, Pedro. *Taller 99*. Catálogo Exposición Taller 99. Santiago: CAL Ediciones, 1982.

188. Ministerio de Cultura, Comunidad de Madrid, Instituto de Cooperación Ibero Americana y Círculo de Bellas Artes. "Chile vive: muestra de arte y cultura", 19 enero–18 de febrero, 1987.

189. Miranda, Hernán. Santiago: Ediciones Galería Arte Actual, 1985.

190. Mistral, Gabriela. "Recado sobre el maestro Juan Francisco González a Alfonso Bulnes". *Revista de Sociedad de Escritores de Chile* 1 (1945).

191. Molina, Julio. "Cabalgata de la Escuela de Bellas Artes". *Revista de Educación* 18 (julio, 1969).

192. Montaner, Ricardo. "Homenaje a don Pedro Lira". *El Mercurio*, 23 de junio de 1912.

193. Moreno, Cecilia. *La artesanía urbano marginal*. Santiago: CENECA-PEMCI, 1984.

194. Moreno, José María. *Cuatro pintores de Chile*. Catálogo Exposición del Grupo Signo. Madrid, 1962.

195. _____. *Matta*. Galería Aele. Madrid, 1974.

196. Mori, Camilo. "La generación del 28". *Boletín de Arte* (diciembre, 1960).

197. _____. "Sobre pintura moderna en Chile". *Atenea* 428 (1973).

198. Mostny, Grete, y Hans Niemeyer. *Arte rupestre chileno*. Colección Historia del Arte Chileno, Vol. 8; Serie: Patrimonio Cultural Chileno. Santiago: Departamento de Extensión Cultural, Ministerio de Educación, 1982.

199. Mostny, Grete. *Culturas precolombinas de Chile*. Santiago, 1960.

200. Muñoz, G., L. Oyarzun, y Nelly Richard. *Fuera de Serie. Brugnoli, Dávila, Dittborn, Duclos, Errázuriz, Leppe*. Santiago: Galería Sur y Bucci, 1985.

201. Museo de Arte Precolombino. *Arte precolombino*. Santiago, 1982.

202. _____. *Diaguitas: pueblos del Norte Verde*. Santiago, 1986.

203. _____. *Mapuche*. Santiago, 1985.

204. _____. *Catálogo de exposición de platería araucana*. Santiago, 1983.

205. Museo Chileno de Arte Precolombino. *Taino: los descubridores de Colón*. Santiago, 1988. (Catálogo)

206. Museo Nacional de Bellas Artes. *Catálogo de pintura chilena*. Santiago, 1978.

207. _____. *Plástica chilena*. Santiago: Ilustre Municipalidad de Temuco, Dirección de Bibliotecas, Archivos y Museos, Ministerio de Educación, 1988.

208. Museo Regional de Araucanía. *Plata de la Araucanía*. Santiago: Ilustre Municipalidad de Talagante, Museo Regional de Araucanía, 1988.

209. Núñez y Domínguez, J. "Centenario del pintor Rugendas". *El Mercurio*, 6 de enero de 1959.

210. Olea Carrillo, Paz. *Artesanía de Rari*. Linares: Museo de Artes de Linares, 1985.

211. Olmos, Pedro. *Olmos y los escritores*. Santiago, 1989.

212. Orrego, Carlos. *Alberto Orrego Luco*. Santiago: Editorial Universitaria, 1964.

213. Ortuzar Cariola, Mariano. *Luz y paz. Light and Peace*. Santiago, 1981.

214. Oyarzun, Aureliano. "Las calabazas pirograbadas de Calama". *Revista Chilena* (1929).

215. Paiva, Manuel, y María Hernández. *Arpilleras de Chile*. Santiago, 1983.

216. Palacios, José María, y Enrique Solanich Sotomayor. *200 años de pintura chilena*. 2 vols. Santiago: Departamento de Extensión Cultural, Ministerio de Educación, 1979.

217. _____. "Un 'medium' pictórico: Mario Toral". *El Cronista*, 7 de agosto de 1977.

218. Paredes, Rafael. *Técnica y apreciación de la cerámica*. La Serena: Departamento de Artes y Letras, Universidad de Chile, 1975.

219. Pedregal, Sonia del. *El arte de la cerámica en frío*. Santiago, 1988.

220. Pereira Salas, Eugenio. "Bosquejo panorámico de la pintura colonial". *Atenea* 428 (1973).

221. _____. *Historia del arte en el reino de Chile*. Santiago: Universidad de Chile, 1965.

222. Pérez, Alberto. *Desechos (de olvido y de memorias)*. Santiago: Galería Carmen Waugh, 1986.

223. Pérez, Amelia. *Artesanía de la Ligua: producción y comercialización*. Boletín, Serie Desarrollo Social. Santiago: Facultad de Agronomía, Universidad de Chile, 1979.

224. _____. *La artesanía de lana en Puerto Montt: aspectos económicos y sociales*. Boletín 3, Serie Desarrollo Rural. Santiago: Facultad de Agronomía, Universidad de Chile, 1976.

225. _____. *La artesanía de Pomaire: aspectos económicos y sociales*. Boletín 1, Serie Desarrollo Rural. Santiago: Facultad de Agronomía, Universidad de Chile, 1976.

226. _____. *Artesanías rurales por regiones*. Boletín 12, Serie Desarrollo Rural. Santiago: Facultad de Agronomía, Universidad de Chile, 1978.

227. Piñeiro, O. *La cestería chilena.* Santiago: Museo de Arte Popular Americano, Universidad de Chile, 1967.

228. Philippi Izquierdo, Julio. *Vistas de Chile, por Rodulfo Amando Philippi.* Santiago, 1973.

229. Phillips Chilena. *Calendario Colección Pintura Chilena 1980.* Santiago, 1980.

230. Phillips Chilena. *Calendario 1981 Phillips Chilena: los grandes maestros de la pintura.* Santiago, 1981.

231. Plath, Oreste. *Arte popular y artesanías de Chile.* Santiago: Museo de Arte Popular Americano, Universidad de Chile, 1972.

232. Quintana, Sonia. "Juan Downey". *El Mercurio,* 17 de febrero de 1980.

233. _____, et al. *Resumen de 6 años de actividades artísticas.* Santiago: Ministerio de Educación, 1980.

234. *Retrato de un pintor: Alvaro de la Fuente.* Santiago, 1980.

235. Richard, Nelly, y Juan Forch. *Arte en Chile.* Santiago: Productora Visual, 1986.

236. _____. *La cita amorosa.* Santiago: Ediciones Francisco Zegers, 1985.

237. _____. *Cuerpo correccional.* Santiago, 1980.

238. _____. *Cuerpo sin alma. Juan Dávila: fábula de la pintura chilena. Arte y texto.* Santiago: Galería Sur, 1983.

239. _____. "Chile en la XII bienal de Paris". *La Separata* 6 (julio, 1983).

240. _____. *De la Chilena: pintura, historia, recorrido.* Santiago: Galería Epoca, 1976.

241. Richard, Nelly. *Margins and Institutions.* Melbourne: Ediciones Poss-Taylor Art & Text, 1986.

242. _____. *Los mecanismos de la ilusión en Dávila.* Melbourne: Tollarno Galeries, 1977.

243. _____. *Una mirada sobre el arte en Chile.* Santiago, 1981. (Mecanogr.)

244. Rivera, Anny. *Arte y autoritarismo.* Documento de Trabajo, 33. Santiago: CENECA, 1982.

245. _____. *Notas sobre movimiento social y arte en el régimen autoritario.* Santiago: CENECA, 1983.

246. _____. *Transformaciones culturales y movimiento artístico en el orden autoritario: Chile 1973–1982.* Santiago, 1983.

247. Richón-Brunet, Ricardo. "Alfredo Helsby". *Selecta* 3 (julio, 1909).

248. _____. "Alfredo Valenzuela Puelma". *Selecta* 2 (junio, 1909).

249. _____. *El arte en Chile: catálogo oficial ilustrado*. Santiago, 1910.

250. _____. "Don Pedro Lira". *Selecta* 1 (abril, 1912).

251. Riesco, Carlos. *Plateros de la luna*. Santiago: Biblioteca Nacional de Chile, 1988. (Catálogo)

252. Ríos, Silvia. "Tres pintores instintivos". En *El arco y la lira*. Santiago: Facultad de Bellas Artes, Universidad de Chile, 1978.

253. Robles, Armando. *La pintura en Chile*. Santiago: Imprenta Universo, 1921.

254. Rojas, Alicia. *Historia de la pintura en Chile*. Santiago, 1981.

255. Rojas Abrigo, Alicia. *Nuevos enfoques para la educación del arte en la escuela primaria*. Santiago, 1980.

256. _____. *Pinturas franciscanas*. Santiago: Museo de San Francisco, 1981.

257. Rojas, Manuel. *La imagen artística de Chile*. Santiago: Editorial Universitaria, 1970.

258. Romera, Antonio. *Alfredo Valenzuela Puelma*. Catálogo de la Exposición Retrospectiva. Santiago: Imprenta Barcelona, 1975.

259. _____. *Asedio a la pintura chilena*. Santiago: Editorial Nascimento, 1969.

260. _____. "Burchard o el lenguaje pictórico". *El Mercurio*, 15 de junio de 1964.

261. _____. *Dibujos de Lukas*. Catálogo de la Exposición Contando a Chile. Santiago: Instituto Cultural de Las Condes, 1975.

262. _____. *Exposición de pintores de la generación del Trece*. Santiago: Instituto Cultural de Las Condes, 1973. (Catálogo)

263. _____. "La generación de 1940 de la Escuela de Bellas Artes". *Aisthesis* 9 (1975–1976).

264. _____. *Historia de la pintura chilena*. Santiago: Zig-Zag, 1968.

265. _____. *Historia de la pintura chilena*. 4. ed. Santiago: Ediciones Universitarias de Valparaíso, 1977.

266. _____. "La letra y los artistas chilenos". *El Mercurio*, 10 de diciembre de 1965.

267. _____. *El movimiento forma espacio*. Santiago, 1971. (Catálogo)

268. _____. *Panorama de la pintura chilena desde los precursores hasta Montparnasse: muestra retrospectiva basada en la* Historia de la pintura chilena *de Antonio Romera*. Santiago: Instituto Cultural de Las Condes, 1987. (Catálogo de Exposición)

269. _____. "Matta en la universidad". *El Mercurio*, 17 de enero de 1961.

270. _____. *Pedro Lira y su obra: catálogo de la exposición retrospectiva*. Santiago: Imprenta Barcelona, 1974.

271. _____. "Supuesta peligrosidad del arte". *El Mercurio*, 20 de febrero de 1969.

272. Rosenfeld, Lotty. *Proposición para (entre) cruzar espacios límites: acciones de arte en límites territoriales*. Santiago: Productora Visuala, 1983.

273. _____. *Una herida*. Santiago: Tatiana Gaviola, 1982.

274. _____. *Una milla de cruces sobre el pavimento: primera acción de arte en una zona urbana de Santiago como intervención a un signo de tránsito*. Santiago: Producción de Lotty Rosenfeld, 1979.

275. Roser Bru. *Cuerpo calado*. Santiago: Galería Carmen Waugh, 1987. (Catálogo)

276. Sabella, Andrés. *12 dibujos línea y color*. Santiago, 1988.

277. Sallenave, Daniel. *Mirando a Itaca: Guillermo Núñez*. Santiago: Lord Cochrane, 1987.

278. *Salón Nacional de Gráfica*. Santiago: Universidad Católica de Chile.

279. Sanz, Claudio. *Arte joven: grabados*. Santiago: Galería Espacio Cal, 1987.

280. Saul, Ernesto. *Pintura social en Chile*. Santiago: Editorial Quimantú, 1972.

281. Scarpa, Roque Esteban. *Madurez de la luz*. Concepción: Universidad de Concepción, 1987.

282. SEREC. *Guía de museos, galerías y salas de arte de Chile*. 2. ed. Santiago: SEREC, 1989.

283. Silva, Jaime A. *La artesanía en Chile*. Diagnóstico exploratorio. Santiago: CENECA, 1986.

284. Solanich Sotomayor, Enrique. *Dibujo y grabado en Chile*. Santiago: Departamento de Extensión Cultural, Ministerio de Educación, 1987.

285. _____. *Precursores de la pintura chilena*. Santiago: Departamento de Extensión Cultural, Ministerio de Educación, 1978.

286. Sommer, Waldemar. "Bonati: la identidad a través del retorno". *El Mercurio*, 26 de julio de 1982.

287. Soto, Heriberto. "Vida y obra de Valenzuela Puelma". Santiago. (Ensayo inédito)

288. Smythe, Francisco. *Smythe*. Santiago: Galería Cromo, 1977.

289. Taller de Arpilleras. *Agrupación de familiares de detenidos desaparecidos. Arpilleras: otra forma de denuncia*. Santiago, 1988.

290. Thomson, Augusto. "Arte en el Salón del 1900". *Instantáneas* 33 (1900).

291. "Mario Toral". Exposición de sus obras y lanzamiento del libro de Leopoldo Castedo, *Toral, tres decenios en su obra, 1954–1984*. Santiago, s.f.

292. *Toral, tres decenios en su obra, 1954–1984*. Leopoldo Castedo, editor. Santiago, 1985.

293. Toral, Mario. *Mario Toral: pintura, literatura*. Santiago: Galería Arte Actual, 1988. (Catálogo)

294. _____. *Toral: imagen secreta*. Santiago: Ediciones del Ornitorrinco, 1988.

295. Ulibarri, Luisa. "Las loceras de Quinchamalí". En *Así trabajo yo*, tomo IV. Santiago: Quimantú, 1982, pp. 45-76.

296. Ulloa, Yéssica. *Video-Expresión*. Santiago: CENECA, 1987.

297. Unanue, Jacqueline. *El arte rupestre chileno: un encuentro con el hombre primitivo*. Viña del Mar, 1982.

298. Universidad de Chile. *Arte popular chileno: mesa redonda*. Santiago, 1959.

299. Uribe, Rebeca. "Tras las Máscaras de Mario Toral". *El Mercurio*, 1 de agosto de 1982.

300. Urzua, V. *Pequeña industria y artesanía en Chile*. Colección Estudios, Consejería Nacional de Promoción Popular. Santiago: Editorial del Pacífico, 1965.

301. Valenzuela R., Bernardo. *La cerámica folklórica de Pomaire*. Santiago: Instituto Ramón Laval, Universidad de Chile, 1955.

302.  Valdés, Adriana. *Obra abierta y de registro continuo*. Santiago, 1981.

303.  _____. *Roser Bru: cuatro temas*. Santiago: Arte y Textos, Galería Sur, 1983.

304.  Valdés, Ximena, y Paulina Matta. *Oficios y trabajos de las mujeres de Pomaire*. Santiago, 1986.

305.  Vergara, Ramón. *Hasia-América: geometría andina*. Santiago: Galería Carmen Waugh, 1987. (Catálogo)

306.  Vicaría de la Solidaridad. *Artesanías: una red de amor, dignidad y esperanza*. Santiago, s.f.

307.  Vicuña S., Benjamín. "Don Pedro Lira". *Selecta* (mayo, 1909).

308.  Vila. Waldo. *Pintura joven*. Santiago: Editorial del Pacífico, 1973.

309.  Villavicencio Varas, Fresia. *Arte rarino*. Santiago: Facultad de Bellas Artes, Universidad de Chile, 1964.

310.  Yañez, Nathanael. *El hombre y el artista Pedro Lira*. Santiago: Imprenta El Esfuerzo, 1933.

311.  _____. "En el taller de Valenzuela Llanos". *Zig-Zig* 224 (5 de junio de 1909).

312.  Zamudio, Enrique. *Prueba de estado*. Santiago: Galería Plaza, 1987. (Catálogo de Exposición)

313.  Zegers, Roberto. *Juan Francisco González*. Santiago: Imprenta Universitaria, 1953.

314.  _____. *Juan Francisco González*. Santiago: Ediciones Ayer, 1981.

**Publicaciones Periódicas**

315.  *Arte U.C.* Escuela de Arte, Pontificia Universidad Católica de Chile, Santiago de Chile.

316.  *Aisthesis: Revista Chilena de Investigaciones Estéticas*. Departamento de Estética, Facultad de Filosofía, Pontificia Universidad Católica de Chile, Santiago de Chile.

317.  *Suplemento Artes y Letras*. El Mercurio, Santiago de Chile.

## INDICE ONOMASTICO DE PINTORES
## CHILENOS CITADOS

# III. Art Cataloging and Bibliographic Control

# 32. Visual Research Cataloging at the Getty Center for the History of Art and the Humanities

## Brent F. Maddox

The Photo Archive was formed in 1974 when Paintings curator Burton Fredericksen centralized, in an unclaimed basement room of J. Paul Getty's new Roman villa museum, the photographs that had been accumulating among the three curatorial departments previously housed in the Malibu Ranch House museum. Over the next few years sui generis cataloging schemes were devised to suit the needs of the Antiquities, Paintings, and French Decorative arts curatorial departments. Photos were mounted on 11" x 13" boards and cataloging information was typed on address labels that were then affixed to the boards. Catalog cards were typed, duplicated, and filed in cabinet drawers for each of the three subject sections. Access points varied according to section; in the Paintings section card files were maintained for artist, current location, and subject.

The Photo Archive grew at a steady, moderate rate until greater administrative independence began in 1979 under George Goldner (now Paintings and Drawings curator at the Museum) with a staff of five and a collection of about 100,000 photos that had been purchased from art dealers, commercial photofirms, auction houses, and other museums. The Museum library had 21,000 volumes. At this time it was generally known that Getty had left a large portion of his estate to the Museum. He died in 1976 without seeing his new museum.

In May 1981, businessman Harold Williams was appointed president of the newly formed J. Paul Getty Trust. By March 1982, when the estate was completely settled, the Trustees decided that, given the magnitude of the endowment and Getty's purpose, stated in the Trust indenture as "the diffusion of artistic and general knowledge," the Trust should make a greater contribution to the visual arts than the museum could alone. The Getty Center and five other entities were conceived later in 1982 by Williams's staff and their advisers.[1]

The first stride toward a Photo Archive computer catalog took place in 1982 when the database function of an IBM Displaywriter was used for authority control of painter names.

When the Photo Archive and Library moved to Santa Monica in July 1983 to become part of the new Getty Center for the History of Art and the Humanities, there were 250,000 cataloged photos and a backlog of more than 300,000 photos. The Library had 65,000 volumes.

Center Director Kurt Forster arrived in January 1984. Swiss born, and educated in Berlin, Florence, and Zurich, Forster had been teaching art and architectural history in American universities since 1960. One of his first official acts was establishing the Archives for the History of Art, a new department for the collecting of primary documents that illustrate the development of art history as a discipline, and the general development of creative and critical thinking about art. Representative acquisitions include notes, papers, and correspondence from the estates of art historians as well as artists' notes, letters, and related materials. The Archives recently made microform copies of Frank Lloyd Wright's drawings and records held by the Frank Lloyd Wright Foundation at Taliesin West.

Art historiography is a strong component of the Center's purpose. In blending historical explanation with critical appraisal, it provides a vehicle of emancipation from ideas and interpretations one wishes to supersede.[2] It is misleading, however, to state that the Center's mission is essentially historiographic. For this reason, and for their role in determining collecting policies and cataloging strategies, the broader goals and some of the thinking behind them are worth describing more fully.

In Forster's view, formalist art history (or the history of style) and a tradition weighted toward artistic biography have created a categorical and valuative separation of art from history, making it inevitable that ". . . reasons for what happens in art must be sought within art itself, or, at the most, within biography. The historical reality of artifacts is thereby either estranged into the seemingly 'other' realm of art, or is personalized to an extreme degree."[3]

For Forster, "the only means of gaining an adequate grasp of old artifacts lies in the dual critique of the ideology which sustained their production and use, and of the current cultural interests that have turned works of art into a highly privileged class of consumer and didactic goods."[4]

Coupled with this Frankfurt school orientation and its principle of cultural mediation (which recognizes that culture is not perpetually an instrument of material or economic forces, but is itself a decisive mediating factor in society) is the influence exerted by Aby Warburg (1866–1929) and the Warburg Institute, founded in Hamburg and moved to London after the rise of Nazism.

Warburg's purpose, through the support of his research institute for the systematic study of myth, symbolism, allegory, and style in Western civilization, was to show that European culture is the result of conflicting tendencies like magico-religious practice and mathematical-logical contemplation. The Getty Center is adopting his practice of collecting cultural documents of every sort, of social rituals, of scientific and philosophic material within the relevant compass of art history.

Forster has stated that for Warburg, the production of culture is determined neither by material processes nor by ideas. "[Warburg] felt that the entire economy of culture came down on a psychic balance sheet with the total biological heritage, the social liabilities and expressive expenditures of man oscillating around a precarious equilibrium."[5]

A key premise in Warburg's approach was his expansive definition of art; the idea that "a true history of artistic production needed to recognize both the full spectrum of artifacts and their instrumentality within a cultural context."[6] This idea was developed most effectively by George Kubler in his book *The Shape of Time*:

Let us suppose that the idea of art can be expanded to embrace the whole range of man-made things, including all tools and writing in addition to the useless, beautiful and poetic things of the world. By this view the universe of man-made things simply coincides with the history of art. It then becomes an urgent requirement to devise better ways of considering everything man has made.[7]

*The Shape of Time* was completed in 1962 following a twenty-year period when Kubler had been teaching and writing about Spanish architecture,[8] Latin American art,[9] and pre-Columbian archaeology.[10] His principal source of motivation in enlarging the conception of the history of art was his interest in problems of anonymous objects and in the art of ancient America.

The hub of Center activities is a resident scholar program in which a dozen scholars are invited to Santa Monica from around the world each year to pursue personal research interests. This interdisciplinary emphasis was presaged in John Onians's 1978 founding editorial for the journal *Art History* that encouraged scholars

who show how a study of works of art can help us to understand more about our physiological and psychological makeup, our response to political, social and economic pressures, our reaction to religion, philosophy and literature, and our relationship to the natural environment. This broader interest may naturally lead us to turn to those in other fields, to anthropologists and archaeologists, to students of history and society, of thought and letters, to psychologists and even neurologists.[11]

In addition to its own programs, the Center serves the Museum staff, other Trust programs, and anyone with research interests supported by our collections.

The Photo Archive today has more than 1.6 million photos and a staff of twenty-seven. The Library has 780,000 volumes and the Archive has around 500,000 manuscript items.

Center collecting policies have branched each year. Acquisition forays may be determined by now-or-never availability of important collections such as the Wilhelm Arntz archive of German expressionism, which was purchased in 1986. The Center was obliged to provide bibliographic support after a new Museum Department of Photographs was created in 1984. Systematic acquisition of Latin American materials began during the 1986/87 scholar year when Mayan specialist Berthold Reise was in residence. This year, the presence of four anthropologists has spurred collecting in their respective fields, particularly for serials.

Returning again to the visual collections, I should note that several months after the Archive moved to Santa Monica in 1983 and became part of the Center, a fourth subject section was created to document European Medieval art. At this time administrative attention was directed more to the scholar program, the new art history archives, library acquisitions, and building renovations.

The primary purpose of the Photo Archive cataloging project in late 1983 and early 1984 was to unite disparate cataloging schemes for the Antiquities, Medieval, Paintings, and French decorative arts subject sections into an integrated, on-line public access catalog. A secondary purpose was to streamline the processing of photographs, eliminating or substantially reducing the labor-intensive tasks required to support a manual cataloging system. In-depth, item-level cataloging was the goal. [12]

As we evaluated on-line systems, three items topped our list of criteria to be met: revision flexibility, linked authority files, and a combination of strong retrieval and diverse output capabilities. The STAR system, a product of Cuadra Associates, was chosen. [13]

STAR's flexibility has allowed us to redefine databases at any time, even after data have been entered. This was crucial in creating a common system for the three Museum-based sections with idiosyncratic cataloging schemes, and a nascent Medieval section.

The term "parallel cataloging" best describes the techniques used in STAR to handle Roman copies after Greek originals, repairs and additions to statuary and structures, architectural sculpture reused in later buildings, and detail photos of larger entities. Complex

conditional statements govern the label format permutations for these requisites. This results in homogeneous *input* values, with consistent search and retrieval capability, and the highly specialized *report* capacity needed for the different subject areas. Concurrent activities during our early work with STAR included the selection of bar-code readers and a printer for label production, as well as exhaustive tests of the archival and adherence qualities of bar-code and text labels.

STAR's protean capacities also helped us make ad hoc indexes for certain collections with unwieldy manual finding aids. For example, we made on-line indexes by artist, location, and school to printed ID number lists for the Corpus Photographicum of Drawings, an archive of 120,000 photos of drawings in European public and private collections.

A visual archive of our size and diversity required a largely autonomous approach to authority file construction. The painter name file mentioned earlier became the nucleus of an artist file that now has 18,000 records. Artist names for other subject areas such as Greek vase painting and medieval manuscript illuminations were included in the database. A major task was the building of place-name fields, including corporate body and structure names. Our policy of including the cataloging source in all cataloging records prompted the creation of a bibliographic reference database.

*RILA* guidelines (*Repertoire International de la Litterature de l'Art*, a bibliographical indexing and abstracting service of the Getty Art History Information Program), adapted from the *Anglo-American Cataloging Rules*, were followed in most instances. Source listings in our authority files often correspond to specific data elements such as artist dates, enhancing the reference function of the files. As fields such as "role," "gender," and "regional school" were added to the artist file, or "site/precinct/complex" to the locations database, our authority files started to grow beyond the traditional functions of vocabulary control, collocation, the linking of relationships, and decision recording. They are becoming research fields in their own right, though there are tensions concerning the degree to which we should pursue "truth in minutiae" with rising backlogs. [14]

The Photo Archive artist database is one of seven contributors to the Union List of Artist Names project developed by the Vocabulary Coordination Group of the Getty Art History Information program. The list has nearly 250,000 names, including variants, representing 85,000 artists. [15] Plans are underway for the interchange of Getty artist names with the Library of Congress Name Authority File. In a test matching randomly selected names from *RILA* and the Photo Archive

(to represent both bibliographic and visual collections) against the Library of Congress list, only one out of five Getty names matched.

The Vocabulary Coordination Group is now working on a union database of geographic authorities. Future projects include corporate bodies and titles of works of art.

At this time our system has 100,000 item-level records, 50,000 authority records, and 90,000 other records at varying levels of specificity.

In 1986-87 the subject-based organizational structure of the Photograph Archive, an extension of its curatorial origins in Malibu, was replaced with four functional divisions: reference, collectional management, special projects, and technical services. The innovative priorities of the Center began to eclipse the more traditional identification and cataloging of images of Western art on an encyclopedic scale. A new emphasis was placed on unique materials and on the history of visual documentation. Photographic theories of meaning that opposed affective value vs. informative value, metaphoric signification vs. metonymic signification, theories of imagination vs. theories of empirical truth, and ideas about photography as expression vs. photography as reportage became part of the changing intellectual climate.

We recently agreed to buy or reproduce on microform 30,000 photos of fiestas and popular traditions in rural Spain taken by Cristina Garcia Rodero, a professor at the University of Madrid. We just bought 6,000 American postcards produced between 1893 and 1912. Numerous historical albums documenting fairs, expositions, and events such as the construction of the Eiffel Tower have been purchased. Manuel Alvarez Bravo's collection of photos, self-described as popular art that is deliberately aligned with the artisan, the local craftsman, and the art of pre-Conquest Mexico, is another new collecting tangent. Robert Stevenson, UCLA musicologist, has suggested photo documentation of the illuminations in Plainchant choir books housed in South and Central American cathedrals.

In December 1987, planning began for Photo Archive participation in the Research Libraries Information Network (RLIN) of the Research Libraries Group, Inc. through the new MARC/Visual Materials (VIM) format. The Archives for the History of Art has been creating RLIN records in the Archives and Manuscripts format since shortly after its approval in 1985. MARC is now becoming a vehicle of collaboration among visual resource professionals. Nancy Sahli, author of *MARC for Archives and Manuscript*,[16] described the AMC format, and by extension the VIM format, as "nothing more than a structured container for

administrative and descriptive information about archives and manuscript that uses a labeling system of field and subfield designations to indicate what information elements may be used."[17]  The current RLG descriptive standards for all formats except AMC are the *Anglo-American Cataloging Rules*, 2d edition, and the Library of Congress Name Authority File (LCNAF).  The AMC standard is Steven Hensen's *Archives, Personal Papers, and Manuscript* manual[18] and the LCNAF. There is no explicit RLG archival visual standard, but there is tacit approval for the *AACR2*-derived manuals *Graphic Materials* (Elizabeth Betz)[19] and *Archival Moving Images Materials* by Wendy White-Hensen.[20]  The *MARC for Archival Visual Materials* compendium has guided the preparation of forty collection records to be entered in RLIN.[21]

The malleability of STAR that facilitated the creation of special ad hoc indexes mentioned earlier now became increasingly important in achieving a modicum of control over the collections as item-level processing was largely abandoned, except in selected subject areas.  Our HOLDINGS database has 220 collection-level records describing everything in our collections, including dispersed collections such as art historian Erwin Panofsky's photos, or collections that have been kept intact, like collector-critic Douglas Cooper's photos or the nineteenth-century historical albums.  An output format mapped between local fields and MARC/VIM tags was created by archivist Tracey Schuster as an aid to RLIN record preparation.

Two of the special purpose databases are called KOCH and HUTZEL.  Guntram Koch, a classical archaeologist at Marburg University in West Germany, has sold us nearly 40,000 photographs of Greek, Roman, and Byzantine architecture and sculpture from sites in Turkey, Albania, Greece, Yugoslavia, and countries in the Middle East. Max Hutzel was a German photographer based in Rome, who did extensive photo documentation of north Italian art and architecture in isolated areas.  We bought his archive of 70,000 photos (with negatives) several years ago.  In both of these databases a record represents a single site or monument for which we might have from ten to four hundred photos.  Fields were defined to match the information that had been provided with the images.

Two other special databases provide access to paintings conservation and restoration databases with fields for "state of conservation," "artist attributions," and "treatment dates."  An OLDPHOTS database catalogs important single prints from our rare/historical holdings, particularly nineteenth-century views of classical sites.  Limited field, inventory databases are used for things like a collection of 35,000

negatives that Getty purchased from the New York dealer French &
Company in 1972.

The reorganization has also obviated the need for a massive,
multimedia database for Medieval art. We are in the process of moving
all manuscript illumination records into a separate file. The one-
record/one-site/many photos principle will then be applied to
documentation of Medieval architectural complexes.

Our most heavily used subject access resource is a free text field
used for manuscript illuminates in the Medieval database. The
immense size of our European paintings collections, together with
continuing debates about method have stymied sustained subject
description work for our paintings photos.

Because standard records in RLIN/VIM require the use of Library
of Congress Subject Headings, we have become acutely aware of LCSH
inadequacies in the visual realm. The New York Public Library Prints
and Photographs Division has chosen to make nonstandard records for
the time being, preferring to use the still unofficial *LC Thesaurus for
Graphic Materials: Topical Terms for Subject Access*[22] and, eventually,
the *Art and Architecture Thesaurus*.

Now midway in its development, the purpose of the AAT is to
provide a standardized vocabulary of art and architecture terms for use
in bibliographic and visual databases and in the inventorying of object
collections. The AAT has built its vocabulary from existing subject
authority lists augmented by literature of the field: dictionaries,
encyclopedias, glossaries, and authoritative monographs. The thesaurus,
which is a list of terms showing synonymous, hierarchical, and other
relationships, displays its terms in hierarchies (i.e., conceptual
arrangements showing broader and narrower relationships) and
alphabetical indexes. There is an attempt to provide access points via
all relevant synonyms or variants of a term, and to track the original
sources of terms. This tracking mechanism may in the future enable
the AAT to be used as a switching language by those participating
institutions wishing to preserve their own vocabulary lists. Both on-line
and print versions of the AAT will be updated periodically. Begun in
1979, the AAT became an operating unit within the Art History
Information Program of the J. Paul Getty Trust in 1983. Twenty-one
hierarchies will be published, and RLG has agreed to mount the AAT
on RLIN.[23]

At RLG, the Art and Architecture Programming Committee is
now studying published cataloging tools used for the bibliographic
description of visual materials to see what standards changes will be
needed in the areas of bibliographic description, subject access,

including form and genre terms and physical characteristics access, and standards for deciding among different RLIN files (e.g., Books, AMC) for formats.

A critical MARC/VIM issue that should be addressed soon is whether the objects depicted in photographs may be cataloged instead of (or in addition to) the physical item at hand. The final logical leap in this direction within networked MARC, and a step already taken in a local system by the National Museum of American Art's Inventory of American Sculpture, is to catalog real objects themselves using a MARC format. For computerized catalogs of art objects, communicating information to researchers is often a secondary by-product of a system designed for inventory management, documentation of legal title, and the like. [24]

When Williams Arms suggested using MARC and RLIN to carry data in 1979 during planning stages of the Museum Prototype Project, museum people did not believe this method would meet the complexities of their heterogeneous information needs. With the development of the VIM format as a suitable framework for art information, the museum community is reconsidering, as evidenced by discussion at the Museum Computer Network Conference in October 1988. [25]

In 1990, the Photo Archive, the Archives for the History of Art, and the library's Rare Books Division were administratively merged into a single Special Collections department in preparation for 1995, when the Center will join the Getty Trust's other Los Angeles-based programs (excepting the Antiquities collections in Malibu) on a new hilltop complex overlooking West Los Angeles. Our task over the next few years will be to provide access to multifarious information, including MARC network records, local authority and special collection records, and, we expect, digitized images, from single termini in an integrated system.

Given our geographic proximity to Latin American artistic diversity, and a broadly defined purpose that is cognizant of the complex dynamics wrought by the confrontation of cultures, the Getty Center will participate in the quincentennial commemoration of the landing of Columbus in the Americas and should, in time, become a major resource for scholars of Latin American culture.

## NOTES

1. The other entities, in addition to the J. Paul Getty Museum, are The Getty Conservation Institute, the Getty Art History Information Program, the Getty Center for Education in the Arts, the Museum Management Institute, and the Program for Art on Film (a joint venture with the Metropolitan Museum of Art).

2. John Highham et al., *History* (Englewood Cliffs, NJ: Prentice-Hall, 1965), p. 89.

3. Kurt W. Forster, "Critical History of Art or Transfiguration of Values," *New Literary History* (1971-72), 460.

4. Ibid., p. 462.

5. Idem, "Aby Warburg's History of Art: Collective Memory and the Social Mediation of Images," *Daedalus* 105/1 (1976), 173.

6. Ibid., p. 175.

7. George Kubler, *The Shape of Time* (New Haven and London: Yale University Press, 1962), p. 1.

8. Idem, *Arquitectura española de los siglos XVII y XVIII* (Madrid, 1957).

9. George Kubler and M. Soria, *Art and Architecture in Spain and Portugal and Their American Dominions, 1500–1800* (Baltimore, MD, 1959).

10. George Kubler, *The Art and Architecture of Ancient America: The Mexican, Maya and Andean Peoples* (Baltimore, MD: 1962).

11. John Onians, "Editorial," *Art History* 1/1 (1978), v.

12. James M. Bower, "One-Stop Shopping: RLIN as Union Catalog for Research Collections at the Getty Center," *Library Trends* 37/2 (Fall 1988), 252-262.

13. Brent Maddox, "Automating the Getty Center Photo Archive," *Art Documentation* (Winter 1986).

14. David Berman and Richard Szary, "Beyond Authorized Headings: Authorities as Reference Files in a Multi-Disciplinary Setting," in *Authority Control Symposium*, Occasional Papers 6; papers presented during the 14th Annual ARLIS/NA Conference, New York, NY, February 10, 1986, Karen Muller, ed. (Tucson: Art Libraries Society of North America, 1987), pp. 69-78.

15. Other contributors are: Avery Index of Architectural Periodicals, Census of Antique Works Known to the Renaissance, Foundation for Documents of Architecture, Provenance Index, RILA, and the Witt Computer Index. See Jim Bower, "The Getty Union List of Artist Names," Master Drawings Association/Art History Information Program (MDA/AHIP) International Conference on Terminology for Museums, 23 September 1988.

16. Nancy Sahli, *MARC for Archives and Manuscript: The AMC Format* (Chicago, IL: Society of American Archivists, 1985).

17. Idem, "Using the AMC Format: How do I make sense of this mess?," paper presented at the Society of American Archivists Conference, October 1985, and at ARLIS/NA, February 1988.

18. Steven Hensen, *Archives, Personal Papers, and Manuscript: A Cataloging Manual for Archival Repositories, Historical Societies, and Manuscript Libraries* (Washington, DC: Library of Congress, 1983).

19. Elisabeth W. Betz, *Graphic Materials: Rules for Describing Original Items and Historical Collections* (Washington, DC: Library of Congress, 1982).

20. Wendy White-Hensen, *Archival Moving Images Materials: A Cataloging Manual* (Washington, DC: Library of Congress, 1984).

21. Linda J. Evans and Maureen O'Brien Will, *MARC for Archival Visual Materials: A Compendium of Practice* (Chicago, IL: Chicago Historical Society, 1988).

22. Elisabeth Betz Parker, *LC Thesaurus for Graphic Materials: Topical Terms for Subject Access* (Washington, DC: Library of Congress, 1987).

23. For more information contact The Art and Architecture Thesaurus, 62 Stratton Road, Williamstown, MA 01267, (413) 458-2151.

24. Deirdre C. Stam, "The Quest for a Code, or a Brief History of the Computerized Cataloging of Art Objects," *Art Documentation* (Spring 1989), 7.

25. Ibid., p. 14.

# 33. Bibliographic Control of Art Materials: The Experience of the Universidade de São Paulo

Claudia Negrão Balby

## The Background of Bibliographic Control

The seminal definition of bibliographic control, as proposed in 1950 by UNESCO and the Library of Congress, focuses on the "mastery over written and published records."[1] The concept of universal bibliographic control, initiated by IFLA and UNESCO in 1974, extends the idea to a worldwide network for control and exchange of bibliographic information, where a national bibliographic agency (NBA) in each country is responsible for collecting, formatting, and disseminating information on all the publications of that country.

The collecting responsibility is usually performed through legal deposit; publishers are obliged by law to submit a copy or copies of all publications to their NBA. Record formats for these works should, in theory, follow internationally adopted classification and cataloging practices in order to facilitate the international transfer of information. The publication of national bibliographies has been the most common method of information dissemination.

Establishing and operating an NBA along such lines is a task of major proportions for any country—and an especially hard one for less-developed countries in the context of economic, political, and socio-cultural dependence. This conditions the way in which information of all kinds is produced and circulated, and might cause many of the functions of an NBA not to be performed.

It is useful at this point to keep Anuar in mind, who states that "qualitative standards and performance or output measures [used for library work in developed countries] offer more promise of being workable and useful [when applied to less-developed countries] provided they are based on the principle of service to the greatest number at the least possible cost."[2]

## Problems of National Bibliographic Control in Brazil

The magnitude of the task of national bibliographic control calls for individual strength and effective cooperation between the agencies

401

involved, namely libraries, publishing houses, and legislative/law enforcement bodies.

Brazilian libraries present great disparities in staffing, resources, and buildings, whether on a regional or subject basis. The Biblioteca Nacional (BN), the NBA in Rio de Janeiro, has a collection of approximately 6 million items, and a staff of 400 people. Space in its main building has been exhausted for many years, but a piece of land for expanding it was acquired in January 1989.

The Brazilian book publishing industry only started to operate along modern concepts, with an interplay between the editing, printing, and marketing sides of the business, in the 1920s. Present output is highly concentrated on textbooks at any level and "required reading" fiction titles for use in primary and secondary schools. The government is a major publisher, especially at federal and state levels, issuing not only its own documents but also fiction and poetry titles. Publication of general interest periodicals is a major activity, but such is not the case for scholarly periodicals or nonprint materials. Distribution services operate largely for titles from major publishing houses, and on a minor scale for titles from university presses and foreign imports. Most commercial publishers are concentrated in Rio de Janeiro and São Paulo. Book publishers are congregated in the Sindicato Nacional dos Editores de Livros and in the Camara Brasileira do Livro, which perform cataloging-in-publication services.

Government regulation of economic and cultural activity has always been very strong. During the years of the military dictatorship (1964–1984), Congress was relieved of many of its powers, and legislative action was concentrated in the executive branch. Social control of legislators through organized practices such as lobbying is a relatively new development. The combination of these factors has meant that for the legal deposit law, the area of concern here, there has been a failure on the part of the federal government to enforce the depository responsibility given to the BN by a 1907 decree. Alves and Menegaz relate five occasions where this responsibility was given to other government agencies.[3] Failure has also been noted on the collection of fines from commercial or government publishers who do not comply with the law, as well as in the updating of fine values in a highly inflationary economy.[4]

Alves and Menegaz have made a study of materials received by the BN in 1983.[5] They took a list of 814 periodical titles published in Brazil in 1983/1984 and found that 25 percent had been received regularly, 25 percent had had publication and/or remittance to the BN discontinued, and 50 percent had not been received. Another list of all

periodicals with ISSNs included 2,380 titles, of which 26 percent fell into the first category, 30 percent into the second, and 44 percent into the third. In analyzing the newspaper collection, they found out that the BN regularly receives 40 percent of all titles published in the state of Rio de Janeiro, and 18 percent of all titles published in other states, which led them to suggest that decentralizing deposits on a geographical basis could lesson such gaps in coverage. From a list of the monographic output of ten major Brazilian publishers in the first half of 1983, the BN had received only 60 percent. They also related that catalog cards issued by the Library of Congress were used to claim works not received.

Gorman and Mills have analyzed the usefulness, for selection purposes, of the national bibliographies of sixty-seven Third World countries, proposing a revision of evaluation criteria for reference works that concentrate on currency, breadth of coverage, adequacy of bibliographic data, and the presence of a directory of publishers and booksellers.[6] Marks were assigned in the first three criteria on a scale of one (poor), two (adequate), and three (good). *Bibliografia Brasileira*, Brazil's national bibliography, was considered poor in currency, adequate in breadth of coverage, and poor in adequacy of bibliographic data. A directory of publishers was not found. This result puts Brazil in sixth place in Latin America, on a par with Costa Rica and Mexico. Guyana and Trinidad and Tobago got first place, and the Dominican Republic got last, just below Brazil. The bibliographies of countries outside Latin America such as Iran, Iraq, Ivory Coast, Laos, Namibia, Senegal, and Thailand got the same evaluation as that of Brazil.

This situation has led Caldeira to state that "in a historical perspective . . . bibliographic control in Brazil shows, on one hand, the involvement of the Biblioteca Nacional, the Instituto Nacional do Livro, and private institutions; on the other hand, there is an overlapping between publications, gaps in coverage, and little efficiency."[7]

### Bibliography Work at the Escola de Comunicações e Artes, Universidade de São Paulo

Escola de Comunicações e Artes was started in 1967 within the Universidade de São Paulo, the largest such institution in Latin America (ECA/USP). It offers graduate and undergraduate courses in the following areas: Library Science, Journalism, Publishing, Fine Arts, Theater, Music, Cinema, Radio, Television, Advertising, Public Relations, and Tourism. The Escola de Arte Dramática (EAD) is an affiliated institution that offers a secondary school certificate in Theater.

The library at ECA/USP was started in May 1970 by four graduates of the first class of the school's Library Science program. Initial stock numbered 500 books, 100 subscriptions to periodicals, and an undetermined number of newspaper clippings, phonograph records, and music scores. The scores formed the nucleus of the present Music Section. Stock was greatly increased the following June; with the incorporation of EAD to ECA/USP the library received 3,500 books, 200 periodical titles, 1,000 typed plays, more sound recordings, and some photographs. The Film Section was started in 1972; the Comics Section in 1983; a substantial collection of 15,000 slides was added in 1984; and a large Newspaper Section was consolidated in 1986. Present stock numbers nearly 68,000 items, distributed as follows: 17,921 books, 1,187 theses and dissertations, 715 typed plays, 1,535 pamphlets, 4,534 art exhibition catalogs, 1,197 theater programs, and 260 course texts; 1,453 journal titles, 360 newspaper titles, 3,907 clipping folders, and 877 comic book titles; 15,000 slides, 124 videos, and 1,203 films; 6,020 records, 3,060 cassette tapes, and 8,537 music scores.

Present staff amounts to 18 librarians (13 graduated from ECA/USP) and 28 library assistants (6 are students of librarianship, 4 at ECA/USP).

Bibliographic control activities were exercised by the library almost from its inception. The first publications were catalogs of collections, five of which are analyzed in the next section of this paper. They were followed by the preparation and publication of subject bibliographies drawn from the library's collection and prepared for the school's graduate and extension courses. Three of these are discussed later in this paper. The first major bibliography incorporating references from other institutions was published in 1981, and was followed by three other titles, which also are analyzed later.

These publications are currently distributed to more than 1,400 individuals and institutions, both in Brazil and abroad. There were 128 requests for copies of these titles in 1988.

Bibliography work was initially an all-library activity, which professional and nonprofessional staff shared with their other responsibilities. In 1986, as part of a major administrative reform, a section was created for bibliographic control in the library's Serviço de Aquisição e Difusão. It is staffed by three full-time personnel, two librarians and one library assistant, who manage the day-to-day collection of references on recently processed materials. Larger retrospective efforts, however, require not only the temporary relocation of staff from other library sections but also the employment of temporary help and of staff from other libraries.

All sorts of difficulties have to be overcome before a bibliography gets published. Most of them are of a financial nature. Problems do not stop at publication, however. The Brazilian educational system is textbook centered until the completion of secondary school, and most schools neither have libraries nor stimulate the use of public ones. Students, even at the graduate level, have problems using reference works and require a lot of encouragement to do so. The full spectrum of library service, from bibliographic arrangement to document availability and delivery, must be very efficient in order to increase the probability of further use by students. In spite of all these drawbacks, a strong belief still exists that collections should be made available to a wider audience through the organization and publication of bibliographies.

## Catalogs of Collections

The *Catálogo de filmes*,[8] a catalog published in 1984, presents 124 annotated references to films housed in the library's Film section. It includes films produced by students from the school's Cinema course until 1983, a few other films produced in association with other institutions, and a number of American films, donated by the Consulate in São Paulo. Films are documentaries, fiction, and animated features. Arrangement is alphabetical by film title, with an index to directors. A typical entry contains film title, director, format, duration, color, date of publication, location number, and a short annotation.

The title *Cinema de animação: catálogo de filmes e bibliografia*[9] was also published in 1984. It contains 88 annotated references to animated films, 75 of which are French productions, deposited in the Film library but recently recalled by the French consulate. Films are divided in four categories: cartoons, marionettes and clay figures, puppets, and experimental techniques (such as tabletop animation). Arrangement within category is by film title, with indexes to film duration (1 to 15 minutes), and to the films produced by ECA/USP. A typical entry contains film title, translated title, director, format, date of production, color, location number, and a short annotation. The bibliography at the end of the volume lists 279 references to books, journals, and newspaper articles in the library's collection.

Both publications will be superseded later by an annotated catalog of all 16- and 35-mm films, with an index to directors and an appendix listing films produced for the Cinema course.

*Catálogo de filmes etnológicos*[10] was published in 1987 and contains 62 references to films on Brazilian Indians produced by the Institute for Scientific Films of Göttingen, West Germany. All films are silent and

in 16-mm. They are divided in the following subjects: feather art; necklaces, earrings, etc.; decoration and deformation of the body; masks; agriculture; water; hunting; ceramics; fights and races; cooking processes; cooking utensils; dance; fire; manioc; fishing; fan weaving; toy weaving; basket weaving; weaving of floor coverings; urucu (a vegetable dye); clothing. Entry is by name of Indian group followed by region, title, director, date of production, location number, and a substantial annotation. An index to Indian groups, a small glossary of Indian terms, and a short bibliography can be found at the end of the volume.

The *Catálogo do serviço de difusão de partituras*[11] was published in 1986. The Serviço de Difusão de Partituras (SDP) was created in 1978 to make a growing collection of unpublished scores by Brazilian composers available to a larger public. Most of the collection consists of contemporary pieces, deposited in the collection by the composers. Photocopies are made upon request by users. Ten percent of the copying fee is then returned to the composer (foreign charges are US$2.00 for a minimum of 40 pages). The pioneer quality of this service deserves notice, not with respect to Brazilian music but because copyright law is very incipient in Brazil, causing photocopying to be done extensively without regard for authors' rights. An average of 70 scores are reproduced monthly.

The catalog was published using a specially developed program called AURI which runs on mainframe computers. Arrangement is alphabetical by composer, followed by date of birth when available. Works are entered by title under the following categories: solo voice, choir, instrument(s), instrumental ensembles, orchestra. Entries follow this pattern: location number, title, date, specification of choir composition/instrument, or instrument combination/composition of instrumental ensemble, total number of pages including score and parts. A form for requesting copies can be found at the end of the volume.

This catalog is out-of-print and was superseded in 1989 by a revised edition containing 1,200 scores. It is being produced on an IBM-PC-compatible computer, using UNESCO's Micro CDS-Isis program.

The *Catálogo de teses*[12] published in 1985 lists 347 theses and dissertations from Brazilian universities. Arrangement is by author, followed by standard bibliographic entry and name of advisor. Location numbers precede each reference. Subject and adviser indexes are found at the end of the volume. This catalog is also out-of-print and will be revised.

## Shorter Bibliographies

The *Balanço da modernidade: bibliografia* [13] was published in 1986 to support an extension course offered by the Departamento de Artes Plásticas, called "Balanço da Modernidade: o artístico e o estético nas décadas de 70-80." It contains 411 references to books, theses, pamphlets, and periodical articles published in Brazil, art exhibition catalogs, and slides. Entries follow standard bibliographic form under the first two categories and an adaptation of that under the third. Appendix 1 lists titles of foreign periodicals which were not surveyed but could be of interest to users, and Appendix 2 enumerates records and scores of works by minimalist composers. A list of periodicals with publisher, place of publication, and scope of the collection surveyed is also featured. This bibliography is currently out-of-print.

The *Glauber Rocha: bibliografia* [14] published in 1984, three years after the death of the Brazilian filmmaker, lists 428 references on and by Glauber Rocha. They are further subdivided under monographs, film scripts, journal articles, and newspaper articles. There is an index to films cited in the references, a list of periodicals surveyed, and a biography/filmography.

*Teatro de bonecos: bibliografia,* [15] a bibliography on puppets, marionettes, shadow theater, and masks, published in 1986, has 404 references divided in three sections: works about the subject (books, chapters in books, theses, exhibition catalogs, pamphlets, journal articles, newspaper articles), and plays for puppets and films (documentaries or filmed plays). A list of periodicals surveyed is presented in the final pages.

## Larger Cooperative Bibliographies

*Bibliografia da dramaturgia brasileira (BDB)* [16] is a joint project of the library at ECA/USP and of the library at Museu Lasar Segall. The latter, besides holding a collection of documents on and by that Brazilian painter, also covers the areas of radio, cinema, television, and theater, with special emphasis on Brazil. *BDB* has as its objective the listing of plays by Brazilian authors which can be found in São Paulo libraries.

Materials from the following library collections were included, besides the libraries cited above: the Biblioteca Municipal Mário de Andrade (the city's main public library); the Conservatório Dramático e Musical (a school of music and theater); the Instituto de Estudos Brasileiros/USP (the research institute/archive for Brazilian studies, and especially the collection of Brazilian author Mário de Andrade); the Biblioteca Central/USP (the former main library whose holdings

have now been incorporated into the libraries of the schools and institutes); and the Biblioteca do Conjunto de Letras/USP (the Language Department).

Arrangement is alphabetical by author. A typical entry contains a standard bibliographic reference, the code for the library or libraries where it can be found, and an indication of the number of acts and characters for each play. Indexes by title and by number of characters are found at the end of the volume, as well as a list of periodicals with title and place of publication.

Volume 1 was published in 1981, containing 1,471 references from A to M, and is currently out-of-print. Volume 2 (N-Z) was published in 1983, with 1,602 references. An additional collection was searched for this volume, that of Instituto Nacional de Artes Cênicas in Rio de Janeiro, a research institute subordinate to the Ministério de Educação e Cultura.

The preface to this volume states an intention to publish supplements on a regular basis (which has not been possible because of many personnel and financial problems), as well as a volume on children's plays, published in 1989. This contains 1,085 references through 1988.

*Arte-Educação no Brasil: bibliografia (AEB)* [17] is a bibliography on art education, produced as a joint project of ECA/USP and of Associação de Arte-Educadores do Estado de São Paulo (AESP). The *AEB* lists 803 references found in the following library collections: Museu Lasar Segall, Biblioteca Municipal Mário de Andrade, Centro Cultural São Paulo (a public library/cultural center complex), Centro Brasileiro de Construções Escolares (a Rio-based research center on school buildings), Fundação Armando Alvares Penteado (a São Paulo private college), Faculdade de Educação da Universidade Federal da Bahia, Faculdade de Educação/USP, Instituto de Estudos Brasileiros/ USP, Instituto de Psicología/USP, Museu de Arte Contemporâneo/USP, and ECA/USP.

The *AEB* is divided into thirteen sections: theory and foundations, history, methods and experiences, legislation, creativeness, perception, fine arts, drawing, cinema, music, theater, audiovisual materials, and radio and television.

References are presented under each category, further subdivided into monographs (books, chapters in books, theses) and periodicals (journals and newspapers), and arranged alphabetically by author. The code for the holding library or libraries is also included. An author index and a list of periodicals can be found in the final pages.

A revision and extension of this bibliography covering the years 1984–1988 is in preparation, with some assistance from the Ministério da Cultura.

The *Bibliografia brasileira de comunicação (BBC)*, published since 1978, is perhaps the most comprehensive of all bibliographies analyzed here, both in subject coverage and in frequency of publication.

The first seven volumes published include the following art-related subjects: carnival, cartoons, cinema, circuses, *cordel* literature, creativeness, dance, aesthetics, photography, fine arts, popular music, theater, video.

The driving force behind it is the Sociedade Brasileira de Estudos Interdisciplinares da Comunicação (INTERCOM), a São Paulo-based scientific society with a strong commitment to documentation. Volumes 1-3 and 7 of the *BBC* were organized and published by INTERCOM. Volumes 4-6 were issued in cooperation with the library at ECA/USP.

The first volume[18] covers original and translated books and articles published up to 1977. Straubhaar,[19] however considers the coverage of materials published in the mid-seventies to be most complete. References are arranged alphabetically by author under two broad classes: a "list according to the nature of the object of study," e.g., journalism, leisure, photography, and so on, and a "list according to the point-of-view of the analysis": anthropological, legal, philosophical, linguistic, and so on. References are sometimes repeated in more than one category owing to the absence of a subject index. Such an arrangement, never to be adopted again, could be said to be a reflection of a time when the area of Communications was still in the early stages of definition, and borrowed concepts, from long-established sciences, on a much heavier scale than it is today. References are not annotated. A list of periodicals is included in the final pages.

Volume 2,[20] published in 1979, focuses scope on works published in Brazil in 1978 and expands the list of subjects. The 609 references carry annotations and are presented in alphabetical order under subjects. There are two review articles: one on Brazilian communications periodicals in 1978 and one on books translated in the same period. A retrospective compilation of 258 references on the Brazilian press from 1946 to 1978 has been included, as well as a list of 44 theses and dissertations presented to Brazilian universities in 1978. There is a list of periodicals, but there are no indexes.

The third volume, published in 1981,[21] lists 373 annotated references to books and pamphlets published in the preceding two years. Coverage of theses and periodical articles was dropped owing to

lack of staff for reviewing. Arrangement is by alphabetical order of author under subjects, without indexes.

Volume 4,[22] published in 1982, covers 1981 and 1982. It is the product of a consolidation of INTERCOM's documentation activities, represented by the creation, in January of that year, of the Centro de Documentação da Comunicação nos Países de Língua Portuguesa (PORT-COM), aiming to extend coverage to documents published in lusophone Europe and Africa. This volume was partly financed by Conselho Nacional de Desenvolvimento Científico e Tecnológico (CNPq), a federal institution, and was the first one to be organized in cooperation with the library. The scope was extended to include books on Brazil published abroad, but not periodicals. Theses and dissertations are listed in an appendix with 61 references. The core of the bibliography consists of 154 references arranged in the same pattern as in volumes 2 and 3, and complemented by author and detailed subject indexes. A bibliography on animated films is also included, containing 195 references to books and journal and magazine articles.

The fifth volume,[23] continuing the same scheme of cooperation, was published in 1983 to cover the preceding year. Financial resources from CNPq were channeled through the Instituto Brasileiro de Informação em Ciência e Tecnologia (IBICT), a federal agency responsible for defining and implementing information and documentation policies for Brazil. This volume brought back the coverage of periodical articles, and included a form for requesting copies. The 556 annotated references are again divided under broad subjects, with author and detailed subject indexes. There is a list of theses with 39 items, and one of periodicals that presents the scope of the surveyed collection under each title.

Volume 6,[24] published in 1984 to cover 1983, continued the same agreements for organization and financing as in the preceding volume. It carries 265 references under the same arrangement adopted since volume 4. An appendix lists a substantial bibliography on popular communication in Brazil, organized by INTERCOM, whose introduction makes a call directed at Brazilian researchers toward the establishment of a conceptual and methodological formulation of the field. The bibliography has 238 references, ordered alphabetically under author and extensively annotated. It was the last volume to be organized by the library.

Volume 7[25] was published in 1987, in honor of the ten years of INTERCOM. It is dedicated to works published by the society itself during that period, and brings 408 references with short annotations.

Arrangement is alphabetical by author under broad subjects, and is complemented by an author index.

Joint publication ceased in 1984, but the library has not interrupted the process of collecting references. A decision must be made, which the Bibliography Section cannot do on its own, as to the disposition of the 689 references accumulated since then.

*Bibliografia da música brasileira (BMB)*, [26] published in 1988, covers the years 1977–1984. This is the first step in a broad-based project to collect, organize, and disseminate works on Brazilian popular, classical, and folk music published in Brazil and abroad. The project includes publication of a retrospective volume to 1976, and of updated supplements from 1985. There is also a desire to extend it to other document forms such as music scores, records, films, videos, catalogs, and so on.

This volume was published in cooperation with the research division of the Centro Cultural São Paulo (CCSP). The following library collections were surveyed: the Biblioteca Mário de Andrade, the Biblioteca Nacional, the CCSP, the Instituto de Estudos Brasileiros/ USP, the Instituto Nacional do Folclore, the Pontifícia Universidade Católica de São Paulo, and the ECA/USP. Materials include books, pamphlets, dissertations, and periodical articles. Newspaper articles have been excluded, except for more substantial ones published in several weekly culture and arts supplements.

References number 2,239 and are presented alphabetically by author, with keys to document location. There is a very detailed subject index, as well as a name index. A list of periodicals is also included.

## Conclusion

Urgent revision of legal deposit legislation is required if the Biblioteca Nacional is to perform fully its role as Brazil's NBA. Discussion also is needed on the models of deposit: the present centralized one, or a decentralized model based on the establishment of regional deposit centers, following geographic or subject criteria.

Should the second model be adopted, political considerations are likely to interfere in the choice of regional centers, because of the increased status and financial resources that the chosen library could gain.

In order to minimize the possible negative effects of such an interference, decisions must be preceded by thorough and independent assessments of the bibliographic performance of centers in the regions or subject areas under consideration, among themselves and in relation to the performance of Biblioteca Nacional in the same regions or areas.

It is hoped that this paper, by describing the bibliographic control work of the library at ECA/USP, might serve as an aid to such assessments in the areas of Communications and Arts.

Whichever model is adopted, libraries specializing in those areas might begin by getting to know each other's strengths and weaknesses, in order to establish cooperative programs in all fields of library activity.

## NOTES

1. Julian Warner, "British Library Microform Publications and Their Bibliographic Control," *Journal of Librarianship* 20/3 (July 1988), 159-180.

2. Hedwig Anuar, "The Library and Information Dimensions of the North-South Dialogue: Some Thoughts on the Threshold of the 21st Century," *IFLA Journal* 13/4 (1987), 232.

3. Marília Amaral Mendes Alves and Ronaldo Menegaz, "Depósito legal: Esperança ou realidade" *Revista de biblioteconomia de Brasília* 15/1 (Jan./June 1987), 39.

4. Paulo da Terra Caldeira, "A situação do Brasil em relação ao Controle Bibliográfico Universal," *Revista da Escola de Biblioteconomia da UFMG* 13/2 (Sept. 1984), 270.

5. Alves and Menegaz, p. 42.

6. G. E. Gorman and J. J. Mills, "Evaluating Third World National Bibliographies as Selection Resources," *Library Acquisitions: Practice and Theory* 12/1 (1988), 29-42.

7. Caldeira, p. 281.

8. Universidade de São Paulo, Escola de Comunicações e Artes, Biblioteca, *Catálogo de filmes* (São Paulo: Secretaria de Estado da Cultura, 1984), 26 pp.

9. Ibid., *Cinema de animação: Catálogo de filmes e bibliografia* (São Paulo: Secretaria de Estado da Cultura, 1984), 37 pp.

10. Ibid., *Catálogo de filmes etnológicos* (São Paulo, 1987), 43 pp.

11. Ibid., *Catálogo do serviço de difusão de partituras* (São Paulo, 1986), 38 pp.

12. Ibid., *Catálogo de teses* (São Paulo, 1985), 60 pp.

13. Ibid., *Balanço da modernidade: bibliografia* (São Paulo, 1986), 34 pp.

14. Ibid., *Glauber Rocha: bibliografia* (São Paulo, 1984), 43 pp.

15. Ibid., *Teatro de bonecos: bibliografia* (São Paulo, 1986), 38 pp.

16. *Bibliografia da dramaturgia brasileira*, 2 vols. (São Paulo: ECA/USP, Museu Làsar Segall, 1981–1983).

17. *Arte-Educação no Brasil: bibliografia* (São Paulo: ECA/USP, AESP, 1984), 81 pp.

18. *Bibliografia brasileira de comunicação*, vol. 1 (São Paulo: INTERCOM, 1978), 49 pp.

19. Joseph D. Straubhaar, "The Brazilian Society for Interdisciplinary Study of Communication and Its Brazilian Bibliography of Communication [Bibliografia Brasileira de Comunicação]," *Studies in Latin American Popular Culture* 2 (1983), 262-267.

20. *Bibliografia brasileira de comunicação*, vol. 2 (São Paulo: INTERCOM, 1979), 162 pp.

21. Ibid., vol. 3 (São Paulo: INTERCOM, ECA/USP; São Bernardo do Campo, IMS, 1981), 80 pp.

22. Ibid., vol. 4 (São Paulo: INTERCOM, ECA/USP; Brasília, CNPq, 1982), 93 pp.

23. Ibid., vol. 5 (São Paulo: INTERCOM, ECA/USP; Brasília, IBICT, CNPq, 1983), 152 pp.

24. Ibid., vol. 6 (São Paulo: INTERCOM, ECA/USP; Brasília, IBICT, CNPq, 1984), 209 pp.

25. Ibid., vol. 7 (São Paulo: INTERCOM, 1987), 136 pp.

26. *Bibliografia da música brasileira: 1977–1984* (São Paulo: ECA/USP/Serviço de Biblioteca e Documentação, CCSP/Divisão de Pesquisas, 1988), 275 pp.

# Part Four
# Art Collections

La profunda crisis social, política
y filosófica que sacude esta época,
encuentra en el arte plástico la más
conmovedora, la más elocuente
expresión.

—Felipe Gil
*Uruguayan artist*

# 34. The Museum of Modern Art of Latin America: A Guide to Its Resources

## María Leyva

The Museum of Modern Art of Latin America in Washington, DC, is dedicated exclusively to the collection, exhibition, and study of the art of Latin America and the Caribbean. The programs and collections of the Museum offer an opportunity to examine the twentieth-century art of Latin America within a cultural context and to gain a deeper understanding and appreciation of the diverse cultures and visual traditions of this broad geographical area. Its specific regional focus gives the Museum unique value on both a local and an international level.

Although the Museum was officially inaugurated in October 1976, its history dates back to 1917 and the establishment of an Education Section within the Pan-American Union which included inter-American cultural relations among its activities. The Education Section later became the Office of International Cooperation, with a specialized section on the visual arts which continued to operate under the Department of Cultural Affairs when the latter was created in 1948. As an outgrowth of the Visual Arts Unit, the principal programs of the Museum today have their roots in those of the Unit: the archives and reference files were initiated in the late thirties; the temporary exhibitions program was formally established in 1946; the first donation of artwork was made in 1949; a fund to purchase works for a permanent collection was created in 1957; and the audiovisual program was begun in 1959. The visual arts activity of the Organization of American States (OAS) was closely identified with the name of the Cuban-born art critic José Gómez-Sicre, who during more than thirty-seven years at the OAS, as chief of the Visual Arts Unit and then as founder and first director of the Museum of Modern Art of Latin America, was instrumental in shaping the direction of the exhibitions and collections.

The building that now houses the Museum was formerly the residence of the Secretaries General of the OAS. Completed in 1912, it was designed in Spanish colonial style by architects Paul Cret and

---

*Editor's Note:* In 1991 the Museum was renamed the Art Museum of the Americas.

Albert Kelsey and funded in part by the American philanthropist Andrew Carnegie. The Museum also has a small gallery for temporary exhibitions in the historic OAS Headquarters building, which has ben the site of art exhibits since the 1940s. The audiovisual program and administrative offices are adjacent to the Museum building in what was formerly the carriage house of the Van Ness estate, on the grounds of which the OAS building was constructed. The archives and reference center have recently been relocated to the OAS Columbus Memorial Library.

One of the principal reasons for establishing the Museum of Modern Art of Latin America in 1976 was to give proper care to the art collection acquired through the Visual Arts Unit, which had rapidly outgrown the space available for exhibition. Today the collection continues to be the foundation and principal asset of the Museum.

The first work to enter the collection in 1949 was a painting by Candido Portinari, a gift of José Gómez-Sicre. Over the next several years various gifts were made, including paintings by Pedro Figari, from the Bank of the Republic of Uruguay; by Roberto Matta, from the Workshop Center for ot Arts in Washington, DC; and by Joaquín Torres-García, from Nelson Rockefeller.

In 1957 the OAS Council established a modest Purchase Fund to support the acquisition of art for a permanent collection which was to reflect the contemporary art of the member nations of the OAS. The Museum's purchases were, and continue to be, strongly linked to and influenced by the direction of the exhibition program. A significant number of works in the collection were purchased directly from the artists on the occasion of a temporary exhibition at OAS headquarters. Early purchases were paintings by Alejandro Obregón, Sarah Grilo, Alejandro Otero, Alberto Gironella, Armando Villegas, Eduardo Ramírez Villamizar, Fernando de Szyszlo, María Luisa Pacheco, Carlos Mérida, and a drawing by José Luis Cuevas.

By the end of 1960 the collection numbered a total of forty-nine works. In 1949 it was significantly enriched by a donation from the IBM Corporation which included paintings by Amelia Peláez, Héctor Poleo, Mario Carreño, and Rodrigo Peñalba. This donation was supplemented by IBM in 1985 with a major painting by Emilio Pettoruti.

The funds allocated to the Museum's Purchase Fund have always been minimal, averaging about $2,500 a year from 1957 to date. Despite this limitation, the collection has been continually enriched, in large part through the generosity of collectors and the support of artists

who have allowed the Museum to acquire works at truly token prices. Numbering 230 works in 1976 when the Museum was inaugurated, the holdings, in various media, have grown to more than 800 from 25 countries.

New installations of the permanent collection are periodically mounted to draw attention to varying facets of the art of Latin America and to emphasize new relationships among the work of different artists. The most recent installation, funded in part by a grant from the National Endowment for the Humanities (NEH) in 1985, displays approximately 120 works, primarily paintings. It is divided into five principal sections: Pioneers and Teachers, the Geometric Tradition, Lyric Abstraction, Figurative Artists, and Latin American Folk Visions. Within these broad groupings, the installation and educational materials produced for the exhibition reflect the complex cultural, historical, and socioeconomic factors that have contributed to the diversity of creative expression in Latin American art and highlight regional differences among the countries with strong pre-Hispanic, African, or European traditions.

A recurring motif in the collection, for example, is that of content derived from ancient cultures, particularly evident in the Mexican, Central American, and Andean sections of the collection. This can be a descriptive or archaeological interpretation of pre-Hispanic material or an attempt to penetrate its underlying mythical content.

In the early part of the century the approach tends toward the literal. With the influence of the Mexican muralists, attention was centered on an Indian population that, up to then, had largely been ignored. Nationalism was elevated to the level of artistic doctrine in homage to the Indian and the pre-colonial past.

In the fifties and sixties a concern for the modernization of forms through experimentation with abstraction and with new techniques and surface textures is evident, yet at the same time there persists an emphasis on links with past traditions. The patterning and clustering of forms in abstract compositions, the chromatic effects of color, the rhythmically insistent repetition of hieroglyphic motifs, a sense of ancient geometry, or an inclination toward duality of figures have resonances suggestive of pre-Columbian craftsmanship, ritual, or myth. For instance, the Guatemalan-born Carlos Mérida's investigative research into Mayan mythology and decorative motifs, the rhythms of pre-Columbian dance, regional costumes, and popular traditions is subtly echoed in his abstract paintings. There is recurrent reference to pre-Columbian art in the repertory of symbols evolved by Joaquín Torres-García in his constructivist compositions. In a number of his

paintings a gray chalky background is reminiscent of ancient stone surfaces evoking at times the pillow-like organic quality of Inca masonry. The massive volumes and spiritual tone of the reclining figures of the Mexican Ricardo Martínez are frequently linked to Toltec iconography. On a literal level, the titles given by artists to their works, such as *Pre-Columbian*, *The Feathered Serpent*, *Superstition*, *Ritual Table*, or *The House of Tataniuh*, reinforce the mood. In a somewhat different vein, the isolation of elements associated with present-day Andean imagery (the traditional hat and poncho of the Bolivian Indians, for example) from the expected context of the wearer, heightens their symbolic force in the compositions of Enrique Arnal.

In the Caribbean countries and Brazil, where there has been an important African cultural presence, many artists have explored the possibilities of giving artistic force to these traditions. The popular celebration of carnival is a theme that has appealed to artists such as Emiliano di Cavalcanti and Candido Portinari of Brazil and Pedro Figari of Uruguay. In the shield-like figures, horned shapes, and horse-women that people the work of Cuban Wifredo Lam, there is a ritualistic, fetish-like quality that relates more to an interest in the inner meaning or symbolic value of African cultural elements and their role in Caribbean traditions than to their outward formalistic expressions. The orientation is somewhat different from that of artists working in Paris during the early part of the twentieth century, when motifs of African art were grafted onto modern painting. In the work of the Jamaican Everald Brown, a Rastafari priest and self-taught artist, hidden meanings related to religious practice and beliefs are communicated to an initiated group through a repertory of symbols in a direct and unself-conscious manner.

The visual legacy of the colonial period can be seen in a number of works in the collection. In the paintings of Amelia Pelaez, it is her highly original and personal interpretation of architectural and decorative elements of the colonial period in Cuba which grounds her work in a Latin American context. A thick black line, outlining areas of intense color, may recall the stained glass of fanlights, a free-flowing arabesque line may evoke the baroque design of decorative ironwork or the weave of wicker furniture. In the works of the Panamanian Brooke Alfaro a fusion of traditional religious imagery with popular folk sources is reminiscent of colonial painting.

The treatment of such traditional institutions as the Church, the state, and the military often reflects a similarity of political and cultural history, specific to certain regions in Latin America. The Mexican mural movement, a focal point of the rebirth of Mexico's art, as well as

the visual projection of a new national identity, was directly reflective of the political climate of the time. In the work of Fernando Botero, the treatment of traditional institutions takes on an irreverent tone. In a more serious vein, Alejandro Obregón, another Colombian, has, at different times during his career, produced works related to the political violence in his country since 1948. *The Wake* belongs to a group of paintings commemorating students and popular figures who lost their lives during this period of social unrest. Bananas of monumental proportions are elevated to symbols of national identity in the work of the Brazilian Antonio Henrique Amaral and take on possible political overtones of repression in those compositions where the fruit is bound by ropes and stabbed by forks.

The work of many artists represented in the collection could be included in this discussion of regional references. A number have been highlighted here in the context of one of the principal themes of the SALALM conference—that of artistic diversity stemming from the carryover of past traditions blended with new influences. As elsewhere, Latin American contemporary artists have also manifested interest in the total elimination of subject matter in art in favor of purely geometric form and structure and work that is strictly nonreferential in character. The collection reflects this plurality.

Of the more than 800 works in the collection, about 35 percent are paintings, ranging in date from 1909 to the present, with particular strength in the decades of the fifties and sixties. The following list provides a cursory view of their geographic and artistic representation.

*Argentina*
Víctor Chab, Jorge de la Vega, Ernesto Deira, José Antonio Fernández-Muro, Sarah Grilo, Raquel Forner, Eduardo MacEntyre, Ary Brizzi, Emilio Pettoruti, Rogelio Polesello, Kasuya Sakai, Miguel Angel Vidal

*Bolivia*
Enrique Arnal, María Luisa Pacheco

*Brazil*
Antonio Henrique Amaral, Danilo di Prete, Tikashi Fukushima, Manabu Mabe, Tomie Ohtake, Cândido Portinari, Yutaka Toyota, Cybele Varela, Kazuo Wakabayashi

*Chile*
Enresto Barreda, Roberto Matta, Guillermo Núñez, Rodolfo Opazo, Mario Toral

*Colombia*
  Fernando Botero, Enrique Grau, Luciano Jaramillo, David Manzur, Alejandro Obregón, Eduardo Ramírez-Villamizar, Omar Rayo
*Cuba*
  Cundo Bermúdez, Mario Carreño, Agustín Fernández, Wifredo Lam, Amelia Pelaez, Fidelio Ponce, Rene Portocarrero
*Ecuador*
  Estuardo Maldonado, Enrique Tabara, Aníbal Villacis, Manuel Rendón
*El Salvador*
  Benjamín Cañas
*Guatemala*
  Rodolfo Abularach, Carlos Mérida, Elmar Rojas
*Mexico*
  Pedro Coronel, Rafael Coronel, Alberto Gironella, Manuel Felgúerez, Ricardo Martínez, Vicente Rojo, Antonio Pelaez
*Nicaragua*
  Alejandro Aróstegui, Armando Morales, Rodrigo Peñalba
*Panama*
  Brooke Alfaro, Alberto Dutary, Guillermo Trujillo
*Paraguay*
  Pablo Alborno, Carlos Colombino, Enrique Careaga
*Peru*
  Carlos Dávila, Fernando de Szyszlo, Armando Villegas, Venancio Shinki
*Puerto Rico*
  Luis Hernández Cruz, Julio Rosado del Valle
*Uruguay*
  José Cúneo, Pedro Figari, Joaquín Torres- García
*Venezuela*
  José María Cruxent, Carlos Cruz Díez, Humberto Jaimes Sánchez, Alejandro Otero, Héctor Poleo, Alirio Rodríguez, Jesús Soto

The graphics collection, which includes prints, drawings, and a small number of photographs, makes up approximately 60 percent of the collection of which nearly two-thirds are prints. By its very nature printmaking had a strong appeal for the Latin American artist. The relatively low cost of materials and the desire to communicate on an intimate scale with the viewer may account in part for the importance assigned to printmaking in Latin America.

The print collection includes both artists who have dedicated the greater part of their careers to printmaking and those best known as painters who have experimented with graphics. It reflects both the aesthetic, thematic, and conceptual changes in Latin American art history and the technical advances in the printmaking field. The artists included range in time from the Mexican José Guadalupe Posada (1852–1931) in individuals born in the 1950s. The first print to enter the collection was a lithograph by Rufino Tamayo acquired in 1960. A significant number of prints were obtained for the collection as a result of an artist-in-residence program funded by the OAS Fellowship Office in the early 1960s. Gifts and extended loans from private collectors and from corporations such as Cartón y Papel have also enriched the Museum's graphic holdings.

Highlights of the print collection include a number of Posada's *calaveras*, in which people, things, even ideas are given the forms of living skeletons, a recurring motif in Mexican popular tradition derived from both pre-Hispanic and Catholic religious roots; Carlos Mérida's *Carnivals of Mexico, Dances of Mexico*, and *Costumes of Mexico*; prints by the Mexican muralists José Clemente Orozco and David Alfaro Siqueiros, and by artists of the Taller de Gráfica Popular (TGP); and woodcuts by José Sabogal and Lasar Segall. Also represented are artists highly influential in the graphic arts renaissance of the 1950s and 1960s and in the growing recognition given to printmaking, such as Antonio Berni, Mauricio Lasansky, José Luis Cuevas, Antonio Frasconi, Luis Solari, Francisco Toledo, and Omar Rayo. A traveling exhibition drawn from the print collection, entitled "Huellas gráficas," was recently presented at the VII San Juan Printmaking Biennial in Puerto Rico.

Only a small part of the collection—about five percent—is devoted to sculpture, partly because of cost and transportation difficulties. Sculptors represented in the collection include Alfredo Bigatti of Argentina, Juan José-Sicre and Roberto Estopiñan of Cuba, Edgar Negret of Colombia, Hermann Guggiari of Paraguay, Joaquín Roca Rey and Raúl Validivieso of Chile, Alfredo Halegua of Uruguay, and George Liautaud of Haiti.

Building a strong permanent collection continues to be a key mission of the Museum. Limitations of funds and accessibility have contributed to certain regrettable omissions both of countries and of artists. The collection is not static but continually changing. The Museum plans to strengthen it by filling gaps gradually as circumstances and budgets permit.

In 1985 the Museum published a catalog of selected holdings with an introduction by the Argentine-born art critic Marta Traba. The 222-page publication covers 130 works with reproductions (in black and white and color) for each entry. The catalog is available for purchase.

The temporary exhibition program, initiated in the 1940s as a means of giving Latin American artists the opportunity to show their work outside of their countries, is the oldest continuing program of its kind in the United States. Up to 1985 more than 2,500 artists had exhibited at the OAS headquarters. For many of them, such as Botero, Cuevas, Obregón,Szyszlo, Forner, and Mabe, to name but a few, these exhibitions constituted their first opportunity to present a one-man show in the United States and, in many cases, the first exhibition outside their native country. Artists who exhibited either individually or in group during the early years of the program include Figari and Peláez (1946); Portinari, Mérida, Tamayo, Poleo, Dr. Atl, Charlot, Orozco, Rivera, and Siqueiros (1947); Frasconi, Antúñez and Otero (1949); Mérida (1951); Torres-García (1950); Matta (1955); and Orozco (1958).

The program of temporary exhibitions continues to be an integral part of the Museum's activities. Generated both from within the institution and from outside, they explore broad themes in Latin American art or are devoted to the art of a single nation or individual artist. To name a few: "Amelia Pelaez: a Retrospective," "The Magic Line: Drawings by Pedro Figari," "Latin American Artists in Washington Collections," and "Images of Silence: Photography from Latin America and the Caribbean in the Eighties." By also continuing to introduce the work of young talented artists, the program offers the U.S. public an opportunity to come into contact with new values and current artistic concerns in Latin America. Since 1976 the Museum has inaugurated a "tribute" series of retrospective or anthological exhibitions in recognition of the subsequent contributions of artists who exhibited early on in their careers through the temporary exhibitions program. To date, those featured in this series include Cuevas; Mabe; Botero, Grau, Obregón, Negret, and Ramírez-Villamizar (in the exhibition "Five Colombian Masters"); Poleo; Pacheco; and Cañas.

A chronological listing of all the exhibitions presented at the OAS since 1946, containing for each entry a reprint of the original exhibit catalog with introductory texts, checklists, and artists' biographical data, is currently being prepared. To facilitate its use as a reference source, it will be indexed both by artist and by country.

The Museum's audiovisual program, initiated in the late fifties, is an important complement to the art and archival collections, broadening their significance by providing insight into the cultural heritage of Latin America. Given the difficulty of obtaining this kind of material both in the United States and in Latin America, the program serves as a particularly important educational resource for institutions and individuals interested in the study of Latin American art and culture.

The program is composed of a collection of color slides, 16-mm films, and video cassettes on cultural expression in Latin America. The photographic archive houses a collection of more than 20,000 color slides. From among them the program has produced more than 300 slide sets composed of ten 35-mm slides, each with an accompanying descriptive pamphlet. Titles include sets on housing, agriculture, architecture, markets, regional traditions, dances, carnival, crafts, religious festivals, general views of major cities, and pre-Columbian, colonial and twentieth-century painting, sculpture, and graphics, as well as sets on the permanent art collection and on the construction and dedication of the Pan-American Union Building designed by architect Paul Cret.

The audiovisual program has also produced a series of more than forty documentary films on Latin American art and culture. These include films on individual artists represented in the collection, on specific themes such as the eighteenth- and nineteenth-century *santos* of Puerto Rico or the pre-Columbian monoliths of San Agustín, and on general patterns of culture within a particular country. The films have been narrated by such well-known personalities as Joan Crawford, José Ferrer, John Gavin, Dolores del Río, Shirley Temple Black, Claudette Colbert, Amelia Bence, and China Zorrilla. The documentary on the Honduran artist José Antonio Velasquez won honorable mention at the Bratislava International Film Festival and CINE's Golden Eagle Prize in the United States. The documentary film on the Venezuelan artist Jesus Soto was also awarded a Golden Eagle.

In the late seventies, through a grant from the Cafritz Foundation, the Museum initiated a classic film collection which now numbers about fifty films from Argentina, Brazil, Mexico, Peru, and Venezuela. The directors represented include María Luisa Bemberg, Luis Penzo, and Luis Saslavsy of Argentina; Carlos Diegues, Bruno Barreto, and Glauber Rocha of Brazil; Luis Buñuel and Emilio Fernández of Mexico; and Franco J. Lombardi of Peru.

A catalog of audiovisual materials for sale through the Museum is produced annually and distributed to close to 20,000 institutions in the

United States and Latin America. The most recent lists 312 slide sets and 43 films available in all videocassette formats (U-MATIC 3/4" VHS or BETA) and in Spanish and English versions.

The Museum's archives and reference center is devoted to the collection and preservation of printed materials related to Latin American art and constitutes one of the richest existing sources of documentation on this subject, in reality, this important collection is more a library than an archive. With its unique regional focus the archival collection greatly amplifies the significance of the Museum's permanent art collection and serves as a central clearinghouse for information on art that in many cases is not readily accessible elsewhere. Initiated in the late 1930s, the collection comprises books, critical studies, exhibition catalogs, monographs, autographed artists' letters, artists' biographies, writings and statements, newspaper and magazine clippings, black-and-white photographs of art objects in public and private collections around the world, Museum administrative papers, and other documents related to the study of art movements and artists in Latin America. Although primarily focused on twentieth-century art, the holdings also include small collections on pre-Columbian art and on film and theater. Items have been received from artists, OAS offices away from headquarters, galleries, museums, artists, collectors, universities, and other sources. The collection is regularly consulted by staff, students, scholars, collectors, curators, and others interested in the art of Latin America. Roughly 400 linear feet in size, it is arranged alphabetically by individual artist or country, and chronologically by OAS exhibition. A card catalog refers the user to the corresponding file. Historical records on the institution and individual art objects in the collection are grouped separately.

The OAS Columbus Memorial Library, adjacent to the Museum but administered separately, complements the resources of the archives, housing more than 500,000 volumes on Latin America and collections of periodicals, rare books, manuscript, photographs, and other graphic materials. The Museum is currently adding to the Library's on-line database all art books in the archives, making bibliographic data for these items more readily accessible to the international community. Cataloging at the Library is accomplished through the OCLC system.

The wide variety of material included in the artists' files not only provides a vision of the creative process of specific artists but also reflects, during a particular time period, many of the issues faced by artists throughout Latin America working outside of Western mainstream art. The files capture the spirit of the polemical discussions

surrounding debates on abstract versus figurative art and the question of maintaining and preserving an authentic cultural identity within the international art community, without being limited to the folkloric or the local.

# 35. Artistic Representation of Latin America in German Book Collections and Picture Archives

## Wilhelm Stegmann

German studies of Latin America, which started with Alexander von Humboldt at the beginning of the nineteenth century, developed in successive stages. Humboldt and his followers—traveling explorers, geographers, and artists—delivered a firsthand description of Latin America, thus acquainting the German public with a continent that hitherto had been virtually unknown to them. The explorers often brought back their own drawings of what they had seen or they employed artists who accompanied them. Humboldt was the guiding genius of these travelers whose drawings and paintings reflected, a few years before the advent of photography, a fairly exact image of what people, customs, architecture, and landscapes were like in Latin America then. Some artists like Johann Moritz Rugendas, Ferdinand Bellermann, Carlos Nebel, Eduard Hildebrandt, Alban Berg, and Otto Grashof, to name the best known among them, undertook the hazardous trips on their own account, although financially supported by the King of Prussia and other influential and wealthy sponsors. A representative selection of the works of some of these artists can be seen in the Ibero-Amerikanische Institut of Berlin, which also organized a touring exhibition of this material in four German cities and along the east coast of Latin America starting from Mexico City, in Caracas, Rio de Janeiro, São Paulo, Montevideo, and Buenos Aires (July 1978–September 1980), an exhibition that is now being repeated with slight modifications in other parts of the subcontinent (Bogotá, Quito, Santiago de Chile, Asunción, and Brasilia).

The second half of the nineteenth century witnessed the beginning and flowering of archaeological and ethnological studies on Latin America, which had their center in the newly founded Museum of Ethnology in Berlin. Great scholars like Adolf Bastian and Eduard Seler established a long tradition of collecting and research, which has lasted until the present day. With the beginning of the twentieth century we register a new general interest in a variety of Latin American studies. In Aix-la-Chapelle, Hamburg, Würzburg, and later on in Berlin, new institutes were founded to promote such studies, all

of them with a multidisciplinary orientation. Two of them were short-lived; the ones in Hamburg and Berlin still exist today. The intensification of Germany's political and economic relations with the Latin American countries demanded an increased knowledge and understanding of their history, politics, economics, and geography. These formerly neglected studies soon met with greater response than ever before. Research in Latin American literature was initiated between the two world wars, but did not reach its culmination until this literature came to full bloom and undisputed world importance in the sixties and seventies. Interest in Latin American art lagged behind; only the art of the Colonial Period soon found a widening echo. Little attention was paid to Latin American art of the nineteenth and twentieth centuries; many aspects of it were not considered autochthonous and original, but merely imitative of European art. Lately this tendency has been changing, however, and German museums are beginning to concede more space to objects of modern Latin American art, although pre-Columbian art displays still predominate.

This survey of the development of Latin American studies in Germany shows that the situation of Latin American art research is somewhat unbalanced in this country, a fact that is also reflected in the library holdings of the subject. An investigation into the holdings of museum libraries, major art institute libraries, and large research libraries gives evidence of an excellent provision with books on pre-Columbian art in some libraries, the stock of books on colonial art is generally fair, whereas the supply of literature on modern Latin American art is with a few exceptions inadequate. A special case is that of the Historical Picture Archives in West Berlin, which is considered at the end of this paper.

The first type of library I want to mention here is the museum library, which is the topic of this panel. Since museum libraries vary considerably in size, I have excluded the ones with less than 50,000 volumes and those which serve only the museum employees without admitting any outside readers. The most significant holdings in the field of pre-Columbian art or Indian art of Latin America are to be found in the libraries of the Museums of Ethnology in Berlin and Hamburg, each of them totaling some 70,000 or 80,000 volumes. No exact figures are available, but it is estimated that each collection contains from 15,000 to 18,000 volumes on Latin America. Especially the Berlin Museum of Ethnology is outstanding for its research in Indian arts and for collecting Americana. It has a magnificent collection of pre-Columbian art objects on display and in storage, objects that are particularly valuable for research purposes, because the

museum library possesses about 9,900 negative pictures of them, of which paper prints can be made at any time for the benefit of scholars and their publications. Of these pictures 6,000 show objects from the South American lowlands, that is, from Panama, Venezuela, Guyana, Brazil, Argentina, and Chile, and 3,900 of them represent the Andean region and Mesoamerica. The library further owns 400 colored slides on Brazil, mainly on the Xingu region, and another 3,200 slides on the Andean region and Mesoamerica again. Finally there are some 8,000 old photographs awaiting cataloging, most of them in a provisional order, but only part of them completely identified. The library of the Museum of Ethnology in Hamburg is equally well provided with literature on pre-Columbian art and archaeology, but it lacks the stupendous picture archives of its Berlin counterpart. Periodical subscriptions run up to 410 titles (535 in Berlin), and, the Hamburg Museum of Ethnology being affiliated with the local university, books can be taken home on loan by faculty members and students.

Other German museum libraries do not in any way compare with the Latin American holdings of the two above-named institutions in Berlin and Hamburg, but in the category of larger museum libraries with more than 50,000 volumes the following should at least be mentioned:

The Library of the Hamburg Gallery of Arts: 100,000 vols.

The Library of the Karlsruhe State Art Collections: 139,000 vols.

The Library of the Westphalian State Museum for the History of Art and Culture at Münster: 81,600 vols.

The Library of the Kassel State Art Collections: 60,000 vols.

The Library of the Städelsche Art Institute and Municipal Gallery at Frankfurt: 53,000 vols.

The total figures of these art libraries are impressive, but upon closer examination they contain comparatively little material on colonial and modern Latin American art. Notable is above all the Diepenbroick Portrait Archives in the library at Münster. Baron von Diepenbroick was a Westphalian nobleman devoted to collecting engraved portraits of famous and sometimes not so famous personalities from the periods of history prior to the invention of photography. He brought together, often under great sacrifices, over 100,000 engravings of such personages. It is true that only a small part of these engravings portray persons of Latin American history, but most of them are of excellent quality and great artistic value. Bolívar, San Martín, Miranda, Santander, Sucre, O'Higgins, and many lesser personalities highlight the Latin American

part of this unique collection, which many publishers make ample use of, but which is really not too well known by the general public.

A singular position among museum libraries is held by the Art Library of the Prussian Cultural Heritage State Museums in West Berlin. It is one of the oldest and most important libraries dedicated to art and art studies in the world, and its history dates back to 1867, when the German Trade Museum attached an art library to its collections. The Library became an independent institution among the Royal Museums in 1894. Extensive acquisitions and the incorporation of large private collections then led to a form of organization that still characterizes the library today. Besides the actual reference and research library there is the Collection of Ornamental Engravings and Original Drawings, the Lipperheide Costume Library, and the Collection of Applied Art and Design. These collections of graphic art and a rich stock of literature provide good opportunities for study and research in almost every area of Western art and cultural history.

Four main fields characterize the collecting activity of this library: Peninsular and Latin American art up to 1900, art of the Anglo-Saxon countries up to 1900, Scandinavian art up to 1900, and architecture of the twentieth century. Some 25,000 of the total 200,000 volumes are estimated to deal with colonial and modern Latin American art. Of particular interest is the Lipperheide Costume Library named after its founder Franz von Lipperheide, whose incomparably beautiful collection in the field of international folk costumes and fashions was acquired in 1899 and has been extended ever since. It now comprises about 25,000 volumes and 34,00 graphic drawings and plates, quite a few of which depict people in historical costumes from Spain, Portugal, and Latin America. Costumes are here understood in the widest sense of the word: folk costumes, fashionable clothing, uniforms, working clothes, suits and dresses for special occasions, for state ceremonies, folk festivals, sports, and games of all sorts. Mention should also be made of the Art Library's large poster collection (45,000 pieces), which is very valuable for its posters announcing Spanish and Latin American art exhibitions in Germany and other European countries.

In 1989 the Art Library began a stage of considerable expansion. It absorbed the Central Library of the Prussian Cultural Heritage State Museums (140,000 volumes) and eight small museum libraries. A new building is under construction and will eventually accommodate 350,000 volumes of the greatly enlarged Art Library.

West Berlin also houses the library of a large school of arts divided into six departmental collections of 210,000 volumes and 35,000 colored slides in total. Latin American holdings are negligible,

however, wherefore no further details are necessary here. A similar situation prevails in the libraries of most university art institutes, an exception being the Institute for the History of Art at Heidelberg University. Its library possesses a good stock of literature on colonial and modern art in Latin America. The reason for this is that Germany's leading scholar in Latin American art, Erwin Walter Palm, taught in Heidelberg until his death in 1988. Between 1940 and 1960 he was engaged in teaching and research in the Dominican Republic.

The most significant group of German libraries with holdings in Latin American art is a select number of large research libraries. These are either general libraries receiving certain funds for special acquisitions, special collections devoted to different aspects of Latin American culture, or a multidisciplinary Latin American collection like that of the Ibero-Amerikanische Institut.

This group includes two large general research libraries: the Hamburg State and University Library (1.7 million volumes) and the Heidelberg University Library (2.4 million volumes). Until 1974 the former library had been receiving regular allowances for the purchase of Latin American publications. The money came from the German Research Association, and organization sponsoring research and library programs in West Germany. As a result of the above-mentioned program Latin American art publications printed before 1975 are particularly well represented in Hamburg. The Heidelberg University Library is still receiving such allowances from the same source, in this case for scholarly publications in the arts of all nations and cultures, including of course Latin American art. This library is, therefore, particularly suited for students interested in Latin American art on a comparative basis. In this respect it competes with the Art Library of Berlin, although the latter is mainly concerned with international art up to the end of the nineteenth century, whereas Heidelberg offers a good stock of literature on the very latest trends in art too.

The next library is an older collection, with which members who attended SALALM XXXI in West Berlin and also took part in the excursion to Wolfenbüttel are quite familiar. The Herzog-August-Bibliothek (Duke Augustus Library) has 700,000 volumes consisting mainly of an ancient, very valuable stock of German literature; it is, however, not only a collection of books but also an institute where research is being done by resident scholars and where national and international meetings take place at frequent meetings. The present director is now expanding his acquisitions to cover Spanish and Latin American art, a development which has barely passed its initial stage but which seems to be making good progress. The library is receiving

regular donations from the Volkswagen Foundation in Lower Saxony, funds that enable it to purchase such valuable rare books as the so-called Malerbücher (painters' books), small-edition publications of Spanish and Latin American poetry in which pages of text alternate with others of engravings, drawings, and watercolors by famous artists. Many of them were on display in 1986, and I suppose that those who visited Wolfenbüttel then remember them well. A collection of poetry by Octavio Paz was illustrated with engravings by Antonio Tápies, 30 of Pablo Neruda's poems appeared with etchings by Alfred Hrdlicka, *Las Alturas de Macchu Picchu* by the same author was interpreted in 10 colored woodcuts by H.A.P. Grieshaber, Picasso had illustrated several works of Spanish literature, among others *La Celestina*, and there was a series of 36 watercolors by Joan Miró: "Je travaille comme un jardinier." These are but a few examples of the wealth of illustrations that accompanies Latin American and Spanish literature in Wolfenbüttel.

The activities of the Institut für Auslandbeziehungen (Institute for Foreign Relations) in Stuttgart are focused on German foreign relations in the field of culture. It publishes an important monthly journal on cultural exchange (*Zeitschrift für Kulturaustausch*), organizes exhibitions largely in the art of different countries, and maintains a research library of 330,000 volumes. Sixteen of the regular exhibitions held in Stuttgart and Bonn during the last fifteen years deal with Latin American art. They are listed in the Appendix at the end of this paper. The large book collection of the Institute is operated as a public library lending books for two weeks to anyone interested in foreign cultural relations. The extensive material on Latin American art includes monographs and illustrated volumes on architecture, theater, and motion pictures as well as a large number of catalogs of art exhibitions held in West Germany during the last four decades. The library also boasts of a collection of 85,000 slides, nearly 9,000 of which concern Latin American art, architecture, and geography.

The last large book collection discussed here is that of the Ibero-Amerikanische Institut in West Berlin, which hosted SALALM XXXI in April 1986. It is a multidisciplinary collection for Latin American area studies. Spain and Portugal are included. The total figures read as follows: 610,000 volumes, 52,000 geographical maps, 200 autographs, the manuscripts and countless photographs—as yet uncataloged—left behind by five leading scholars in the field of pre-Columbian art and archaeology, the general picture archives on Latin America and the Iberian Peninsula with more than 13,000 and 22,300 colored slides, furthermore 16,100 phonographic records and tapes and a small

Brazilian folklore collection consisting of 70 exhibits. With all this material the library can be considered the largest Latin American collection on the European continent outside of Spain.

Although exact statistical figures are missing, it can be safely said that the holdings in Latin American art of all periods are considerable and tend to be exhaustive, since it has been for a long time the acquisition policy of the Institute to buy Spanish, Portuguese, and Latin American art publications on a large scale, always provided that they are of real value for research and information purposes. A more than sufficient variety of reference works, bibliographies, illustrated art volumes, and monographs in the major European languages are available both for perusal in the reading room and for being taken out on loan.

The Ibero-Amerikanische Institut does not exhibit art objects the way a gallery of arts does, if we except the small Brazilian folklore collection with objects mostly from the State of Bahia. There are, however, some 50 works of art (oil paintings and a few sculptures) on display all over the building. They serve decorative purposes and point to the subject matter of the Institute by representing historical personalities, architecture, and landscapes of Latin America. In the entrance hall Alexander von Humboldt's life-sized painting symbolizes the German effort to explore Latin America. A special case is that of the German painter Johann Moritz Rugendas (1802–1852), who painted a large number of oil sketches on cardboard during his stay in Mexico from 1831 till 1834. Of these sketches, 159 small costumbrista and landscape pictures came into the possession of the Ibero-Amerikanische Institut, which has used them on several occasions for art exhibitions (see Appendix).

In the large general picture archives of the Institute the Mexican section contains 1,770 photos. The pictures are filed according to cities and the following subjects: archaeology, geography, art (churches, paintings, and sculptures), and ethnology. They are in good condition and impart an excellent impression of the state of churches and public buildings as well as of the living conditions in the urban and rural areas of Mexico during the half century between 1890 and 1940. Architecture and urban life in Brazil are the subjects of a large number of black-and-white slides and photographs donated to the Institute by a former trade representative in prewar Berlin. The mainstay of these picture archives is, however, a collection of 22,300 colored slides, half of which are on Latin America and the rest on Spain and Portugal. Most of them turn upon the following subjects: archaeology, sculptures, architecture, and landscapes. The slides can be viewed in the Institute, and a maximum

of fifty of them is generally allowed to be lent to qualified persons wishing to give lectures on Latin American and Peninsular topics. Last but not least, another point should be mentioned in connection with the visual media of the Institute: it has a collection of 1,400 posters, all of which were sent by different institutions to Berlin since the Ibero-Amerikanische Institut was founded in 1930. Spain and Portugal are better represented in this case than Latin America, and the subjects concerned are broadly biographical, geographical (tourism), political, and the arts. Access to this special collection is possible through a small subject catalog. The posters have so far been used to accompany book and art exhibitions in the Institute.

The German libraries with Latin American art holdings do not only contain, as we have seen, art publications and related material in the narrow sense of the word, but they also expand into the wider field of visual media in general. Let me, therefore, wind up by introducing an institution wholly devoted to the visual media, mainly to photographs. It is the Picture Archives of the Prussian Cultural Heritage Foundation in West Berlin, originally owned by a private collector (Lolo Handke) who started it with photographs on historical subjects during World War II. In 1968 it was turned into a public institution which now possesses about 5 million photographs, colored slides and prints, engravings, and the like. It is, therefore, one of the largest picture archives in the world. The number of items it contains says little about the scope and quality of the collection. The pictures illustrate the history of man from the earliest times to the modern age in all parts of the world, and this includes of course Latin America. They display all aspects of human life, political and everyday life events, scientific discoveries as well as portraits of personalities from public life, in short, political and cultural history in all its manifestations. The institution is constantly enlarging its holdings by acquiring new photographic material from well-known professional photographers. In spite of being a public institution the Berlin Picture Archives operates on a commercial basis, charging fees for its service to the extent that it is financially self-supporting. It serves mainly newspaper editors, publishers, film and television producers, advertising agents, scientists, and scholars.

The situation we face here, when describing the role of German book collections in the presentation of Latin American art, is one of unequal partners. We find on the one hand well-equipped libraries like that of the Ibero-Amerikanische Institut with comprehensive holdings and an excellent bibliographical service or that of an ethnological museum library with a good stock of literature on pre-Columbian art

and large picture archives, and on the other hand a number of museums and art galleries which offer barely more than a few reference works on Latin American art. Between these two extremes there are of course many intermediate stages. Comparing German libraries and their Latin American art holdings with the situation in the United States one can probably say that the best special libraries are on a par, whereas the average library in America offers more material in the field of Latin American art than its German counterpart, although the situation seems to be changing now, as Germans are gradually becoming more alert to the challenge of new artistic expressions from Latin America.

## APPENDIX

### Art Exhibitions Organized by the Institut für Auslandsbeziehungen, Stuttgart

Popular Art from Latin America, March–May, 1974

Bolivian Painters, 1974

Contemporary Art from Bolivia, April–June, 1975

Four Brazilian Artists, September 1980

Contemporary Graphic Art from Venezuela, November 1980–January 1981

Contemporary Tapestry from Peru, February–March 1981

Contemporary Art in Uruguay, 1982

René Portocarrero, September–October 1982

1000 years of Peru: Art and Culture in the Land of the Inca, 1984

Art from Cuba, August–September 1984

Carlos Viver and José Carreño, Ecuador, November–December 1984

Francisco Amighetti: Woodcuts from Costa Rica, April–May 1985

Charlotte Zander, Sculptures from Jamaica, April–June 1986

Art from Bolivia, July 1986

Art from Haiti, November 1986–January 1987

Images of Death: Peru or the End of a Dream, April 18–June 18, 1989

### Art Exhibitions Organized by the Ibero-Amerikanische Institut, Berlin

Alexander von Humboldt and His World, June–August 1969

Popular Art from Latin America, March–June 1975

Art from Venezuela. The Sculptor Edgar Guinand and the Painter Carlos Cruz-Díez, November–December 1978

German Artists in Latin America. Painters and Naturalists of the 19th Century Illustrate a Continent:
    Bonn, July-August 1978
    Frankfurt, November–December 1978
    Berlin, April–May 1979
    Hanover, June–July 1979
    Mexico City, September–October 1979
    Caracas, November 1979–January 1980
    Rio de Janeiro, March–April 1980
    São Paulo, May–June 1980
    Montevideo, June–July 1980
    Buenos Aires, August–September 1980

The Road of Maraakame. Woollen Pictures of the Huicholes in Mexico, January–February 1979

Marianne Lautensack. Topics of Spanish Literature in Pictures, May–June 1980

Alfred Pohl. Colored Woodcuts with Motifs from Peru, Colombia, Brazil, Mexico, and Guatemala, September 1980

Annegrete Vogrin and Hasso Hohmann. Mayan Architecture in Copán, December 1980–January 1981

Gertrud Weber and Matthias Strecker. Petroglyphs from Mexico, January–February 1981

Contemporary Graphic Art from Venezuela, March–April 1981

The Expedition of Alexandre Rodrigues Ferreira in Brazil (1783–1792) as Shown in the Drawings by Joaquim José Codina and José Joaquim Freire, April–June 1981

Contemporary Art from Uruguay, June–July 1982

The Travels of Prince Maximilian zu Wied in Brazil (1815–1817) (Watercolors and line-drawings), December 1982–January 1983

Six Young Artists from Venezuela, May–June 1983

Johann Moritz Rugendas in Mexico. Picturesque Travels in the Years 1831–1834:
    Berlin, December 1984–January 1985
    Madrid, January–February 1986
    Mexico City, March–April 1986
    Guadalajara, May–June 1986

Indians in the Highlands of Bolivia, March 1985

Paintings and Drawings by José García y Más, April–May 1985

Hermann Kellenbenz. Travel Sketches from Latin America and the U.S., June–July 1985

Memorial Exhibition for the Chilean Graphic Artist Renzo Pecchenino ("Lukas"), February–March 1988

Alexander von Humboldt. Inspirador de una nueva ilustración de América:

> Bogotá, October–November 1988
> Quito, December 1988–February 1989
> Santiago de Chile, March–April 1989
> Asunción, May 1989
> Brasilia, July 1–20, 1989

# 36. Meadows Museum of Spanish Art Book Collection: An Overview

## Thomas P. Gates

### Art Collection

In the heart of the Bible Belt, in the center of a Methodist university, is located a very remarkable art collection representing saints, the madonna, royalty—the rich palette and Roman Catholic symbolism of Spain. In fact, one could survey the history of Spanish art from the Renaissance through the twentieth century by walking through the galleries of the Meadows Museum of Spanish Art at Southern Methodist University (SMU).

In 1962 Algur H. Meadows gave his Spanish art collection to SMU along with the funds to construct the Meadows Museum. The museum opened to the public in 1965. Included in the collection are masterworks representing the fifteenth and sixteenth centuries—Fernando Gallego, Juan de Borgoña, Alonso Sánchez Coello; seventeenth century—Juan Carreño de Miranda, Juan de Herrera, Bartolomé Esteban Murillo, Jusepe de Ribera, Diego Rodríguez de Silva y Velázquez, Francisco de Zurbarán; eighteenth century—Antonio Palomino, Francisco de Goya; nineteenth century—Antonio María Esquivel, Mariano Fortuny, Manuel Rodríguez de Guzmán; twentieth century—Pablo Picasso, Joan Miró, Antonio Tapies (see Appendix A).

### Book Collection

The core of the Meadows Museum's 450-volume research collection was at first shelved in museum offices, but for lack of space was later relocated to the Fine Arts Library. There are currently 1,600 books on Spanish art, architecture, and related Portuguese and Latin American colonial art. These are shelved separately from the 19,000 books in the Fine Arts Library. Technical processing for both collections is done by the Central University Library, of which the Fine Arts Library is a unit. Books in both collections have limited circulation for faculty, graduate art students, and curators. However, the general public has access to both collections during library hours. The Fine Arts Library collection with its focus on acquiring reference materials in the history of western European art provides the Meadows

439

Museum with necessary support for research iconography, methodology, and relevant art historical studies.

## Book Collection Development

The SMU Fine Arts Librarian, curators of the museum, and a faculty member with expertise in Spanish Art oversee the acquisition of Meadows Museum research materials. The Meadows Museum book collection focuses on acquiring titles related to artists and art historical periods represented in the museum art collection.

One of the key tools for collecting basic bibliographies in the literature of art history is Arntzen and Rainwater's *Guide to the Literature of Art History*. In this source entries for Spanish, Portuguese, and Latin American reference books form the basis for developing the Meadows collection, which has about two-thirds of the titles listed. They are found under the headings: Spain and Portugal—"Dictionaries and Encyclopedias," "Histories and Handbooks," "Painting," and "Sculpture" (see Appendix B).

Monographs, catalogues raisonnés, and major exhibition catalogs of Spanish artists are a priority in collection development for the Meadows Museum. Also important is the acquisition of catalogs and inventories of Spanish private collections and museums necessary for establishing provenances and locating relevant works for future exhibitions and research. Important artists in the Meadows Museum collection—Zurbarán, Ribera, Velázquez, Murillo, Goya, and Picasso—are well represented by monographs in the research collection (see Appendix B).

Periodicals from Spain are also sought, and the collection includes such scholarly and popular titles as: *Boletín del Museo de Prado; Archivo Español de Arqueologia, Arte Español: Revista de la Sociedad Española de Amigo del Arte; Goya; Reales Sitios; Catalònia; Artes de Mexico*; and *Cuadernos de Arte Colonial*.

The museum has a modest budget for book and periodical purchases which is supplemented by creative collection development; examples of this are acquisition of current exhibition catalogs by exchange agreements with other museums and selection of relevant titles from approval book plans funded by SMU's Central University Library. These book plans include: Worldwide Exhibition Catalogs, Baker and Taylor, and Blackwell's of Oxford.

## Bibliographic Sources for Spanish Art History

The 1976 and 1978 editions of *Bibliografía del Arte en España* are useful indexes for identifying periodical citations in Spanish art history.

However, there is no ongoing Spanish national bibliography of art historical publications. One must be creative in gathering information about recent and out-of-print titles by using a variety of sources. The books-in-print source for Spanish publications is *Libros Españoles en Venta*, published by Ministerio de Cultura in Madrid. The 1984–1986 edition has three volumes with volume 1, *Autores*, volume 2, *Títulos*, and volume 3, *Materias*. The "Bellas Artes" section in *Materias* is frequently consulted under relevant subject headings: "Filosofía y critica del Arte," "Escultura," "Pintura," "Dibujo," "Grabados," and "Estampas." The "Indice Alfabetico de Editores" in volume 1 is useful for locating addresses of Spanish publishers.

Book reviews and announcements of Spanish exhibitions and catalogs are reported in most international art history periodicals and are consulted frequently for gathering the latest information. These include Spanish ones already mentioned as well as *Gazette des Beaux Arts*, *Apollo*, *The Burlington Magazine*, *Bollettino d'Arte*, and *Kunst Chronik*.

### Sources for Spanish Art History Publications

The purchasing of Spanish art history titles can be a problem because vendors for recent and out-of-print materials have to be identified both in this country and abroad. Sources in the United States for Spanish publications include Howard Karno in Valley Center, and Libros Latinos in Redlands, California; and El Cascajero, F. A. Bernett, and Richard C. Ramer in New York. Otto Harrassowitz in Wiesbaden, West Germany, is an efficient source for searching out-of-print German publications on Spanish art, and Thomas Heneage & Co. Ltd. in London at times offers antiquarian and out-of-print Spanish catalogs. In Spain, frequently used vendors include: Leon Sanchez Cuesta, Librería Mirto, Libros Argensola, and Alianza Editorial in Madrid. The Ministerio de Cultura in Madrid publishes an annual catalog, and Hesperia in Zaragoza and Puvill in Barcelona are also helpful for acquiring necessary titles. University publishers in Spain are another important source. These include: Universidad Complutense de Madrid, Universidad de Barcelona, and Universidad de Sevilla. Many important titles have also been published by Instituto Diego Velázquez under the Consejo Superior de Investigaciones Científicas in Madrid (see Appendix C).

## SMU Resources for Spanish and Latin American Art History Research

Research for Meadows Museum temporary exhibitions is also supported by the Fine Arts Library which acquires basic art history titles in various languages focusing on periods represented by the graduate art history curriculum and the scholarly needs of the faculty.

There are other libraries and special collections at SMU with Latin American and Spanish research material such as the DeGolyer-Fikes Library with books on Latin American architecture and Southwest culture of the United States.

The Jerry Bywaters Collection on Art of the Southwest holds photographs, correspondence, and other documents pertaining to twentieth-century Mexican art and its influence on American artists. The donor of this collection, SMU art professor Jerry Bywaters, learned techniques of mural painting from Diego Rivera in the 1920s and wrote one of the earliest articles concerning Rivera's work to appear in the United States. The Bywaters collection includes photographs of Rivera's work by Tina Modotti, correspondence from the family of David Alfaro Siqueiros, and extensive material on the career of Mexican sculptor Octavio Medellin, including an oral history interview. The collection also includes archival material illustrating the influence of Mexican artists on the painters and sculptors of the American Southwest.

## Future Developments for the Meadows Museum and Fine Arts Library at SMU

The Meadows Museum, the Fine Arts Library, and related SMU art collections are progressing into the twenty-first century with a focus on unity and accessibility.

The museum has recently been awarded the Trofeas Goya by the Asociación Española de Amigos de Goya in Madrid. Temporary exhibitions in the museum include group and solo shows for artists such as the Spaniard Pedro Cano and the Mexicans Frida Kahlo and Claudio Bravo. Future exhibitions include photographs of Portuguese churches and the works of Jorge Castillo. Spanish colonial paintings are also acquired by the museum. The most recent is by Fray Alonso López de Herrera, a Spaniard who worked in Mexico and who painted around 1639 a double-sided painting on a copper plate representing St. Thomas Aquinas and St. Francis of Assisi.

Southern Methodist University's Fine Arts and Music Library is anticipating a move to a new combined arts library. The Jake and Nancy Hamon Arts Library is a four-floor addition to the Meadows

School of the Arts and will boast the latest in computer and audiovisual technology, databases, and facilities. The Bywaters Collection and other special arts collections will be housed in one area, facilitating a variety of research in all aspects of the visual arts.

## APPENDIX

A. Selected List of Artists in the Meadows Museum Collection

*Fifteenth and Sixteenth Centuries*
   Fernando Gallego (ca. 1440–after 1507). *Acacius and the 10,000 Martyrs on Mount Ararat.* Tempera and oil on panel.
   Juan de Borgoña (active between 1495 and 1533). *The Investiture of St. Ildefonsus.* Painted ca. 1508–1514. Tempera and oil on panel.
   Alonso Sánchez Coello (1531/32–1588). *Portrait of Alessandro Farnese.* Painted in 1561. Inscribed: "Aetatis sue XVI, 1561." Oil on canvas.

*Seventeenth Century*
   Juan Carreño de Miranda (1614–1685). *The Flaying of St. Bartholomew.* Painted in 1666. Signed: "Juan Carreño, Fat ano 1666." Oil on canvas.
   Juan de Herrera (Spanish Colonial). *Virgin and Child with the Young St. John the Baptist.* Painted in 1641. Signed: "J. Herrera, 1641." Oil on canvas.
   Bartolomé Esteban Murillo (1618–1682). *Sta. Justa.* Oil on canvas. *Sta. Rufina.* Oil on canvas.
   Jusepe de Ribera (1591–1652). *Portrait of a Knight of Santiago.* Painted in 1630. Oil on canvas.
   Diego Rodríguez de Silva y Velázquez (1599–1660). *Sibyl with Tabula Rasa.* Painted ca. 1644–1644. Oil on canvas. *Portrait of Queen Mariana.* Painted ca. 1656. Oil on canvas.
   Francisco de Zurbarán (1598–1664). *The Mystical Marriage of St. Catherine.* Painted in the 1640s. Oil on canvas.

*Eighteenth Century*
   Antonio Palomino (1655–1726). *The Immaculate Conception.* Painted around 1716. Oil on canvas.
   Francisco de Goya (1746–1828). *Madhouse at Saragossa.* Painted in January 1794. Oil on tin. *Portrait of Francisco Sabatini.*

Painted between 1775 and 1778. Oil on canvas. *Los Caprichos: No. 43, The Sleep of Reason Produces Monsters.* First edition, 1799. Intaglio. *Los Desastres de la Guerra: No. 61, Perhaps They Are Another Breed.* First edition, 1863. Intaglio.

*Nineteenth Century*

Antonio María Esquivel (1806–1857). *Girl Removing Her Garter.* Painted in 1842. Signed: "A. Esquivel ft., 1842." Oil on canvas.

Mariano Fortuny (1838–1874). *Beach at Portici.* Painted around 1873–74. Oil on canvas.

Manuel Rodríguez de Guzmán (1818–1867). *Folk Festival: Romería del Rocío.* Painted in 1856. Signed: "M. Rodriguez de Guzmán, 1856." Oil on canvas.

*Twentieth Century*

Pablo Picasso (1881–1973). *Still-Life in a Landscape.* Painted in 1915. Signed: "Picasso." Oil on canvas. *Sonnets of Gongora, Special Edition,* 1948. Etching.

Joan Miró (1893–1983). *Queen Louise of Prussia.* Painted in 1929. Oil on canvas.

Antoni Tapies (1923–). *Great Black Relief (Grand Noir),* 1973. Signed U.L.: "Tapies." Mixed media, canvas on board.

B. Selected List of Spanish Art History Monographs
and Reference Sources

Aguilo, María Paz, Amelia López-Yarto, and María Luisa Tarraga. *Bibliografía del arte en España: artículos de revistas clasificados por materias.* Madrid: Consejo Superior de Investigaciones Científicas, Instituto Diego Velázquez, 1976.

_____. *Bibliografía del arte en España: artículos de revistas ordenados por autores.* Madrid: Consejo Superior de Investigaciones Científicas, Instituto Diego Velázquez, 1978.

Alcolea, Santiago. *Escultura española.* Barcelona: Ediciones Polígrafa, 1969.

_____. *La Pintura en Barcelona durante el siglo XVIII.* Anales y boletín de los museos de arte de Barcelona. Vols. 14, 15. Barcelona: Industrias Gráficas Seix y Barral Hnos, 1969.

Aldana Fernández, Salvador. *Guía abreviada de artistas valencianos.* Publicaciones des archivo municipal de Valencia. Serie primera: Catálogos, guías y repertorios, 3. Valencia: Ayuntamiento de Valencia, 1980.

_____. *Pintores valencianos de flores, 1766–1866.* Valencia: Servicios de Estudios Artísticos, Institución Alfonso el Magnánimo, Diputación Provincial de Valencia, 1970.

*Anales del Instituto de Estudios Madrileños.* Madrid: Consejo Superior de Investigaciones Científicas, 1966–.

*Anales y boletín de los museos de arte de Barcelona.* Barcelona: Ayuntamiento de Barcelona, 1941–.

Angulo Iñiquez, Diego, and Alfonso E. Pérez Sánchez. *Historia de la pintura española.* Madrid: Consejo Superior de Investigaciones Científicas, Instituto Diego Velázquez, 1969–1972.

Aparicio Olmos, Emilio Maria. *Palomino: su arte y su tiempo.* Valencia: Servicio de Estudios Artísticos, Institución Alfonso el Magnánimo, 1966.

*Archivo de arte valenciano.* Publicación de la Real academia de bellas artes de San Carlos. Valencia: Imprenta de A. López y c., 1915–.

Arntzen, Etta, and Robert Rainwater. *Guide to the Literature of Art History.* Chicago, IL: American Library Association, 1980.

*Ars Hispaniae. Historia universal del arte hispánico.* 22 vols. Madrid: Editorial Plus-Ultra, 1947–1977.

Asensio y Toledo, José Maria. *Francisco Pacheco: sus obras artísticas y literarias, especialmente el Libro de descripción de verdaderos retratos de ilustres y memorables varones, que dejó inédito, apuntes que podran servir de introducción á este libro, si alguna vez llega á publicarse.* Seville: Litografía y Librería Española y Estrangera de José M. a Geofrin, 1867.

Barettini, Fernández, Jesús. *Juan Carreño, pintor de cámara de Carlos II.* Madrid: Dirección General de Relaciones Culturales, 1972.

*Bartolomé Esteban Murillo.* London: Royal Academy of Arts, 1982.

Beruete y Moret, Aureliano de. *The School of Madrid.* New York, NY: C. Scribner's Sons, 1909.

_____. *Valdés Leal: estudio crítico.* Madrid: V. Suárez, 1911.

Beruete y Moret, Aureliano de, and Francisco Javier Sánchez Cantón. *Goya.* Madrid: Imprenta de Blass, s.a., 1928.

Bosque, A. de. *Artistes italiens en Espagne du XIVme siècle aux rois catholiques*. Panoramique 8. Paris: Editions du Temps, 1965.

Bottineau, Yves. *L'art de cour dans l'Espagne de Philippe V, 1700–46*. Bordeaux: Ferret & Fils, 1960.

*Catálogo monumental de España*. Madrid: Ministerio de Instrucción Publica y Bellas Artes, 1915–.

Ceán Bermúdez, Juan Agustín. *Diccionario histórico de los más ilustres profesores de las bellas artes en España*. 6 vols. Madrid: Ibarra, 1800; reprint, New York: Kraus, 1965.

Ceán Bermúdez, Juan Agustín, and Eugenio Llaguno y Amírola. *Noticias de los arquitectos y arquitectura de España desde su restauración*. 4 vols. Madrid: Ediciones Turner, 1977.

*Diccionario biográfico enciclopédico de la pintura mexicana*. Mexico: Quinientos Años, 1979.

Dirección General de Archivos y Bibliotecas. *Carlos V y su época; exposición, bibliográfica y documental*. Barcelona: Dirección General de Archivos y Bibliotecas, 1958.

Doménech Gallissá, Rafael. *Goya en el Museo del Prado*. Barcelona: Hijos de J. Thomas, 191–?.

Felto, Craig, and William B. Jordan, eds. *Jusepe de Ribera lo Spagnoletto, 1591–1652*. Fort Worth, TX: Kimbell Art Museum, 1982.

Gállego, Julían, and José Gudiol. *Zurbarán, 1598–1664 Biography and Critical Analysis; Catalogue of the Works*. Trans. Kenneth Lyons. London: Secker & Warburg, 1977.

García Melero, José E. *Aproximación a una bibliografía de la pintura española*. Madrid: Fundación Universitaria Española, 1978.

Gassier, Pierre, and Juliet Wilson. *The Life and Complete Work of Francisco Goya*. François Lachenal, ed. 2d ed. New York, NY: Harrison House, 1981.

Gaya Nuño, Juan Antonio. *Claudio Coello*. Madrid: Consejo Superior de Investigaciones Científicas, Instituto Diego Velázquez, 1957.

_____. *La pintura española del siglo XX*. Madrid: Ibérico Europea, 1970.

_____. *Vida de Acisclo Antonio Palomino: el historiador, el pintor: descripción y crítica de sus obras*. Córdoba: Excma. Diputación Provincial de Córdoba, 1981.

Gestoso y Pérez, José. *Biografía del pintor sevillano, Juan de Valdés Leal*. Seville: Oficina tip. de J.P. Girones, 1916.

_____. *Catálogo de la pinturas y esculturas del museo provincial de Sevilla.* Madrid: Imp. de J. Lacoste, n.d.

_____. *Ensayo de un diccionario de los artífices que florecieron en Sevilla desde el siglo XIII al XVIII inclusive.* 3 vols. Seville: Oficina de La Andalucía Moderna, 1899–1909.

Gómez-Moreno, Manuel. *The Golden Age of Spanish Sculpture.* New York, NY: Graphic Society, 1964.

Gudiol, José. *Goya.* Trans. Priscilla Muller. New York, NY: Abrams, 1985.

_____. *Goya.* 4 vols. Barcelona: Ediciones Polígrafa, s.a., 1970.

Guinard, Paul. *Zurbarán y los pintores españoles de la vida monástica.* Trans. Astolfo Hernandez Vidal. Madrid: Joker, 1967.

Hagen, Oskar. *Patterns and Principals of Spanish Art.* 2d ed. Madison: University of Wisconsin Press, 1943.

Iñiguez, Diego Angulo. *Juan de Borgoña.* Madrid: Consejo Superior de Investigaciones Científicas, Instituto Diego Velázquez, 1954.

Kinkead, Duncan Theobald. *Juan de Valdés Leal (1622–1690): His Life and Work.* New York, NY: Garland Publishers, 1978.

Kubler, George A., and Martin Soria. *Art and Architecture in Spain and Portugal and Their American Dominions, 1500–1800.* Pelican History of Art. Baltimore, MD: Penguin, 1959.

Larco, Jorge. *La pintura española moderna y contemporánea.* 3 vols. Madrid: Castilla, 1964–65.

Lassigne, Jacques. *Spanish Painting.* Trans. Stuart Gilbert. 2 vols. New York, NY: Skira/Rizzoli, 1977.

López-Rey, José. *Velázquez: A Catalogue Raisonné of His Oeuvre, with an Introductory Study.* London: Faber and Faber, 1963.

Marzolf, Rosemary. *The Life and Work of Juan Carreño de Miranda.* Ann Arbor, MI: University Microfilms, 1968.

Mayer, August Liebmann. *Historia de la pintura española.* 2d ed. Madrid: Espasa-Calpe, 1942.

Morales y Marín, José Luis. *Diccionario de términos artísticos.* Zaragoza: UNALI, 1982.

Ossorio y Barnard, Manuel. *Galería biográfica de artistas españoles del siglo XIX.* Madrid: Libreria Gaudi, 1975.

Páez Ríos, Elena, ed. *Iconografía hispana: catálogo de los retratos de personajes españoles de la Biblioteca Nacional.* 5 vols. Madrid: Biblioteca Nacional, Sección de Estampas, 1966.

Palol, Pedro de, and Max Hirmer. *Early Medieval Art in Spain.* New York, NY: Abrams, 1967.

Palomino de Castro y Velasco, Acisclo Antonio. *El museo pictórico y escala óptica . . .* 3 vols. in 1. Madrid: M. Aguilar, 1947.

————. *Lives of the Eminent Spanish Painters and Sculptors.* Trans. Nina Mallory. New York, NY: Cambridge University Press, 1987.

Pantorba, Bernardino de [José López Jiménez]. *Goya, ensayo biográfico y crítico.* Madrid: Imp. Zoila Ascasíbar y Compañía, 1928.

————. *José de Ribera: ensayo biográfico y crítico.* Barcelona: Iberia, 1946.

————. *la vida y la obra de Velázquez; estudio biográfico y crítico.* Madrid: Compañía Bibliográfica Española, 1955.

Pamplona, Fernando de. *Diccionario de pintores e escultores portugueses ou que trabalharam em Portugal.* 4 vols. Lisbon, 1954–1959.

Pérez Sánchez, Alfonso E. *Catálogo de la colección de dibujos del Instituto Jovellanos de Gijón.* Madrid: Alfonso E. Pérez Sánchez, 1969.

————. *D. Antonio de Pereda y la pintura madrileña de su tiempo.* Madrid: Ministerio de Cultura, Dirección General del Patrimonio Artístico, Archivos y Museos, 1978.

————. *Juan Carreño de Miranda.* Avilés: Ayuntamiento de Avilés, 1985.

————. *La obra pictórica completa de Ribera.* Clásicos del Artes, 60. Barcelona: Editorial Noguer, 1979.

————. *Pintura española de bodegones y floreros de 1600 a Goya.* Madrid: Ministerio de Cultura, Dirección General de Bellas Artes y Archivos, 1983.

Pérez Sánchez, Alfonso, and Diego Angulo Iñiguez. *A Corpus of Spanish Drawings.* 3 vols. London: Harvey Miller, 1975.

————. *Historia de la pintura española.* Madrid: Consejo Superior de Investigaciones Científicas, Instituto Diego Velázquez, 1969.

Picon, Gaëtan. *Joan Miró: Catalán Notebooks: Unpublished Drawings and Writings.* Trans. Dinah Harrison. New York, NY: Rizzoli, 1977.

Pontual, Robert. *Dicionário das artes plásticas no Brasil.* Rio de Janeiro: Civilização Brasileira, 1969.

Post, Chandler Rathfon. *A History of Spanish Painting.* 14 vols. Cambridge, MA: Harvard University Press, 1930–1966.

Proske, Beatrice Irene (Gilman). *Castilian Sculpture, Gothic to Renaissance*. Hispanic Notes and Monographs. New York, NY: Hispanic Society of America, 1951.

Quilliet, Frédéric. *Dictionnaire des peintres espagnols*. Paris: L'auteur, 1816.

Ráfols, José F. *Las cien mejores obras de la escultura española*. Barcelona: Ediciones Selectas, 1943.

_____. *El arte romántico en España*. Barcelona: Editorial Juventud, 1954.

Rejón de Silva, Diego Antonio. *Diccionario de las nobles artes para instrucción de los aficionados, y uso de los profesores* . . . Segovia: Impr. de d.A. Espinosa, 1788.

Ruiz Cabriada, Agustín. *Aportación a una bibliografía de Goya*. Madrid: Junta Técnica de Archivos, Bibliotecas y Museos, 1946.

Saltillo, Miguel Lasso de la Vega, and López de Tejada, Marqués del. *Artistas Madrileños, 1592–1850*. Madrid: Hauser y Menet, 195–?.

San Ramon y Fernandez, Francisco de Borja de. *Alonso Sánchez Coello*. Lisbon: Museu Nacional de Arte Antiga, 1938.

Sánchez, Cantón, and Francisco Javier. *Fuentes literarias para la historia del arte español*. 5 vols. Madrid: Imprenta Clásica Española, 1923–1941.

_____. *Treasures of Spain*. 2 vols. Treasures of the World. Geneva: Skira, 1965–1967.

Spinosa, Nicola. *Velázquez: The Complete Paintings*. Trans. Catherine Atthill. Complete Paintings. New York, NY: Granada, 1980.

Stirling-Maxwell, Sir William. *Annals of the Artists of Spain*. 4 vols. London: J.C. Nimmo, 1891.

_____. *Stories of the Spanish Artists until Goya*. New York, NY: Tudor Publishing Co., 1938.

Sullivan, Edward J. *Baroque Painting in Madrid: The Contribution of Claudio Coello with a Catalogue Raisonné of His Works*. Columbia: University of Missouri Press, 1986.

*Summa artis, historia general del arte*. 32 vols. Madrid: Espasa-Calpe, 1931–<1988>.

Takács, Marianna H. *Bartolomé Esteban Murillo*. Welt der Kunst. Berlin: Henschelverlag, 1978.

Torres Martín, Ramón. *La naturaleza muerta en la pintura española*. Barcelona: Seix y Barral, 1971.

Trapier, Elizabeth Du Gué. *Valdés Leal: Baroque Concept of Death and Suffering in His Paintings*. Hispanic Notes and Monographs. New York, NY: Hispanic Society of America, 1956.

————. *Velázquez*. 2 vols. Hispanic Notes and Monographs. New York, NY: Hispanic Society of America, 1948.

————. *Valdés Leal, Spanish Baroque Painter*. New York, NY: Hispanic Society of America, 1960.

Valdivieso, Enrique. *La obra de Murillo en Sevilla*. Biblioteca de Termas Sevillanos, 24. Seville: Servicio de Publicaciones del Ayuntamiento de Sevilla, 1982.

Viñaza, Cipriano Muñoz y Manzano, Conde de la. *Adiciones al Diccionario histórico de los más ilustres profesores de las bellas artes en España de Don Juan Agustín Ceán Bermúdez*. 4 vols. Madrid: Tip. de los Huérfanos, 1889–1894.

————. *Goya, su tiempo, su vida, sus obras*. Madrid: Tip. de M.G. Hernández, 1887.

Weise, Georg. *Die Plastik der Renaissance und der Frühbarock im nördlichen Spanien: Aragón, Navarra, die baskischen Provinzen und die Rioja*. 2 vols. Tübingen: Hopfer, 1957–1959.

————. *Spanische Plastik aus sieben Jahrhunderten*. Tübinger Forschungen zur Archäologie und Kunstgeschichte. 4 vols. Reutlingen: Gryphius, 1925–1939.

Young, Eric, and Alfonso E. Pérez Sánchez. *Todas las pinturas de Murillo*. Trans. Pere Rubiralta. Barcelona: Noguer, 1982.

Zervos, Christian. *Pablo Picasso*. 33 vols. Paris: Editions "Cahiers d'art," 1951.

## C.  Selected List of Sources for Spanish Art History Publications

Alianza Editorial
C/. Milán, 38.E28043
Madrid, Spain

El Cascajero
The Old Spanish Book Mine
506 West Broadway
New York, NY 10012

Consejo Superior de Investigaciones
Científicas
"Diego Velázquez'
Duque de Medinaceli 4
Madrid, 14 Spain

F. A. Bernett Inc.
2001 Palmer Avenue
Larchmont, NY 10538

Hesperia
Plaza de Los Sitios, núm. 10
50001 Zaragoza, Spain

Howard Karno Books
P.O. Box 2100
Valley Center, CA 92082-9998

León Sánchez Cuesta
Serrano, 29
Madrid, 1 Spain

Librería Mirto
Ruiz de Alarcón, 27
28014 Madrid, Spain

Libros Argensola
C/ Argensola, 20
28004 Madrid, Spain

Libros Latinos
P.O. Box 1103
Redlands, CA 92373

Ministerio de Cultura
Servicio de Publicaciones
Fernando el Católico, 77
28015 Madrid, Spain

Otto Harrassowitz
Booksellers & Subscription
Agents
Taunusstrasse 5
P.O. Box 2929
D-6200 Wiesbaden
West Germany

Puvill Libros S.A.
Boters, 10 y Paja, 29
Barcelona, 2 Spain

Richard C. Ramer
225 East 70th Street
New York, NY 10021

Thomas Heneage & Co. Ltd.
42 Duke St. St. James's
London SW1Y6DJ

Universidad Complutense de Madrid
Ciud. Universit.
28040 Madrid, Spain

Universidad de Barcelona, Ediciones
Llorens i Artigas
08028 Barcelona, Spain

Universidad de Sevilla, Serv. de Publ.
San Fernando, 4
41004 Seville, Spain

# Part Five

# Marginalized Peoples and Ideas

One cannot live in a country so
full of crisis without that being
reflected in one's art.

—Fernando Sziszlo
*Peruvian painter*

# 37. Guidelines for Collecting Documentation on Marginalized Peoples and Ideas in Latin America

## Peter T. Johnson

The focus of the guidelines is on the collection of documentation written and generally published by groups and organizations that represent peoples and ideas on the margin of political, economic, and/or social power and prominence. Such documentation is a valuable primary source, vital for recording the ideas, aspirations, actions, and responses of these peoples. Collecting in this area requires detailed thought on adjustments to a collection development policy as well as how to foster successful cooperation efforts with other libraries.

### Identification of Issuing Bodies

Research and field familiarity are essential for identifying and selecting those groups from which documentation will be sought. As many organizations issuing information are marginal in terms of physical presence, political influence, and personnel, frequent personal contact is often the only way to ensure familiarity and a current working knowledge. As most situations that enable the creation and continuing existence of such groups are dynamic or unstable, continual monitoring of current information is essential for maintaining an awareness of new groups, the demise of others, and the combination of some into alliances or common fronts. For many organizations publishing is not a highly organized activity, for example, production may be sporadic, quality of writing and material may be poor.

Sources of background information include current news magazines and daily newspapers issued in the country as well as the working papers of independent research institutes. Occasionally, scholarly studies and reference directories or handbooks may provide information. For example, the Foreign Broadcast Information Service records the activities of certain organizations, particularly those involved in political areas. Theses and dissertations based upon fieldwork usually provide acknowledgments for assistance from individuals and groups as well as bibliographies emphasizing primary sources.

Field trips by bibliographers, faculty, and students also serve to identify such organizations. Latin American visitors to U.S. institutions should be interviewed in order that the latest information be obtained.

## Obtaining Imprints

Consistent and prompt acquisition requires tenacity and creativity. Field trips prove essential in establishing personal contact with a particular agency, and thus inclusion on their mailing list, even though such arrangements often must be renewed by correspondence or subsequent visits. Maintaining current listings of institutions and persons providing materials must be part of any acquisition strategy. Because of the continual flukes caused by the political, economic, and social conditions that shape many of these organizations' activities, and consequently, availability of their publications, it becomes necessary for a reliable and interested bookdealer or other agent representing the library to make timely and systematic visits to their headquarters to obtain noncommercially available imprints. Reliance upon such contacts is basic and often is the most efficient method of operation. In selecting a collection agent, special attention to the individual's personal empathy and demeanor proves essential given the fact that many issuing bodies have politically and/or socially controversial and sensitive agendas. Such strong personal contacts are more likely to yield comprehensive coverage, including the *circulación interna o restringida* publications which the casual visitor will seldom obtain. Given political and economic conditions in some countries, bookdealers find it difficult, if not impossible, to maintain such sensitive imprints in stock. Complete runs of serials prove elusive.

For some organizations directly providing imprints it may be necessary to offer exchange, provide postage costs, purchase individual pieces, place subscriptions, or perhaps offer, when practical, microfilmed copy of the materials supplied. Libraries should also indicate their willingness to pay for whatever documentation is needed and, when provided free of charge, to promptly acknowledge receipt in order to foster continued relations.

Other sources of documentation include the libraries of some research institutes, political parties, newspapers, and activists groups. Such organizations often contain extensive holdings that might be photocopied. Finally, private collectors, while in small numbers, do exist in Latin America and should be contacted. Some may wish to sell their collections or duplicates or act as the library's agent in collecting materials.

## The Documentation and Its Evaluation

Emphasis is on primary sources—those imprints written by local, regional, and national groups. Considerable care must be taken to ensure that those imprints of the greatest substantive nature are collected; of major importance are the fullest available texts of constitutions, platforms, position papers, debates, and whenever possible internal working papers of the organization itself. Representative samples of imprints distributed for popular level consumption should also form part of the collection. These examples merit close scrutiny for they can reveal the existence of larger, more substantive documentation. Of secondary importance are nonsubstantive, derivative, or repetitious materials such as translations of texts available elsewhere or extracts and abstracts of larger works.

Materials such as broadsides, posters, and photographs that offer primarily or exclusively iconographic information are valuable complements to such collections. Documentaries and photographic essays offer interpretations and suggestions to further collecting efforts in specific realms. Special efforts should be made to assure adequate coverage for organizations working in areas with high illiteracy rates or under conditions otherwise conducive to such illustrated message conveyance.

Existing collections require periodic checks against incoming materials in order to identify new organizations and serious gaps in documentation. "Want lists" for bookdealers and collecting agents as well as requests directly to issuing agencies should result from these reviews. Such lists may also serve to sharpen a collecting profile, especially in cases where specific titles are unavailable. Collecting agents with blanket order profiles require *immediate* assessment reports which should evaluate the documents, indicating which are inappropriate (and why), suggest comprehensive or selective future purchasing, and advise which serials to place on subscription. Such prompt reports will save field collecting time by placing the emphasis on what is actually necessary.

## Administrative Considerations

On the collection development side, increased emphasis should be given to primary sources in Latin American collections. A reassessment of collection development policies might be necessary. Standard blanket order or approval plans will require adjustment or the preparation of separate profiles to encompass these types of organizations and imprints. More attention to incoming receipts from

bookdealers will be necessary because of the diversity of imprints and qualitative variations from standard trade press publications.

On the collection processing side, procedures for processing and holding, priority for cataloging, and reader services will possibly be different from those existing for monographs and serials. Cataloging these frequently unconventional materials requires imaginative approaches. Several models that embrace a preservation angle exist, including those of the Library of Congress's Brazilian pamphlets (DCLC88953222-B or NJPG89-B6956) and Princeton University Library's Latin American ephemera (e.g., NJPG89-B7904). Both emphasize ease of access, preservation, and availability through microfilm. Given their sensitive political content and context, many of these documents by and about marginalized peoples require immediate preservation measures by microfilming to ensure future availability inside and outside the country of publication.

## Summary

Quality research collections depend upon clear visions of what is worth collecting and why. Of major importance must be primary sources issued by organizations representing marginalized groups such as the disenfranchised and those espousing ideas contrary to the mainstream. Collecting materials of these groups aids in a library's obligation to offer opposing points of view. Refocusing collection development, acquisitions, processing, and public service aspects is necessary as the implications of collecting such documentation, even on a modest scale, are systemic. A shift in acquisition funds might be necessary, and certainly more professional time will be required initially to establish, evaluate, and monitor programs designed to cover specific areas. Partnerships with bookdealers, collecting agencies, and issuing bodies are essential to developing and maintaining such a program.

# 38. Transición política en Chile: Documentación y fuentes

## Marta Domínguez Díaz

En actual proceso político y social en Chile está marcado por la tensión entre las fuerzas que luchan por superar la situación de dictadura y las fuerzas que tratan de mantenerla. La situación es compleja, porque el régimen militar que dura ya casi 16 años, produjo cambios radicales en la estructura económico-social del país. El énfasis de la ideología autoritaria está puesto en la política económica neoliberal y obviamente el sistema neoliberal acarrea el problema de la exacerbación de las desigualdades sociales. Chile vive actualmente un proceso de polarización muy peligroso, de ahí que la Iglesia y otros sectores cristianos busquen por todos los medios, la reconciliación de los chilenos.[1] Lo que tipifica la situación chilena es la combinación de autoritarismo y libertad económica.

Es obvio que estas transformaciones de la estructura económica han generado cambios en el empleo, estratificación social, situación del trabajo, calidad de vida de las diferentes capas sociales, y de manera muy especial en la relación con el Estado. (Sobre estos fenómenos existen abundantes estudios realizados por equipos de centros especializados: CIEPLAN, CED, ICAL, de alternativa; ODEPLAN e INE, oficialistas; y PREALC, CEPAL, UNICEF, internacionales.) Toda esta circunstancia económica está íntimamente ligada a la situación política de todos los sectores.

En relación a prácticas democráticas y participativas en la base social, se ha realizado un trabajo sistemático y abundante por parte de la Iglesia a través de sus Vicarías Pastorales, extendidas hacia áreas marginales de Santiago; por parte de centros de apoyo, de acción social y educacional (CIDE, CEAAL, ECO, SUR, TAC, CEDAL, etc.). Existe una extensa bibliografía sobre este tipo de apoyo hacia los mapuches, en educación popular en medios poblacionales, rurales y sindicales (CES, GIA, GEA, AGRARIA, AGRA, SUR, etc.). En relación a la vida política de los sectores populares, se ha escrito muy poco. La vida política del país la realiza la élite dirigente del gobierno y de los partidos políticos, con la excepción de los partidos políticos de extrema izquierda, que por estar proscritos, la realizan en forma

clandestina y la informan a través de sus órganos oficiales (e.g, *El Siglo*, *El Rodriguista* y *Venceremos*). De modo que el arco político va desde el gobierno pasando por la Derecha y el Centro hasta la Centro Izquierda. Tal es la aparente legitimidad de la política aceptada por el consenso oficial, los demás movimientos políticos, son ignorados. El acomodo político es tal, que nunca como ahora la política se ha realizado en marcos tan estrechos y tan ligada a las estructuras partidarias, las que son aparentemente débiles después de 16 años de proscripción política y no tienen aún muy claros los mecanismos de comunicación con la sociedad civil.[2] Este es el resultado neto de la política de disgregación, dispersión y represión de gobierno militar. Este no sólo ilegalizó la función política, sino que su propia acción política frente a los grupos sociales fue absolutamente disruptiva. La cohesión social se debilitó de tal forma que el sentido de nación desapareció. En sentido estricto, las clases subordinadas han quedado marginadas de la sociedad. De manera que la lucha política de los sectores populares es la lucha por salir de la marginalidad y de la dominación gubernamental.[3] Sólo en el período de las protestas que comenzaron en mayo de 1983 y finalizaron en octubre de 1984, hubo una acción persistente por saltar el cerco que los separa del país. Estas protestas convocadas por el movimiento sindical comprometieron a amplios sectores de las capas medias, de modo que significaron una ruptura en la política de aislamiento. La dinámica de evolución de ellas significó un enfrentamiento cada vez más agudo entre el gobierno y los pobladores. Sobrevino fuerte represión, luego un período de negociación política que fracasó, y por último la imposición del Estado de Sitio. Las protestas dejaron como saldo a favor la apertura de un espacio para la acción visible de los partidos políticos. Con ello se produce un evidente progreso en el proceso político chileno, ya que los partidos sólo operaban, algunos en la clandestinidad, otros desde el exilio, y otros no realizaban acción política. La actividad política estaba concentrada en los Centros de Estudio y realizada más bien por académicos, que por políticos. De manera que la más abundante bibliografía sobre la evolución del proceso político está constituida por los Documentos de Trabajo del CEP, CED, FLACSO, ILET, VECTOR, SUR, etc. Como conclusión podría establecerse que la movilización popular que significó decenas de muertes y relegaciones, permitió abrir un espacio para que las élites políticas se incorporaran a la escena nacional. Los sectores populares, en cambio, no han ingresado a una actividad política convencional. Su acción está restringida a organizaciones sociales de tipo poblacional, sindical y cultural. La actividad cultural les ha creado canales de comunicación, muy importantes, sobre todo a la juventud. La oferta

cultural del régimen no logró entusiasmar a los jóvenes, que desde muy temprano establecieron modos de comportamiento y redes de comunicación propias, definiendo valores completamente ajenos al modelo dominante. Una encuesta reciente del CEP y otra de GALLUP a 600 jóvenes de 7 universidades metropolitanas, muestra que más del 70% se define políticamente, de los cuales sólo un 5.5% en la Derecha y un 8.3% en la Centro Derecha. Los jóvenes trabajadores son en su mayoría ex-estudiantes que se vieron forzados a suspender sus estudios. Hay cifras abismantes en las poblaciones marginales. El mundo laboral está plagado de hombres y mujeres jóvenes que tuvieron otras expectativas, fundamentalmente de estudio, pues entraron a la escuela en un período de expansión social y democratización y salieron en una época de cierre. En 1982, había, según estudios del CIDE, 125.000 jóvenes en el Gran Santiago que, habiendo dejado de estudiar, no podían incorporarse al trabajo.[4] Esta negación de futuro y esta discriminación, según ellos, favorece la formación de pandillas en algunos casos, y/o el consumo de drogas y alcohol. Los jóvenes perciben que los canales de inserción y participación están cerrados para ellos, que se les brinda escasas posibilidades de desarrollo y crecimiento. La expresión más límite de este hecho es la imposibilidad de crear una familia. Para el régimen el auténtico representante del joven chileno, depositario privilegiado de la "modernidad", sería la imagen del joven estudiante de clase medio, caracterización que no incluye a los jóvenes pobladores que son vistos y pensados como antisociales y calificados de peligrosos, por lo que deben ser vigilados, normalizados y castigados por la sociedad. Aunque las políticas del régimen hacia los jóvenes han sido insuficientes, ha habido una acción subsidiaria en empleo y educación, de disciplinamiento en centros carcelarios de rehabilitación y la Comisión Nacional de Drogas, y la participativa a través de DIGEDER para los deportes y recreación. En síntesis, ninguna de estas acciones se planteaba la solución de los problemas centrales de la juventud. Encuestas y estudios realizados señalan que el proyecto educativo del régimen ha fracasado en su aspiración de formar una juventud despolitizada y solamente interesada en el logro material individual. Para un 62.1% de la población joven, y en porcentaje aún más alto para los sectores de las de 12 años de estudios, la política juega un rol importante.[5]

En los que se refiere a la niñez, el sociólogo Fernando Dahse realizó en 1982, un estudio con 1.948 menores de 6 años, pertenecientes a familias de nivel socio-económico bajo. Constató que las condiciones de vivienda eran deficientes, a veces chozas con material de desecho. En cuanto al tamaño de las familias, el 72% estaba constituido por 5 o

más personas y el 35.7% por más de 7 personas. Entre en 60 y 88% de los niños no satisfacían sus necesidades mínimas de alimentación, estableciéndose un alto grado de asociación entre el tamaño familiar y la desprotección del niño. Los padres del 31% de los menores estuvieron cesantes el año anterior a la encuesta y un 46% de ellos estaba integrado al sector informal de trabajo. Los estudios acerca del daño en el ambiente familiar constata el alto grado de hacinamiento, precocidad sexual, maltrato físico, aspiración de neoprén y alcoholismo infantil.

Esta situación de deterioro familiar ha provocado la movilización de la mujer hacia actividades solidarias en la población (ollas comunes, comedores abiertos, talleres productivos), lo que les ha permitido un desarrollo personal y colectivo. La mujer pobladora tiene su autoestima muy baja debido a la discriminación de que es víctima. Tradicionalmente ha tenido muy poca participación política y en su conducta electoral o en momentos de crisis han apoyado mayoritaria-mente a las tendencias más conservadoras. Las mujeres apoyaron al gobierno militar, en mayor proporción que los hombres, para el plebiscito de 1979 sobre la Constitución de 1980, lo que ayudó a estabilizar al régimen. Sin embargo también se observa el alto grado de compromiso que adquiere en las luchas por derechos para su núcleo familiar (por ejemplo, tomas de sitios para vivir, familiar de detenidos desaparecidos, familiar de presos políticos, y organizaciones solidarias). Hoy día juega un rol importante en la búsqueda de canales que le permitan enfrentar el problema de la subsistencia. Ha aumentado considerablemente el número de mujeres que han pasado a constituirse en jefes de hogar y las organizaciones poblacionales, hoy día, están formadas mayoritariamente por mujeres.[6]

El movimiento poblacional ha impulsado desde sus bases y a través de sus organizaciones la unidad en todos los sectores pobla-cionales, como mecanismo de defensa y de apoyo solidario. La creación de las Coordinadoras Comunales y Zonales y la formación de varios comités, apuntan en este sentido. Al calor de una olla común, surgen las Coordinadoras de Ollas Comunes para combatir el hambre y la cesantía. Otras organizaciones poblacionales, la Coordinadora de Agrupaciones Poblacionales (COAPO), la Coordinadora Metropolitana de Pobladores (METRO) y el Movimiento Poblacional Dignidad, vienen desarrollando sus luchas antidictatoriales desde los primeros años del gobierno militar con un enorme costo social. Su desafío de este momento es la democratización de las "Juntas de Vecinos", integradas por representantes del régimen, la municipalización.

El movimiento sindical, sin duda el más estructurado de todos los movimientos sociales, logró formar en 1988 la Central Unitaria de Trabajadores (CUT), en medio de la atomización del cuerpo social constituido por los trabajadores, los que además temen participar debido a la inestabilidad laboral y la continua amenaza de despido.

Dentro de este escenario, el gobierno llamó a Plebiscito, establecido en la Constitución de 1980, para que el pueblo de Chile respondiera "Sí" o "No" a la continuidad de Pinochet como Presidente de la República, por 8 años más, previo a que la Junta de Gobierno lo nominara candidato, con lo cual completaría 23 años de gobernante. Al poco tiempo que el gobierno llamara al Plebiscito, Pinochet aparecía disminuyéndole importancia, manifestando que se trataba de una mera "consulta" respecto a la acción de su gobierno, y que su resultado por lo tanto (todas las encuestas imparciales daban de ganador al No) no pondrían en cuestión su obra más allá del evento. Esta situación dio origen a la formación del Comando Contra el Fraude, integrado por relevantes personalidades. Al mismo tiempo, desde las bases comenzó a surgir con renovadas fuerzas, las exigencias de unidad amplia, sin exclusiones. Situaciones como la reconciliación nacional, la impunidad frente al atropello a los derechos humanos, la justicia frente a las víctimas y victimarios, ocupan el primer plano en las reuniones y acuerdos de los distintos frentes.[7] Lo concreto es que a esta altura del tiempo la dictadura seguía imponiendo sus reglas: en los primeros días de marzo de 1988 renovó el Estado de Emergencia y el Estado de Peligro de Perturbación de la Paz Interior, que le permitían prohibir reuniones públicas y detener, incomunicar, relegar y exiliar. Además mantuvo el absoluto control de la TV en circunstancias que el Canal Nacional es el único que llega a todas las regiones del país, y por lo tanto el único medio de información del chileno medio y de los estratos rurales. Desde que Pinochet fuera nominado candidato, todos los canales de TV, inclusive los Universitarios, cubrían profusamente sus movimientos y giras electorales. Los 13 partidos de la Concertación por el No a Pinochet advirtieron que desconocerían el Plebiscito si el resultado no estaba revestido de garantías de transparencia y limpieza. Lo mismo expresó la Iglesia, en reiteradas ocasiones.

Tanto la posición del "Sí" como la del "No" implicaban la aceptación en parte de la institucionalidad impuesta por el régimen militar. La izquierda y los sectores populares enfrentan después del triunfo en el Plebiscito el serio dilema de definir su inserción política, ya que la Constitución de 1980 prevé una institucionalidad altamente autoritaria, donde las fuerzas armadas, a través del Consejo de Seguridad Nacional, ejercerán una especie de tutela sobre los poderes

del Estado. Es la democracia protegida que postula el régimen. Se pensaba en una negociación con las fuerzas armadas que se ha ido haciendo inviable. En el frente económico se realizan planteamientos sobre mantener el esquema neoliberal y en forma prioritaria el irrestricto respeto a la propiedad privada. Un sector de la Izquierda más tradicional y no renovada, se resiste a plantear el cambio de régimen autoritario a democracia, sin tocar el sistema económico imperante. Sobre este punto se afirma el gobierno para atemorizar a la opinión pública y a las fuerzas armadas sobre el peligro de un retorno de la Unidad Popular.

Volviendo a los resultados del Plebiscito del 5 de octubre de 1988, el triunfo de la oposición provocó de por sí una profunda conmoción dentro del régimen. El gabinete de ministros debió modificarse de acuerdo a las nuevas circunstancias. En los mandos de las fuerzas armadas se han producido relevos y se alejan de las labores gubernativas. Los sectores partidarios de Pinochet han descartado sus posibilidades de continuidad y se han ido paulatinamente alejando de él. Es el caso del partido de derecha, Renovación Nacional, liderado por Sergio Onofre Jarpa. La demanda por reformar la constitución abarca a sectores cada vez más amplios. Los Partidos de la Concertación han ratificado su decisión de postular a la presidencia con un candidato único de consenso.

La alegría desbordante de los primeros días después del triunfo del "No" a Pinochet, dio paso a un clima de mayor tranquilidad, pero no falto de optimismo, aún cuando Pinochet actúa ignorando su derrota, y dificultando la transición con todos los poderes de que dispone. La coyuntura política actual frente al fracaso de la demanda por algunas reformas a la Constitución, en la que Carlos Cáceres, como Ministro del Interior de la dictadura, representaba al gobierno, vuelve a colocar a la oposición en la confrontación: el continuismo del régimen militar o la democracia. Por ello existe gran agitación política frente a las elecciones del 14 de diciembre de 1989 y gran agitación popular e intelectual porque la inquietud electoralista, no relegue a segundo plano las demandas sociales, y la demanda por justicia frente al atropello a los derechos humanos en los 16 años de dictadura.[8]

Puede agregarse aquí, la grave violación a los derechos de las minorías étnicas chilenas, quienes, ante esta situación discriminatoria, han logrado ir haciendo una resistencia y encontrando los cauces necesarios para sobrevivir, luchando por su dignificación, la liberación y los derechos que les corresponden. La Iglesia ha jugado un papel relevante en el apoyo y defensa de la dignidad de los indígenas a través de sus obispados regionales. Recientemente los indígenas han formado

el Partido de la Tierra y la Identidad (PTI), cuyo objeto es impulsar su participación, como chilenos, en la vida nacional. Su proyecto de trabajo propicia su representación en el Parlamento, el reconocimiento institucional como pueblos, la oficialización de los distintos idiomas y la educación bilingüe y bicultural. La Comisión Política del PTI la conforman representantes de los pueblos aymará, rapanui y mapuche.

Sobre el estado de la justicia chilena en el momento, es importante hacer mención a que, al inaugurar el último año judicial en dictadura, el Presidente de la Corte Suprema, Luis Maldonado, se refirió a la hipertrofía de la justicia militar en estos 16 años, pidiendo que una norma constitucional impida la extensión de su competencia a civiles, y abogó por el indulto a prisioneros políticos condenados por su ingreso al país. Expresó que los tribunales castrenses juzgan a mayor cantidad de civiles que militares en un porcentaje de 80%.

Regresando al plano político, la Constitución de 1980 establecía que el 11 de marzo de 1989, finalizaba el período de 8 años de gobierno del general Pinochet, pero al mismo tiempo la Carta le asignaba un año más de ejercicio, es decir hasta el 11 de marzo de 1990. Su gobierno de este año deberá tener un carácter provisional, cuya principal tarea consiste en convocar y garantizar la realización de elecciones generales de Presidente de la República y Congreso Nacional. Las recién aprobadas por el gobierno, Ley Orgánica de Distritos, Pactos Electorales e Inhabilidades Parlamentarias, junto a la escalada de privatizaciones de empresas públicas estratégicas y la determinación de que la propaganda electoral tenga un alto costo en el canal del Estado, la que antes fue gratuita, indica, como lo afirma José J. Brunner de FLACSO, la intención de quitarle a la elección de diciembre su rol de instancia legítima de traspaso del poder y envolverla desde ya en un clima de polarización de conflictos. Se trata de crear las condiciones que vuelvan inviable, bloqueado y estéril el gobierno democrático elegido por la oposición. El problema más grave para el régimen en este momento es la postulación a la presidencia del ex-Ministro de Hacienda del régimen, Hernán Büchi, el que podría ser en Chile lo que fue Adolfo Suárez en España. Ellos estiman que Büchi perturba su estrategia, pues de mantenerse su candidatura, ésta tendría la capacidad de reorganizar las fuerzas del régimen.

Por último citaremos los términos de una intervención reciente de Manuel Antonio Garretón, en Washington, en mesa redonda sobre "La Literatura Chilena Bajo el Régimen Militar", que tienen relación con la coyuntura política chilena:

Las tres instituciones conservadoras de la sociedad, la Iglesia, le Educación y la Familia, no lograron ser permeadas por el régimen, fueron refugio de la expresión

de la cultura alternativa, y desde ese refugio, el sector más reacio a la cultura dominante es el que se ubica entre 15 y los 39 años de edad, exactamente el sector en que se centró la campaña política del Plebiscito. Este mundo juvenil es una mezcla de rechazo a la institucionalidad vigente, una mezcla de barricadas y neoprén en las poblaciones, y de zapatillas Adidas y "rock" en la clase media.

Garretón resumió también lo que Chile ha aprendido de las otras transiciones a la democracia: aprendimos de los españoles, que había que tener instituciones mediadoras; de los brasileños, que había que meterse en la institucionalidad; de los uruguayos, que los plebiscitos se pueden ganar; de los filipinos, que hay que tener un sistema de cómputos paralelos; de los coreanos, que hay que movilizarse para pedir una reforma constitucional; y, también de los coreanos, que si se va dividido, en la segunda vuelta se reproduce el régimen autoritario.

## NOTAS

1. Frente al proceso de polarización social que vive Chile bajo el gobierno militar que lleva ya 16 años, la Iglesia chilena representada por sus obispos y vicarías y otros sectores cristianos, como el Servicio de Paz y Justicia, ha publicado un número de libros llamando a la reconciliación de los chilenos: *Derechos humanos: camino de reconciliación*, del padre José Aldunate, vocero del Movimiento contra la Tortura y la Impunidad "Sebastián Acevedo"; *Reconciliación y participación*, de los obispos Carlos Camus, Tomás González y Jorge Hourton; *Iglesia, reconciliación y democracia*, de Patricio Dooner; *La no-violencia activa durante la dictadura*, por Domingo Namuncura, director del SERPAJ; *Exigencias concretas para la reconciliación*, publicado por SERPAJ en 1988, y otros.

2. Sobre la estructura económica neoliberal establecida por el régimen militar y que ha generado cambios en el empleo, estratificación social, situación del trabajo, calidad de vida de las diferentes capas sociales, existen abundantes estudios realizados por equipos de investigadores de centros especializados: PET, CIEPLAN, CED, ICAL, ECOSURVEY, entre los no-gubernamentales; ODEPLAN, INE, Banco Central, PROCHILE, fuentes gubernamentales y CEPAL, PREALC, UNICEF, organismos internacionales. (Véase la bibliografía anexa.) En relación a prácticas democráticas y participativas en la base social, se ha realizado un trabajo sistemático y abundante por parte de la Iglesia, a través del Arzobispado, por el CISOC, el CIDE, la revista *Mensaje*, a través de sus vicarías pastorales extendidas hacia áreas marginales de Santiago: por ejemplo, Vicaría Pastoral Obrera, Pastoral Educacional, Pastoral Juvenil, que constituyen centros de apoyo, capacitación y acción social. Igualmente la Academia de Humanismo Cristiano que en marzo de 1989 se constituyó en Universidad Academia de Humanismo Cristiano, coordina centros de investigación educacional como el PIIE que publica resultados de sus investigaciones en forma de libros y documentos de trabajo, muy solicitados por su riguroso contenido, pero de muy baja tirada. También un grupo de profesores investigadores del PIIE dan salida a una revista de análisis crítico de la política educacional actual llamada *El Pizarrón*. En el ámbito de la investigación educacional se destaca además el CIDE, ECO, SUR, FLACSO. En capacitación y programas de alfabetización, se suman a los anteriores, el TAC, CEDAL y CES. En el campo de la educación popular, en medios poblacionales y rurales, incluyendo a los mapuches, existe extensa bibliografía producida por CEPAL y el Centro El Canelo de Nos, con sus publicaciones en documentos de estudios, libros y sus revistas *Apuntes* y *El Canelo*, respectivamente. En investigación agraria y rural se destacan los centros GIA, GEA, AGRA, AGRARIA alternativos y ODEPA, perteneciente al Ministerio de Agricultura. Todos ellos producen sus estudios en forma de documentos de trabajo y publicaciones periódicas.

En relación a la vida política de los sectores populares se ha escrito muy poco, salvo lo que ellos entregan a través de sus *Boletines Poblacionales*, que son muchos, pero de aparición espontánea, de distribución interna, y de vida tan efímera que rara vez alcanzan el número 2 o 3. El movimiento poblacional y sus luchas han venido siendo estudiadas por FLACSO, CES, ECO, CODEPU, la Vicaría Pastoral Obrera, a través de libros, documentos de trabajo y seminarios.

La vida política del país la realiza la élite dirigente del gobierno y de los partidos políticos, de manera que la producción de bibliografía más abundante sobre la materia, proviene de centros de estudio y editoriales pertenecientes a estas instancias, entre los que se encuentran, por parte del gobierno, DINACOS, la Procuraduría General de la República, el Instituto Geográfico Militar, las Ediciones Estado Mayor General del Ejército, ODEPLAN y la Presidencia de la República junto a los ministerios de las distintas ramas. En relación a los partidos políticos se cuentan los centros de estudios de la Derecha, CEP, Centro de Estudios Liberales y Corporación de Estudios Nacionales; de la Democracia Cristiana, el CED, SUR, Editorial Aconcagua, Editorial Andante, Ediciones Revista HOY; del Socialismo Renovado, el Instituto para el Nuevo Chile, CESOC, ILET, VECTOR; de la Izquierda, se conocen el ICAL y ediciones especiales del diario *El Siglo*; de centro izquierda, el Centro de Estudios Políticos Latinoamericanos "Simón Bolívar" y otros. (Véase la bibliografía anexa.)

3. El gobierno no sólo ilegalizó la función política, sino que su propia acción política fue absolutamente disruptiva. Notables sociólogos, políticos y periodistas han destacado la situación de los dos Chiles, como se le llama a la política discriminatoria del régimen militar. Advierten su peligrosidad en obras como *La otra mitad de Chile*, de María A. Meza; *Chile entre el Sí y No*, de las periodistas Florencia Varas y Mónica González; *La otra juventud*, de José Weinstein, y *La otra ciudad*, de Sergio Wilson.

4. La problemática del joven chileno ha sido profusamente estudiada en casi todos los centros de investigación por especialistas como José Weinstein y Oscar Corvalán del CIDE, Irene Agurto de SUR, Mario Marcel de CIEPLAN, Luis Eduardo González del PIIE, así como por el CODEJU y la Vicaría Pastoral Juvenil.

5. Encuestas y estudios realizados señalan que el proyecto educativo del régimen militar ha fracasado en su aspiración de formar una juventud despolitizada y sólo interesada en el logro material individual, así lo señalan estudios de investigadores de SUR, Instituto Blas Cañas, ILET, etc.

6. Los estudios acerca del deterioro en el ambiente familiar, constatan datos alarmantes sobre la pobreza, delincuencia infantil y juvenil, alcoholismo, hacinamiento. Ellos han sido realizados desde el ámbito universitario por investigadores del Instituto de Sociología, Universidad Católica, y del Departamento de Sociología de la Universidad de Chile (trabajos de Doris Cooper Mayr, *Conflicto familiar: características sociales y variables asociadas en la extrema pobreza*, 1986). La más afectada con esta situación de deterioro familiar ha sido la mujer, cuya problemática de marginalización ha sido estudiada por los centros de estudios de la mujer: el CEM, ISIS Internacional; la Morada, casa de la mujer chilena; el PET; el CISOC del Centro Bellarmino, donde investiga sobre el tema Cristián Vives ("Crisis en la Familia Popular").

7. Dentro de un clima de gran efervescencia política, el gobierno militar llamó el 30 de agosto de 1988 a un plebiscito a realizarse el 5 de octubre de 1988, preestablecido en la Constitución de 1980, en el que el pueblo de Chile debería pronunciarse en favor o en contra de la continuidad de Pinochet como Presidente de la República. El plebiscito desató una explosión de publicaciones por parte de los partidarios del gobierno y de los partidarios de la oposición, que desde aquí para adelante pasaron a llamarse "los del Sí" y "los del No". Después de 15 años de proscripción política se hacía necesaria la producción de materiales de apoyo a la educación política democrática de los jóvenes que teniendo 18 años en 1988, deberían votar en el plebiscito y que en el momento del golpe militar, tenían sólo 3 años de edad. Así nacieron el *Manual del ciudadano* de la Editorial Andante, y otro de Ediciones Revista *Hoy*, e innumerables cartillas, trípticos y panfletos de ambas posiciones contricantes, los que pueden apreciarse en la publicación de SEREC,

*Una visión de la expresión ciudadana a través del panfleto y el volante*, vol. IV, *El plebiscito en Chile, 5 de octubre de 1988.* El llamado también abrió la esperanza de una real transición a la democracia y desde todos los ángulos políticos y eclesiásticos comenzaron a emerger libros, declaraciones y documentos sobre la "Transición a la democracia". (Véase la bibliografía anexa.)

8. A partir del 5 de octubre, día del triunfo de la oposición en el plebiscito, aparece todo un bagaje de literatura relacionada con el evento enfocada desde distintos ángulos: políticos, sociales, de derechos humanos, de proposiciones para dar solución a los problemas de la pobreza, de los exiliados y retornados, de las organizaciones de familiares de presos y desaparecidos políticos, etc. (Véase la bibliografía anexa.) Llegan al país primeras ediciones de libros publicados en el exilio, o testimonios de ex-presos políticos retornados: *Isla 10* de Sergio Bitar, o *De improviso la nada* de Erich Schnake, o desde otro ángulo, el libro de Jorge Arrate, o *El país prohibido* de Volodia Teitelboim, o *Exilio, y sin embargo vida* de María Carelli, etc. Se publican además, dentro del país, segundas ediciones de libros cuya primera edición no fue autorizada para leerla. Se produce así un comienzo de apertura espontánea, sin autorización oficial. Esta nueva etapa influye en todos los géneros literarios. Las publicaciones adquieren formas más económicas para difundir lo coyuntural, lo contingente; inserciones y solicitadas en revistas de mayor circulación como *APSI, Cauce, Análisis, Hoy.* Los partidos políticos dan a conocer sus propuestas frente a la transición, de las prioridades tales como negociación con las fuerzas armadas, para su retorno a la profesionalidad y a los cuarteles, la revisión de las privatizaciones llevadas a cabo por el gobierno después de su derrota, y las reformas urgentes a la Constitución y a sus mecanismos de reforma. Todas estas obras están en la bibliografía anexa.

## SIGLAS
### (Descripción de las siglas usadas, correspondientes a las fuentes)

AGRA. Sin descripción
AGRARTA. Desarrollo Campesino y Alimentario
CEAAL. Consejo de Educación de Adultos para América Latina
CED. Centro de Estudios del Desarrollo
CEDAL. Centro de Asesoría Profesional
CEP. Centro de Estudios Públicos
CEPAL. Comisión Económica para América Latina
CEPLA. Centro de Estudios Políticos Latinoamericanos "Simón Bolívar"
CES. Centro de Estudios Sociales
CESOC. Centro de Estudios Sociales
CIDE. Centro de Investigación para el Desarrollo de la Educación
CIEPLAN. Corporación de Investigaciones Económicas para América Latina
CISOC. Centro de Investigaciones Socioculturales
CODEJU. Comité de Derechos Juveniles
CODEPU. Comité de Defensa de los Derechos del Pueblo
DINACOS. Dirección Nacional de Comunicación Social
ECO. Educación y Comunicaciones
ECOSURVEY. Economic & Financial Survey
FLACSO. Facultad Latinoamericano de Estudios Sociales
GEA. Grupo de Estudios Agrarios
GIA. Grupo de Investigaciones Agrarias
ICAL. Instituto de Ciencias "Alejandro Lipchutz"
ILET. Instituto Latinoamericano de Estudios Transnacionales
INE. Instituto Nacional de Estadísticas
ODEPA. Oficina de Planificación Agrícola, Ministerio de Agricultura
ODEPLAN. Oficina de Planificación Nacional, Presidencia de la República
PET. Programa de Economía del Trabajo, Academia de Humanismo Cristiano

PREALC. Programa Regional del Empleo para América Latina y el Caribe
PROCHILE. Promoción de Exportaciones, Chile
SERPAJ. Servicio de Paz y Justicia
SUR. Educación/Documentación
TAC. Taller de Acción Social
UNICEF. Fondo de las Naciones Unidas para la Infancia
VECTOR. Centro de Estudios Económicos y Sociales

## BIBLIOGRAFIA

Agurto, Irene. *Juventud chilena: razones y subversiones*. Santiago: ECO, 1985.

_____. *Juventud y política: cuatro enfoques*. Santiago: SUR, 1988.

_____. *Visión del mundo de la juventud popular urbana: algunos elementos para su comprensión*. Santiago: Universidad Católica de Chile, 1984. Tesis.

Albuquerque, Mario, y G. Jiménez. *Actores sociales más allá de la transición*. Santiago: Proyecto Alternativo, 1988.

Albuquerque, Mario, y Víctor Zúñiga. *Democracia, participación, unidad: una mirada a la estrategia sindical desde el sindicato de base*. Santiago: CETRA-CEAL, 1987.

Albuquerque, Mario, et al. *Los movimientos sociales en la coyuntura post plebiscitaria: un tiempo peligroso*. Santiago: ECO, 1988.

_____. *Una propuesta socialista para un Chile posible*. Santiago, 1988.

Aldunate, José, s.j. *Derechos humanos: camino de reconciliación*. Santiago: Paulinas, 1988.

Almeyda M., Clodomiro. *Interacción de lo político y lo sindical en Chile*. Santiago: CES, 1989.

Alvarez, Jorge, comp. *Los hijos de la erradicación*. Santiago: PREALC, 1988.

Auth, José. *Esperando la esperanza: los jóvenes y el plebiscito*. Santiago: SUR, 1988.

Aylwin Oyarzún, José. *La reforma municipal: un mecanismo para la proyección del régimen*. Documento de Trabajo, 63. Santiago: Comisión Chilena de Derechos Humanos, Programa de Derechos Económicos, Sociales y Culturales, 1988.

Aylwin, Patricio, et al. *Una salida político constitucional para Chile*. Santiago: ICHEH, 1985.

Barrera, Manuel. *Consideraciones acerca de la relación entre política y movimiento sindical: el caso de Chile*. Santiago: CES, 1988.

_____. *La coyuntura política pre-plebiscito en Chile y los actores sociales más significativos*. Santiago: CES, 1988.

Bossle, Lothar, et al. *Chile: camino a la democracia*. Santiago: Instituto de Ciencia Política, Universidad de Chile, 1988.

Buenaventura, Pablo, et al. *¿Transición a la democracia?: un modelo de análisis y una propuesta*. Santiago: Terranova, 1989.

Buzeta, Oscar. *Las fuerzas armadas y la sociedad civil en democracia*. Santiago: ICHEH/Fundación Frei/CESOC, 1986.

Calderón Azócar, Carlos. *Chile: la otra historia y la nueva historia*. Santiago: CEPLA, 1988.

Calderón Azócar, Carlos. *¿Qué es la dictadura?* Santiago: CEPLA, 1988.

Campero Q., Guillermo. *Movimientos sociales y movimientos de mujeres*. Santiago: Ediciones La Morada, 1988.

Camus, Carlos, Tomás González y Jorge Hourton. *Reconciliación y participación*. Santiago, 1988.

Cárdenas, Juan Pablo, y F. Castillo Velasco. *Chile, una esperanza*. Santiago: CEPLA, 1988.

Castillo L., Fernando. *Iglesia liberadora y política*. Santiago: ECO, 1986.

Celedón, María Angélica, y Luz María Opazo. *Volver e empezar*. Santiago: PEHUEN, 1987.

Centro de Estudios Públicos. *Estudio social y de opinión pública*. Santiago, 1989.

Centro de Estudios de la Realidad Contemporánea. *Informe preliminar sobre primera encuesta nacional, enero 1988*. Santiago, 1988.

Centro de Estudios Sociales. *Documentos de apoyo para el trabajo de educación política democrática*. Santiago, 1988.

Cerri, Marianela, y Elisa Neumann. *El desarrollo juvenil en condiciones de marginalidad*. Documento de Trabajo, 20. Santiago: CIDE, 1983.

Comité Político de la Izquierda Unida. *Propuesta para la transición por la conquista de un régimen auténticamente democrático*. Santiago, 1989.

Conferencia Episcopal de Chile. *Desarrollo y solidaridad: dos claves para la paz. Los pobres no pueden esperar. XVI Semana Social*. Santiago, 1988.

Correa, Enrique, y José A. Viera-Gallo. *Iglesia y dictadura*. Santiago: Ediciones Chile América, 1987.

Delpiano, Adriana. *Proyecto de capacitación de la mujer pobladora*. Santiago: Vicaría Zona Norte/CIDE/FLACSO, 1985.

Dooner, Patricio. *Iglesia, reconciliación y democracia: lo que los dirigentes políticos esperan de la Iglesia*. Santiago, 1989.

Dos Santos, Mario, y Angel Flisfisch. *Concertación social y democracia*. Santiago: CED, 1985.

Echenique L., Jorge, y Nelson Rolando N. *Plebiscito en el campo*. Santiago: AGRARIA, 1988.

Espinosa, Malva. *De la modernización democrática a la modernización perversa: Chile, un caso paradigmático*. Santiago: CES, 1988.

Esponda, Jaime. *La dimensión educativa del hacer justicia en la transición democrática*. Santiago: CEAAL, 1987.

Faiguenbaum, Sergio. *Capacitación de dirigentes poblacionales*. Santiago: CIDE/PIIE, 1985.

Fernández, Mario. *Más allá de la transición*. Santiago: Editorial Andante, 1986.

_____. *Sistemas electorales: sus problemas y opciones para la democracia chilena*. Santiago: ICHEH, 1985.

Filp, Johanna. *Desarrollo infantil y pobreza*. Documento de Discusión, 29. Santiago: CIDE, 1987.

Flisfisch, Angel. *Gobernabilidad y consolidación democrática: sugerencias para la discusión*. Santiago: CED, 1987.

Foxley, Alejandro. *Algunas ideas sobre reencuentro nacional y cambios económicos*. Santiago: CIEPLAN, 1987.

_____. *Chile puede más*. Santiago: Ediciones Planeta, 1988.

Franco, R., et al. *La juventud marginal y su papel en el proceso de cambio social*. Santiago: Vicaría Sur, Area de Capacitación, 1980.

Frei Bolívar, Arturo. *La esperanza de Chile*. Santiago: Editorial Andante, 1985.

Friedman, Reinhard. *La política chilena de la "a" a la "z", 1964–1988*. Santiago: Melquíades, 1988.

Gaete B., Carlos. *Evangelizar la política, magisterio de la Iglesia en Chile (1973–1988)*. Santiago: CESOC, 1988.

García Huidobro, Juan Eduardo. *Capacitación laboral de jóvenes desocupados*. Santiago: CIDE, 1986.

García Huidobro, Juan Eduardo, y José Weinstein. *Diez entrevistas sobre la juventud chilena actual.* Documento de Trabajo, 10. Santiago: CIDE, 1983.

Garretón, Manuel Antonio. *Escenarios e itinerarios para la transición.* Santiago: Instituto para el Nuevo Chile, 1985.

_____. *Evolución política del régimen militar chileno y los problemas de la transición a la democracia.* Santiago: FLACSO, 1982.

_____. *1986–87, entre la frustración y la esperanza.* Santiago: Instituto para el Nuevo Chile/Documentas, 1987.

_____. *El plebiscito de 1988 y la transición a la democracia.* Santiago: FLACSO, 1988.

_____. *Reconstruir la política: transición y consolidación democrática en Chile.* Santiago: Editorial Andante, 1987.

_____. *Transición a la democracia en Chile e influencia externa.* Santiago: FLACSO, 1986.

Garretón, Manuel Antonio, Ignacio Walker, et al. *La transición democrática en Chile.* Roma: Fundación Rafael Campalans, 1988.

Garretón, Oscar Guillermo. *Cambios estructurales y movimiento sindical en Chile.* Santiago: CES, 1989.

Gaviola Artigas, Edda, et al. *Queremos votar en las próximas elecciones.* S.l.: Ediciones La Morada, 1986.

Gazmuri, Jaime, et al. *Chile en el umbral de los noventa.* Santiago: Editorial Planeta, 1988.

Geisse, Francisco, y Rafael Gumucio. *Elecciones libres y plebiscito.* Santiago: Ediciones Chile América/CESOC, 1987.

González, Mónica, Patricia Verdugo, et al. *Chile entre el dolor y la esperanza.* Serie El Sonido de la Historia. Santiago: Editorial Emisión, 1987. 2 cassettes.

González, Tomás, Monseñor. *Etica y política, participar o ser excluidos: el artículo octavo de la Constitución de 1980.* Santiago: Documentas, 1988.

Gormaz, Enrique. *Movilización política, fuerzas armadas y transición democrática.* Santiago: FLACSO, 1986.

*Hacia el logro de una democracia sólida.* Santiago: Estado Mayor General del Ejército, 1987.

Hardy, Clarisa. *Hambre + dignidad = ollas comunes.* Colección Experiencias Populares, 1. Santiago: PET, 1986.

Hidalgo, Paulo. *Liderazgo juvenil y cultura política de centro y de izquierda.* Documento de Trabajo. Santiago: ILET, s.f

Jans, Sebastián, y Ricardo Lagos. *¿Qué es el P.P.D.?* Santiago, 1988.

Kirkwood, Julieta. *Ser política en Chile: las feministas y los partidos.* Santiago: FLACSO, 1986.

Kotliarenko, M. A. *Aspectos psico-sociales de la influencia marginal en Chile.* Santiago: CIDE, 1983.

Lagos, Ricardo. *Carta abierta a los demócratas chilenos.* Santiago, 1989.

_____. *Democracia para Chile: proposiciones de un socialista.* Santiago: PEHUEN, 1985.

_____. *Hacia la democracia.* Santiago: Documentas, 1987.

Larraín, Hernán. *Gobernabilidad en Chile luego del régimen militar.* Santiago: CED, 1987.

_____. *Ideología y democracia en Chile.* Santiago: Andante, 1988.

Lechner, Norbert. *La democratización en el contexto de una cultura post-moderna.* Santiago: FLACSO, 1986.

_____. *Los patios interiores de la democracia: subjetividad y política.* Santiago: FLACSO, 1988.

472 MARTA DOMÍNGUEZ DÍAZ

Lira, Pedro. *La concertación social para la paz y la democracia: los trabajadores chilenos.* S.l.: Editorial Tiempo Nuevo/Vicaría Pastoral Obrera, 1988.

Mac-Clure, Oscar. *Resultados de la negociación colectiva durante el régimen militar.* Santiago, 1988.

Madrid, E. *Las comunidades eclesiales de base: aproximación a una realidad desconocida.* Santiago, 1983. Mimeo.

Magendzo, Salomón. *Y así fue creciendo . . . la vida de la mujer pobladora.* Santiago: PIIE, 1983.

Maira, Luis. *La constitución de 1980 y la ruptura democrática.* Santiago: Emisión, 1988.

Marcel, Mario. *La joven generación chilena: del régimen militar a la democratización.* Nota Técnica, 64. Santiago: CIEPLAN, 1984.

Martínez, J. *Juventud y exclusión social: el caso chileno.* Santiago: CEPAL, 1985.

Martínez, J., y Eugenio Tironi. *Las clases sociales en Chile: cambio y estratificación, 1970–1980.* Santiago: SUR, 1986.

Marx, T. *Antecedentes para la comprensión de la realidad de los jóvenes chilenos.* Santiago: Comisión Nacional de Pastoral Juvenil, 1985.

Mera, Jorge. *Derechos humanos y plebiscito: Programa de Derechos Humanos, A.H.C.* Santiago, 1988.

Meza, María Angélica, et al. *La otra mitad de Chile.* Santiago: Instituto para el Nuevo Chile/CESOC, 1986.

Molina Johnson, Carlos, Tte. Grl. *1973: algunas de las razones del quiebre de la institucionalidad política.* S.l.: Estado Mayor General del Ejército, 1987.

Molina, Sergio, y José Zabala. *Acuerdo nacional y transición a la democracia.* Santiago: CEP, 1986.

*La mujer en el momento presente.* Santiago: Academia de Humanismo Cristiano, 1989.

Mujica A., Rodrigo, y Alejandro Rojas P. *Mapa de la extrema pobreza en Chile.* 2. ed. Santiago: Instituto de Economía, Universidad Católica de Chile, 1988.

Muñoz, Heraldo, ed. *Chile: política exterior para la democracia.* Santiago: Pehuén, 1989.

Namuncura, Domingo. *Desafíos sociales y políticos de la no violencia activa en la lucha por la democracia.* Santiago: SERPAJ, 1988.

_____. *La no violencia activa durante la dictadura.* Santiago: SERPAJ, 1988.

Naranjo, Jaime. *Los trabajadores temporeros: realidad y derechos laborales.* Linares: Obispado de Linares, 1989.

Nogueira Alcalá, Humberto. *Fundamentos cívicos para mi voto.* Santiago, 1988.

Ochoa, J., y E. Santibáñez. *La niñez: un concepto que discrimina.* Santiago: CIDE, 1985.

ODEPLAN. *Chile 1977: un país con visión de futuro.* Santiago, 1988.

_____. *Chile: realidad y futuro.* Santiago, 1988.

_____. *Sumando logros alcanzamos el desarrollo.* Santiago, 1988.

Olivares B., Eliana, comp. *Primer Seminario "Los derechos económicos, sociales y culturales: desafío para la democracia".* Santiago: Comisión Chilena de Derechos Humanos, 1988.

Orrego, Francisco. *El papel de las fuerzas armadas en la redemocratización de Chile.* Santiago: CED, 1987.

_____. *Transición a la democracia en América Latina.* Buenos Aires: Grupo Editor Latinoamericano, 1985.

Ortíz, Iván. *Proyecto inos juntamos! ¿y?.* Santiago: CIDE, 1986.

Pérez S., Enrique. *El régimen autoritario y la transición a la democracia: una aproximación.* Santiago: Instituto de Ciencia Política, Universidad Católica, 1987.

Pérez de Arce, Hermógenes. *¿Sí o no, qué puede pasar . . . habrá democracia en Chile?* Santiago: Zig-Zag, 1988.

Piña, Carlos. *Ollas comunes.* Santiago: Vicaría Oriente, 1985.

Pinochet Ugarte, Augusto. *Mensajes presidenciales.* Presidencia de la República de Chile, 1983–.

_____. *Política, politiquería y demagogia.* Santiago: Renacimiento, 1983.

Pinto, Myriam. *Nunca más Chile.* Santiago: Terranova, 1986.

Programa de Economía del Trabajo. *Concertación social y reformas institucionales.* Indicadores Económicos y Sociales, 64. Santiago, 1988.

Rivera, Teodoro. *El procedimiento de reforma de la Constitución de 1980.* Santiago: CEP, 1987.

Rojas M., Darío. *El fenómeno Büchi.* Santiago de Chile, 1989.

Rozas, Patricio, y Gustavo Marín. *1988: el mapa de la extrema riqueza 10 años después.* Santiago: CESOC, 1989.

Sapag, Reinaldo, et al. *Empresa privada y democracia.* Santiago: Ediciones Copygrph, 1988.

Schkolnik, Mariana, y Berta Teitelboim. *Encuesta de empleo en el gran Santiago: empleo informal, desempleo y pobreza.* Santiago: PET, 1988.

Schmidt, Helmut, et al. *Seminario "Fuerzas armadas, estado y sociedad".* Santiago: CED, 1988.

Schnake, Erich. *De improviso la nada, testimonio de prisión y exilio.* Santiago: Documentas, 1988.

Sepúlveda, Juan, et al. *Justicia y no violencia: conferencia de obispos, pastores y laicos.* Santiago: SERPAJ, 1988.

SERPAJ. *Exigencias concretas para la reconciliación: llamado a los partidos políticos de la oposición chilena.* Santiago, 1988.

Silva B., Alejandro. *Bases constitucionales de una institucionalidad castrense.* Santiago: CED, 1987.

Teitelboim V., Volodia. *En el país prohibido.* Concepción: LAR, 1988.

Tironi, Eugenio, et al. "Plebiscito y elecciones". En *Proposiciones, Sur* (Santiago de Chile), junio 1988, no. 16.

Valdés, Teresa. *Poblaciones y pobladores: notas para una discusión conceptual.* Material Discusión, 33. Santiago: FLACSO, 1982.

_____. *Venid, benditas de mi padre, las pobladores, sus rutinas y sus sueños.* Santiago: FLACSO, 1988.

Valdivieso Ariztía, Rafael. *Crónica de un rescate.* Santiago: Andrés Bello, 1988.

Valenzuela, Arturo. *El quiebre de la democracia en Chile.* Santiago: FLACSO, 1989.

Valenzuela, Eduardo, y Ricardo Solari. *Los jóvenes de los ochenta: una interpretación sociológica de la actual generación estudiantil de clase media.* Santiago: SUR, 1982.

_____. *La rebelión de los jóvenes.* Colección Estudios Sociales. Santiago: SUR, 1984.

Varas, Augusto. *Las fuerzas armadas en la transición y consolidación democrática en Chile.* Santiago: CED, 1987.

Varas, Florencia, y Mónica González. *Chile entre el sí y el no.* Santiago: Ediciones Melquíades/La Epoca, 1988.

Vergara, Pilar. *Auge y caída del neoliberalismo en Chile.* Santiago: FLACSO, 1985.

Vicaría de la Solidaridad. *Derechos humanos en Chile, enero-diciembre 1988.* Santiago, 1988.

Vicaría Pastoral Obrera. *Problemática juvenil popular: informe de trabajo.* Santiago, s.f.

Vicuña, Ricardo, y Gerardo García. *Estudio de la extrema pobreza en Chile.* Santiago: INE, 1985.

Vives, Cristiana. *Crisis en la familia popular y su visión del futuro.* Santiago: CISOC/ Centro Bellarmino, 1983.

Vives, F., M. Silva y Claudia Serrano. *Diagnóstico de la juventud marginal: un estudio de caso San Gregorio.* Santiago: DECU, 1983.

Walker, Horacio. *Realidad rural marginal.* Santiago: CIDE, 1984.

Walker, Ignacio, José A. Viera Gallo et al. *Democracia en Chile: doce conferencias.* Santiago: CIEPLAN, 1986.

Weinstein, José. *Entre la ausencia y el acoso: apuntes bibliográficos sobre jóvenes pobladores, vida cotidiana y estado en Chile hoy.* Documento Discusión, 22. Santiago: CIDE, 1988.

————. *Estado y jóvenes pobladores: figuras culturales, políticas sectoriales y consecuencias psico-sociales.* Documento Discusión, 13. Santiago: CIDE, 1988.

————. *La otra juventud: el período juvenil en sectores de extrema pobreza urbana.* Documento Trabajo, 7. Santiago: CIDE, 1985.

Wilson, Sergio. *La otra ciudad: de la marginalidad a la participación social.* Santiago: EDIAR CONOSUR, 1988.

Yáñez, Cecilia. *Familia urbana marginal.* Santiago: CIDE, 1983.

## Obras de referencia sobre el tema

Lladser, María Teresa. *Centros privados de investigación en ciencias sociales en Chile.* Santiago: Academia de Humanismo Cristiano/FLACSO, 1986. Indica publicaciones y fuentes.

Servicio de Extensión de Cultura Chilena, SEREC. *Indice general de la revista Hoy, 1977–1985.* Santiago, 1986.

————. *Le libro chileno en venta 1981–1988.* Santiago, 1989. Bibliografía anotada.

————. *La revista chilena en venta 1981–1988.* Santiago, 1989. Bibliografía anotada.

Silber Editores Limitada. *Directorio de instituciones de Chile.* Santiago, 1989.

## Publicaciones Periódicas
## (Area de Ciencia Política)

*Análisis*
*APSI*
*Cauce*
*La Epoca*
*Ercilla*
*Estrategia*
*Fortín Mapocho*
*Hoy*
*Mensaje*
*El Mercurio*

*La Nación*
*Pastoral Popular*
*Pluma y Pincel*
*Política*
*Política y Espíritu*
*Que Pasa*
*Revista de Ciencia Política*
*Solidaridad*
*El Siglo*

# 39. Cracks in the Mirror: The Nicaraguan War and Human Rights in Honduras

## Fred G. Morgner

One of the most tragic consequences of the conflict between Nicaraguan counterrevolutionaries and the Sandinista government was the erosion of human rights in neighboring Honduras. The region along Honduras's southeastern border underwent serious convulsions owing to the influx of Nicaraguan refugees escaping economic hardship and Contra rebels fleeing the pursuit of the Sandinista army. The additional factor of U.S. pressure on the Honduran government to allow the Contra army to use Honduran territory as a safe haven and a base of operations contributed greatly to regional tensions and an escalation in political violence, erupting in a wave of human rights violations during the 1980s.

The Honduran military has had a long history of repression against political dissidents, labor leaders and peasant organizations, but through the 1970s repressive activities were limited primarily to specific conflicts. The introduction of global politics into this brew escalated the doctrine of national security to new heights. The subordination of Honduran national interests to U.S. policy considerations during the 1980s provoked strong criticism from traditional dissidents and spurred the formation of new organizations, such as peace groups, families of disappeared persons, and human rights advocates. This heightened level of protest, seen in the context of feared Sandinista expansion and international communism, led Honduran paramilitary forces and Contra zealots to respond with death threats, assassinations, kidnappings, and assaults against the architects of the new Honduran dissent. The mounting repression, exacerbated by escalating U.S. military presence and the massive introduction of arms into the area, in turn sparked a terrorism of the left by a small but active number of domestic revolutionaries. Such incidents were then used by the right wing to justify even further repression, resulting in a spiral of violence for which Honduras paid a heavy price.

The Nicaraguan civil war forced Honduras to absorb two armies within its borders. Several thousand U.S. troops were rotated in and out of numerous bases, increasing dramatically in number during

periodic "war games," usually held near Nicaraguan territory. More important was the presence of between 6,000 and 12,000 Contra forces in the provinces of El Paraiso and Choluteca, resulting in thousands of dislocated Hondurans, a disruption of the area's economy, and continued outbreaks of armed violence. An area of approximately 450 square acres of territory in southern Honduras bordering Nicaragua became known as "Nueva Nicaragua." Towns such as Arenales, Cifuentes and Capire were accordingly renamed "Casey," "Kirkpatrick," and "Ciudad Reagan" by Contras in nearby encampments. With U.S. military aid and the acquiescence of the Honduran army, Contra forces used their bases in Honduras to attack targets in northern Nicaragua. As such incursions became more frequent and violent, the Ejercito Popular Sandinista (EPS) responded by shelling Contra camps in Honduras and at times pursuing fleeing Contras across the border, often leaving land mines after their return to Nicaragua. As is the case in such conflicts, local peasants became caught in a deadly squeeze.

While the southern sector of Honduras was increasingly devastated, the administrations of Suazo Cordoba and Azcono Hoyo, caught between U.S. pressure and the growing complaints of their own countrymen, alternately disavowed Contra occupation and acknowledged sporadic presence while claiming that they were powerless to combat it. Later in the decade, pressured by the Arias peace initiative, they more readily admitted the Contras were there while begging time to remove them. Never did they acknowledge the policy of benevolent restraint, the very least demanded by U.S. Ambassador John Negroponte. To anyone who visited the area such a policy was apparent. Author-journalist Edward Sheehan, who spent five days in a Contra camp near the border in 1986, related that during the drive from Tegucigalpa he was subjected to various checks by the Honduran military. Once inside Nueva Nicaragua and the vicinity of Contra camps, however, he noted that Honduran troops were conspicuously absent.[1]

As the zone became more convulsed, critics of the Contra presence and the Reagan administration that supported it grew increasingly vocal. Local dissidents began to pay a price, such as Choluteca teacher César Agosto Cadalso, assassinated by machine gun in 1982. By 1983 displaced persons from the area held their first organized demonstration in Tegucigalpa, arguing for peace and the expulsion of the army disrupting their land. By the mid 1980s complaints were heard more frequently, such as the denunciation by the archbishop of Copan over the rape of Honduran women near the

camps and the outcry over the murders of several anti-Contra families in Danli. Prominent leaders who voiced such criticism, including national legislators, local coffee growers, and human rights leaders, received growing numbers of death threats.

As intimidation, disappearances, and assassinations in the southern zone were publicized, organizations appeared in the early 'eighties to represent the interests of the victims, most notable of which were the Comité de Familiares Desaparecidos de Honduras (COFADEH) and the Comité para la Defensa de Derechos Humanos en Honduras (CODEH). Based in large population centers, as these groups began to attract attention their leaders became the targets of threats, violent forms of intimidation, disappearances, and assassinations. Thus the pattern of violence spread from the southern region to the capital of Tegucigalpa and the leading industrial center of San Pedro Sula. Creating even more tension were the sporadic armed attacks that began against U.S. military personnel and installations at and near the major base of Palmerola. A macabre rhythm of violence was underway.

The decade was marked by three periods of varying levels of human rights abuses, which were in large part related to the changing leadership of the Honduran armed forces. The period of 1981 through the spring of 1984 was characterized by a sharp escalation of repression during the ascendancy of General Gustavo Alvarez Martínez as supreme military commander. With Alvarez at the helm and Ambassador Negroponte articulating policy for the Reagan administration, two years of heightened human rights abuses occurred, lasting until shortly after Alvarez's ouster as military chief in March of 1984. The middle years of the decade witnessed a relative decline in domestic violence and human rights violations, which were held in check by Alvarez's more restrained successor, Air Force General Walter López Reyes. When López Reyes was forced from office in early 1986 and replaced by General Humberto Regalado Hernández, the number of disappearances, assassinations, bombings, and cases of torture took a renewed and sharp upswing and remained so until the end of the decade.

General Gustavo Alvarez reigned as head of the Honduran military from January of 1982 to March of 1984, a period characterized by Amnesty International as one marked by a "selective though systematic campaign" of repression against leftist unions, agricultural organizations and cooperatives, political and civic groups, educational and student leaders and human rights activists.[2] A staunch anti-communist and Contra sympathizer, Alvarez had been trained in

Argentina by the architects of the infamous *guerra sucia*, many of whom were brought to Honduras as military advisors and trainers during his ascendancy. Championed by Negroponte, Alvarez became a favorite of the Reagan administration and was awarded the Pentagon's Legion of Merit in Washington.

Under what has become known in Honduras as "Alvarismo," an apparatus for stifling dissent was established. Those who challenged the Reagan definition of Honduran national security were viewed and represented as part of a conspiracy to undermine democracy and to aid the spread of international communism. In addition to the existing security agencies of the Fuerza de Seguridad Pública (FUSEP) and the civilian-clad Departamento Nacional de Investigaciones (DNI), new antisubversive groups were formed. These included the Cuerpo de Policia Anti-Subversivos (COBRAS), the Tropas Especiales para Operaciones de Selva y Nocturnas (TESON), and the organization most commonly associated with political violence, the Batallón 3-16. Many of the 3-16 personnel were graduates of the now defunct International Police Academy in Washington and have been viewed by human rights investigators as bearing much responsibility for the rash of disappearances under Alvarez. Such political kidnappings soared from only one in 1980 to over seventy during the years 1982-1984. Figures for cases of death threats, torture, arbitrary detentions, and assassinations followed a similar upswing. The invigorated state apparatus was bolstered by a harsh new antiterrorist law as well as the establishment of Comités de Defensa Civil. These committees were neighborhood groups charged with local surveillance and information-gathering on suspected subversives, reminiscent of similar groups established by the Sandinistas in Nicaraguan neighborhoods during the same period.

The wave of repression was facilitated by the structure of the Honduran judicial system. A true elite in society, the Honduran military has been traditionally immune from the jurisdiction of civil courts, making effective prosecution of human rights excesses next to impossible. Of the many cases of disappearances under Alvarismo, only two were attributed to the military, and these only after years of international investigation and litigation in the regional Inter-American Court of Human Rights. In 1987 a Honduran supreme court judge, known for his criticism of the military's immunity for crimes against civilians, was gunned down for allegedly running a military road block. The officer held responsible for the judge's death was initially ordered held for civilian trial, but later released by a military court and transferred to a military *cuartel*.

Repression during the Alvarez years was justified by the appearance in the early 'eighties of various revolutionary fronts within Honduras. The armed Partido Revolucionario de Trabajadores Centroamericanos (PRTC) was defeated in a skirmish with the Honduran military in 1983. The survivors of the clash were allegedly executed, including U.S. Jesuit priest James Francis Carney, who has achieved status as a martyr among the left as Padre Guadalupe. Another small band of alleged revolutionaries were captured and exhibited in 1984, known as the Fuerza Popular Revolucionaria Lorenzo Zelaya. A third group, which has claimed credit for a number of anti-United States bombings and assassinations of Honduran rightists, is the Movimiento Popular de Liberación, or Chinchoneros. The existence of these radical fragments and their ideological support for the Nicaraguan Sandinistas were cited as evidence by groups like the Batallón 3-16 that a network of internal subversion, linked to the Sandinistas and supported by communists masquerading as advocates of peace and human rights, threatened Honduran national security.

Because human rights abuses under Alvarez went largely uninvestigated by Honduran authorities, it is speculative to determine the involvement of the Contras in the actions of organizations like the 3-16. Throughout the decade, however, revelations surfaced from former members of the state security system that the Honduran military and Contra members had cooperated in acts of violence against Honduran dissidents. As early as 1982, former army Colonel Leonidas Torres charged from Mexico City that such death squads had formed in Honduras. In November of 1985 the San Pedro Sula daily *El Tiempo* revealed the existence of a military center near Tegucigalpa known as La Quinta Escuela, used as a training base for Contra forces. Nicaraguan rebel leader Edgar Chamorro claimed that his forces had been trained at the base since 1982, with instruction offered by Honduran as well as Argentine officers. In March of 1987 Walter López Reyes charged on U.S. television news that death squads, organized by Contras, had assassinated alleged Nicaraguan and Honduran subversives in Honduran territory. In May of the same year Florencio Caballero, a former member of the Batallón 3-16, revealed in the U.S. press that he had interviewed dissidents before they were killed, that "Padre Guadalupe" and his comrades had indeed been executed after their capture, and that he knew of military detention and torture centers in Honduras. He further alleged that U.S. military advisors had participated in the design of these centers and offered guidance on effective means of psychological interrogation. Based upon these revelations and their own investigations, Amnesty International

began to reach conclusions similar to those already arrived at by
Honduran human rights groups

that anti-government Nicaraguan forces with bases in Honduras, have possessed
ties with the 3-16 Batallion and have cooperated in kidnappings and assassinations
under orders from the chiefs of the agency, and that personnel of the United
States government proportioned assistance in their organization.[3]

Paradoxically, the woeful record of the Alvarez years was compiled
as the Reagan administration propagandized its staunch ally as a
showcase of democracy, pointing to the new 1982 constitution as a
model of reform and the elections of 1982 and 1986 as the first free
elections in Honduras in nineteen years. In the mid 1980s human rights
violations indeed decreased significantly, but this was more related to
Alvarez's exile in 1984 than constitutional reform or elections.
Alvarez's forced departure under guard has been seen as the result of
his power manipulations within the military rather than a repudiation of
his excesses. Walter López Reyes nevertheless brought a voice of
reason and logic to the highest office of the armed forces in mid 1984,
and for the next two years human rights abuses were substantially
reduced. The number of disappearances dropped from about 70 during
the Alvarez years to about 25 during López's tenure. In 1984 the air
force general launched an internal investigation into disappearances.
The report, released the following year, was lauded by the Honduran
government but proved disappointing to human rights activists. Of 112
cases investigated, 8 were reported as deportations or persons still
remaining in Honduras. The remaining 108 cases were deemed as
unsolvable and it was further argued that some were the result of
internecine struggles within the ranks of irregular foreign forces, that is,
the Contras.

If Alvarez was feared because of his drive for power, López was
viewed by many within the military as too weak with leftists and
subversives. With López Reyes's forced departure in 1986, General
Humberto Regalado Hernández occupied the position as chief of the
armed forces. Cut more from the mold of Alvarez, the period of
liberalization ended and a renewed level of violence ensued in late 1986
and 1987, increasing to even greater heights in 1988 and 1989. In its
report for 1987, the Comisión para la Defensa de Derechos Humanos
en Centro América (CODEHUCA) reported renewed activity by
Honduran death squads, suggesting that assassination was replacing
disappearance as a means of dealing with alleged subversives.
Meanwhile, U.S. Secretary of State George Schultz announced in
August of 1987 that "significant progress" had been made by Honduran

authorities in curtailing human rights abuses during the first six months of that year.

Terrorist attacks were marked not only by the activities of right wing death squads but by attacks from the extreme left as well. Owing to increased U.S. military presence, there was no scarcity of U.S. targets. From 1981 through 1988 51 military maneuvers were conducted in Honduras with a combined number of 38,000 U.S. troops and 23,000 Hondurans. Not only were several bombs placed at or near Palmerola, but the Contra headquarters in Tegucigalpa was strafed with machine-gun fire, the Israeli embassy was bombed, and a member of the Batallón 3-16 was assassinated. The Chinchoneros claimed credit for a number of such activities. On the other end of the spectrum, leftist union leader Cristóbal Pérez was assassinated and bombs were placed at human rights headquarters, in the cars of union leaders, and at the office of the rector of the national university.

Focusing on terrorism from the left, in February of 1988 President Azcona and General Regalado announced that a "plan of rural and urban insurgency" had been launched against Honduran institutions by subversive elements. Regalado went on to implicate such noted Honduran intellectuals as author Aníbal Delgado and Jesuit priest José María Ferrero. Spurred by such official rhetoric, a number of right wing groups sprouted in 1988, including the Movimiento Honduras Libre, the Comité Hondureño por la Paz y la Democracia, and most notably, the Alianza de Acción Anticomunista (AAA). These organizations soon plastered the buildings of the capital with leaflets and took ads in the press which identified human rights activists and union leaders as part of an alleged communist conspiracy of subversion and terror. The AAA is deemed by human rights authorities to have been responsible for well over half the death threats issued during 1989 and 1990.

In such a climate human rights violations increased during the final years of the decade. Although disappearances remained few at 12, death threats increased to 66, and political assassinations became more common, as did bombs and gunfire attacks aimed at people and offices. After years of death threats against the two leading officers of the major human rights group, CODEH, terrorists struck in 1988. CODEH's second in command, Miguel Angel Pavón, was shot in the head while sitting in a car in San Pedro Sula. Killed with him was Moisés Landaverde, head of a teachers' union.

A political decision by the United States in 1988 did much to further anger and violence. The continued military presence of the United States was already a matter of resentment for many Hondurans,

as was a plan to transport garbage from the east coast of the United States to a proposed sewage plant in Honduran territory. The case of Ramón Matta Ballesteros was seen as a final insult to Honduran sovereignty and symbolic of the government's subservience to U.S. interests. Matta, a convicted drug kingpin, had dramatically escaped from a Colombian prison in 1986 and returned to his native Honduras, where the constitution and courts provided him immunity from extradition. Placing its war on drugs over basic political awareness, the Reagan administration, in collaboration with the Azcona government, seized Matta from a private residence and transported him to Chicago for prosecution. Shortly afterward, on April 7, more than 2,000 students and other dissidents filled the streets and marched in protest against the U.S. embassy, more to voice outrage over another humili-ation of Honduran sovereignty than to defend the interests of a drug lord. After a confrontation with police and the army, the toll was one consulate burned, the offices of the U.S. Information Service burned, thirty diplomatic vehicles burned, four students killed, and the militarization of the nation's leading urban centers and campuses for days following. The incident is symbolic of U.S. policy toward Honduras during the entire decade. As in the case of the Contras, Reagan's policymakers had placed their own perceived interests above the consequences their policies would provoke within the borders of their leading Central American ally.

Political violence reached new levels during the remainder of 1988 and well into 1989. The violence seemed to defy a pattern and tumbled helter-skelter from all directions. FUSEP reported that even street crime was up 50 percent during the first six months of 1988. Human rights groups incidentally reported that the number of common delinquents found dead after having been detained by the DNI was also up sharply. In the political arena, assassinations and attempts seemed out of control. In December of 1988 the bodyguard of Contra chief Enríque Bermúdez was assassinated by another Nicaraguan rebel in an internal dispute. Later that month a grenade attack against a former DNI agent resulted in injuries to him and the death of his companion. In January of 1989 political violence grew even more frequent and random:

January 2:   Gunfire from a heavy caliber weapon destroyed the automobile of Maria Elena de Custodio, wife of CODEH's president.

January 6:   Emilio Pavón, security agent of Honduras's tele-communications center, was assassinated.

January 7:   Contra chieftain Manuel Adán Rugama was assassi-
nated. Although Contras claimed the deed was the work
of Sandinista agents, it was also rumored that Rugama
had been selling arms to Salvadoran rebels.

January 23:  Ramón Matta's lawyer, Carlos Díaz del Valle, was
assassinated in front of his home.

On January 25 the most dramatic assassination of that
particularly grisly month occurred. While riding through the streets of
a Tegucigalpa neighborhood, Gustavo Alvarez Martínez and his
chauffeur were riddled with bullets. Alvarez had recently returned
from exile in the United States, ironically to enjoy retirement as a born-
again Christian. The revolutionary Chinchoneros claimed responsibility
for the killing. In response to Alvarez's death, the Alianza de Acción
Anticomunista issued a list of Honduran subversives it marked for
death. The list included left wing union leader Héctor Hernández,
Liberal Party leader Jorge Arturo Reina, author Oscar Aníbal Puerto,
and CODEH president Dr. Ramón Custodio (fig. 1). During February
a rash of bombings against U.S. military and corporate targets followed,
which primarily succeeded in maiming Honduran employees. Military
spokesmen pointed to these attacks as further proof of the network of
subversion, while government critics claimed that they were planted by
right wing paramilitary groups to justify further repression against
dissidents. At this point in the escalating violence it was often
impossible to logically speculate on exactly who was maiming or
murdering whom.

Throughout the waves of violence during the 1980s, Honduras's
leading human rights activist, CODEH's president Dr. Ramón
Custodio, stood out as a figure of reason, courage, and dignity. Despite
repeated death threats, the strafing of his medical office and his wife's
automobile, and the periodic defacing of CODEH's headquarters, he
persevered in his investigations and denunciations of politically inspired
human rights abuses. The facade of CODEH's Tegucigalpa office,
appropriately located opposite the Iglesia de los Dolores, was painted
with the letters "AAA" (Alianza de Acción Anticomunista) and
political slogans against Custodio, including "Dr. Sandinista" and
"Kustodio Traidor." Thus, human rights activists were identified not
only as enemies of the state but also as Sandinista collaborators
working against the cause of the Contra "freedom fighters." The
government-sponsored human rights organization, the Comisión
Interinstitucional de Derechos Humanos, further charged Custodio
himself with organizing the assassination of his friend and colleague,

**ACCION URGENTE ACCION U**

# PELIGRA VIDA
# DE PRESIDENTE
# DEL CODEH Y DE
# CODEHUCA

Dr. RAMON CUSTODIO LOPEZ

Presidente del Comité para la Defensa de los

Derechos Humanos en Honduras

Presidente de la Comisión para la Defensa de

los Derechos Humanos en Centroamérica

Fuentes fidedignas nos informan que a nivel de Altos Mandos de los ejércitos de
Honduras y El Salvador, se ha planificado asesinar, a corto plazo, al Dr. RAMON
CUSTODIO LOPEZ, Presidente de CODEH Y CODEHUCA.

Estos hechos tienen relación directa con el Juicio ante la Corte Interamericana
de Derechos Humanos, contra el Estado Hondureño por Desaparición Forzada de Per-
sonas, donde el Dr. Custodio ha jugado un papel muy importante.  Es a partir de
ese momento en que las acciones de amedrentamiento contra el CODEH, y en especial
contra su Presidente, se han agudizado.

En vista de la gravedad de esta situación les solicitamos de la manera más urgen-
te llevar a cabo cualquiera de las siguientes acciones:

Llamadas Telefónicas, envío de telex o telegramas a:

|                                              | teléfono  | telex                    |
|----------------------------------------------|-----------|--------------------------|
| Presidente de Honduras, Ing. José Azcona.    | 22 82 88  | 1129  MHIR ATT. PRESIDENTE |

Representación Diplomática de Honduras en
sus respectivos países.

Fig. 1.  Poster issued in response to death threats against
human rights leader Dr. Ramón Custodio

Miguel Angel Pavón. Custodio's motives, speculated the Comisión, were to further discredit the Honduran military and to eliminate his major source of competition for power within CODEH. In November of 1988, however, Sergeant Fausto Reyes, a deserter from the Honduran military, charged in the U.S. press that the Batallón 3-16 was responsible. The U.S. embassy aided the attempts to discredit Custodio, sponsoring a release in the daily *El Heraldo* in October of 1988 charging him of manipulating human rights information in order to discredit the Honduran military. Embassy spokesmen consistently downplayed the seriousness of human rights violations by Honduran authorities and Contra rebels throughout the decade of the 1980s.

The unprecedented level of repression against Honduran dissidents during the decade was integrally linked to the presence of the Contras in Honduras. In its unrelenting campaign against Sandinista Nicaragua and support for the Nicaraguan rebels, the Reagan administration escalated political extremism in Honduras by encouraging a climate in which dissidents and opponents of the Contra presence were seen as enemies of the state. After a frustrating interview at the U.S. embassy in Tegucigalpa, Edward Sheehan was prompted to make an analogy of a nation not only compromised, but prostituted. "My country was turning Honduras, once only a banana republic, into a brothel. I was, I felt, somehow an accomplice."[4]

Honduran intellectuals viewed the process with even greater alarm. Victor Meza, head of the prestigious investigative research group, the Centro de Documentación de Honduras (CEDOH), decried what he termed the "Guatemalization of Honduras":

Everything appears to indicate that the political violence has acquired its own dynamics, that is, an uncontrollable course. Organized groups that have traditionally exercised their monopoly [over violence] have begun to lose it, it is escaping from their hands. Other groups and sectors begin to cloak themselves with justice, real or supposed, for their own causes. Violence has become a means available to everyone, or nearly everyone. . . . The bullets and bombs are slowly weaving a dense network of terror and blood into which our entire society has been drawn.[5]

In its myopic political vision and unrelenting passion to undo the Sandinistas, the Reagan administration not only ran afoul of the laws of its own land but also seduced Honduran leaders into an affair of terror which grew beyond anyone's ability to direct or control. The lyrics of a popular song of the period suggest the process of seduction and irresistible violence that, once underway, plunged Washington, Contra rebels, and Hondurans into a deepening spiral.

Crimes of passion, you'll pay the price
If you do it once, why not do it twice?
Cracks in the mirror, bombs in the moonlight,
　　those whims of vice
Just how much terror can one kiss entice?[6]

## POSTSCRIPT 1991

The dawn of a new decade saw many positive changes in the region which indicated promise for the future. The fruition of Oscar Arias's long and tenacious struggle for peace resulted in the signing of a regional accord. The defeat of the Sandinistas in February of 1990 and the election of "peace candidate" Violeta Chamorro brought an end to the Nicaraguan war, followed by the exodus of the Contra army from Honduras. The election of a candidate promising an end to human rights abuses in Honduras became a reality. Many believed that because the external tensions that fed repression in Honduras during the 1980s had abated, a significant decline in political violence was at hand. Based upon the figures of human rights groups for 1990, however, this has not been the case (see Appendix). Perhaps the "uncontrollable force" of violence of which Victor Meza wrote has indeed begun to feed on its own momentum, unresponsive to external factors or considerations of logic. If this grim assessment is true, Honduran society may be years in recovering from the hurricane set in motion by events of the previous decade.

## APPENDIX

### 1. Cases of Torture: 1980–1990

| 1980 | 1981 | 1982 | 1983 | 1984 | 1985 | 1986 | 1987 | 1988 | 1990 |
|------|------|------|------|------|------|------|------|------|------|
| 2 | 48 | 31 | 63 | 31 | 55 | 17 | 31 | 72 | 96 |

### 2. Forced Disappearances: 1980–1990

| 1980 | 1981 | 1982 | 1983 | 1984 | 1985 | 1986 | 1987 | 1988 | 1990 |
|------|------|------|------|------|------|------|------|------|------|
| 1 | 49 | 20 | 15 | 17 | 8 | 5 | 14 | 12 | 0 |

## 3. Human Rights Violations: 1988–1990

|  | *1988* | *1990* |
|---|---|---|
| Political assassinations | 2 | 5 |
| Attacks against persons (includes death threats) | 86 | 118 |
| Attacks against property (includes forcible evictions) | 18 | 18 |
| Illegal detentions | 349 | 357 |
| Illegal searches | 30 | 34 |
| Attacks on freedom of expression | 20 | 28 |

*Sources:*

Comisión para la Defensa de los Derechos Humanos en Centroamérica (CODEHUCA), *Informe anual: mayo, 1988-mayo, 1989.* *Situación de los derechos humanos en Centroamérica* (San José: CODEHUCA, n.d. [circa 1989-1990]), pp. 93-100.

Comité para la Defensa de los Derechos Humanos en Honduras (CODEH), *Informe anual: la situación de los derechos humanos en Honduras, 1988* (Tegucigalpa: CODEH, 1989), pp. 19-20, 27-31.

_____, *La situacion de los derechos humanos en Honduras, 1990* (Tegucigalpa: CODEH, 1991), pp. 31, 51.

## NOTES

1. Edward F. Sheehan, *Agony in the Garden: A Stranger in Central America* (Boston: Houghton Mifflin, 1989), pp. 3-8.

2. Amnistia Internacional, *Honduras; autoridad civil—poder militar: Violaciones de los derechos humanos en la década de 1980* (London: Amnistia Internacional, 1988), p. 11.

3. Ibid., p. 24.

4. Sheehan, p. 51.

5. Centro de Documentacion de Honduras (CEDOH), *Boletin informativo Honduras* 93 (Jan. 1989), 1.

6. "Crimes of Passion," lyrics by Jim Carroll, music by Dann Huff; from Bozz Scaggs, *Other Roads* (New York, NY: CBS Records Inc., 1988).

## BIBLIOGRAPHY

A significant body of literature was published in Central America during the 1980s which documents the process of political polarization in the region, the impact of the Reagan administration's policies toward the Sandinistas and the deterioration of human rights in Honduras. Investigative groups and human rights organizations played a key role in producing this literature.

## Monographs

Monographs on the impact of regional conflict on Honduran society and human rights:

Barry, Tom. *El conflicto de baja intensidad: un nuevo campo de batalla en Centro América.* Tegucigalpa: Centro de Documentación de Honduras (CEDOH), 1988. 59 pp.

Becerra, Longino. *Cuando las tarántulas atacan.* Tegucigalpa: Ed. Baktun, 1987. 226 pp.

*Derechos humanos en Honduras.* Tegucigalpa: CEDOH, 1984. 211 pp.

Isaula, Roger. *Honduras: crisis y incertidumbre nacional. Hacia un analisis de coyuntura, 1986-1987.* Tegucigalpa: Editores Unidos, 1988. 194 pp.

Meza, Victor, ed. *Honduras: pieza clave de la politica de EE.UU. en Centroamérica.* Tegucigalpa: CEDOH, 1986. 171 pp.

Meza, Victor, ed. *Honduras—EE.UU.: subordinación y crisis.* Tegucigalpa: CEDOH, 1988. 111 pp.

Oseguera de Ochoa, Margarita. *Honduras hoy: sociedad y crisis politica.* Tegucigalpa: CEDOH, 1987. 221 pp.

Ramos, Ventura. *Honduras: guerra y anti-nacionalidad.* Tegucigalpa: Ed. Guaymuras, 1987. 205 pp.

Vergara Meneses, Raul, et al. *Centro America: la guerra de baja intensidad.* San José: Departamento Ecumenico de Investigaciones, 1987. 240 pp.

A number of organizations have produced material documenting the deterioration of human rights in Honduras during the 1980s. For an overview, see Amnistia Internacional, *Honduras: autoridad civil–poder militar: violaciones de derechos humanos en la década de 1980* (London: Amnistia Internacional, 1988), 59 pp.

## Serials

For yearly reports from 1986 on the situation of human rights in every Central Amerian nation, see the *Informes anuales* of the Comisión para la Defensa de los Derechos Humanos en Centro América (CODEHUCA), San José, Costa Rica. A valuable three-volume collection of organizations, resources, and publications on human rights in Central America, published by the same group is: *Documentos sobre derechos humanos en Centro América*, 3 vols. (San José: CODEHUCA, 1987), 320 pp. A more concise guide to nongovernmental human rights groups in Latin America is: Instituto Interamericano de Derechos

Humanos (IIDH), *Guía de ONG de derechos humanos* (San José: Jimenez & Tanzi, 1991).

The most detailed sources for human rights abuses are found in the *Informes anuales* of the Comité para la Defensa de los Derechos Humanos en Honduras (CODEH), published throughout the 1980s (Tegucigalpa: CODEH, 1984-1990). See also the special report by CODEH: *Informe del Comité para la Defensa de los Derechos Humanos en Honduras ante la Comisión Internacional de Verificacion y Seguimiento (CVS)* (Tegucigalpa: CODEH, 1988), 66 pp.

CODEH has been criticized by the Honduran government, the U.S. Embassy in Honduras, and human rights analysts sympathetic to the Contras as exaggerating the level of repression in Honduras. For such material see statements and releases by the human rights organization created by the Honduran government in the early 1980s to defend itself in cases of disappeared persons, the Comision Inter-institucional de Derechos Humanos (CIDH).

An organization sympthetic to the cause of the Nicaraguan resistance is the Asociación Nicaragüense Pro-Derechos Humanos (ANPDH). Based in Costa Rica during the mid- and late 1980s, this organization has recently moved its offices to Managua. For positive analyses of the human rights record of the Contras, see: *Informe de seis meses sobre derechos humanos en la resistencia nicaragüense* (San José: July 1987), 55 pp.; *Segundo informe de seis meses sobre derechos humanos en la resistencia nicaragüense* (San José: Jan. 1988), 49 pp.; *Tercer informe de seis meses sobre derechos humanos en la resistencia nicaragüense* (San José: June 1988), 55 pp. It should be noted that the ANPDH reports deal primarily with the human rights record of the Contras in waging war in Nicaragua, and not with their activities in Honduras.

The leading independent investigative oganization in Honduras is the Centro de Documentación de Honduras. Its serial publications provide an excellent chronological record of political, economic, and diplomatic developments. See especially the monthly periodical, *Boletín informativo Honduras* and the irregularly published (2-4 per year) *Boletín informativo especial*. Both publications include analysis of major news developments in the nation. In-depth analyses of single issues are provided in the irregularly published *Serie cronólogicas*. Issues in this series consulted for this paper were:

No. 2. *Militarismo en Honduras: el reinado de Gustavo Alvarez*. 1985. 26 pp.

No. 6. *Los refugiados en Honduras, 1980-1986*. 1986. 36 pp.

No. 7.  *La Contra en Honduras.* 1987.  36 pp.
No. 8.  *La tortura en Honduras.* 1987.  20 pp.
No. 10.  *Desplazados de guerra hondureños.* 1989.  12 pp.

For the most detailed reports on the problems of disappeared persons in Honduras, see the publications of the San José-based Asociación Centroamericana de Familiares de Detenidos-Desaparecidos (ACAFADE), especially the annual reports published since 1988, *Desaparecidos en Centro América.* For earlier reports, see the six issues of *Informes periodísticos* published during 1986–1987. For information on the only cases of disappearances in Honduras to be tried before the Inter-American Court of Human Rights, involving two Hondurans and two Costa Ricans who disappeared early in the decade, see:

*Honduras: queremos, esperamos, demandamos justicia.*  ACAFADE, 1987.  107 pp.

*Honduras: desaparecidos, juicio y condena.* ACAFADE, 1989.  286 pp.

*Caso de Fairen Garbi y Solís Corrales: sentencia de 15 de marzo de 1989.* ACAFADE, 1989.  40 pp.

*Análisis de la sentencia Fairen-Solís.* ACAFADE, 1989.  16 pp.

*Sentencia del caso Angel Manfredo Valazquez Rodriguez.* ACAFADE, 1988.  43 pp.

# 40. Recent Political Events in Brazil as Reflected in Popular Poetry Pamphlets: Literatura de cordel

## Cavan M. McCarthy

### Introduction

Brazil has a strong tradition of popular poetry, brief pamphlets written by authors with little formal education and sold in marketplaces to the masses. This *literatura de cordel*, or literature that is displayed on string (*cordão*) on market stalls, has attracted considerable attention from researchers, collectors, and enthusiasts (see Bibliography entries 2, 34, 38, 39, 47, 106). Cordel authors originally produced romantic stories in verse, but rapidly diversified into accounts of war and banditry, modern manners, and politics. Such events as the murder of João Pessoa in 1930, or the suicide of Getúlio Vargas in 1954, inspired numerous pamphlets, as did Brazil's participation in World War II (44). In recent years cordel has been affected by the same modernizing influences as have swept Brazil; persons of a higher educational level have come to write pamphlets and one publisher operates on an industrialized scale. Cordel was, until recently, a phenomenon of North East Brazil, but spread south during the massive migrations of the postwar period. Rio de Janeiro is now probably the main center for cordel, but the texts still reflect the culture and beliefs of people from North East Brazil. The production of pamphlets that comment on political events continues and numerous interesting items have appeared during the years of political transition. This study examines, categorizes, and describes recent popular poetry pamphlets on political themes.

The pamphlets themselves are small booklets, size 16 x 12 cm; commentaries on current political affairs normally occupy eight pages and include a thin wrapper in colored paper. Printing is traditionally by handset letterpress, although offset, mimeographed, or even photo-copied pamphlets can now be found. Such a booklet usually contains twenty to forty stanzas of six or seven lines each, using simple rhyme schemes (*xaxaxa, ababccb* or *xaxabba*). The language used and the sentiments expressed are normally of a relatively straightforward nature: "Wake up, Brazil, wake up/People of all classes/let us think of the

future/You can smile with happiness/Because Tancredo has been elected/As our new president" (102); "Our giant Brazil/Since it was discovered/Has been through many phases/Of anguish and suffering/But it has heroically overcome/All the difficulties it faced" (4). Portuguese is a language that can be rhymed with extreme facility; many poets are capable of making up and declaiming rhymed verse immediately. The pamphlets have strong, simple cover designs printed in black. They are often true woodcuts; simpler alternatives cut designs in sheet rubber or make drawings that resemble woodcuts. This type of cover illustration is cheap, can be quickly prepared, reinforcing the simplicity and popular appeal of the booklets. The title appears in large letters at the head of the wrapper; poets like to use an attention-grabbing verse as title; probably the most memorable of recent years was that of Apolônio Alves dos Santos commenting on the conflict between the president and an opposition leader: "Brizola wants to set fire to Sarney's mustache" (76). Pamphlets of this nature are considered to be in the "traditional format." There is also an "industrialized format" with more pages, larger page sizes, and colored, photogravure wrappers. This requires considerably more investment and is rarely used for ephemeral matters such as politics.

This study is largely based on a major collection of cordel literature formed by the author of this paper. These booklets are usually published by the poet, who is rarely able to arrange wide distribution. As a result many pamphlets scarcely circulate beyond the city or state in which they were published. I live in Pernambuco, so many examples cited come from that state. But as Pernambuco has been very active in recent years, both politically and as a publisher of cordel, such bias as might have crept into this text will doubtless have the effect of making it even more interesting.

The period covered is that of the Brazilian political transition, the governments of João Figueiredo, 1979–1985, and José Sarney, 1985 to date. Most of the cordel literature on political themes deals with events of national importance, such as elections and deaths of presidents, or economic policy and shock treatments. Because of their bulk these pamphlets have been divided chronologically into three subcategories: the Figueiredo government; the election and death of Tancredo; and the Sarney government. Further sections of this study deal with pamphlets relating to individual politicians or to general political subjects. The text concludes with a discussion of religious influences and the use of specialized poetic presentations.

## The Figueiredo Government, 1979–1985

Relatively little political cordel was produced during the early years of the government of General João Figueiredo. His presidency marked the transition from a rigid military dictatorship, during which civil rights, especially writing and publishing, were systematically repressed. Cordel authors, poor people who could not stand up against the military machine, had generally kept a low profile during this period. It was well into Figueiredo's term, the period known as the "democratic opening," when they regained their confidence and began to comment widely on current affairs. Figueiredo was a dour general who never enjoyed presidential duties; as one pamphlet described him, "President John the Stubborn" (94). The Minister of Planning, Delfim Netto, came in for criticism for economic ineptitude, corruption, and for selling Brazil to foreigners. He was a fat gourmet; the wrapper of a typical pamphlet showed him eating Brazil for dinner (91); on another he was cutting up Brazil and giving pieces to top-hatted capitalists (7).

Perhaps the greatest achievement of Figueiredo was the amnesty of 1979 which cleared the way for a return to constitutional normality. The campaign for a general amnesty for political exiles was the first major public movement that Brazil had seen for a decade, but was basically limited to the middle classes and produced few pamphlets (66). The return of specific exiles was sometimes commemorated in print, notably in the case of Miguel Arraes (107, 108). Before his exile he had been governor of Pernambuco, a state that is a center for cordel literature and where he had been highly popular with the masses. The return of Luís Carlos Prestes, communist leader, also warranted a pamphlet (27). The attacks on supermarkets in early 1983 marked the return of the masses to street politics; these prompted immediate comment in a photocopied text from São Paulo (50).

The outgoing military government intended to have the next president elected by an electoral college, but in 1984 there was an attempt to have Figueiredo's successor elected directly, by the whole population. A grass roots campaign for direct elections sprang up and rapidly became the most significant mass movement of the decade in Brazil, with millions of people attending mass meetings. Cordel publishers backed up the campaign with appropriate texts (43, 52). Of special interest were crude, mimeographed pamphlets which were produced for distribution at these demonstrations; their wrappers showed crowds of people (23, 48). The sentiments expressed were worthy of the most fervent revolutionary: "Comrades, comrades/Our people will never see/Light at the end of the tunnel/Unless we begin to struggle/With faith, force and courage/Until blood begins to flow" (23).

Despite rhetoric on this level, the amendment to permit direct elections did not pass.

## The Election and Death of Tancredo Neves, 1985

The attention of the country and of the authors of cordel turned to the upcoming indirect elections in which the electoral college was to choose between Tancredo Neves and Paulo Maluf. Tancredo, the opposition candidate, was a traditional politician from Minas Gerais seen as a serious person committed to democracy. Paulo Maluf, former governor of São Paulo, was frequently described as a corrupt upstart who had hijacked or purchased his nomination as government candidate. Cordel writers had no doubt where they stood on this issue: at least two pamphlets compared Maluf directly with the devil (4, 41). The most outspoken, "The son of satan in the electoral college," tells how the "damn Turk" bought votes to become governor of São Paulo and on being elected said: "Now I am going to govern/To fill my pockets with money/Screw the Brazilian people/They can go to the depths of hell" (8).

With public criticism of Maluf running at this level, it was not surprising that the electoral college voted against him. Cordel publishers had time to put out a few quick pamphlets celebrating Tancredo's victory before that elderly gentleman fell ill, became a victim of medical incompetence, and died before he could be sworn in. The electoral college met on January 15; Tancredo was to be sworn in on March 15 but fell ill the day before and died on April 21. Poets who had published pamphlets on his victory were forced to rush out new texts describing his illness and death. In at least one case the pamphlet that celebrated his victory used the same cover illustration as that which mourned his death (12, 14). One poet from Caruaru, not wishing to throw away his printed text on the victory of Tancredo, simply pasted it into the back of his pamphlet on Tancredo's death (104). This major national tragedy was fully reflected in a large number of cordel pamphlets. It is probably safe to say that no political event since the death of Vargas has inspired so many cordel pamphlets as the election and death of Tancredo; there was even a book on the subject, written by the folklorist Veríssimo de Melo (60). This largely consisted of an organized series of quotations from pamphlets on Tancredo, with connecting commentary. The bibliography listed eighty-nine cordel pamphlets on Tancredo. The only event in recent years to have had a similar impact on cordel writers was Pope John Paul's visit to Brazil in 1980; a book was also written on the cordel relating to this event (110). The bibliography to this book listed 34 pamphlets, but far more than

that were published; I have heard it said that around 120 items were published on the papal visit.

The public did not have time to become disillusioned with Tancredo in power, who came to be described in the most glowing terms: "Everything that he promised/He was capable of doing . . . He was an admirable person/First in almost everything" (9); "Dr. Tancredo is from Minas/A Brazilian without equal/A civilian and politician/Who works without stopping/I don't know if he likes generals/But being a lawyer/He can help the poor" (14). Tancredo represented, above all, hope for change after twenty-one years of military rule. The greatest living cordel writer, Manoel de Almeida Filho from Aracaju, Sergipe, described Tancredo as "The hope that does not die" (4). Another writer christened Tancredo the "Messenger of hope" (26).

The unbelief at his untimely death was such that it became common to describe him in terms such as "The martyr who did not die" (9). A mimeographed text expressed the widely held opinion that "Tancredo did not die; they killed him" (71). The most prolific cordel poet of all time, Rodolfo Coelho Cavalcante, descended into prose on the back cover of his pamphlet number 1721 to say that Tancredo, "the glorious martyr of the New Republic . . . did not die because he will live on in spirit in the hearts of the people" (29). This text was entitled, in Portuguese, "A paixão e morte do Dr. Tancredo Neves"; the word "paixão" in this sense is normally only used in Portuguese to describe the sufferings and crucifixion of Christ. His status as a martyr prompted titles such as "Dr. Tancredo Neves, a life for democracy" (6). Much was made of the fact that he died on the anniversary of the execution of Brazil's national hero, Tiradentes. Azulão, a cordelista from Rio, rushed out a photocopied pamphlet entitled "Tancredo: the second Tiradentes" (85) while the state government of Bahia sponsored a pamphlet entitled "Tancredo Neves: A New Tiradentes" (87). Gonçalo Ferreira da Silva, a prolific writer from Rio, canonized Tancredo in his pamphlet "Saint Tancredo Neves has died, leaving the nation in mourning" (93).

There was a sad incident during the later stages of Tancredo's illness when one cordel author, Franklin Maxado, told a newspaper that he had a pamphlet ready for the death of Tancredo. He was severely criticized for this by another poet, Raimundo Santa Helena (40). Franklin has a university education and is ont of the best organized cordel publishers. It was natural to prepare a pamphlet on this subject when it was common knowledge that the vice president carried with him at all times the text of the speech he was to make when Tancredo's death was announced. Within a few minutes of Tancredo's death the

largest TV network was showing a major poet, Affonso Romano de Sant'Anna, reading a poem in his memory. Perhaps Maxado should have been more reticent about his preparations. Certainly he cannot be described as anti-Tancredo; he wrote a pamphlet in favor of Tancredo's candidacy (53). It is possible that this incident encouraged Maxado to collaborate with another poet in a remarkable pamphlet called "The miracles of Saint Tancredo" (69). This publication goes so far as to suggest that, by dying in São Paulo, Tancredo reincarnated Saint Paul; the back cover prints a "Prayer to Saint Tancredo of Brazil."

This is not the only pamphlet on this theme: Minelvino Francisco Silva wrote about the "Tales of Tancredo's grave and its miracles" (99). Minelvino is perhaps the last of the old-style producers of cordel; he lives in the interior of Bahia, where he writes his texts, cuts woodblocks for his wrappers, prints his pamphlets and then sells them directly to purchasers. Most of his sales are made at Bom Jesus da Lapa, a city in Bahia which attracts numerous poor pilgrims. Cordel is produced by persons who grew up within traditional society and who attempt to interpret modern events within the framework of their cultural background. The news stories on the death of Tancredo included such elements as modern hospitals, intensive-care units, and transfer of a sick person between hospitals in different cities by jet plane. Media events included daily press conferences on color TV transmitted by satellite, as well as newspaper and radio coverage. It was an event of crucial importance to Brazilians, which they had to understand and absorb. By placing elements of the story into a familiar context within the format of cordel literature authors were able to write about shocking events and help their readers, the mass of common people, to come to terms with a major tragedy. Stories of miracles related to the graves of famous or holy people are an integral part of religious culture. They are so deeply ingrained in popular consciousness that even socialist countries are careful to preserve the bodies of their famous dead in elaborate mausoleums.

Many of the typical themes of cordel literature appear in relation to Tancredo. The "Entry into heaven" is a common story line in cordel; for instance, Juscelino Kubitschek's death and arrival in heaven was put into verse (100). Tancredo Neves's arrival in heaven was celebrated in a cheerful pamphlet by Manoel Santa Maria, whose cover showed a smiling Tancredo, already with a halo, shaking hands with Saint Peter (55). Letters from heaven are another common feature of cordel; they enable the poet to speak with, literally, higher authority; President Figueiredo received a letter from heaven which spoke in favor of the poor (77). Tancredo had become such a hero that mere death

did not deter him from maintaining a voluminous correspondence with those he had left behind (16, 62, 82, 90). These letters are full of commonsense advice on political matters: "Please settle the debts/ Between Brazil and foreign countries/Make a great effort/To pull us out of the mud/So that our country/Does not remain in bondage" (62). Meetings between the illustrious departed also occur in cordel; Tancredo was again active in this respect, meeting various important figures from Brazil's past. He had at least two meetings with Getúlio Vargas (101, 114) and spoke to Tiradentes 945) and Juscelino Kubitschek (51). This is a convenient way to place Tancredo within a historical context.

## The Government of José Sarney, 1985–

Tancredo was substituted by his vice president, José Sarney, a traditional politician from the least developed state of the North East. He had been president of the political party set up by the military to protect their interests until switching sides a few months before Tancredo's election. Two poets from Rio were able to psychograph a letter from Tancredo in heaven to Sarney in the presidential palace, asking him to "Take are of Brazil/Look after our nation well/Don't let the poor suffer/In the claws of the sharks/Reduce their hardships/By fighting inflation" (62).

Cordel literature is rare in Sarney's home state, Maranhão, but it would appear that the president took this appeal to heart, because in February 1986 he announced the first of Brazil's economic shocks, known as the Cruzado Plan, when a new currency, the cruzado, replaced the cruzeiro and prices were frozen. This was successful for about six months, made Sarney, temporarily, into a national hero, and received full coverage in cordel literature in pamphlets with titles like "The end of the squeeze and the freeze on prices" (89) and "The war against inflation and the value of the cruzado" (79). The economic shock treatment was seen largely as a personal decision and victory of Sarney: "President Sarney: thank you for your decision" (32). The president's short-lived popularity was fully reflected in cordel at that time: "The Hero President and the famous economic package" was the title of a pamphlet put out to coincide with the elections of November 1986 by a candidate who described himself as supporting Sarney's economic policy (63). Another pamphlet described Sarney as "the people's president" (75). Hero worship of Sarney reached extremes in a pamphlet entitled "The cruzeiro has been knocked out by the cruzado"; this went so far as to refer to Sarney as a saint: "Everybody listen to the speeches/Of Saint Sarney, the miracle worker" (57). As is

clear from the example of Tancredo, a notable person can be raised to
the level of sanctity in the popular culture of North East Brazil; even
so, the use of such a term for a living president while in office is quite
remarkable.

But unfortunately Brazil found out, as Argentina has also since
discovered, that rabbit-from-hat solutions are not effective in modifying
basic economic mechanisms and solving problems efficiently in a field
as complex as national economy. The Cruzado Plan soon led to the
disappearance of milk and meat from the shops, a major shock which
prompted a couple of memorable pamphlets. Apolônio Alves dos
Santos of Rio de Janeiro put out a pamphlet with a woodcut wrapper
showing people lining up outside a butcher's shop and demanding meat
(81); another pamphlet had a cover showing a cow, with the words
"Wanted: dead or alive" (56). The Cruzado Plan was finally aban-
doned a few days after the November 1986 elections; there were sudden
massive price rises and it was generally felt that the government had
tricked the public. "A new economic package after the election—it was
a betrayal" trumpeted Apolônio Alves dos Santos (80).

Such pamphlets as now appear on President Sarney are almost
uniformly negative. Two anti-Sarney pamphlets even appeared with
official sponsorship, published in Fortaleza by the far-left "Popular
Administration" of Mayor Maria Luiza Fontenelle, elected on a
Workers' Party ticket. One considered Sarney, the price of gasoline,
and inflation to be Brazil's three major problems; the other claimed
that, with Sarney, Brazil is driving on the wrong side of the road (42,
61). Gonçalo Ferreira da Silva published a text with a harsh caricature
of Sarney on the wrapper and the title "Wanted: a president to replace
José Sarney" (95). The traditional cordel theme of the letter from
heaven turns up again in this context in the "Letter from Jesus Christ
to Sarney" (30). Here Jesus spoke through the verse of two poets from
Rio and seemed to be well informed of Brazilian public opinion
because his letter advised Sarney to resign together with his ministers,
hand over the presidency to a more competent person, go back to his
farm, and look after his cattle. This, of course, is exactly what Sarney
did not want to do. The cordelistic postal service between heaven and
earth obviously operates in both directions, because Sarney wrote back
to Jesus defending himself. He explained, for instance, that the price
freeze was correct but failed due to bankers, businessmen, mercenary
politicians, and the "crude oil gringos" who raised the price of gasoline
(15). It is especially interesting to note that this cordelistic defense of
the government was written by Abraão Batista, who had got himself

into serious trouble during the military regime when he used cordel with the opposite objective, that of exposing official scandals (37).

The Constitutional Assembly held in 1987–88 prompted relatively few pamphlets; this reflected the deep national disappointment with politics. Three major mass movements, to hold direct elections for the presidency, to have Tancredo as president, and to support the Cruzado Plan had all totally failed, leaving the country confused and listless. A few poets made suggestions; Tancredo Neves, naturally, wrote messages from heaven to the Constitutional Assembly (82, 90). When Tancredo spoke through the verse of Gonçalo Ferreira da Silva he summed up popular opinion of the tortuously slow Constitutional Assembly: "Hundreds of men/In perfectly cut suits/Submit to each other/Texts which are so repetitious/That we blush with shame/When they are read out loud/A fortune spent on paper/For an unworkable study/Which produces a result/With so little content/That they trip themselves up/Then do it all over again" (90).

Cordel poets are already preparing for the next election; several pamphlets have appeared about the opposition leader, Brizola. Perhaps the most memorable has a woodcut cover design showing Brizola setting fire to Sarney's mustache! (76). Azulão, a politicized poet from Rio, is blunter: "Brizola is the solution" (84). A couple of recent events have also prompted interesting pamphlets, notably the death of three strikers in Volta Redonda in November 1988 (78) and the murder of the ecologist Chico Mendes in the Amazon the following month (58).

## Individual Politicians

Pamphlets on individual politicians are most frequently issued in connection with elections. Numerous such items appear, but it is not possible to quantify them. Pamphlets will be handed out at political meetings, in the streets, at traffic lights, or on beaches but only a minute percentage of them ever reach collectors. Poets are paid to write them and they all offer a positive image of the candidate, but it would be unfair to accuse the poet of selling his soul for political silver. In general, a poet will only write for candidates with whom he feels at least some political affinity. In other cases these pamphlets may be anonymous or pseudonymous. During Brazilian elections the streets are inundated by millions of leaflets, in which the photograph of the candidate appears in a prominent position, together with name, initials of the party, and/or electoral number. These are known as *santinhas* because of their similarity with the pictures of saints carried by Catholics. Traditional electoral cordel used similar cover designs, a few lines of text around a photograph (112, 113).

Recently more sophisticated electoral products have begun to appear; for instance it is now common to reproduce the voting form on the back wrapper of the pamphlet. This occurred on a pamphlet from Goiás entitled "The rhyming history of a hell of a candidate: he stood up to the dictatorship without fear of menaces" (36). The front cover of this elaborate publication shows the politician, Fernando Cunha, leading a group of workers, including women and peasants, against the monsters of violence, hunger, unemployment, multinational companies, foreign debt, corruption, and unpunished criminals. This was a large format pamphlet and was also unusual in that it had illustrations on the inside pages; a typical drawing showed Cunha protecting a political prisoner.

Pamphlets commemorating electoral victories are fewer in number but probably remain available for a longer period and thus have a better chance of reaching collectors. In Pernambuco several items commemorated the 1987 return to the governor's palace of Miguel Arraes, ousted by the military in 1964 (5, 86, 97). Another former exile, Waldir Pires of Bahia, had his successful campaign celebrated in verse at the same time (73). During their administrations politicians use cordel to inform the electorate of their achievements; in Recife Mayor Jarbas Vasconcelos had several such pamphlets issued; a typical example, about the revitalization of the downtown area, was called "The people are in the center" (96). Also in Pernambuco the Mayor of Caruaru, a city known as a major center for cordel, sponsored pamphlets which sang his praises (13).

Tancredo Neves was not the only politician to have his death commemorated in cordel during this period. One of Brazil's most colorful politicians, Tenorio Cavalcanti, famous for carrying a machine-gun beneath his black cloak, died in 1988. He was a North Easterner who had emigrated to Rio, where he became political boss of the migrants in the poorer suburbs. As he was a hero to many people from the North East, several pamphlets marked his passing (83, 92, 98). The mysterious death of the left-wing land reform minister Marcos Freire, very popular in his home state of Pernambuco, also prompted cordel (10, 88). Land reform also figured in the death of Dr. Evandro, city councillor and lawyer to various agricultural workers' unions in the interior of Pernambuco. He was gunned down in front of his wife in 1987; his daughter was wounded in the shooting. Olegário Fernandes da Silva, a semiliterate but quite prolific poet from Caruaru, dedicated a pamphlet to him, with a horrifying woodcut wrapper showing the gunman in action, a huge black shadow towering over the dead man (103).

Readers will note that certain Brazilian cities and states are constantly mentioned in the text, whereas others do not appear. Cordel is a phenomenon of North East Brazil, and was originally strongest in this major states of that region, Pernambuco, Bahia, and Ceará. It has been taken by migrants to places in which people from the North East have settled, such as Rio de Janeiro, São Paulo, and Brasília. Rio, the traditional focal point for Brazilian culture, is now also the largest and best-organized center for cordel. So a politician from Pernambuco, Bahia, Ceará, or Rio de Janeiro is quite likely to have his praises sung in cordel whereas this is less probable for politicians from other states. The situation in São Paulo is more complex, because the cordel of this period attacks major politicians from that state, such as Delfim Netto and Paulo Maluf.

**Politics and Ideology**

Politics in Brazil frequently depends on conflicts between personalities, rather than parties or ideologies, but some interesting pamphlets have recently appeared which discuss political ideas in general. The ideology of political cordel over the last decade has been entirely liberal to left wing; it is now difficult to find texts that applaud right-wing political attitudes. I can recall having seen only about half a dozen recent examples, all published before the Figueiredo government. Right-wing figures such as Delfim Netto and Paulo Maluf are uniformly denigrated in cordel. This reflects a deep popular longing for a liberal, civilian government in Brazil. The cordel writer frequently sells direct to the purchaser and his product must reflect popular aspirations. It is also important to note that a liberal, democratic process will offer specific advantages to cordel writers. They cannot work in conditions of heavy censorship, and political campaigns offer numerous opportunities to write and sell verses. Many cordel poets are also spontaneously versifiers, that is, they make up and recite verse on the spot on specified subjects. Such persons are much in demand in political campaigns in the North East to warm up crowds at public meetings.

The political parties that used cordel to communicate with their supporters were also firmly on the left of the political spectrum; political cordel was issued either by the Workers' Party, or by the left-of-center PMDB, or by the PDT, the party of Leonel Brizola, a major left-wing figure. The Workers' Party was well organized and produced numerous publications of all types with interesting text and good presentation. Its leader, Luis Inácio da Silva, known as Lula, was born in Pernambuco, a state with a deep tradition of cordel publishing. The Workers' Party saw the value of cordel in communicating with the

masses and was responsible for some of the most interesting political cordel (24, 111). A 1981 pamphlet from Paraíba state left no doubt as to its political orientation: "The duel in verse of the Workers' Party against the dictatorial beast and the capitalist monster" (67). In Piauí state the socialist realism message came over visually in a crude woodcut on the wrapper of a cordel pamphlet (70). It showed a woman holding a flower and a worker with a sickle and is clearly reminiscent of the famous statue of a factory worker and a woman collective farmer that dominates a Moscow suburb. The anonymous artist did, however, add some unmistakable North Eastern elements; the couple had holes where their stomachs should be and a burning sun dominated the sky. Despite this it would be wrong to dismiss the Workers' Party as just another communist faction; it shows considerable dynamism and ideological flexibility. This enables it to successfully raise support from sectors as diverse as factory workers and ecologists, and also explains its bright, interesting propaganda materials. A poet did write an independent pamphlet when the communist leader Prestes returned from exile (27), but I cannot recall having seen cordel sponsored by the traditional Brazilian communist parties.

One of the most interesting phenomena of the 'eighties was the meteoric appearance of a self-styled factory gate poet, Crispiano Neto. He wrote and mimeographed several brief pamphlets for São Paulo workers, with titles like "They are roasting workers at Continental Stoves," "Metalite is only light for scabs and bosses," and "At Columbia the worker only has the right to be sacked." The pamphlets deal with items of immediate interest: "Overtime on Sundays/Steals the worker's day of rest/Extra bus fares to pay/Then there's a row with the boss/Who tries to rip us off/Paying below the overtime rate" (64). There are relatively few such pamphlets because after tasting São Paulo factory life Crispiano Neto went back to the North East to live on a farm.

Another important group of politically inspired pamphlets consists of those related to agrarian reform and land wars. The cover of a pamphlet on settlers in Maranhão state used a woodcut by Ciro Fernandes, which showed a typical family trudging through the countryside carrying their belongings (49). There was a man, woman, child and hungry dog; the man was carrying a rifle. Many of the pamphlets relating to land wars are produced in reaction to specific local events and use covers showing crowds of people; raised hoes are a common feature of such covers (22, 31, 46); raised fists can also be seen (21). The sentiments expressed are equally strong: "The strength of the peasants/Is in their union/With the strike we keep singing/While the

boss is crying/Be strong, peasant/Unite with your companions/Stop working together/Our victory depends/Upon the unity of everybody" (21). Religious organizations were prominent both in the land reform movement and as publishers of this type of cordel (31, 33, 74). In Pernambuco such pamphlets were used to announce specific meetings of the rural workers' union (21, 22).

Cordel writers were as nationalist as they were left wing, and it was easy to find comments against foreigners, capitalists, and colonialists. A comment on a strike included the words "We know that the bosses/are foreigners, are evil" (64). Franklin Maxado is one of the many people who suggested that Brazil should fail to pay its foreign debt (54). From Piaui the Workers' Party proclaims: "The multinationals/Are dominating everything/The government closes its eyes" (70). Abraão Batista, defending the government, put anti-American criticism into the mouth of no less a person than President Sarney: "America has already imposed upon us/Difficulties and humiliation/On top of the foreign debt/They talk about retaliation" (15).

It was common to find pamphlets that denounce the high cost of living; they are not covered in this study because they seem to be an almost constant feature of cordel and there is no clear correlation between their appearance and the inflation rate. It seems to be easier to find pamphlets of this type from the 'seventies than from the 'eighties, even though inflation became much higher in the latter period. Presumably the public became so depressed about high inflation that they no longer wished to read about it. Another factor is that in periods of extreme inflation it is very difficult to print cordel. Printshop costs cannot be effectively controlled by government decree; cordel publishers are rarely well organized commercially and can have severe difficulties in crises.

### Religious Influences

There is a close interrelationship between cordel and religion; many pamphlets include religious references, even in unlikely circumstances. We have seen examples above of how famous politicians are considered saints who go to heaven and work miracles for those who visit their tombs. But even a run-of-the-mill political pamphlet can begin with an affirmation of the type: "Jesus Son of God the Father/ Give me the wisdom/To tell the traditions/Of the city of Pedras de Fogo/And the achievements/Of its present Mayor" (105). The pamphlet tells how the mayor built schools, repaired the court house, bought an ambulance, etc., then ends returning to a religious theme:

"Let us ask Jesus/Jehova, Father of Fathers/So that our Mayor/May achieve much more/Than he has already done/And end in Holy Peace."

During this period much cordel was also produced by religious organizations, especially those working with landless peasants. Helder Câmara, Archbishop of Olinda and Recife, was famous for his defense of the people and of the oppressed; human rights organizations working out of his offices used cordel to tell rural workers about their rights (25). There was even a pamphlet about the Archbishop (3). He was replaced by a conservative successor in 1985 and this type of publishing ceased in Recife. Some political cordel is available through a religious documentation center in São Paulo, the Centro Pastoral Vergueiro. This organizes, preserves, and distributes literature by popular organizations of all types. It was responsible for preserving the fascinating political cordel of Crispiano Neto, the factory gate poet, by publishing it in book form (64). Crispiano is one of the most heavy politicized of cordel poets, but even he wrote a poem about Christ and described one exceptionally dirty factory as a "subsidiary of hell."

The religion in these cordel pamphlets is mainstream Catholicism; a significant number of Brazilians belong to Afro-Brazilian sects or are evangelical Protestants, but these tendencies are rarely reflected in cordel. This type of verse originated in the interior, the uplands or *sertão*, and continues to reflect the religious attitudes of that area, even though it is now largely produced in urban, coastal contexts.

Major religious figures of the North East also appeared in cordel; perhaps the most significant was Father Cicero, a charismatic leader in the uplands at the turn of the century. He lived in Juazeiro do Norte, Ceará, a major center for cordel, and was frequently cited in political pamphlets (17, 18). Both these texts were written by Abraão Batista, an important writer, illustrator, and publisher of modern cordel. He got into serious trouble during the military government for pamphlets that denounced scandals involving local politicians (37). When the political winds changed he became responsible for cultural affairs in Juazeiro no Norte. One of his texts was especially interesting because it had a picture of Father Cicero on the front wrapper, while the back wrapper publicized the electoral preferences of the author (18). Father Cicero is such an important figure in the culture of the North East that a pamphlet describing a visit of Sarney to Juazeiro mentioned Father Cicero almost as often as it did the president (19). Readers were told how Sarney signed documents in front of the bronze statue of Father Cicero, visited the monument to him, laid flowers on his tomb, and prayed there. Modern religious leaders also appeared in cordel; an electoral pamphlet of Nilo Coelho, senator for Pernambuco, used on

the wrapper a photograph of him with Friar Damian, a missionary famous in the interior (72).

In traditional Catholicism there are sinners and saints, heaven and hell; in political cordel there are good politicians and bad, with no shades of gray. Tancredo literally became a saint, while Maluf was frequently compared to the devil. At one stage pamphlets on Sarney were almost totally positive, then they became almost entirely negative. Such contrasts can be noted in the writings of other North Easterners, such as Jorge Amado. Another interesting point is that the image of the president in political cordel is not very different from that of God in traditional Catholicism. Both are far-off figures over which mere mortals have little control; both are capable of doing anything they desire while the destiny of the people depends solely upon their decisions.

### Specialized Cordel Formats

Cordel is normally presented as a verse story, but several other specialized verse presentations were also used in a political context in the period discussed. One common format is the "ABC," a set of twenty-six verses, each beginning with a different letter of the alphabet. Rodolfo Coelho Cavalcante, the most prolific cordel writer of all time, prepared an "ABC of Delfim Netto and the problem of inflation" (28). The National Conference of Brazilian Bishops also used the format to inform rural workers of their rights (1). Sá de João Pessoa invented a creative variation in his "Tancredo: 39 days of agony": each verse described one day of the period when Tancredo was dying in the hospital (68).

Another typical cordel format is the verse duel, known as a *peleja*, where two poets speak alternate verses and attempt to gain the upper hand. An interesting one was published to support the campaign for direct elections. Two poets held a verse duel in a restaurant in Brasília and published a pamphlet to publicize the event (109). More recently a poet matched José Sarney and the PMDB candidate as his successor, Ulysses Guimarães, in a verse duel (59). The "galloping hammer" is a verse form very effective in public presentations but little used in printed pamphlets. Crispiano Neto, the factory gate poet, used it to great effect in a pamphlet entitled "My hammer" (65). This is, clearly, the hammer that is normally comrade to the sickle: "My hammer is made of Polish steel/Forged by a Sandinista/On orders from the PLO/A message came from El Salvador/Where they need that kind of hammer."

## Conclusions

In the past the cordel poet had a role similar to that of a journalist, informing the semiliterate population of events of importance. José Soares of Recife called himself the "Poet-Reporter" and would rush out a pamphlet on every event of interest. The situation seems to be slightly different now; readers are constantly bombarded by factual information from television, radio, and newspapers; modern media have achieved a deep penetration among the urban poor. Cordel readers will not, in general, encounter new factual information in the pamphlets they read; many pamphlets openly describe imaginary events. The writer of political cordel is often commenting upon an occurrence whose basic facts are already known to the reader, via radio or TV. No Brazilian, even in the most remote regions of the country, could have been unaware of Tancredo's election, illness, and death. Purchasers of cordel did not buy pamphlets to discover that fact; they bought them to find out what the poet had to say about the event and to have a cheap memento of something that had affected them deeply. Here the cordel poet is in roughly the same position as a cartoonist, making a creative comment that can help people to relate to a confusing, complex, universe. There is nothing negative about this evaluation; the cartoon is prominently displayed on the editorial pages of most newspapers every day. For many people it is the first item they examine on the inside pages of the paper. The fact that journalists and photographers are available to convey the hard facts of an event releases cartoonists and poets to make their personal creative contribution.

For the student of Brazilian politics, cordel opens another cultural window, unusual, fascinating, a pleasant relief from the grinding march of political events and the pages of ideological prose. It is normal for writers of books on politics to illustrate their texts with reproductions of relevant cartoons and posters. Such resources break the tedium of the printed page and bring the story alive for the reader. The writer on Brazilian politics has an additional resource; it is possible to quote from cordel literature, or use the wrappers of pamphlets as illustrative materials.

Historians and sociologists frequently lament the lack of texts left to posterity by the silent majority, the mass of the population that is born, lives, and dies without ever leaving written records of their opinions. It is difficult to obtain texts in which ordinary people—workers, farmers, slaves, or housewives—write of their lives. But cordel is written by persons of low social status: mostly skilled working class, emerging middle class at the highest. Such people have produced

thousands of texts relating to political events, life in Brazil and the world as they see it. It is not possible to ignore this wealth of material in studies on Brazil. Cordel literature opens a fascinating window on Brazilian reality and offers us insights into popular attitudes which are not available for other countries and cultures.

## BIBLIOGRAPHY

1. *ABC da parceria.* Recife: CNBB, 1980?. 8 pp.

2. Almeida, Atila Augusto F. de, and José Alves Sobrinho. *Dicionário bio-bibliográfico de repentistas e poetas de bancada.* João Pessoa: Editora Universitária, 1978. 2 vols.

3. Almeida, Júlio Gomes. *Dom Helder: o irmão dos pobres.* São Paulo: 198-?. 8 pp.

4. Almeida Filho, Manoel de. *O Presidente Tancredo: a esperança que não morre.* São Paulo: Luzeiro, 1985. 32 pp.

5. Alves, Edeildo. *A esperança voltou.* Recife, 1987. 8 pp.

6. Alves, Celestino. *Doutor Tancredo Neves: uma vida pela democracia.* Brasília, 1985. 31 pp.

7. Alves, Raul de Carvalho. *O Brasil encontrou a saída?* S.l., 1979?. 28 pp.

8. Arruda, Zé de. *O filho de Satanás no colégio eleitoral.* Recife, 1984. 6 pp.

9. Barros, Homêro do Rêgo. *Tancredo de Almeida Neves: o mártir que não morreu.* Recife, 1985. 8 pp.

10. _____. *A trágica morte do Ministro Marcos Freire e dos seus companheiros do INCRA.* Recife, 1987. 8 pp.

11. _____. *A vitória de Tancredo e a vibração nacional.* Recife, 1985. 8 pp.

12. Basílio, Manoel. *O Brasil chora por Tancredo.* 3d ed. Caruaru, PE, 1985. 8 pp.

13. _____. *O prefeito desafio que mudou Caruaru: José Queiroz, primeiro ano de administração.* Caruaru, PE, 1986? 8 pp.

14. _____. *Vitória de Tancredo e o fim da ditadura.* Caruaru, PE, 1985. 8 pp.

15. Batista, Abraão. *Carta-resposta do Presidente Sarney a Jesus Cristo.* Juazeiro do Norte, CE, 1988. 8 pp.

16. _____. *A misteriosa carta de Tancredo Neves ao povo brasileiro.* Juazeiro do Norte, CE, 1985. 16 pp.

17. _____. *Relato da macabra campanha política de 1986 em Juazeiro do Norte.* 3d ed. Juazeiro do Norte, CE, 1987. 8 pp.

18. _____. *Respeitem o Padre Cícero e o povo de Juazeiro do Norte.* 2d ed. Juazeiro do Norte, CE, 1986. 3 pp.

19. _____. *A visita do Presidente Sarney a Juazeiro do Norte.* Juazeiro do Norte, CE, 1986. 8 pp.

20. Bezerra, Gonçalo Gonçalves (Poeta Gongon). *Nova república, novas medidas e novo Brasil: governo José Sarney, defensor do nosso povo.* Brasília, 1986. 4 pp.

21. *Camponeses unidos!* Recife: FETAPE/CONTAG, 1979. 16 pp.

22. *Camponeses unidos: lutam por seus direitos.* Recife, 1980. 9 pp.

23. Carneiro, Iverson. *Todos na rua outra vez: diretas já.* Rio de Janeiro, 1984. 8 pp.

24. Carneiro, J. *Manifesto ao povo nordestino: cordel.* Rio de Janeiro?, 1986?. 5 pp.

25. *Carta aos trabalhadores da cana.* Recife: CNBB, 1981. 12 pp.

26. Carvalho, Elias A. de. *Tancredo, mensageiro da esperança.* Duque de Caxias, RJ, 1985. 8 pp.

27. Carvalho, Rafael de. *A volta de Prestes.* São Paulo:, 1979. 15 pp.

28. Cavalcante, Rodolfo Coelho. *ABC de Delfim Netto e o problema da inflação.* Literatura de cordel, 1577. Salvador, 1982. 8 pp.

29. _____. *Paixão e morte do Dr. Tancredo Neves: o glorioso mártir da nova república.* Literatura de cordel, 1721. Salvador, 1985. 8 pp.

30. "Chiquinho do Pandeiro" and João José dos Santos (Azulão). *A carta de Jesus Cristo ao Presidente Sarney.* Rio de Janeiro, 1987?. 8 pp.

31. Coelho, Antonio Resplandes. *A história dos 13 posseiros do Araguaia: como eles foram enganados e injustiçados.* Belém: Movimento pela Libertação dos Presos no Araguaia, 1983. 19 pp.

32. Conceição, Antônio Ribeiro da (Bule-Bule). *José Sarney obrigado pela sua decisão.* [Salvador], 1986. 8 pp.

33. Costa, Paulo Vasconcelos da. *A greve dos assalariados rurais de São Francisco do Pará* (Paracrévea). São Francisco do Pará, PA, 1985. 10 pp.

34. Curran, Mark J. *A presença de Rodolfo Coelho Cavalcante na moderna literatura de cordel.* Rio de Janeiro: Nova Fronteira, 1987. 324 pp.

35. Freitas, José. *O Presidente Sarney trazendo a Lei do Cruzado.* Juazeiro do Norte, CE, 1986. 8 pp.

36. Heitor, L. *História rimada de um candidato porreta: ele enfrentou a ditadura sem ter medo de careta.* Anápolis, 1986. 16 pp.

37. Hallewell, Laurence. *Books in Brazil: A History of the Publishing Trade.* Metuchen, NJ: Scarecrow Press, 1982. 485 pp.

38. Hallewell, Laurence, and Cavan McCarthy. "Bibliography of Brazilian Chapbook Literature." In Dan C. Hazen, ed., *Latin American Masses and Minorities: Their Images and Realities.* SALALM XXX. Princeton University, Princeton, New Jersey, June 19–23, 1985. Madison, WI: SALALM, 1987. Vol. 2, pp. 683-707.

39. _____. *Brazilian Chapbook Literature.* In ibid., vol. 1, pp. 361-379.

40. Helena, Raimundo Santa. *Desagravo ao Tancredo.* Rio de Janeiro, 1985. 8 pp.

41. _____. *Direta jaz na cova do satanás.* Rio de Janeiro, 1984. 7 pp.

42. Jucá, Ana Lúcia Sabino. *Sarney está indo com o Brasil de contramão.* 2d ed. Fortaleza, 1987? 15 pp.

43. Leonardo. *Queremos diretas já! para todos brasileiros.* Recife, 1984. 8 pp.

44. Lessa, Origenes. *Getúlio Vargas na literatura de cordel.* Rio de Janeiro: Documentário, 1973. 150 pp.

45. Lima, Luiz Gonzaga de (Gonzaga de Garanhuns). *O grande encontro de Tancredo e Tiradentes no céu.* Garanhuns, PE, 1985. 8 pp.

46. Lima, Manoel Costa. *A caminhada e a luta dos agricultores de Coqueirinho e Cachorrinho pela desapropriação.* João Pessoa: CDDH, [1979]. 16 pp.

47. Luyten, Joseph M. *Bibliografia especializada sobre literatura popular em verso.* São Paulo: ECA/USP, 1981? 104 pp.

48. Luzeiros, Labareda dos. *ABC das diretas.* [São Paulo?, 1984]. 7 pp.

49. Maia, Ary Fausto. *Os posseiros do Maranhão.* Rio de Janeiro, 1986?. 10 pp.

50. Macedo, Téo. *O tumulto dos desempregados em São Paulo.* [São Paulo:, 1983]. 8 pp.

51. Machado, Franklin (Franklin Maxado Nordestino). *O encontro de Juscelino com Tancredo no paraíso.* São Paulo:, 1985. 8 pp.

52. _____. *Eu quero é botar meu voto na urna direta para presidente.* São Paulo:, 1983. 8 pp.

53. _____. *Maxado apoia Tancredo, mas luta pelas diretas.* São Paulo:, 1984. 8 pp.

54. _____. *Vamos dar o calote para sobrevivermos.* São Paulo:, 1983. 8 pp.

55. Maria, Manoel Santa. *A chegada de Tancredo no céu.* 2d ed. Araruama, RJ, 1985. 8 pp.

56. _____. *Cruzado II: um chute no saldo da classe média.* Araruama, RJ, 1986. 8 pp.

57. _____. *Cruzeiro vai a nocaute com um cruzado da direita.* Araruama, RJ, 1986. 12 pp.

58. _____. *Morte de Chico Mendes deixou triste a natureza.* Araruama, RJ, 1988. 8 pp.

59. _____. *Peleja de Zé Sarney com Ulisses Guimarães.* Araruama, RJ, 1988. 8 pp.

60. Melo, Veríssimo de. *Tancredo Neves na literatura de cordel.* Série Brasílica, 1. Belo Horizonte: Itatiaia, 1986. 63 pp.

61. Menezes, Otávio. *Zé Sarney, gasolina e inflação: as desgraças do Brasil.* Fortaleza, 1988. 8 pp.

62. Moreira, Flávio Poeta Fernandes, and Apolônio Alves dos Santos. *A carta de Tancredo endereçada a Sarney.* Duque de Caxias, RJ, 1985. 8 pp.

63. Moreira, Flávio Poeta Fernandes. *O herói presidente e o famoso pacotão.* Duque de Caxias, RJ, 1986. 8 pp.

64. Neto, Crispiano. *Cordel nas portas das fábricas.* São Paulo: Centro de Pastoral Vergueiro, 1984. 52 pp.

65. _____. *Meu martelo.* Mossoró, RN, 1983?. 4 pp.

66. Nobre, Carlos. *Conversa de cumpadre sobre anistia em versos.* Crateus, CE: Comité brasileiro pela Anistia: CE, 1979. 4 pp.

67. *A peleja do P.T. contra o bicho ditadura e o monstro capitalismo.* Campina Grande, PB: Partido dos Trabalhadores, Comissão Provisória Estadual da Paraíba, 1981?. 20 pp.

68. Pessoa, Sá de João. *Tancredo: 39 dias de agonia.* São Paulo:, 1985. 8 pp.

69. Pessoa, Sá de João, and Franklin Machado (Franklin Maxado Nordestino). *Os milagres de São Tancredo.* São Paulo:, 1985. 8 pp.

70. Piripiri, João José. *A hora e a vez do trabalhador.* Teresinha, PT-Pi, 1980. 11 pp.

71. Queiroz, Souza. *Tancredo não morreu, mataram.* São Bernardo do Campo, SP, 1985. 8 pp.

72. Quixabeira, Manoel. *Porque voto em Nilo Coelho.* Caruaru, PE, 1978. 8 pp.

73. Ramos, João Crispim. *A vitória de Waldir e a queda da ditadura.* Feira de Santana, BA, 1986. 8 pp.

74. *Reforma agrária já: o apelo dos bispos trocado em miúdos.* Recife: CDDH-CNBB, 1985. 16 pp.

75. Regis, Iracema M. *Seu Zé Sarney, o presidente do povo.* Mauá, SP, 1986?.

76. Santos, Apolônio Alves dos. *Brizola quer tocar fogo no bigode de Sarney.* Rio de Janeiro, 1988?. 8 pp.

77. _____. *Uma carta que veio do céu para o Presidente Figueiredo falando à favor do pobre.* Rio de Janeiro, 1981. 8 pp.

78. _____. *Greve e mortes em Volta Redonda, RJ.* Rio de Janeiro, 1988. 8 pp.

79. _____. *A guerra contra a inflação e o valor do cruzado.* Rio de Janeiro, 1986.

80. _____. *Novo pacote depois da eleição: foi traição!* Rio de Janeiro, 1986. 8 pp.

81. _____. *A sonegação da carne difama o Plano Cruzado.* Rio de Janeiro, 1986. 8 pp.

82. _____. *Tancredo envia do céu mensagem a Constituinte.* Rio de Janeiro, 1987. 8 pp.

83. _____. *Vida e morte de Tenório, o homem da capa preta.* Rio de Janeiro, 1988. 8 pp.

84. Santos, João José dos (Azulão). *Brizola é a solução.* Rio de Janeiro, 1988. 8 pp.

85. _____. *Tancredo: o segundo Tiradentes.* Rio de Janeiro, 1985. 8 pp.

86. Santos, Leonardo Rodrigues dos. *Vitória esmagadora de Miguel Arraes de Alencar no Estado de Pernambuco.* Recife, 1985. 8 pp.

87. Santos, Valeriano Feliz dos. *Tancredo Neves: um novo Tiradentes.* Simões Filho, BA, 1986?. 8 pp.

88. Silva, Antonio Manoel da. *Vida, luta e morte do Ministro Marcos Freire*. Caruaru, PE, 1987. 8 pp.

89. Silva, Expedito F. *O fim do arrocho e os preços congelados*. Cordel, 149. Rio de Janeiro, 1986.

90. Silva Gonçalo Ferreira da. *Carta de Tancredo Neves aos constituintes*. Rio de Janeiro, 1987. 8 pp.

91. _____. *Delfim deu fim no Brasil*. Rio de Janeiro, 1980?. 8 pp.

92. _____. *Morreu o valente Tenório*. Rio de Janeiro, 1987. 8 pp.

93. _____. *Morreu São Tancredo Neves deixando o Brasil de luto*. Rio de Janeiro, 1985. 8 pp.

94. _____. *Presidente João Teimoso*. Rio de Janeiro, 1980?. 8 pp.

95. *Procura-se um presidente*. Rio de Janeiro, 1987. 8 pp.

96. Silva, João José da. *É povo no centro*. Coleção folhetos nordestinos, 9. Recife: 1987. 8 pp.

97. _____. *A vitória de Arraes e a volta ao Palácio das Princesas*. Recife, 1987. 8 pp.

98. Silva, José Arnaldo. *As memórias de Tenório, o homem da capa preta*. Nova Iguaçu, RJ, 1988.

99. Silva, Minelvino Francisco. *História da cova de Tancredo Neves e seus milagres*. Itabuna, BA, 1985?. 8 pp.

100. _____. *A morte do Doutor Juscelino e sua chegado no céu*. Itabuna, BA, 1976. 8 pp.

101. _____. *A palestra de Tancredo Neves com Getúlio Vargas no céu sobre a reforma agrária*. Itabuna, BA, 1985. 8 pp.

102. _____. *A vitória de Tancredo Neves e a derrota de Paulo Maluf*. Itabuna, BA, 1985. 8 pp.

103. Silva, Olegário Fernandes da. *A morte de Dr.* Evandro vereador de Surubim. Caruaru, PE, 1987. 8 pp.

104. _____. *A morte do Presidente Tancredo Neves*. Caruaru, PE, (1985). 4 pp. Bound with his: *A vitória de Tancredo*. 4 pp.

105. Silva, Severino Pereira da. *O prefeito Luiz Francisco de Vasconcelos e suas realizações*. Pedras de Fogo, PB, 198-? 12 pp.

106. Slater, Candace. *Stories on a String: The Brazilian Literatura de Cordel*. Berkeley, CA: University of California Press, 1982. 313 pp.

107. Soares, José. *Anistia ampla e a volta de Arraes.* Recife, 1979. 8 pp.

108. _____. *A chegada de Arraes.* Recife, 1979. 8 pp.

109. Sousa, José Moacir de, and Zé Golvéia. *Peleja das diretas: o desafio do ano.* Brasília, 1984. 8 pp.

110. Sousa, Manoel Matusalém. *A igreja e o povo na literatura de cordel.* São Paulo: Edições Paulinas, 1984. 123 pp.

111. Sousa, Paulo Teixeira de. *PT e o Brasil brasileiro.* Rio de Janeiro, 1986?.

112. Torres, Heleno Francisco. *Biografia do candidato a Deputado Estadual, José Joventino Melo Filho (Zito).* Guarabiraba, PE, 1978. 8 pp.

113. "O Travador Sertanejo." *Mata de São João e sua política: Edvaldo Ribeiro, candidato a prefeito.* Mata de São João, BA, 1978?.

114. Zênio, Francisco. *Encontro do Presidente Tancredo Neves com Getúlio Vargas.* Juazeiro do Norte, CE, 1985?. 8 pp.

# About the Authors

GERALD ALEXIS FILS is Director General and Curator of the National Museum of Haiti. At the time of the conference he was on leave at the University of Texas at Austin as a Fulbright Scholar.

CLAUDIA NEGRÃO BALBY is a librarian and supervisor of Serviço de Biblioteca e Documentação de São Paulo, Brazil.

ELSA BARBERENA B. is a professor at the Graduate School of Library Science and Coordinadora de Bibliotecas, Faculdad de Filosofía y Letras, Universidad Nacional Autónoma de México. She is responsible for the biobibliographical database MEXICOARTE.

DAVID BLOCK is Latin American Librarian at Cornell University. His introduction to the Andes and their textiles came as a Peace Corps volunteer in the late 1960s. He maintains keen interest in both.

JORGE I. BUSTAMANTE is Director General of Multiconsult and Dataconsult in Mexico City and professor at the Graduate School of Library Science at the Universidad Nacional Autónoma de México.

MARTHA DAVIDSON is picture researcher, photo editor, and consultant for publishers, film producers, and museums, and Grants Manager for the Center for Conservation and Technical Studies of the Fogg Art Museum at Harvard University.

MARTA DOMÍNGUEZ DÍAZ, specialist in Chilean publications, is Director of the book export firm Servicio de Extensión de Cultura Chilena al Mundo (SEREC) in Santiago, Chile.

GEORGE ESENWEIN is Library Specialist for the Latin American and North American collections at the Hoover Institution, Stanford University.

MARTA GARSD is an art historian. She has lectured at the University of California, Davis and at the American University in Washington, DC. Her most recent publication on Latin American art is a study on the work of Cuban painter Wifredo Lam (1987).

THOMAS P. GATES is Fine Arts Librarian for the Meadows School of the Arts at Southern Methodist University.

NELLY S. GONZÁLEZ is Head of the Latin American Library Services Unit and Associate Professor of Library Administration at the University of Illinois at Urbana-Champaign.

WERNER GUTTENTAG TICHAUER is bibliographer, bookdealer, publisher, and owner of Los Amigos del Libro in Cochabama, Bolivia.

J. NOÉ HERRERA C. is owner of Libros de Colombia y Latino-América in Bogotá, Colombia.

PETER T. JOHNSON is Bibliographer for Latin America, Spain, and Portugal and a lecturer in the Program in Latin American Studies at Princeton University.

BEVERLY JOY-KARNO is a bookdealer and specialist in Latin American art. She is co-owner of Howard Karno Books in Valley Center, California.

DAVID L. LEVY is Attorney-Advisor in the Visual Arts Section, Examining Division, Copyright Office, Library of Congress and a member of the Washington, DC and the U.S. Supreme Court Bars.

MARÍA LEYVA is a graduate student at the School of Library and Information Science, Catholic University of America, Washington, DC. At the time of the conference she was Curator for the Permanent Collection at the Museum of Modern Art of Latin America, of the OAS, in Washington, DC.

PATRICIA LONDOÑO is Profesora Asociada, Departmento de Sociología, Universidad de Antioquia in Medellín, Colombia, a member of the technical committee of the Centros de Memoria Visual, and author of numerous articles on Colombian historical photography.

CAVAN M. MCCARTHY is a professor in the Departamento de Biblio-teconomia, Universidade Federal de Pernambuco, Recife, Brazil, and a specialist in publications of the Brazilian North East.

BRENT F. MADDOX is Assistant Photo Archivist at the Getty Center for the History of Art and the Humanities and review editor for *Visual Resources: An International Journal of Documentation*, and contributor to the Visual Resources Association *Bulletin*.

ANA MARÍA MAGALONI, Keynote Speaker at the conference, is Director General of Libraries, Secretaría de Educación Pública, in Mexico, since 1983, researcher at the Centro Universitario de Investiga-ciones Bibliotecólogicas, and professor at the Graduate Library School of the Universidad Nacional Autónoma de México.

ANDREW MAKUCH is Bibliographer for Collection Development at the University of Arizona.

FRED. G. MORGNER, specialist in publications of political movements and marginalized groups, is co-owner of the book export firm Literatura de Vientos Tropicales.

BARBARA MORRIS is Assistant Professor of Spanish in the Department of Modern Languages at Fordham University. A specialist in contemporary narrative of Spain and Latin America, her articles on women in Hispanic cinema appear in *Letras femeninas* and *Discurso literario*.

ALAN MOSS is a librarian at the University of the West Indies, Cave Hill Campus, Bridgetown, Barbados, and a bookseller.

RHONDA L. NEUGEBAUER is Latin American Art Specialist in the Hayden Library at Arizona State University. At the time of the conference she was Latin American Specialist and Cataloger at the Watson Library of the University of Kansas.

OSCAR E. QUIRÓS, specialist on Cuban popular culture and cinema, is a doctoral candidate in the Department of Theater and Film at the University of Kansas. His directing credits include films in Costa Rica and theater productions at the University of Kansas.

WILLIAM RATLIFF is Curator of the Latin American and North American collections for the Hoover Institution at Stanford University.

STELLA M. DE SÁ RÊGO is Photoarchivist in the Special Collections Department of the General Library of the University of New Mexico and art historian. She has published on modern Brazilian painting, nineteenth-century Brazilian photography, and cataloging of photographs.

BARBARA J. ROBINSON is Curator of the Boeckmann Center's Collection and Selector for Iberian and Latin American Studies at the University of Southern California Libraries. She was President of SALALM in 1988–1989.

SONIA T. DIAS GONÇALVES DA SILVA is Directora Técnica de Coleções Especiais da Universidade Estadual de Campinas, Estado de São Paulo, Brazil.

LEE R. SORENSEN is Head of Reference at the East Campus Library of Duke University. At the time of the conference he was the Art Librarian for Reference at the University of Arizona Library. He holds a Masters in Art History from the University of Chicago.

WILHELM STEGMANN, Director of the Ibero-Amerikanische Institut in Berlin from 1974 to 1986, continues in retirement his research on Latin America and edits the journal *Ibero-Amerikanisches Archiv*.

PETER A. STERN is Latin American Librarian of the Latin American Collection at the University of Florida, Gainesville.

SCOTT J. VAN JACOB is Serials Librarian at Dickinson College.

ALFONSO VIJIL is owner of Libros Latinos and Libros Centro-americanos in Redlands, California.

MARGARITA JARABEK WUELLNER is an Architectural Historian with Land and Community Associates in Charlottesville, specializing in historic preservation and community planning. At the time of the conference she was a Masters candidate in architectural history at the University of Virginia and Library Assistant to the Ibero-American Bibliographer.

# Conference Program

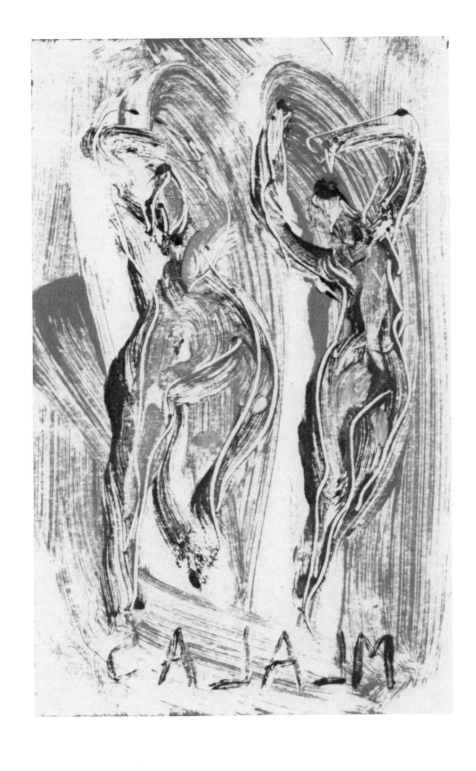

SEMINAR ON THE ACQUISITION OF
LATIN AMERICAN LIBRARY MATERIALS XXXIV

MAY 27 - JUNE 1, 1989

*ARTISTIC REPRESENTATION OF
LATIN AMERICAN DIVERSITY:
SOURCES AND COLLECTIONS*

ALDERMAN LIBRARY
UNIVERSITY OF VIRGINIA
CHARLOTTESVILLE

## SALALM EXECUTIVE BOARD

**President:**

Barbara J. Robinson
University of Southern California

**Vice-President/President-Elect:**

Ann Hartness
Library of Congress, Rio de Janeiro Office (1988-89)

**Past President:**

Paula Anne Covington
Vanderbilt University

**Treasurer:**

Jane Garner
University of Texas at Austin

**Executive Secretary:**

Suzanne Hodgman
University of Wisconsin-Madison

**Members at Large:**

Rafael Coutín
University of North Carolina, Chapel Hill (1986-89)

Deborah Jakubs
Duke University (1986-1989)

Donald Gibbs
University of Texas at Austin (1987-1990)

Ann Wade
British Library (1987-1990)

Lygia Ballantyne
Library of Congress (1988-1991)

C. Jared Loewenstein
University of Virginia (1988-1991)

**Rapporteur General:**

Charles S. Fineman
Northwestern University

## LOCAL ARRANGEMENTS COMMITTEE

C. Jared Loewenstein, Chairman
Kenneth O. Jensen
Linda L. Phillips
Jacqueline A. Rice
Rebecca A. Summerford
Carl C. Wuellner
Margarita Jerabek Wuellner

## SPONSOR

Alderman Library
University of Virginia

## MEETING SITE

All meetings will take place in the Omni
Charlottesville Hotel, located in the Downtown
Historic District.

The SALALM Conference Office is located in MR 8.

## REGISTRATION SCHEDULE

Saturday, May 27    Noon-5:00
Sunday, May 28      Noon-5:00
Monday, May 29      9:00-Noon

## EXHIBITS SCHEDULE

Book exhibits are located in the East Ballroom, Omni Charlottesville Hotel.

A sale exhibit of contemporary Haitian art is located in the Atrium, Omni Charlottesville Hotel.

An exhibit of recent Cuban art is located in the McIntire Room, Jefferson-Madison Regional Library, Downtown Branch, at 201 East Market Street, three blocks east and one block north of the hotel.

**Monday, May 29**

Book Exhibits
10:00-5:00

Art Exhibits
10:00-7:00

**Tuesday, May 30**

Book Exhibits
9:00-5:00

Art Exhibits
10:00-7:00

**Wednesday, May 31**

Book Exhibits
9:00-5:00

Art Exhibits
10:00-7:00

**Thursday, June 1**

Book Exhibits
9:00-Noon

Art Exhibits
10:00-Noon

## SATURDAY, MAY 27

**NOON-5:00** Conference Registration: Prefunction area

**1:00-2:30** Subcommittee on Serials (Birkhead): MR 1

Subcommittee on Non-Print Media (Malish): MR 4

Subcommittee on National-Level Cooperation (Jakubs): MR 2 & 3

Committee on Constitution and Bylaws (Loewenstein): MR 5

Subcommittee on Cuban Bibliography (Varona): MR 6 & 7

**2:30-4:00** Subcommittee on Gifts & Exchange (Miller): MR 1

Subcommittee of OCLC Users (Marshall): MR 6 & 7

Subcommittee of RLG Members (Rozkuscka): MR 4

Library, Bookdealer, Publisher Subcommittee (Ilgen): MR 2 & 3

HAPI (Valk): MR 5

**4:00-5:30**    Committee on Official Publications (Brem): MR 1

Subcommittee on Bibliographic Instruction (Hallewell): MR 5

Subcommittee on Reference Services (Hoopes): MR 3

Subcommittee on Special Bibliographic Projects (Rodríguez): MR 6 & 7

**New Member Orientation (Wisdom): MR 4**

Nominating Committee (Read): MR 2

**7:00-10:00**    LAMP (Gutiérrez-Witt): Junior Ballroom

## SUNDAY, MAY 28

**NOON-5:00** Conference Registration: Prefunction area

**8:00-9:30**    Subcommittee on Marginalized People & Ideas (Johnson): MR 2 & 3

Subcommittee on Cataloging & Bibliographic Technology (Phillips): MR 6 & 7

Subcommittee on Library Education (Ayala): MR 1

Editorial Board (Valk): MR 5

**9:00-6:00**    Book Exhibits set up: East Ballroom

| | |
|---|---|
| **10:00-11:30** | Acquisitions Committee (Block): MR 1 |
| | Outreach/Enlace (Sonntag): MR 4 |
| | Policy, Research, & Investigation Committee (Gibbs): MR 2 |
| | Membership Committee (Loring): MR 3 |
| **1:00-2:30** | Bibliography Committee (McNeil): MR 2 |
| | Task Force on Standards (Robinson): MR 1 |
| **2:30-4:00** | Library Operations & Services Committee (Williams): MR 1 |
| | Research Guide Editorial Board (Covington): MR 2 |
| | Finance Committee (Wisdom): MR 3 |
| **3:00-4:30** | Art Exhibit Lectures: Junior Ballroom |

|  |  |
|---|---|
| Introduction: | Rachel C. Barreto Edensword, U. S. Embassy (Mexico) |
| Cuban Art: | Deborah Schindler, Printmaker, Bethesda, Maryland |
| Haitian Art: | Gérald Alexis, Director, Musée de Panthéon Nationale d'Haiti |

| | |
|---|---|
| **4:00-5:30** | Inter-Library Cooperation Committee (Hazen): MR 1 |

**7:30-9:30**    Film: Junior Ballroom

              *Frida*

## MONDAY, MAY 29

**9:00-Noon**  Conference Registration: Prefunction area

**9:00-Noon**  Executive Board Meeting: MR 2 & 3

**10:30-11:30** Film & Coffee: Junior Ballroom

              *Art and Revolution in Mexico*

**1:15-2:30**    Opening of SALALM XXXIV: West Ballroom

Opening:         Barabara J. Robinson,
SALALM President,
University of Southern
California

Introductory
Remarks:      C. Jared Loewenstein,
Ibero-American Bibliographer,
University of Virginia Library

Welcome:      Ray W. Frantz, Jr.,
University Librarian,
University of Virginia

Welcome:      Donald L. Shaw,
Brown-Forman Professor of
Latin American Literature,
Chair, Latin American Studies,
University of Virginia

Keynote
Address:       Ana María Magaloni,
Director General of Libraries,
Secretaría de Educación
Pública, México
*El papel del Gobierno Mexicano
en en apoyo del desarrollo
cultural*

**2:30-3:00**    Film & Coffee: Junior Ballroom

*Through the Camera Lens: Views of Slavery in
19th-Century Brazil and the United States*
(video)

**3:00-5:00**    Theme Panel I: West Ballroom

*Art and Photography as Teaching Aids and Research Resources*

Chair: Glenn Read, Indiana University

Russell Salmon, Indiana University: *Show and Tell: Teaching Latin American Literature through the Arts*

Robert M. Levine, University of Miami: *Through the Camera Lens: Views of Slavery in 19th-Century Brazil and the United States*

Patricia Londoño, University of Antioquía, Medellín, Colombia: *A Visual Study of Daily Life Among Urban Colombian Women, 1800-1930*

Ludwig Lauerhass, University of California, Los Angeles: discussant

Rapporteur:    Sheila A. Milam
                        Arizona State University

**5:30**    Buses leave Hotel (Water St. entrance) for Ash Lawn Reception

**6:00-8:00**    Book Dealers' Reception at Ash Lawn, Home of U.S. President James Monroe

## TUESDAY, MAY 30

**8:30-10:00**  Workshop: MR 2 & 3

*The Latin American Presence in the Arts in Madrid During ARCO '89*

Chair: Linda L. Phillips, Alderman Library, University of Virginia

**8:30-10:00**  Workshop, Sponsored by the Subcommittee on Reference Services: MR 6 & 7

*Reference Service in the Arts*

Chair: María Segura Hoopes, Main Library, University of Arizona

Scott Van Jacob, Dickinson College: *Dramatic Arts in Latin America: A Guide to Reference Sources*

Lee Sorensen, Main Library, The University of Arizona: *Art Reference: Looking at Visual Information for Latin America*

Andrew Makuch, Main Library, University of Arizona: *From Zarabanda to Salsa: An Overview of Reference Sources on Latin American Music*

**10:00-10:30**  Film & Coffee: Junior Ballroom

*Nandutí*

**10:30-Noon** Theme Panel II: West Ballroom

*Art and Politics in 20th-Century
Latin America*

Chair: Rafael E. Tarragó, Hesburgh Library,
University of Notre Dame

Marta Garsd, Art Historian: *Reflexions on
Some Aspects of Argentinian Art Under the
Military Dictatorship, 1973-1986*

Peter Stern, University of Florida Libraries:
*"Levantando al pueblo": Art and the State in
Post-Revolutionary Mexico and Cuba*

David Block, Cornell University Libraries:
*Andean Textiles: Aesthetics, Iconography, and
Political Symbolism*

Rapporteur:   Tamara Brunnschweiler
Michigan State University

**1:30-3:00**     Theme Panel III: West Ballroom

*Challenges of Collecting and Using*
*Latin American Art Materials: Understanding*
*The Access Issues*

Chair:  Rhonda L. Neugebauer,
        University of Kansas

Dr. Selma Holo, Director, University of
Southern California, Fisher Gallery:
*Contemporary Mexican Art: Beyond Muralism*

Alberto Ruy Sánchez, (Director Comercial)
<u>Artes</u> <u>de</u> <u>México</u>: *Production and Utilization of*
*Art Journals in Research*

Dra. Elsa Barbarena, Professor, Library
Science, Universidad Nacional Autónoma de
México: *Researching Latin American Art:*
*Access Through Published Materials and*
*Databases*

Dr. Jorge I. Bustamante, Director,
Multiconsult, and Professor, Universidad
Nacional Autónoma de México: *Optical Disk*
*Possibilites in the Distribution of Information on*
*Latin American Art*

Rapporteur:   María Otero-Boisvert,
              Columbia University

**3:00-3:30**     Film & Coffee: Junior Ballroom

*Art of the Fantastic: Latin America, 1920-1987*

| 3:30-5:00 | Theme Panel IV: West Ballroom |
| --- | --- |

*The Art Museum Library: Resources for the Study of Latin American Arts*

Chair: Beverly Joy Karno,
   Howard Karno Books

Ben Huseman, Curatorial Assistant, Amon Carter Museum: *19th-Century Mexican Lithographs in the Amon Carter Collection*

Tom Gates, Fine Arts Librarian, Meadows School of the Arts

María Leyva, Museum of Modern Art of Latin America, Organization of American States

Wilhelm Stegmann, Retired Director, Ibero-Amerikanisches Institut Preussischer Kulturbesitz, Berlin: *Artistic Representation of Latin America in German Book Collections and Picture Archives*

Rapporteur:   Pamela F. Howard
   Arizona State University

| 5:30 | Buses leave Hotel (Water St. entrance) for Library Reception |
| --- | --- |
| 6:00-8:00 | University of Virginia Grounds Tour and Alderman Library Reception |

## WEDNESDAY, MAY 31

**8:30-10:00**  Workshop, sponsored by the Subcommittee on Cataloging and Bibliographic Technology: MR 2 & 3

*Workshop on Cataloging*

Chair:  Richard F. Phillips,
   Princeton University

Brent F. Maddox, Assistant Photo Archivist, Getty Center for the History of Art & the Humanities: *Visual Resource Cataloging at the Getty Center for the History of Art & the Humanities*

Claudia Negrão Balby, Universidade de São Paulo: *Bibliographic Control of Art Materials: the Experience of the University of São Paulo*

**8:30-10:00** Workshop, sponsored by the Subcommittee on Marginalized Peoples and Ideas: MR 6 & 7

*Meeting the Guidelines for Improving the Representation of Marginalized Peoples and Ideas in Latin American Collections*

Chair: Peter T. Johnson,
Princeton University

Vera de Araujo Shellard, Susan Bach, Ltd.:
*Brazilian Ethnic Groups and Political Parties*

Alfonso Vijil, Libros Latinos: *Nicaraguan FSLN and its Opposition*

Marta Domínguez Díaz, Servicio de Extensión Cultural al Mundo: *Chilean Political Transition*

Fred G. Morgner, Literatura de Vientos Tropicales: *The Nicaraguan War & Human Rights in Honduras*

Peter T. Johnson, Princeton University:
*Guidelines for Collection Documentation on Marginalized Peoples and Ideas*

Cavan McCarthy, Universidade Federal de Pernambuco: *Recent Political Developments as Illustrated by Cordel*

**10:00-10:30** Film & Coffee: Junior Ballroom

*Carmen Carrascal*

**10:30-Noon** Library of Congress Roundtable: MR 2 & 3

*Collection Developments at the Library of Congress*

Chair: Cole Blasier, Chief, Hispanic Division, Library of Congress

William Sittig, Collections Development Office, Library of Congress

Terry Peet, Hispanic Acquisitions Section, Exchange and Gift Division, Library of Congress

E. Christian Filstrup, Overseas Operations, Library of Congress

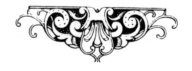

**10:30-Noon**  Theme Panel V: West Ballroom

*The Use and Care of Photographic Collections:*
*Access, Conservation and Copyright Issues*

Co-Chairs:  Martha Davidson, Center for
Conservation and Technical
Studies, Harvard University
Art Museums

Stella de Sá Rego,
General Library, University of
New Mexico

Stella de Sá Rego: *Access to Photographic*
*Collections*

Peter Mustardo, Conservation Department,
New York Municipal Archives: *Care and*
*Conservation of Photographs*

David Levy, Attorney, Visual Arts Section,
Copyright Office, Library of Congress: *Use*
*and Reproduction of Photographs: Copyright*
*Issues*

Rapporteur:  Angela M. Carreño
New York University

**Noon-1:30**  Film: Junior Ballroom

*Plaff!*

**1:30-3:00**   Theme Panel VI: West Ballroom

*New Issues on Latin American Cinema*

Chair:  Gayle Williams, University of
New Mexico General Library

Barbara Morris, Department of Modern
Languages, Fordham University: *Configuring
Women: the Discourse of Empowerment in
Spanish-American Cinema*

Oscar Quiros, Center for Latin American
Studies, University of Kansas: *Values and
Aesthetics in the Cuban Cinema*

Rapporteur:   Shelley J. Miller
University of Kansas

**3:00-3:30**   Film & Coffee: Junior Ballroom

*Art of Central America and Panama*

**3:30-5:00**   Bookdealers' Panel: West Ballroom

Chair: Joan Quillen,
   Libros Centroamericanos

Alan Moss, Alan Moss Current and
Antiquarian Caribbean Books: *Art Publishing
in the Contemporary Caribbean*

Alfonso Vijil, Libros Latinos: *Art Materials in
Central America*

Marta Domínguez Díaz, Servicio de
Extensión Cultural al Mundo: *Chilean Popular
Art of Marginalized Groups*

Werner Guttentag T., Los Amigos del Libro:
*Publication of Art Materials in Bolivia*

Noé Herrera, Libros de Colombia:
*Artísticamente: Colombia es la Atenas
suramericana...o apenas suramericana*

**7:00-9:00**   Meeting: MR 2 & 3

Intensive Cuban Collecting Group

**7:00-9:00**   Meeting: MR 6 & 7

Finance Committee

**THURSDAY, JUNE 1**

**8:30-10:00**   Workshop: MR 2 & 3

*Sources, Traditions and Innovations in Latin American Architecture: From the Bookshelf to Beyond Brasilia*

Chair:  Margarita Jerabek Wuellner,
School of Architecture,
University of Virginia

Margarita Jerabek Wuellner: *A Case Study in Approaching 19th- and 20th-Century Latin American Architecture: Sources and Methodology in the Investigation of Julián García Nuñez (1875-1944)*

Humberto Leonardo Rodríguez-Camilloni, Virginia Polytechnic Institute and State University: *Traditions and Innovations in 20th-Century Brazilian Architecture*

**8:30-10:00**  Theme Panel VII: West Ballroom

*Role of Posters in Latin American Information*

Chair: Lygia Ballantyne, Library of Congress

William Ratliff, Hoover Institute:
*Latin American Posters at the Hoover Institute:*
*Lexicon of Revolution and Politics*

Otílio Díaz, Casa de la Herencia Cultural
Puertorriqueña: *Puertorican Poster Art:*
*Perspectives of a Private Collector*

Lygia Ballantyne, Library of Congress:
*Collecting Posters for the Library of Congress:*
*the Brazilian Experience*

Fred G. Morgner, Literatura de Vientos
Tropicales: *Posters and the Sandinista*
*Revolution*

Rapporteur:   Nancy L. Hallock
University of Pittsburgh

**10:00-10:30**  Films & Coffee: Junior Ballroom

*Filemón y la Gorda*
*Guadalajara Library Mural*

**10:30-Noon**  Closing Session: West Ballroom

Business Meeting

Introduction of New Vice President/
President-Elect and Officers

**Noon-1:30**     Banquet (buffet luncheon): West Ballroom

**Noon-4:00**     Book Exhibits removed

**2:00-4:00**     Executive Board Meeting: MR 2 & 3

# EXHIBITORS

Alan Moss
4, Hopefield Close
Paradise Heights
Saint Michael
Barbados

Books From Mexico
Apartado Postal 22-037
Delegación Tlalpan
14000-México, D. F.
México

Caribbean Imprint Library Services
P. O. Box 350
West Falmouth, Massachusetts 02574
USA

Chadwyck-Healey, Inc.
1101 King Street
Alexandria, Virginia 22314
USA

Coutts Library Services, Inc.
736 Cayuga Street
Lewiston, New York 14092-1797
USA

Ediciones del Norte
P. O. Box A130
Hanover, New Hampshire 03755
USA

Editora Taller, C. por A.
Isabel la Católica 309 y 260
Santo Domingo
República Dominicana

Feria Internacional del Libro
Hidalgo 1417
AP 39-130
Guadalajara, Jalisco
44170 México

Fernando García Cambeiro
Latin American Books & Serials
Cochabamba 244
1150 Buenos Aires
Argentina

Herta Berenguer Publicaciones
Av. 11 de Septiembre 2155
Torre B. Oficina 511
Santiago
Chile

Howard Karno Books
P. O. Box 2100
Valley Center, California 92082
USA

Iberoamericana/Klaus Dieter Vervuert
Wielandstr. 40
6000 Frankfurt 1
West Germany

The Latin American Book Store
204 North Geneva Street
Ithaca, New York 14850
USA

Latin American Literary Review/Press
2300 Palmer Street
Pittsburgh, PA 15218

Librería de Antaño
Sánchez de Bustamante 1876
Buenos Aires
Argentina

Librería Linardi y Risso
Juan Carlos Gómez 1435
Montevideo
Uruguay

Librhisa Dominicana
Arzobispo Meriño 208
Apto. 207, Apartado Postal 2633
Santo Domingo
República Dominicana

Libros Centroamericanos
P. O. Box 2203
Redlands, California 92373
USA

Libros Latinos
P. O. Box 1103
Redlands, California 92373
USA

Literatura de Vientos Tropicales
Apartado 186
Código 1017
San José 2000
Costa Rica

Luis A. Retta-Libros
Paysandú 1827
C. C. 976
Montevideo
Uruguay

Melcher Ediciones
Apdo. 6000
San Juan, Puerto Rico 00906

Mexico Sur
P. O. Box 1682
Redlands, California 92373
USA

Multiconsult, SC
Insurgentes Sur 949-9
Col. Nápoles, 03810 México, D.F.
México

The Philadelphia Rare Books and Manuscripts Company
P. O. Box 9536
Philadelphia, Pennsylvania 19124
USA

Puvill Libros S. A.
Boters 10
Barcelona 08002
Spain

SALALM
728 State Street
Madison, Wisconsin 53706
USA

Scarecrow Press
52 Liberty Street
P. O. Box 4167
Metuchen, New Jersey 08840
USA

SEREC-CHILE
Portugal 12
Depto. 46
Santiago
Chile

Venezuelan Book Service
M-313 Jet Cargo International
P. O. Box 020010
Miami, Florida 33102-0010
USA

*This program for SALALM XXXIV
has been issued in an edition of
200 copies.*

*Graphic design and layout by
Margarita Jerabek Wuellner.*

*Cover monotype by
Linda Phillips.*